PRINTS AND RELATED DRAWINGS BY THE CARRACCI FAMILY

PRINTS AND RELATED DRAWINGS BY THE CARRACCI FAMILY

PRINTS AND RELATED DRAWINGS
BY THE CARRACCI FAMILY

A Catalogue Raisonné

DIANE DeGRAZIA BOHLIN

Indiana University Press, Bloomington and London

National Gallery of Art, Washington

First cloth edition published by Indiana University Press in association with the National Gallery of Art, 1979

This catalogue raisonné was produced by the Editors Office, National Gallery of Art, Washington

Printed by the Meriden Gravure Company, Meriden, Connecticut. Set in Garamond by Composition Systems Inc., Arlington, Virginia.

Designed by Melanie B. Ness

Published in conjunction with the exhibition
Prints and Related Drawings by the Carracci Family
held at the National Gallery of Art, Washington
March 18-May 20, 1979

Title page: Agostino cat. no. 200, state IV. Paris, Bibliothèque Nationale
Front end sheet: Agostino cat. no. 153 (detail). *Back end sheet:* Agostino cat. no. 154

Library of Congress Cataloging in Publication Data
Bohlin, Diane DeGrazia
Prints and related drawings by the Carracci family.
Includes bibliographical references and indexes.
1. Carracci family—Catalogs. I. United States.
National Gallery of Art. II. Title.
NE662.C288A4 1979 769'.92'2 79-51386
ISBN 0-253-12066-7

CONTENTS

INDEXES

FOREWORD

THE NATIONAL GALLERY OF ART IS PLEASED TO PRESENT THIS exhibition and catalogue in our continuing effort to sponsor scholarly studies of the prints and drawings of major artists. This is the first extensive exhibition of the prints of the Carracci family to appear in the United States and the first catalogue raisonné of their engravings and etchings since Bartsch's of 1818. We hope that, like the modern re-evaluations of their painted oeuvre, this re-evaluation of their graphic production will aid the growing appreciation of Bolognese art by the American museum public. Most of the works have never been displayed before, and their exhibition here presents an expanded and little-known side of the talents of this artistic family.

We are especially grateful to the public and private collectors who have generously allowed their works to appear in this exhibition. We would also like to thank all the members of the staff of the National Gallery of Art who have contributed their time and expertise to make this exhibition possible.

J. CARTER BROWN
Director

LENDERS
TO THE EXHIBITION

Graphische Sammlung Albertina, Vienna

Anonymous Lenders

The Art Institute of Chicago

The Art Museum, Princeton University

The Visitors of the Ashmolean Museum, Oxford

The Baltimore Museum of Art

The Trustees of the British Museum, London

The Trustees of the Chatsworth Settlement, Devonshire Collection

The Cleveland Museum of Art

Her Majesty Queen Elizabeth II

Fogg Art Museum, Harvard University, Cambridge

Grunwald Center for the Graphic Arts, University of California at Los Angeles

Hamburger Kunsthalle, Kupferstichkabinett

Houghton Library, Harvard University, Cambridge

Istituto Nazionale per la Grafica—Calcografia, Rome

The Library of Congress, Washington, D.C.

Cabinet des Dessins du Musée du Louvre, Paris

The Metropolitan Museum of Art, New York

The Pierpont Morgan Library, New York

Musée des Beaux-Arts et Archéologie, Besançon

Museo e Gallerie Nazionali di Capodimonte, Naples

Museum of Fine Arts, Boston

Nationalmuseum, Stockholm

The New York Public Library

Philadelphia Museum of Art

Tim Rice

Staatsgalerie Stuttgart, Graphische Sammlung

Gabinetto disegni e stampe degli Uffizi, Florence

The University of Chicago, The Joseph Regenstein Library

John Winter

ACKNOWLEDGMENTS

MY GRATITUDE GOES FIRST TO MY COLLEAGUE AT THE NATIONAL Gallery of Art, H. Diane Russell, who suggested some time ago that I work on an exhibition of Carracci prints. In what turned out to be a larger project than anticipated, she offered advice, read portions of the manuscript, and discussed, almost daily, numerous technical and art historical problems. During his internship in the Graphic Arts Department at the National Gallery, David Steel, Jr. enthusiastically contributed vast amounts of time and energy to various aspects of the catalogue, including the indexing and numbering of the entries, and also solved many iconographical puzzles. Nancy Ward Neilson kindly allowed me access to her extensive notes on the Carracci family prints. Mary Newcome Schleier and Charles Dempsey were especially generous with their time and expertise. Many colleagues listened to my questions, discussed thorny problems, and gave me photographs, among them Ian Bennett, Veronika Birke, Annamaria Edelstein, John Gere, Elizabeth Harris, Adrian Ward-Jackson, David Landau, Denis Mahon, Mariel Oberthür, Stephen Ostrow, Erich Schleier, Julien Stock, Yvonne Tan Bunzl, and Clovis Whitfield. The curators and museum personnel from all the American and European print and drawing departments I visited were helpful in answering requests; I would like to thank in particular Karen Beall, Suzanne Boorsch, Victor Carlson, Raffaello Causa, Peter Day, Peter Dreyer, Françoise Gardey, Ulrike Gauss, Ellen Jacobowitz, Peter Märker, Anna Marzia Positano, Sue Reed, John Rowlands, Annamaria Scardovi in Bonora, Werner Schmidt, Stephanie Stepanek, Margret Stuffmann, Christel Thiem, Gunther Thiem, the late Thomas Wragg, and the staff of the Pinacoteca Nazionale, Bologna. The private collectors who wish to remain anonymous were especially hospitable in sharing their collections with me.

While I was writing this catalogue, the following people helped with translations of Latin and Italian texts: Mirka Beneš, Thomas Kaufmann, Alexis Mazzocco, Thomas McGill, and Ljubica Visich. Ruth Fine, John Hand, and Ann Percy read portions of the manuscript and offered cogent suggestions. At the National Gallery, the staff of the Library assisted me in locating books and articles, and the staff of the Photographic Archives and Photographic Services cheerfully ordered photographs or had them made on short notice. In the Editor's Office, Frances Smyth helped with photographic orders and editorial advice. Special thanks go to my editor, Paula Smiley, who endured long, arduous hours over the final draft of the manuscript, and to Melanie Ness, who designed the catalogue and often listened to Carracci talk. Susanne Cook of the Graphic Arts Department typed much of the manuscript.

In relation to the exhibition, Jack Spinx handled the correspondence on the loan requests, which sometimes required much extra work. Our paper conservator Shelley Fletcher treated several of the objects in the exhibition. Sally Freitag of the Registrar's Office saw that all loans arrived safely. Gordon Anson of the Exhibitions Department is responsible for the attractive design of the exhibition.

In addition, to the above and to all those other colleagues and friends who listened patiently to my running commentary during the slow progression of this project, I offer my sincerest thanks.

Diane DeGrazia Bohlin

ABBREVIATIONS
FOR FREQUENTLY
CITED SOURCES

Andresen Andreas Andresen. *Handbuch für Kupferstichsammler.* vol. 1. Leipzig, 1870. pp. 239-243.

B. Adam Bartsch. *Le Peintre Graveur.* vol. 18. Vienna, 1818. Sections on the Carracci.

Bacou Paris, Musée national du Louvre, Cabinet des dessins. *Dessins des Carrache.* Paris, 1961 (catalogue by Roseline Bacou).

Baglione Giovanni Baglione. *Le vite de'Pittori Scultori et architetti dal pontificato di Gregorio XIII del 1572. In fino a'tempi di Papa Urbano Ottavo nel 1642.* Rome, 1642.

Bartsch Adam Bartsch. *Le Peintre Graveur.* 21 vols. Vienna, 1802-1821.

Basan F. Basan. *Dictionnaire des Graveurs Ancien et Modernes.* vol. 1. Paris, 1767.

Bellini Paolo Bellini. "Printmakers and Dealers in Italy during 16th and 17th centuries." *Print Collector,* no. 13 (May-June, 1975): 17-45.

Bellori Giovanni Pietro Bellori. *Le vite de pittori scultori et architetti moderni.* Rome, 1672.

Bertelà Giovanna Gaeta Bertelà. *Incisori Bolognesi ed Emiliani del sec. XVII.* Bologna, 1973.

Bertelà suppl. Bologna, Pinacoteca nazionale Gabinetto delle stampe. *Incisori Bolognesi ed Emiliani del sec. XVI Appendice ai volumi "Incisori Bolognesi ed Emiliani del '600 e del '700."* Catalogue by Stefano Ferrara and Giovanna Gaeta Bertelà. Bologna, 1975.

Berton Charles Berton. *Dictionnaire des Cardinaux.* Paris, 1857.

Bianchi Filippo Bianchi. *Trattato de gli huomini illustri di Bologna.* Ferrara, 1590.

Bierens de Haan J. C. J. Bierens de Haan. *L'oeuvre gravé de Cornelis Cort.* The Hague, 1948.

Bodmer 1935 Heinrich Bodmer. "L'accademia dei Carracci." *Bologna rivista mensile del comune.* 13, no. 8 (August, 1935): 61-74.

Bodmer 1938 Heinrich Bodmer. "Bemerkungen zu Annibale Carraccis Graphischem Werk." *Die Graphischen Künste.* 3, no. 3-4 (1938): 107-117.

Bodmer 1939 Heinrich Bodmer. "Die Entwicklung der Stechkunst des Agostino Carracci." *Die Graphischen Künste.* neue folge, 4, no. 4 (1939): 121-142.

Bodmer 1940 Heinrich Bodmer. "Die Entwicklung der Stechkunst des Agostino Carracci II." *Die Graphischen Künste.* neue folge, 5 (1940): 41-71.

Bodmer *Lodovico* Heinrich Bodmer. *Lodovico Carracci.* Burg b.M., 1939.

Bodmer *Old Master Drawings* Heinrich Bodmer. "Drawings by the Carracci: an Aesthetic Analysis." *Old Master Drawings,* no. 32 (March, 1934): 51-66.

Bolognini Amorini Antonio Bolognini Amorini. *Le vite di Lodovico, Agostino, Annibale ed*

altri dei Carracci. Bologna, 1840.

Boschini	Marco Boschini. *La Carta del Navegar Pitoresco.* Edizione critica, edited by Anna Pallucchini. Venice-Rome, 1966 (original publication 1660).
Boschloo	A. W. A. Boschloo. *Annibale Carracci in Bologna, Visible Reality in Art after the Council of Trent.* The Hague, 1974.
Boschloo 1972	A. W. A. Boschloo. Review of Posner in *Paragone,* no. 269 (July, 1972): 66-79.
Brunet	Jacques-Charles Brunet. *Manuel du Libraire et de l'Amateur de Livres.* Berlin, 1922 (original publication 1878-1880).
Calvesi, *Commentari*	Maurizio Calvesi. "Note ai Carracci." *Commentari* 7 (1956): 263-276.
Calvesi/Casale	Maurizio Calvesi and Vittorio Casale. *Le incisioni dei Carracci.* Rome, 1965.
Campori	Giuseppe Campori. *Raccolta di cataloghi ed inventarii inediti di quadri, statue, disegni, bronzi, dorerie, smalti, medaglie, avori, ecc. dal secolo XV al secolo XIV.* Modena, 1870.
Cardella	Lorenzo Cardella. *Memorie storiche de'cardinali della Santa Romana Chiesa.* 9 vols. Rome, 1792-1797.
Ciaconi	Alphonsi Ciaconii. *Vitae, et res gestae Pontificum Romanorum et S.R.E. Cardinalium ab initio nascentis Ecclesiae usque ad Clementem IX. P.O.M.,* 1667.
Cicognara	Leopoldo Cicognara. *Catalogo ragionato dei libri d'arte e d'antichità posseduti dal Conte Cicognara.* Pisa, 1821.
Cosenza	Mario Emilio Cosenza. *Biographical and Bibliographical Dictionary of the Italian Printers and Foreign Printers in Italy from the Introduction of the Art of Printing into Italy to 1800.* Boston, 1968.
Crespi	Luigi Crespi. *Vite de'pittori bolognesi non descritte nella Felsina Pittrice alla Maesta di Carlo Emanuele III. Re di Sardegna.* Rome, 1769.
Cristofari	Maria Cristofari. "La tipografia vicentina nel secolo XVI." *Miscellanea di scritti di bibliografia ed erudizione in memoria di Luigi Ferrari.* Florence, 1952. pp. 191-214.
Crollalanza	G. B. Crollalanza. *Dizionario storico-blasonico delle famiglie nobili e notabili italiane estinte e fiorenti.* 3 vols. Pisa, 1886-1890.
Disertori	Benvenuto Disertori. "I Caracci e i Caracceschi." *Emporium* 58 (November, 1923): 259-272.
Dizionario biografico degli italiani	*Dizionario biografico degli italiani.* Rome: Istituto della Enciclopedia Italiana, 1960-.
Dizionario Bolaffi	*Dizionario Enciclopedico Bolaffi dei Pittori e degli incisori italiani dall' XI al XX secolo.* Turin, 1972.
Dolfi	Pompeo Scipione Dolfi. *Cronologia delle famiglie nobili di Bologna.* Bologna, 1670.
Ellesmere Sale	Sotheby and Co., *Catalogue of the Ellesmere Collection of Drawings by the*

Carracci and other Bolognese Masters Collected by Sir Thomas Lawrence, London, July 11, 1972.

Emiliani	Andrea Emiliani. *Mostra di Federico Barocci.* Bologna, 1975.
Fantuzzi	Giovanni Fantuzzi. *Notizie degli Scrittori Bolognesi.* 9 vols. Bologna, 1781-1794.
Foratti	Aldo Foratti. *I Carracci nella teoria e nella pratica.* Città di Castello, 1913.
Gelli	Jacopo Gelli. *Divise-Motti e Imprese di famiglie e personaggi italiana.* Milan, 1928.
Gori Gandellini	Giovanni Gori Gandellini. *Notizie istoriche degli intagliatori di Giovanni Gori Gandellini.* Siena, 1808-1816 (1st edition 1771).
Graesse	Jean George Théodore Graesse. *Trésor de Livre Rares et Precieux ou Nouveau Dictionnaire Bibliographique.* Milan, 1950.
Heinecken	K. H. Heinecken. *Dictionnaire des Artistes, dont nous avons des estampes avec une notice détaillée.* vol. 2. Leipzig, 1789.
Hollstein	F. W. H. Hollstein. *Dutch and Flemish Etchings Engravings and Woodcuts.* Amsterdam, 1949-.
Joubert	F. E. Joubert. *Manuel de L'Amateur d'Estampes.* vol 1. Paris, 1821.
Kristeller	Paul Kristeller. *Kupferstich und Holschnitt in vier Jahrhunderten.* Berlin, 1905.
Kurz 1951	Otto Kurz. "'Gli Amori de'Carracci': Four Forgotten Paintings by Agostino Carracci." *Journal of the Warburg and Courtauld Institutes* 1, no. 14 (1951): 221-233.
Kurz 1955	Otto Kurz. "Engravings on Silver by Annibale Carracci." *Burlington Magazine* 97 (1955): 282-287.
Lambert-Oberthür	Gisèle Lambert and Mariel Oberthür. "Marc-Antoine Raimondi, Illustrations du catalogue de son oeuvre gravé par Henri Delaborde publié en 1888." *Gazette des Beaux Arts,* series 6, 92 (July-August, 1978): 1-52.
LeBlanc	Charles LeBlanc. *Manuel de L'Amateur d'Estampes.* vol. 1. Paris, 1854. 597-607.
Litta	Pompeo Litta. *Famiglie celebri italiane.* Milan, 1820-1856.
Lugt	Frits Lugt. *Les Marques de Collections de Dessins d'Estampes.* Amsterdam, 1921.
Mahon	Denis Mahon. *Studies in Seicento Art and Theory.* London, 1947.
Malvasia	Carlo Cesare Malvasia. *Felsina Pittrice, Vite de Pittori Bolognesi.* vol. 1. edited by Giampietro Zanotti. Bologna, 1841 (original edition 1678; vol. 2 is referred to as Malvasia II).
Malvasia 1686	Carlo Cesare Malvasia. *Le Pitture di Bologna.* edited by A. Emiliani. Bologna, 1961 (first edition Bologna 1686).

Mancini	Giulio Mancini. *Considerazioni sulla Pittura.* edited by Adriana Marucchi, comments by Luigi Salerno. Rome, 1956-1957 (written c. 1617-1621).
Marchesini	Cesare G. Marchesini. "Le incisioni dei Carracci e della loro scuola." *Gutenberg Jahrbuch* (1944/1949): 161-178.
Mariette	Pierre Jean Mariette. *Abecedario de P. J. Mariette et autres notes inédites de cet amateur sur les arts et les artistes.* Paris, 1851-53.
Mariette ms.	P. J. Mariette. *Catalogues Alphab. M.ss par Divers.* Unpublished, undated manuscript in the Bibliothèque Nationale, Paris.
Martin	John Rupert Martin. *The Farnese Gallery.* Princeton, 1965.
Memorie	Bologna, Accademia de'Gelati. *Memorie ritratti ed imprese de S.S.ri Accademici Gelati di Bologna.* Bologna, 1671.
Morello	Benedetto Morello. *Il Funerale d'Agostin Carraccio fatto in Bologna sua Patria da gl'incaminati Academici del Disegno.* Bologna, 1603.
Mortimer	Harvard College Library, Department of Printing and Graphic Arts. *Catalogue of Books and Manuscripts part II: Italian 16th Century Books.* Compiled by Ruth Mortimer. Cambridge, 1974.
Mostra-Dipinti	Bologna. *Mostra dei Carracci.* Bologna, 1956.
Mostra-Disegni	Bologna. *Mostra dei Carracci, Disegni.* Catalogue by Denis Mahon. Bologna, 1956.
Nagler	G. K. Nagler. *Die Monogrammisten.* Munich and Leipzig, 1858-1879.
Nagler 1835	G. K. Nagler. *Neues allgemeines Künstler-Lexicon oder Nachrichten von dem Leben und den Werken der Maler, Bildhauer. . . .* vol. 2. Munich, 1835.
Oberhuber	Vienna, Graphische Sammlung Albertina. *Die Kunst der Graphik III Renaissance in Italien 16. Jahrhundert.* Catalogue by Konrad Oberhuber. Vienna, 1966.
Oretti	Marcello Oretti. *Notizie dei professor del disegno, cioè dei pittori, scultori ed architetti bolognesi e de'forestieri di quella scuola.* Bologna, Biblioteca comunale, ms. B. 125 III, n.d.
Orlandi	Fr. Pellegrino Antonio Orlandi. *Notizie degli scrittori bolognesi e dell'opere loro stampate e manoscritte.* Bologna, 1714.
Ostrow	Stephen Ostrow. *Agostino Carracci.* New York University. PhD dissertation, 1966 (unpublished).
Parker	Oxford University, Ashmolean Museum. *Catalogue of the Collection of Drawings in the Ashmolean Museum.* vol. 2. *The Italian Schools.* Catalogue by K. T. Parker. Oxford, 1956.
Petrucci	Alfredo Petrucci. "L'Incisione Carraccesca." *Bollettino d'arte* 35 (1950): 131-144.
Petrucci 1953	Carlo Alberto Petrucci. *Catalogo Generale delle stampe tratte dai Rami incisi posseduti dalla Calcografia Nazionale.* Rome, 1953.
Pillsbury and Richards	Edmund P. Pillsbury and Louise S. Richards. *The Graphic Art of Federico*

Barocci, Selected Drawings and Prints. New Haven, 1978.

Pittaluga — Mary Pittaluga. *L'Incisione italiana nel cinquecento.* Milan, 1930 (1st ed. 1928).

Posner — Donald Posner. *Annibale Carracci, A Study in the Reform of Italian Painting around 1590.* London, 1971.

Stix-Spitzmüller — Vienna, Albertina. *Beschreibender Katalog Der Handzeichnungen in der Staatlichen Graphischen Sammlung Albertina, Die Schulen von Ferrara, Bologna, Parma und Modena, der Lombardei, Genuas, Neapels und Siziliens. . . .* Catalogue by Alfred Stix and Anna Spitzmüller. Vienna, 1941.

Strutt — Joseph Strutt. *A Biographical Dictionary of All the Engravers.* vol. 1. London, 1785.

Thieme-Becker — Ulrich Thieme and Felix Becker. *Allgemeines Lexikon der Bildenden Künstler.* 37 vols. Leipzig, 1907-1950.

Tiraboschi — A. B. Girolamo Tiraboschi. *Biblioteca Modenese o Notizie della Vita e delle opere degli Scrittori notii degli stati del Serenissimo Signor Duca di Modena.* Modena, 1786.

Vasari — Giorgio Vasari. *Le vite de più eccellenti pittori scultori ed architettori.* Annotations by Gaetano Milanesi. Florence, 1878-1885 (first ed. 1550 Florence, 2nd ed. 1568 Florence).

Wittkower — Rudolf Wittkower. *The Drawings of the Carracci in the Collection of Her Majesty the Queen at Windsor Castle.* London, 1952.

Zani — Pietro Zani. *Enciclopedia metodica critico-ragionata delle Belle Arti.* Parma, 1820.

PREFACE

THE HISTORY OF THE STUDY OF THE CARRACCI FAMILY PRINTS IS AS checkered as that of their paintings. Contemporary sources discussed engravings only if extremely important (Mancini) or as an afterthought. The first listing of the prints occurred over fifty years after the deaths of the three artists (Malvasia), and a catalogue raisonné did not appear until the early nineteenth century (Bartsch), two hundred years removed from the artists' lives. An attempt to rectify the lack of a modern catalogue of their prints was made in 1965 (Calvesi/Casale), but the results were less than satisfactory. It is evident that, at this time, a catalogue raisonné of their engravings and etchings is overdue. This fully illustrated catalogue is an attempt to fill that lacuna in Carracci studies.

Lucio Faberio's oration in Benedetto Morello's 1603 publication of the funeral of Agostino Carracci, who had died the previous year, is the earliest account of Agostino's oeuvre. Unfortunately, Faberio discussed some of the artist's paintings but failed to mention by name any engravings. He did, of course, laud Agostino's genius in the field,[1] but, understandably for the period, emphasized his works in oil. Mancini, writing in c. 1620, barely mentioned this aspect of Agostino's activity and noted only Annibale's engraving of the *Tazza Farnese*.[2] This manuscript, not published until 1956, included short biographies of artists not discussed by Vasari and those who lived after Vasari's *Lives* was written. Consequently, only a few pages were given to the Carracci.

Giovanni Baglione, in his book of lives of artists working in Rome from 1572 to 1642, when he wrote, recognized the importance of prints in an artist's oeuvre and attempted to mention at least those which were considered major.[3] In the case of the Carracci, he noted thirteen engravings by Agostino and seven prints by Annibale. Since Lodovico did not work in Rome, his biography is missing.

In 1672 Giovanni Pietro Bellori, in his *L'Idea del Pittore, dello Scultore, e dell'Architetto,* gave Annibale and Agostino Carracci primary positions among the twelve artists of the recent past worthy for his biographies. The Carracci works, he said, restored painting to the heights of Raphael from the abyss of the *maniera,* when artists abandoned the study of nature.[4] With his discussion of Annibale's work on the ceilings of the Palazzo Farnese, Bellori was the first biographer of artists to attempt to describe fully an artistic program. Following the biographies of each of the artists, in which he described their paintings, he listed their prints, in Agostino's case, dividing them into those whose compositions he invented and those which were reproductive in nature. For Agostino he listed thirty-four separate engravings or engraving projects; for Annibale, fifteen. Thus, Bellori was not only the first major biographer of the Carracci, devoting a quarter of his book to them, but also the first writer to consider their graphic production seriously.

Partly as a rebuttal to Bellori's Roman bias, Carlo Cesare Malvasia in 1678 published his *Felsina Pittrice,* with biographies of artists from his native Bologna. As expected, the largest accounts were those of the Carracci, with emphasis on the hegemony of Lodovico, the eldest of the

three, who taught his cousins and remained in Bologna. In spite of Malvasia's Bolognese chauvinism, his discussion of the lives of the artists—based on documents, conversations with those still living who knew the Carracci, and on the works themselves—remains the most complete and accurate account of their lives from an early source. Malvasia discussed the prints of the Carracci within the context of their biographies, often giving the history and anecdotes relating to the commission of a particular work or reactions of others to it.[5] In a separate section, he made a list of all the engravings and etchings he believed were executed by the Carracci. Along with these, he listed prints by other artists after Carracci compositions. Malvasia registered over two hundred original prints by Agostino, seventeen by Annibale, and five by Lodovico. With such a large listing of prints and fuller discussion than previous writers, it is Malvasia's account that has served as a basis for all subsequent studies on Carracci prints. It is still of great value to us today, although unfortunately some of these prints are now unidentifiable, due either to the disappearance of the work or to the now sketchy description given by Malvasia.

A gap of about a hundred years passed before more was written on the graphic production of the Carracci. But it was during this period that feverish activity took place in the collecting of both prints and drawings by the family. In the late seventeenth and eighteenth centuries the great collections of prints at the Albertina in Vienna and the Bibliothèque Nationale in Paris were amassed, as well as the important and large collections of drawings at the Louvre and Windsor Castle.[6] Pierre-Jean Mariette (1694-1774), the son of the well-known seventeenth-century collector, catalogued the prints in the Bibliothèque Royale in Paris, now the Bibliothèque Nationale, and those of Prince Eugene of Savoy, now in the Albertina.[7] His unpublished and undated manuscript in the Bibliothèque Nationale records the prints by the Carracci family in that collection. Although written in small script and sometimes difficult to decipher, the manuscript is important as a guide to the best-preserved collection of prints by the Carracci family. Several prints in that collection are unique examples, known only to Mariette. The manuscript does not distinguish between works by or after the Carracci and, like Malvasia's account, is often sketchy in description and therefore does not function as a true catalogue raisonné. In 1841 Mariette's notes on prints were published under the title of *Abecedario de P. J. Mariette et autres notes inédites de cet amateur sur les arts et les artistes,* but in regard to the Carracci notes, the book does not follow the original manuscript. Mariette is important not only for his listing of prints in the Bibliothèque Nationale and as Bartsch's precursor, but also as a critic of the authenticity of the works listed. Even though there is no discussion of the prints, the mere organization and attribution of the vast amount of material is a feat unequaled in his day.

In Italy in c. 1775 Marcello Oretti wrote several manuscripts, still unpublished, on paintings and artists of Bologna. His section on the prints of the Carracci family, however, is no more than a repetition, often verbatim, of Malvasia's lists. In 1771 the Sienese Gori Gandellini's catalogue of printmakers, published posthumously, was one of the first works to list systematically only the prints of artists. As such, it followed the method initiated by Mariette. In terms of the Carracci,

Gori Gandellini added little new beyond Malvasia. Shortly after the first edition of Gori Gandellini's catalogues, Carl Heinrich von Heinecken began publishing his catalogue raisonné of various artists' prints. Following alphabetical order, he reached the letter D. His list of Carracci prints in the 1789 volume published in Leipzig, initiated a new pattern of arrangement according to subject matter, a plan followed soon after in Bartsch's *Le Peintre Graveur.* Heinecken included not only works by the Carracci but also prints copied after them, causing us some confusion when reading the catalogue. He used as his material prints in German print rooms, including the rich collection of Carracci prints in Dresden.[8] Obviously influenced by Mariette's ground-breaking work, Heinecken wrote in French, the language preferred by collectors and connoisseurs.

Without Mariette's catalogue of prints in the Albertina and the Bibliothèque Nationale, Adam Bartsch's twenty-one volume *Le Peintre Graveur* may never have been finished. For the 1818 volume 18 on the Carracci, Bartsch also referred to the earlier works of both Gori Gandellini and Heinecken, but his importance lies not only in the fact that his catalogues of prints were completed, but also in his arrangement, inclusions, and discussions of the works themselves. Bartsch based his attributions of Carracci prints on the collections now in the Albertina, the largest Carracci holdings known, and on some dispersed private collections. Because he did not have access to them at the time, he did not discuss some of the rare prints included in the present catalogue which are found in German or French museums. His full description of the prints which he did cover and the availability of the prints in the Albertina today, make his catalogue the basis for all subsequent studies. Although a number of his attributions are here rejected, it is evident that his scholarship, considering the number of artists he catalogued, was indeed perceptive and his connoisseurship enviable.

In the nineteenth century, the prints of the Carracci family were included in the numerous print catalogues that proliferated during the period, such as LeBlanc, Basan, and Andresen, but were never discussed. Like Nagler five years earlier, Bolognini Amorini in his 1840 *Le vite di Lodovico, Agostino, Annibale ed altre dei Carracci* followed Malvasia's lists. Andresen considered only a few of the Carracci prints in his catalogue, but because he had the benefit of working in the German print rooms, he found many states not described by Bartsch. LeBlanc followed Bartsch closely in subject arrangement and attributions, and Nagler generally also conformed to attributions by both Bartsch and Malvasia.

Not until Bodmer's reevaluation of the prints, in his three articles on the Carracci written between 1938 and 1940, with numerous reproductions, was serious consideration again given to the artists' graphic oeuvres. Perspicacious in his point of view of the Carracci as innovators in painting, he nevertheless gave their prints a minor role. His attempt at a chronological development without the basis of a catalogue raisonné or the firmly documented, signed and dated prints as touchstones resulted in mistakes of dating if not of attribution.

Earlier, Pittaluga's inclusion of the Carracci in her 1928 book on Italian sixteenth-century prints reiterated the eclectic label already pinned on the artists' paintings and subsequently given to the prints by Disertori and others. According to Pittaluga, very little of note was produced by the Carracci family in printmaking. Petrucci's 1950 article

on the prints of the Carracci also reflected the Italian viewpoint that Agostino was merely a reproductive craftsman who followed his brother's style, that of other artists, and his own academic program. He felt that Annibale's work, on the other hand, was a precursor of later Italian etching and even mezzotint.

The exhibition of paintings, drawings, and prints in Bologna in 1956 did as much to renew esteem for the Carracci and to revitalize Carracci studies as did Mahon's 1947 *Studies in Seicento Art and Theory*. Unfortunately, the prints played a small role in the exhibition, and only the most well-known were included. Not until 1965 was an exhibition given over entirely to prints by the Carracci family; this one prepared by Maurizio Calvesi and Vittorio Casale in Rome. The catalogue, now out of print, posed more questions than it answered. It has been used as a catalogue raisonné when, in fact, only prints in Italian collections were included; states were mentioned arbitrarily; and numerous mistakes of attribution and dating were made. Moreover, there was no attempt at a discussion of stylistic development or an evaluation of the artists' importance in the printmaking world. Instead, as before, the prints were seen as adjuncts to the paintings.

Stephen Ostrow included prints in his 1966 unpublished doctoral thesis on Agostino Carracci to establish a documented chronology for the paintings, the main subject of the paper. Consequently, only those signed and dated examples were covered. In addition, Ostrow stressed the commercial aspect of the engravings at the expense of their artistic merit. He saw Agostino in somewhat the same light as had Petrucci before him, as a reactive rather than an innovative artist, a chameleon taking on the colors of the artists he reproduced. Donald Posner's important catalogue raisonné of Annibale's oeuvre also includes prints, but again in relation to his painted work and without comparison with his contemporaries in the graphic field.

Clearly a reevaluation of the printed oeuvres of the Carracci family will yield uncharted depths to their personalities as have the recent interpretations of Annibale's paintings.[9] This, of course, can only be done when their prints have been published and studied *in toto* and for themselves, rather than merely in relation to their paintings. The purpose of this catalogue is not only to reproduce those engravings and etchings attributed by this author to the three Carracci, but also to include photographs of those works attributed by previous catalogues but rejected here. With this as a new basis for study, future scholars will be able to recognize other prints which belong to the artists and to their lesser-known contemporaries and followers. Since the two main catalogues of Carracci prints which include still identifiable works are those of Bartsch and Calvesi/Casale, it is these two studies on which the section of rejected and questioned prints is based. If prints are missing here that have been attributed to the Carracci by other recent writers on the subject but not by Bartsch and Calvesi/Casale, it should be assumed that the author rejects those prints from the Carracci oeuvres.[10] The present catalogue is based on a study of prints in numerous European and American print rooms unavailable to Mariette, Bartsch, or Calvesi/Casale, and some new works have been found which can now be included among the accepted Carracci prints, several of which help to change the chronology of Annibale's and Agostino's oeuvres.[11]

In all, this catalogue includes 213 prints accepted as authentic works from Agostino's hand (Bartsch accepted 276, Calvesi/Casale 185), 20 works which are questionable but may still be his, and 59 prints which Bartsch or Calvesi/Casale accepted which must be removed from his oeuvre. For Annibale, 22 prints are considered authentic and 3 rejected (Bartsch included 18, Calvesi/Casale 23); for Lodovico, 4 accepted works and 1 rejected print (Bartsch: 5, Calvesi/Casale 5). The prints are arranged chronologically rather than by subject matter to provide a view of the stylistic development within each artist's oeuvre. There is a discussion of the place of each print in the artist's development as well as a comparison with related works of the same period, whether preparatory drawings, related drawings, or paintings. The Introduction to the catalogue presents the Carracci in relation to one another and discusses their working methods, their chosen subject matter, and their relationship with other graphic artists of the period. Preceding the Introduction to the catalogue is a chronological table listing the salient events in the lives of the Carracci as well as their documented prints and paintings. Following the catalogue is an appendix of publishers and printers involved with the Carracci family, some of whom are known only by their signatures on Carracci prints. A concordance of numbers of this catalogue with those of Bartsch, Calvesi/Casale, and Ostrow completes the volume. In most catalogues raisonné of prints there is an appendix of watermarks, often helpful in dating the prints themselves. Such an appendix is missing here since few watermarks are found on Carracci prints, many of which are laid down in albums, making the search impossible. Those which are known have added nothing to the dating of the prints.

An exhibition at the National Gallery of Art is presented simultaneously with the publication of the catalogue raisonné. Arranged according to subject categories and artistic interrelationship among the three Carracci, it consists of prints, drawings, copper and silver plates, and books. The exhibition, which includes many works never exhibited before in either Europe or America, will introduce the scholar and layman to the beauties and importance of the graphic production of the Carracci.

NOTES

1 Morello, p. 30, found also in Malvasia p. 306: "qual eccellenza egli fosse nel disegnare, intagliare e pingere." For the complete bibliography of the authors mentioned in the Preface see the Abbreviations for Frequently Cited Sources.

2 Mancini, p. 220: "Tagliò benissimo/ a bulino, come si vede in alcune sottocoppe di Giulio Cesare Abbate (854), et in acquaforte, nel quale modo si vedano molte stampe."

3 Baglione p. 387, reprinted Introduction.

4 Bellori pp. 19-21: "All'hora la Pittura venne in grandissima ammiratione de gli huomini, e parve discesa dal Cielo, quando il divino Rafaelle, con gli ultimi lineamenti dell'arte, accrebbe al sommo la sua bellezza, . . ." "Siche, mancato quel felice secolo, dileguossi in breve, ogni sua forma; e gli Artefici, abbandonando lo studio della natura, vitiarono l'arte, con la maniera, o vogliamo dire fantastica idea, appoggiata alla pratica, e non all'imitatione." and "Così quando la Pittura volgevasi al suo fine, si rivolsero gli altri più benigni verso l'Italia, e piacque à Dio, che nella Città di Bologna, di scienze maestra, e di studi, sorgesse un elevatissimo ingegno: e che con esso risorgesse l'Arte caduta, e quasi estinta. Fù questi Annibale Carracci, . . ."

5 As one example, his discussion of Agostino's *Crucifixion* after Tintoretto (cat. no. 147) so admired by the painter (Malvasia pp. 74-75).

6 For a history of these collections see Wittkower's excellent introduction to the Windsor catalogue of Carracci drawings, especially Wittkower pp. 20-22 and Roseline Bacou's account of the Louvre collection: Bacou pp. 9-11. See also *Mostra-Disegni* pp. 12-15.

7 See the informative article by Walter Koschatzky, "Adam von Bartsch, An Introduction to his Life and Work" in *Le Peintre Graveur Illustré* vol. I *Italian Chiaroscuro Woodcuts,* edited by Caroline Karpinski (University Park and London, 1971), xi-xxi for a history of the Albertina collection.

8 The Dresden collection of prints and drawings was amassed over a long period of time beginning in the sixteenth century, but the Carracci prints were there before Heinecken's book, and he may have acquired them himself for the museum when he headed the print cabinet in Dresden from 1746 on. For a history of the collection of the Kupferstichkabinett see *The Splendor of Dresden: Five Centuries of Art Collecting* (New York, 1978), 243-246.

9 Especially Posner, Boschloo, and Dempsey.

10 For example, those engravings and etchings added to the Carracci oeuvres in Bertelà and Bertelà suppl.

11 See the guide to the catalogue for a list of museums and libraries consulted.

CHRONOLOGY

The following brief chronology includes only the most important documented paintings and all documented prints by the Carracci family. Travels and other events in their lives are mentioned when pertinent. The best-documented chronology of the three Carracci, although updated by more recent studies, is found in the *Mostra-Dipinti,* pp. 67-104. For Agostino, one should also refer to Ostrow, pp. 560-594.

1555	April 21, Lodovico Carracci, son of Vincenzo, a butcher, baptized in Bologna.
1557	August 16, Agostino Carracci, son of Antonio, a tailor, baptized in Bologna.
1560	November 3, Annibale Carracci, son of Antonio, baptized in Bologna.
c. 1570-1575/1580	The *studioso corso* of Lodovico Carracci. Studies with Fontana in Bologna and Passignano in Florence. Travels to Parma, Mantua, Venice.
1574	Agostino recuts copperplates for second edition of Achille Bocchi's *Bonon symbolicarum quaestionum. . . .* Included is earliest engraving, *Skull of an Ox* (cat. no. 1).
1576	Agostino's first signed and dated engravings: *Holy Family* (cat. no. 3), *Holy Family with Saints Catherine of Alexandria and John the Baptist* (cat. no. 4).
1577	Agostino in Bartolomeo Passarotti's studio.
1578	Lodovico requests membership in painters guild.
1579	Agostino working for Domenico Tibaldi.
	Signed and dated engravings by Agostino: *Pietà* (cat. no. 9), *Mater Dolorosa* (cat. no. 10), *Allegory of the Psalm of David* (cat. no. 11), *Adoration of the Magi* (cat. no. 12).
1580	Agostino and Annibale in Venice and Parma?
	Agostino engraving, *Christ and the Samaritan Woman* (cat. no. 21).
1581	Agostino in Rome (cat. no. 40).
	Annibale's first signed and dated print: *The Crucifixion* (cat. no. 1).
	Agostino engravings: *Tobias and the Angel* (cat. no. 26), *Frieze to Accompany a Map of the City of Bologna* (cat. no. 29).
1582	Agostino and Annibale found the Accademia degli Incamminati in Bologna.
	Agostino in Cremona? Work begun on the engravings for the *Cremona Fedelissima* (cat. nos. 56-92).
	Agostino in Venice. Engravings after Venetian artists or published by Venetian firms: *The Mystic Marriage of Saint Catherine* (cat. no. 104), *The Martyrdom of Saint Justina of Padua* (cat. no. 105).
	Annibale engraving: *Holy Family with Saints John the Baptist and Michael* (cat. no. 2) (in competition with Agostino's *Holy Family with Saints?*, cat. no. 54).

1583-1584	Annibale in Tuscany, in Parma?
1583	Annibale's first signed and dated painting: the *Crucifixion* in S. Nicolò in Bologna (Posner 6a).
	Agostino engraving: *St. Paul Raising Patroclus* (cat. no. 108).
1584	Completion of frescoes of the *Story of Europa* and the *Story of Jason* in the Palazzo Fava, Bologna, by the three Carracci (Posner 14-15).
	Agostino engraving: *Portrait of Bernardino Campi* (cat. no. 127).
1585	Agostino in Venice? (cat. no. 133).
	Dated paintings by Annibale: *Baptism*, S. Gregorio, Bologna (Posner 21a), *Pietà*, Pinacoteca Nazionale, Bologna (Posner 24a).
	Agostino engravings: *Portrait of Carlo Borromeo* (cat. no. 132), *The Mystic Marriage of Saint Catherine* (cat. no. 133).
	Publication of the *Cremona Fedelissima* by Antonio Campi in Cremona (cat. no. 56).
1586	Agostino in Parma? (cat. no. 142).
	Agostino painting: *Madonna and Child with Saints*, Pinacoteca Nazionale, Parma (*Mostra-Dipinti* cat. no. 37, Ostrow cat. no. I/7).
	Publication of the *Vita di Cosimo de' Medici* by Aldo Manuzio with prints by Agostino (cat. nos. 135-139).
	Agostino engravings: *Saint Francis Receiving the Stigmata* (cat. no. 140), *The Cordons of Saint Francis* (cat. no. 141), *The Madonna of Saint Jerome* (cat. no. 142).
1587	Agostino in Parma? (cat. no. 143).
	Agostino in Venice (cat. nos. 145-146).
	Engravings by Agostino: *Ecce Homo* (cat. no. 143), *Portrait of Titian* (cat. no. 145).
	Annibale painting: *Assumption of the Virgin*, Dresden, Gemäldegalerie (Posner 40).
1588	Agostino in Venice (cat. no. 146).
	Lodovico's first signed and dated painting, the *Madonna dei Bargellini*, Pinacoteca Nazionale, Bologna (*Mostra-Dipinti* cat. no. 8).
	Agostino engraving: *The Madonna Appearing to Saint Jerome* (cat. no. 146).
	Annibale painting: *Madonna and Child Enthroned with Saints*, Dresden, Gemäldegalerie (Posner 45).
1589	Agostino in Venice (cat. nos. 147-149).
	Probable date of birth of Antonio, son of Agostino, in Venice.
	Agostino in Florence? (cat. nos. 150-154).
	Agostino engravings: *The Crucifixion* (cat. no. 147), *Mars Driven Away from Peace and Abundance by Minerva* (cat. no. 148), *The Madonna and Child Seated on a Crescent Moon* (cat. no. 150).
1590	Publication of *La Gerusalemme Liberata* by Torquato Tasso in Genoa with engravings by Giacomo Franco and Agostino after Bernardo Castello (cat. nos. 155-164).

Publication of the *Ricreationi amorose de gli Academici Gelati di Bologna* in Bologna with engravings by Agostino (cat. nos. 165-174).

Agostino engraving: *Portrait of Giovanni Battista Pona* (cat. no. 175).

Annibale etching: *Holy Family with Saint John the Baptist* (cat. no. 11).

1591 Lodovico painting: *Madonna and Child with Saints Francis and Joseph and Donors,* Museo Civico, Cento (*Mostra-Dipinti* cat. no. 13).

Agostino engraving: *Portrait of Pope Innocent IX* (cat. no. 194).

Annibale etching: *Mary Magdalen in the Wilderness* (cat. no. 12).

1592 Completion of the fresco decoration of the *Story of the Founding of Rome* in the Palazzo Magnani, Bologna, by the three Carracci (Posner 52).

Lodovico painting: *Predica del Battista,* Pinacoteca Nazionale, Bologna (*Mostra-Dipinti,* cat. no. 15).

Annibale paintings: *Assumption,* Pinacoteca Nazionale, Bologna (Posner 69), *Venus and Cupid,* Galleria Estense, Modena (Posner 65).

Agostino painting: *Pluto,* Galleria Estense, Modena (*Mostra-Dipinti,* cat. no. 40, Ostrow I/11).

Annibale etching: *Venus and a Satyr* (cat. no. 17).

Lodovico etching: *The Virgin Nursing the Christ Child* (cat. no. 2).

1593 Annibale painting: the *Resurrection,* Paris, the Louvre (Posner 73).

Terminus ante quem of Annibale's etching *The Madonna and Child* (cat. no. 16).

1594 Toward end of the year: Annibale and Agostino in Rome at request of Cardinal Odoardo Farnese.

1594-1609 Annibale in Rome except for a brief trip back to Bologna in 1595 and one to Naples in 1609.

1595 Agostino returns to Bologna.

Probable date of completion of Annibale's painting of the *Almsgiving of St. Roch,* Dresden, Gemäldegalerie (Posner 86a).

Agostino engravings: *Aeneas and his Family Fleeing Troy* (cat. no. 203), *Saint Francis Consoled by the Musical Angel* (cat. no. 204).

1595-1597 Annibale paintings in the Camerino in the Palazzo Farnese, Rome (Posner 92).

1596 Agostino engravings: *Portrait of Francesco Denaglio* (cat. no. 206), *Portrait of Ulisse Aldrovandi* (cat. no. 207).

1597-1600 Agostino in Rome.

Frescoes in the vault of the Galleria Farnese in the Palazzo Farnese, Rome, by Annibale, aided by Agostino (Posner 111).

Annibale engraving: the *Tazza Farnese* (cat. no. 19).

1597 Annibale etching: *Pietà (The "Christ of Caprarola")* (cat. no. 18).

Agostino engraving: *Holy Family* (cat. no. 208).

1598 Agostino painting: *Portrait of Giovanna Parolinae Guicciardini,* Berlin-Dahlem (*Mostra-Dipinti* cat. no. 46, Ostrow cat. no. I, 19).

Agostino engraving: *Pietà* (cat. no. 209).

1599	Agostino engraving: *Omnia Vincit Amor* (cat. no. 210).
1600	Lodovico painting: the *Martyrdom of Saint Ursula,* Imola, SS. Nicola e Domenico (*Mostra-Dipinti,* cat. no. 24).
1600-1601	Annibale painting: the *Assumption,* Cappella Cerasi, S. Maria del Popolo, Rome (Posner 126).
1600-1602	Agostino in Parma.
	Paintings by Agostino in the Camerino of the Palazzo del Giardino, Parma (Ostrow, cat. no. I/22).
1602	February 23, death of Agostino Carracci in Parma at age fifty-four.
	May 31-June 13, Lodovico in Rome.
1603	January 18, Funeral of Agostino in Bologna with obsequies by members of the Accademia degli Incamminati.
	Publication of Benedetto Morello's *Il funerale d'Agostin Carraccio* . . . in Bologna, describing the services of January 18th.
1604-1605	Lodovico frescoes in the Cloister of S. Michele in Bosco, Bologna (almost totally destroyed). (Bodmer *Lodovico,* pls. 60-65).
1604	Lodovico drypoint: *Virgin and Child and Saint John* (cat. no. 4).
1605	Beginning of Annibale's debilitating sickness.
1606	Annibale etchings: *Madonna della Scodella* (cat. no. 20), *Christ Crowned with Thorns* (cat. no. 21).
1606-1609	Lodovico in Piacenza. His frescoes in the courtyard and vault of the Duomo, Piacenza.
1607	Completion of frescoes in the Herrera Chapel in S. Giacomo degli Spagnuoli, Rome, designed and supervised by Annibale.
1609	Annibale in Naples briefly.
	July 15, death of Annibale Carracci in Rome at age forty-nine.
1616	Lodovico's painting: *The Adoration of the Magi,* Brera, Milan (*Mostra-Dipinti* cat. no. 35).
1619	November 13, death of Lodovico Carracci in Bologna at age sixty-four.

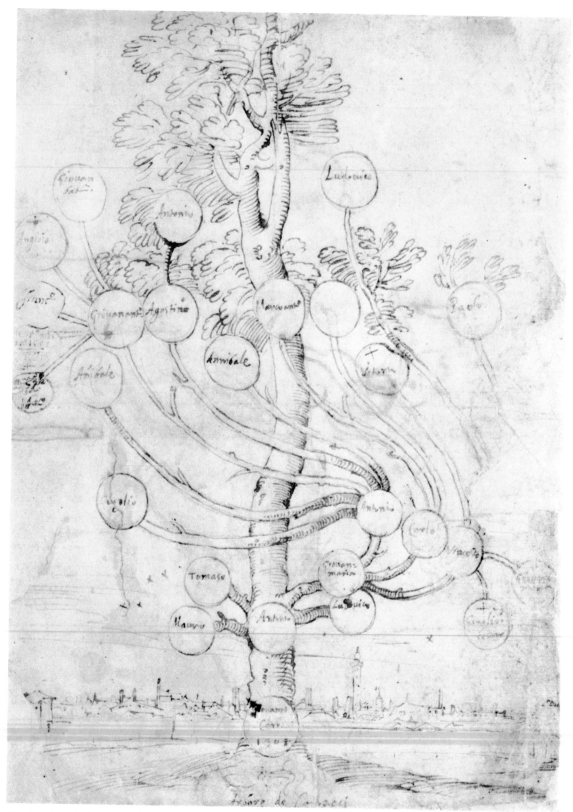

Agostino Carracci, *Carracci Family Tree*. London, The British Museum

INTRODUCTION

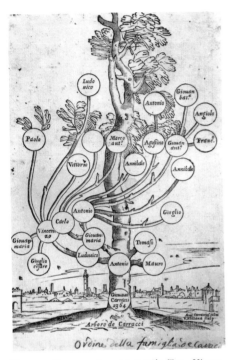

Vincenzo Fontana, *Carracci Family Tree*. Vienna, Graphische Sammlung Albertina

Religious atmosphere of Bologna

Background and Stylistic Development

THE CARRACCI BROTHERS, Agostino (1557-1602) and Annibale (1560-1609), and their cousin Lodovico Carracci (1555-1619) were born in Bologna of a Cremonese family which settled in the Emilian city in the early sixteenth century. Agostino, obviously proud of his Cremonese background, signed one of his earliest prints *Augusti.Cre.fe.,* indicating the family's origin (Agostino cat. no. 4). Later, however, in a drawing of the Carracci family tree, now in the British Museum, he fully accepted the family's Bolognese home by placing the city of Bologna, with its unmistakable towers, in the background of the sheet.[1]

From Agostino's drawing, engraved later by Vincenzo Fontana,[2] one sees that Annibale and Agostino, sons of Antonio, were second cousins of their colleague, Lodovico, son of Vincenzo Carracci. Besides producing these three artists, Antonio and Vincenzo were the progenitors of other artistic heirs: Antonio, Agostino's son; Francesco, Agostino and Annibale's nephew (whose minor contribution in prints is discussed in the catalogue); and Paolo, Lodovico's brother.[3] It was not unusual for the period that so many members of one family undertook the same occupation. Unprecedented, however, is the importance of three members of one family, each well known in his time and lauded by biographers since. The Carracci triumvirate—Agostino, Annibale, and Lodovico—put the Carracci family and the city of Bologna on the art historical map. Together they redirected the course of Italian painting in the last years of the sixteenth century. Their influence reached far beyond their native city, especially after Agostino and Annibale moved to Rome in the 1590s. The art of seventeenth-century Rome was dependent on the Carracci's experiments with color and light, on their rediscovery of classical and Renaissance forms, and on their intense interest in the natural world. From their famous academy, founded in 1582, their teaching reached to such younger artists as Guido Reni, Domenichino, and Guercino, who in turn continued the Bolognese painting tradition well into the seventeenth century.

The university town of Bologna was a stimulating, active city in the second half of the sixteenth century when the Carracci attained maturity. A literary and scientific center of the peninsula, it provided a harmonious environment for the inquiring minds of the brothers and their cousin. From 1512, Bologna remained under papal rule during almost all of the sixteenth century. The city was ruled by a cardinal legate appointed by the pope and consequently was the site of important events affecting all of Europe, such as the concordat between Pope Leo X and Francis I in 1516, the coronation of Charles V as Holy Roman Emperor in 1530, and the historic but unproductive meetings of the Council of Trent in 1547. The noble families of Bologna belonged to the senate, but the real power lay with the church. The peaceful years of the sixteenth century brought prosperity to Bologna but also subjugation to the authority of the papacy.

The Counter-Reformation was strongly felt there through the voice and writings of the Bolognese bishop, Cardinal Gabriele Paleotti (1522-1597), a close friend of Carlo Borromeo, the bishop of Milan, and a keen reformer of social and religious institutions.[4] Paleotti's importance to the development of religious art in the city must be emphasized, for he was interested in art as a tool of instruction. His *Discorso intorno alle imagini sacre e profane* was written as a guide to the correct form art must take to educate the masses in the ways of God. Although the *Discorso* was never completely published, an edition of parts of it was available in Bologna in 1582.[5] Coincidentally, this was the year of the founding of the Carracci Academy, the Accademia degli Incamminati, where instruction was given in the practical aspects of painting and drawing. The academy also provided a forum for discussions of theory, anatomy, literature, and other subjects pertinent to art. It is likely that the Carracci discussed at length the merits of Paleotti's writings and how his proposals might affect their own work. In fact, Paleotti had shown his manuscript notes to some of the leading artists of Bologna, probably as early as 1578. Among those who read the notes were Domenico Tibaldi, Agostino's teacher and employer c. 1579-1581; Prospero Fontana, Lodovico's first teacher; and Pirro Ligorio. Ulisse Aldrovandi, the great Bolognese naturalist and friend of both Agostino Carracci and Paleotti, also read the notes.[6]

The connection between Paleotti's writings and the Carracci has been discussed at length, but not conclusively, by Boschloo and Foratti before him.[7] Paolo Prodi's proposal that Paleotti's theories provided a background and guide for the artists, to use to the extent they wanted, rather than an edict that had to be followed is the most intelligent analysis. The subject matter of the Carracci's prints as well as paintings was varied, as was their treatment of it, especially after Agostino and Annibale went to Rome. In Bologna, the artists were aware of Paleotti's work and probably attempted to incorporate his theories in their art as long as they did not conflict with their own naturalistic tendencies and scientific inquiries. It is likely that in their attempt to reform the art of painting at the end of the sixteenth century, the Carracci were encouraged by Paleotti's *Discorso* to portray religious themes in a manner comprehensible to the illiterate churchgoer.[8]

The religious discussions taking place in Bologna in the late sixteenth century seem to have strengthened rather than stifled the inquiring minds in the city. Paleotti himself sought the advice of artists, and artists in turn sought the advice of theologians, scientists, and the literati. We have proof that the Carracci were directly involved in the cultural and intellectual ambience of the city, which was dominated by the presence of the university. At work there during the period of the Carracci's activity and possibly influential on the artists were Gaspare Tagliacozzi (1545-1599), the father of plastic surgery and the first to study the subject based on scientific criteria, and Girolamo Mercuriale (1530-1606), who taught the critical scientific method of medicine. We have evidence that the Carracci knew Ulisse Aldrovandi (1522-1604/1605), the noted botanist who pioneered the study of plants through observation. Malvasia related that Aldrovandi gave lectures in the Carracci Academy, and there is at least one portrait of Aldrovandi executed by Agostino (see Agostino cat. no. 207).

The Carracci were involved with Bolognese literary activity, also encouraged by the presence of the university. Fledgling publishing houses, such as the Benacci, gained strength during the late sixteenth century, and poetry was important and prevalent in the city. Giulio Cesare Croce (1550-1609) wrote about the common people, using the Bolognese dialect. Annibale's drawings of the trades of Bologna (known through the engravings after them by Guillain and Mitelli popularly called *Le Arti di Bologna*) are reminiscent of Croce's poetry, and we know that Croce also dedicated some of his verses to Agostino. Melchiore Zoppio (c. 1544-1634, Agostino cat. no. 174) was another dominant figure in the literary sphere of Bologna, especially after he founded the Accademia de' Gelati in 1588. The academy was devoted to the study and publication of poetry and literature. Many well-known Bolognese poets, philosophers, and writers belonged (Agostino cat. nos. 165-174, and RI-RIO). Agostino was made an adjunct member of that academy (see cat. no. 165) when he made the prints for Zoppio's *Ricreationi Amorose degli Accademici de' Gelati di Bologna* (cat. nos. 165-174). Benedetto Morello published poems praising Agostino by Zoppio and by Cesare Rinaldi (1559-1636), another poet active during that period.[9] Agostino also knew Aldo Manuzio the Younger (1547-1597), who held the chair of rhetoric at the university in 1585. In 1586 Agostino did engravings for Manuzio's *Vita di Cosimo de' Medici* (Agostino cat. nos. 135-138) and made the *Pastoral Scene for the Title Page of Horace's* Odes (Agostino cat. no. 139), a work edited by Manuzio.

Artistic atmosphere of Bologna

In spite of the intense literary and scientific activity in Bologna in the 1570s and 1580s, when the Carracci began working, there were no artists of genius active in the city until the Carracci appeared on the pictorial scene. In fact, no new stylistic currents were in evidence. Time was ripe for change. The best and most original painters active earlier in Bologna were either dead (Parmigianino, Niccolo dell'Abbate, Primaticcio) or had moved elsewhere (Nicolo, Primaticcio, Pellegrino Tibaldi).[10] The painters still at work in the 1570s were Orazio Sammacchini (1532-1577), Lorenzo Sabbattini (1530-1576), the Fleming Denys Calvaert (1540-1619), Bartolomeo Cesi (1556-1629), Prospero Fontana (1512-1597), and Bartolomeo Passarotti (1529-1592). Although each is interesting in his own right, none can be said to have been an artist of the first order. The styles of Sammacchini and Sabbattini, influential on the rest, combined Florentine and Roman elements. Their work emphasized a monumentality of figural conception from Michelangelo and a Raphaelesque sweetness of expression and vivacity of color. Compositions were presented unimaginatively with formulistic rigidity and linear definition, characteristic of Vasari and the Zuccari. The subject matter of these artists was also consistent. Mainly they painted religious pictures, depicting the lives of the Virgin or saints and many representations of the Holy Family. These subjects reflected the new demand for sacred images nurtured by the Counter-Reformation and possibly by Paleotti himself. Very little mythological painting was done in Bologna in the 1560s and 1570s, and only Bartolomeo Passarotti ventured into new territory, that of low-life genre, which was developed to a mature idiom in the works of Annibale Carracci.[11]

Sixteenth-century Italian printmaking

While the state of Italian painting in the 1570s and 1580s, when the Carracci so radically changed its direction, has been amply discussed by

others,[12] the situation in the graphic arts during the same period has been given minimal treatment. An understanding of the Carracci's development in the graphic media depends on an understanding of the state of the graphic arts in Italy in the 1570s, when Agostino first picked up the burin. Consequently, precursors to our printmakers will be discussed here at some length. Prints, highly portable objects made in multiples, greatly enlarged the artistic milieu by making it possible to know the works of artists from the entire continent without traveling. A printmaker could learn new techniques and know new compositions without leaving his native city. Thus, ideas passed rapidly from country to country and artist to artist.

What then was the situation of Italian printmaking in the second half of the sixteenth century? We can no longer accept Hind's outdated evaluation that "the middle of the sixteenth century was nowhere a time of great achievement in engraving, and, unhappily for the student, the deficiency in quality was far from being accompanied by a paucity of production."[13] Unfortunately, the onus Hind placed on the works of engravers in the late sixteenth century, including Agostino Carracci, has stuck. Unlike painting, the art of printmaking was still in its infancy in the sixteenth century, and the middle of the century was a period of expansion of the technical developments made earlier. In most cases, Italian engravers were either following the style of Marcantonio Raimondi (c. 1480-after 1530) or diverging from his manner, so prevalent in the first half of the century. His technical method remained popular until Cornelis Cort improved it in the 1560s. Marcantonio, a Bolognese, was primarily a reproductive engraver, like most Italian printmakers of the sixteenth century. His style was dependent on the technical achievement of effecting light and shade in engraving and on the successful transferral of the painted image to paper. Early on, he had traveled to Venice where he came under the influence of Dürer's prints. In 1509-1510 he went to Rome and there, in Raphael's commercial reproductive printmaking studio, he copied Raphael drawings. Through his engravings, Marcantonio disseminated the Italian High Renaissance ideal.[14] In such works as the *Hercules and Antaeus* after Giulio Romano (fig. A), he worked out a highly sophisticated system of hatching, cross-hatching, curved lines, and dots to reproduce the monumental figures and delicate nuances of the pen drawings of Raphael and his school. All this was accomplished without any differentiation in the size of the burin line and with little tonal variation. Although his followers such as Jacopo Caraglio (c. 1500-1565) and Giulio Bonasone (active 1531-1574) made their engravings in a darker manner by placing the hatched lines closer together or increasing the number of ornamental flourishes, they basically used the same system.[15] In the 1550s Giorgio Ghisi (1520-1582), from Mantua, developed this system still further, using a delicate burin for closely spaced and undulating lines which contrasted with the bright white of the paper. Like Caraglio and Bonasone, his style is based on a development of earlier principles rather than on technical innovation. The precious extravagance of Ghisi's prints is a perfect counterpart to the mannerist goldsmith work and sculpture of the same period.[16]

Thus, at mid-century the system of engraving was not much different from what it had been in the 1520s. New, however, was the constant interchange of ideas between the northern centers of engraving and

Marcantonio Raimondi

fig. A Marcantonio Raimondi, *Hercules and Antaeus*. Washington, National Gallery of Art, Gift of W. G. Russell Allen

those of the south and the increasing importance of print publishers who employed numerous engravers to reproduce book illustrations, portraits, ornamental prints, maps, and whatever else was in demand by the buying public. One of the most important European publishers of the century was Hieronymous Cock (1510-1570), who, at the "Sign of the Four Winds" in Antwerp, employed artists such as Giorgio Ghisi, Philip Galle, and Cornelis Cort (1533-1578) and published works after designs by Marten van Heemskerck and Pieter Brueghel.[17] Although large Italian publishing centers thrived in Venice and Rome, none was comparable to Cock's studio. It was in Cock's shop that Cornelis Cort made an important technical innovation in engraving—the swelling burin line—which changed the course of engraving in Italy and expanded the possibilities of reproducing the coloristic effects of paintings in the graphic medium. The swelling burin line is one which begins delicately, deepens and spreads out, and then tapers to a dot at the end of the line (fig. B).

Primarily a reproductive artist, Cort's importance for print production in Italy and the Netherlands in the late sixteenth century is often underestimated. Born in Holland, Cort was working for Hieronymous Cock in Antwerp by 1552.[18] There, he may have been apprenticed under Giorgio Ghisi, whose metallic surfaces appear in his early prints.[19] Typical of his early works is his *Auditus* (fig. C), from the set of *The Five Senses* after Frans Floris, dated 1560. The elongated figure, wooden and lacking in sentiment, is placed against a landscape background engraved in a more delicate line to indicate depth. Here contours disappear as Cort delineated forms by suggesting edges rather than fully defining them. Thus, the forms tend to melt into the surrounding space.

Cornelis Cort

fig. B Example of swelling burin lines (detail of fig. J)

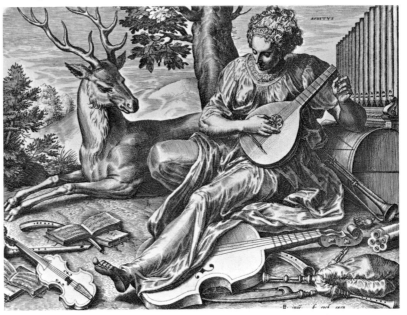

fig. C. Cornelis Cort, *The Five Senses: Auditus*. Washington, National Gallery of Art, Ailsa Mellon Bruce Fund

The important development of Cort's style took place after his move to Venice, where his dated prints after Titian are known from the year 1565. In Italy Cort worked after numerous artists, but he is best known for his engravings after Titian, Giulio Clovio, and Federico Zuccaro. In 1566 he was in Rome, back in Venice in 1567, and permanently in

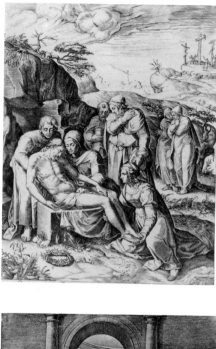

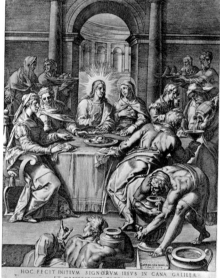

HOC FECIT INITIVM SIGNORVM IESVS IN CANA GALILEÆ
ET MANIFESTAVIT GLORIAM SVAM · Ioan. 2º.

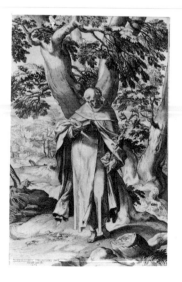

Rome in 1572. Tradition takes him on one of his journeys to Bologna where, although he was not Agostino's teacher, he may well have had dealings with Domenico Tibaldi, with whom Agostino studied.[20] In fact, Tibaldi copied at least one of Cort's engravings, the *Entombment* (fig. D).[21]

Cort's *Marriage at Cana,* after the Bolognese Lorenzo Sabbattini (fig. E), dated 1577, suggests how his burin technique had developed in variety and scope since his years in Cock's shop. Not interested in sharp contrasts of light and shade, Cort was able to portray a new and rich variation of tone and to reproduce the subtle changes that take place as monumental figures, sumptuously clothed, recede in space. He did this by his use of various sized strokes juxtaposed in myriad ways. For example, in the arched doorway behind Christ and the Virgin are burin lines of different lengths, varying from dots to short strokes to long curving lines, from straight hatching to triangular patterns, crosshatched in the same manner. Shading is not accomplished merely by increasing crosshatching to form deep shadows but by contrasts of hatching. The faces of the figures in the background are covered with hatching that not only plunges them into darkness but also, by the use of hatching in various directions, keeps each figure distinct from the backdrop and wall behind. Unlike the followers of Marcantonio Raimondi, Cort used a thicker burin, varying the placement of its strokes, and usually putting them farther apart.[22]

Insofar as his influence on the prints of the Carracci is concerned, the most important of Cort's technical innovations is his use of the swelling and curving burin line, apparent in some of the folds of the garments and tablecloth in the *Marriage at Cana,* but highly visible in such works as the *Rest on the Flight into Egypt* of 1576, after Passari (Agostino fig. 39a), which Agostino copied (Agostino cat. no. 39), and in the *Saint Dominic* of 1573 after Bartolommeo Spranger (fig. F). In these prints, movement and depth are emphasized by the use of a swelling burin line.

This enlarged line, increasing and decreasing in width, juxtaposed with other similar lines, gives the optical effect of a shimmering, undulating surface where it appears, as in the bodice of the saint or on the rocks to his right. This new use of the line, added to Cort's use of a larger burin than most, his variety of hatching technique, increased use of curved lines, and contrast of a thicker burin for foreground and a thinner one for background, made him the most important engraver of the period. In spite of being a foreigner, he was highly praised for his prints by Baglione in his *Vite*.[23] Works such as the *Saint Dominic* and the *Rest on the Flight into Egypt* were copied by other artists not only because of the popularity of the painted original but also for Cort's interpretations, for his virtuoso handling of the line, his endless variety of strokes, and his beautifully conceived forms moving in complicated rhythms amid lush and anthropomorphic vegetation.[24]

Cort's swelling burin line was influential on his contemporaries and on the following generation of Italian and northern printmakers. It is certainly the major technical innovation in engraving in the sixteenth century. Following Cort, two artists brought this innovation to new heights—in the north Hendrick Goltzius (1558-1617), and in the south Agostino Carracci. Each in his way understood the possibilities inherent

Domenico Tibaldi

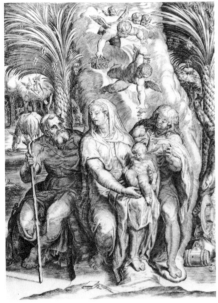

fig. G Domenico Tibaldi, *Rest on the Flight into Egypt*. Vienna, Graphische Sammlung Albertina

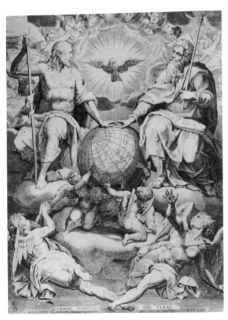

fig. H Domenico Tibaldi, *Trinity*. Vienna, Graphische Sammlung Albertina

in the use of the swelling line: for Goltzius, it was the complication of the line, its intricacies and movement; for Agostino, it was the contrast of light and shade, the possibility of reproducing coloristic effects in prints. Other artists working at the same time picked up Cort's manner; they were often confused with Agostino, but none seems to have understood the naturalistic or ornamental possibilities as did Agostino and Goltzius.[25] In fact, these two trends merged in the 1590s when Agostino took on Goltzius' style and technique.

Cort's style was transmitted to Agostino through Domenico Tibaldi (1541-1583), for whom he worked c. 1578/1579-1581. Domenico's abilities have been obscured by confusion with his famous brother, Pellegrino, who was probably his teacher, and with Agostino Carracci, his student. Domenico was not only an engraver but also worked as a sculptor and architect. Some of his works include the design of the Palazzo Magnani in his native Bologna, where the Carracci later worked, and the seated statue of Pope Gregory XIII on the archway to the Palazzo Pubblico, facing the Piazza Maggiore of the same city.[26] Although Bartsch credited Tibaldi with only nine prints (Bartsch XVIII, 12-17.1-9), all signed, it is certain that he produced many more. In this catalogue, his engraved oeuvre has been enlarged by seven prints (fig. D, cat. nos. R 54-R 59), and further research would most likely uncover additional works. In his funeral oration for Agostino, Faberio credited Tibaldi with numerous engravings and attempted to upgrade his importance.[27] Malvasia noted that he was a fine engraver who did not often sign his prints, and Zanotti, lamenting his obscurity, added that many of Tibaldi's engravings were sold as Agostino's, increasing the latter's fame.[28]

Tibaldi's first dated print is the 1566 *Palace of Ferrara* after Galazzo Alghiso (Bartsch VIII, 17.9). Not unusual for an architect is this neat, carefully executed rendering. It does not as yet suggest a knowledge of Cornelis Cort's works. By the use of finely engraved parallel hatching—without crosshatching, or gradual transitions between light and dark, between foreground and background—the print indicates that Tibaldi was then working in the tradition of Marcantonio Raimondi. In other engravings, such as the *Peace* (Bartsch XVIII, 15.6) and the *Rest on the Flight into Egypt* (Bartsch XVIII, 12.1; fig. G), although employing crosshatching and curved lines, the artist still read his figures as surface patterns, failing to vary the width and seldom the length of his burin strokes. Although the *Fountain of Neptune* dates from 1570, like the preceding engravings, it falls within the range of works made before Tibaldi was influenced by Cort. In fact, these prints are closest to works by Marcantonio's follower, Giulio Bonasone, who worked in both Bologna and Rome.[29] Yet, the 1570 *Trinity* (Bartsch XVIII, 12-13.2; fig. H), after Orazio Sammacchini, shows that Tibaldi had begun studying Cort's works. There is more variety in the hatching, greater complexity in composition, and, in general, more movement. Although Tibaldi always employed delicate, closely spaced burin lines, he began to explore the possibilities of using the burin in different directions. In his prints after Parmigianino, the *Madonna of the Rose* (Bartsch XVIII, 13.3, fig. I), and Passarotti, *Gregory XIII* of 1572 (Bartsch XVIII, 16.7), Tibaldi employed Cort's formulae for reproducing shimmering effects of garments, increasing folds, and suggesting materials and textures. The

robes of the pope are a clear indication that Tibaldi had not only reached maturity but was an excellent reproductive engraver. As witnessed in the works here attributed to him (cat. nos. R54-R59), by 1575 Tibaldi had completely assimilated Cort's technique. In the *Madonna and Child Seated on a Cloud* (cat. no. R55) and in the *Annunciation* (cat. no. R54), Tibaldi successfully employed Cort's swelling and tapering line to indicate depth and movement. Moreover, he slowly began to increase the width of his burin line, but continued his penchant for the delicate.

As Tibaldi's student, Agostino was the first of the three Carracci to make prints and, unlike his brother or cousin, this became his primary occupation, his fame resting mostly on his graphic activity. And for this reason, it is around him this introduction is focused. Like many engravers, Agostino began his career as a goldsmith. None of this work survives, but judging from his carefully detailed engraving, it is obvious that he would have been successful at this trade. According to Malvasia and others, he then passed to the studio of Prospero Fontana and to that of Bartolomeo Passarotti.[30] A drawing of Tiburzio Passarotti in a studio, dated 1577, attributed to Agostino, suggests that he was with Passarotti that year.[31] Agostino's earliest dated work, the recutting of Bonasone's plates for Bocchi's *Symbolicarum* in 1575 (see Agostino cat. no. 1), was probably done before he entered the studios of Fontana or Passarotti. The following year, Agostino signed his first engravings, made after earlier Bolognese artists. His efforts of 1576 (Agostino cat. nos. 3-4) do not reveal the precociousness which Malvasia would have us believe.[32] The composition and figures are simple; there is little understanding of forms in depth or of correct anatomical structure. The burin used is rather broad, as is characteristic of all of Agostino's works, but there is little variation in its use. In his earliest prints Agostino employed hatching and crosshatching of the same width and often of the same length, seldom curving the lines. The difference between these works and Cort's indicates Agostino could not have been his student. Instead, our artist began his career by following in the footsteps of the Marcantonio school.

We have no products from Agostino's apprenticeship period with Fontana or Passarotti. If we believe Malvasia, he did little for a year or so after his apprenticeship, considering other careers, until he turned back to engraving seriously and entered Tibaldi's studio.[33] This was in either 1578 or 1579; his signed prints indicate a giant leap in his development (Agostino cat. nos. 9-10) in 1579. Under Tibaldi Agostino learned the skill and complexity of the burin, as introduced to his teacher through Cort's work.[34] Tibaldi's methods of instructing Agostino in Cort's manner probably consisted of having the young artist copy works by Cort and works by himself in Cort's manner. In the *Madonna and Child Seated on a Crescent Moon* (Agostino cat. no. 15), probably after Tibaldi's engraving (Agostino cat. no. R56, Agostino achieved a wavy-line effect in the clouds and on the garments of the Virgin, but he had not yet mastered the art of Cort's swelling and tapering burin line. In other works made under Tibaldi's aegis, the young Agostino approached his employer's technique closely. In his two prints after Michelangelo (Agostino cat. nos. 9-10) and in the *Adam and Eve* and *Tobias and the Angel* (Agostino cat. nos. 23-24), Agostino's use of a fine burin line with straight parallel placement of uninterrupted hatching recalls Tibaldi's work of ten years earlier, such as the *Trinity* of 1570 (fig. H).

Agostino 1570s

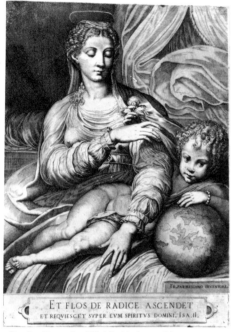

ET FLOS DE RADICE ASCENDET
ET REQVIESCET SVPER EVM SPIRITVS DOMINI. ISA.II.

fig. I Domenico Tibaldi, *Madonna of the Rose*. Vienna, Graphische Sammlung Albertina

While Agostino worked for Tibaldi, he vacillated between a style characterized by silvery, delicate tones, reminiscent of Bonasone and other mid-sixteenth-century Italian artists of the Marcantonio school and of Tibaldi's early style, and an awakening sense of Cort's new, more dramatic technique. The latter is most noticeable in the foliage of his trees and foregrounds, as in the *Adam and Eve,* and in his copies of Cort's engravings (Agostino cat. nos. 17, 20). It is in these and similar works of the years between 1579 and 1581 that Agostino reached technical proficiency as an engraver. From then on, he concentrated on the refinement of technique and development of the style which was to make him famous.

Agostino's "independent style"

This slow development from an apprentice engraver in 1576 to such proficient engravings as the *Tobias and the Angel* in 1581 and later to the magnificent *Portrait of Titian* (Agostino cat. no. 145) led Ostrow to divide Agostino's works between the reproductive and the original, suggesting that the latter were made in his "independent style."[35] According to Ostrow, until the mid 1580s Agostino's reproductive engravings were technically more advanced than those prints inspired by his own imagination. Part of the basis for this argument rested on the acceptance of certain works which are rejected here and the rejection of others accepted here.[36] In addition, engravings such as the *Holy Family* (Agostino cat. no. 3), thought to be original engravings by Agostino, have turned out instead to be reproductive in nature. In studying the engravings accepted in the present catalogue, a distinction between the reproductive and independent styles disappears. Instead, the gradual development of an artistic language in both types of print becomes evident.

Agostino 1579-1581

Agostino's style was becoming distinctive between 1579 and 1582, yet at that early period he could only be placed among the many followers of Cornelis Cort. But in his reproductive engravings, especially those after Cort himself, Agostino was not a slavish imitator. In the *Saint Roch* (Agostino cat. no. 17), for example, Agostino managed to give more drama and depth to the subject than had Cort, even without the use of the swelling burin line. The *pentimento,* visible in some early pulls, of the dog at right indicates that the artist was experimenting with the placement of the animal, finally choosing the spot at left away from the saint to add to the figure's monumentality. In Cort's print (Agostino fig. 17a), the dog complicates and confuses the stance of Saint Roch, whereas in Agostino's he complements the figure. More important, however, is Agostino's tendency to simplify forms and clarify their placement in space. Although the folds of the garment are the same in each print, Agostino used more of the white of the paper to give contrast between the folds, showing them receding more in space, and in the background there is a clear indication that the saint is far to the front of the landscape added by the artist. In Cort's print, on the other hand, Saint Roch stands against an evenly hatched curtained backdrop. The loosening of the figures from the background and the use of the brightness of the paper for contrast are hallmarks of Agostino's style, even in his early years. The figures are almost always volumetrically conceived, monumental forms, unlike Tibaldi's and Cort's flat, planar figures.

Except for a few reproductions after artists active in Rome, until 1582 Agostino's work was mainly after Bolognese mannerist artists such

as Sammacchini and Sabbattini. Although he probably traveled to Rome in 1581 (see Agostino cat. no. 40), the impact of Renaissance and classical art did not strike him until the trip he took during the late 1590s.

1580 trips to Parma and Venice

This leads us to an examination of trips taken by Agostino and his brother Annibale in 1580 to Venice and Parma. Malvasia published two letters, dated April 18 and April 28, 1580, purportedly written by Annibale from Parma to his cousin Lodovico in Bologna.[37] (Reprinted in Appendix III with an English translation.) In these letters Annibale discussed his enthusiasm for Correggio's work and how he expected Agostino to join him in Parma to learn Correggio's style. The two rambling letters are followed by a fragment supposedly written by Agostino in Venice to Lodovico saying that Annibale had joined him there and discussing the brothers' enthusiasm for Veronese, who, they believed, even surpassed Correggio. These letters have been dismissed by most scholars as forgeries or as works edited by Malvasia. They based their arguments on the lack of influence of either Venetian or Parmese artistic style on Annibale's earliest dated painting, the *Crucifixion* of 1583.[38] Although Malvasia published the letters to emphasize the Lombard strain in Annibale's art and his new regard for Correggio prompted by his cousin Lodovico, it is unfair to brand the letters completely Malvasia's invention or rewriting. In the first place, there was no reason for Malvasia to make up a nonexistent early trip to stress the importance of Correggio for Annibale's art or to stress Lodovico's regard for the *studioso corso*, or study trip. Secondly, why choose the year 1580 for this trip, when Malvasia himself indicated that Agostino was looking for new paths to follow even before he entered Tibaldi's studio? Why not push the trip back to 1578? It is this author's opinion that these letters may in fact reflect the Carracci's attitude toward Parmese and Venetian art in 1580. Venetian influence has been noted by several scholars on Annibale's *Crucifixion*,[39] and, as suggested below, a drawing from c. 1582 by Annibale shows Correggio's influence.[40]

Although one cannot prove that Agostino and Annibale went to Parma or Venice in 1580, there seems no reason to doubt that they would. Lodovico had been traveling in the 1570s to Florence, Rome, and Venice to study the paintings of other artists and encouraged his cousins to do the same. If Agostino and Annibale began traveling in 1580, Lodovico must have completed his study trips by that year. This *studioso corso* in the life of Agostino and Lodovico was emphasized by Malvasia and biographers since; why not the same for Annibale, whom we believe was taught first by his cousin Lodovico, whose method of instruction included stressing travel for young artists to learn the variety of stylistic possibilities open to them. Moreover, we see no Roman influence on Agostino in 1581, yet believe he went to Rome; his first Venetian trip and Annibale's first Parmese trip do not mean that their developing styles suddenly became Correggesque or Venetianizing. Other considerations to be taken into account are their contacts with non-Bolognese artists visiting or working in Bologna, who also may have encouraged them to travel. Dempsey emphasized the progress of Barocci's influence carried to Bologna via Francesco Vanni (1563-1610), a Sienese artist who was working in Passarotti's studio in 1577. Coincidentally, Agostino was in the same studio the same year. As Dempsey

convincingly showed, Vanni may have followed the path of Barocci's style to its origin in Correggio.[41] He may also have instilled the desire to do the same in the Carracci. If Lodovico's and Vanni's inspiration were not enough, one must finally admit that Parma does not lie far from Bologna and is in the path from Bologna to Cremona, the city of the Carracci family's origin. It would be most likely that two young artists would take a short trip to see the works of the famous Parmese artists, Correggio and Parmigianino.[42] If their influence did not show up for several years, it may be that these were the crucial developing years of all three Carracci. Moreover, their painting styles for 1580 are not yet known, although they must have been painting that early. When the painted works prior to 1583 come to light, we will know more about their early travels and influences.

During the early eighties, Agostino was teaching Annibale how to use the burin. According to Malvasia, Annibale was first taught the art of painting by his cousin Lodovico and the art of engraving by his brother Agostino. Malvasia asserted that Agostino assisted Annibale with his first print, which the biographer supposed was the *Saint Jerome* (Annibale cat. no. 4), dated by most scholars c. 1585.[43] This seems a rather late date for Annibale to venture into the field with assistance from his brother. Agostino's first dated print comes from 1576, and Annibale was only three years his junior. If Annibale was a precocious artist, as Malvasia asserted, one would assume that he was attempting to learn the art of engraving earlier than his twenty-fifth year, especially when his brother was already so proficient. Indeed, by 1585 the Carracci had run their academy for three years, had finished their first success in the Palazzo Fava a year earlier, and were becoming recognized artists in northern Italy. It seems likely that Annibale, if he did learn the engraving technique from his brother, would have done so several years prior to this. Moreover, if Agostino assisted Annibale with his earliest work, one would assume the engraving technique and style would approach his own, and the *Saint Jerome* does not betray Agostino's hand. It would seem, therefore, that several earlier prints, rejected from Annibale's oeuvre by some critics for their proximity to Agostino's style, must be reconsidered. These engravings are signed, two are dated, and they belong to the years 1581 and 1582 (Annibale cat. nos. 1-3). The *Crucifixion* of 1581 (Annibale cat. no. 1) approaches Agostino's prints of the same year, especially the *Baptism of Christ* and the *Tobias and the Angel* (Agostino cat. nos. 23, 26). It is likely that this is the engraving with which Agostino assisted his brother, who, proud of his first excursion into the medium, signed and dated the sheet in the lower left. Why else would he sign it? No impression exists without the signature, and it is doubtful that it was added at a later date. Moreover, Agostino certainly would not have signed his own print with his brother's name, and Annibale would not have dared sign his brother's print with his name. Logically, the signature and date must be accepted as genuine.

Thus, at the beginning of the 1580s the brothers were working together in printmaking, and they must have also been painting together before their first frescoed masterpieces of the *Rape of Europa* and the *Story of Jason* in the Palazzo Fava, Bologna, finished in 1584.[44] Agostino engraved two prints after designs by Annibale in c. 1581, the *Baptism of Christ* and the *Adam and Eve* (Agostino cat. nos. 23, 25). The

following year, 1582, was the most important period in the working relationship between the brothers and with their cousin Lodovico. In this watershed year, the three founded the Accademia degli Incamminati, a painting academy where students could discuss theory, hear lectures from professors from the university, study the anatomy of corpses, and draw from the living model.[45] The intellectual atmosphere of the academy heightened the interaction of the Carracci family, and in 1582 Agostino and Annibale each made prints of the same subjects, and Lodovico also joined in with a painting. They may have made these works as studio exercises in friendly competition or in their unquenchable search for perfect forms.

Agostino and Annibale 1582

Annibale's print of the *Holy Family with Saints Michael and John the Baptist* (Annibale cat. no. 2) of 1582 has been rejected by Posner and Calvesi/Casale on the basis not only of its similarity to Agostino's works but because it is reproductive in nature.[46] This judgment seems unacceptable in view of the fact that there are known drawn copies after Correggio by Annibale, and, as shown here, Annibale based at least one etching, the *Venus and a Satyr* (Agostino cat. no. 17), on a drawing by Agostino. Similar to Annibale's engraving is Agostino's *Madonna and Child with Saints Peter, Stephen, and Francis* (Agostino cat. no. 54). Each is after a Bolognese mannerist artist (Annibale's after Sabbattini, Agostino's after Sammacchini), the compositions are similar, and the technique alike. What differs in these works is the morphological signatures of each of the artists, as explained in the catalogue entries. But, in 1582, Annibale had advanced as far technically in printmaking as had his brother. The drawing for the *Holy Family with Saints Michael and John the Baptist* (Annibale fig. 2), attributed here to Annibale, is enlightening in regard to the controversy over a Parmese trip. The facial features of the Christ Child and Saint John the Baptist approach many of the Correggesque figures in the Palazzo Fava and also the red chalk *putti* which are copies after Correggio.[47] The secure date of the print, and thus the drawing, suggests that these Correggesque and Baroccesque elements in the Palazzo Fava stem from a knowledge of Parmese art dating to before 1582.

The second joint subject taken up by Annibale and Agostino in 1582, their copies of Barocci's etching of the *Madonna and Child on the Clouds* (Agostino cat. no. 98, Annibale cat. no. 3), may have been done in conjunction with a painting of *San Vincenzo* by Lodovico (Agostino fig. 140a) with the same motif. In any case, the Carracci were interested in Barocci's art in 1582 and were working out their reactions to him. In these three earliest engravings by Annibale, and especially in this last one, the younger artist was dependent on his older brother for advice in the technical aspect of the craft. But already, a different personality was emerging. Although carefully conceived and executed in an exacting burin technique, the *Madonna and Child on the Clouds* by Annibale reflects an understanding of Barocci's atmospheric qualities missing in Agostino's print. Annibale continued to work in engraving in the 1580s, but his concept of the medium changed, and in the rest of the decade he concentrated on painting.

Agostino 1582

Agostino, on the other hand, became more involved in engraving in 1582. In this year, he traveled to Venice for an extended period and began work on his portraits for the *Cremona Fedelissima*, engravings after

Antonio Campi (cat. nos. 55-92). As noted in the entries to those engravings, Agostino's work for the *Cremona Fedelissima* started before his move to Venice and may have included a trip to Cremona. Agostino's 1582 trip to Venice was the turning point in his engraving style and carried him into full artistic maturity. Obviously, the light and color of Venetian painting, especially that of Veronese, caught the Bolognese artist's fancy. In Agostino's copy of Veronese's *Crucifixion* in San Sebastiano (Agostino cat. no. 107), this subtle stylistic change is evident. To increase the play of light on the surface and to recreate Veronese's glittering effects of fabrics, Agostino employed a thicker burin line, broke up the surfaces by greater contrasts between the light and shaded areas, and increased the variety of burin strokes of various parts. He eschewed the use of parallel, repetitive lines to shade areas in the background planes, such as appeared in the *Adam and Eve* (Agostino cat. no. 25) of the year before. Agostino's Venetian experience also imbued in him an appreciation of lustrous materials and details of garments. From this point on, he developed an interest in contrasting fur and silk, hair and skin, etc., in such a way as to give the viewer a true feeling of texture. This was one of his greatest accomplishments in printmaking and most evident in his famous *Portrait of Titian* of 1587 (Agostino cat. no. 145). In that work, the delicate, closely placed lines of the beard contrast with the thicker, wavy lines of the fur collar. The uninterrupted hatching of the cap and bodice, placed almost next to each other, with fewer lines in that part of the garment closest to the foreground, adds a richness to the satiny texture of the shirt. The short strokes around the eyes, contrasting with the white of the paper, give the craggy appearance of age to the face. Different depths are achieved by means of simple crosshatching on the ear, leaving some light of the paper; this is juxtaposed to the brighter white in the beard next to it and the deeper black, with almost no white of the paper, on the cap behind it. By varying the use of the white of the sheet and the length, width, and curvature of the hatching employed, Agostino achieved the tonal and textural effects so characteristic of Venetian painting.

Agostino and Annibale 1580s

Agostino was back in Bologna in 1583-1584 working with Annibale and Lodovico on the Palazzo Fava frescoes, the series of paintings which ensured fame for the Carracci. Concurrently, he engraved his series of apostles (Agostino cat. nos. 108-123), continued on the *Cremona Fedelissima* portraits, and made some half-length figures of saints (Agostino cat. nos. 124-126). It is likely that these small devotional prints were made at the same time as similar works by Annibale (Annibale cat. nos. 4-7), but in comparing the prints, the increasing technical and stylistic diversity between the brothers is evident. In Agostino's works, as usual, there is an exacting method of hatching and crosshatching. Annibale, on the other hand, was exploring the possibilities of linear freedom. In the *Saint Jerome* (Annibale cat. no. 4), for example, hatching is irregular, lines hastily drawn, forms open, and the background sketchy. Unlike Agostino's prints of the same period, hatching overlaps contours, and lines vary radically in length rather than being juxtaposed in a careful progression. The result is a more atmospheric rendering, somewhat like a quickly executed sketch. These attributes are apparent in Annibale's other engravings made during the 1580s (cat. nos. 4-10), qualities more akin to etching than to engraving. During the

rest of the 1580s, Annibale was busy with drawing and painting altar-
pieces and private religious and mythological commissions. When he
returned to printmaking in 1590, he did so in the etching and not the
engraving medium. His paintings of the same period show an increasing
awareness of Barocci's and Correggio's art, perhaps indicating another
trip to Parma. The Venetianizing trend also increased toward the end of
the decade, suggesting another trip to that city.

Agostino 1580s

The 1580s were an increasingly busy time for Agostino. During
this decade his popularity increased,[48] his painted and engraved output
was immense,[49] he was involved with students in the newly founded
academy, and he traveled widely, increasing his knowledge of other art-
ists' styles. In 1580 he was probably in Venice and Parma, in 1581 in
Rome, and in 1582 in Cremona and Venice. In 1585 he may have again
traveled to Venice, was definitely in Parma in 1586 and 1587, again in
Venice in 1587/1588-1589, and probably in Florence in 1589.[50] During
this decade Agostino, possibly through his work with the academy, be-
came friends with the artistic, literary, and scientific minds of the
period. Besides Rinaldi, Zoppio, and Aldrovandini, noted earlier, he
met Jacopo Tintoretto, who was godfather to his son Antonio in 1589.[51]
Agostino's reputation as the leading engraver in Italy was firmly estab-
lished by his remarkable works after Tintoretto in 1588 and 1589, most
notably the intricate *Madonna Appearing to Saint Jerome* of 1588 (Agostino
cat. no. 146), the large and complicated *Crucifixion* of 1589 (Agostino
cat. no. 147), and the dramatic *Mars Driven Away from Peace and Abun-
dance by Minerva* (Agostino cat. no. 148) of the same year. These works
exhibit a consolidation of the technical developments begun with Agos-
tino's Venetian trip of 1582, a development and complication of hatch-
ing giving further possibilities of textural and tonal contrasts, and the
ever present need to simplify forms and clarify compositions.

The three Carracci 1590s

The early 1590s saw the brothers and their cousin working together
again, in both paintings and prints, but with far different results than in
the early 1580s. Each artist had developed along different lines, their
personalities determining the directions they took artistically.[52]
Agostino—the gregarious intellectual, the poet, musician, artist—was
enlarging his artistic commissions. He painted, drew, engraved, did
portraits, coats of arms, frescoes. His range of talent was immense.
Annibale—the ill-kempt, the melancholic, the sharp witted, the antiso-
cial genius—was experimenting with color and form in his paintings and
with atmosphere in his prints. His works were becoming more and more
intimate. Lodovico—the elder, the solid teacher—was still working with
the academy and attracting large commissions for the family and his
students. He, too, was at last turning to printmaking, at a late date in
comparison with his younger cousins.

Lodovico 1585-1590s

The problems encountered in relation to Lodovico's graphic produc-
tion are different from those of his cousins. For Agostino, engravings are
central to an understanding of him as an artist; for Annibale, prints were
a private means of expression. For Lodovico, prints could have been a
needed diversion from his main occupation as painter and teacher. With
an oeuvre of only four prints, it is difficult to discuss a development in
his work, even though the four prints span at least ten to fifteen years.
His earliest print, an engraving, of the *Holy Family under an Arch*, in-
spired by Andrea del Sarto (Lodovico cat. no. 1), like his cousins' earliest

efforts, is reproductive in nature. Because of its relationship with the dated painting of the *Madonna dei Bargellini* of 1588, the print is dated here c. 1585-1590. In technique it lies somewhere between Agostino's carefully controlled hatching and Annibale's linear freedom. Like Annibale's etching of the *Holy Family* of 1590 (Annibale cat. no. 11), this print too is influenced by the etchings of Federico Barocci. Lodovico attempted here in the finer medium of engraving, as had Annibale in his copy of Barocci in 1582 (Annibale cat. no. 3), to achieve the *sfumato* effects characteristic of Barocci's style. If, as Dempsey convincingly showed, Lodovico had brought back from Florence during his early travel years ideas of Barocci's painting style, perhaps too, with this work, Lodovico showed the way, years later, to Barocci's graphic style. *The Holy Family under an Arch* is also close enough compositionally and stylistically to Annibale's *Holy Family* to indicate a connection. By faceted drapery with light playing over the surface and small hatched dots to suggest *sfumato*, Lodovico attempted an emulation of Barocci, but his enclosed contour lines stop short of a true integration of Barocci's technique.

Annibale 1590s

It was Annibale, turning to etching in 1590, who successfully achieved the *sfumato* inherent in Barocci's paintings and prints. Contours melt into the background, and forms flow harmoniously within each other. By employing a net of contour lines and numerous dots and small broken lines, instead of long, continuous hatching, and by widening the spaces between lines, Annibale achieved the effects of a faceted light breaking up the forms—an atmospheric rendering. His diverse system of hatching, with its use of multitudinous, juxtaposed strokes, is not unlike that employed by Barocci. In fact, technically, it is little different from that seen in Barocci's prints, although somewhat freer. What is new is the classical breakdown of the composition into monumental triangular and regular parts, a kind of codification of geometrical forms inherent in nature. There is a possibility, as Posner suggested, that Annibale was making a friendly critique of his cousin's engraving in Barocci's style. He may have also been trying to show his brother Agostino how the etching needle should be handled. About this time Agostino made his only etchings (Agostino cat. nos. 153-154) but treated the medium as if it were engraving.

The newest technical developments in printmaking in the late sixteenth century took place in the field of etching rather than in engraving, and Annibale found greater possibilities within this medium. While Agostino was a reflective artist with the ability to perfect an already developed craft, Annibale was innovative, and he had to try his hand at changing existing norms. Although he continued to work in printmaking with Agostino and sometimes followed his designs (Annibale cat. nos. 16, 17, 19), Annibale was no longer dependent on his elder sibling for advice or technical help. He had mastered his technique in his earliest prints, and his genius needed to be tested in other areas. Other master painter-printmakers of the sixteenth century, such as Dürer and Parmigianino, expressed themselves in etching in an attempt to extend the atmospheric rendering of a painted composition to paper or to approximate the technique of pen and ink and wash or chalk *sfumato*. Annibale, too, used this now established medium for experimentation.[53]

Posner was correct in asserting that Annibale's new interest in ren-

dering atmosphere in prints was based on his Venetian experience,[54] but the aura of *sfumato* in his prints after 1590 also incorporated his renewed interest in Barocci. This atmospheric quality, along with the random penlike use of the etching needle, looks forward to the Bolognese and Roman etching manner of the seventeenth century, which is based on much of Annibale's work. For example, in the 1592 *Venus and a Satyr* (Annibale cat. no. 17), after Agostino, the use of hatching and crosshatching is subordinated to the linear structure of the forms; the system has been simplified to the most basic crosshatching for deep shadow and single hatching to indicate volume. Lines suggest forms, as in the trees in the background, instead of detailing them. Forms are simplified and blocked out with more abrupt transitions in depth, as in the folds of the drapery, and bright light casts harsh shadows on the figures. In other words, all but the necessary lines are eliminated, focusing attention on the main outlines of the composition and forms, suggesting the rest. Like a hastily executed drawing, the etching suggests form instead of elaborating it. Although this system of hatching varies slightly in Annibale's late etchings (Annibale cat. nos. 20-22), the concept remains the same: shapes are simplified, background is minimized, emphasis remains on the massive forms and triangular structure of the composition. In fact, forms are further reduced and idealized.

Agostino early 1590s

In the early 1590s the most important of the Carracci's many commissions was the fresco cycle of the *Story of the Founding of Rome* in the Palazzo Magnani, in Bologna, finished in 1592.[55] For Agostino, the period was especially productive graphically,[56] as he produced book illustrations for the *Gerusalemme Liberata* (Agostino cat. nos. 155-164) and the *Ricreatione Amorose degli Accademici de' Gelati* (Agostino cat. nos. 165-174), both published in 1590. At the same time he made many mythological works and coats of arms for Bolognese and Roman families, most of these after his own designs. In the artist's original engravings, he preferred to simplify the hatching technique to concentrate on the subject matter. In the *Lascivie* (cat. nos. 176-190), especially, the basically simple compositions take on the character of quickly executed pen sketches. In contrast, his reproductive prints are always more complicated, not because Agostino lacked the ingenuity to embellish his own works with a complicated technique, but because there was no need to recreate the tonal effects inherent in paintings. In these works, Agostino was creating images, not recreating color. Moreover, the distribution of these prints was more limited—the *Lascivie* probably sold clandestinely, the coats of arms for the patron only—and the need to satisfy a mass audience with technical virtuosity became unnecessary.

The Carracci in Rome 1595

A major stylistic change in Agostino's and Annibale's paintings and prints occurred after 1594 when Cardinal Odoardo Farnese called them to Rome to paint for him in the Palazzo Farnese. The two brothers heeded the honor, but Lodovico preferred to remain in Bologna, continuing the work of the academy and obviously busy enough at home with commissions.[57] Both artists returned briefly to Bologna in 1595; Annibale was back in Rome permanently the same year, Agostino following him in 1597. The move to Rome is so important to their work that one usually divides the entire Carracci output into two periods, Bolognese and Roman. For Agostino, at least, another significant factor made him reassess his stylistic and technical methods: his contact with Hendrick Goltzius.

Hendrick Goltzius was the best-known and most sought after en-
graver in the north about this time, as Agostino was in the south. He
was born in the Netherlands and was a pupil of Dirck Coornhert and
Philip Galle, from whom he learned Cort's style and technical innova-
tions. His use of Cort's swelling and tapering line was exaggerated to
such a degree as to make it a tour de force. Most of his works in the
1580s were influenced by northern mannerist painters, as seen in the
elongated figures with tiny heads and exaggerated body musculature,
incredible antinaturalistic placement in space, curving and twisting or-
namental forms, and surface decoration. In a typically complicated com-
position such as the *Mars Surprised by Venus* of 1585 (Hollstein vol. VIII,
p. 30; Bartsch III, 43.139), dramatic contrasts of bright light against
deep shadows, undulating lines and swirling bodies and clouds
exemplify Goltzius' penchant for the melodramatic and dynamic.[58]

In 1590-1591 Goltzius made an extended trip to Italy, passing
through Bologna to and from Rome.[59] Although van Mander related
that Goltzius traveled incognito, it is probable that he met with the
Carracci on his visits to Bologna. He and Agostino may even have ex-
changed prints. It has been suggested more than once that he actually
copied an engraving by Agostino, when the opposite is probably the
truth (Agostino cat. no. 211). In fact, stylistic evidence suggests it was
Agostino who was impressed with Goltzius' elaborate, virtuoso tech-
nique. Unfortunately, few prints by Agostino are dated between 1590
and 1595, and therefore the exact point at which he turned earnestly to
Goltzius cannot be pinpointed. The first dated prints that reflect
Goltzius' influence appear in 1595 (Agostino cat. nos. 203, 205) at
about the same time the influence of his Roman experience appeared.
Why it took Agostino so long to assimilate Goltzius' technique is a
mystery which cannot be solved by accepting Ostrow's suggestion that
Agostino did not engrave much between 1590 and 1594 but spent his
time painting.[60] His painted works of the early 1590s also show no
influence of northern mannerism. There seems no reason to doubt that
Agostino continued engraving during this period, as asserted here, for in
the 1580s he was able not only to take on painting and engraving com-
missions, but also to work with the academy and to travel extensively. It
is likely that Agostino's trip to Rome was the catalyst for his change in
style and that he chose Goltzius' technical idiom as the best way to
express this change.

Goltzius' influence on Agostino shows up first in the *Saint Jerome*
(after Vanni) and the *Aeneas and his Family Fleeing Troy* (after Barocci),
both dated 1595 (Agostino cat. nos. 203, 205). Concurrent with
Goltzius' manner is Agostino's obvious interest in ancient and Renais-
sance sculpture, evident in many of his drawings of the period.[61] The
figures in the *Saint Jerome* and *Aeneas* engravings are enlarged, plastic
forms embodying a sense of monumentality. More apparent, however, is
the assimilation of Goltzius' manner. The abnormally sharp contrasts of
light and shade in the intricate and angular drapery folds is characteristic
of Goltzius' work, as is the ornamental quality of such delicate forms as
hair and clouds. Most clearly taken from Goltzius is the exaggerated and
indeed mannered forms of the musculature of the bodies of Anchises and
his son Aeneas in *Aeneas and his Family Fleeing Troy*. These bulbous,
curving, and bumpy forms are absent in Barocci's original, but Agos-

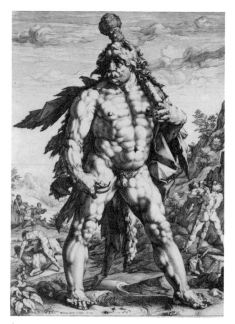

fig. J Hendrick Goltzius, *The Great Hercules*. Washington, National Gallery of Art, Ailsa Mellon Bruce Fund

Agostino in Rome

Annibale and Agostino in Rome

tino's interpretation is akin to some of Goltzius' nudes, for example, his *Great Hercules* of 1589 (fig. J; Hollstein XVIII, p. 32). The overdeveloped musculature, catching the light striking the rounded lumps, exaggerates the strength of Hercules by overemphasis. Agostino was fascinated not only with the decorative aspects of these undulating forms, but also with the technical virtuosity of Goltzius' burin work and the possibilities inherent in its use to capture plastic forms in space. By various, juxtaposed hatching contrasted directly with the white of the paper, sharp recession in depth was achieved and the forms made more sculptural and monumental. In accepting Goltzius' technique, Agostino also took on his style, that is, the style of northern, decorative mannerism. This complicated, virtuoso manner was to appear again in Agostino's last engraving, the unfinished *Saint Jerome* of 1602 (Agostino cat. no. 213).

It is interesting that this exaggerated technique does not appear in all of Agostino's prints after his arrival in Rome. In fact, a parallel but divergent development occurred, based on a balance of idealized classical forms and a simplification of technique to express monumentality. The influence of Raphael and Michelangelo and ancient sculpture appears in most of his paintings, drawings, and prints between 1597, when Agostino moved to Rome, and 1600, when he left the city for good. It was the period of the Palazzo Farnese frescoes and Agostino's last intense working relationship with his brother Annibale. In the engraving of the *Holy Family* (Agostino cat. no. 208), dated 1597, Agostino's Roman experience and Annibale's influence are at their heights. In this work, the calm, quiet strength, lost in his virtuoso display in the *Aeneas and his Family Fleeing Troy,* is supported by the simplification of technique. The burin line tapers less, and lines for the most part are the same width, although different tools were employed for thicker lines when necessary. Depth was achieved not by swirling, tapering, and swelling lines, but by the juxtaposition of light against dark and of rounded linear forms set against a simple background. The culmination of the Roman style, characterized by a balance of classical subject matter and forms, is found in Agostino's *Omnia vincit Amor* of 1599 (Agostino cat. no. 210), in which figures relate to each other and to the landscape in an ideal and idyllic atmosphere of calm.

Annibale and Agostino worked together on one last print project before their well-known quarrels divided them permanently.[62] Agostino assisted his brother on the ceiling frescoes of the Galleria Farnese, following Annibale's designs for the project, but the two also collaborated on the silver dishes or *tazze* for Cardinal Farnese (Annibale cat. no. 19). In this case, as discussed more fully in the catalogue entry, Agostino may have initiated the original designs. However, the brothers were growing farther apart during the Roman years, personally and artistically. Annibale differed from his brother not only in technical aspects of printmaking but also in his attitude toward his subject matter. Annibale had the ability to evoke strains of emotion hardly tapped in Agostino. The comparison of the *Christ of Caprarola* (Annibale cat. no. 18) and Agostino's copy (Agostino cat. no. 209) points out the differences clearly. In Annibale's work, the Madonna swoons in sorrow and is supported in her grief by the other Marys and Saint John. Expressive content is underlined by the broken contours of the forms and the resultant

movement of flickering light on the surface. In Agostino's print, the light does not bathe the protagonists and connect them but rather isolates them in their emotions. Annibale softened the forms and Agostino, concerned with technical mastery at the expense of human feelings,[63] hardened them.

Agostino in Parma

Had Agostino not returned to Emilia, at the request of Ranuccio Farnese,[64] and spent the remaining two years of his life in Parma from 1600-1602, this might have been the end of the story of his artistic development. In fact, in his paintings in the Palazzo del Giardino in Parma, commissioned by Ranuccio, Agostino's painting style continued in a direct line of progression from his frescoes of *Aurora and Cephalus* in the Galleria Farnese in Rome.[65] But Agostino's return to Parma must also have reawakened in him an appreciation for Emilian mannerist works. In his drawings for the *Saint Jerome* (Agostino cat. no. 213), definite parallels can be made with drawings by Parmigianino, more so than in any of his works since the early 1580s.[66] At the same time, Agostino looked again at Goltzius' prints. The mannered musculature of Saint Jerome's body is a toned-down version of his engraving of *Aenaes and his Family Fleeing Troy*. Although less dramatic than the earlier print—the calm of his Roman works still prevails—the tendency toward exaggeration returned. It appears that Goltzius, although more important to Agostino in 1595, was still having a profound effect on the artist. Had Agostino lived, one wonders if his engraving style would have become more complicated, more involved, tending toward greater elaboration. In direct contrast, his brother Annibale's graphic and painting style after 1600 became more intensely idealistic, with further simplification and clarification of subject and forms.

Annibale after 1600

Annibale made no prints from c. 1600, the latest date for completion of the *Tazza Farnese* (Annibale cat. no. 19), to c. 1606 when he etched his last three prints (Annibale cat. nos. 20-23), two of which are dated. Annibale's melancholic strain was externalized in these late prints, probably executed after he stopped painting in c. 1605 due to his final debilitating illness.[67] The emotional impact of these personal statements is astounding: forms and technique are radically simplified to focus primarily on the subject. Classical idealism and simplification of technique are subordinate to the psychological drama of the scenes. The *Christ Crowned with Thorns* (Annibale cat. no. 21), especially, in its geometrical abstraction draws attention to the suffering of Christ as much as it suggests the classical idealism of the figures.

Lodovico after 1600

After Agostino's death, Lodovico made a trip to Rome bringing with him the *Saint Jerome* print by his cousin for publication by Pietro Stefanoni.[68] While in Rome in 1602, or immediately after, he made his last print, of the *Madonna and Child with Saint John* (Lodovico cat. no. 4). Although printmaking was never of central importance to Lodovico's work, his previous prints had shown that he liked to experiment with the technical aspects of the printmaking media (see Lodovico cat. no. 2). In his final print, he attempted a new medium—drypoint. Unfortunately, damage to the plate even before the earliest printings mars the effect of the deep, rich burr. As with his cousins, the Roman experience was influential on his work, both in paintings and in this print. Forms became rounder, classical features appeared; but in the long run, Rome's magic was brief for Lodovico and only placed a gloss over his established

Bolognese style.[69]

From the foregoing, it is evident that the Carracci depended on each other for new ideas and for advice on projects already begun. According to Boschloo, it was Agostino who led the way in bringing in ideas relating to art from other disciplines.[70] Boschloo felt that Agostino stimulated his brother with new motifs and helped him change toward classicism in c.1593 and that Agostino's closed, balanced compositions were reflected in Annibale's works in the 1590s. All this is true to some extent, but the constant interchange among all three Carracci indicates that they each fed on the other's knowledge and ideas. They painted together after each other's drawings in their fresco projects and probably discussed changes in projects daily. It was Lodovico who led the way to an appreciation of Barocci's art in the late 1570s and early 1580s, Agostino whose colorism in engravings led to an understanding of Venetian art in the late 1580s, and Annibale's absorption of classical motifs and search for ideal form after 1595 which led to the new idealism in the brothers' art in their joint project in the Palazzo Farnese and in Agostino's Palazzo del Giardino paintings.[71]

Subject Matter and Working Methods

Like most of the paintings, sculpture, and prints of the post-Tridentine era, the majority of the Carracci prints were of religious themes. Paleotti, especially, wished that religious images should reach a wide audience, and what better way than through prints. Prints became a necessary vehicle for the distribution of religious propaganda and for education. These small works were "read" in place of books by the illiterate, viewed in the home instead of paintings by the poor, and they encouraged devotion by a knowledge of the new sacred iconography. Like paintings and books, they were probably sold in the street. In the *Arti di Bologna* there are examples of book and picture sellers hawking their wares. In the *Vende Quadri* (fig. M), the picture seller holds up sacred works for sale.[72] We can easily imagine a print seller doing the same. No wonder the great majority of single prints by the Carracci were of religious subjects; their commercial value was at its height. Except for the subject of landscape, which was of marginal importance in the prints while playing a major role in drawings and paintings, and Agostino's *Lascivie,* which was not in general circulation anyway, the Carracci treated the same range of subjects in their prints as did most artists of the late sixteenth century. Besides mythological and religious themes, Agostino made coats of arms, frontispieces, and book illustrations. And the subject he explored most successfully was that of portraiture.

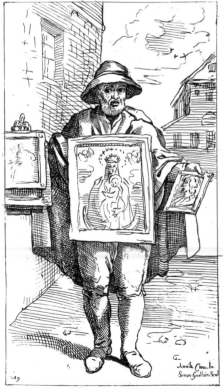

fig. M Simon Guillain, *Vende Quadri*. Washington, Library of Congress

Since the early seventeenth century, the Carracci have been justly praised for their portraiture. Attributions of the painted portraits is disputed, but it is known that each of the Carracci was a master in this genre.[73] Although Annibale's portraits in oil are the most numerous and present the most penetrating representations of the sitters, only Agostino widely disseminated the likenesses of his subjects through engravings. In the 1580s in the Carracci Academy, the artists drew portraits of each other, their relatives, their students, and whomever else would sit. These rapid sketches capture the lifelike essence of the men and women portrayed, their eyes alive with interest and excitement.[74] Portraiture

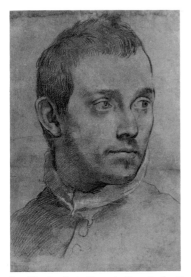

fig. N Annibale Carracci, *Portrait of a Young Man.*
Princeton University, the Art Museum, The Elsa
Durand Mower Collection, Given by Margaret Mower

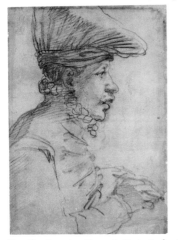

fig. O Agostino Carracci, *Portrait of a Young Man.*
Windsor Castle, Royal Library, Her Majesty Queen
Elizabeth II

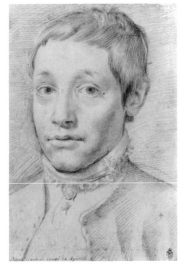

fig. P Agostino Carracci, *Portrait of Antonio Carracci.*
The Art Institute of Chicago

was one of the prime subjects of Renaissance art, and the need to keep up one's public stature and achieve visual immortality did not diminish toward the end of the century. The demand for artists who worked in this genre is evident if one studies the oeuvres of the greatest artists of the sixteenth century. Apart from the specialists in portraiture, such as Moroni, most artists at one time or another were called upon to immortalize their patrons. The great portraits of the early part of the century came from the hands of Raphael, Titian, Pontormo, Bronzino, Parmigianino, and the like. At the end of the century, the greatest portraits were by the Carracci, such as the *Portrait of a Lute Player* by Annibale, the *Portrait of Hanna Guicciardini* by Agostino, and the *Portrait of the Tacconi Family* by Lodovico.[75] Fortunately, drawings for some of these as well as for other portraits abound. Annibale's drawing of a young man, in Princeton (fig. N)*, represents his mature style of graphic portraiture.[76] Emphasis lies on the head, which is in a lively three-quarter view with only the barest of essentials to indicate the rest of the body. The highly finished quality of this sheet suggests that it may have been a final study for a painting. We do not know if the Carracci made these drawings as finished products to be gifts to their friends, although the possibility is strong. As Posner asserted, these drawings probably grew out of the Carracci's interest in recording all facets of the natural world,[77] and it is important to note how their numerous representations of individuals differ from earlier portraiture. In the portraits of Renaissance and mannerist artists from Florence, Emilia, and Venice (e.g. those of Bronzino, Parmigianino, and Titian), the sitter is usually portrayed in a three-quarter length pose confronting the viewer. He carries with him the trappings of his profession or the symbols of his authority. These portraits were meant to impress the viewer with the sitter's position of power and/or knowledge. Not so with the Carracci. Although some portraits such as Annibale's *Lute Player* or Agostino's *Sivello* (Agostino cat. no. 212) do portray the special interest of the sitters, the emphasis was on their features (often with withdrawn expressions). Instead of confronting a figure set purposefully apart from the rest of humanity, we are drawn to the very aspects of the sitter which bind all humanity. In Agostino's portrait drawings, like the one in Windsor of c. 1590 (fig. O)* or the late one of his son Antonio (fig. P)* in Chicago, a sympathy is set up between the viewer and sitter and a melancholic atmosphere, akin to apprehension, bespeaks the vulnerability of these youths.[78]

Agostino's first engraved portraits were the thirty-four in the *Cremona Fedelissima,* begun in 1582 (cat. nos. 55-92).[79] When Agostino set himself the task of engraving these likenesses after drawn models by Campi, there lay behind him a long tradition of engraved portraiture on which to lean. Engraved portraits, like painted ones, in the mid-sixteenth century tended to be overly elaborated, decorative affairs, which minimized the impact of the sitter while emphasizing his accomplishments. The iconic figures were becoming mere symbols of themselves. Cartouches of strapwork, columns, arms and armor, symbolic figures, and animals surrounded and sometimes buried the portraits within. Contemporaneous with this trend was one in which the portrait represents only the bust of the sitter, unencumbered by anything but his dress. It was this, mostly northern, side of portraiture which Agostino

chose to follow and upon which the Carracci improved.[81] The engraving style of Agostino's earliest portrait, that of Caterina Sforza (Agostino cat. no. 55), depends on his northern predecessor, Martin Rota.[82] Agostino employed a fine burin line as had Rota in his *Portrait of Ferdinand I* (Bartsch XVI, 268.68), but already Agostino's form is more sculptural and less two dimensional than Rota's, and the face is more expressive. It is evident that Agostino also looked to Rota's other engravings. In 1586 he finished the cartouche that surrounds Rota's portrait of Cosimo I (Agostino cat. no. 136) for Aldo Manuzio's *Vita di Cosimo de' Medici*. Another engraving by Rota, of Francesco de' Medici (Agostino fig. 136a), was also in the book. It was Rota's interest, gleaned from Dürer, in textural surfaces of garments which Agostino developed in his most famous *Portrait of Titian* (Agostino cat. no. 145) and which is a mark of his engraving style in general. In this, as in the *Portrait of a Man* (Agostino cat. no. 144) of the same period, Agostino concentrated on the expressive features of his sitters. Whether destined for book illustrations, like the *Portrait of Giovanni Battista Pona* (Agostino cat. no. 175), or for popular distribution, like the *Portrait of Titian*, Agostino's portrait engravings emphasized the penetrating gazes of those portrayed. The *Portrait of a Man* is surrounded by a cartouche, but a simple one, which does not detract from the sitter's contact with the viewer. In fact, the use of curved hatching behind the sitter hints at a convex mirror from which the man emerges, suggesting that he is in fact viewing himself in a contemporary mirror. Thus, he seems to be staring at us while gazing back at himself, penetrating his own thoughts.

Agostino's last portrait, that of Sivello (Agostino cat. no. 212), carries this theme of self-awareness further. One wonders if the actor Sivello is merely showing us his mask to apprise us of his profession or if he has removed it to reveal his true self. Agostino's late pen and ink study of a young courtier (Agostino fig. 212a) indicates a similar attempt to see through to the core of his viewer. It is typical of the Carracci portraits that the sitters appear to be surveying us or Agostino as he drew them. Consequently, we come away knowing little of what lies behind their facial features.

The Carracci's fascination with their fellow man extended in a direct progression from portraiture to caricature, a genre which they were credited with inventing by the earliest sources.[83] Believing that portraiture merely represented the facade and the outward aspects of personality, they attempted to go beyond the mask to penetrate the true features of the person. They felt that by a distortion of the outer features, the inner nature could be portrayed. One example of this is found in a drawing of grotesques by Agostino in the Fogg Art Museum (fig. Q). It is of a type reported by Massini, in which a human head is made to resemble an animal.[84] In this case, a monk in profile is slowly changed in succeeding stages, like Jekyll changed to Hyde, from a harmless looking individual to the monster he really is. Although Agostino was prolific as a caricaturist, most of these drawings have disappeared, and he did not commit any of them to copperplates, as did the caricaturists who succeeded him.

A genre in which Agostino excelled and for which his cousin Lodovico made drawings but in which Annibale did not take part is that of engraved coats of arms. Such engravings were not new, but, until

Caricature

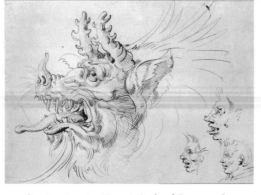

fig. Q Agostino Carracci, *Studies of Grotesques*. Cambridge, Courtesy of the Fogg Art Museum, Harvard University, Transferred from the Busch-Reisinger Museum

Agostino, they do not seem to have been popular or in everyday use. In fact, they were quite rare in the north and almost unknown in Italy. In no case was the coat of arms the central subject of the engraving.[85] For the first time, Agostino liberated this decorative aspect of other works and used it to stand alone as a symbol of its owner. At least eleven of these engravings by Agostino are known, and they span his career from 1581 until he went to Rome. Agostino's earliest engraved coat of arms contains the arms of Bologna, Cardinal Paleotti, and Pope Gregory XIII, which he elaborated in a two-sectioned engraving to accompany a map of the city of Bologna by another artist (Agostino cat. no. 29). In his first single coat of arms, that of Cardinal Fieschi of c. 1581 (Agostino cat. no. 30), Agostino placed the shield against a simple backdrop, upheld by symbols of Justice and Peace. Later coats of arms, those from the early and mid 1590s, on the other hand, were extremely elaborate, often flanked by full figures, and entwined with strapwork, cords, masks, etc. From these intricate engravings evolved a whole art form in the early seventeenth century. Exemplified by the works of Brizio and Valesio in Bologna and by Stefano della Bella in Florence, these later engravings depict shields which are held aloft by flying crowds of angels or flanked by river gods. In Valesio's elaborate stage settings the arms, the supposed *raison d'être* of the engravings, are again reduced to a relatively minor role.[86] The sculptural effect of Agostino's prints tends to support the theory that stylistic sources for his coats of arms are the stone or stucco decorative arms on Bolognese palaces, either surmounting doorways or fireplaces or placed on end walls in courtyards.[87]

There is only one extant drawing by Agostino for a coat of arms (Agostino fig. 196a).[88] One could extrapolate from this that the artist designed all these engravings himself, if it were not for the recent discovery of a design by Lodovico (Agostino fig. 202b) for arms which Agostino engraved. Since both the Agostino and Lodovico drawings lack a family identification, it may be that Agostino kept on hand decorative models from which the patron could choose. There is also one engraving of a cartouche which lacks the coat of arms, and the artist may have engraved many of these works before a customer was available (Agostino cat. no. 201). Moreover, some of the engravings were made in various states, with only the family arms changed (Agostino cat. nos. 196,200). Most of Agostino's patrons were Bolognese, but several were well-known Roman cardinals, and these prints may have been done between his first and second trip to Rome in the 1590s, that is c. 1594-1597. Stylistically, none appears to come from his Roman period.

The commercial nature of these engravings is obvious, but their purpose is another matter. Since they were needed in some quantity by the patron, single sheet drawings would have been inappropriate. There are several explanations for the existence of these works. Their primary function was probably that they were used in letters, as calling cards, or sent with messengers to prove the missive was indeed from the person supposed. Their use as ex libris cannot be ruled out, although many of them are too large for this purpose, and this author has found none in books.[89] Although less likely, it may be that some of them were employed as models by craftsmen who were repeating the coat of arms motif on tapestries or on stuccoed and frescoed decorations in the *palazzi* of the patron, like the ones which influenced Agostino. A single draw-

ing would not have been sufficient for the number of artisans employed to repeat the arms on all the interior and exterior decorations. In any event, engraved coats of arms were highly popular in succeeding centuries, and their original purpose of identification of the family was lost as they became ceremonial symbols of the magnificence and importance of the patron and his family.

Primarily for commercial gain, like the coats of arms, title pages and book illustration were done by Agostino during his period in Bologna. The book industry in Italy and in all of Europe saw an immense flowering in the second half of the sixteenth century, and the obvious need for engravers to illustrate these works arose. The title page to a book changed tremendously in style during the first half of the century. Books were usually illustrated by woodcuts early in the 1500s, but the short life of the woodblock and the need for further editions of a volume demanded the change to engraved illustrations. These could be reprinted in larger quantities. The presentation of the title of a book changed too. In 1500 titles were decorated, if at all, with simple vignettes, floral patterns, or enclosing designs, but in 1558 when Eneo Vico, a prolific book illustrator, engraved the title page to *Augustarum Imagines* . . . (Bartsch XV, 343.321), it was complete with allegorical figures, strapwork, grotesques, etc. By the middle of the century, title pages had become elaborate architectural facades meant to introduce the reader to the interior of the volume, somewhat like a passageway into a building.[90] The title of a work became less important visually than the design surrounding it. According to Barberi, Agostino's engraving for the title page of the *Cremona Fedelissima* (Agostino cat. no. 56) broke with this mannerist tradition of reducing the importance of the message in favor of the design elements.[91] The figures in Agostino's work are no longer decoration but, as in a painting, partake in the three-dimensional scene almost as if they are on stage. It is this stage setting with participating actors which looks toward the title pages of the seventeenth century. Yet, it is not Agostino who invented this composition; rather, Antonio Campi must be credited with this transitional work. Agostino's title page for *La Gerusalemme Liberata* (Agostino cat. no. 155) of 1590 was probably executed after a design by Bernardo Castello, and, although it represents a window to a landscape, it cannot be said to contain anything innovative. His *Portrait of Carlo Borromeo* (Agostino cat. no. 132) of 1585, like the *Cremona Fedelissima* title page, goes farther in the concept of the stage design. Figures in the foreground move around a three-dimensional altar containing Borromeo's effigy. *Putti* sit on the volutes, and allegorical figures perch atop the architectural setting. But, again, another artist, Francesco Terzo, was responsible for the design. If Agostino were active in this breakthrough, it must be found in his own inventions, not in his reproductive engravings.

Agostino's own inventions for frontispieces and title pages, such as the *Portrait of Tommasso Constanzo* (cat. no. 96), the *Portrait of Bernardino Campi* (cat. no. 127) of 1584, the *Vita di Cosimo de' Medici* (cat. no. 135) title page of 1586, with the cartouche around Cosimo's portrait (cat. no. 136), the three frontispieces for a book of saints (cat. nos. 129-131), and the *Ricreationi Amorose de gli Accademici Gelati di Bologna* (cat. no. 165) of 1590, all indicate that Agostino's conception of title pages and frontispieces was steeped in the tradition of the sixteenth century. True, his

surrounding allegorical figures are three-dimensional sculpturesque forms, but they are in reality decorative objects rather than liberated protagonists in a stage setting. In each of these works Agostino conceived of a central, framed picture, either a portrait or a scenario, around which he placed his decorative, supporting figures. What is different from mannerist frontispieces is Agostino's use of his framework to direct our attention to the central focus of the page, either the scene portrayed (Agostino cat. no. 130) or the title of the work (Agostino cat. no. 135). Unlike Vico's title pages which distract the viewer in secondary directions, Agostino's elaborations are always subordinate to the central purpose of the engraving, as title page or frontispiece. His penchant for clarification is most obvious in these works, and his elaboration never detracts from the main focus of the sheet.

Agostino must have had many commissions for decorative frameworks and frontispieces which were never carried out. Several drawings have studies which may have been preliminary to engraved frontispieces. One of these, in Besançon (fig. R)*, is found in the middle of a study sheet containing a landscape, mythological figures, a stork, and some writing.[92] The title page, as it must have been intended to be, is made

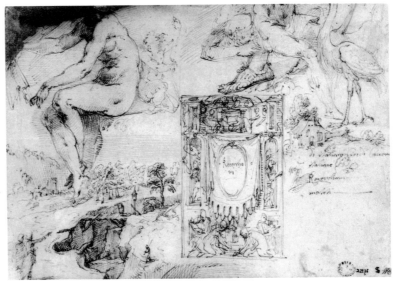

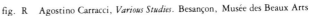

fig. R Agostino Carracci, *Various Studies*. Besançon, Musée des Beaux Arts

up of decorative figures surrounding a draped oval with the words *Ricerchaldi*. Even in the quickly executed technique, it is apparent that Agostino was making a *mis en scène* of kneeling figures before an altar, above which hangs a cloth and around which are allegorical figures emerging from deep niches. As in the title page of the *Cremona Fedelissima,* the figures here also act as if they are participants in a drama and not just decorative adjuncts to the title. Agostino in his own designs was attempting to integrate the action of his decorative figures as Campi had done in the design for the *Cremona Fedelissima* title page which Agostino engraved.

Another drawing in Windsor Castle (fig. S)*[93] was probably intended as an illustration for a book. The forms are too unreal to assume it was a model for an actual fountain, and the decorative borders and enclosing lines suggest the edge of a page. In this drawing, Agostino let his imagination run wild, if not amuck: the fantastic forms atop the

fig. S Agostino Carracci, *Design for a Book Illustration*. Windsor Castle, Royal Library, Her Majesty Queen Elizabeth II

precarious base recall mannerist conventions in which the balance of the composition is constantly threatened. Unlike the artist's other decorative studies, this one tends toward elaboration rather than simplification, a good reason for suspecting it to date in the 1580s.[94] Agostino's designs for title pages and frontispieces and also his completed engravings vacillate in style between decorative complication and simplification, a problem unresolved in his lifetime, making him a transitional figure in the field of book illustration in the sixteenth century.[95]

Lodovico and Annibale

Lodovico handled only religious themes in his few prints and cannot be credited with anything innovative. In his prints, Annibale chose to depict the normal range of religious and mythological themes, but he preferred to portray those that contained human frailty, emotions or suffering. His prints of the Madonna and Child (Annibale cat. nos. 3, 5, 15, 16) reflect the love of a mother for her son, instead of portraying a regal queen with an infant ruler. His protagonists are always connected by love (Annibale cat. no. 20), lust (Annibale cat. no. 17), or hatred (Annibale cat. no. 21). In his prints of saints, he chose *Mary Magdalen in the Wilderness* (Annibale cat. no. 12) and *Saint Jerome in the Wilderness* (Annibale cat. no. 13), subjects which reflected the inner solitude of all men, and of himself in particular.[96] In the mythological works (Annibale cat. nos. 17, 19), human frailty is again the theme. Annibale's emphasis on the humanity and suffering of mythological and religious figures looks forward to the dramatic themes popular in baroque art. Unlike some seventeenth-century works, which were based on the formulas of portraying human suffering and emotion set down by the Carracci in their teaching of the *affetti*,[97] Annibale's works were based on the direct study of nature and the understanding of human problems. The theme of melancholy, so much a part of his own personality, runs throughout his works.

Working methods

The working methods of the Carracci printmakers is something which we can only attempt to reconstruct, lacking the complete oeuvre of their preparatory drawings. From those that are extant and from the few unfinished early states, it is evident that they carefully prepared their compositions by working them out quickly in their entirety, reworking the placement of the figures, and finally making a last drawing to transfer the composition to the finished plate. In this, they did not differ from most sixteenth-century printmakers. Agostino's method was the most exacting; he was the printmaker by trade, and because he made more prints, there are more drawings extant for his works than for either Annibale's or Lodovico's. In many cases the final preparatory sheet is missing, probably having been destroyed in transferring the image to the plate. In several examples, however, we can begin to understand the artist's ideas from first thought to final product.

With Agostino's *Saint Jerome* (Agostino cat. no. 213) we have the most complete extant series of preparatory drawings; and from the undescribed first state of the *Holy Family with Saints Anthony Abbot and Catherine* (Agostino cat. no. 103) and the engraving of *Jacob and Rachel at the Well* (Agostino cat. no. 27), we can begin to understand how Agostino transferred his ideas to the plate. In the early preparatory drawings for the *Saint Jerome,* he began by making numerous studies for the entire composition (Agostino figs. 213a, b). He sought the effect of the figure of the saint confronting the viewer in ecstasy (Agostino fig. 213b,

lower left) or in meditation (Agostino fig. 213a, center), in the end choosing a three quarter view of the saint. He continued working on a side view of the saint kneeling on an altar step (Agostino fig. 213c) but finally chose to place him by a makeshift altar in the wilderness. In succeeding sketches (Agostino figs. 213c, d, g), he worked out the direction in which the saint would face, taking into account the reversed image on the copperplate. As he worked with the main figure, he also attempted different placements of the lion (Agostino figs. 213e, f). After the composition was set in his mind, Agostino probably worked on various parts of the saint's body, studying these from nature. The final preparatory study, in reverse of the engraving (Agostino fig. 213g), was transferred to the plate, most likely by blackening the verso of the sheet and incising the main outlines of the figures, which transferred some of the chalk from the verso to the plate itself. Transfer could be made by means of a variety of materials other than chalk: the metal plate can be coated with an oily or resinous substance or with anything that would pick up the lines indented on to it through the drawing. Those lines were then lightly traced on the metal with a fine burin or drypoint. From this point on Agostino drew directly on the plate, working out the details of the landscape and hatching on the copper. As evidenced by the first state of the print, left incomplete at the artist's death, Agostino filled in the main outlines of the composition from the center outwards, detailing the main form first and leaving the background for last. In this case, however, it was Brizio who added the finishing touches.

The working method described above is not unusual, and most engravers followed a similar procedure of transferring the final image to the plate. It appears, however, from Agostino's existing drawings, drawings by other artists he copied, and the extant copperplates that this was not Agostino's only method of engraving, but rather that he was such a masterful craftsman that he often worked directly on the plate, copying in freehand from drawings he reproduced. The evidence for this can be seen in the first state of his engraving after Paolo Veronese of the *Holy Family with Saints Catherine of Alexandria and Anthony Abbot* (Agostino cat. no. 103). The freely drawn outlines in the first state of this engraving suggest that Agostino worked directly on the plate from a model, lightly sketching the outlines to be filled in. He did so with a drypoint needle, and the burr is still evident on this early pull, although it is completely worn away in later impressions. The column at left varies slightly from its final, ruined condition, and the whole center part of the pedestal and details of the column below Saint Anthony's feet are missing. On this plate Agostino sketched in only the outlines with which he worked first: the figures, the outlines of the architecture, and finally the details. However, he finished entire figures or parts of them at will, not working outward from the center or from the most important to the least important as might be expected, but on those forms which must have defined the composition best for him. As with most of Agostino's reproductive prints, the engraving is in the same direction as the original it reproduces, the painting by Veronese in San Francesco della Vigna, Venice. Agostino may have reversed the image mentally, or he may have made several intermediate drawings or perhaps used a mirror before transferring the main outlines to the plate.

In the instance of *Jacob and Rachel at the Well* after Denys Calvaert

(Agostino cat. no. 27), it appears that Agostino may have used counter-proofs in his method of transferring images. The original from which Agostino worked, a drawing by Calvaert in the Louvre (Agostino fig. 27a), is in the same direction as the engraving. A second drawing (Agostino fig. 27b), also extant in the Louvre, is a counterproof of the first drawing and was Agostino's model for the engraving. As explained in the catalogue entry, there are problems in the dating and authorship of these drawings, but the fact that Agostino used the counterproof seems certain. The counterproof was made by wetting a sheet of paper, placing it on the original drawing, and using pressure from either a press or heavy felt cloths to transfer the chalk to the wet paper. With the reversed counterproof before him, Agostino transferred the image freehand to the copperplate; when the plate was printed the engraving reflected the direction of Calvaert's original.

Annibale's working methods are easy to trace through the many extant drawings that show the progression from early idea to finished print. Like Agostino, Annibale first worked out the main outlines of his composition. Unlike his brother, however, he did not dwell on the separate forms in various intermediary sheets, but rather, he often made *pentimenti* directly on the primary compositional drawing (Annibale fig. 20a). Like Agostino, he transferred the sketchiest of compositions to the plate. But Annibale's method was usually to transfer his drawings to an etching ground from the reversed incised drawn image. Afterwards he worked the rest of the composition directly on the plate. In the few prints of Lodovico and the extant drawings, it is evident that he worked in the same manner as Annibale, transferring the reversed image to the copperplate by indenting his drawings.

Importance and Influence

Reproductive engravings

If more space is given in this introduction to Agostino than to his better-known relatives, it is because Agostino was the printmaker of the family. Unfortunately, because a great number of his engravings were reproductive in nature, his fame has declined through the centuries. In truth, he and his contemporaries are denigrated for their masterful interpretations of sixteenth-century painters. Like Hind, many critics dismiss Cort and Agostino as mere reflective craftsmen contributing little to the development of their art. This unnecessary condemnation may be because we have been looking at sixteenth-century engravers with the eyes of the twentieth century, an era in which new ideas alone account for genius. To appreciate the works of such engravers as Agostino and Cort, we must understand the purpose of reproductive engraving in the sixteenth century.

First of all, reproductive prints were popular and, indeed, necessary in the late sixteenth century. As mentioned earlier, most of these prints were of religious images, and their distribution encouraged devotion and knowledge of the new sacred iconography, as set down by the Council of Trent. Educationally, they had value as religious propaganda; their small, intimate size allowed them to be read in place of the original, usually in homes, making the message more direct. In this way prints were widely popular. But, in the aesthetic sense (which is the level on which these works are today misunderstood) in the sixteenth century a

copy indicated only that the original image was repeated; in no way did it mean that the copy was inferior or of less importance than the original. Reproductive prints functioned as photographs do today but their use was not merely to disseminate the images of famous artists to those unable to see the original work. Artists making reproductive prints were not simply craftsmen who through their skill could bring to mind the genius of a Raphael or a Michelangelo. If only that, these men would not have signed their prints, as many did, nor would they have been praised so lavishly by biographers and theorists such as Baglione, Bellori, and Malvasia. Malvasia listed not only original works by engravers but also prints made after other artists. Baglione explained in his *Vite* exactly why he chose to include engravers:

> Gen. Sogliono, o Signor mio, esser'anche intedenti di disegno i buoni Intagliatori d'acqua forte, o di bulino; e pero tra Dipintori possono havere il luogo; poiche, con le loro carte anno perpetue l'opere che'piu famosi maestri: benche le fatiche loro al cospetto del publico non sempre sieno stabili, e si mirino, pure non sipuo negare, che li lor fogli non nobilitino, & arrichiascano le Citta del Mondo. Anzi alcuni Artefici di Pittura, in fin essi hanno d'acquaforte, o di bulino le proprie opere intagliate, e come erano Pittori, cosi anche Intagliatori furono; & in loro questo Virtu hebbero commune il vanto, & in indistinta la lode.[98]

If Baglione's words sound like an "apologia," Malvasia's do not. For him the purpose of prints was not only to reproduce but to improve, as he felt Agostino's did:

> Di quelle pero de'miei paesani, de'quali solo io qui tratto, m'intendo, e che l'opre piu famose della scuola romana, della lombarda, della bolognese, e della veneziana ci resero cosi famigliari e comune; perche poche troveremo di Rafaelle che Marc Antonio, e 'l Bonasone non pubblicassero; e le piu insigni del Sabbatini, del'Samacchini, del gran Paolo, del Tintoretto, e del Coreggio date successivamente si videro in luce da Agostino Carracci, con tante intelligenza e possesso, che nella correzione, e grandezza di maniera superano alle volte gli originali stessi.[99]

Idea *and* imitatio

In reproductive engraving, the composition and subject of the painting remain, while the color is transmitted through tones of gray. Because of this, the engraver's interpretation of the original becomes important: he brings to the work his conception of the meaning behind the painting or drawing. Thus, prints are a transcription and a kind of translation, another way of interpreting the painter's ideas. Throughout the sixteenth century, controversies went on among art theorists and artists as to the importance of the original model. Was that model, or *idea,* an abstract, universal one which did not belong to the artist but existed *a priori,* or was the *idea* formulated in the artist's mind, based on either an inner concept (*concetto*) or on nature? For Raphael, a certain *idea* would direct his work, an *idea* which did not substitute for external experience but was a guide to imitation (*imitatio*) or the act of creating the painting. The *idea* he sought was an image in the artist's mind (*idea interno*). Pietro Bembo took the definition further, believing that the concept of imitation was a means of getting to the universal or divine *idea.* Conversely, Vasari felt that the *idea* originated in experience and not *a priori,* and that the artist's duty was to imitate nature. Both Giovanni Paolo Lomazzo and Federico Zuccaro, writing in 1590 and

1604 respectively, indicated that the *idea* artists sought was universal or divine. Although theorists of the period disagreed as to the meaning of the term *idea,* they did agree that it was the aim of art to reflect that *idea,* whether it was based on experience and nature or existed *a priori.* Unfortunately, some of the artist-theorists like Zuccaro and Vasari often made conflicting statements or did not practice what they preached. Not until Bellori codified and explained his meaning of *idea* was there some kind of resolution of the problem, if one agreed with him. For Bellori, the *idea* was created by God's supreme intellect, and the aim of art was to reflect that perfection created by God. Thus, for Bellori, originality as we know it, was irrelevant. Each artist seeks to imitate the already existing divine *idea.* Sixteenth-century printmakers, and especially Agostino, in making copies of paintings, considered their work in the light of these theoretical arguments. Surely, Agostino agreed with Bellori's definitions which, although not published until 1672, were in circulation in the late sixteenth century. Consequently, Agostino's reproductive engravings were seen as a means of reaching the universal *idea* behind the painted work he copied.[100]

Agostino as emulator

Malvasia, as noted, believed that Agostino improved on the original compositions of the artists he copied. Perhaps the story he related that Tintoretto believed Agostino's *Crucifixion* (Agostino cat. no. 147) equaled his own painting is apocryphal.[101] In the light of the theoretical controversies, Agostino was considered an artist who sought the ideal, that is, the universal *idea* beyond nature and beyond another work of art. Faberio quoted a sonnet by Melchiore Zoppio, praising Agostino for not merely imitating nature, but emulating it:

> Emulo ancor de la natura sei
>> Non pur' imitator Carracci, ch'ella
>> Suo difetto apre in consumando quella,
>> Che vivente assai piacque à gli occhi miei.
> Tu per virtù de l'arte avvivi in lei
>> L'aria, il color, lo spirto, e la favella
>> E se viva non è, come à vedella
>> Altrosenso, che vista io non vorrei.
> Ma come può giammai privo sembiante
>> Di lingua articolar voce non sua?
>> Tacito anco il suo stil ti grida in lode.
> Non sai, ch'occhi per lingua usa L'Amante,
>> E de gli occhi il parlar per gli occhi s'ode,
>> Che dice amami, io son l'Olimpia tua.[102]

In this poem, Zoppio alluded to a portait of his wife by Agostino[103] and was amazed at Agostino's ability to bring alive the "air, color, spirit and voice" of his beloved. Zoppio must also have been impressed with Agostino's ability in prints to emulate, not imitate: Agostino's interpretations were never calculated to reproduce the model exactly, but to enlarge upon the basic image. As a brilliant craftsman he could translate color into tonal contrasts and alter the relationship of the figures to their surroundings. Agostino was lauded in his time not as a copyist, as he has been called recently,[104] but as an original interpreter of art and nature.

The act of imitation was emphasized in the Carracci Academy, where students were taught not only to copy models of nature but to improve upon them by keeping in mind the concept of ideal form.

Dempsey has discussed this practice at some length, believing that as exercises the students were taught to make engraved as well as drawn copies after other works of art.[105] One copied both nature and art in search of the ideal form or universal *idea*. Malvasia credited Agostino with genius in this practice, observing that he was "judicious" in knowing what to imitate in nature and in *"artificiali cose."*[106] Consequently, because of Agostino's judgment and brilliant craftsmanship, his reproductive engravings were considered original works of art in themselves.

Influence

The role of the Carracci family in the development of seventeenth-century Bolognese and Roman painting has been discussed at length by writers on the Carracci and on Guido Reni, Domenichino, Guercino, Poussin, Rubens, and other less well-known artists. Very little has been said, however, about their influence on seventeenth-century engravings and etchings, probably because so little has been said about the Carracci prints themselves. In Bologna the artists trained in the Accademia degli Incamminati learned Agostino's engraving style and passed it on to the next generation of printmakers. Much of Agostino's style was disseminated through the series of prints by other engravers collected together and entitled *Scuola perfetta per imparare a disegnare* . . . (never actually published as a book), with numerous prints after Agostino's designs,[107] although not all the compositions are by Agostino and not all the engravers his followers. In spite of this, the prints are correctly connected with Agostino and the studio practice of the Accademia degli Incamminati. Most of the engravings are of various parts of the anatomy, such as eyes, hands, feet, etc. The prints were certainly made as teaching tools to help lead young artists who copied them toward knowledge of correct anatomical form. Calvesi/Casale rightly noted that many of the prints appear to be after Agostino's designs from the Roman period, and the publisher of the series, Pietro Stefanoni, was Roman. In addition, the only artist we can securely say was connected with the project was Luca Ciamberlano, active in Rome, whose initials are found on several of the engravings. The prints were probably not made under Agostino's supervision but most likely date to the early seventeenth century when his popularity was at its height. Lodovico may have brought some of Agostino's drawings with him on his trip to Rome in 1602 to give to Stefanoni for engraving. In any case, there are many examples of the engravings extant in single sheets and in bound versions, varying in the number of prints included, and the works must have been extremely useful to artists during the period.[108] Indeed, this kind of exercise book became popular in succeeding generations.[109]

Agostino's influence

Agostino's influence in Bologna was apparent first in Francesco Brizio (1575-1623),[110] a Bolognese who actually studied under the Carracci and was an active printmaker and painter in Bologna, contemporaneous with the Carracci family. Yet, he did not have the capacity to go beyond the innovations of Agostino, and all his prints seem to be solely reproductive in nature. In engravings he specialized in coats of arms and book illustrations, copying many of Lodovico's designs. Other Bolognese in the early and mid-sixteenth century who continued Agostino's work, but with less success, were Oliviero Gatti (active first half seventeenth century), Giovanni Luigi Valesio (1579-1623), Francesco Curti (1603-1670), and Lorenzo Tinti (1634-c. 1672).[111] None of these engravers was able to recapture the vitality of the burin work in Agos-

fig. T Luca Ciamberlano, *Studies of Hands*. Washington, National Gallery of Art, Gift of Mr. and Mrs. Arthur E. Vershbow

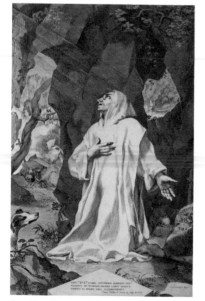

fig. U Claude Mellan, *Saint Bruno*. Washington, National Gallery of Art, Ailsa Mellon Bruce Fund

tino's engravings. Their coats of arms, title pages and reproductive religious subjects became increasingly hard and arid, and they were often merely elaborate interpretations of earlier compositions. Agostino's heritage died early in his native city.

In Rome, Luca Ciamberlano, who was active from c. 1599 to 1641, was Agostino's closest follower, and his prints are sometimes confused with Carracci's.[112] Ciamberlano's works in the *Scuola perfetta . . .*, such as the print of hands writing (fig. T),[113] indicate that he was a mechanically proficient artisan. Unfortunately, he added nothing new to the art of engraving, merely following Agostino's technique and style. Besides Ciamberlano, at least one other engraver was actively carrying on Agostino's work in Rome, Francesco Villamena (1566-1624), who is said to have been Ciamberlano's teacher. Villamena's style, like Ciamberlano's, was much like Agostino's of the Roman period: large plastic forms, carefully defined by thick, controlled burin strokes. Villamena worked with the Carracci, and his best-known engraving, the *Paniere Farnese* after Annibale (Annibale fig. 19m), exemplifies his style and his indebtedness to Agostino. Yet, eventually, in both Bologna and Rome, Agostino's style was eclipsed by a different, more open mode based on the etchings of his brother Annibale.

Rome was also where Agostino's prints were disseminated to northern artists and became the basis for much of the seventeenth- and eighteenth-century reproductive engraving style in Europe. Many northern engravers passed through Rome in the last years of the sixteenth and early seventeenth centuries, and when they returned to their homes, they carried with them the classical idealism of Annibale's paintings and Agostino's engravings. Jan Sadeler (1550-1600), Cornelis Galle (1576-1650), and Theodore Galle (1571-1633) made some copies of Agostino's works and attempted to emulate his style. In Cornelis' and Theodore Galle's book illustrations after Rubens, especially, these Flemish artists worked in the engraving style of Agostino. Large, classical figures, illuminated by the direct contrast of strong light and shade, flank large tablets with the titles of the publications. Similar to these works and influential on them were Agostino's large prints in the *Cremona Fedelissima* (Agostino cat. nos. 56-58), which, judging from the numerous examples still extant in European libraries, was printed in a large edition and became very popular.[114]

Claude Mellan (1598-1688), a Frenchman who was in Rome from 1624 to 1635, studied with Francesco Villamena and Simon Vouet in Italy and became enmeshed in the Carracci style of painting and engraving. Through the intermediary of Villamena, he learned Agostino's engraving technique and style, and in such a print as the *Saint Bruno* (fig. U), Agostino's bold lines and dramatically simple contrasts of light and shade come through.[115] Mellan took this style back to France, where he simplified it further by his own technique of single hatching rather than crosshatching; but, by retaining the swelling and undulating burin line, he created a tour de force of the Italian manner.

Agostino's most important convert, however, was an artist of no less genius than Peter Paul Rubens (1577-1640), who, during his stay in Italy from 1600 to 1608, came under the spell of the Carracci's ideal style.[116] Rubens made copies of Annibale's paintings and Agostino's engravings, as he made copies of other Italian artists.[117] As Jaffé pointed

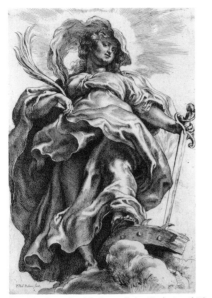

fig. V Peter Paul Rubens, *Saint Catherine of Alexandria in the Clouds*. Washington, National Gallery of Art, Ailsa Mellon Bruce Fund

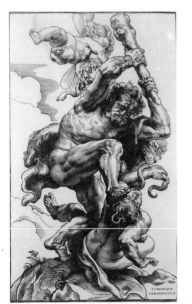

fig. W Christoffel Jegher, *Hercules and Envy* (after Rubens). Washington, National Gallery of Art, Ailsa Mellon Bruce Fund

out, even his drawing style took on the full-blown, classical ease of the Carracci chalk sheets.[118] Rubens' drawing style, the studio practice of careful preparation in anatomy and composition, and his classically inspired forms were taught to him through the Carracci works, and these qualities stayed with him throughout his life. It is probable that he met all the Carracci when he lived in Italy. He traveled to Parma and Bologna when he was staying in Mantua and could have known Agostino before the latter's death in 1602 in Parma. Rubens would have wanted to meet Lodovico, the head of the academy in Bologna. He was in Rome in 1601-1602 and copied in the Farnese Gallery, perhaps introduced to Cardinal Farnese by Cardinal Montalto, the papal legate to Bologna. It is certainly evident he would have wanted to meet Annibale, still active before his 1605 illness.[119] Rubens made only one print in his lifetime (and the attribution of that to him has been disputed), the style and technique of which are dependent on Agostino Carracci's engravings and the Carracci manner in general. *Saint Catherine on the Clouds* (fig. V), an etching dating after 1621, represents a single figure of classical proportions and features, wearing voluminous drapery, set against a white background and on a simple group of clouds. The complicated play of dramatic light and shade on her body and the carefully hatched and crosshatched lines, emphasizing her sculptural form, are reminiscent of Agostino's Roman works, in particular the *Holy Family* (Agostino cat. no. 208). Because of his interest in the Carracci family, Rubens brought their style home to the Flemish artists who made prints after his works. Engravers such as the Galles and Schelte a Bolswert (c. 1586-1659) combined a dark manner of working the background with the dramatic intensity of light and shade from Agostino's works. It is interesting to note that after 1600, two concurrent engraving styles were dominant in Europe—a virtuoso, complicated, and convoluted style based on Goltzius' works and a more rational organization of form and composition based on Agostino's style. In the works by the school of Rubens, the engravers leaned more toward Agostino. Christoffel Jegher (1596-1642/1643), who worked almost exclusively after designs by Rubens, made woodcuts (fig. W) which in their simplicity of technique, sculptural forms, and emphasis on the white of the paper look back to the medium of engraving as handled by Agostino.[120]

Agostino has been called the "Italian Goltzius," and some critics believed that he was very influential on his northern counterpart.[121] As discussed already, it is Agostino who came under the spell of Goltzius, not the other way around. There are a few works by Goltzius, some after Italian artists like Barocci, which may have been influenced by Agostino. In the *Portrait of Frederik de Vries* of 1597 (Hollstein VIII, p. 71), for example, some of Agostino's style may have rubbed off on Goltzius. The shimmering textural naturalism of the dog's coat and the compositional simplicity of the representation are traits that Goltzius may have picked up from his southern contemporary. But, in the main, the two artists followed parallel developments from Cort, Goltzius exploring the virtuoso possibilities of the medium and Agostino exploring the coloristic possibilities. And the two divergent manners fostered different followers. It is interesting to note, however, that in the eighteenth century, their styles were already becoming confused. An engraving by Goltzius of *Moses with the Tablets of the Law* of 1583 (fig. X), was attributed by the

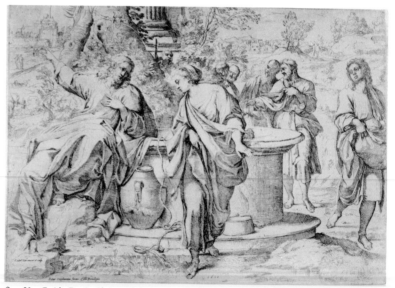

well-known collector John Barnard to Agostino Carracci.[122] In studying the engraving, the similarities of the artists' early styles, grounded in Cort's work, are apparent. It is Agostino's work of the 1590s which in its extreme classicism veered farther and farther away from this tight and fussy manner.

The influence of Lodovico Carracci on the world of printmaking is negligible, due to his limited printed oeuvre, but Annibale Carracci's twenty-two prints (three of which were not printed until recently) had a great impact in the field of etching in seventeenth-century Bologna and Rome. His style, characterized by few and often random strokes, reminiscent of pen work, open contours, and hatching placed far apart and at irregular intervals, and the use of the white of the paper to emphasize light was taken up by such Bolognese artists as Reni, Cantarini, Grimaldi, and Guercino.[123] Guido Reni (1575-1642) was trained in the Carracci Academy. In his prints of the *Madonna with a Pillow* (Annibale R 3) and the *Christ and the Samaritan Woman* (fig. Y),[124] after Annibale, Reni's style and technique approach the master so closely that the etchings have often been attributed to Annibale himself. Reni's hand is betrayed, however, in his faulty understanding of parts of the human anatomy. He was especially interested in the atmospheric tendencies of Annibale's prints and followed these tendencies back to their source in Barocci and Parmigianino, the latter whom he often copied in his prints. Simone Cantarini (1612-1648), whose subject matter and compositions also recall Annibale, not unlike Reni, emphasized the airy openness of Annibale's contour lines, using short strokes to suggest the qualities of a

fig. X Hendrick Goltzius, *Moses with the Tablets of the Law.* The Baltimore Museum of Art, Garrett Collection

Annibale's influence

fig. Y Guido Reni, *Christ and the Samaritan Woman.* New York, The Metropolitan Museum of Art, Harris Brisbane Dick Fund, 1926

pen drawing. But, the atmospheric *sfumato* of Annibale's etchings was foreign to his mentality. Giovanni Francesco Grimaldi (1606-1680?), like the others a Bolognese working in Rome, enlarged the scope of subject matter by his numerous landscape etchings, all of which reflect the open, airy style of both Annibale's etchings and his landscape paintings. Yet, although Grimaldi attempted to emulate the atmospheric quality of Annibale's landscape drawings, his charming prints are frozen interpretations of Annibale's bright and sunny compositions. Perhaps the

two prints by Giovanni Francesco Barbieri (called Guercino, 1591-1666) come closest to Annibale's in temperament by a combination of suggested *sfumato* and quickly executed pen style.

The combination of Annibale's brightly lit backgrounds and pen-like burin work with the atmospheric rendering of Parmigianino's and Barocci's etchings led to the Roman style of etching in the seventeenth century, exemplified in artists such as Pietro Testa (1607/1611-1650) and Salvator Rosa (1615-1673). It is known that even Rembrandt van Rijn (1606-1669) admired Annibale's work and copied at least one of his prints.[125] What may have influenced this great master and others was Annibale's intense involvement with the humanity and emotions of his protagonists as well as his deceptive ease of technique.

Importance

Agostino and Annibale Carracci's prints were admired by the greatest artists of the seventeenth century, but Agostino's star faded when reproductive prints came to be considered merely a record of the work of another artist instead of an interpretation of it. Unfortunately, Hind and Pittaluga saw Agostino's prolific output as the source for the myriad nineteenth-century reproductive artists who rolled out uninspired versions of religious works by Raphael, the Carracci, and Reni. Moreover, after the invention of the photograph and the decreased production of reproductive prints, critics assumed the purpose of all reproductive engravings was only to reiterate the image of the original. Annibale's influence lasted much longer than his brother's, probably because in succeeding centuries the use of engraving declined in favor of etching, the medium preferred by painter-printmakers for its expressive qualities. As the appreciation of the paintings by the Carracci increased after their reevaluation by Mahon, that of their prints lagged behind.

With the present evaluation of their etchings and engravings, we can begin to understand the Carracci's importance for the history of printmaking. First of all, their role in the reform of painting may also apply to prints, a medium in which they sought true clarification of form and subject. In all three Carracci, the focus of the viewer's attention is never distracted from the main action of the engraving or etching. Compositions are reduced and simplified. Agostino, in his attempt to simulate the color of paintings in his engravings, chose a technical idiom already becoming widespread. His importance lies in his technical mastery of this idiom, of his success in evoking color and tonal variations in his engravings, and in his further refinement and dissemination of the idiom. Annibale did not develop new forms of etching either, but he explored the atmospheric and emotional qualities inherent in the medium and successfully evoked the intimate relationships between human beings. Indeed, in their prints, as in their paintings, the Carracci strove for increased expression in both technique and subject matter, and it is this search for the ideal which is their contribution.

NOTES

1 British Museum Inv. no. 1892-4-11-6. Pen and brown ink. 288 x 207 mm. Laid down. The drawing must date after 1595, the year in which Francesco was probably born. (See Malvasia p. 374.) For the Carracci's Cremonese background, see *Mostra-Dipinti* p. 67.

2 Engraved seventeenth century. The print is published in the 1841 edition of Malvasia facing p. 326. Since Malvasia did not know the drawing or the print, he confused several of the relationships of the family, considering Agostino and Annibale to be first cousins of Lodovico and Francesco to be their brother. In the *Mostra-Dipinti* p. 67, the engraving of the family tree was mentioned, and its attribution to Agostino doubted, but the

British Museum drawing seems perfectly acceptable as from Agostino's hand. Agostino also would have known the family history, and his inquisitive personality suggests this is the type of drawing he would make.

3 For information on these artists see Malvasia pp. 369-374. Also for Antonio see Luigi Salerno, "L'Opera di Antonio Carracci," *Bollettino d'arte* (1956): 30-37. For Francesco, see the section on him in this catalogue, p.

4 For an excellent biography of Paleotti see Paolo Prodi, *Il Cardinale Gabriele Paleotti* (1522-1597), (vols. I and II) (Rome, 1959-1967). For Paleotti's friendship with Borromeo see Paolo Prodi, "San Carlo Borromeo e il Cardinale Gabriele Paleotti: due Vescovi della Riforma Cattolica," *Critica Storica,* 3, (1964), 135-151 and for a discussion of the extensive correspondence between the two men regarding religious matters and means of reform.

5 Published by the Benacci in Bologna, the manuscript was ready in 1581 when it was sent to Borromeo for his comments. (Prodi, *Paleotti,* p. 533.)

6 Prodi, *Paleotti,* p. 532.

7 Boschloo devoted much of his book on Annibale Carracci to the cultural and religious atmosphere of Bologna, including a chapter on Paleotti, pp. 110-113, and on his *Discorso,* pp. 121-141. Unfortunately, he depended too heavily on the correspondence between Paleotti and the Carracci, as if everything the artists painted was dependent on the cardinal's writings, either in accordance with them or in opposition to them. Aldo Foratti ("La contrariforma a Bologna ed i Carracci," *L'archiginnasio,* 9, 1914, pp. 15-28) unconvincingly emphasized the Carracci as artistic spokesmen for the Counter-Reformation. Other writers have brought the *Discorso* into a discussion of the Carracci works, but have not used it as a basis or *raison d'être* for their oeuvres, as Boschloo implied. (See e.g. Arcangeli in *Mostra-Dipinti,* p. 105). Prodi's analysis seems consistent with the importance of Paleotti's arguments for the artists of the day. He said (*Paleotti* pp. 534-535) that the *Discorso,* although reflecting ideas of others, incorporated Paleotti's suggestions for his own diocese and not for the entire church, in case the theories were to cause trouble in Rome. The *Discorso* incorporated some of the concepts adopted at the twenty-fifth session of the Council of Trent of December 3, 1563, but was not written to be an edict. It reflected a trend in Counter-Reformatory art, but what the Carracci painted in their Bolognese period did not directly depend on it, but of course reflected their cultural and religious ambience (p. 548).

8 It is beyond the scope of this Introduction to compare the Carracci oeuvre piece by piece with Paleotti's writings and the influence of the Counter-Reformation on their art. That is a complete study in itself and has yet to be undertaken with positive results. In such a painting as Annibale's *Pietà with Saints* in the Galleria Nazionale in Parma of 1585 (Posner 24), Paleotti's suggestions for clear presentation of the subject and emotions is apparent. Paleotti may also have liked Annibale's *Portrait of a Young Man* in Chatsworth (Posner 33b), a drawing of a hunchback. Rendered with sympathy, the young man stares at us imploringly, and the inscription at right reads *Non so se Dio m'aiuta.* The state of the meek and impoverished youth seeking God's aid would have appealed to Paleotti's protective tendencies. Other works by the Carracci, such as Agostino's *Lascivie* (Agostino cat. nos. 176-190), some of their caricatures and scatological drawings, and perhaps the Farnese Gallery itself, would not have sat well with the Bolognese bishop.

9 For Annibale's trades of Bologna see Posner I, figs. 15-18 and Giovanni Mosini, *Diverse figure al numero di ottanta* . . . (Rome, 1646), with Guillain's prints and G. M. Mitelli, *Di Bologna l'Arti per via d'An.ibal Ca.raci* . . . ([Bologna], 1660). See Boschloo pp. 116-119 for Croce's relationship with the Carracci. For Zoppio's poem see Morello pp. 38-39, reprinted here p. 56. For Rinaldi's poem see Morello p. 44, reprinted in Malvasia p. 312.

10 Parmigianino died in 1540; his work in Bologna dated from the late 1520s. Niccolo died in Fontainebleau in 1572, where he had been since the 1550s. Primaticcio died in Paris in 1570; he had been in France since 1532. Pellegrino Tibaldi was working at this period in Spain; he transferred there from Milan where he died in 1596.

11 A dissertation by Patrick Cooney for the Institute of Fine Arts, New York University, is in preparation and should yield interesting results on this underrated artist. For a discussion with bibliography on genre paintings of the period see Posner I pp. 9-20.

12 For a discussion of the stylistic development of the Carracci's paintings and their histories, see *Mostra-Dipinti* (for all three Carracci); Posner, Boschloo, and Dempsey (Annibale); Ostrow (Agostino); and Bodmer, *Lodovico* (Lodovico). For their drawings see Wittkower, *Mostra-Disegni,* and Ellesmere sale. The best bibliographies are found in *Mostra-Dipinti,* Posner, and Boschloo, which will direct one to important articles on the paintings and general background of the period.

13 Arthur M. Hind, *A History of Engraving and Etching from the 15th Century to the Year 1914* (New York, 1923; Dover edition, 1963), 118.

14 For information on Italian prints before Marcantonio Raimondi see Jay A. Levenson, Konrad Oberhuber, and Jacqueline L. Sheehan, *Early Italian Engraving from the National Gallery of Art* (Washington, D.C., 1973). See Oberhuber whose work is the best overall source for Italian prints of the sixteenth century (with a good bibliography). Unfortunately the catalogue is out of print. See also for Marcantonio, Oberhuber, pp. 84-86 with previous bibliography and for illustrations see Lambert-Oberthür pp. 1-52.

15 See Oberhuber, pp. 146-147, 175, for bibliography on Caraglio and Bonasone.

16 For information and bibliography on Ghisi see Oberhuber, p. 181. For a comparison with goldsmith work see *The Triumph of Humanism*, The California Palace of the Legion of Honor, San Francisco, October 22, 1977-January 8, 1978, figs. 39-58.

17 An excellent source for information on prints in northern Europe of the mid and late sixteenth century is Timothy Allen Riggs, *Hieronymous Cock (1519-1570): Printmaker and Publisher in Antwerp at the Sign of the Four Winds,* Yale University dissertation 1971, published by Garland, New York, 1977. See also Caroline Karpinski, "At the Sign of the Four Winds," *Metropolitan Museum of Art Bulletin,* 18 (Summer 1959), 8-17.

18 Factual information on Cort comes from Bierens de Haan and Riggs, *Hieronymous Cock.*

19 Bierens de Haan p. 2 and Riggs, *Hieronymous Cock* p. 90. One must take into account, however, that Cort also had relationships with goldsmiths early in his career. In fact, his monogram is that of a borax box, referring to the substance used by goldsmiths for soldering.

20 Malvasia pp. 266-267, suggested that Agostino may have been Cort's student. See note 34. Some biographers have accepted this as fact, but most reject it today. If Cort were in Bologna it would have probably been in 1566 or 1572 on his trips between Venice and Rome. Agostino's first dated print of 1576 shows no influence of Cort's style, however his later prints of 1579-1581 indicate knowledge of the Fleming. Cort was already dead then.

21 339 x 262 mm. Engraving. Undescribed by Bartsch. Undated. Inscription follows Cort's. Lower right in margin: *DF.* Cort's engraving is signed and dated 1568. See Bierens de Haan 92. The original design belongs to Giulio Clovio.

22 Compare this work with Marcantonio's *Hercules and Antaeus* (fig. A) in which the lines are evenly spaced and delicately rendered. No variety at all is apparent in Marcantonio's strokes.

23 Baglione pp. 387-388.

24 Cort's *Saint Dominic* was interpreted poorly in a copy by Antonio Tempesta, who missed the entire point of Cort's style (Bartsch XVII, 140.491).

25 Four of these artists—Martin Rota, Cherubino Alberti, Philippe Thomassin, and Girolamo Olgiati—are discussed in Appendix II.

26 Very little has been written on Domenico Tibaldi. See Malvasia pp. 158-160, Thieme-Becker XXXIII, p. 128 (article by Bodmer) with additional bibliography, and Oberhuber, p. 211. See the section on him in this catalogue, Agostino cat. nos. R54-R59.

27 Morello p. 32, reprinted in Malvasia p. 307: "Non s'ingannò gia nel suo parere Domenico Tibaldi valente disegnatore, intagliatore & architetto, il quale ottenendo, che Agostino fosse acconcio con lui per lungo tempo, ne acquistò credito, & utile di non mediocre importanza, per molti intagli che gli fece in rame, di tanta bellezza, che contendevano il primo luogo con coloro, ch'erano reputati maestri migliori."

28 Malvasia p. 159: "Incise il valentuomo anche in rame, come altrove si disse, ma poche volte pose in quelle stampe il suo nome, col quale solo vedesi fuora in un gran foglio tagliate a bolino il disegno della bellissima Fontana della piazza a'Scaffieri (non sua invenzione, com'altri ingannato da questo rame scrisse, ma del Laureti, al quale più che di buona voglia cedette'egli una tant'occasione, fattoselo di più compare, col farsi tenere una figlia del 1579.) e la tavola della Trinità del Samacchino, che non occorre ridire." Zanotti in Malvasia p. 164, note.

29 For his prints see Bartsch XV, pp. 103-178 and Oberhuber, pp. 146-147, 185-186 for further bibliography.

30 Malvasia pp. 264-265, 266-267.

31 Ostrow cat. I (pp. 109-113) and p. 563 for a discussion. Reproduced Ostrow fig. I. Known to this author only through a photograph.

32 Malvasia p. 266 said that Agostino made his *santini* (Agostino cat. nos. 40-49) when he was sixteen years old. These prints were made in 1581, the date on one of

them, when Agostino was twenty. There is no reason to believe that Agostino made any significant engravings before his earliest dated works of 1575 and 1576.

33 Malvasia p. 266: "Spropositatamente lasciato Prospero prima, poi il Passerotti, voler far di sua testa, studiando or questa or quell'altra opera di quei maestri, che morti, non potean fare con la viva voce la debita impressione. Esser tuttavia un ben conosciuto pretesto, per levarsi di sotto a Lodovico, restare in una piena libertà, per spender poi il tempo in cattar compagni, cercare novelle, e sentir da questo e quell-altro scienziato cose, che a lui poco rilevavano, anzi nulla, dovendo attendere alla pittura o pure tornare all'intaglio, a lasciar andar le baie a persone per altro ben comode e sfaccendate."

34 Malvasia pp. 266-267 suggested that Agostino may have worked under Cort, but the time span is incorrect. See note 20. Cort died in 1577, before Agostino's manner showed his influence. Malvasia p. 267: "Vogliono alcuni, che per qualche tempo travagliasse ancora sotto l'istesso Cort e di lui fosse allievo, apparendo in molti rami di quel maestro il carattere dello scolare, massime in certi paesi che andarono allora, e anche vanno comunemente sotto nome, anzi sotto la marca di quello, e dalla frasca particolarmente meglio assai frappata, dicono, riconoscersi; aggiungendo, che perciò ingelositosene Cornelio, se lo cacciasse di bottega, ond'egli poi, per dispetto e vendetta, si ponesse a ritagliare nello stesso tempo opere che quello imprendeva, come avvenne dello Sponsalizio di S. Caterina e S. Girolamo, tavola in Parma del Correggio, e simili. Comunque siasi, certo è che fra essi passarono disgusti, querele e anco minaccie; come cavasi da una lettera dell'istesso Cort, trovata presso gli eredi de' Carracci, e che fra l'altre, che di quelli ho raunate, conservasi anch'essa." Unless we can redate some of his works earlier, there is no possibility of the two working together. The story of the jealousy of the older artist cannot be substantiated.

35 See Ostrow pp. 49-56 for a discussion of the independent style.

36 For example, Ostrow accepted the *Resurrection* (Agostino cat. no. R52), here rejected, and rejected the *Adam and Eve* (Agostino cat. no. 24), here accepted.

37 Malvasia pp. 268-270.

38 Arcangeli, "Sugli inizi dei Carracci," p. 32, like Voss before him (Hermann Voss, *Die Malerei des Barock in Rom*, Berlin, 1924, pp. 482-483), asserted that Malvasia falsified the letters. Cavalli (*Mostra-Dipinti* p. 72), Ostrow (p. 566), and Posner (I pp. 33-34 and pp. 157-158, note 38) saw no influence of such a trip on the 1583 *Crucifixion*. Posner suggested that the letters may have been edited and dated from later than 1580, probably before the 1584 Palazzo Fava frescoes, which show Correggio's influence. Walter Friedlaender in his review of Bodmer *Lodovico* (*Art Bulletin*, XXIV, 1942, p. 192) stated that nothing proved the letters to be fabrications. The one very bothersome passage is found at the beginning of the second letter in which Annibale talks about the "beret-wearing" group which attacks their work. It is doubtful that the Carracci would have been criticized before they completed their controversial paintings in the Palazzo Fava in 1584.

39 By Boschloo p. 10, who suggested that this influence came from Agostino's print of the *Crucifixion* after Veronese (Agostino cat. no. 107). In his review of Posner (Boschloo 1972, p. 70), he stated that Annibale probably was not in Venice before the painting. Dempsey p. 87, note 71, on the other hand, suggested that Annibale did know Veronese's paintings in 1583: "I would go farther than Boschloo has in insisting that the rich colorism and broad brushwork in the *Crucifixion* suggest a first-hand acquaintance with Veronese's paintings."

40 The study in Chatsworth for the *Holy Family with Saints John the Baptist and Michael* (Annibale cat. no. 2).

41 Dempsey pp. 8-9. Vanni's change in style to a Baroccesque idiom took place after 1580, however.

42 Posner I p. 26 admitted that the Carracci probably took short trips to Modena and Parma.

43 Malvasia p. 265 for Annibale's precocity and early training, p. 294 for Agostino retouching the *Saint Jerome*.

44 Posner 14-15.

45 For a history of the academy and its founding see Bodmer 1935.

46 Posner II, p. 12, and 213 [R]. See Annibale cat. nos. 1-3 for a list of writers who accepted or rejected the works.

47 Note especially the correspondence with the children in the painting *The Infant Jason Carried in a Coffin to Cheiron's Cave* in the Palazzo Fava (Posner 15b). See the red chalk drawing in Sacramento after Correggio which must be by Annibale, reproduced in A. E. Popham, *Correggio's Drawings* (London, 1957), 84, fig. 37. See also the two red chalk drawings of *putti* in Dresden (Inv. nos. 1860, 368-1860, 369), Popham, *Correggio's*

Drawings, cat. nos. A23-A24.

48 See Campi's remarks at the end of some copies of the *Cremona Fedelissima:* "Ricercava la virtù d'Agostino Carazzi Bolognese, ch'io ne facessi memoria in altro luogo, nondimeno, poiche per inavertenza non mi è venuto fatto, io non vo tacere quivi, che tutti i Ritratti, + il disegno del Caroccio sono stati intagliati in Rame dal detto Carazzi, il quale è à nostri tempi rarissimo in questo professione."

49 See Ostrow for a discussion of his paintings during the period.

50 For a 1585 Venetian trip see cat. no. 133; for the Parma trip see cat. nos. 141-143; for the second Venice trip see cat. nos. 146-150; for a Florentine trip see cat. nos. 150-154.

51 See Morello p. 44 for Rinaldi's poem. See cat. no. 165 for Agostino's relationship with Zoppio; cat. no. 207 for his portrait of Aldrovandi; cat. no. 147 for his relationship with Tintoretto.

52 Malvasia pp. 265-266 and p. 327 ff. for a discussion of the personalities of the artists.

53 As is known, Dürer was the first artist to use the etching technique successfully, but it was Parmigianino in Italy between 1530 and 1540 who developed further the means to approximate pen and wash drawings. Barocci, too, in his few etchings and especially in his *Madonna and Child on the Clouds* (Agostino fig. 98a) extended this technique to complicated compositions. In north Italy, Bologna, and Milan, Passarotti and Camillo Procaccini (1571-1629) experimented with etching grounds with varying results. In Procaccini's *Transfiguration* (Bartsch XVIII, 20-21.4), although the ground broke, the resultant otherworldly feeling of Christ rising in the mist was successful not only as art but as iconography. In central Italy, Francesco Vanni and Ventura Salimbeni (1567-1613) followed Barocci's footsteps; Schiavone (before 1522-1563) followed Parmigianino in Venice; and Bernardino Passari (c. 1540-1590) in Rome developed a style in etching based mainly on the engraving technique. Consequently, when Annibale began to etch, there was a tradition on which to rely.

54 Posner I p. 45 believed that Annibale made a Venetian trip before or in 1588. As suggested earlier, Annibale had probably been to Venice before the Fava frescoes and maybe even in 1580. He could easily have returned before 1588, perhaps with his brother in 1582 and again in 1585 or 1588 (see chronology). One must agree with Bissell (R. Ward Bissell, review of Posner in *Art Bulletin,* LVI, 1974, p. 132) that Posner was too rigid in his period divisions of Annibale's art.

55 Reproduced Posner 52. See Posner also for bibliography and dating.

56 See cat. nos. 151-205 for works that were made between 1590-1595.

57 See the *Mostra-Dipinti,* cat. nos. 11-19 for a discussion of Lodovico's paintings that belong to this period.

58 For reproductions of Goltzius' engravings and woodcuts see Hollstein vol. VIII, pp. 1-129 and *Hendrik Goltzius, The Complete Engravings, Etchings, and Woodcuts,* edited by Walter Strauss, 2 vols. (New York, 1977).

59 Carel van Mander, *Dutch and Flemish Painters Translation from the Schilderboeck* (New York, 1936, original Dutch edition 1604), p. 360.

60 Ostrow p. 549.

61 For example, see the drawing of a *Head of a Faun in a Roundel* (Annibale fig. 19a) in the National Gallery of Art, Washington, D.C.; also Wittkower 154.

62 Bellori p. 111 mentioned only that there were disagreements between the brothers, and therefore Agostino left Rome: "Essendo dopo nato qualche disparere fra di loro, egli si partì di Roma. . . ." Malvasia quoted the 1580 letters in which Annibale implied there were disagreements from an early date (see Appendix III). Malvasia p. 295 went into the arguments in Rome more fully, implying that others exacerbated their disagreements and were happy to see them separated.

63 But Annibale, also after his transfer to Rome, developed along similar lines as his brother and continued to look at Agostino's drawings and prints. A case in point is a drawing of *Saint Catherine of Alexandria* (fig. K),* probably by Annibale, but so close to Agostino in style that doubt enters into the attribution. (The sheet is in Windsor Castle, Inv. 2144, Wittkower 408 as Annibale, 270 x 179 mm. Pen and brown ink and wash over black chalk.) Like Agostino's figures of the Roman period, Saint Catherine is represented as a sculpturesque, bulky form with a rounded face and classical features. However, the flowing contours and expressive features are reminiscent of an earlier drawing by Annibale of *Saint Catherine* (fig. L). (This sheet, in a private collection, is in pen and brown ink and gray wash, squared in black chalk. 140 x 88 mm. See Sotheby Parke Bernet and Co., London, *Catalogue of Fine Old Master Drawings,* December 5, 1977, lot 8 for collections and bibliography. Known to the author only in photographs.) Thus, al-

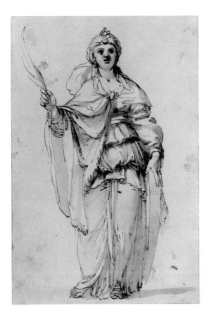

fig. K Annibale Carracci(?), *Saint Catherine of Alexandria,* Windsor Castle, Royal Library, Her Majesty Queen Elizabeth II

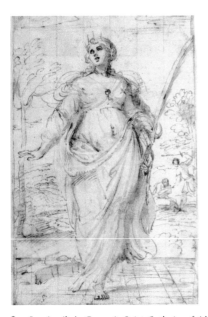

fig. L Annibale Carracci, *Saint Catherine of Alexandria.* Private Collection

though the more static representation of the form in the Windsor drawing suggests Agostino, the Roman experience and Agostino's influence on Annibale's pen style are at work here.

64 For information on the dating of this transfer see Ostrow pp. 591-593. For his paintings in Parma see Jaynie Anderson, "Sala di Agostino Carracci in the Palazzo del Giardino," *Art Bulletin,* 52 (March, 1970): 41-48.

65 See Jaynie Anderson, "Sala di Agostino," for reproductions.

66 Note especially the two sided drawing in Frankfurt (Agostino fig. 213a-b). The elongated and elegant torsos and the florid pen work recall Parmigianino's pen and ink sheets.

67 The illness is mentioned by Bellori p. 68, and Malvasia pp. 318-319.

68 The trip is documented by a letter from Lodovico to Francesco Brizio dated June 8, 1602. See *Mostra-Dipinti* p. 94; Malvasia p. 297.

69 Classical and Renaissance idealized figures never seem to have wholly impressed Lodovico, whose willowy, nonsculptural figures exist in a world of their own.

70 Boschloo saw Agostino influencing Annibale (p. 176, note 3) and both of them influencing Lodovico (p. 203, note 30). For the change of direction of Annibale to classicism, c. 1593, see Boschloo p. 23, 186, note 29. See also pp. 66-67 for Agostino's introducing new ideas from outside the circle. On p. 68 Boschloo said, "It was not so much through his own creativity (whose scope was limited) that Agostino inspired his brother, but through his knowledge of all matters relating to art (and other fields) inside and outside Bologna, through his understanding of what was topical and had quality, and through his desire to absorb as much as possible of it in his own interpretations. Thus during all his years in Bologna, Annibale was supported in his work by Agostino's knowledge and experience." This assessment of Agostino seems fairly accurate. Calvesi, *Commentari* pp. 271-272 discussed the influence of prints on Annibale's work in the Farnese Gallery and suggested that he must have gotten this interest from Agostino. Boschloo pp. 30, 68 suggested that Agostino in the mid 1580s probably gave Annibale the idea of painting a saint close up in the landscape (see Posner 29, 90) from his saints prints. But, those prints could be contemporary with Annibale's of the same type, and the influence could have been mutual.

71 For drawings by one Carracci for paintings by another see the drawings for the Palazzo Fava, e.g. Posner 15k by Lodovico Carracci for the *Meeting of Jason and King Aeëtes.* The painting (Posner 15j) is by Annibale. Also see the drawing by Annibale (Posner 15m) for the painting by Agostino of *Jason Giving the Golden Fleece to Pelias* (Posner 15n). The same occurred in the Palazzo Magnani (see Posner 52i-k, 52m and n). These are examples actually extant. There are probably numerous others.

72 Library of Congress NC 1155 C3, no. 19. 272 x 167 mm.

73 In his funeral oration, Faberio, pp. 36-38 emphasized Agostino's ability in portraying both the living and the deceased: "Ma se gran fatto è il saper in presenza ben ritrarre del naturale, se maggiore il far il medesimo in absenza; grandissimo è senza dubbio e maraviglioso il farlo, dipingendo persona già morta, sepolta, non mai veduta, senza disegno o impronto, ma per sola e semplice relazion d'altri." He observed that in his portraits Agostino did not just represent the body but the very soul of his sitters: "ricopriva con arte, e con sì gentil maniera l'imperfezioni e le mancanze della natura, sempre accrescendo le bellezze, che non si poteva desiderar meglio." Malvasia p. 358 and p. 354 listed portraits by Annibale and by Lodovico. See also Posner pp. 20-22 and the article by D. Stephen Pepper, "Annibale Carracci ritrattista," *Arte illustrata,* 6, 53 (May, 1973): 127-137. (This author does not agree with the attributions of figs. 4, 8, 10, 11 and the color plate to Annibale.)

74 See Wittkower 167-168, 360; Ellesmere sale 47, 51 *Mostra-Disegni* pl. 5 for examples of some of these sheets.

75 Reproduced Posner 76, *Mostra-Dipinti* 10, 46.

76 Princeton University Art Museum. Inv. no. 62-51. Red chalk heightened with white. 410 x 277 mm. Bibliography and collections in Felton Gibbons, *Catalogue of Italian Drawings in the Art Museum, Princeton University* (Princeton, 1977), 58-59, no. 156.

77 Posner I, pp. 20-22 for a discussion of Annibale's portraiture and its relationship to genre drawing.

78 Windsor 2276 (Wittkower 168). Black chalk. 191 x 134 mm. Verso is of same subject in different direction. Art Institute of Chicago Inv. no. 1973.152. Red chalk. 360 x 252 mm. Collections and bibliography in Art Institute of Chicago, *European Portraits 1600-1900 in the Art Institute of Chicago* (Chicago, 1978), 96-97, no. 23.

79 His first extant portrait drawings, however, can be dated earlier, such as the youthful *Self-Portrait* in Windsor (Wittkower 164).

80 An excellent example of this would be Eneo Vico's *Portrait of Charles V* (Bartsch XV, 339.255). In Agostino's time Cherubino Alberti was well known for this kind of engraving. See, e.g., the *Portrait of Henry IV* of 1595 (Bartsch XVII, 93-94.124).

81 The northern tradition of portraiture in prints stems from Albrecht Dürer, who in such an engraving as the 1524 *Portrait of Willibald Pirckheimer* (Bartsch VII, 113.106) reproduced the upper torso and head of the sitter, simply juxtaposed against a white background. Most of Dürer's followers elaborated this basic representation by adding hatching to the background, more elaborate dress, coats of arms, etc.

82 Of course, Agostino would have looked directly at Dürer's prints too. For more on Rota see Appendix II.

83 Giulio Mancini, *Considerazioni sulla Pittura* (c. 1620), 1, Rome 1956-1957 (edited by A. Marucchi and L. Salerno), pp. 136-137. Malvasia p. 335. No caricature drawings by Lodovico are known. See Posner I, pp. 65-70 for a discussion of the foundation of caricature and the Carracci and for a further bibliography see Posner I p. 163, note 63. He asserted (as did Mahon before him, p. 259, note 43) that Annibale was the inventor of caricature: "According to the literary sources, whose unanimity and certainty on this point is very impressive, Annibale Carracci invented the genre and also the word 'carica-ture.'" (Posner I, p. 66). He based this belief on Massini's preface, but Massini, al-though weighing in favor of Annibale as the inventor, mentioned that it was in the "Scuola de'Carracci hebber nome di Ritrattini carichi; s'aggiugneua (diceua Annibale) la terza cagione del diletto, cioè la caricatura;" (Massini is Giovanni Mosini, *Diverse figure* . . ., Rome, 1646, reprinted in Mahon p. 260). Mancini mentioned Annibale's talent in the genre, but he also noted that Agostino made "composition facete accompagnate con terzetti e madrigali, che si son in piu occasinio sue Pitture redicole che un gentilhuomo di studio ne ha un libretto." Thus, when Mancini wrote in 1620, both Agostino and Annibale were mentioned when referring to the new genre of caricature. When in 1646 Massini wrote that Annibale invented the word, one must take into account that he was writing a preface to a book of prints after Annibale, and there was a reason to connect him with this by now popular genre. The workmen in the drawings by Annibale from which the book derives were portrayed with the same humor and sensitivity to their professions as the Carracci used in portraying individual features of a man in caricature. Agostino had nothing to do with *Diverse figure* . . . and thus would *not* be mentioned in the preface. Bellori's comments on the subject (pp. 75-76) do not lead us to believe that Annibale was the inventor of the genre, but that he was a practitioner of it. On the other hand, as Posner (p. 66) admitted, there are no secure caricature drawings by Annibale, and the two drawings which Posner published in Windsor (Posner fig. 59) and the Louvre (Posner fig. 60) as by Annibale should be returned to Agostino where they be-long. Since the discussion of caricature gets away from the subject of this book, there is no attempt here to prove who, in fact, first said the words "ritratti carichi" in relation to portraits made for fun or teaching purposes in the Carracci Academy. But, as with other phases of art by the Carracci, Agostino's influence and importance should not be elimi-nated. Malvasia, when bringing up the subject of the pictorial games played in the Academy, noted Agostino's primary role: "Di qui que'biribissi, que' pelachiu, quell' oche disegnate con si spiritose figurette e di acquerelle di colori miniate non solo, ma que' nuovi giuochi, che a simiglianza de'suddetti e piu giudiciosi ancora, ritrovo Agos-tino, donandone a Dame e ad amici." and "Di qui trassero il principio quelle caricature tanto gustose, . . ." (Malvasia, p. 335). The problem is of course insoluble on the evi-dence available, but the extant drawings by Agostino, e.g., in Stockholm (D 31.903, C 12.767, D 11.618), Darmstadt (Inv. AE 1494) and on the art market (Sotheby July 4, 1977, lot 108), indicate his total involvement in pictorial games and caricature. In the first drawings, the artist's skill at using one line never lifted from the sheet to characterize an entire head, and sometimes the entire body, suggests that Agostino's practice of the art must have been as influential on his students as his brother's was. More work on the caricature drawings is needed to separate the artists' hands.

84 Inv. no. 1955.63. Formerly called unknown Italian. *Studies of Grotesques*. Pen and brown ink. 250 x 370 mm. The sheet probably dates from c. 1590-1595.

85 In the north see the print by Jost Amman (Bartsch IX, 365.23) where the coat of arms occupies a small portion of the engraving toward the bottom.

86 For reproductions of Brizio's and Valesio's coats of arms, see Bertelà 43-57 and 968-1029.

87 This suggestion demands further research. Stylistically, however, some of Agos-tino's arms are similar to ones on the exteriors of some Bolognese *palazzi*, e.g., the one in the courtyard of the Palazzo Pubblico. One can understand Agostino's interest in arms, as it appeared to be of importance to Bolognese civic and private life. The frescoed arms of the Bolognese aristocracy in the courtyard of the Palazzo dell'Archignnnasio are an impressive testimony to the Bolognese family pomp which would have cowed any

sixteenth-century citizen. (Reproduced G. Gherardo Forni and G. Battista Pighi, *Gli stemmi e le iscrizioni minori dell'Archiginnasio,* 2 vols. (Bologna, 1964). See also the *putti* holding the arms of the Magnani above the central window on the top floor of the facade of the Palazzo Magnani, where the Carracci worked in 1592 and above the fireplace in the *Salotto*. (Reproduced in Giampiero Cuppini, *I palazzi senatorii a Bologna,* Bologna, 1974, pl. 69, p. 217, and Posner 52a.) For a history of the palace and bibliography see Cuppini pp. 304-305. Also note the mermaids holding cartouches of arms above the windows of the facade on the Palazzo Fava where the Carracci worked in 1584. (Reproduced Cuppini pp. 213-214, pl. 66-67.)

88 There are other drawings which have been incorrectly attributed to Agostino. One is a study for a coat of arms of a cardinal of the Borghese family. Belonging to a French private collection, it was published in 1971 by the Galerie Claude Aubry in Paris (*Dessins du XVI^e et du XVII^e siècle dans les collections privees françaises,* December, 1971, cat. no. 27). The drawing is in fact by Oliviero Gatti (active in Bologna in the first half of the seventeenth century) and is a study for his engraving of the same subject (Bartsch XIX, 13.37, reproduced Bertelà 641). The other drawing, in the Hessisches Landesmuseum in Darmstadt (Inv. no. AE 1370) is a doubtful sheet. Another sheet, in New Zealand with a cartouche in the upper portion, is only possibly by Agostino (Auckland City Art Gallery, Auckland, New Zealand, *Studies,* 1963, no. 27, p. 7, from photograph in Louvre).

89 Ex libris are known as early as c. 1450 and were engraved c. 1500. According to Mantero, ex libris and visitor's cards were sometimes used interchangeably, the earliest visitor card in 1572. Ex libris became very popular in the seventeenth century as private libraries flourished, especially in Italy. Although not very complete, for a summary of the history of ex libris and further bibliography see Gianni Mantero, "L'Exlibris" *I quaderni del conoscitore di stampe,* no. 3 (Dec.-Jan., 1971): 23-26 and "Appunti storici sugli ex libris," *I quaderni . . . ,* no. 12 (May-June, 1972).

90 For a clear and concise history of engraved frontispieces in Italy in the sixteenth century see Francesco Barberi, *Il frontespizio nel libro italiano del quattrocento e del cinquecento* (Milan, 1969). Also good are his articles: "Derivazioni di frontespizi," in *Contributi alla storia del libro italiano: Miscellanea in onore di Lamberto Donati* (Florence, 1969), pp. 27-52 and "Frontespizi italiani incisi del cinquecento," *Studi di storia dell'Arte Bibliologia ed Erudizione in onore di Alfredo Petrucci* (Milan and Rome, 1969), 65-74 in which he added forty-nine works to Johnson's list of engraved title pages. For these see the classic work by Alfred Forbes Johnson, *A Catalogue of Italian Engraved Title-Pages in the Sixteenth Century* (Oxford University Press, 1936).

91 Barberi, *Il frontespizio,* pp. 141-142.

92 Agostino's method of using the whole sheet for ideas is well known and need not be discussed here. See Wittkower p. 13 for a discussion of his drawing method. Besançon Musée des Beaux-Arts. Inv. no. 2276. 185 x 267 mm. Pen and brown ink. Probably datable to the end of the 1580s or early 1590s. Literature: Winslow Ames, "Two Agostino Carracci Drawings," *Art Quarterly,* 16, no. 4 (Winter, 1953): 344-345.

93 Inv. 1966 r. 410 x 254 mm. Pen and brown ink and gray wash. Wittkower 185. 1966 v. is Wittkower 160.

94 Wittkower (60 and 185), on the basis of the head in profile on the folded side of the sheet, dated the drawing to the Roman period, but that head could have been added later. It is not of the true classical type Agostino made after 1595. Moreover, the mask to the left of the landscape oval in the margin reappears in a drawing by Agostino in the Art Institute of Chicago (Inv. no. 22.19) which certainly dates earlier.

Another drawing in Düsseldorf (Inv. no. FP 3814. 340 x 233 mm. Pen and brown ink, Düsseldorf Kunstmuseum, *Meisterzeichnungen der Sammlung Lambert Krahe,* Düsseldorf 1969, no. 31, fig. 40), also has a decorative framework in the upper part, but it was probably destined for the frame of a Trinity (as the composition in the center appears to be). Like Agostino's drawing in Besançon, here, too, the framework is active with movement and becomes part of the central composition by the overlapping of some of the cartouched elements, a precursor of the later connection of frame and subject in seventeenth-century frescoes.

Yet another sheet, in Bayonne (Winslow Ames, "Two Agostino Carracci Drawings," *Art Quarterly,* 16, no. 4, Winter, 1953, p. 344) of the Roman period, also contains a study for an elaborate altar, but the plaque set aside for writing in the lower section and the enclosure of the whole design may indicate that it was intended for an engraving.

95 An unusual drawing by Annibale in a private collection in New York (Annibale fig. 22f)* should be mentioned here. Although it is suggested in Annibale cat. no. 22 that this drawing may relate to the Aldobrandini lunettes, there is always the possibility it was a thought for a book illustration. The unusual, rusticated, double-arched form has the look of the windows of many sixteenth-century book illustrations, such as Agostino's

title page for the *Gerusalemme Liberata* (Agostino cat. no. 155). However, Annibale is now known to have worked in book illustrations at all, and no other drawings in this manner are known.

96 For a discussion of Annibale's personality and disposition, see Malvasia pp. 327-328 and Malvasia pp. 318-319, and Bellori p. 68 where his increasing melancholy in later years is described.

97 See the discussion by Bellori p. 105 about the teachings in the academy and the *Scuola perfetta per imparare i disegni* after drawings by Agostino in which expressions were explored which could project certain emotions. Faberio (Morello p. 37, reprinted Malvasia p. 309) emphasized the importance of painting human attitudes according to decorum: "Dipingendo il Carracci alcuno dal naturale, considerava la qualità, l'età, il sesso, il luogo, & l'occasione. Osservava quelle parti della Fisionomia ch'erano più proprie del volto, che ritrar dovea, e gli affetti & le passioni, e dipoi con tanta facilità, e felicità lo rappresentava al vivo, che niente più."

98 Baglione p. 387. 99 Malvasia p. 57.

100 For an interesting discussion of the use of reproductive prints in the sixteenth century and their attempt to comprehend the original *idea* see Giulio Carlo Argan, "Il valore critico della 'stampa di traduzione,'" *Essays in the history of art presented to Rudolf Wittkower* (London, 1967), 179-181. See also, for religious importance of prints, Eugenio Battisti, "Reformation and Counter Reformation," *Encyclopedia of World Art* (New York, 1966), column 902. See the summary of imitation in sixteenth-century art in Eugenio Battisti, "Il concetto d'imitazione nel Cinquecento italiano," in *Rinascimento e Barocco* (Turin, 1960), 175-215. The classic work, of course, is that of Erwin Panofsky, *Idea, A Concept in Art Theory,* translated by Joseph J. S. Peake (Columbia, 1968). The comments in this section are meant to be brief and do not include the names of other theorists who entered into the controversy such as Pico di Mirandola, Michelangelo, and Dolce. For a better understanding of their writings see Panofsky and the above articles for further bibliography. See Dempsey pp. 60 ff. for an excellent discussion of *imitatio* as understood by the Carracci. For the ideas preceding Bellori which were circulated in the Carracci circle, see Clovis Whitfield, "A Programme for 'Erminia and the Shepherds' by G. B. Agucchi," *Storia dell'arte,* 19 (1973): 217-229, in which Agucchi in a letter of 1602 said that one should copy both nature and art, concluding that it was profitable to imitate art in some cases. It was necessary for artists to draw on the images of the past. Previously, in the mid-sixteenth century, for fear of the decline of art, Vasari had advocated the need to imitate examples of great art, examples of authority. Thus, even before Agucchi and Bellori advocated copying images of nature and art, the precedent was set. In fact, throughout the sixteenth century, printmakers were considered recreators, not copyists, of images.

101 As told by Boschini, see cat. no. 147.

102 Morello, pp. 38-39, reprinted in Malvasia p. 309.

103 Faberio (Morello p. 38, reprinted in Malvasia p. 309) mentioned Agostino's paintings of both Zoppio and his wife.

104 Pittaluga p. 338 and Ostrow p. 96.

105 Dempsey pp. 96-97, note 132 and in discussions with the author.

106 Malvasia p. 309: ". . . una sol cosa mi basterà per argomento del grande ingegno del Carracci, cioè: che per essere stato nell'onorata sua professione giudicioso imitatore delle naturali e artificiali cose, ha meritato il nome di grande, e ammirabile pittore. Non senza cagione io lo chiamo giudizioso imitatore: perchè egli considerando, che la pittura è oggetto dilettevole dell'occhio umano, applicava sempre l'imitazione al meglio, guardandosi dall'error di molti ch'amano più tosto la somiglianza, anco nelle parti non buone, che la bellezza libera d'ogni emenda." and in painting: "Dipingendo il Carracci alcuno dal naturale considerava la qualità, l'età il sesso, il luogo, e l'occasione." See Dempsey pp. 48-49.

107 Bartsch XVIII, 158-170. 1-81. See Calvesi/Casale 185 for a short history of the attributions.

108 There are no examples of complete sets of the prints in contemporary bindings, with a publication date. It seems, rather, that after most of the prints were finished, they were gathered together and bound by Stefanoni, who had the title page added. The prints vary in quality and type, several even seem to be by northern artists, some are after artists earlier than Agostino, etc. It is not known that the prints were intended to form a book. Study of the hands of the engravings should yield interesting results, but that is beyond the scope of this work.

109 The authors of some of the earliest exercise books of this type were Odoardo Fialetti, a Bolognese: *Il vero modo et ordine per dissegnar tutte le parti et membra del corpo humano* (Venice, 1608) and Giacomo Franco, a Venetian: *De excellentia et nobilitate*

delineationis libri duo (Venice, 1611). They contained works by Palma Giovane. See David Rosand, "The Crisis of the Venetian Renaissance Tradition," *L'Arte,* 3, no. 11, 1970, pp. 5-53 and Bertelà 613. Similar works by Bolognese artists besides Fialetti were those of Francesco Curti (Bertelà 535-553), Oliviero Gatti (Bertelà 654-674), and Valesio (Bertelà 947-963). The tradition was carried on in the north in Adriaen Bloemart's drawing book of 1740. See also note 97 and Dempsey p. 79, note 21.

110 For information on Brizio see Agostino cat. nos. R28-R37.

111 For reproductions of the works of these artists see Bertelà 615-698 (Gatti), Bertelà 939-1029 (Valesio), Bertelà 480-563 (Curti), Bertelà 931-933 (Tinti).

112 For information on Ciamberlano see Agostino cat. nos. R45-R49.

113 Engraving. 174 x 120 mm. National Gallery of Art, Washington, D.C.

114 For reproductions of the Galles' book illustrations after Rubens, see John Rowlands, *Rubens Drawings and Sketches* (London, the British Museum, 1977), cat. nos. 204-222.

115 National Gallery of Art, B27460. 237 x 360 mm. See Anatole de Montaiglon, *Catalogue raisonné de l'oeuvre de Claude Mellan* (Abbeville, 1856). In his introduction to the catalogue, Mariette (p. 314) mentioned the influence of Agostino on Mellan.

116 For the chronology of Rubens' trip see Michael Jaffé, *Rubens and Italy* (Oxford, 1977), 7-13; for influence on him from the Carracci see Jaffé, pp. 54-56 and Michael Jaffé, "The Interest of Rubens in Annibale and Agostino Carracci: Further Notes," *Burlington Magazine,* 99 (1957): 375-379, and Rowlands, cat. no. 52.

117 After Agostino's *Lot and his Daughters,* Agostino cat. no. 177, Jaffé, *Rubens and Italy,* pl. 64; after Annibale's Farnese ceiling frescoes, Jaffé, *Rubens and Italy,* pl. 164; and a painting dependent on Annibale's *Portrait of Claudio Merulo,* Jaffé *Rubens and Italy,* pl. 166. It is doubtful that the counterproof after Annibale's *Tazza Farnese* is by Rubens, Jaffé, *Rubens and Italy,* pl. 163. See Annibale cat. no. 19.

118 See especially Rubens' drawings of nudes and heads, Jaffé, *Rubens and Italy,* pl. 98-99, 287, 293, etc., and Rowlands, cat. nos. 64, 69 etc. Also note the pen and ink style of the classical *Head of Hercules,* reminiscent of Agostino's pen and ink technique: Jaffé, *Rubens and Italy,* pl. 278; see also Rowlands, cat. no. 15.

119 An interesting comparison can be made between Annibale's *Sleeping Venus* (Posner 134a) and Rubens' copy of *Leda and the Swan* after Michelangelo (Jaffé, *Rubens and Italy,* pl. 209), both of which date c. 1602. The torso of Leda is much like that of Annibale's Venus. To go even further, the study for this painting by Annibale in Frankfurt (Inv. no. 4060, Pen and brown ink and wash over black chalk with white heightening on green paper. 277 x 377 mm; reproduced Posner 134b) has an interesting second sketch of the figure in the upper left which is extremely close to Rubens' pen style. If the ink were not the same as the rest of the sheet, and the sketch did not have a *pentimento* of the right arm which shows up in the painting, one would be tempted to think that Rubens did the retouching. As it is, at this point in Annibale's career, his pen style comes very close to Rubens'.

120 For works by Bolswert see Hollstein III, pp. 71-92. But compare especially a work such as the *Resurrection* (Hollstein 29) with Agostino. For Jegher see Hollstein IX, pp. 181-192.

121 Calvesi/Casale p. 10. See also Agostino cat. no. 211.

122 Baltimore Museum of Art, Inv. no. L.30.10. The engraving is Hollstein VIII, 1.1, reproduced. This section is part of a larger engraving including three plates, one of which is signed by Goltzius. Also interesting about the inscription by Barnard on the engraving is his reflection of contemporary taste against engraving in favor of painting: "that all Lovers of Painting lamented He should leave off an Art in which He so much excell'd, to follow the inferiour Profession of a Graver." For information on Barnard see Lugt 1419.

123 For reproductions of Reni's etchings see Bertelà 842-908; for Cantarini, Bertelà 74-138; for Guercino, Bertelà 10-11; for Grimaldi, Bertelà 701-724.

124 Etching. 286 x 417 mm. (sheet: MMA). Lower left: *Anibal Car: invent et sculp.* Lower edge toward left: *Petrus Stephanonius formis Cum Privilegio.* Lower edge, center: *1610.* (Bartsch XVIII, 304-305.52). Attributed by Bodmer 1938, pp. 109-111 to Annibale, based on a now lost print in Munich, signed and dated 1595. Most examples are dated 1610. Given by most scholars to Reni.

125 For Testa's prints see Paolo Bellini, *L'opera incisa di Pietro Testa* (Vicenza, 1976). For Salvator Rosa, see Luigi Salerno, *L'opera completa di Salvator Rosa* (Milan, 1975), appendix. For the influence of Annibale on Rembrandt see Ludwig Münz, *Rembrandt's Etchings a Critical Catalogue,* I (London, 1952), 40.

THE CATALOGUE

GUIDE

The catalogue is divided into four parts: Agostino, Annibale, Lodovico, and Francesco. Within each part, authentic prints, arranged chronologically, are followed by questioned prints and rejected prints. A reference to "cat. no." within a section indicates another of that artist's prints. If the print is dated, the date follows the title; otherwise the date given (with c.) is approximate. An asterisk (*) indicates that the work is in the exhibition. An asterisked remark designating the collection from which the exhibited print was borrowed may follow the text of the entry; if not the print reproduced is the one in the exhibition. Unless indicated otherwise, measurements, in millimeters, are taken at the plate mark of the print, height preceding width, measured at the right and bottom. If the plate mark is missing, the explanation "sheet" followed by an abbreviation for a collection means that the entire sheet from the collection noted was measured. All drawing measurements refer to the entire sheet. Following the title of the print is the Bartsch number (B). States indicated by roman numerals are those of the author; arabic numerals are those of either Bartsch (B), Calvesi/Casale (CC), Ostrow (Ost), or Posner (Pos). Abbreviations following states and copies indicate locations. As many locations as possible are given for the states of the prints, but only one location is given for each copy.[1]

Abbreviations of locations:

Alb	Graphische Sammlung Albertina, Vienna
Balt	Baltimore Museum of Art
BM	British Museum, London
BMFA	Museum of Fine Arts, Boston
BN	Bibliothèque Nationale, Paris
Bo	Pinacoteca Nazionale, Bologna
Ber	Staatliche Museen, Preussischer Kulturbesitz, Kupferstichkabinett, Berlin-Dahlem
Br	Kunsthalle, Bremen
Dar	Darmstadt Hessisches Landesmuseum
Dres	Staatliche Kunstsammlungen Kupferstichkabinett, Dresden
Ham	Hamburger Kunsthalle
LC	Library of Congress, Washington, D.C.
MMA	Metropolitan Museum of Art, New York
NGA	National Gallery of Art, Washington, D.C.
PAFA	Philadelphia Museum of Art, The Academy Collection
Par	Biblioteca Palatina, Parma
Ro	Gabinetto nazionale delle stampe, Rome
Stu	Stuttgart Staatsgalerie
U	Gabinetto disegni e stampe degli Uffizi, Florence

1 The following print and drawing cabinets and libraries were studied:

The United States: The Museum of Fine Arts, Boston; the Boston Public Library; the Fogg Museum of Art, Cambridge; the Houghton Library, Cambridge; the Metropolitan Museum of Art, New York; the Cooper Hewitt Museum of Design, New York; the New York Public Library; the Philadelphia Museum of Art; the Princeton Art Museum; the Baltimore Museum of Art; the National Gallery of Art, Washington; the Library of Congress, Washington; the Folger Shakespeare Library, Washington; the Cleveland Museum of Art; the Chicago Art Institute; the Newberry Library, Chicago; the University of Chicago Library; the Los Angeles County Museum of Art; the Henry E. Huntington Library, San Marino; the Grunwald Center for the Graphic Arts, Los Angeles; the Achenbach Foundation for the Graphic Arts, San Francisco.

In England: The British Museum, London; the Victoria and Albert Museum, London; the Ashmolean Museum, Christ Church, Oxford; the Fitzwilliam Museum, Cambridge; Royal Library, Windsor Castle; Duke of Devonshire Collection, Chatsworth.

In France: The Bibliothèque Nationale, Paris; the Louvre, Paris; Institut Néerlandais, Paris.

In West Germany: Staatliche Museen Preussischer Kulturbesitz, Berlin-Dahlem; Frankfurt Städelisches Institut; Bremen Kunsthalle; Hamburger Kunsthalle; Darmstadt Hessisches Landesmuseum; Stuttgart Staatsgalerie; Munich Graphische Sammlung.

In East Germany: Dresden Staatliche Kunstsammlungen Kupferstichkabinett.

In Austria: Graphische Sammlung Albertina, Vienna.

In Italy: the Biblioteca Ambrosiana, Milan; the Raccolta Bertarelli, Milan; Palazzo Rosso, Genoa; the Biblioteca Reale, Turin; Biblioteca Nazionale, Turin; the Biblioteca Statale, Cremona; the Biblioteca Palatina, Parma; the Biblioteca Universitaria, Bologna; the Biblioteca Archiginnasio, Bologna; Accademia delle Belle Arte, Bologna; the Pinacoteca Nazionale, Bologna; the Biblioteca Correr, Venice; the Galleria Estense, Modena; the Uffizi, Florence; the Biblioteca Nazionale, Florence; the Calcografia Nazionale, Rome; the Biblioteca Nazionale Centrale, Rome; the Gabinetto nazionale delle stampe, Rome; the Museo Nazionale di Capodimonte, Naples.

In Spain: the Biblioteca Nacional, Madrid; the Prado, Madrid; Palacio Real, Madrid; Accademia di San Fernando, Madrid.

AGOSTINO CARRACCI
(1557-1602)
Cat. nos. 1-213

I

Skull of an Ox

(B. 257) 1574

Engraving. 111 x 83 mm. (after Giulio
Bonasone woodcut Bartsch XV, 158)

Literature: Malvasia pp. 84, 266 and note 1;
Oretti pp. 839-840; Heinecken p. 640, no. 10;
Gori Gandellini p. 242; Mariette I, p. 311;
LeBlanc 137; Bolognini Amorini p. 60;
Bodmer 1939, p. 125; Marchesini p. 165; Petrucci pp. 141-142, note 6; Mario Praz, *Studies
in Seventeenth-Century Imagery,* Rome, 1964,
p. 276; Calvesi/Casale 3; Ostrow 4 (with additional bibliography); Bertelà 290.

States:

	B	CC	Ost
I	1	1	1

As reproduced. No inscriptions. (Alb, Ber, Bo,
MMA, and others)

In 1574 a second edition of Achille Bocchi's *Bonon symbolicarum quaestionum de universo genere, quas serio ludebat, libri quinque* was published in Bologna with the 151 plates of Giulio Bonasone, from the 1555 first edition, entirely recut. An engraving, the *Skull of an Ox*, was added to replace a woodcut of the same subject from the first edition (fig. 1a). As Ostrow remarked, the woodblock had probably worn beyond repair and could not be reutilized for this second edition; consequently a new plate was engraved. According to Malvasia, the *Skull of an Ox* was Agostino's first venture into engraving after the *santini* at the age of sixteen.[1] Most writers have accepted Malvasia's attribution,[2] and it is on this tradition alone that one can judge the engraving, since its simplicity of execution and its reiteration of an earlier composition make it almost impossible to attribute it stylistically.

In contrast to Bonasone's woodcut, there are subtle changes evident in Agostino's copy: more contrast of light and shade gives a greater plasticity to the skull. Also, the hammers on either side of the skull have tips at the ends and seem thicker; the curved ribbons appear thinner and have smoother contours. There are more holes in the skull in the copy, and the shading is somewhat changed. Agostino's copy is more vibrant and less flat than the original woodcut.

As Ostrow contended, Agostino, who began his artistic career as a goldsmith's apprentice, could easily have been called upon at this time, at the age of nineteen, to do the technical job of recutting the worn copperplates of Bocchi's volume. It seems likely then that he would also cut a new plate of the *Skull of an Ox* to replace the earlier unusable woodblock.

1 See cat. no. 40 for a refutation of Malvasia's early dating of the *santini* series.

2 Malvasia, p. 84: "Nel bel libro de' Simbolo Bocchiani a spese della Compagnia de'Stampatori di Bologna ristampati del 1574. il primo simbolo del teschio di bue scarnato, coronato di alloro e ornato da due martelli dalle parti cadenti; quale nella prima stampa era in legno, e ritocchi molti di que' simboli già logori." Bodmer questioned the print, and Petrucci rejected it.

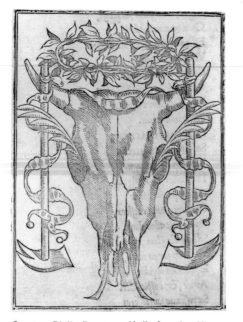

fig. 1a Giulio Bonasone, *Skull of an Ox.* Vienna,
Graphische Sammlung Albertina

LIB. I.

VICTORIA EX LABORE

HONESTA, ET VTILIS.

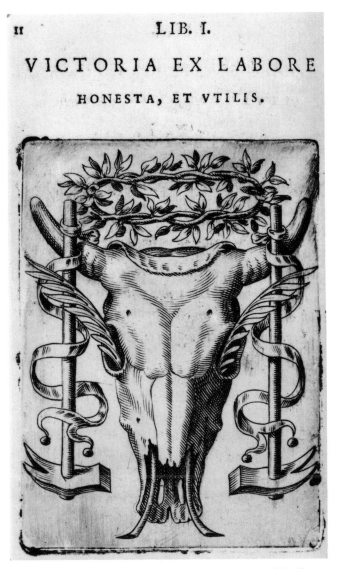

cat. no. 1, only state. Rare Book Division, The New York Public Library, Astor, Lenox and Tilden Foundations

2

Holy Family with Saints Elizabeth, John the Baptist, and Four Angels
(B. 44) c. 1575

Engraving. 228 x 168 mm. (sheet: Berlin)
(Recut plate of an earlier artist)

Literature: Mariette ms. 26; Heinecken p. 631, no. 2; Mariette, III, 78; Nagler I, no. 634; Bodmer 1935, p. 125; Bodmer 1940, p. 71; Petrucci p. 132; Calvesi/Casale 1; Ostrow 1.

States:

	B	CC	Ost
I	1	1	1

Lower margin: VIRGO DECVS *Generis TV. LVS. Spes. Gloria/Nostri Ecce Parens Hominis Est Deus; Ipsa Dei: Bonnonia Anno* MDLXX (Alb) (This state is not by Agostino.)

II	2	2	2

Lower left: AG.C. Plate recut; inscription omitted (plate cut to exclude margin) (Alb, Ber, BM, BN, Dres, MMA, and others).

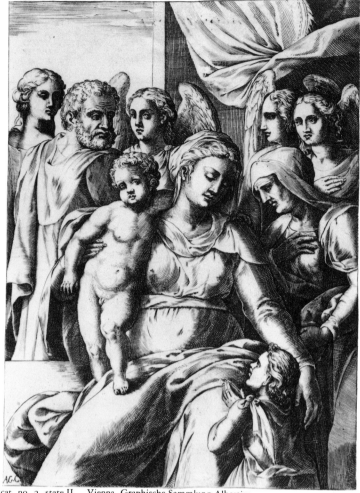

cat. no. 2, state II. Vienna, Graphische Sammlung Albertina

The print has been rejected by both Bodmer and Heinecken, but wholeheartedly accepted by Bartsch, Petrucci, and Calvesi/Casale as Agostino's first print, signed and dated 1570. Moreover, they believed the work to be after Andrea del Sarto. The original composition, however, appears Bolognese and not Florentine. Ostrow wisely noted that the second state of the print has been entirely recut, that the date is omitted, and that it is signed for the first time with Agostino's initials. He tentatively dated the sheet a few years after 1570. A date of c. 1575 does not seem unreasonable if one compares the youthful groping of the burin technique with Agostino's prints of 1576. (cat. nos. 3-4). Moreover, rather than copying other prints, Agostino here reworked an already existing plate, availing himself of the composition in front of him. It is consistent that an artist learning his trade would begin by recutting worn plates. Thus, Agostino took the plate dated 1570 of an earlier, unknown artist, cut off the margin and felt confident enough to add his initials to the reworked composition.[1]

1 A drawing of the *Holy Family with St. Francis* in the Frankfurt Städelisches Kunstinstitut (Inv. no. 588), erroneously attributed to Baldassare Peruzzi, is suspiciously close stylistically to this print. Similar anatomical inaccuracies in shoulders and in the baby occur in both. The style of the drawing points to a Bolognese working in the manner of Lorenzo Sabbattini but without his ability. A similar, or the same, Bolognese artist of little talent could be the original author of this print.

3*

Holy Family
1576

Engraving. 168 x 197 mm. (sheet: Albertina)
(after engraving by school of Marcantonio
Raimondi: Bartsch XIV, 67.60)

Literature: Ostrow 8; Bertelà suppl. 758.

States:

	Ost
I	I

Lower left, next to Madonna's skirt: ·*Re*·/*1576*/
·*AG·C* (Alb, Bo)

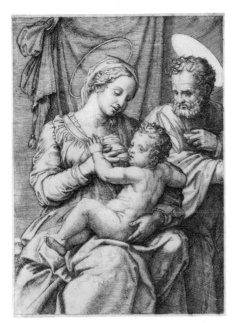

fig. 3a. School of Marcantonio Raimondi, *Holy Family*. London, The British Museum

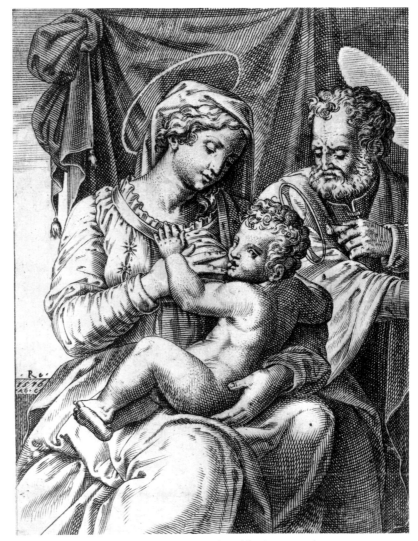

cat. no. 3, only state. Vienna, Graphische Sammlung Albertina

Ostrow believed this rare print to be Agostino's first signed nonreproductive work. Bertelà, on the other hand, doubted the work, citing that the handling was too mature for Agostino of this early period. She suggested that perhaps it was reproductive in nature, which would explain the security with which Agostino engraved it. The print is in fact a reproductive sheet after a work by the school of Marcantonio Raimondi (fig. 3a). Agostino tried to capture the original without imbuing the new print with his own personality; however, if one compares the sheet with his other dated work of 1576 (cat. no. 4), one sees that Agostino's typical morphological characteristics are already evident. The sweetened expression of the Madonna could be taken from the same model (cat. no. 4), rather than from works by diverse artists. The "Re" of the signature could refer to Raimondi, thus acknowledging the inventor of the composition.[1]

1 There is a poorly drawn copy of the composition in Bologna by an anonymous artist (Inv. no. 1722), 158 x 115 mm. Pen and brown ink and wash. Squared in black chalk. Indented. A note on the mat by Philip Pouncey suggests the connection with a Marcantonio print. Another note states that Malagussi attributed it to Prospero Fontana.

4

Holy Family with Saints Catherine of Alexandria and John the Baptist
(B. 94) 1576

Engraving. 174 x 133 mm. (sheet: Albertina)
(after Giovanni Battista Ramenghi, called
Bagnacavallo)

Literature: Malvasia p. 80; Oretti pp. 817-818;
Heinecken p. 632, no. 13; Bolognini Amorini
p. 57; LeBlanc 31; Nagler 1835, p. 397;
Nagler I, no. 653; Bodmer 1939, p. 124; Petrucci p. 133; *Mostra-Dipinti* p. 67; Ostrow 7.

States:

I

Lower left on pedestal: *Agusti. Cre./fe.* Lower
right: *gioá batista bgna cavalo/inv.* Lower right:
BONA/*1576.* (Alb)

Copies: 1. Unfinished engraving in reverse.
147 x 128 mm. (sheet: Parma).

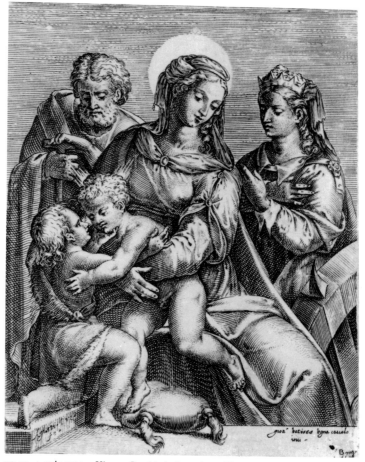

cat. no. 4, only state. Vienna, Graphische Sammlung Albertina

The only extant impression of this print is in the Albertina. It has been accepted by all the critics who noted it, although erroneously dated 1578 by Petrucci. The work by Bagnacavallo from which the print derives is at this time unknown. Bartsch noted the signature: "Agusti. Cre./fe." and suggested that Agostino was probably traveling in Cremona at this time. On the contrary, on two early works, Agostino used a signature which referred to his Cremonese background.[1] Stylistically and in the burin technique, the print is similar to cat. no. 3. At this early date, Agostino had not as yet discovered the possibilities inherent in Cornelis Cort's use of the swelling line. Instead, each figure, simply delineated, is defined by a method of straight hatching and crosshatching, broken only by the use of dots to add some shading to those areas more in the light. At this period in the artist's career, there is little perception of the volumetric forms of the figures; this style is basically an outgrowth of Marcantonio Raimondi's. Between the *Holy Family with Saints Catherine of Alexandria and John the Baptist* and the next signed works of 1579, Agostino learned to represent his figures convincingly within a spatial environment. This knowledge and ability probably was acquired during his apprenticeship with Domenico Tibaldi.[2]

1 See also cat. no. 34. See Introduction for a discussion of the Carracci background.

2 See Introduction for a discussion of Agostino's involvement with Domenico Tibaldi's work.

5-8

Four Female Saints
c. 1576-1578

This series of four standing female saints was attributed to Agostino Carracci by Heinecken and Bodmer but ignored by the other sources, possibly because of the rarity of the prints, which are found solely in the print cabinet in Dresden. The prints are not signed in the plate but have been attributed to Agostino by an inscription in ink by an old hand. Morphologically similar to later prints by Agostino (cat nos. 50-53), these show that the use of bowed lips and sweetened expressions, typical of Agostino's female figures, is already in evidence at this early date. The burin technique is simple and regular and without much advancement over the dated works of 1576 (cat. nos. 3-4). Bodmer rightly dated this series very early in Agostino's career, and the influence of Marcantonio's style of engraving is apparent here as in his previous prints. Agostino must have been looking at prints of standing saints by Marcantonio and his school in which the burin is used merely to delineate the subject and not to enhance the surface quality of the engraving.[1] Agostino moved away from this type of objective representation after his apprenticeship with Domenico Tibaldi and his appreciation of Cornelis Cort's engravings.

The rarity of these prints could be the result of several factors: 1) that they were devotional images and therefore used in homes and destroyed or 2) very few impressions were taken. One would tend to accept the latter hypothesis as the prints vary in quality and may not have enjoyed enough success to warrant a large edition. The *Saint Catherine* (cat. no. 5) is lively in movement and expression whereas the *Saint Margaret* (cat. no. 8) is flat and awkward. Although the figures themselves depend on prints by Marcantonio and his circle, the background landscapes which have been hastily outlined are already reminiscent of some of Cort's backgrounds.

1 See Marcantonio's print of St. Catherine (Bartsch XIV, 101.115) and especially the three saints (Lucy, Catherine, and Barbara) on one sheet (Bartsch XIV, 107-108.120). Bodmer probably noticed the same influence when he indicated an influence of the High Renaissance on the sheets.

5

Saint Catherine

1576-1578

Engraving. 192 x 131 mm. (sheet: Dresden)

Literature: Heinecken p. 634, no. 63; Bodmer
1939, p. 124.

States:
I As reproduced. No inscriptions.
(Dres)

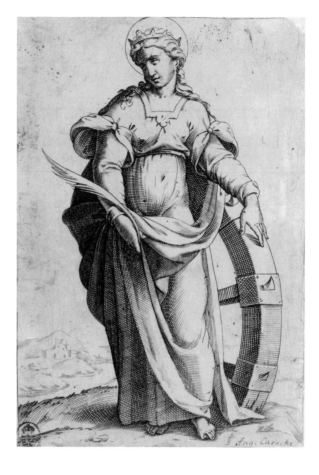

cat. no. 5, only state. Dresden, Staatlichen Kunst
sammlungen, Kupferstichk abinett

6

Saint Lucy

1576-1578

Engraving. 220 x 152 mm. (sheet: Dresden)

Literature: Heinecken p. 634, no. 70; Bodmer
1939, p. 124.

States:
I Lower center: *S. Lutia* (Dres)

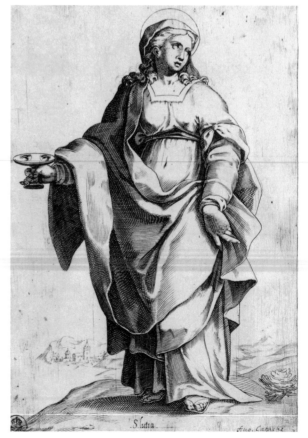

cat. no. 6, only state. Dresden, Staatlichen Kunst-
sammlungen, Kupferstichk abinett

7

Saint Agatha

1576-1578

Engraving: 204 x 135 mm. (sheet: Dresden)

Literature: Heinecken p. 637, no. 75; Bodmer 1939, p. 124.

States:

I As reproduced. No inscriptions.
(Dres)

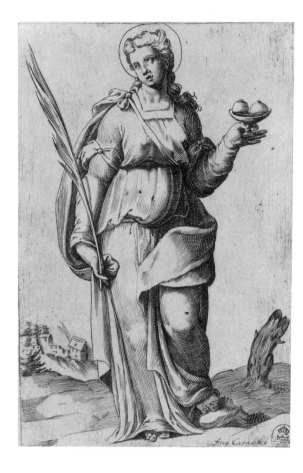

cat. no. 7, only state. Dresden, Staatlichen Kunst-sammlungen, Kupferstich abinett

8

Saint Margaret

1576-1578

Engraving. 202 x 147 mm. (sheet: Dresden)

Literature: Heinecken p. 637, no. 73; Bodmer 1939, p. 124.

States:

I As reproduced. No inscriptions. (Dres)

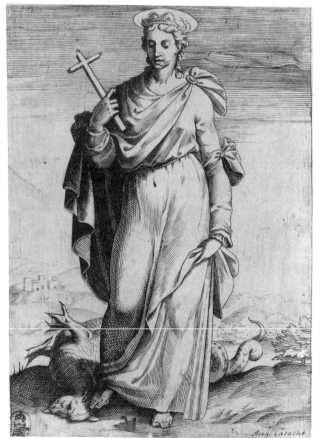

cat. no. 8, only state. Dresden, Staatlichen Kunst-sammlungen, Kupferstichkabinett

9*

Pietà
(B. 104) 1579

Engraving. 449 x 304 mm. (sheet: Albertina)
(after graphic copy of Michelangelo sculpture in
Vatican)

Literature: Heinecken p. 631, no. 26; Gori
Gandellini p. 318, no. XIV; Joubert p. 347;
Nagler I, no. 603; Nagler 1835, p. 397;
LeBlanc 53; Bodmer 1939, p. 132; Petrucci
pp. 133-134; *Mostra-Dipinti* p. 71; Calvesi/
Casale 8; Ostrow 12; Boschloo pp. 13, 181,
note 12.

States:

	B	CC	Ost
I	I	I	I

Under mantle of Virgin at left: *AC. f.* On rock
at lower left: *Michel angelo/Bonarotti/inven:/
1579.* In the margin: P/PET/III. CHRISTVS
SEMEL PRO PECCATIS NOSTRIS MORTVVS EST.
(Alb, Ham, U)

Since there are few surviving examples of this print, in rather poor condition, either it must have been very popular during the late sixteenth century or very few impressions were taken. The technical mastery evident in this engraving indicates how far Agostino had advanced from his signed prints of 1576. Unfortunately, there are no extant dated sheets of the years between to follow his progress.

Petrucci suggested that Agostino had taken a Roman trip in 1579 in order to produce this print as well as the following engraving (cat. no. 10), also after Michelangelo. Ostrow rejected the theory on the basis that Agostino must instead have copied Giulio Bonasone's print of the same subject (Bartsch XV, 123.53).[1] The difference in concept between the two prints is so vast as to preclude Agostino's having copied the Bonasone print. Michelangelo's *Pietà* was copied in prints and drawings so frequently, however, that there may be a lost source for Agostino's copy.[2] The print has more relation to a linear rather than a sculptural model, so that we may assume that Agostino had a graphic source from which to work. Moreover, at the age of twenty-two, he had not yet produced any nonreproductive prints. His first secure nonreproductive engraving[3] comes from the year 1581 (cat. no. 21) and shows that the artist was not as yet capable of translating a sculptural idea into a graphic medium without an intermediary graphic source. Thus, Agostino probably did not need to travel to Rome to produce this print. His other work after Michelangelo (cat. no. 10) also follows a graphic source.[4]

1 Nagler, who doubted the authorship of Agostino, also said the Bonasone was the original from which it was copied.

2 Other prints after Michelangelo's *Pietà* include ones by Adamo Mantovano, G. B. dei Cavalieri and others. See Petrucci p. 142, note 12.

3 It is not secure that cat. nos. 5-8 are nonreproductive in nature.

4 Boschloo pointed out the influence of the figure of Christ on Annibale's 1585 painting of the *Pietà* (Posner 24a) in the Galleria Nazionale, Parma. For a further discussion of this, see cat. no. 105.

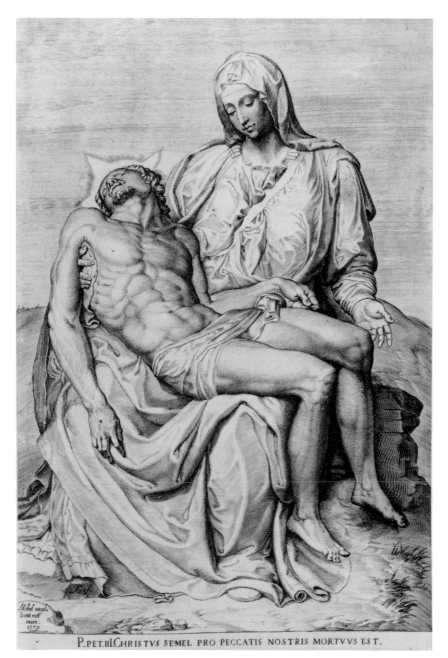

P.PET.III.CHRISTVS SEMEL PRO PECCATIS NOSTRIS MORTVVS EST.

cat. no. 9, only state. Vienna, Graphische Sammlung Albertina

I0

Mater Dolorosa
(B. 103) 1579

Engraving. 411 x 287 mm. (after Michelangelo drawing in the Isabella Stewart Gardner Museum in Boston, through intermediary Giulio Bonasone engraving: Bartsch XV, 127.64)

Literature: Heinecken p. 631, no. 27; LeBlanc 52; Nagler 1835, p. 397; Nagler I, no. 273; Bodmer 1939, p. 132; Petrucci p. 133-134; *Mostra-Dipinti* p. 71; Calvesi/Casale 7; Ostrow 13.

States:

	B	CC	Ost	
–		–	I	–

Before Letters.

	–	–	I

Lower left: MICHEL ANGELO/BONAROTI. IN. Toward bottom left: *1579.* On cross: TORCULAR CALCAVI SOLUS. ISA. LXIII.

I		I	2	2

As above with the addition of AC at right. (Alb, Br, Dres, U, and others)

The author has not found a state of this print before letters, as noted by Calvesi/Casale, or one without the monogram of Agostino Carracci, as mentioned by Ostrow. Petrucci suggested (as with cat. no. 9) that Agostino was in Rome in 1579 to copy a drawing by Michelangelo of this subject, which may be the one now in Boston (fig. 10a).[1] Calvesi/Casale suggested that Agostino used an original drawing for his source as had other printmakers before him.[2] Ostrow correctly believed, however, that Agostino's direct source was the Bonasone print of 1546 (fig. 10b) and not Michelangelo's drawing. The hillock on which the action takes place is similar in both, and the shading and hatching in Agostino's print come directly from that of Giulio Bonasone. Agostino did change the shape of the cross and added his typically Cort-inspired landscape and town in the background.[3] In both this and the previous print, Agostino's burin technique, influenced by his teacher Domenico Tibaldi, is clearly evident. The very closely spaced hatching and the delicate burin strokes as well as the use of numerous dots to contrast with the linear system are characteristics of Tibaldi's works and of Agostino's of this early period.[4]

1 Isabella Stewart Gardner Museum. Inv. no. B 1429.

2 Other versions of the subject are by Beatrizet in 1547 (Bartsch XV, 251.25) and Bonasone (Bartsch XV, 127.64).

3 See discussion of Cort's influence on Agostino in the Introduction.

4 See, e.g., figs. D, G, H, I and cat. nos. R54-R59 by Tibaldi.

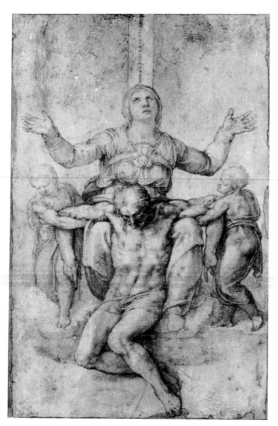

fig. 10a. Michelangelo, *Virgin Seated at the Foot of the Cross with Dead Christ and Two Angels.* Boston, Isabella Stewart Gardner Museum

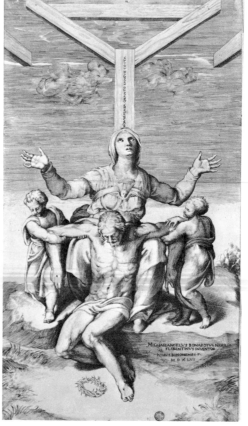

fig. 10b. Giulio Bonasone, *Virgin Seated at the Foot of the Cross with the Dead Christ and Two Angels.* London, The British Museum

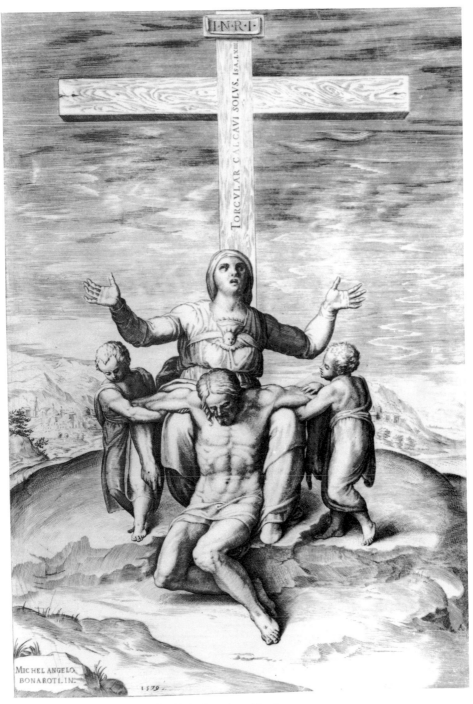

cat. no. 10, only state. Vienna, Graphische Sammlung Albertina

II

Allegory of the Psalm of David (B. 5) 1579

Engraving. 266 x 210 mm. (sheet:MMA) (after Orazio Sammacchini drawing in the Albertina)

Literature: Malvasia pp. 78, 270; Oretti p. 805; Heinecken p. 640, no. 1; Bolognini Amorini p. 56; Nagler 1835, p. 394; LeBlanc 7; Nagler II, no. 1871; Bodmer 1939, p. 133; Calvesi/Casale 13; Ostrow 11, Bertelà 143.

States:

	B	CC	Ost
I	1	1	1

On base at left: *1579*. At base at right: *A.F.* in reverse. In margin: MISERICORDIA ET VERITAS OBIAVERVNT SIBI IVSTITIA ET PAX OSCVLATÆ SVNT *David psal. 84.* (Alb)

	B	CC	Ost
II	2	2	2

1579 has been changed to *1580* and HORATII SAMACHINI IN. has been added to step at right. (Alb, Ber, Bo, BM, Dres, Ham)

Copies: 1. Engraving in same direction. At right on step: HORATII SAMAC M IN. In margin: MISERICORDIA ETVERITAS OBIAVERVNT SIBI IVSTITIA ET PAX OSCVLATÆ SVT *Davit psal. 8* [on side] *z.* Very deceptive, contemporary 280 x 222 mm. (Par, Ro) 2. Engraving in reverse by Theodore de Bry. 138 x 138 mm. Circular composition within a decorative circular band within a square format. (MMA). 3. Engraving in the same direction. 282 x 211 (sheet: Ham) Lower right: *Lorenzo: mag: form: floren:* In margin: MISERICORDIÆT VERITAS OBVIAVERVNT SIBI IVSTITIA ET PAX OSCVLATAE SVNT. *Horat. Samach. inv.* (Ham)

The source of this print is an unpublished drawing by Orazio Sammacchini, now in the Albertina (fig. 11a).[1] Ostrow pointed out that the engraving was Agostino's only print of this year after a Bolognese source. He quoted Bodmer's assertion that Agostino removed the "maniera propensities" from Sammacchini. Now that the Sammacchini original is known, it is evident that Agostino did very little to change the volumetric conception of the work but instead copied it as faithfully as possible. As with the two prints after Michelangelo of the same year, Agostino followed Tibaldi's style of engraving, filling up the entire surface with burin work as Tibaldi was prone to do.[2]

1 Inv. no. 2032. 272 x 205 mm. Pen and brown ink and wash over black chalk with white heightening on brown paper. Poor condition. Konrad Oberhuber first attributed the drawing to Sammacchini. Previously it was thought to be a copy of Agostino's engraving.

2 Malvasia incorrectly called the subject of this print Psalm no. 8 verse 11 rather than Psalm 84 verse 11 as noted on the print itself. Bodmer incorrectly identified the print as Bartsch 35 instead of Bartsch 5.

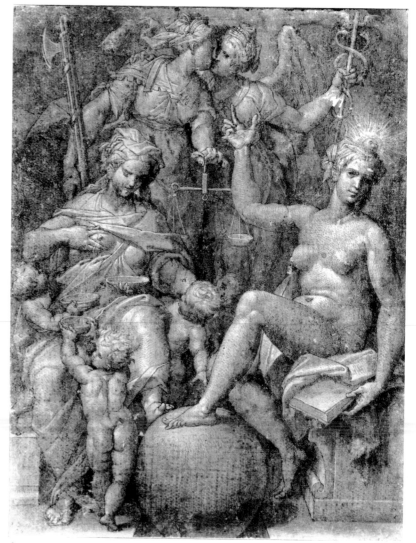

fig. 11a. Orazio Sammacchini, *Allegory of the Psalm of David.* Vienna, Graphische Sammlung Albertina

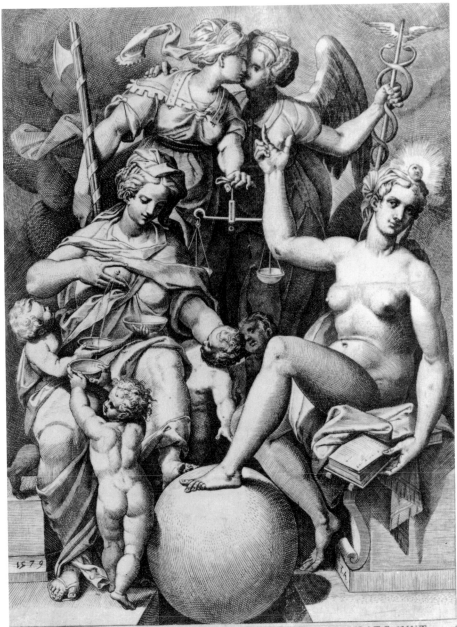

MISERICORDIA ET VERITAS OBIAVERVNT SIBI IVSTITIA ET PAX OSCVLATÆ SVNT Duuet pinx

cat. no. 11, state I. Vienna, Graphische Sammlung Albertina

12

Adoration of the Magi
(B. 11) 1579

Engraving made up of seven sheets. Dimensions of individual plates are 1) lower left: 403 x 531 mm. 2) lower right: 405 x 528 mm. 3) upper left: 330 x 249 mm. 4) upper right: 324 x 247 mm. 5) upper center: 327 x 571 mm. 6) center left: 407 x 533 mm. and 7) center right: 403 x 531 mm. Entire composition measures about 1116 x 1053 mm. (after a drawing by Baldassare Peruzzi in the National Gallery, London)

Literature: Malvasia pp. 74, 267; Oretti pp. 787, 793; Basan p. 110; Strutt p. 180; Heinecken p. 630, no. 10; Gori Gandellini p. 318, no. VII; Bolognini Amorini p. 55; Nagler 1835, p. 393; Nagler I, no. 296(11); Mariette II, 57; Joubert p. 347; LeBlanc 19; Andresen 2; Foratti p. 168; Bodmer 1939, p. 131; Pittaluga p. 343; Disertori p. 262; Petrucci p. 133; Calvesi/Casale 10; Ostrow 10 (with additional bibliography); Cecil Gould, *The Sixteenth-Century Italian Schools, National Gallery Catalogues,* London, 1975, p. 197.

States:

	B	CC	Ost
I	1	1	2

Lower left: *Co' privilegio.* In banner in lower center: *Ill.ᵐᵒ et R.ᵐᵒ D.D. gavrieli paleoto S.R.E. presb. Card./Tituli S. Martini in montibus Episc. Bonon./ac princip Amplissimo Dicatum./1579.* Lower right: *Baldassare Perutio/Sanese Inven.* (Alb)

II	—	—	—

As state I but in banner lower right: BONONIÆ IN ÆDIBVS COMITIS/CONSTANTIS BENTIVOLII/BALTASS. PERVTIVS SENEN. INVENTOR/APVD DOM. TEBALDVM BONONIÆ/PRIMIS FORMIS. (Br)

III	2	2	1

Lower left after *Co' privilegio* is added *Summi Pontificis/et Superior. licentia.* On architrave lower left-center: AVG.ˢ CARICIVS SCVLPSIT. Banner in center has been enlarged. Dedication to Paleotti has been changed to: *Illmᵐᵒ et R.ᵐᵒ D.D. Michaeliangelo Tonto tt. S. Bartholmaei in Insula/S.R.C. Card. Nazareno nuncupato S.D.N. Papae Prodatario.* Added below that is *En (Amplissime Cardinalis) Munusculum, adoratione' Regio Regum Verbo in Nazareth/denominationis tui Cardinalatus Decor) divinitus annunciato, et incarnato, nato autem in/Bethlehem, à tribus illis Regibus exhibitam representans, quod tibi virtutù, et illas colencio/Amatori, et Protetori, qua potest Animi summissione offert, dedicatqe, ac Scipsum dicat/Humillimus eius sertus Philippus Thomassinus Trecensis.* In banner at right, APVD DOM. TEBALDVM BONONIÆ has been charged to APVD PHILIPPVM THOMASSINVM ROMAE. The *Baldas-*

Agostino's engraving reproduces an elaborate composition by Baldassare Peruzzi (1481-1536), a large cartoon (fig. 12a) executed by the latter when he was in Bologna in 1522-1523. Vasari recorded that the drawing was made for Giovanni Battista Bentivoglio, who had a copy made of it in oil by Girolamo da Treviso (active 1524-1544) (fig. 12b).[1] Both works, now in the National Gallery in London, would have been available to Agostino in Bologna in 1579.[2] The drawing, in poor condition, is the direct source for the print and almost of the same size. Slight variations are evident, mainly in the addition to the engraving of the four seated angels and the cherubic heads in the upper corners.

Ostrow confused the states of the print (as is easy to do) and noted that there were nine rather than seven separate plates. He also suggested that Agostino's horizons were widening at this time, as the artist looked away from Bolognese artists toward earlier works produced in Rome. However, Agostino had much earlier been interested in Roman works, as witnessed by his copy of Marcantonio's engraving of the Holy Family (cat. no. 3).[3] It is more likely that Agostino was always interested in a variety of styles.

This was the artist's most ambitious print to date and proves that at this time he had completely mastered the craft of reproductive engraving on a grand scale. The influence of Cort is everywhere evident: in the landscape backgrounds, in the burin technique, and in the flatness of the forms marked by little contrast of light and shade.

Most interesting about the discovery of the unknown second state at Bremen is the inscription of Domenico Tibaldi as publisher of the print. This is the only known instance of Tibaldi signing a print as publisher. It suggests that perhaps he himself first published all of the prints which emerged from his hand and from his workshop during this period. The inscription also gives us definite proof, other than the statements of the early writers, that Agostino worked with Tibaldi. Although one can prove stylistically that Agostino followed Tibaldi's methods of working by comparing Carracci's early prints with those of his master, this provides the proof that there was actually a working relationship between the two men.

1 Giorgio Vasari, *Le Vite de' più Eccellenti Pittori Scultori ed Architettori* edited by Gaetano Milanese, 1878, vol. IV, p. 597. The passage is reprinted in Gould, p. 196.

2 Peruzzi: Inv. no. 167. 1125 x 1070 mm. Pen and brown ink and wash with white heightening over black chalk on paper tinted brown. Laid down. Signed lower right on column: BAL. SENEN·/F. History and bibliography in Gould, pp. 196-197. Girolamo da Treviso: Inv. no. 218. 1442 x 1257 mm. Oil on panel. History and bibliography in Gould, pp. 115-117. Gould ascribed the painting to Girolamo da Treviso but had some question that it was securely his and the painting mentioned by Vasari. Bodmer believed that the present cartoon is a sixteenth-century copy of Girolamo da Treviso's "fresco" in the Palazzo Bentivoglio.

3 Although Peruzzi was Sienese (as Marcantonio was Bolognese), both artists worked mostly in Rome.

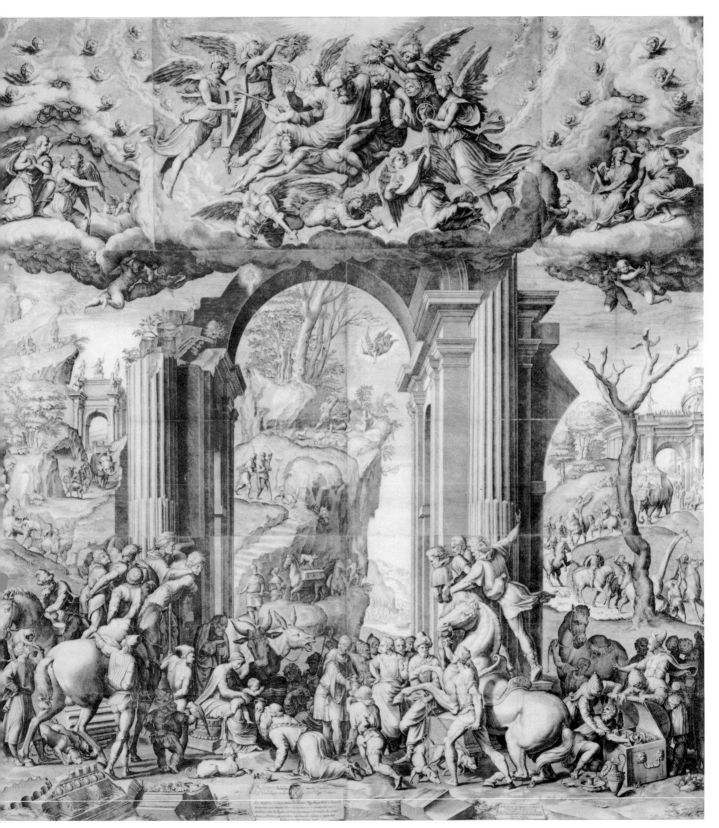

sare Perutio/Sanese Inven. at right has been effaced. (BM, BN, U, Ro, Stu)

— — — 3

As state III but with Peruzzi's name effaced.

IV — — —

On column fragment to left of right banner is added: *In Iacobus. de' Rabiis form. /Roma* (Boston Public Library, Milan: Raccolta delle Stampe).

V — — —

This last effaced and replaced by hatching. Banner at center crossed out. Lower left: *Roma presso la Calcografia Camerale.* (Rome: Calcografia Nazionale)

The plates are extant in the Calcografia Nazionale, Rome. See cat. nos. 13-14.

Copies: 1. Engraving. Seventeenth century, of the figures of the Madonna and Child group. (BN)

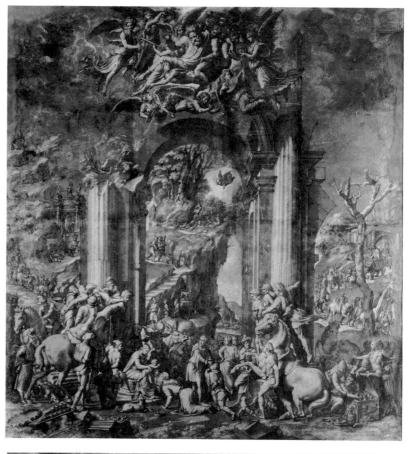

fig. 12a. Baldassare Peruzzi, *Adoration of the Magi.* Reproduced by courtesy of the Trustees, the National Gallery, London

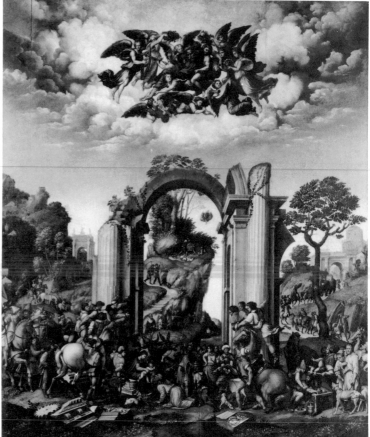

fig. 12b. Girolamo da Treviso, *Adoration of the Magi.* Reproduced by courtesy of the Trustees, the National Gallery, London

13

Various Studies

Engraving. 324 x 247 mm.

Unpublished.

States:

I As reproduced. No inscriptions (Calc. Naz. Rome)

Plate extant in Calcografia Nazionale, Rome (verso of cat. no. 12)

cat. no. 13, only state. Rome, Istituto Nazionale per la Grafica-Calcografia

Impressions from the extant plate in the Calcografia Nazionale were first taken in 1978. As with the versos of other plates by the artist (cat. nos. 134, 199), Agostino here also practiced with the burin before working on the recto of the plate. The face without a hat in this print is that of the turbaned figure facing front to the left of the rearing horse in the lower part of the *Adoration of the Magi* (cat. no. 12). The largest head here is probably a study for the long-bearded magi at the foot of the Madonna and Child in the composition on the recto of the plate. The small beardless turbaned head appears as one of the figures near the horses filing down the hill at the right in the same composition. At this early stage in Agostino's career, he obviously felt it necessary to try the burin before making irreversible lines in the final composition. This accords with Malvasia's view of Agostino as a careful artist who made studies of all parts of his compositions before completing them.[1]

1 Malvasia pp. 346-347 discussed how Agostino used models for parts of the anatomy, in particular.

I4

Various Studies

Engraving. 330 x 249 mm.

Unpublished.

States:

I As reproduced. No inscriptions (Calc. Naz., Rome)

Plate extant in the Calcografia Nazionale, Rome (verso of cat. no. 12).

Impressions from the extant plate in the Calcografia Nazionale were first taken in 1978. This and cat. no. 13 are the only two of the seven extant plates for the *Adoration of the Magi* (cat. no. 12) on which the artist made studies on the versos. The face in the center right is not found in the composition of the Adoration on the recto. Agostino was here mainly working on hands, with which he seems to have had special trouble at this stage.

cat. no. 14, only state. Rome, Istituto Nazionale per la Grafica-Calcografia

15

Madonna and Child Seated on a Crescent Moon

(B. 38) c. 1579

Engraving. 256 x 184 mm. (after Domenico Tibaldi print, cat. no. R 55)

Literature: Bolognini Amorini p. 56; LeBlanc 24; Bodmer 1939, p. 128.

States:

	B
I	—

Lower right: LAV. SAB. (Ham)

II	I

As state I but with AVG. CAR. F. lower edge toward the right. (Alb)

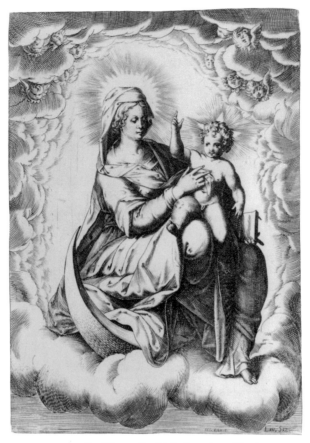

cat. no. 15, state II. Vienna, Graphische Sammlung Albertina

Several problems arise in the attribution of this print: its relationship to a similar print of the same subject (cat. no. R 55) and its connection with a drawing in the same direction in the National Gallery of Canada, attributed to Lorenzo Sabbattini (fig. 15a).[1] This engraving is much closer to the other print, attributed here to Domenico Tibaldi, than it is to the Sabbattini drawing. The light and shade of the print are the same as in Tibaldi's work, and the burin work is a simplified version of that engraving. It differs from the earlier engraving, dated 1575, in several minor aspects, such as the change of the halo around the head of Christ and the addition of the angelic heads in the clouds. The heads do appear in the drawing, however, and one assumes that Agostino must also have known the original composition. The drawing, which is indented for transfer, is closer in dimensions to the Tibaldi print than to Agostino's, suggesting that Tibaldi probably used such a drawing as his source. The facial types of Agostino's print reflect those of Tibaldi's engraving rather than those of the drawing by Sabbattini.

The date of c. 1579 for the print reflects a time in which it is certain that Agostino worked with Tibaldi.[2] Stylistically, however, the print could have been done any time between 1576 and 1579.[3]

fig. 15a. Lorenzo Sabbattini, *Madonna and Child Seated on a Crescent Moon.* Ottawa, The National Gallery of Canada

1 Inv. no. 293. 388 x 262 mm. Pen and brown ink and brown wash over black chalk on buff paper, heightened with white, outlines indented for transfer. Discussed in A. E. Popham and K. M. Fenwick, *European Drawings (and two Asian Drawings) in the Collection of the National Gallery of Canada* (Ottawa, 1965), 32-33, cat. no. 42.

2 See cat. no. 12.

3 Bodmer dated it 1578.

16

Rest on the Flight into Egypt
(B. 99) c. 1579

Engraving. 476 x 323 mm. (after Giorgio
Ghisi's 1578 engraving after Giulio Campi,
Bartsch XV, 385.4)

Literature: Heinecken p. 632, no. 3; LeBlanc
37; Bodmer 1939, p. 135.

States:

	B
I	1
Before letters (Alb)	
II	2
Lower left: *Donati Rasicoti form.* (Ber)	
III	—
Lower center: *in Bassano per il Remodini. 1492.*	
Very weak. (Par, Ro)	

This rare engraving reproduces rather faithfully a Giorgio Ghisi print after Giulio Campi (fig. 16a).[1] Although at first one may tend to reject the print on the basis of the extreme use of curvilinear rhythms rare in Agostino's work, after comparison with the Ghisi original, it is obvious that Agostino straightened many of the curves and eliminated the fussiness of detail apparent in Ghisi's work. Changes occur in the simplification of the background, in the negation of the curlicues of the hair, and in the broadening of the burin technique. Agostino, either consciously or unconsciously, classicized a mannered composition by simplifying its forms. This became a characteristic of the artist's working style in the following decade (see, e.g., cat. nos. 98-107).

Agostino's interest in Ghisi may have come through contact with the artist, since Ghisi (1520/21-1582), a Mantuan, after working in Antwerp in the 1550s, spent most of his life in his native city.[2] Ghisi's print is dated 1578; thus a date of 1579 for the present engraving would be fitting, assuming the Ghisi composition was available immediately after its publication. Moreover, the closely spaced parallel hatching of Agostino's print still reflects the influence of his teacher Domenico Tibaldi.[3]

1 Ghisi's print is inscribed IVLIVS CAMPVS/ CREMONENSIS/ IN.

2 For a discussion of Ghisi and his importance in the late sixteenth century in Flanders and Italy, see Timothy Riggs, *Hieronymous Cock Printmaker and Publisher in Antwerp,* Yale dissertation, 1971 (New York and London: Garland Publishing, 1977).

3 Nancy Ward Neilson noted a small painting in the Tiroler Landesmuseum after the print, attributed to Giulio Campi.

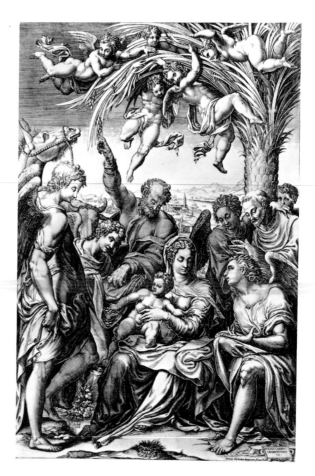

fig. 16a. Giorgio Ghisi, *Rest on the Flight into Egypt.*
Vienna, Graphische Sammlung Albertina

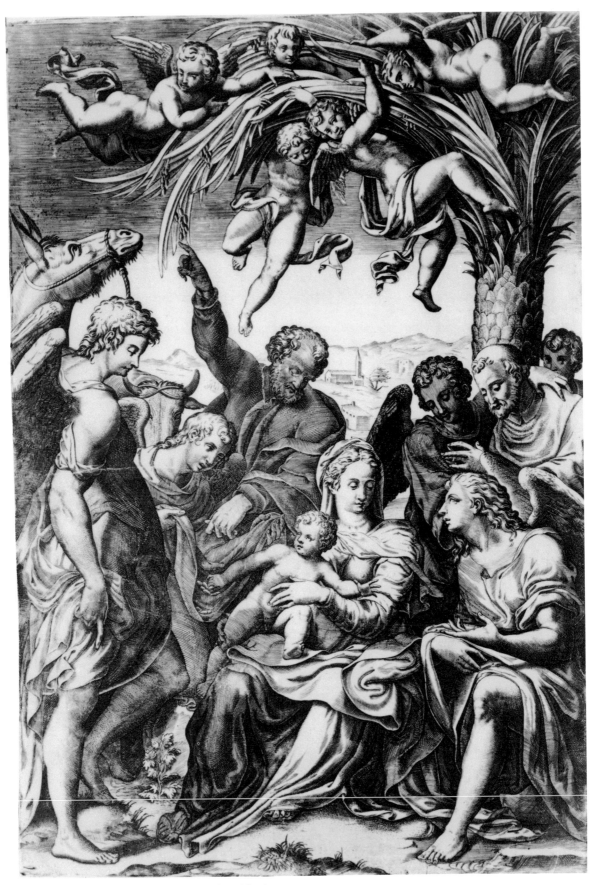

cat. no. 16, state I. Vienna, Graphische Sammlung Albertina

95 AGOSTINO

17

Saint Roch
(B. 87) 1580

Engraving. 352 x 247 mm. (after Cornelis Cort engraving after Hans Speckaert: Bierens de Haan 146)

Literature: Malvasia p. 77; Oretti p. 799; Mariette ms. II, 80; Heinecken p. 636, no. 55; Nagler 1835, p. 397; LeBlanc 73; Mariette III, 130; Foratti p. 168; Bodmer 1939, pp. 133-134; Calvesi/Casale 22; Ostrow 15; Bertelà 205.

States:

	B	CC	Ost
I	1	—	1

Lower left: *1580.* In margin: *Qui morbos ope dive fugas et corpora sanas Pelle animis pestes hoc opis esto tuae* (Alb, Ber, BN)

	B	CC	Ost
II	—	1	2

As in state I, plus *Donati Rasicoti form.* after *1580* (Alb, Bo, Ham, Dres, Milan: Raccolta delle Stampe, MMA)

	B	CC	Ost
III	—	2	3

F. Fracia iv. added after *Donati Rasicoti form.* (not found)

	B	CC	Ost
IV	—	—	—

Lower left: *AC.* Lower right in margin *in Bassano per il Remondini 32* (Milan: Raccolta delle Stampe) Weak.

	B	CC	Ost
V	—	—	—

In Venetia à S.ᵀᴬ Fosca replaces *1580 Donati Rasicoti form.* (Alb, Frankfurt)

	B	CC	Ost
VI	—	—	—

Publishers and date hatched out. Extremely weak. (Stu)

Malvasia believed this engraving to be a copy of Francesco Francia's painting in the Church of S. Giuseppe fuori Porta Saragozza in Bologna, but it is in fact (as observed by Nagler and Bierens de Haan) a copy in reverse of Cornelis Cort's 1577 engraving after Hans Speckaert (fig. 17a).[1] The figure of the saint comes directly from the Cort engraving, but the landscape and dog have been altered. Cort's dog appears rather confusing to the eye, sitting behind the saint's legs. Agostino separated the dog from the saint, giving each a rational place in space. The landscape behind the saint (in the Cort work nonexistent) has been developed in the latter engraving. This is the first dated instance in which Agostino copied a print by Cort. It is obvious that in Agostino's *Adoration of the Magi* (cat. no. 12) Cort's style was already having an influence on him, but after 1580 Carracci set out to emulate consciously the Flemish artist's technique and style by copying his engravings.

The *Saint Roch* forms a pendant with the engraving *Saint Sebastian* (cat. no. 18), similar in dimensions, composition, and date. With these prints Agostino launched his career as an engraver of monumental figures. Stylistically, the prints compare well with such engravings as the two *Christ and the Samaritan Woman* (cat. nos. 20-21), of the same period.

In early impressions of this print, one can see that Agostino had considered placing the dog to St. Roch's left: *pentimenti* of an animal's head are still visible.

·1　The third state of the print carries the attribution of the invention of the composition to *F. Francia.* The original composition by Hans Speckaert is unknown. The Cort print (217 x 131 mm.) is signed *Iohannes Spekart in C. cort f 1577.* Verses in margin are same as this print. Bierens de Haan assumed Malvasia right in saying that the original composition was indeed by Francesco Francia. Unfortunately, the Francia painting in Bologna is no longer extant.

Another copy of Cort's print is by Sadeler: 200 x 132 mm. (sheet: NYPL) and is signed: *J. Sadeler excudit*/IANNES·SPECKART. ÎVETOR.

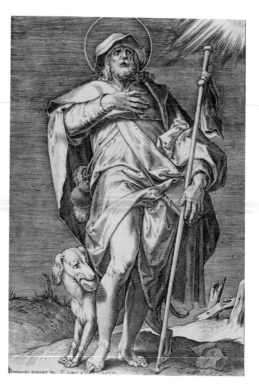

fig. 17a. Cornelis Cort, *Saint Roch.* Paris, Bibliothèque Nationale

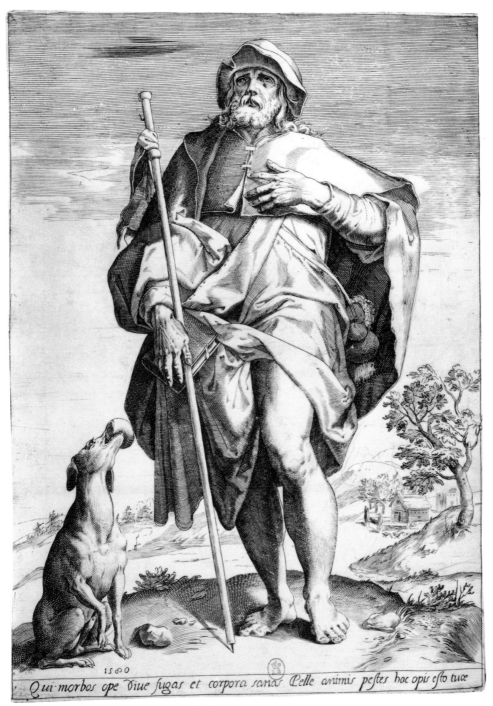

Qui morbos ope diue fugas et corpora sanas Pelle animis pestes hoc opis esto tuæ

cat. no. 17, state I. Paris, Bibliothèque Nationale

18

Saint Sebastian
(B. 88) 1580

Engraving. 355 x 247 mm. (after Francesco
Francia painting formerly in S. Giuseppe fuori
Porta Saragozza, Bologna)

Literature: Malvasia p. 77; Oretti p. 799;
Heinecken p. 635, no. 53; Gori Gandellini
p. 319, no. XXX; Bolognini Amorini p. 56;
Mariette II, 86 and Mariette III, p. 129;
LeBlanc 74; Foratti p. 168; Bodmer 1939,
pp. 133-134; Calvesi/Casale 21; Ostrow 16;
Bertelà 206.

States:

	B	CC	Ost
I	I	I	I

In banner lower left: *1580* (Alb, BM,
BN, Bo, Br, Dres, MMA, Ro, and others)

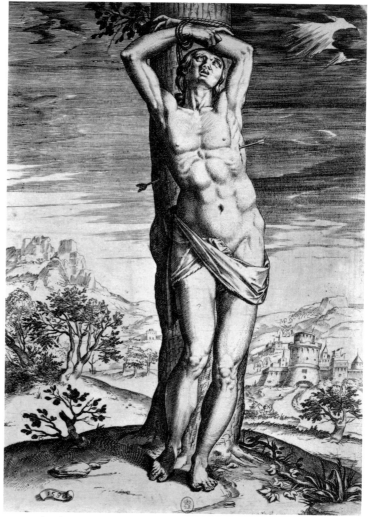

cat. no. 18, only state. Paris, Bibliothèque Nationale

The painting by Francesco Francia which this print supposedly repro-
duces was recorded by Malvasia as being in S. Giuseppe fuori Porta
Saragozza in Bologna in 1686. It was still recorded in the church in
1792 but has since been lost.[1] Like its pendant *Saint Roch* (cat. no. 17),
this engraving was influenced by the style of Cornelis Cort, especially in
the calligraphic rendering of the background landscape. For the first
time Agostino tried to render volume by the Cort method of a swelling
burin line. The crosshatching to the left of Saint Sebastian's right foot
was an early attempt by Agostino to express plasticity and movement by
optical illusion in the variation of the size of his burin lines. Later Agos-
tino fully exploited this technique to express his virtuosity with the
burin.[2]

 Although influenced by Cort, Agostino here expressed the in-
dividuality which would mark most of his mature prints by emphasizing
the strong contrasts of light and shade instead of reducing the atmos-
phere to an overall neutral tone. In his reproductive prints of this period,
Agostino experimented with these contrasts while retaining the delicate
burin technique acquired from his teacher Domenico Tibaldi.

1 Malvasia 1686 (1969 edition), p. 339.

2 See, e.g., his print after Vanni of *Saint Jerome* of 1595 (cat. no. 205).

19

The Parable of the Devil Sowing Tares in the Field
(B. 28) c. 1580

Engraving. 192 x 265 mm.

Literature: Heinecken p. 630, no. 14; LeBlanc 42; Nagler 1835, p. 395; Nagler I, 273; Bodmer 1939, p. 130.

States:

	B
I	1

Lower right in scroll: *AC* (Alb)

II	2

Plate broken vertically in center (Alb, Ber, BN, Br, Dres)

The inscription "AC" on this print indicates that the sheet is by Agostino, and stylistically it is close to other works of this period attributed to him. The landscape is similar to the backgrounds of both *Saint Roch* and *Saint Sebastian* (cat. nos. 17-18), and the shapes of the trees and the foliage compare favorably with the signed and dated print of this year, *Christ and the Samaritan Woman* (cat. no. 21). As with the other prints from the period when Agostino worked with Domenico Tibaldi, the influence of Cornelis Cort's burin technique is apparent.[1]

1 See especially the calligraphic strokes used in the landscape and the slightly curved parallel hatching for the foliage of the trees. Compare, e.g., Cort's *Saint Peter Walking on Water* after Muziano (Bierens de Haan, cat. no. 59, fig. 16). The parable comes from Matthew 13:24-30, 36-43.

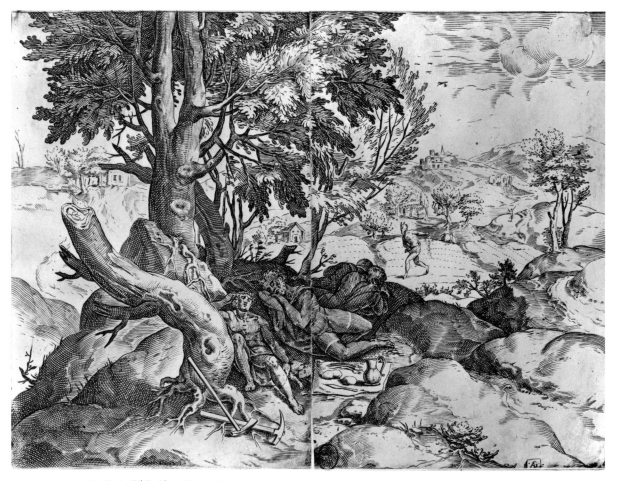

cat. no. 19, state II. Paris, Bibliothèque Nationale

20

Christ and the Samaritan Woman
(B. 27) c. 1579-1581

Engraving. 359 x 460 mm. (after Cornelis Cort engraving after Federico Zuccaro: Bierens de Haan 75)

Literature: Mariette ms. 11; Heinecken p. 630, no. 16; Nagler 1835, p. 395; Mariette II, 9, 11; LeBlanc 41; Petrucci p. 142, note 19; Calvesi/Casale 19.

States:

	B	CC
I	–	–

Before letters (Alb)

	B	CC
II	1	1

Lower right: *Donati Rasicoti form.* (BN, Br, Ro)

This engraving reproduces in reverse Cornelis Cort's print dated 1568 (fig. 20a).[1] Agostino was the second artist to copy this engraving in reverse; Girolamo Olgiati had signed a copy dated 1570 (fig. 20b).[2] Unlike Olgiati's dramatic rendering, Agostino's copy is imbued more with his own personality than that of Cort. He changed several things from the original; e.g., the Samaritan's hand is seen pointing rather than supplicating, and the sky has become more animated. The figures are given more depth and plasticity, while the general composition remains unchanged. More contrast of light and dark emerges, and forms become more distinct from each other, because more of the white of the paper is visible.

Heinecken was the only writer to reject this print, but with little reason. By this period, Agostino's reproductive engravings became more individual and his ability to shape a composition and distinguish forms is apparent. The confusion of the forms in Cort's and Olgiati's prints is negated by the simplification of detail and by the increased size of the format.

1 The Cort print measures 233 x 312 mm., much smaller than Agostino's. Carracci attempted to monumentalize the work by increasing its size. Cort's work is inscribed: *C. Cort. f.,* lower left, and *1568.*

2 The Olgiati print comes close in size to Cort's: 221 x 305 mm. It is inscribed lower right: *Girolamo Olgia/ F./ 1570.*

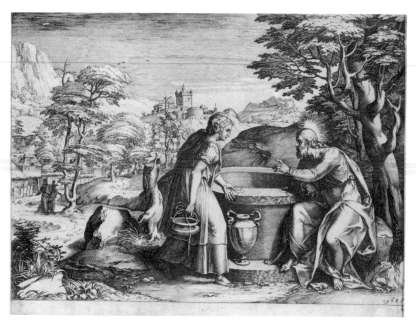

fig. 20a Cornelis Cort, *Christ and the Samaritan Woman.* Courtesy Museum of Fine Arts, Boston. Harvey D. Parker Collection

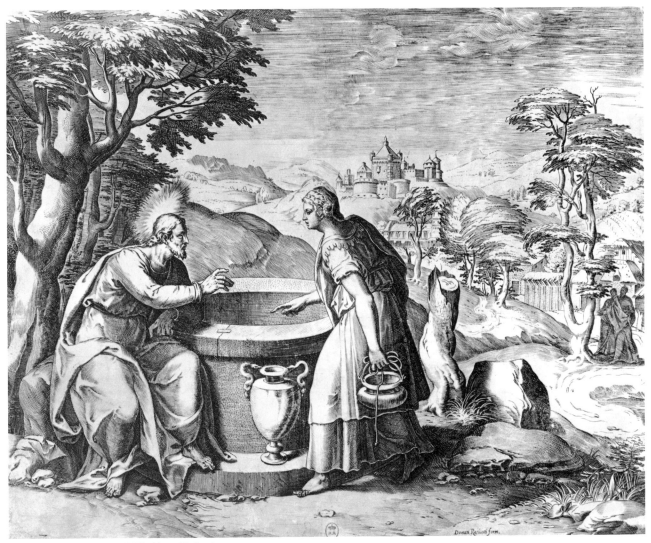

cat. no. 20, state II. Paris, Bibliothèque Nationale

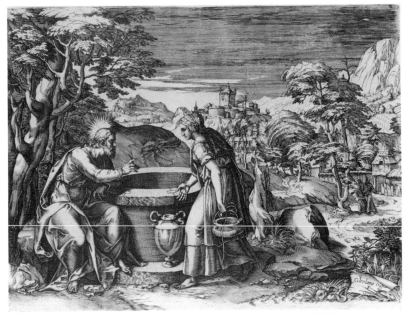

fig. 20b. Girolamo Olgiati, *Christ and the Samaritan Woman*. Berlin (Dahlem),
Staatliche Museen Preussischer Kulturbesitz, Kupferstichkabinett.

21*

Christic and the Samaritan Woman
(B. 26) 1580

Engraving. 245 x 326 mm.

Literature: Mariette ms. 9; Heinecken p. 630, no. 15; Gori Gandellini p. 314, no. XXI; Joubert p. 344; Nagler 1835, p. 395; LeBlanc 40; Bodmer 1939, p. 134; *Mostra-Dipinti* p. 72; Calvesi/Casale 20; Ostrow 14; Posner, under no. 144; Bertelà 155.

States:

	B	CC	Ost
I	1	1	1

Lower right: *Augustinus de Caratijs/Inventor et Incidit Bon./1580.*[1] (Alb, BMFA, BN, Br, Bo, Dres, MMA, and others)

	B	CC	Ost
–	–	–	2

Lower left: *Cietro Bertelli.*

	B	CC	Ost
II	2	–	–

Lower left: *Pietro Bertelli for.* (BN, Br, and others)

	B	CC	Ost
III	–	–	–

Added to right of publisher's address of state II: *in Bassano per il Remondini.* (Dres, Fitzwilliam Museum, Philadelphia)

	B	CC	Ost
IV	–	–	–

The address of state III burnished out. (Par)

This is Agostino's first signed and dated nonreproductive print, but although it is an original composition, it depends for much of its placement of forms on Agostino's copy of Cornelis Cort's engraving of the same subject (see cat. no. 20). Bodmer suggested that Agostino had copied with variations Olgiati's *Christ and the Samaritan Woman* (fig. 20b), but there is no reason why Agostino would not have gone back directly to Olgiati's and his own source (cat. no. 20)—the Cort print itself (fig. 20a). In fact, the style is still dependent on Cort: the figures of both the Samaritan woman and Christ wear the hardened, contoured drapery so characteristic of Cort's works. Ostrow noted the awkward and frozen figure of the Samaritan woman as an indication of Agostino's "independent style."[2] Although Agostino misjudged the placement of the well in space and tilted the interior too high on the picture plane, and although there is no solid relationship between the foreground figures by the well and the background landscape, he successfully imbued his forms and the landscape with freshness and movement by varying the types of burin strokes employed. Moreover, the flowing lines cascading down the hill to the right of Christ's head[3] tend to emphasize the emotional connection between Christ and the woman at the well.

Calvesi/Casale and Posner remarked that Annibale's painting of c. 1604/1605 of the same subject in the Kunsthistorisches Museum in Vienna was influenced by this engraving.[4] The figure of Christ appears to be copied from Agostino's.

*Engraving in exhibition from the Museum of Fine Arts, Boston, Katherine Eliot Bullard Fund.

1 Heinecken and Gori Gandellini mentioned a state before letters, not found by this writer. Joubert mistook the date for 1586.

2 See Introduction on the "independent style."

3 Perhaps influenced by Olgiati's similar flowing lines.

4 Reproduced Posner, pl. 144.

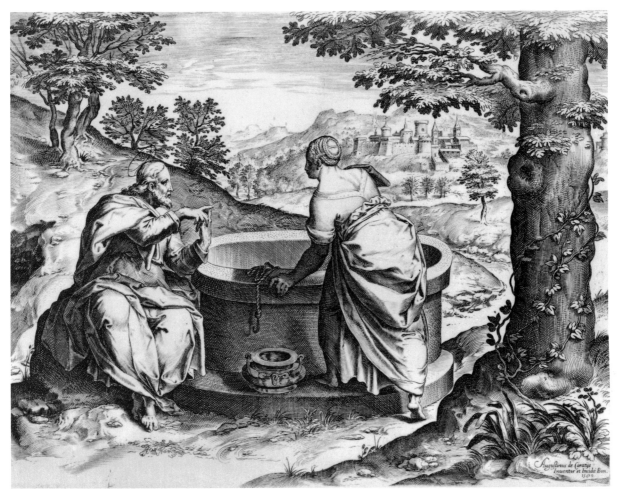

cat. no. 21, state I. Vienna, Graphische Sammlung Albertina

22

Adoration of the Magi
(B. 10) c. 1580

Engraving. 491 x 340 mm. (after Marco del
Moro)

Literature: Heinecken p. 630, no. 11; Gori
Gandellini p. 318, no. VIII; Joubert p. 347;
LeBlanc 18.

States:

	B
I	—

On rock lower right: *Luca Bertelli formis.*[1] (Alb,
Ber, Fitzwilliam Museum)

II	I

As state I but with *Marco dil Moro inventor* bot-
tom right. (Alb, Dres, Ham, MMA)

This engraving, which has been ignored by contemporary sources, was
doubted by Bartsch on the basis of the similarity of manner with cat.
no. 28, which he also doubted. At this period, Agostino's style was
rather stiff, not only in his nonreproductive prints but also in his repro-
ductive sheets. The awkwardness seen here could depend on the lost
source of the engraving. When working with a poorly conceived origi-
nal, Agostino was not always able to improve upon its style.[2] The amus-
ing camels appeared earlier in his 1579 print of the *Adoration of the Magi*
(cat. no. 12), and a similar stiffness was also evident in the *Madonna and
Child Seated on a Crescent Moon* (cat. no. 15), both signed prints.

Besides a stylistic resemblance to other works of this early period,
there is an internal reason for dating the engraving c. 1580. On the
Albertina impression of state I a rather light inscription has been bur-
nished out. The inscription may have read: *Bertellj / formit / 1580.*

1 Heinecken and Gori Gandellini mentioned a state before letters, not found by this
writer.

2 Note the awkward well in *Jacob and Rachel at the Well* in Agostino's print after
Calvaert's drawing in the Louvre (cat. no. 27). The same well appears in the original by
Calvaert (fig. 27a).

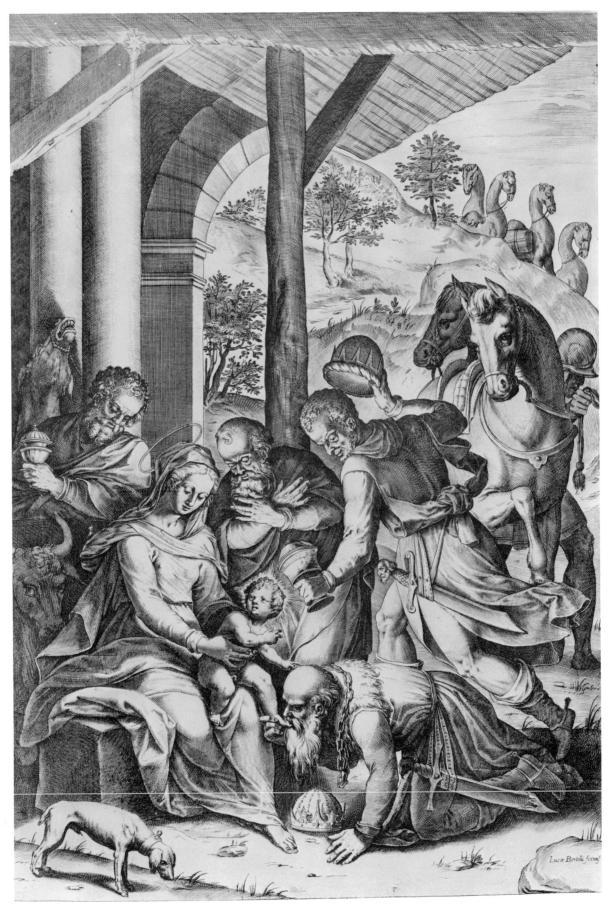

cat. no. 22, state I. Vienna, Graphische Sammlung Albertina

23*

Baptism of Christ
(B. 17) c. 1581

Engraving. 407 x 290 mm. (after Annibale Carracci)

Literature: Heinecken p. 630, no. 13; Nagler 1835, p. 395; Nagler I, no. 1046; Mariette III, 83; LeBlanc 39; Bodmer 1939, p. 130; Calvesi/Casale 23; Bertelà 148.

States:

	B
I	1

On scroll lower right: ANI. IN. (Alb, BN, Bo, Br, Dres, MMA, Par, and others)

This print, which tends to come in rather light impressions, is universally accepted as by Agostino from his youth. Calvesi/Casale noted that the composition has some iconographic connection with Lodovico's *Baptism* in Munich of 1584/1585.[1] The inscription indicates that Agostino, whose signature does appear here, was following a design by his brother Annibale. This is the first of three prints by Agostino after his younger brother, who at this date would have been about twenty-one years old.[2] As discussed in the Introduction the two artists began their working relationship with Agostino teaching his brother the art of engraving.[3] By 1581, however, Annibale, whose earliest engraving dates from this year, would have had enough proficiency that his brother could reproduce his compositions.

There is some possibility that Annibale worked with Agostino on this print. The signed *Crucifixion* of Annibale of 1581 (Annibale cat. no. 1) is extremely close in morphological and technical features.[4] Malvasia wrote that Agostino taught Annibale the rudiments of the craft and corrected his early work.[5] What better place to begin than with an engraving after one's own work?

The majority of the sheet must, however, belong to Agostino. The delicate burin work is characteristic of the years 1579-1581 when he was in Tibaldi's studio, working for the older artist. The technique reiterates the pattern of Tibaldi's works.[6] Comparisons with some of Agostino's signed engravings of the period also confirm that the print is his. The stiff, awkward gestures and limbs and the planar parallel hatching recur in the *Tobias and the Angel* of 1581 (cat. no. 26), as do similar foliage and sharp-edged contours. Also from the same mold is the unsigned print of 1581 of *Adam and Eve* (cat. no. 25).

If Agostino and Annibale were working together in this year when Agostino probably left Tibaldi's studio to venture out on his own, it is not surprising that the signed and dated prints by each of the artists would be comparable in style and technique.

*Engraving in exhibition from Stuttgart Staatsgalerie, Kupferstichkabinett.

1 Reproduced *Mostra-Dipinti,* pl. 3. The connection is solely in the attitudes of the figures.

2 According to a note on the impression in Bologna, the composition follows a work by Prospero Fontana of 1540. The other prints after Annibale are cat. nos. 25 and 209.

3 Introduction p. 37

4 Cf., e.g., the angular hands in both engravings as well as the similarity of features between the crucified Christ and the Christ baptized. The similarity of the handling of the burin in the clouds and elsewhere is readily apparent.

5 Malvasia, p. 294. See Introduction p. 37

6 Cf., e.g., cat. nos. R57-R58 in which similar delicate networks of lines are employed.

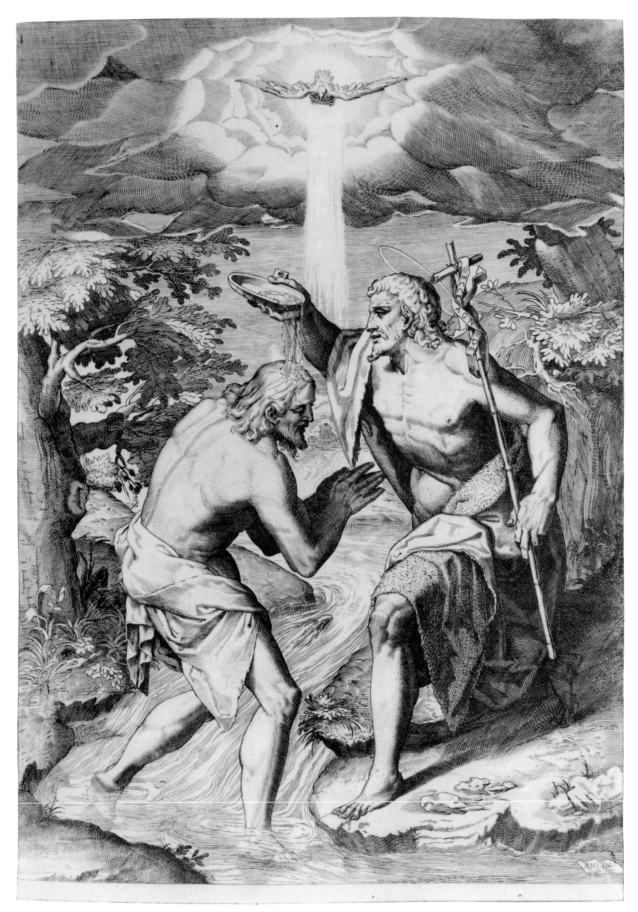

cat. no. 23, only state. Vienna, Graphische Sammlung Albertina

24*

The Sudarium of Veronica
1581

Engraving. 277 x 222 mm. (sheet: Ham)

Unpublished.

States:

I Lower right: *1581.* (Ham)

This previously unknown engraving, found today in but one impression, is certainly a work by Agostino of 1581. It is especially close in style to the *Veronica* (cat. no. 43) which is nonreproductive in nature, as this work may be. Moreover, the flat network of lines is extremely close to all of the prints of this period.

A note in French (by Mariette?) on the print in Hamburg suggests that this is the "sudario santissimo" attributed to Brizio by Bartsch. In fact, the Brizio engraving is a different composition.[1]

1 Bartsch XVIII, 172.7 and XVIII, 256-257,6. Reproduced in Bertelà, 39. The Brizio engraving was incorrectly attributed to Agostino by Malvasia, p. 84.

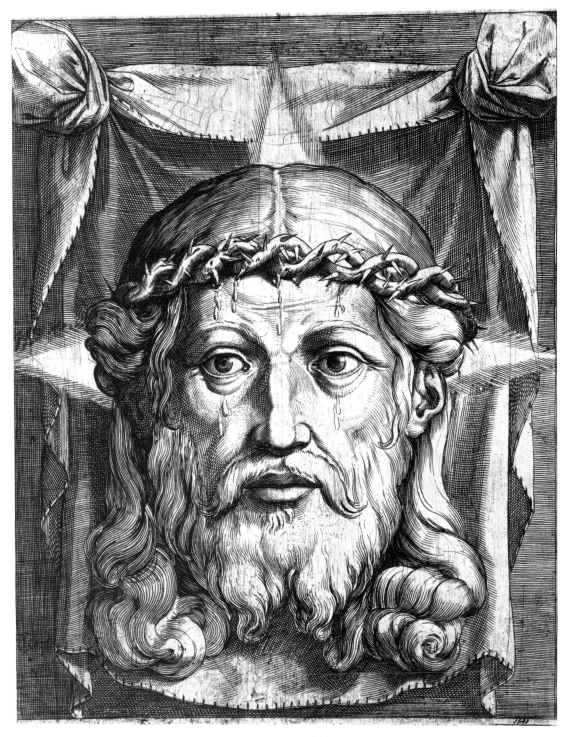

cat. no. 24, only state. Hamburg, Hamburger Kunsthalle, Kupferstichkabinett

25*

Adam and Eve
(B. 1) 1581

Engraving. 492 x 357 mm. (measured left and bottom) (after Annibale Carracci)

Literature: Heinecken p. 629, no. 1; Gori Gandellini p. 313, no. XIV; Joubert p. 345; LeBlanc 1; Ostrow 23.

States:

	B
I	I

Bottom toward left: *1581.* In margin: IN ADAM OMNES MORIVNTVR. *I. cor 15.* (Alb, BM)

Copies: 1. Engraving in same direction attributed to Adam Elsheimer. 203 x 163 mm.[1]

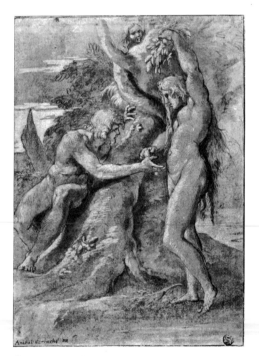

fig. 25a. Annibale Carracci, *Adam and Eve.* Paris, Cabinet des dessins du Musée du Louvre

The critics have varied in their appraisal of this print. Gori Gandellini and Joubert believed the work to be not only engraved by Agostino but also after his own design. Bartsch doubted the piece and suggested that if by Agostino it was produced before the date of 1581 which is inscribed on the print. LeBlanc rejected it, as did Ostrow, the only recent writer to discuss the engraving. According to Ostrow, the flatness of the forms and the lack of plasticity in the lion are not possible from Agostino in the year 1581, a period when his craftsmanship had reached greater heights. Although the hatching is pedestrian and the figures awkward, these are indeed traits which Agostino exhibited during his working relationship with Domenico Tibaldi. They are characteristics which Carracci acquired from Cort, probably through Tibaldi. Similar hatching is seen on the trees and in the landscape of Agostino's signed engraving of *Tobias and the Angel* of the same year (cat. no. 26). Moreover, the figure of Adam is cast from the same mold as the figures of Christ and Saint John the Baptist in the *Baptism of Christ* (cat. no. 23), here attributed to Agostino. It becomes apparent that during these crucial years between 1579 and 1581 Agostino varied greatly in his stylistic conception of a composition, sometimes injecting a great plasticity to the forms as in *Jacob and Rachel at the Well* (cat. no. 27) and at other times falling back on the planar formation of figural and landscape representations as in the *Tobias and the Angel.*

A drawing in the Louvre* (fig. 25a) suggests that Annibale was the author of the composition of *Adam and Eve.*[2] The stances of the protagonists are alike, although facing different directions, and Eve's flowing hair and Adam's curly locks are similar. The anthropomorphic snake appears in both. It is possible that this sheet was an early preparatory study for the engraving. The freedom of wash and heightening on Annibale's drawing places the sheet at the beginning of his career, making the connection of drawing and engraving tenable. If Annibale is the inventor of this composition, the attribution of the engraving to his brother Agostino is strengthened.[3]

1 David Steel pointed out this print which is reproduced in Keith Andrews, *Adam Elsheimer,* Oxford, 1977, cat. no. 52, fig. 4. Andrews noted that the composition of Elsheimer's print was copied from a print by Jan Sadeler after Martin de Vos. Those works are unknown to this author. There is also a stained glass painting of the composition in reverse in the Historical Museum in Frankfurt, according to Andrews. The latter is dated 1594. Andrews dated the Elsheimer print c. 1597. The Agostino engraving, dated 1581, would have to be the prototype for the rest. Sadeler may have been the transmitter of the composition to the north.

2 Inv. no. 7135. 278 x 200 mm. Pen and brown and black ink and brown wash with white heightening over black chalk on paper washed buff. Laid down. Lower left: "Anibal Carrache." Unpublished.

3 Of course, the composition is not at all unusual. Agostino may have known a variant of Titian's painting of the subject which was in Spain by 1585. (See Harold E. Wethey, *The Paintings of Titian: I. The Religious Paintings,* London, 1969, p. 63, cat. no. 1, pl. 162.) Attitudes are similar as is the general composition. This does not, however, rule out Annibale as the primary source for Agostino's print.

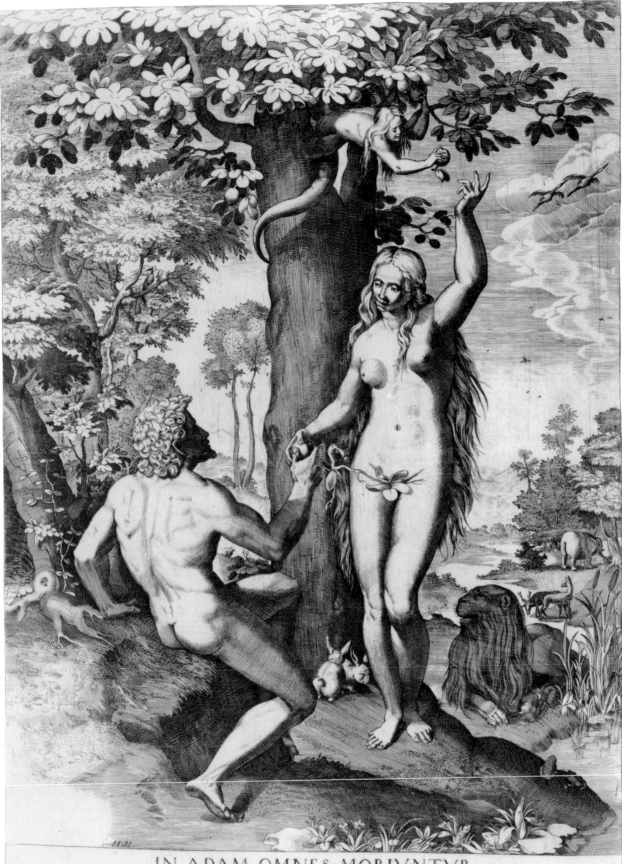

IN ADAM OMNES MORIVNTVR.

cat. no. 25, only state. Vienna, Graphische Sammlung Albertina

26*

Tobias and the Angel
(B. 3) 1581

Engraving. 406 x 287 mm. (after Raffaellino da Reggio drawing in the Uffizi[1])

Literature: Malvasia pp. 76, 270; Oretti p. 797; Heinecken p. 629, no. 5; Gori Gandellini p. 317, no. IV; Joubert p. 347; Bolognini Amorini p. 55; Nagler 1835, p. 394; Nagler I, no. 1380; Mariette II, 44, III, 59; LeBlanc 3; Foratti p. 167; Bodmer 1939, p. 130; Petrucci p. 134; Calvesi/Casale 24; Ostrow 18; Bertelà 141.

States:

	B	CC	Ost
I	1	1	1

Lower left: *Raphael Regien.ᵗ In:/ Aug.ᵗ Car: fe:/ 1581.* In margin: RAPHAEL COMES IN VIA MEDICVS DOMI. (Alb, BM, BN, Br, Milan: Raccolta delle Stampe, MMA, and others)

	B	CC	Ost
II	2	2	2

Regien. changed to *Vrbin.* In margin lower right: *Franco Forma.* (Alb, Ber, Bo, Dres, Ro, and others)

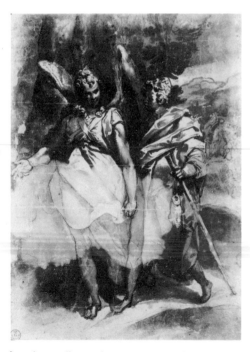

fig. 26a. Raffaellino da Reggio, *Tobias and the Angel* Florence, Gabinetto disegni e stampe degli Uffizi

Although signed and dated, this print has disturbed several critics, including Bartsch, who believed that if the engraving is indeed by Agostino, it comes from an earlier period than 1581. Malvasia placed the print with others done while in Tibaldi's shop.[2] Foratti and Bodmer also believed that the engraving could have been dated by the publisher after its execution, and that a date of the late 1570s was more fitting. Petrucci, without basis, used this print as an indication of Agostino's supposed early trip to Rome c. 1577-1579. Ostrow and Calvesi/Casale correctly interpreted the inscription to mean exactly what it purports: that the engraving is by Agostino from the year 1581. The writers have also pointed out that the original source for the print is Raffaellino da Reggio's drawing of *Tobias and the Angel* now in the Uffizi (fig. 26a), rather than the painting by the artist in the Borghese Gallery in Rome.[3] There is no reason to doubt the drawing as the source, and it is interesting to note that Agostino at this period was perfectly able to fill out a composition which was left indistinct in a preparatory drawing. The background and most of the ground plane appear to be Agostino's invention, and although Ostrow believed that foreground and background are awkwardly contrasted, Agostino interpreted these parts very well, adding foliage and other original details. In translating Raffaellino's dramatic chiaroscuro contrasts into another graphic medium, the artist scaled down the theatricality of the original into a rather placid, balanced contrast of light and shade. As discussed in cat. no. 25, Agostino at this period was rather pedestrian in his use of hatching and crosshatching to indicate depth. Yet, in juxtaposing the rather flattened patterns of the hatching, Agostino produced a visually interesting interplay in the draperies of the two figures.

It is certainly likely that Agostino knew Raffaellino's drawing from his Roman trip (see cat. no. 40). On the other hand, it is also possible that the drawing could have traveled to Bologna. A second drawing, known only through photographs to this writer, formerly in the Gabinetto delle Stampe in Milan, by Raffaellino and almost identical to the one in the Uffizi, has recently come to light.[4] It is not possible to say exactly which drawing Agostino employed as his working sheet.[5]

*Engraving in exhibition from the Museum of Fine Arts, Boston, Harvey D. Parker Collection.

1 Inv. no. 2014 F. 347 x 271 mm. Brown pen and wash over red chalk. Laid down. Nancy Ward Neilson called attention to a chiaroscuro woodcut after Raffaellino's drawing: Bartsch XII, 1.9.

2 The other works mentioned are cat. nos. 27, 11, and 29, the latter dated 1581, indicating that Malvasia believed that Agostino remained in Tibaldi's shop at this date (Malvasia, p. 270).

3 Ostrow noted that the painting by Raffaellino (c. 1550-1578) was in the Safior family in 1616 and that it was doubtful that it could have been his source. Reproduced in Luciano Ferrara, *La Galleria Borghese* (Novara, 1960), 122-123.

4 Il Gabinetto delle Stampe, *Disegni dal XV al XVIII secolo* (Milan, November, 1977) no. 5, reproduced. According to the authors it is this sheet which Agostino used as his working model.

5 Another copy of Raffaellino's composition, in reverse, is found in a chiaroscuro woodcut by an anonymous artist (Bartsch XII, 27.9), reproduced in *Le Peintre Graveur Illustré* (University Park and London, 1971), vol. 1.

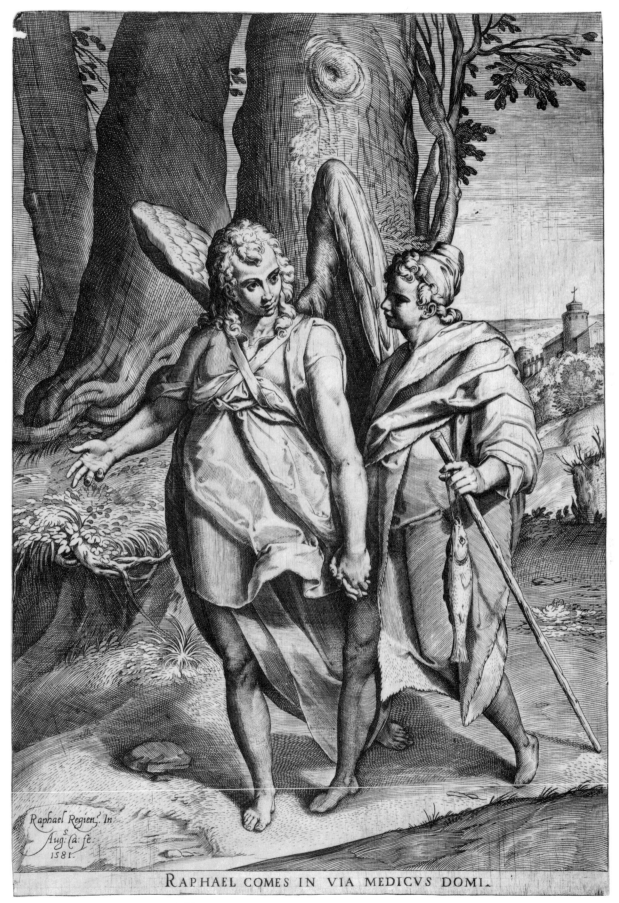

RAPHAEL COMES IN VIA MEDICVS DOMI.

cat. no. 26, state I. London, The British Museum

27*

Jacob and Rachel at the Well (B. 2) 1581

Engraving. 396 x 293 mm. (after Denys Calvaert drawing in the Louvre[1])

Literature: Malvasia pp. 76-77 and note 6, p. 270; Oretti p. 798; Heinecken p. 629, no. 2; Gori Gandellini p. 317, no. II; Joubert p. 346; Bolognini Amorini p. 55; LeBlanc 2; Petrucci p. 134; Italo Faldi, "Contributi a Raffaellino da Reggio," *Bolletino d'Arte,* XXXVI, 1951, p. 333, note 29; Calvesi/Casale 25; Calvesi, *Commentari,* 1956, p. 264, note 5; Bodmer 1939, p. 136; Foratti p. 167; Ostrow 19; Bertelà 40.

States:

	B	CC	Ost
I	I	I	I

On rock at left: *1581.* In margin: JACOB *intuitus Rachel oves patris ducentem/Consobrinae comodo. maxima dilectione/Inservire cupiens anunculj/ Amavit lapidem, quo putes clauditur/ Aquam offert Gregi ad bibendum. Gen:* XXIX:/ DIONISIVS CALVART IN: BON: *1581.* (Alb, Ber, BM, Bo, Dres, Ro, and others)

II	—	—	—

BON: *1581* replaced by *Ro f. Bertellis for.* (Dres, Par)

III	—	—	2

The Calvaert and Bertelli citations burnished out and replaced with *Io Franciscus Rot excud. Aug Car.* added before *1581*[2] (Fitzwilliam Museum, MMA)

Except for Zanotti and Foratti, critics have continuously attributed this print, with good reason, to Agostino Carracci. Similar female figures are seen in other prints of this period, and the flat reading of the sharpened right arm of Rachel is characteristic of most of Agostino's forms of these years.[3] The source for Agostino's engraving is a signed drawing by Denys Calvaert in the Louvre (fig. 27a). The sheet, dated 1578, is supposedly preparatory to a lost painting of the same year.[4] A second drawing, also in the Louvre (fig. 27b) is a counterproof of Calvaert's sheet and may give us an insight into Agostino's working methods.[5] Either Calvaert or someone else made the counterproof of the original red chalk drawing. The chalk on the original sheet must have been somewhat smeared in the process, and the artist therefore made corrections in black chalk to strengthen the lines. Consequently, the counterproof, in red chalk, corresponds only to the underlying red of the original Calvaert sheet. It is probable that the counterproof was taken solely for the purpose of making the engraving. With the reversed image of the counterproof (fig. 27b) before him, Agostino transferred the composition to the plate, with a resultant image in the same direction as Calvaert's original drawing (fig. 27a). It is also possible that the counterproof was made by Agostino himself, and that Agostino then made the black chalk reinforcements on the first drawing. These additions are carefully executed in an engraver's technique, somewhat like the print itself, whereas the original, as mirrored in the counterproof, lacks this intricate crosshatching.

Agostino, while remaining faithful to Calvaert's composition and to his sense of light and shade and plasticity of forms in space, added his own details to the scene. As in the *Tobias and the Angel* (cat. no. 26), he added a background landscape to locate the story in some kind of pastoral setting. He also animated the facial expressions of the protagonists, heightening the sense of interaction between them. Rather than the stiff feminine form in Calvaert's drawing, Rachel has become a demure woman, eyes cast toward the ground. Jacob has taken on a pensive attitude missing in the drawing. Even the dog and sheep appear to take part in the drama, eyes alert to the human tableau before them.

By 1581, in engravings such as this, Agostino was able to translate to his reproductive prints a heightened drama which was often missing in the original.

*Engraving in exhibition from the Baltimore Museum of Art, Garrett Collection.

1 Inv. no. 19838. Black and red chalk heightened with white on buff paper. At right appears the date "1578" (with the "8" on its side, which was read as "1570" by Ostrow and Bergmans—see below, note 4). The drawing measures 340 x 258 mm., smaller than the engraving, but some of the engraving's composition has been enlarged, as at top and left.

2 Ostrow incorrectly called this state a copy by Rota.

3 Cf. the face of Rachel with those in cat. nos. 32 and 35. Cf. the limbs with those in the *Baptism of Christ* (cat. no. 23).

4 Simone Bergmans, "Denis Calvart Peintre Anversois Fondateur de l'Ecole Bolonaise," *Académie royale de Belgique Classe des Beaux-Arts Memoires,* 2nd series, vol. 4, pt. 2, 1934, p. 28 and note 3 and Bergmans, *Catalogue Critique des oeuvres du peintre Denis Calvart* (Brussels, 1931), p. 31, no. 176.

5 Inv. no. 19847 as Denys Calvart. 338 x 249 mm. Red chalk. After the counterproof in red chalk was taken, white heightening was added. Unpublished. Collections: Antoine Coypel (Lugt 478), lower right.

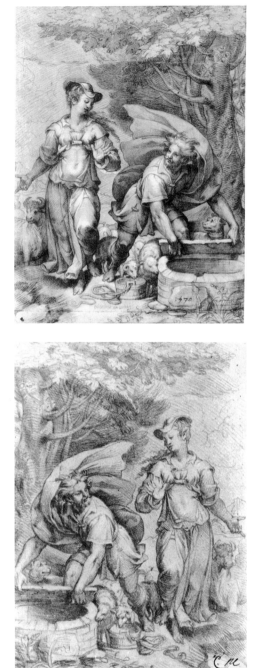

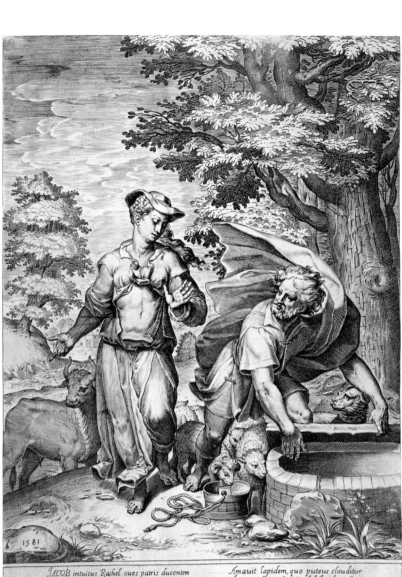

cat. no. 27, state I. London, The British Museum

fig. 27a. Denys Calvaert (and Agostino Carracci?),
Jacob and Rachel at the Well. Paris, Cabinet des dessins
du Musée du Louvre (top)

fig. 27b. Counterproof of fig. 27a. Paris, Cabinet des
dessins du Musée du Louvre (bottom)

28

Adoration of the Shepherds
(B. 9) 1581

Engraving. 494 x 356 mm. (sheet: BN) (after Marco del Moro)

Literature: Malvasia p. 76, note 1; Nagler I, no. 296; Mariette III, no. 71; LeBlanc 17; Ostrow 22.

States:

	B	Ost
I	–	–

Lower left on rock: *1581* (BN, Dres, Stu)

	B	Ost
–	I	I

As above with letters *A.C.* stamped on the print. (Alb)

	B	Ost
II	–	–

Below rock lower left: *Marco dil moro inventor.* (Dres)

There is some confusion in the literature as to states of this print. Bartsch and Ostrow incorrectly called the impression in the Albertina with the letters "A.C." stamped on the print a state when these letters are not part of the engraving itself.[1] A second state of the print lacking these letters confirms this fact.

Malvasia, in attributing this engraving to Agostino, believed that the invention of the composition could be credited to Prospero Fontana. Bartsch called the work mediocre and not by Agostino, and LeBlanc followed him in doubting the work. Ostrow reinstated the print to Agostino's oeuvre, but agreed with Bartsch on the unattractiveness of the sheet, attributing this to Agostino's working in his "independent style," unable to translate his own compositions into coherent form during these early years.[2] The excuse for the awkwardness of faces and limbs and flatness of surface hatching cannot be ascribed to Agostino working as a nonreproductive artist if we are to believe the attribution of the invention of the print to Marco del Moro, even though it is found on the second state of this engraving. The composition is similar to that of the *Adoration of the Shepherds* by Marco del Moro (cat. no. 22), with the adoring figures approaching from the right and their forms balanced by columns of architecture on the left. Moreover, similar paintings are found in Marco del Moro's oeuvre. Consequently, it becomes apparent that Agostino's independent style as outlined by Ostrow is not entirely divergent from his reproductive style.

Stylistically, the print is similar to others attributed to Agostino from this period. The Virgin's features are much like those of the Virgin in cat. no. 97, the figure of the Christ Child closely resembles the one in the *Rest on the Flight into Egypt* (cat. no. 39), and similar drapery folds are seen again in Agostino's print after Veronese in 1582 (cat. no. 103). The regularity of the burin technique, which varies in size or modulation, is characteristic of most of the prints from this period.

1 Ostrow did concede that since the initials are stamped on the print, one cannot in reality consider this a "signed" print.

2 See a discussion of Ostrow's use of the term "independent style" and this author's refutation of it in the Introduction.

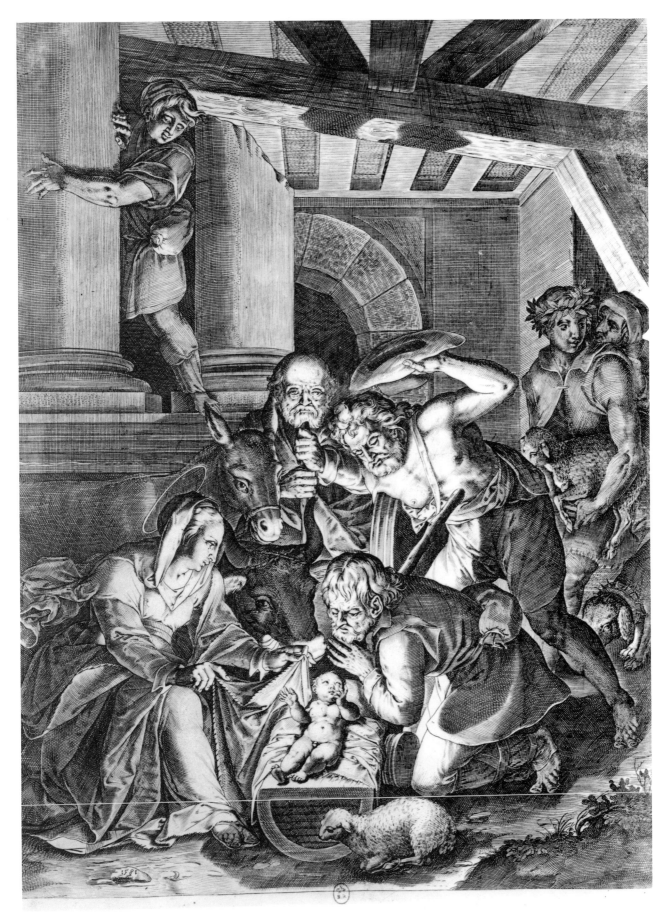

cat. no. 28, state I. Paris, Bibliothèque Nationale

117 AGOSTINO

29*

Frieze to Accompany a Map of the City of Bologna
(B. 263) 1581

Engraving. Two plates. Left: 211 x 410 mm. (sheet: BN) Right: 209 x 407 mm.

Literature: Malvasia p. 75; Bellori p. 116; Oretti p. 794; Heinecken p. 642, no. 13 and 643, no. 24?; Gori Gandellini p. 320, note 125; Bolognini Amorini p. 55; LeBlanc 246; G. B. Comelli, *Piante e vedute della Città di Bologna,* Bologna, 1914, no. IV; Bodmer 1940, p. 51; *Mostra-Dipinti* p. 72; Calvesi/Casale 26; Ostrow 21.

States:

	B	CC¹	Ost
I	1	–	1

Above: BONONIA DOCET MATER STVDIORVM. In left cartouche a dedication to Cardinal Paleotti beginning with *All' Ill^{mo} et Ro.^{mo} Sig.^{re}* . . . and ending with: *De l'anno 1581 / D.V.S.ILL.^{ma} R^{ma} / Servo devosiss. Augustino Carazzi.* At right another long history of Bologna beginning with: *Fu Bologna da Toscani edificata,* . . . (Alb)

II	2	–	2

The same as above, but with a cross added beneath the cardinal's hat (Alb, BN, Bo, Bologna: Private Collection, Dres)²

There has been no disagreement about the attribution of this engraving to Agostino; however, there have been differences of opinion as to the authorship of the map which it accompanied. Malvasia, noting its rarity, attributed the map to Agostino. Bartsch and later Calvesi/Casale attributed it to an unknown artist, but Ostrow implied that it was executed by Agostino. Unfortunately, the map, which was known in 1914 in three impressions, exists in only one known impression today, in a private collection in Bologna.³ Like the frieze above, the map is dated 1581, but unsigned. It was published by Giovanni Rossi. A cursory comparison of the frieze with the map, in spite of the difference in purpose and therefore necessarily in technique, suggests that the two are by different hands and that Agostino did not execute the map itself.⁴

The frieze above the map,⁵ signed by Agostino, is one of his earliest nonreproductive efforts, executed on a grand scale, probably in Bologna, as suggested by Ostrow. The hatching is less pedestrian here than in other prints of the period, but there is still a flatness to the cartouches and coats of arms as well as an overall uniformity of light. In contrast to the map below, however, a sculptural effect is achieved.

*Engraving in exhibition from the Graphische Sammlung Albertina, Vienna.

1 Calvesi/Casale gave no indication of states.

2 The cross below the hat of Cardinal Paleotti indicates that this second state was pulled after his death in 1597.

3 Comelli noted three impressions of the map: in the Accademia di Belle Arti in Bologna, in the Sala Breventani in the Biblioteca Arcivescovile in Bologna, and a third in the collection of Giuseppe Guidicini, which was sold years before. It was not possible to locate any of these sheets.

4 Known to the author only through a photograph.

5 In the cartouche at left is a dedication by Agostino to Cardinal Paleotti, who, he said, commissioned the work. At right is a history of the city of Bologna. The coats of arms are (left to right): Cardinal Gabriele Paleotti, Pope Gregory XIII (Ugo Buoncampagni), and the city of Bologna.

cat. no. 29, state II above map by an anonymous artist. Bologna, Private collection

cat. no. 29, state II.
Paris, Bibliothèque Nationale

30

*Coat of Arms of
Cardinal Fieschi*[1]
(B. 170) c. 1581

Engraving. 149 x 106 mm.

Literature: Malvasia p. 83; Oretti p. 832;
Heinecken p. 643, no. 20; Bolognini Amorini
p. 59; LeBlanc 258; Calvesi/Casale 28; Bertelà
267.

States:

	B	CC
I	I	I

As reproduced (Alb, Bo)

cat. no. 30, only state. Vienna, Graphische Sammlung Albertina

Both Bartsch and Calvesi/Casale dated this rare print early in Agostino's
career. Calvesi/Casale, who placed it c. 1581-1582, noted a similarity
between this cartouche and that in the portrait of Cosimo de' Medici
(cat. no. 136), executed by Agostino several years later. The cartouche,
as well as the simple handling of the burin, appeared earlier in the dated
print of the *Frieze to Accompany a Map of Bologna* (cat. no. 29) of 1581.

 This engraving, which is the first of many coats of arms of cardinals
and clergymen,[2] reflects a compositional technique which Agostino
began to use at this period, in which he placed his figures or forms in a
receding niche from which a coat of arms or similar device projects.[3]
This technique, which seems to have been Agostino's own, was most
vividly demonstrated in his 1582 title page for the *Cremona Fedelissima*
(cat. no. 56) in which the figures are set on a stage, and the tableau
projects into the viewer's space.[4]

1 The Fieschi family, which came from Genoa, produced at least nine cardinals, as
mentioned by Cardella; but none from this period is known. Ciaconi mentioned no
Fieschi cardinals at all. Berton, p. 899, listed a Nicolas Fieschi, but he seems to have
been a cardinal in the early seventeenth century. Thus, it is not possible to identify
specifically the cardinal whose arms are portrayed by Agostino.

2 See Introduction for a discussion of Agostino as a maker of coats of arms
and of his contribution to this art form.

3 Cf., e.g., cat. nos. 56, 135, 144.

4 Of course, the design of that print is attributed to Antonio Campi, who probably
influenced Agostino in this kind of composition.

31

Presentation in the Temple
(B. 12) c. 1579-1581

Engraving. 406 x 287 mm. (after Orazio Sammacchini drawing in the Louvre)

Literature: Malvasia p. 171; Malvasia 1686, p. 88; Heinecken p. 630, no. 8; Gori Gandellini p. 317, no. V; Nagler 1835, p. 395; Joubert p. 347; LeBlanc 10; Pittaluga p. 344; Bodmer 1939, pp. 126-127; Calvesi/Casale 18; Bertelà 145; Graham Smith, "A Drawing by Orazio Samacchini for his 'Presentation in the Temple,'" *Master Drawings,* XIII, 4 (Winter, 1975): 370-371.

States:

	B	CC
I	I	I

On altar step: OPVS HORATII SAMACHINI IN ECCL·S·IOACOBI BONON·/ AD ALTARE M· DN·LAVRENTII DE MAGNANIS. (Alb, Ber, BM, BN, Bo, Dres, MMA, and others)

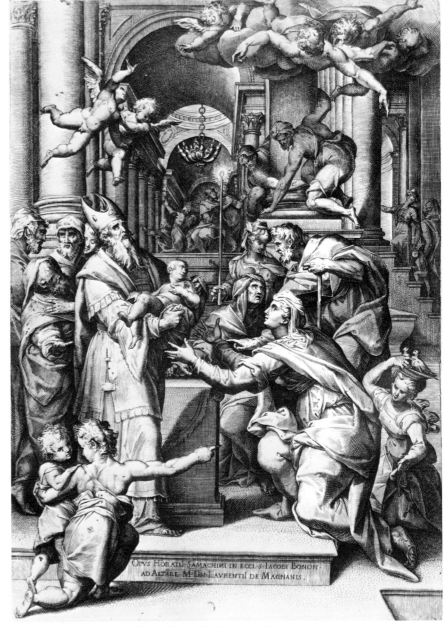

cat. no. 31, only state.　Vienna, Graphische Sammlung Albertina

There has been some disagreement in the past about the attribution of this print to Agostino; however, modern writers have been unanimous in their acceptance of it. Malvasia first mentioned the print as Agostino's, and thus the tradition of attributing it to him began as early as the seventeenth century. Bartsch, like Nagler later, was hestitant in his acceptance of the print, citing its weakness and suggesting that perhaps Philippe Thomassin was the author. At the Bibliothèque Nationale in Paris, the print is found with the works of Cornelis Cort, and it was not mentioned by Mariette as Agostino's. Calvesi/Casale, accepting the engraving, compared its style with Agostino's other works after Sammacchini of the same period. But, in fact, there is a divergence between this print and the three following engravings after Sammacchini (cat. nos. 32-34). Burin strokes tend to be shorter in this print, figures more

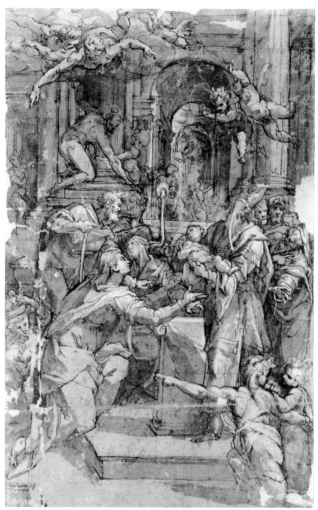

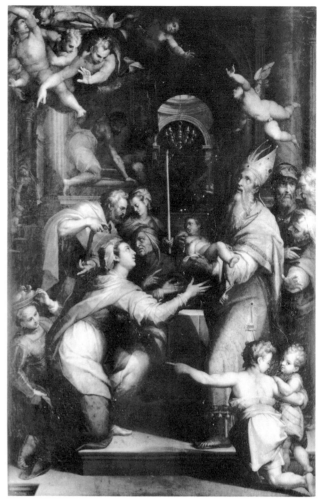

fig. 31a. Orazio Sammacchini, *Presentation in the Temple*. Courtesy of the Detroit Institute of Arts

fig. 31b. Orazio Sammacchini, *Presentation in the Temple*. Bologna, San Giacomo Maggiore

elongated and less voluminous, and drapery folds sharper. Although these characteristics are reminiscent of Cornelis Cort's work, they are also at times apparent in Agostino's oeuvre in these early years when the artist was strongly influenced by Cort's style.[1] Besides, the features of the Madonna and other figures have the tender look characteristic of Agostino's reproductions after Sammacchini, which is lacking in Cort's engravings.

Graham Smith published a drawing in the Detroit Institute of Art (fig. 31a)[2] which he believed to be Agostino's working model. He noted the many changes between Sammacchini's preparatory drawing and his finished painting in San Giacomo Maggiore in Bologna (fig. 31b), finding Agostino's engraving closer to the drawing. However, an unpublished drawing by Sammacchini in the Louvre (fig. 31c), highly worked up, was Agostino's actual working model.[3] This second drawing is almost the same size as the engraving and was indented for transfer to the plate. Agostino reproduced the details of the Louvre sheet almost line for line, preserving the angularity of Sammacchini's original. This engraving also marks one of the few instances in which Agostino reversed the composition of the original to the print, a normal procedure with most artists but unusual for Agostino, who was interested in pre-

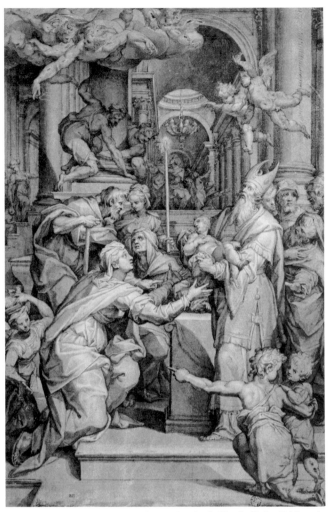

fig. 31c. Orazio Sammacchini, *Presentation in the Temple*. Paris, Cabinet des dessins du Musée du Louvre

serving the direction of the original composition. This suggests that this print may precede the others after Sammacchini, especially since stylistically it is less advanced in volumetric rendering of forms and more dependent on Cort's style. Bodmer dated the print c. 1577, believing it was done before Sammacchini's death this year.[4] There is little reason to assume Sammacchini should have been alive while the print was made. Calvesi dated the print c. 1579-1580, as he did the other works after Sammacchini. A date in this period is fitting, probably closer to the beginning than the end.

1 Cf. cat. nos. 17, 20, 21, 25, and 26.

2 Inv. 34.152. 282 x 180 mm. Pen and brown ink and wash, heightened with white over black chalk and squared in black chalk. Known to the author only in photographs. See Smith for further details.

3 Inv. 11273. 408 x 268 mm. Pen and brown ink, gray wash heightened with white on paper washed green. Some oxidation. Incised. A note by Mario di Giampaolo on the mat indicates a weaker version of the drawing in Bologna, not known to this writer. A number of similar drawings of a composition like this is not unusual in Sammacchini's oeuvre. He often copied his sheets with little variation.

4 The painting by Sammacchini dates to 1575 by documents for the altarpiece. See Smith p. 370.

32

The Virgin Dropping the Holy Girdle to Saint Thomas

(B. 106) c. 1579-1581

Engraving. 447 x 318 mm. (sheet: BN) (after Orazio Sammacchini)

Literature: Heinecken p. 632, no. 4; Gori Gandellini p. 314, no. XIX; Mariette II, 52; Joubert p. 344; LeBlanc 91; Bodmer 1939, p. 128; Calvesi/Casale 16.

States:

	B	CC
I	I	I

In margin: QVASI AVRORA CONSVRGENS. *Can. VI.* (Alb, BN, Br, Dres, Par, Ro)

All critics have accepted this engraving as Agostino's work from an early period.[1] Bodmer was the only writer to suggest that the original composition was by Sammacchini. This is a reasonable assumption if one compares the composition of this work with that of cat. no. 33, securely Sammacchini's. Moreover, the same full-bodied forms inhabit each work. At this period Agostino seems to have been very interested in the works of both Sammacchini and Sabbattini, Bolognese mannerists whose styles included a plasticity of form missing from the works of Cornelis Cort.[2] In reproducing Sammacchini's works, Agostino developed his burin technique by varying the types of strokes used and incorporating more and more swelling lines. The results are greater contrast of light and shade and increased volume to the forms.

The following engraving of the *Coronation of the Virgin* (cat. no. 33) may have served as a pendant to this one: the compositions are complementary and the measurements similar.[3]

1 Bodmer dated it c. 1577-1579; Calvesi/Casale from c. 1579-1580.

2 A painting by Sabbattini of the *Assumption* in the Pinacoteca Nazionale in Bologna (reproduced in Andrea Emiliani, *La Pinacoteca Nazionale di Bologna,* Bologna, 1967, fig. 160) is somewhat close to the upper part of this engraving, but the representation of the Assumption in this manner was common. For angels similar to those supporting the clouds see a drawing by Sammacchini in the Louvre, Inv. no. 4390. The angel holding the Madonna's left leg in the engraving is morphologically similar to Sammacchini's drawing, supporting the thesis that he was the author of the composition.

3 *The Annunciation* (cat. no. 34) is also similar in measurement to these two and also after Sammacchini. It is not close in composition, however. There is a possibility that Agostino was contemplating a series of prints after Sammacchini of the life of the Virgin. The present engraving relating an incident during the Assumption is sometimes called the *Virgin of the Scapular.*

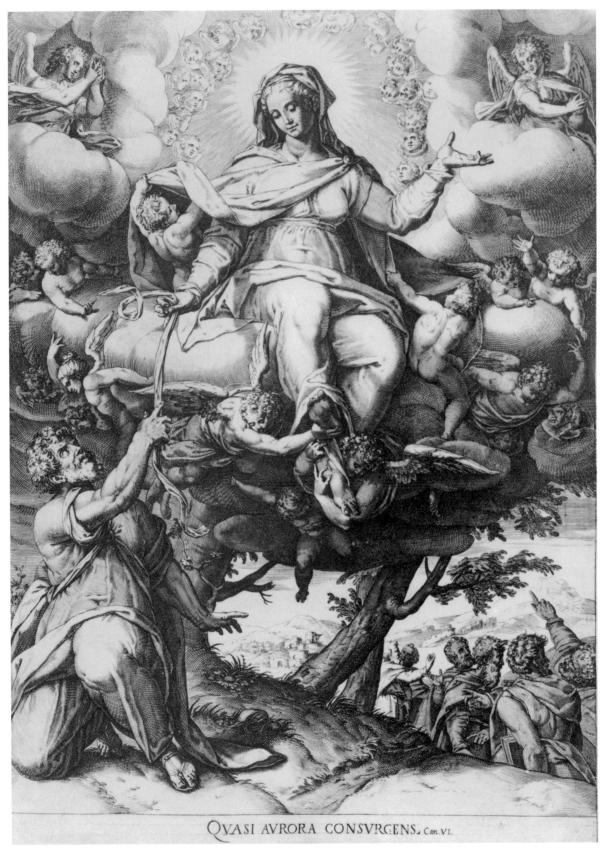

QVASI AVRORA CONSVRGENS. Can.VI.

cat. no. 32, only state. Vienna, Graphische Sammlung Albertina

33*

Coronation of the Virgin
(B. 93) c. 1579-1581

Engraving. 455 x 325 mm. (sheet: Alb) (after Orazio Sammacchini)

Literature: Malvasia p. 171; Malvasia 1686, pp. 261-262; Nagler 1835, p. 397; Bodmer, 1939 p. 127; Calvesi/Casale 17; Catherine Johnston, *Mostra di Disegni Bolognesi,* Gabinetto Disegni e Stampe degli Uffizi XL, Florence, 1973, under no. 11; Boschloo 1972, p. 76.

States:

	B	CC
I	I	I

In margin: POSITVS EST THRONVS MATRI REGIS. ET SEDIT AD DEXSTERAM EIVS. III. *Reg. XV* (Alb, Chatsworth, U)

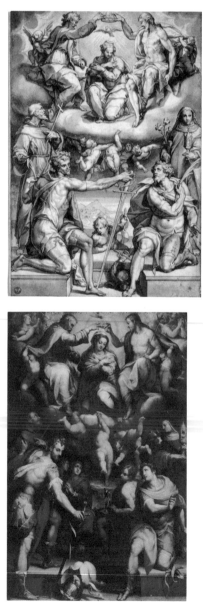

Bartsch, Bodmer, and Calvesi/Casale believed that Lorenzo Sabbattini was the inventor of this composition. However, Malvasia had known the inventor to be Sammacchini, and Catherine Johnston pointed out the connection between the print and Orazio Sammacchini's drawing in the Uffizi (fig. 33a) for his painting of the *Coronation of the Virgin* (fig. 33b), originally in SS. Naborre e Felice and now in the Pinacoteca Nazionale in Bologna.[1] The engraving partially reproduces in reverse the upper part of the composition for the painting. It is likely that the lower portion of the print, with the distant landscape, was invented by Agostino himself. But the drawing in the Uffizi was probably not the drawing by Sammacchini used by Agostino. First of all, the Uffizi drawing is smaller than the comparable portions of the engraving. In addition, several changes have been made: the angels holding the cloaks of God the Father and Christ have disappeared; God the Father crowns the Virgin with his inside arm rather than with the arm closer to the viewer as in the drawing; Christ's legs are extended in a standing-walking stance in the engraving whereas he is seated in the drawing; the Virgin's hands are held in prayer in the engraving but are crossed in the drawing; and the Holy Ghost is placed above rather than below the crown in the engraving. The angels now populating the clouds and the change of the landscape are typical revisions made by an engraver, but the other differences are too far removed from the original forms to have been made by Agostino. If one studies Sammacchini's working methods, it is apparent that he reworked his compositions and even sometimes did several slightly varied copies of his own paintings.[2] Numerous carefully prepared drawings which rework ideas exist for his paintings.[3] It seems likely, then, that Agostino based his engraving on a lost preparatory drawing by Sammacchini for the *Coronation of the Virgin* in Bologna.[4]

As discussed in the previous catalogue entry, this engraving was probably a pendant to the *Virgin Dropping the Holy Girdle to Saint Thomas* (cat. no. 32).[5]

*Engraving in the exhibition from Florence, Gabinetto Disegni e Stampe degli Uffizi.

1 Inv. no. 1481F. 362 x 244 mm. Pen and brown ink and wash with black chalk on paper squared for transfer. Johnston p. 27, no. 11.

2 There are several versions by Sammacchini of the *Annunciation* which Agostino reproduced in engraving. See cat. no. 7 for an explanation of these.

3 There are two other drawings which have been connected with the *Coronation of the Virgin* : one in Amsterdam and one in Reggio Emilia. (See Amsterdams Historisch Museum, *Italïe 15e-18e eeuw,* Amsterdam, 1976, cat. no. 47). For Sammacchini's lost painting of the *Trinity,* numerous drawings exist (see Catherine Johnston, cat. no. 9 for a listing of these drawings). See also the drawings for the *Presentation in the Temple* (cat.no. 31).

4 Note Malvasia's confusing statement in his life of Orazio Sammacchini (Malvasia p. 171) about the drawings in Leopold's collection, containing the Sammacchini sheet now in the Uffizi: "L'osservarono anche i Carracci, studiando le sue pitture; vedendosi presso i disegni del Sereniss. Sig. Cardinale Principe Leopoldo, di mano di Lodovico la parte superiore della mentovata tavola della Badia [the *Coronation*], oltre il disegno tutta d' Orazio, più schizzi dalle sue cose cavati da Annibale; e non isdegnando Agostino di sua mano intagliata sotto il 1580." From this it appears all three Carracci were very interested in Sammacchini.

5 Boschloo 1972, p. 76, noted the relationship of this print to Annibale's c. 1596/1597 *Coronation of the Virgin* in the Metropolitan Museum. He mistakenly attributed the invention of the composition to Sabbattini and not Sammacchini.

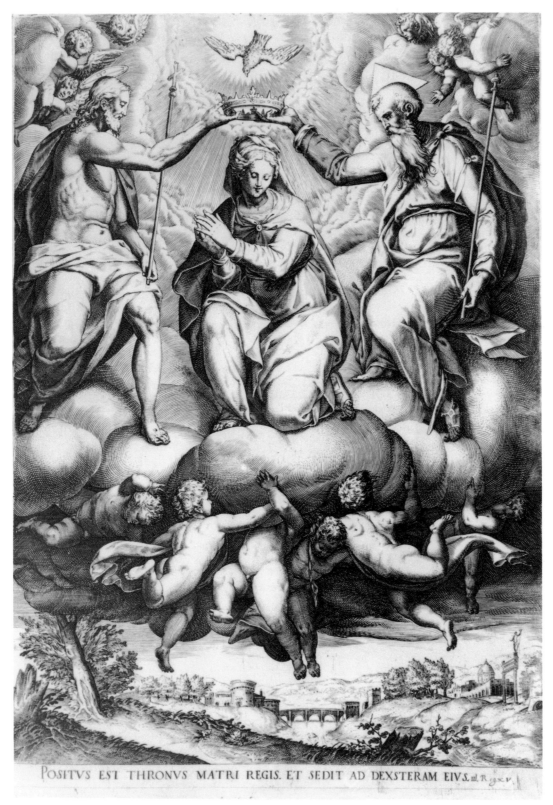

POSITVS EST THRONVS MATRI REGIS. ET SEDIT AD DEXSTERAM EIVS. III. Reg. x v.

cat. no. 33, only state. Vienna, Graphische Sammlung Albertina

fig. 33a. Orazio Sammacchini, *Coronation of the Virgin*. Florence, Gabinetto disegni e stampe degli
Uffizi (top left)

fig. 33b. Orazio Sammacchini, *Coronation of the Virgin*. Bologna, Pinacoteca Nazionale (lower left)

34

The Annunciation
(B. 7) c. 1579-1581

Engraving. 448 x 324 mm. (after Orazio Sammacchini)

Literature: Malvasia p. 76, note 3; Heinecken p. 629, no. 6; Nagler 1835, p. 395; LeBlanc 598; Pittaluga p. 344; Bodmer 1939, p. 128; Calvesi/Casale 15; Giampiero Cuppini and Anna Maria Matteucci, *Ville del Bolgnese,* 2nd edition, Bologna, 1969, p. 101, fig. 97, p. 345; Catherine Johnston, *Mostra di Disegni Bolognesi dal XVI al XVII secolo,* Florence, 1973, p. 28, under no. 12.

States:

	B	CC
I	–	–

Bottom left above margin: *Augustino Cremona fe.* (Alb)

	B	CC
II	1	–

With the words in state I burnished out and with inscription in margin: ET SVSCITABO DAVID GERMEN IVSTVM. JERE. XXIII. (Alb, Ber, Stu, U)

	B	CC
	2	1

With inscription in margin and signature of state I.

fig. 34a. Orazio Sammacchini, *Annunciation.* Forlì, Pinacoteca

Bartsch mistook the second state of this print for the first, not seeing that the inscription had been removed. Calvesi/Casale followed him in reporting the same state. Malvasia noted that the painting by Sammacchini which this print reproduces was in the church of the Suore degli Angeli in Bologna. The church no longer exists. There are two other paintings of the *Annunciation* by Sammacchini still extant. One of them, a fresco in the Villa Guastavillani in Bologna,[1] may be by a student of Sammacchini and is not the painting copied by Agostino.[2] The second painting in the Pinacoteca in Forlì (fig. 34a) is closer to the engraving, but only in the figures of the two protagonists. Extraneous detail and background have been altered in the engraving. Consequently, Agostino either may have used a preparatory drawing for this painting, or, as supposed by Malvasia, he may have worked after drawings for the lost painting in the Suore degli Angeli.[3]

However, it is this writer's opinion that Agostino was not working after Sammacchini's drawings at all but was interpreting another engraving after Sammacchini by Domenico Tibaldi (cat. no. R 54). As discussed in the catalogue entry to Tibaldi's engraving, it is obvious that these two prints are linked, one a copy of the other. It is almost impossible to recount which print is the earlier and which the copy, but since this is the signed engraving, it would appear that this sheet is by Agostino. If, as proposed here, this is the copy of the other print, it would be likely that Agostino's teacher was the author of the earlier engraving. As a Bolognese, Tibaldi would have had access to Sammacchini's drawings and to the painting itself. The contrast of light and shade in the folds of drapery, in the clouds depicted with their swelling lines, and in the deep shadows in this print are consistent with Agostino's other engravings after Sammacchini's work. On the other hand, in the print here attributed to Domenico Tibaldi (cat. no. R 54), the flattened surface pattern of crosshatching evident in the canopy of the bed, in the folds of the archangel's drapery, and in the clouds, using no swelling burin lines, is consistent with Domenico Tibaldi's burin technique in his signed prints.

Bodmer dated this engraving too early, c. 1577-1579. A date after 1579 is more consistent with our knowledge of when Agostino was in Tibaldi's studio.

1 Reproduced in Cuppini and Matteucci, p. 183, fig. 88.

2 See Cuppini for a discussion of the attribution of the fresco cycle in the chapel of the Villa Guastavillani.

3 There is a drawing by Sammacchini for the Virgin Annunciate for this painting in the Uffizi (Johnston, p. 28, no. 12).

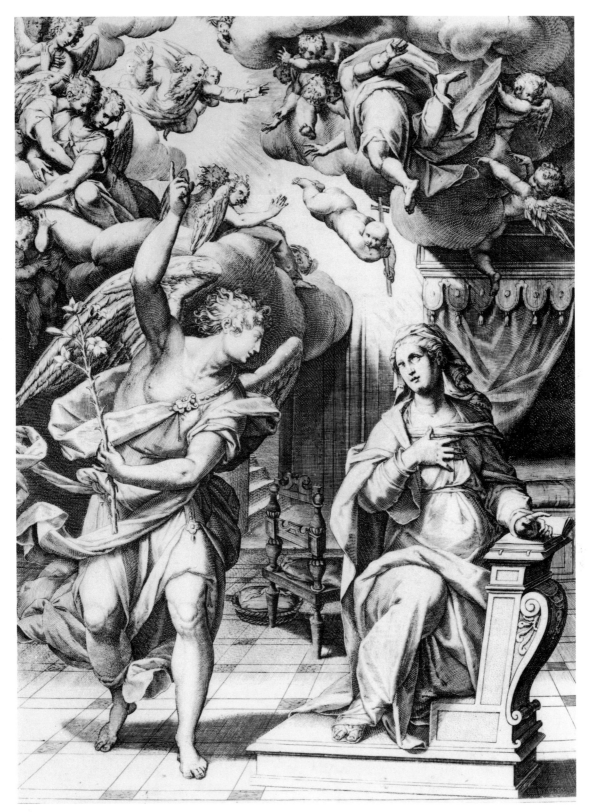

cat. no. 34, state II. Vienna, Graphische Sammlung Albertina

35

Judith with the Head of Holofernes
(B. 4) c. 1579-1581

Engraving. 304 x 229 mm. (after Lorenzo Sabbattini)

Literature: Malvasia p. 77 and note 5; Oretti p. 802; Heinecken p. 629, no. 3; Gori Gandellini p. 317, no. III; Nagler 1835, p. 394; Joubert p. 347; Nagler IV, no. 931; Bolognini Amorini p. 56; LeBlanc 4; Andresen 1; Foratti p. 167; Bodmer 1939, pp. 128-130; Calvesi/Casale 9; Bertelà 142; Maurizio Marini, "La 'Giuditta' del Sabatini," *I quaderni del conoscitore di stampe,* no. 28 (Sept.-Oct., 1975): 13-15.

States:

	B	CC
I	I	I

Lower left: *Laren. Sab: inve:* (Alb, Ber, Bo, U, and others)

Copies: 1. Engraving in same direction. 333 x 239 mm. Six lines (in two sections) of verses beginning with: IVDITHA . . . and ending with . . . *sit ubique Deus.* Probably seventeenth century. Deceptive. (BM).

Although Zanotti, in his notes to Malvasia, doubted it, only LeBlanc has cited this print as by an artist other than Agostino. There is no reason to doubt that the engraving is by Agostino and comes from the transitional period when he followed the style of his teacher Domenico Tibaldi and copied works by Bolognese mannerist artists.

Gori Gandellini reported that the painting by Sabbattini which Agostino reproduced belonged to the Bianchetti family in Bologna. The painting was lost until recently when it appeared in the Gabinetto delle Stampe in Milan (fig. 35a). According to their catalogue, it is the same painting which was in the Bianchetti collection.[1] The differences between the painting and engraving are slight in composition but great in concept.[2] Agostino removed the decorative design around the table to project a more sweeping diagonal into the composition. The figure of Judith has been developed plastically so that she is a larger presence than in the painting. But, the greatest change comes in her facial expression. In the painting, she faces us as if she has just carved a roast she is preparing for the daily meal. In Agostino's version, however, Judith becomes a sympathetic heroine whose kind expression belies the deed she performed. As in most of Agostino's reproductive prints, he here added a dimension of his own to the interpretation of the story.

1 It is not clear that this is the same painting that was formerly in the Bianchetti collection. The proof is rather sketchy in the catalogue entry. It has been suggested that the painting is a copy of the print, but this seems fallacious when contrasting the features with those in the print. There is a possibility that it is not the original but is a copy of Sabbattini's painting.

2 The engraving could reproduce a lost drawing by Sabbattini which was preparatory to the painting. This could account for some of the changes made from painting to engraving.

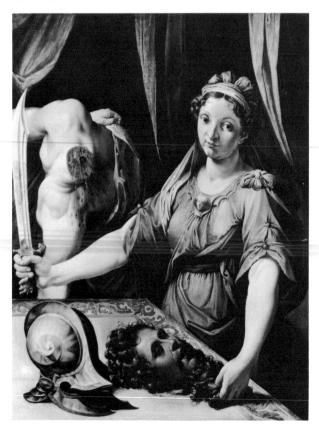

fig. 35a. Lorenzo Sabbattini(?), *Judith with the Head of Holofernes.* Milan, Gabinetto delle stampe

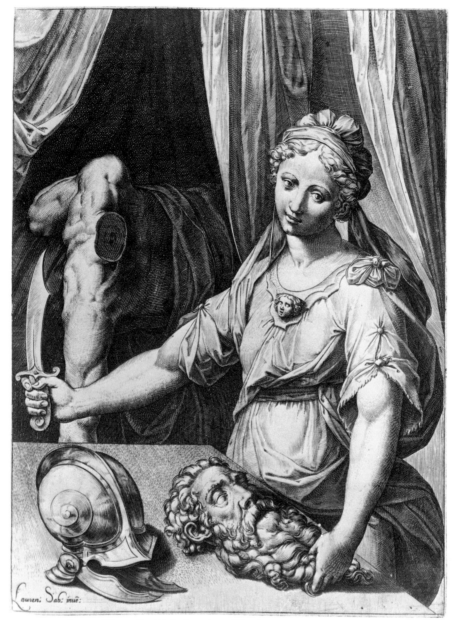

cat. no. 35, only state. Vienna, Graphische Sammlung Albertina

36

The Flagellation
(B. 18) c. 1579-1581

Engraving. 452 x 324 mm. (after Orazio Sam-
macchini drawing in the Rijksmuseum,
Amsterdam[1])

Literature: Heinecken p. 630, no. 17; LeBlanc
43; Nagler 1835, p. 395; Bodmer 1939,
p. 128; Calvesi/Casale 12.

States:

	B	CC
I	1	1
Before letters (Alb, U)		
II	2	2

In margin: CONGREGATA SVNT SVPER ME
FLAGELLA. *Tren.* XXXIII. (Alb, Br, Par, Stu)

Copies: 1. Engraving in same direction.
452 x 324 mm. Not all columns adorned with
rosettes as in original. Same inscription but
written differently. Below inscription is added:
Doloroso 2. (Alb) Very deceptive. (A second state
with *Gaspar Albertus Successor Columbus Formis*
[Alb].)

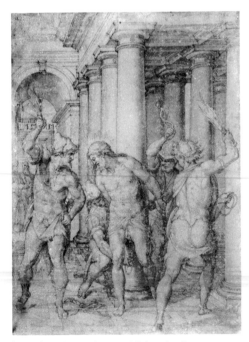

fig. 36a. Orazio Sammacchini, *Flagellation.*
Amsterdam, Rijksmuseum

Bartsch dated this print during Agostino's apprenticeship with
Domenico Tibaldi and suggested that the composition may have been by
Tibaldi himself. LeBlanc suggested that it might be after Pellegrino
Tibaldi, Domenico's brother. Since then critics have agreed that the
composition was invented by Denys Calvaert; his painting of the subject
is in the Galleria Borghese in Rome.[2] There is a drawing in Amsterdam
(fig. 36a), there attributed to Calvaert as a study for his painting in
Rome, which is the true source of Agostino's engraving. The drawing,
however, is not by Calvaert but by Orazio Sammacchini and could have
also been employed by Calvaert for his painting.[3] The figure of Christ is
by the same hand as the drawing of the *Redeemer* in the Uffizi by Sam-
macchini.[4] The use of lightly applied wash to indicate shading within
continuous contour lines is another characteristic of Sammacchini's
style.[5]

Agostino's print follows Sammacchini's drawing almost exactly. He
kept the same figures and all the architectural details. Shading follows
Sammacchini's exact pattern. An attribution of the engraving to Agos-
tino is fitting if one compares the figures at the right with the archangel
Gabriel in the *Annunciation* (cat. no. 34), also after Sammacchini. Both
Sammacchini's drawing and painting and Calvaert's painting are based
on Sebastiano del Piombo's *Flagellation* in San Pietro in Montorio in
Rome,[6] very well known in the late sixteenth century.

Dating of this print to the period 1579-1581 is based on the simi-
larity of lighting and burin technique to other prints after Orazio Sam-
macchini. One can note the likeness of the head of the figure on the
right to the lost profile of one of the two kneeling boys in the left of the
Presentation in the Temple (cat. no. 31).

1 Inv. no. A1402. 440 x 332 mm. Pen and ink and wash. Squared. (Medium known
to this writer only through photograph.)

2 Reproduced in Simone Bergmans, "Denis Calvart Peintre Anversois Fondateur de
l'Ecole Bolonaise," *Académie royale de Belgique Classe des Beaux-Arts Memoires,* 2nd series,
vol. 4, part 2, 1934, plate VI.

3 Compositionally drawing and painting are similar, although Calvaert changed the
number of columns in his painting as well as adding a figure behind the kneeling soldier
tying Christ. The background is also altered by different buildings and has only one
instead of two onlookers. It is not unusual to see two artists in Bologna working together
(or one after another's drawing) as here. Note for instance the painting of the *Holy Family
with Saint Michael* by Sabbattini and Calvaert (Annibale fig. 3a). Another painting of the
Flagellation by Calvaert, in the Pinacoteca Nazionale, Bologna, is less close composi-
tionally to the engraving by Agostino and not related to it (reproduced Andrea Emiliani,
La Pinacoteca Nazionale di Bologna, Bologna, 1967, no. 171). Sammacchini's painting of
the *Flagellation* in S. Salvatore, Bologna (photo in Witt Library) differs markedly from
his drawing. The figure at right is an exact replica of the one in the drawing, however,
and if a comparison is made between these figures and Calvaert's in his painting of the
subject, the morphological differences from Calvaert's work are apparent.

There is a pen and brown ink and wash copy of Sammacchini's drawing which,
according to a note on the photograph in the Witt Library, was sold at Sotheby Parke
Bernet, New York in 1970 (as Sammacchini), but a search of their records failed to turn
up the sale. The emphasis on contours in the drawing and lack of *sfumato,* apparent in
the Amsterdam drawing, suggests the Parke Bernet sheet is the copy. Sammacchini, on
the other hand, did repeat his compositions on occasion, as with the *Annunciation* (see
cat. nos. 34, R54). Calvaert is another candidate as the copyist, using the sheet for his
painting. Unfortunately, the author knows both drawings only in photographs.

4 See Catherine Johnston, *Mostra di Disegni Bolognesi* (Florence: Gabinetto Disegni e
Stampe degli Uffizi, XL, 1973), cat. no. 9, fig. 3.

5 See figs. 11a, 37a.

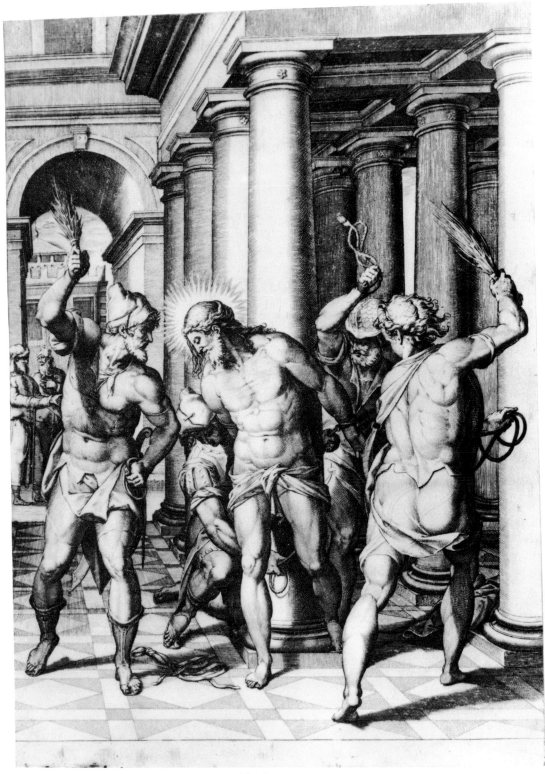

cat. no. 36, state I. Vienna, Graphische Sammlung Albertina

6 Reproduced Luitpold Düssler, *Sebastiano del Piombo* (Basel, 1942), pl. 35. In fact, all the paintings and drawings by both Sammacchini and Calvaert mentioned here (see note 3) are based on Sebastiano's painting.

37

Holy Family with Saint John the Baptist and an Angel
(B. 45) c. 1582

Engraving. 407 x 284 mm. (after Orazio Sammacchini drawing in Darmstadt[1])

Literature: Malvasia p. 76, note 4; Mariette ms. II, no. 38; Heinecken p. 632, no. 10; Gori Gandellini p. 314, no. XX; Joubert p. 344; LeBlanc 28; Bodmer 1939, p. 128.

States:

	B
I	I

As reproduced. No inscriptions. (Alb, Ber, BN, Dres, Windsor)

fig. 37a. Orazio Sammacchini, *Holy Family with Saint John the Baptist and an Angel.* Darmstadt, Hessisches Landesmuseum

Malvasia suggested that this engraving may have been a copy of a composition by Sammacchini or Sabbattini or perhaps an invention by Agostino himself. Bartsch indicated that Agostino was the inventor. There is a drawing in Darmstadt from which this print was taken, the composition reversed (fig. 37a). Although it is difficult to see if there were incisions on the drawing to transfer it to the plate, it is apparent that this was the final drawing used for the engraving. Dimensions are similar, and the forms transferred to the engraving are the same.[2] But, the morphology is slightly changed, and therefore Agostino could not have been the inventor of the composition. The drawing style is closest to Orazio Sammacchini: the very full-bodied forms and dramatic intensity of light and shade bespeak his hand. Moreover, the emphasis on the figures in relation to the background is typical of his style.[3]

Bodmer dated this engraving c. 1577-1579, during Agostino's earliest period. However, the advancement in the burin technique and the understanding of anatomy and relationship of the forms does not appear in Agostino until 1579 and after. This engraving could have been done anytime after that date, but it seems that Agostino did not concentrate on works by Sammacchini until after 1580. This interest declined after 1582, a year in which there are several prints after his works.[4] The increased interest in volume and light and shade suggests that this engraving comes at the end of Agostino's first period but before his trip to Venice in 1582.

1 Inv. no. AE 1474. 317 x 232 mm. Pen and brown ink and wash with white heightening on green paper.

2 The dimensions of the drawing are smaller than the engraving, but the composition is not complete in the drawing, which was obviously cut down.

3 Cf. e.g. Sammacchini's *Coronation of the Virgin* and *Assumption* (cat. nos. 33, 32) in which the monumental forms dwarf all else in the composition. There is a photograph in the Witt Library, London, of a painting of this composition attributed to Sabbattini, which was formerly in the Cavalieri Collection in Bologna. From the photograph it appears to be a copy of Sammacchini's lost painting and not an original composition.

4 E.g., cat. no. 54, dated in this year. Also see the controversial print signed by Annibale (Annibale cat. no. 2) which has in the past also been attributed to Agostino.

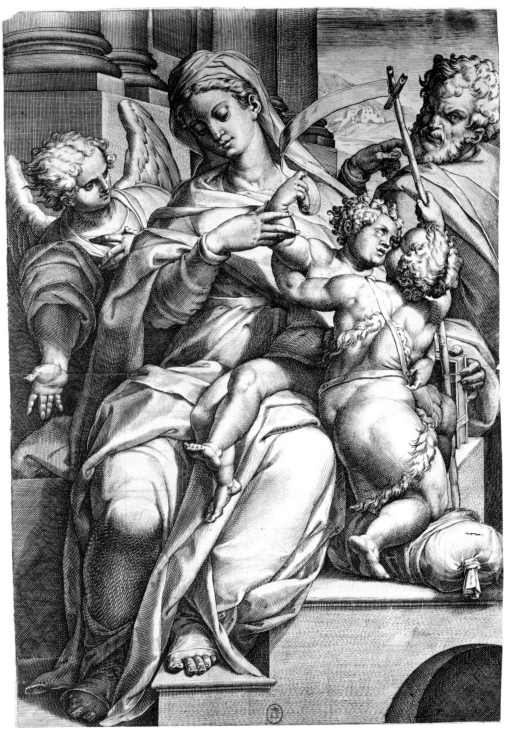

cat. no. 37, only state. Paris, Bibliothèque Nationale

38

Preparation for the Flight into Egypt
(B. 14) c. 1579-1581

Engraving. 293 x 224 mm.

Literature: Malvasia p. 78; Oretti p. 805; Heinecken p. 630, no. 12?; Gori Gandellini p. 314, no. XVII; Bolognini Amorini p. 56; Nagler 1835, p. 395; Mariette III, 81; Joubert p. 345?; LeBlanc 35; Calvesi/Casale 14; Bertelà 146.

States:

	B	CC
I	1	1

In margin two Italian couplets beginning with: *Per passar in egitto . . .* and ending with: *. . . il Salvatore.* (Alb, BN)

II	2	2

Lower right: *In Venetia, à s.^{ta} Fosca.* (Alb, Bo, MMA, Par, Ro)

Copies: 1. Engraving in reverse. 245 x 199 mm. (image: Par) No inscriptions. Deceptive.

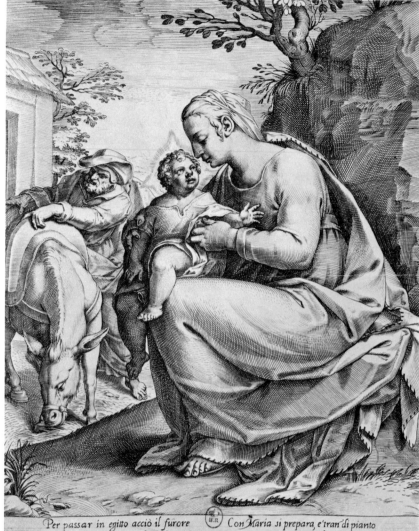

Per passar in egitto acciò il furore
D'Herode nõ s'addempia, il Vecchio santo

Con Maria si prepara, e'tran'di pianto
Se stessi, à noi saluando il Saluatore.

cat. no. 38, state I. Paris, Bibliothèque Nationale

Malvasia thought that this print was weak in design and therefore reflected Agostino's own invention. There is a possibility that this is Agostino's composition, but the large figure of the Virgin also recalls works by Lorenzo Sabbattini. If the composition is Agostino's, he looked for inspiration to Cornelis Cort's print of the same subject (fig. 39a) which he copied in another engraving (cat. no. 39). The print dates from the productive period between 1579 and 1581 when the artist experimented with his own designs as well as copying those of others. The features of the Child recall Christ's in the *Adoration of the Magi* after Marco del Moro (cat. no. 22).

39

Rest on the Flight into Egypt
(B. 15) c. 1581

Engraving. 281 x 199 mm. (after Cornelis Cort engraving after Bernardino Passari : Bierens de Haan 42)

Literature: Malvasia p. 79, note 3; Heinecken p. 633, no. 20; Gori Gandellini p. 319, no. XXVIII; Bolognini Amorini p. 57; LeBlanc 36; Nagler 1835, p. 395; Zani II, p. 34; Nagler I, no. 651; Bodmer 1940, p. 43; Calvesi/Casale 29; Bertelà 147.

States:

	B	CC
I	1	1

Lower left in grass: *Agu. fe.* Lower right: BER-NARDINVS/ PASSARVS/ IN. In margin: IOSEPH MONITVS IN SOMNIS AB ANGELO FVGIENS DVCIT/ PVERVM ET MATREM EIVS IN AEGIPTVM· MATTHÆ·II. (Alb, Bo, Br, Dres, Fitzwilliam Museum, Par, Stu)

Copies: 1. Engraving in reverse. 281 x 197 mm. Lower left: *Gio. maria Variana formis Genuae.* Same couplets below except for only one "T" in "MATTHAE" (Par). 2. Engraving in same direction. 274 x 185 mm. *Agu.fe.* Same inscription in margin. Below that lower left: *Avec priv. du Roy a la maniere* (something burnished out at this point). Lower center: *N-°-8-Se.* [?] [crossed out] Lower right: *de Paris chez M. Remondini.* Very good copy.

cat. no. 39, only state. Vienna, Graphische Sammlung Albertina

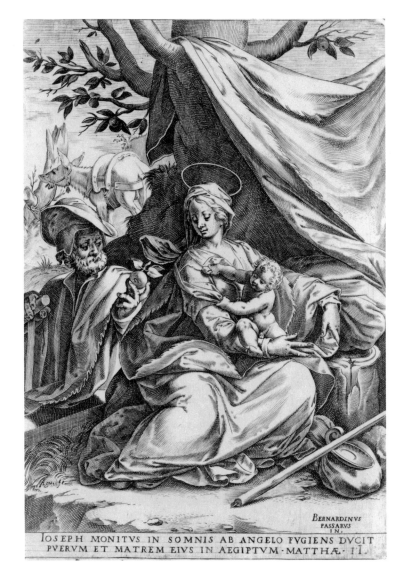

IOSEPH MONITVS IN SOMNIS AB ANGELO FVGIENS DVCIT
PVERVM ET MATREM EIVS IN AEGIPTVM·MATTHÆ·II·

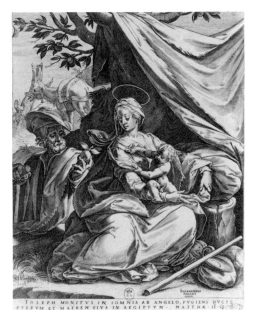

fig. 39a. Cornelis Cort, *Rest on the Flight into Egypt.*
Paris, Bibliothèque Nationale

This engraving reproduces almost exactly Cornelis Cort's engraving of 1576 (fig. 39a).[1] It is apparent that during this period Agostino's powers with the burin had reached a stage in which he could faithfully copy any print set before him. Although Agostino never worked with Cort, who died in 1578, there may be some truth to Malvasia's statement that there was a rivalry between them.[2] The young artist was trying to emulate the work of a distinguished and respected, successful engraver. With his early works after Cort and his print after Cort's *Madonna of Saint Jerome* (cat. no. 142), Agostino proved to the world that he was as proficient a technician as Cort. In this print and in the *Madonna of Saint Jerome,* the attempt is not to inject his own personality into the work, but rather to reproduce exactly the work of another.

1 Cort's print is 266 x 206 mm. The original composition by Bernardino Passari is unknown. There is a 1583 print by Passari of the *Rest on the Flight to Egypt* (Bartsch XVII, 36.70) which may give some idea of his earlier composition. Bodmer mistook the Bartsch number of the Agostino print as Bartsch 14.

2 Malvasia, p. 267: ". . . che perciò ingelositosene Cornelio, se lo cacciasse di bottega, ond'egli poi, per dispetto e vendetta, si ponesse a ritagliare nello stesso tempo opere che quello imprendeva, come avvenne dello Sponsalizio di S. Caterina e S. Girolamo, tavola in Parma del Correggio e simili. . . ."

40-49
The So-called Santini

Literature: See individual prints.

There has been much discussion as to the dating of the following ten prints, which visually and stylistically form a cohesive series. They are divided here into two groups according to border design and size. The first four prints (cat. nos. 40-43) vary only slightly in overall measurement, and each has a similar decorative border. In addition, they all have inscriptions in the margins and the indication that they were executed in Rome. The following six prints (cat. nos. 44-49), although not as closely knit a group, have characteristics in common and are discussed further under cat. no. 44.[1]

Although all critics have attributed these prints to Agostino, each has offered a different dating for them. Malvasia first recorded the prints as "Molti Santi, mezze figure di onc. 3 e mez o d'once tre in circa, tagliate per prova in gioventù venduti poi i rami dal Locatelli allo Stefanoni, che alterò loro l'anno, e vi aggiunse Romae."[2] Later he referred again to these works: "Le prime cose da lui tentate, come per saggio, furono certi Santini fatti in età di quattordici anni (ancorchè dallo Stefanoni mentito il millesimo, accrescendolo di molto) e la bella testa di bue. . . ."[3] Thus, Malvasia believed that these prints were executed in 1569 rather than 1581, as appears on the print of *Mary Magdalen* (cat. no. 40), and that Stefanoni altered the date and added the city of Rome. Calvesi/Casale also believed that Malvasia was correct in assuming that the date was altered, but asserted that the date was changed backward rather than forward. They assumed by the style ("pictoricism" as they called it) that Agostino must have executed these prints after his Venetian trip of 1582. Ostrow, on the other hand, correctly interpreted the inscription as meaning what it says: that Agostino made these prints in 1581 in Rome. Ostrow pointed out that there was space allowed on the prints (see cat. no. 41) for the indication of the city, and therefore it was not added at a later date by the publisher. Bodmer had also written that Agostino must have taken a trip to Rome in 1581 and executed the prints there.

Although Malvasia reported that Stefanoni had bought the prints from Locatelli and changed the date, there is no proof that this is so. On none of the ten prints is there a publisher's address; Malvasia alone asserted that Locatelli or Stefanoni owned the prints.

Although there is no signature on the first group of four prints (cat. nos. 40-43), they are stylistically connected with the following group of six prints, one of which carries Agostino's name in the second state (cat. no. 49). There is no reason to doubt the 1581 date of this print nor to doubt that Agostino took a trip to Rome in this year. Other engravings from the same year show that Agostino was interested in artists working in Rome, such as Raffaellino da Reggio (cat. no. 26).

These four prints are Agostino's first group of independent works of a nonreproductive nature in which he attempted to organize a composition and a series without the influence of major artists. It is true that his early print of *Christ and the Samaritan Woman* (cat. no. 21) and perhaps the *Preparation for the Flight into Egypt* (cat. no. 38) were his inventions, but these prints were based on a tradition of compositional techniques which Agostino learned from Cort and Bolognese mannerist artists. The *santini* are of a truly original nature. Thus, one understands Malvasia's hesitancy to ascribe them to this, in his opinion, late date of execution, when his technical proficiency was more advanced. But, if one accepts

the inscriptions as authentic, it becomes clear that Agostino's talents varied with each production. In this case, he was probably executing a series for devotional purposes and for commercial profit. Intricacy of execution may have been eschewed in favor of quantity of production. If he did produce these prints on a trip to Rome in 1581, a time element may have been involved: perhaps he needed the works completed quickly for the Roman market before he returned to Bologna. In any case, as noted by others, the care taken in these prints was slight. Yet, there is every reason to accept these prints as Agostino's: the sweetened facial expressions are typical of his prints of this period, and the awkward limbs and hands reappear in other prints attributed to him.[4] It is also apparent that in a simple devotional sheet such as this, Agostino did not attempt to use his increasing ability to plasticize forms by employing swelling lines and varying the kinds of burin strokes used. Instead, he executed these sheets in the simplest, and probably quickest, manner possible.

1 There is also a problem as to which are the *santini* discussed. Malvasia mentioned eleven prints, in two series of eight and three. Bartsch did not group the *santini*. Calvesi/Casale listed fifteen; Bodmer fourteen; and Ostrow four. Here the group is classed as ten (cat nos. 40-49), all of which must come from the same year and form a group.

2 Malvasia p. 84.

3 Malvasia p. 266.

4 Cf. cat. nos. 26-28, 38.

40*

Mary Magdalen
(B. 80) 1581

Engraving. 88 x 70 mm. (sheet: Br)

Literature: Malvasia p. 84; Heinecken p. 636, no. 60; Bolognini Amorini p. 59; Oretti p. 837; Mariette ms. II, 91?; LeBlanc 81; Nagler 1835, p. 396; Bodmer 1939, p. 136; Calvesi/Casale 48; Ostrow 20; Bertelà 200.

States:

	B	CC	Ost
I	I	I	I

In margin: SPECVLVM PENITENTIÆ. Below border center: ROMA 1581 (with 8 on its side). (Alb, BN, Bo, Br, Dres, Fitzwilliam Museum, MMA, Par)

See previous discussion.

*Engraving in exhibition from Graphische Sammlung Albertina, Vienna.

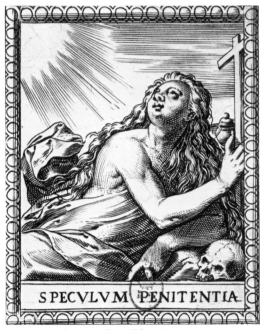

cat. no. 40, only state. Paris, Bibliothèque Nationale

41*

The Virgin Annunciate
(B. 30) 1581

Engraving. 87 x 81 mm. (sheet: Bremen)

Literature: Malvasia p. 84; Oretti p. 837; Heinecken p. 634, no. 32; Bolognini Amorini p. 59; LeBlanc 14; Bodmer 1939, p. 138; Ostrow 20C; Bertelà 30.

States:

	B	Ost
I	I	I

In margin: ECCE ANCILA DOMINI. *Roma.* (Alb, Ber, BM, BN, Bo, Br, Dres, Frankfurt, MMA, Par)

See previous discussion.

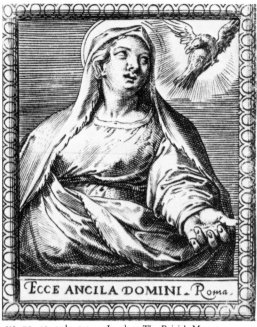

cat. no. 41, only state. London, The British Museum

42*

Ecce Homo
(B. 19) 1581

Engraving. 87 x 70 mm. (sheet: BM)

Literature: Malvasia p. 84; Oretti p. 837; Heinecken p. 630, no. 19 or 20; Joubert p. 344; Bolognini Amorini p. 59; Mariette I, pp. 311-312 and Mariette III, 85; LeBlanc 44; Bodmer 1939, pp. 138, 140; Calvesi/Casale 43; Ostrow 20-B; Bertelà 149.

States:

	B	CC	Ost
I	I	I	I

In margin: ECCE HOMO. *Roma.* (Alb, BN, Bo, Dres, MMA, and others)

Copies: 1. Engraving in reverse. 82 x 70 mm. In margin: ECCE HOMO. Contemporary. (BM). 2. Engraving in same direction. 131 x 98 (sheet) In oval. Below: *EG Sadeler fecit.* 3. Engraving by Vespasiano Strada? In reverse, with the figure of Pilate at left and showing more of the figures. (Bartsch XVII, 304.2) See below.

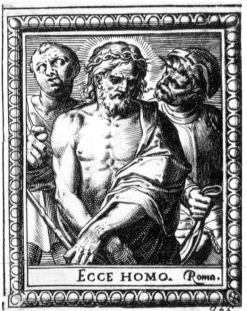

cat. no. 42, only state. New York, The Metropolitan Museum of Art, Harris Brisbane Dick Fund, 1926

Mariette, Bartsch, and Heinecken all believed that this print was a copy of a work by Vespasiano Strada; however, Ostrow pointed out that Strada (c. 1575/1582-1622) was at most six years old at the time.[1] Strada did do a similar print (Bartsch XVII, 304.2) which is larger than Agostino's, an expanded composition, and in reverse. It is probable that Strada's print follows Agostino's engraving (or that they each have a common source).

1 Bartsch gave a birth date of 1575, making the artist too young to have made a print which Agostino would have copied. Thieme-Becker gave a birth date as c. 1582. In any case, the Roman artist, who became a member of the Academy of St. Luke in 1604, supposedly died young. His first dated print is 1595. See Bartsch XVII, 302-303 and Thieme-Becker vol. XXXII, p. 148. This print by Strada (142 x 176 mm.), an etching, is signed: VESP. STR. I.F. indicating (I [nvenit] F [ecit]) that Strada was the inventor of the composition. This ascription of the design to Strada is obviously erroneous.

43*

Veronica Holding the Sudarium
(B. 89) 1581

Engraving. 88 x 72 mm.

Literature: Malvasia p. 84; Oretti p. 837;
Heinecken p. 636, no. 68; Bolognini Amorini
p. 59; LeBlanc 85; Bodmer 1939, p. 138;
Calvesi/Casale 49; Ostrow 20-A; Bertelà 207.

States:

	B	CC	Ost
I	1	1	1

In margin: SPECVLVUM SINE MACVLA. *Roma.*
(Alb, BN, Bo, Br, Dres, Fitzwilliam Museum,
Ham, MMA)

See previous discussion.

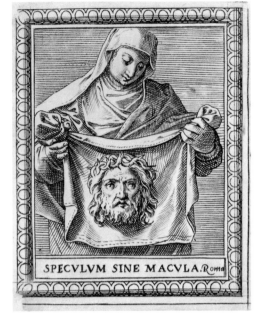

cat. no. 43, only state. New York, The Metropolitan
Museum of Art, Harris Brisbane Dick Fund, 1926

44

Saint Jerome
(B. 72) 1581

Engraving. 86 x 73 mm.

Literature: Malvasia p. 84; Oretti p. 837;
Heinecken p. 635, no. 43; Bolognini Amorini
p. 59; Mariette III, 122; LeBlanc 65; Bodmer
1939, p. 138; Calvesi/Casale 47; Bertelà 186.

States:

	B	CC
I	1	1

In margin: DOMINE EXAVDI *meā.* (Alb,
BM, BN, Bo, Br, Dres, MMA, Ro, and others)

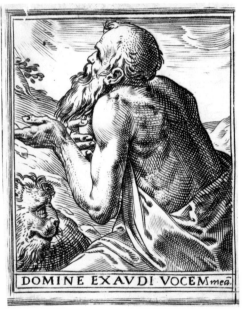

cat. no. 44, only state. London, The British Museum

This engraving forms part of a series of five prints (cat. nos. 44-48)
which are alike in size, subject matter, and borders. A sixth print (cat.
no. 49) differs slightly in size and lacks an inscription in the margin,
but in other respects can be included with them. As discussed earlier
(cat. no. 40), these prints were attributed by Malvasia to Agostino at the
age of fourteen, but they were in actuality executed in Rome in 1581.
The previous series carries the date 1581 and the city "Roma." On two
of the prints in this series the place name, "Roma," is also found. It is
therefore assumed that these prints were produced by Agostino on the
same trip to Rome as the 1581 series. Moreover, exclusive of border
type, these prints are very close technically and stylistically to the
others.

The sixth print (cat. no. 49), although slightly narrower than these, is alike in simplicity of composition, size, background, and subject matter. Stylistically, it must be classed with the others. That sheet of the *Holy Family* carries the inscription, in the second state: *Aug. Carax fe,* and it is on this basis that the entire group of ten prints has been attributed to Agostino Carracci. Stylistically, however, the authorship of the series can also be assigned to Agostino,[1] and with the date on the *Mary Magdalen* (cat. no. 40), one may class the entire group as by the same hand and executed during the same year.

1 See previous discussion of *santini* as a group.

45

Saint John the Baptist
(B. 71) 1581

Engraving. 86 x 75 mm.

Literature: Malvasia p. 84; Oretti p. 837; Heinecken p. 634, no. 37; Bolognini Amorini p. 59; LeBlanc 64; Bodmer 1939, p. 138; Calvesi/Casale 46; Bertelà 185.

States:

	B	CC
I	I	I

In margin: ECCE AGNIVS DEI: *Roma.* (Alb, BM, BN, Bo, Br, Dres, MMA, and others)

See cat. no. 44.

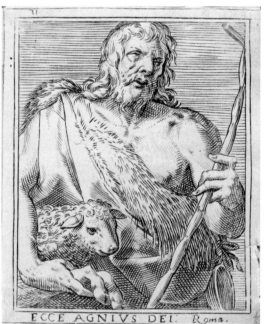

cat. no. 45, only state. New York, The Metropolitan Museum of Art, Harris Brisbane Dick Fund, 1927

46

Salvator Mundi
(B. 91) 1581

Engraving. 88 x 73 mm. (sheet: Bremen)

Literature: Malvasia p. 84; Oretti p. 837; Heinecken p. 634, no. 36; Bolognini Amorini p. 59; LeBlanc 89; Bodmer 1939, p. 138; Calvesi/Casale 50; Bertelà 209.

States:

	B	CC
I	I	I

In margin: SALVATOR MVNDI SALVA NOS. (Alb, Ber, BM, BN, Bo, Br, Dres, Ham, MMA)

See cat no. 44.

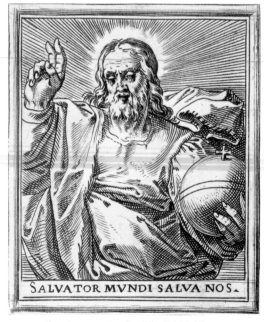

cat. no. 46, only state. London, The British Museum

47
The Madonna
(B. 29) 1581

Engraving. 89 x 76 mm. (sheet: Bremen)

Literature: Malvasia p. 84; Bolognini Amorini p. 59; Oretti p. 837; LeBlanc 13; Bodmer 1939, p. 138; Calvesi/Casale 44; Bertelà 156.

States:

	B	CC
I	1	1

In margin: ECCE ANCILA DOMINI *Roma.* (Alb, BM, BN, Bo, Br, Fitzwilliam Museum, Ham, MMA)

See cat. no. 44.

48
Body of Christ Supported by Angels
(B. 100) 1581

Engraving. 89 x 75 mm.

Literature: Malvasia p. 83;[1] Mariette ms. II, 58; Heinecken p. 631, no. 30; Mariette I, pp. 311-312; LeBlanc 49; Bodmer 1939, pp. 138, 140; Calvesi/Casale 51; Bertelà 214.

States:

	B	CC
I	1	1

In margin: MORS MEA VITA TVA. *Roma.* (Alb, Ber, BM, BN, Bo, MMA, and others)

Copies: 1. Engraving in reverse. 77 x 65 mm. Lower right: *A. Ca.* In margin: MORS MEA VITA TVA. (Alb) State 2 of this copy with: *C. Hulpeau ex.* before *A. Ca.* (Par).

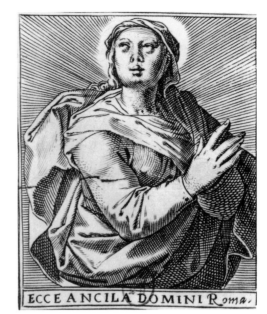

cat. no. 47, only state. Paris, Bibliothèque Nationale

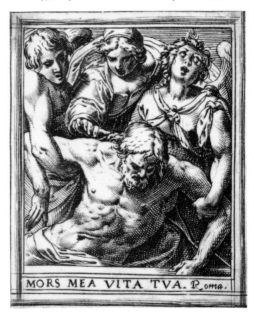

cat. no. 48, only state. London, The British Museum

LeBlanc is the only critic to have rejected this print, attributing it instead to an anonymous artist. Since it is part of the series discussed previously (see cat. nos. 40 and 44), it is acceptable as a print by Agostino executed in Rome in 1581. It has been suggested by Bartsch that this print reproduces a work by Vespasiano Strada, but since Strada was less than six years old in 1581,[2] Agostino obviously did not copy his work (Bartsch XVII, 304-305.4). As with cat. no. 42, there is a possibility that Strada's work reproduces Agostino's in reverse or that they come from a common source.[3]

1 Malvasia does not include this print in his group of *santini.* 2 See cat. no. 42, note 1.

3 Strada's print measures 181 x 138 mm. and is an expanded composition from Agostino's. Another figure is added, and Christ is supported above his tomb. In the lower left is VESPASIANO . ST[A] . I. F. As with cat. no. 42, Strada ascribed the invention of the composition to himself, either deceitfully or in the belief that his additions constituted a new composition.

49
The Holy Family
(B. 42) 1581

Engraving. 87 x 71 mm.

Literature: Heinecken p. 633, no. 18; LeBlanc 25; Calvesi/Casale 45; Bertelà 161.

States:

	B	CC
I	–	–

Without inscription. (BM, BN)

II	I	I

Lower left in margin: *Aug. Carax fe.* (Alb, Ber, BN, Bo, Dres, Fitzwilliam Museum, MMA, Ro)

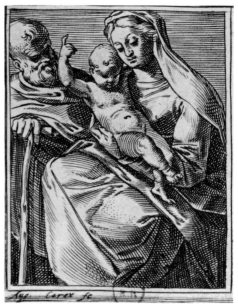

cat. no. 49, state II. Paris, Bibliothèque Nationale

Although the border and size is slightly at variance with the preceding five prints (cat. nos. 44-48), the composition, subject matter, and style indicate that this print belongs with the others. The features of the Madonna are much like others in this series. The signature does not come in the first state, but there is no reason to doubt that it was added during Agostino's lifetime, perhaps with the realization of the need for recognition. The sheet without doubt comes from the same year as the previous engravings and was also executed in Rome.

50

Saint Catherine of Alexandria
(B. 64) c. 1581

Engraving. 120 x 95 mm.

Literature: Heinecken p. 636, no. 63; Mariette ms II, 100; Nagler I, no. 1380; Bodmer 1939, p. 138; Calvesi/Casale 52; Bertelà 179.

States:

	B	CC
I	1	—

Without letters (Alb, BM, BN, Fitzwilliam Museum)

	B	CC
II	—	1

Lower left: *Aug. Car. fe.* Across top: s. CATARINA. (Alb, Ber, Bo, Ham, MMA, Par, and others)

	B	CC
III	—	—

As state II but with *Guidotti for./ in Bologna* lower right. (Achenbach, Balt, Br)

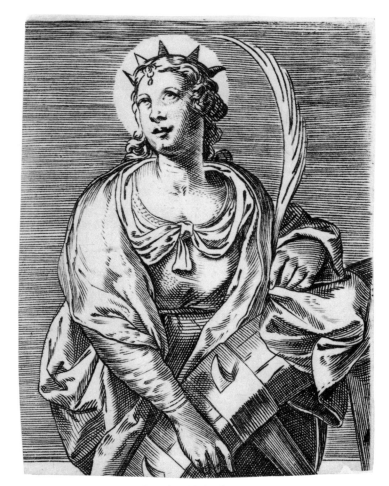

cat. no. 50, state I. Paris, Bibliothèque Nationale

Bartsch accepted this print and the following three as early works by Agostino. Bodmer correctly dated the sheets to 1581. Calvesi/Casale dated the prints c. 1582, after Agostino's trip to Venice, and discussed these sheets in relation to the previous ten prints (cat. nos. 40-49), which they believed showed a "pictoricism" inherent in the artist's work after the influence of Venetian art. On the contrary, these prints exhibit the same kind of simplicity of execution as the ten prints produced in Rome in 1581 and probably come from the same year and certainly were executed before Agostino's trip to Venice. There is no evidence of the abiding interest in light which pervades the artist's works after 1582. The awkwardness of the limbs, the lack of detail, the calmness of expression, and the simplicity of hatching link these works with Agostino's nonreproductive engravings of his earliest period. Although the signature was added in the second state, it was probably done so during Agostino's lifetime. State III was not pulled until the eighteenth century when Guidotti was active in Bologna.[1]

These four female saints form a series (cat. nos. 50-53). The backgrounds are alike; the saints appear half-length; haloes are similar except for the Magdalen's; and the measurements vary only slightly.

1 See Appendix I for information on Guidotti.

51

Saint Justina of Padua
(B. 77) c. 1581

Engraving. 128 x 96 mm.

Literature: Mariette ms. II, 98; Heinecken
p. 636, no. 66; LeBlanc 78; Nagler I,
no. 1380; Calvesi/Casale 58; Bertelà 196a.

States:

	B	CC
I	I	I

In margin: S. IVSTINA. (Alb, BM, BN, Bo, Br,
Dres, MMA, and others)

| II | – | – |

As state I but added below left: *Luigi Guidotti*
and below right *forma in Bologna*. (BM)

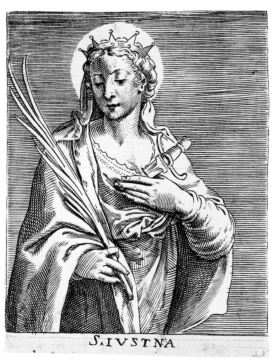

cat. no. 51, state I. London, The British Museum

This print forms part of the series of four female saints (cat. nos. 50-53)
as discussed in cat. no. 50.

52

Saint Lucy
(B. 79) c. 1581

Engraving. 122 x 94 mm.

Literature: Malvasia p. 84; Oretti p. 838;
Mariette ms. II, 93 (or 103?); Heinecken
p. 637, no. 71; Bolognini Amorini p. 59;
LeBlanc 80; Nagler I, no. 1380; Bodmer 1939,
p. 138; Calvesi/Casale 56; Bertelà 198.

States:

	B	CC
I	I	–

Without letters (Alb)

| II | – | I |

In margin: S. LVCIA. (Ber, BM, BN, Bo, Dres?,
MMA, and others)

| III | – | – |

In margin lower left: *Luigi Guidotti*. Lower
right: *forma in Bologna*. (Br, Milan: Raccolta
civile)

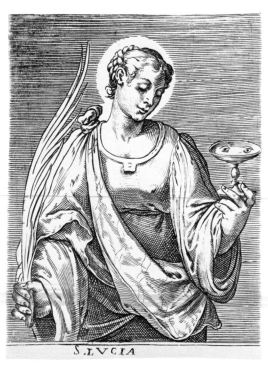

cat. no. 52, state II. London, The British Museum

This print forms part of the series of four female saints (cat. nos. 50-53)
as discussed in cat. no. 50.

53*

Mary Magdalen

(B. 81) c. 1581

Engraving. 124 x 92 mm.

Literature: Malvasia p. 84; Oretti p. 838;
Mariette ms. II, 106; Heinecken p. 636,
no. 59; LeBlanc 82; Nagler I, no. 1380;
Bodmer 1939, p. 138; Bodmer 1940, p. 71;
Calvesi/Casale 57; Bertelà 201.

States:

	B	CC
I	1	1

In margin: S. MARIA MADALENA. (Alb, Ber,
BM, BN, Bo, Dres, MMA, and others)

| II | — | — |

As in state I but with *Guidotti forma* lower left
in margin and lower right in margin: *in
Bologna.* (Br, Balt, Milan: Raccolta Civile,
PAFA)

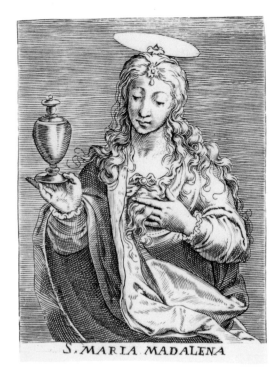

cat. no. 53, state I. London, The British Museum

See cat. no. 50.

54

Madonna and Child with Saints Peter, Stephen, and Francis
1582

Engraving. 322 x 235 mm. (after Orazio Sammacchini)

Literature: Gori Gandellini p. 317, no. VI?; Joubert p. 347; Calvesi/Casale 40.

States:

	CC
I	1

Lower left: *Horatius Samach?/ inve: 1582*. (Alb,[1] Dres, U)

| II | – |

Lower left: *Horatius Samach?/ inven./ In Venetia. à S.ta Fosca*. (Fogg)

| III | – |

1656 after *inven.* Lower right: *N°. 13* (Par)

| IV | – |

N°. 13 burnished out. (Stu)

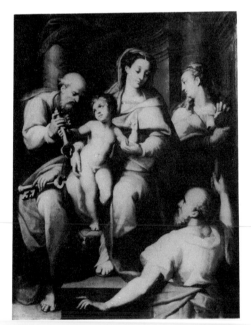

fig. 54a. Orazio Sammacchini, *Madonna and Child with Saints Peter, Joseph(?), and Mary Magdalen.* Modena, Galleria Estense

This engraving went unnoticed by Bartsch but was discovered by Calvesi/Casale in an impression at the Uffizi and attributed to Agostino.[2] They cited the closeness in style with the engraving of the *Holy Family with Saints John the Baptist and Michael* (Annibale cat. no. 2) which they attributed to Agostino. As will be discussed in the entry to that print, the styles, although similar, are divergent. It is true that the compositions are alike, but each is based on originals by the same artist, Orazio Sammacchini. Otherwise, the features are different[3] and the use of the burin varies. The use of dots is more prevalent in this sheet than in the print here attributed to Annibale. In addition, the network of hatching, especially in the folds of St. Peter's garment, is exactly like that in other prints of the pre-1582 period signed by Agostino.[4] The elegant figure of the Christ Child reappears later in Agostino's figures which flank the title of the *Vita di Cosimo de' Medici* (cat. no. 135).

This engraving most likely reproduces a preliminary drawing for Sammacchini's painting of the *Madonna and Child with Saints Peter, Joseph (?) and Mary Magdalen* in Modena (fig. 54a) or one like it. The figure of Mary Magdalen which appears in the painting has been altered to that of St. Francis in the print. St. Stephen in the engraving replaces the kneeling saint in the painting. The stocky figures of all the protagonists have been elongated and made more elegant; movement has been imparted to the composition by the shimmering use of light and shade.[5] The composition has been extended by the engraver at bottom, unless, of course, the painting in Modena was originally larger.[6]

1 The Albertina impression reproduced here has had the "2" of "1582" changed to an "8." It is in fact a "2."

2 Gori Gandellini and Joubert mentioned a print which could be this one: "La Madonna col Pargoletto Gesù, che dà le chiavi a S. Pietro (118), con altri Santi, *id. pinx. 1588. gr. in fol.*" (Gori Gandellini). The 1588 noted by each could have been misconstrued as was the one in the Albertina.

3 Note especially those of the Christ Child and Saint John. The concept of the babies' heads with their high foreheads in Annibale's print is far from the more mature Christ Child in Agostino's print.

4 Cf., e.g., those of the angel in *Tobias and the Angel* (cat. no. 26) and of both Jacob and Rachel in *Jacob and Rachel at the Well* (cat. no. 27).

5 This has been accomplished by the use of crosshatching for the dark areas, dots for intermediate areas, and the plain white of the paper for the brightest areas.

6 The author has studied this painting only in photographs and does not know its original size.

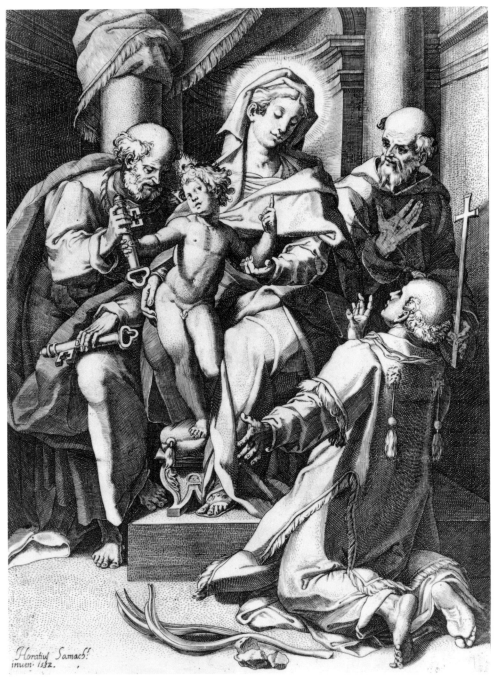

Horatiuſ Samach
inuen· 1582·

cat. no. 54, state I. Vienna, Graphische Sammlung Albertina

55

Portrait of Caterina Sforza[1]
1582

Engraving. 257 x 196 mm. (after Antonio Campi)

Unpublished.

States:
I

Around oval portrait: CATHERINA DE NOBILI SFORZA CO. DI SANTO FIORE. On pedestal at left: *Antonio Campo.* Below on pedestal: *Merta divin Poeta il suo valore/ Che 'l mondo infiora d'alte glorie è sante,/ Cosi à ritrar il nobil suo sembiante/ Converria studio di divin Pittore:* Center bottom on base of pedestal: *1582* (Alb, Cremona, Par)

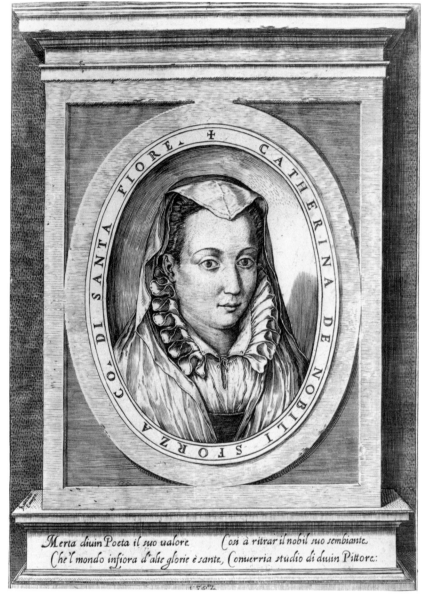

cat. no. 55, only state. Vienna, Graphische Sammlung Albertina

This hitherto unpublished portrait cannot be discussed separately from the portraits in the *Cremona Fedelissima,* which it resembles. The date of this print and the newly found date of 1582 on a first state of the title page of the *Cremona Fedelissima* change our view of when Agostino Carracci was working with Antonio Campi on his book.[2] It is now evident that Agostino began work on the *Cremona Fedelissima* in 1582 rather than 1583 or later. According to Malvasia, Agostino engraved the print of *Saint Paul Raising Patroclus* (cat. no. 108) to show his abilities in the hope of acquiring the large and important commission of illustrating the *Cremona Fedelissima.*[3] That print, however, is dated 1583, and by that year Agostino, with his prolific engravings after Venetian artists made during his trip to Venice in 1582,[4] had probably become a well-known printmaker definitely without need to prove himself. Moreover, if the commission for the book was for the production of portraits, it seems likely that Campi would have asked Agostino to engrave a portrait like

the ones he wished to adorn his volume. Consequently, this portrait of Caterina Sforza, a Milanese noblewoman like the Milanese portrayed in the *Cremona Fedelissima,* would have been the perfect trial proof made by Agostino to obtain the commission.[5] Not only is the representation of a similar personality, but the bust-length portrait, seen in three-quarter view set within an oval frame with an inscription, became the format for the series of portraits in the book.

Although the engravings for the *Cremona Fedelissima* were executed over several years time,[6] the idea was germinating as early as 1582 or before. The style of this portrait as well as the frontispiece to the volume indicate that Agostino began work on the book before his journey to Venice in 1582.[7] The finely executed burin work of the face with the strict parallel spacing and the juxtaposition of thinly placed dots is evident in Agostino's work while he was still under the influence of his teacher Domenico Tibaldi. The face even resembles that of the Madonna in Tibaldi's *Rest on the Flight into Egypt* (Bartsch XVIII. 12, 1; Introduction fig. G). In addition, the crinkly folds of the drapery are reminiscent of Tibaldi's drapery in the *Madonna of the Rose* after Parmigianino (Bartsch XVIII. 13, 3; Introduction fig. I). After Agostino's trip to Venice, this fading dependence on Tibaldi's style disappeared completely in favor of an increased interest in sharp contrasts of light and shade and a thickened burin line.

Although the engraving is not signed by Agostino, the style is definitely his and not that of his teacher Tibaldi. The small pinched lips, shy diffident expression, and fullness of the face are characteristics of Agostino's women, especially during his early period.[8]

With this unobtrusive portrait, Agostino's career as a famous portraitist and book illustrator was launched. Since he obtained the commission to illustrate the *Cremona Fedelissima,* it is obvious that Antonio Campi must have been pleased with this engraving.

1 Caterina Sforza (c. 1463-1509) was the illegitimate daughter of Galeazzo Maria Sforza and Lucrezia Landriani. She was legitimatized by her father. In 1477 she was married to Girolamo Riario, nephew to Pope Sixtus IV. This beautiful and cultivated woman was married a second time to Giovanni Pierfrancesco de' Medici in 1496/1497, to whom she bore a son in 1498, Giovanni dalle Bande Nere, from whom derived the granducal line of Tuscany.

2 The complete dating of this book is discussed in the following entry to the *Cremona Fedelissima.*

3 Malvasia p. 79.

4 See cat. no. 101 after Tintoretto and cat. nos. 103-106 after Veronese.

5 There is an eighteenth- or nineteenth-century inscription on the impression in Cremona (which is bound with the *Cremona Fedelissima*): *Fatto incidere dal Campi Antonio ad Agostino Carracci per prova dei ritratti della Sua storia di Cremona.*

6 Probably 1582 to 1584, as explained in the following catalogue entry.

7 Based on style, Ostrow believed that Agostino executed the title page after his trip to Venice. As will be explained in the following entry, this is doubtful.

8 Cf., e.g., the face of Judith in the unsigned print of *Judith with the Head of Holofernes* (cat. no. 35) and the Madonna in the *Madonna Dropping the Holy Girdle to Saint Thomas* (cat. no. 32), also unsigned. Neither print has ever been doubted.

56-92

Illustrations to the Cremona
Fedelissima
1582-1584

Engravings after various artists, mainly Antonio
Campi. 405 x 264 mm. average page size of
book.

Literature: Bellori p. 115; Malvasia p. 82, no.
2; Oretti p. 841; Mariette ms. 6; Heinecken
pp. 627-28; Gori Gandellini pp. 316-317, note
116; Cicognara 3977; Nagler I, no. 296(17);
LeBlanc 184-220; Nagler 1835, p. 399; Bolog-
nini Amorini p. 58; Foratti pp. 178-184;
Brunet I.1526; Pittaluga pp. 347-348; Bodmer
1940, p. 41; Graesse, II, p. 30; Marchesini p.
165; Erica Tietze-Conrat, "Notes on Portraits
from Campi's 'Cremona Fedelissima,'" *Raccolta
Vinciana,* vol. xvii, part 1, 1954, pp. 251-260;
Mostra-Dipinti p. 75, Calvesi/Casale 75-112;
Ostrow 33; Mortimer pp. 140 ff, no. 100; Bos-
chloo pp. 46, 202, note 22.

The *Cremona Fedelissima* was published in the house of its author Antonio
Campi in Cremona in 1585. The volume is made up of four books, the
first two detailing the history of Cremona until 1584 and the last two
relating the lives of the Dukes and Duchesses of Milan, the territory to
which Cremona belonged.[1] The book was dedicated to Philip II, king of
Spain, and its purpose was to glorify the city of Cremona, Campi's
birthplace.

Throughout the volume are numerous engravings: a title page, an
elaborate portrait of Philip II surrounded by personifications and coats of
arms of his territories, an allegory of the city of Cremona, the *carroccio* of
Cremona, and engraved portraits of the author and of thirty-two of the
rulers of Milan. As noted within each catalogue entry, most of the
portraits were engraved after drawings by Antonio Campi after effigies
available to him. Some of his drawings still exist (figs. 82a, 85a, 91a,
and 92a). There are also engravings of the Baptistery of Cremona, the
Duomo, a map of the city of Cremona, and a map of the surrounding
territory. Woodcut borders surround the pages, and woodcut initials are
found on various pages. Also, there is one portrait done on wood: that of
Ezzelino (on page 53) (fig. 56a).

Attribution of the engravings to Agostino has been traditional since
Bellori and Malvasia first discussed the volume.[2] Besides, on the errata
page found in most copies of this book is the attribution by the author:
"Ricercava la virtù d'Agostino Carazzi Bolognese, ch'io ne facessi
memoria in altro luogo,[3] nondimeno, poiche per inavertenza non mi è
venuto fatto, io non vo tacere quicii, che tutti i Ritratti, + il disegno
del Caroccio sono stati intagliati in Rame dal detto Carazzi, il quale è à
nostri tempi rarissimo in questa professione." Therefore, Campi himself
related that Agostino was the engraver of the portraits and the print of
the *Carroccio* (cat. no. 59). This leaves seven engravings unattributed in
Campi's acknowledgment, plus the woodcut borders, initials, and
portrait of Ezzelino (fig. 56a). The engravings of the maps of Cremona
and of the surrounding territory, usually following books three and four
are signed by David de Laudi of Cremona, and these are therefore not
cogent to the discussion here. The two prints of the Duomo and the
Baptistery, although unsigned, are of a harsh character akin to the maps
and could also be attributed to the engraver de Laudi, who is otherwise
unknown to us.[4] Moreover, in style they are unlike the three remaining
prints.

No one has doubted the attribution to Agostino of the title page
(cat. no. 56) and the *Portrait of Philip II* (cat. no. 57). And there should
be no reason to doubt these sheets as our artist's: the drapery, the burin
technique, the features of the protagonists are all typical of Agostino's
style, as is explained in the catalogue entry for each engraving. Calvesi/
Casale did suggest that the *Allegory of the City of Cremona* (cat. no. 58)
was not by Agostino but cited no reason for doubting it. It too falls
within the general stylistic type of Agostino before his trip to
Venice.[5]

Why then did Antonio Campi mention only the portraits and the
Carroccio as Agostino's? Since this acknowledgment comes only on the
errata page, it seems likely that it was added as an afterthought, perhaps
because by this period—1585—it was an asset to name the well-known
Carracci as the engraver of the prints in the book. On the other hand,
there is no good explanation for including the *Carroccio* and excluding
the other prints, unless it was assumed by everyone that the first three
prints were obviously of Agostino's style whereas it was more difficult to
tell he was the author of the portraits, not having executed any other

portraits at this period.[6] The *Carroccio*, too, differs in style from the previous three engravings.

The attribution of the woodcut initials, border, and portrait of Ezzelino have been attributed to Agostino only by Calvesi/Casale. They failed to notice the signature "GB" found on some of the initials.[7] It is probable that this craftsman-woodcutter designed the blocks and the initials and also did the portrait of Ezzelino. There is no stylistic basis for attributing the woodcuts to Agostino; nor do we have any reason to assume he ever did any woodcuts. There is a possibility that Campi had first intended to decorate his book with woodcut portraits instead of engravings but changed his mind after the project began. Woodcuts never would have lasted through the numerous printings of this volume, nor by the 1580s was it a popular form of illustration.[8]

Dating of the *Cremona Fedelissima* has been another much debated problem. The introduction by Campi is signed and dated January 2, 1585,[9] but in all known bound volumes of the work the title page carries a date which appears at first to have been 1583 changed to either 1585 or 1586. The unaltered date is not found on any bound edition. Yet, numerous writers have claimed that there is an edition of the *Cremona Fedelissima* from the year 1582.[10] There is other evidence to indicate the project was conceived at least this early: the map by de Laudi of Cremona is dated 1582, and the map of the territory of Cremona is dated 1583.[11]

Although no bound edition of the 1582 volume has been located, this writer has found a first state of the title page in the Bibliothèque Nationale in Paris (cat. no. 56) with the date 1582. It may have been this sheet which was known to Brunet and others, yet none of them mentioned that the title was also changed in the second state from "Cremona/Citta Fedelisima" to "Cremona fedelisima . . ." (see reproductions). It is apparent then that Agostino had been working with Campi as early as 1582[12] and that the title page may never have been bound in an edition until after January 2, 1585 when Campi signed his dedication. At that time, it was probably decided to alter the date (as well as the title) from 1582 to 1585.[13]

Is it possible that Agostino engraved this title page after his trip to Venice, or was he in Cremona working with Campi previous to this journey, which was to affect his style so drastically and change the course of his work? Although Ostrow believed that the style of these engravings bespeaks a trip to Venice, there does not seem to be any specific influence from Venetian art. In fact, the overall tonal gradations are consistent with the prints produced up until this time. Especially notable is the continued influence of Cornelis Cort on the *Allegory of the City of Cremona*. There is no overall use of swelling lines in these prints, yet after Agostino's journey to Venice, this technique becomes prevalent. Moreover, the simplicity of lines—e.g., the use of fewer lines, a larger burin, and more widely spaced strokes—becomes a hallmark of the artist's style after 1582. The result, of course, is a style in which the white of the paper plays a prominent role, and the great contrast of light and shade produces more dramatic renderings.[14] One must therefore conclude that Agostino, whose first portrait connected with this book (cat. no. 55) is definitely pre-Venetian, began the series of engravings for the *Cremona Fedelissima* before his trip to Venice.

If Agostino began the prints in 1582, when were they completed? This is extremely hard to judge due to the standard form of the portraits

and the variety in quality. It is this writer's opinion, however, that the four nonportrait prints by Agostino (cat. nos. 56-59) and the *Portrait of Antonio Campi* (cat. no. 60) were executed toward the beginning of the period 1582-1584. It is not possible to approximate dates within this period for the other portraits due to the uniformity of type. When quality varies, it may not be due so much to development as to haste or lack of care with which some were made. Moreover, the originals from which the prints were taken may also have varied in quality. One can only conclude from the evidence available that Agostino took part in the project from before his trip to Venice in 1582 until 1584 when the last of the names of the council in Cremona are listed.[15]

1 Mortimer catalogued and explained fully the pagination, etc. of the Harvard copies of the book. A fifth book on the religious men and churches of Cremona was never completed. See Mortimer pp. 140-141.

2 Malvasia: "Così non dico già, nè protesto de' rami che di sua mano si veggono nell'Istoria di Cremona (1), composta dal famoso pittore Anton Campi, ancorchè tanto tassati e biasimatigli da quell'Autore per troppo grossolani di taglio, e negligenti; e perciò lodatigli, e preferitigli que' di David de' Laudi Ebreo, che le cose più infime, e senza muscoli gl'intagliava; cioè le piante di quella Città e del Contado, il Duomo, il Battisterio, e 'l Campanile; fin che intagliandogli poi il suo proprio ritratto così sottile e sullo stile del suo paesano Marco Antonio, che altro mai non facea che commendargli, lo facesse ricredere della sua erronea opnione. Sono questi 33. ritratti, compresovi anche quello dell'Autore del libro, e senza quello in legno di Ezelino, che per brevità non nomino, bastando solo il dire la misura, che è in ovato di onc. 4. e 3. quart. onc. 3. e mez. gagl. per dirit. acciò incontrandosi in qualcun di essi, che più volte ho veduto separati nelle raccolte, si sappia non esservi tutti, ed esser porzione della storia di Cremona, a' quali aggiunge il cagione, gli altri tre più importanti rami, cioè il superbo frontispicio del libro, le due susseguenti bellissime Virtù, che coronano il medaglione di Filippo II. Re delle Spagne, con Bellona, o Cremona che sia, con sotto li tre fiumi, il Po, l'Adda e 'l Tesino, disegni tutti del Campi." Only Heinecken, without reason, suggested that some of the portraits were engraved by Annibale. Calvesi/Casale believed that Agostino did not engrave the *Allegory of Cremona* (cat. no. 58).

3 It is not known where else Campi referred to Agostino as he said here.

4 The print of the territory of Cremona is signed: DAVID DE LAVDE/ HEBREVS CREMONE./ INCIDI. The print of the city of Cremona (cat. no. R51) is signed: *David de Laude Crem. Incid.*

5 That is, the emphasis has not shifted from neutral tones to strong contrasts of light and shade, and the burin work is not as thick and is simpler than it was before the trip. Further explanation is made in cat. no. 56 as to the attribution to Agostino.

6 Except for the 1584 portrait of Bernardino Campi (cat. no. 127), which may have been contemporaneous with the completion of this book.

7 "GB" is found on pages 102, 106, 112, and 118 of book four. The woodcuts have been repeated often. The border design is repeated on every page.

8 See Francesco Barberi, *Il frontespizio nel libro Italiano del quattrocento e del cinquecento* (Milan, 1969), 48, 107 for an explanation of the change which occurred about mid-century from the prevalent use of woodcut illustrations in Italian books to the almost exclusive use of engraved illustrations. The reasons were twofold: first of all, the newer art of engraving was more adaptable to detailed illustration, and the plates could be used over and over again. When they wore out, they could be recut (see cat. no. 1).

9 Found on the second page following the *Allegory of the City of Cremona*.

10 Brunet and Graesse mentioned editions of 1582. Bodmer also cited a 1582 edition but said that the only published edition was 1585. It seems rather that the title page and the earlier engravings were produced c. 1582 and that the only edition published was that of 1585, bound only after the title page had been altered to agree with the publication date.

11 These maps are found usually following books three and four.

12 As is also evidenced by his trial engraving of the *Portrait of Caterina Sforza* (cat. no. 55) for this book.

13 Therefore, the prints which are not dated must fall within the period 1582-1584 if the book was dedicated at the beginning of 1585.

14 Cf. especially Agostino's print after Federico Barocci dated 1582 (cat. no. 98) which bears all these characteristics. Also evidencing this change is the *Crucifixion* after Veronese (cat. no. 107).

15 *Cremona Fedelissima*, pp. lxxvj-lxxvij of book three.

56*

Title Page to the Cremona Fedelissima: *Allegory in Honor of Philip II*
(B. 192) 1582

Engraving. 314 x 193 mm. (after Antonio Campi)

Literature: Bellori p. 115; Heinecken p. 643, no. 3; Oretti p. 841; Gori Gandellini p. 316, no. LV; Pittaluga p. 348; Bodmer 1940, p. 42; Calvesi/Casale 75; Ostrow 33; Francesco Barberi, *Il frontespizio nel libro Italiano del quattrocento e del cinquecento* (Milan, 1969), 84, 141-142.

States:

	B	CC	Ost
I	—	—	—

In title box: CREMONA/ CITTA FEDELISSIMA ET NOBILISSIMA COLONIA DE ROMANI/ D'VNA BREVE HISTORIA DELLE PIV SEGNALATE COSE DI QVELLA/ ILLVSTRATA ET IN DISEGNO CON DILIGENZA RAPPRESENTATA/ DA ANTONIO CAMPI CREMONESE/ AGGIVNTOVI LE VERE EFFIGIE DE'DVCHI ET DVCHESSE DE MILANO DAL/ MEDESIMO AVTTORE RITRATTE CON VN COMPENDIO DELLE VITE L'ORO/ AL PONTISSIMO ET FELLICISSIMO/ RE DI SPAGNA/ FILIPPO II. D'AVSTRIA. In tablet: PHILIPPO/ II./ AVSTRIACO/ HISPANIARVM/ CATHOLICO/ REGI/ MAXIMO/ S. Lower center on base of pedestal: IN CREMONA IN CASA DELL' ISTESSO AVTTORE./ 1582. (BN)

	—	I	I

Same as state II but date reads 1582 or 1583.

II	I	2	2

In title box: CREMONA FEDELISSIMA CITTA. ET NOBILISSIMA/ COLONIA DE ROMANI RAPPRESENTATA IN DISEGNO COL/ SVO CONTADO. ET ILLVSTRATA D'VNA BREVE HISTORIA/ DELLE COSE PIV NOTABILI APPARTENENTI AD ESSA./ ET DE I RITRATTI NATVRALI. DE DVCHI. ET DVCHESSE/ DI MILANO. E COMPENDIO DELLE LOR VITE/ DA ANTONIO CAMPO PITTORE E CAVALIER CREMONESE/ AL POTENTISSIMO. E FELICISSIMO/ RE DI SPAGNA/ FILIPPO II. D'AVSTRIA. Lower left on pedestal: ANT. CAM. IN. Date has been mutilated to read 1585 or 1586. (Alb, BM, BN, Bo, Dres, LC, and many others)

Copies: 1. Engraving in same direction. 225 x 147 mm. *Blanc Inc.* at step left. On step: IN MILANO IN CASA DI GIO. BATTISTA BIDELLI. MDCXLV. Instead of dedication to Filippo II, dedicated to Filippo IIII. This is the title page for the edition published in Milan in 1645. (Houghton, LC, and others). See Mortimer p. 141.

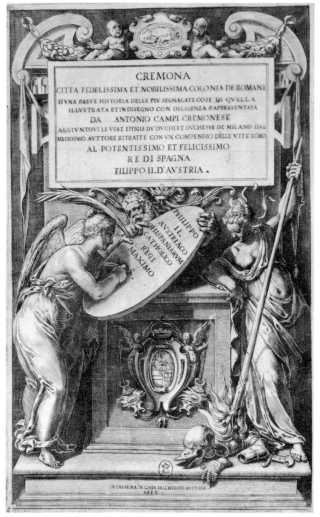

cat. no. 56, state I. Paris, Bibliothèque Nationale

Two female personifications (Fame and Peace) lean upon a pedestal, and a male personification holds a tablet upon which Fame writes the name of Philip II. At right Peace destroys the arms of war. These figures are not contained within a prearranged boxlike space but appear as living allegories. The title page, according to Barberi, is the first such tableau in the history of art and leads to the more realistically rendered frontispieces of the seventeeth century.[1] Previous to this engraving, frontispieces and title pages were separated from the viewer by decoration and were themselves made to appear as tablets. There was no indication of action taking place on a stage, only static figures presenting the title to the viewer. Barberi attributed this change to Agostino, marking him as a forerunner of the baroque style of book illustration. However, Agostino cannot be credited with this important and drastic change in title page illustration, for the inventor of the composition was not Agostino but Antonio Campi. Therefore, Campi was the first artist to look ahead to a new kind of frontispiece type.

Stylistically, this print must be attributed to Agostino Carracci. The two *putti* which support the cartouche above the title appear in Agostino's *Print for the Confraternity of the Name of God* (cat. no. 100) of the same year. They also have diminutive relatives in the *Arms of Cardinal Fieschi* (cat. no. 30) and the *Frieze to Accompany a Map of the City of*

detail, cat. no. 56, state I

detail, cat. no. 56, state II

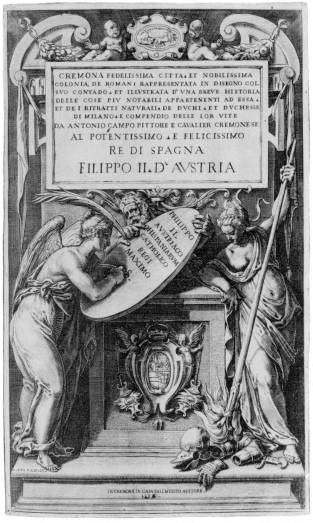

cat. no. 56, state II. Washington, Library of Congress, Rosenwald Collection

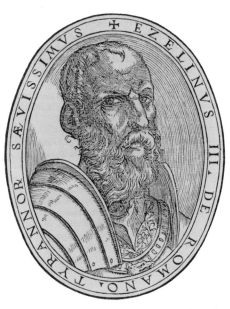

fig. 56a. Anonymous artist, *Portrait of Ezzelino*. Washington, Library of Congress, Rosenwald Collection

Bologna (cat. no. 29), both from c. 1581. The male allegorical figure holding the tablet is a type first encountered in 1576 in the *Holy Family* (cat. no. 3) and apparent in many of the prints of the apostles of 1583 (cat. nos. 109-123). The engraving technique in which dots and short strokes are used to indicate tonal differentiation is typical of Agostino before he traveled to Venice in 1582. The closely spaced curvilinear burin strokes on the helmet below recur in many of the portraits in the *Cremona Fedelissima* securely by Agostino[2] and afterward in portraits such as the *Portrait of a Man* (cat. no. 144) and the *Portrait of Giovanni Battista Pona* (cat. no. 175). This kind of technique was employed by Agostino to give a rich depth to his dark areas; the curvilinear, disconnected strokes concomitantly adding a shimmering appearance to the surface.

1 Discussion of frontispiece and title page types is found in the Introduction. Barberi is the best source for an understanding of the development of frontispieces in Italian book illustration of the sixteenth century. See also his articles, "Derivazioni di Frontespizi," *Contributi alla Storia del libro italiano: Miscellanea in onore di Lamberto Donati* (Florence, 1969): 27-52 and "Frontespizi italiani incisi del Cinquecento," *Studi di Storia dell'Arte Bibliologia ed Erudizione in Onore di Alfredo Petrucci* (Milan and Rome, 1969): 65-74.

2 As noted in the discussion to the *Cremona Fedelissima*, the portraits were attributed to Agostino by Antonio Campi on the errata page of the book.

57

Portrait of Philip II
(B. 195) 1592

Engraving. 353 x 224 mm. (irregular plate)
(after Antonio Campi)

Literature: Oretti p. 841, Bodmer 1940, p. 42;
Calvesi/Casale 76.

States:

	B	CC
I	–	–

Before the inscription lower right: ANT. CAM.
IN. (BN)

II	I	I

As reproduced with this inscription (Alb, BM,
Br, Dres, LC, and others)

cat. no. 57, state II. Washington, Library of Congress,
Rosenwald Collection

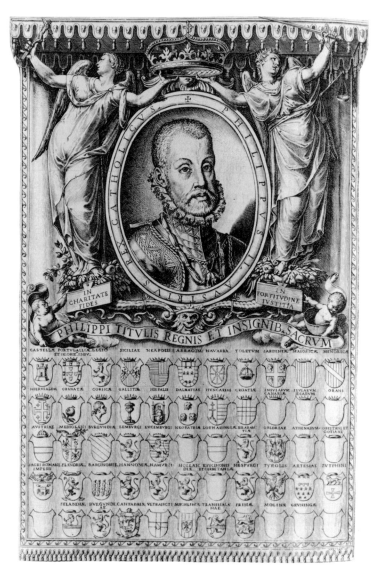

The portrait of Philip II is found on the verso of cat. no. 56, the title
page to the *Cremona Fedelissima* in all examples studied. The first state,
found at the Bibliothèque Nationale on the verso of state I of the title
page, lacks the attribution of the invention to Antonio Campi as does
state I of cat. no. 56. It is assumed that both prints were made about the
same time and that each was given the inscription prior to the edition of
1585.

 The style of the print is analagous to that of the title page and was
thus probably executed before Agostino undertook his journey to Venice.
As on the title page, the personifications of Justice and Faith, which
flank the oval portrait of Philip II, are part of a tableau which extends
into the viewer's space rather than being separated from us by a border.

 In later states of this print, found in seventeenth-century editions of
the book,[1] a different portrait of Philip II has been substituted, which is
the one found on page 112 of the 1585 edition (here cat. no. 88).
Bartsch misinterpreted this portrait as being a separate engraving and
gave it another number (B. 224), when, in actuality, the plate from cat.
no. 88 was superimposed on the portrait of Philip in the oval.

1 The Bidelli edition, Milan, 1645. See Mortimer p. 141.

58

Allegory of the City of Cremona
(B. 193) 1582

Engraving. 348 x 216 mm. (after Antonio Campi)

Literature: Oretti p. 841; Heinecken p. 640, no. 6; Calvesi/Casale 77; Ostrow 33-A.

States:

	B	CC	Ost
I	I	I	I

Lower right: ANT: CAM: IN. Other inscriptions plus inscription in margin. As reproduced. (BM, Br, Dres, LC, MMA, and others)

cat. no. 58, only state. Washington, Library of Congress, Rosenwald Collection

This is the only print which Calvesi/Casale did not attribute to Agostino from this volume. There seems no justification for this rejection. The tiny bowed mouth of the figure of Cremona and her wide-eyed expression are characteristic of Agostino's works. The technique employed for the representation of the composition is based on Cornelis Cort's works, a continuous influence on Agostino before his trip to Venice. Ostrow dated this sheet about 1583, assuming that the compositional prints after Campi and the beginning of the project dated from this year. Since we now know for certain that the project was conceived and begun by 1582, this print must also belong to that era.[1] The influence of the Venetian artists is not apparent here, as suggested by Ostrow.

1 See previous discussion.

59

The Carroccio *of Cremona Led Into Battle*
(B. 194) 1582

Engraving. 182 x 190 mm. (after Antonio Campi) Found on page 13, book two, of the *Cremona Fedelissima.*

Literature: Oretti p. 841, Heinecken p. 637, no. 3; Bodmer 1940, p. 42; Calvesi/Casale 79; Ostrow 33-B.

States:

	B	CC	Ost
I	I	I	I

In margin: *Forma educendi* CARROCIVM *in hostes: quod olim Italiæ ciuitatibus familiare fuit: Ant ÷ Cam in:* (Alb, Br, Dres, LC, and others)

Antonio Campi attributed this print, along with the portraits in the *Cremona Fedelissima,* to Agostino on the errata page of the volume.[1] A similar style of landscape rendering appears in Cornelis Cort's prints which Agostino would have known.[2] The rendering is extremely simple and merely illustrative; it appears that little care was taken with the rendering.

A *carroccio* was a wagon drawn by oxen, which would carry a cross, priests, warriors, and be followed by trumpeters. It was supposedly a representation of the Ark of the Israelites, around which an Italian city or commune would rally. They were known in many Italian cities. The idea was devised by Ariberto, the archibishop of Milan, in 1039 to give the army a tangible object to defend for the city. In war, it would lead the battle; in peace, it would be used as a kind of float to carry distinguished visiting personages through the city.[3]

1 See previous discussion in introduction to cat. nos. 56-92.

2 See especially the landscape series by Cort, Bierens de Haan 248-289.

3 This information is found in Edith E. Coulson James, *Bologna: Its History, Antiquities and Art* (London, 1909). She reproduces opposite p. 118 an illustration of the *carroccio* of Bologna which appears to be a nineteenth-century watercolor copy of Agostino's engraving.

Forma educendi CARROCIVM *in hoftes; quod olim Italiæ ciuitatibus familiare fuit:* Ant: Car:ia:

cat. no. 59, only state. Washington, Library of Congress, Rosenwald Collection

60

Portrait of Antonio Campi
(B. 196) 1582

Engraving. 147 x 115 mm. (oval) (after Antonio Campi)

Literature: Calvesi/Casale 78.

States:

	B	CC
I	I	I

Around oval: ANTONIVS CAMPVS EQVES PICTOR. ET ARCHITECTVS. CREMONENSIS (Br, Dres, LC, and others)[1]

Copies: Engraving in reverse, 199 x 143 mm. Same inscription. A rectangular plate. Around the oval is floral decoration. Found in the 1645 Bidelli edition of the *Cremona Fedelissima.* See Mortimer p. 141.

Bartsch related that Agostino engraved this in a very fine manner because Campi complained continually about the lack of quality exhibited in the portraits. Calvesi/Casale assumed that the print was after a self-portrait by the author, as well it might be. There seems to be no basis for Bartsch's argument that Campi was unhappy with Agostino's work on the book. After all, he did credit him on the errata page for the portraits and in so doing lauded his ability as an engraver.[2] The fine burin work leads us to conclude that this was engraved before Agostino went to Venice when his engraving technique became bolder.

1 Locations of cat. nos. 61-92 are the same as cat. no. 60.

2 See previous discussion.

61

Portrait of Oberto Palavicino
(B. 197) 1582-1584

Engraving. 149 x 113 mm. (oval) (after Antonio Campi) Found on page 46, book three, of the *Cremona Fedelissima.*

Literature: Calvesi/Casale 80.

States:

	B	CC
I	I	I

Around oval: VBERTVS MARCHIO PALAVICINVS DOMINVS ET POTESTAS CREMONÆ AC PLACENCIAE.

Campi said that his effigy of Oberto Palavicino was taken from a fresco in a loggia in the Rocca di Cortemaggiore.[1] Palavicino, who died in 1269, was a head of a Ghibelline faction in Lombardy and Emilia in the thirteenth century. A member of a feudal family which ruled Piacenza, Parma, and Cremona, he was *podestà* of Cremona and Piacenza and fought with Ezzelino (fig. 56a) against the Guelphs. In 1254 he was excommunicated. From 1260- c. 1265 he was *signore* of Milan but without a power base. He was then overthrown and reduced to ruling only Borgo S. Donino.

1 *Cremona Fedelissima,* book three, p. 46.

62

Portrait of Bosius Dovaria
(B. 198) 1582-1584

Engraving. 147 x 113 mm. (oval) (after Antonio Campi) Found on page 57, book three, of the *Cremona Fedelissima.*

Literature: Calvesi/Casale 81.

States:

	B	CC
I	I	I

Around oval: BOSIVS DOVARIA DVX STRENVVS ET CIVIS PRIMARIVS CREMONAE.

Antonio Campi related that the original of this portrait was in his studio.[1] According to the inscription, Dovaria was one of the first citizens of Cremona.

1 *Cremona Fedelissima,* book three, p. 57.

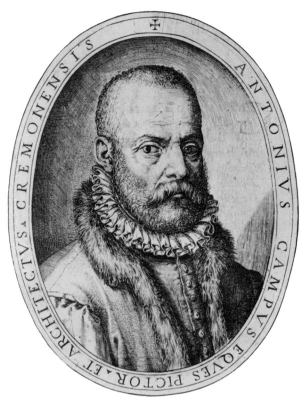

cat. no. 60, only state. Washington, Library of Congress, Rosenwald Collection

cat. no. 61, only state. Washington, Library of Congress, Rosenwald Collection

cat. no. 62, only state. Washington, Library of Congress, Rosenwald Collection

63

Portrait of Guglielmo Cavalcabo
(B. 199) 1582-1584

Engraving. 147 x 114 mm. (oval) (after
Antonio Campi) Found on page 66, book three,
of the *Cremona Fedelissima*.

Literature: Calvesi/Casale 82.

States:

	B	CC
I	I	I

Around oval: GVGLIELMVS CAVALCABOS
CREMONENSIS VITELLIANÆ MARCHIO AC
CREMONAE DOMINVS.

Cavalcabo came from an illustrious Cremonese family. He received the
fiefdom of Viadana from Federico I in 1158. Antonio Campi said that
this portrait was taken from a "ritratto dal naturale."[1]

1 *Cremona Fedelissima,* book three, p. 65.

64

Portrait of Cabrino Fondulo, Vicar of the Empire of Cremona
(B. 200) 1582-1584

Engraving. 147 x 114 mm. (oval) (after
Antonio Campi) Found on page 84, book three,
of the *Cremona Fedelissima*.

Literature: Calvesi/Casale 83.

States:

	B	CC
I	I	I

Around oval: CABRINVS FONVLVS SONCINI
COMES CASTRILEONIS MARCHIO AC CREMONAE
SACRI ROM. IMP. VICARIVS.

Cabrino Fondulo (1370-1425) was a ferocious man who was eventually
executed by Filippo Maria Malatesta. An expert military man, he fought
against the Ghibellines and was proclaimed *signore* of Cremona in 1402
by Ugolino Cavalcabo. Campi copied his drawing from an "effigia natu-
rale."[1]

1 *Cremona Fedelissima,* book three, p. 84.

65

Portrait of Marco Girolamo Vida
(B. 201) 1582-1584

Engraving. 147 x 114 mm. (oval) (after
Antonio Campi) Found on page xxv, book
three, of the *Cremona Fedelissima*.

Literature: Calvesi/Casale 84.

States:

	B	CC
I	I	I

Around oval: MARCVS HIERONYMVS VIDA
CREMONEN. ALBAE EPISCOPVS.

Marco Girolamo Vida (1485-1566) was a poet and bishop from Cre-
mona. There is a definite religious inspiration and solemnity of tone in
his poetry. Inspired by Vergilian poetry and humanism, he traveled to
Mantua and Rome and at Leo X's court he wrote the *Cristiade*. He is
considered an influence on Torquato Tasso. According to Campi, this
portrait is taken from an "effigia sua naturale."[1]

1 *Cremona Fedelissima,* book three, p. xxiiij.

cat. no. 63, only state. Washington, Library of Congress, Rosenwald
Collection

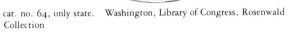

cat. no. 64, only state. Washington, Library of Congress, Rosenwald
Collection

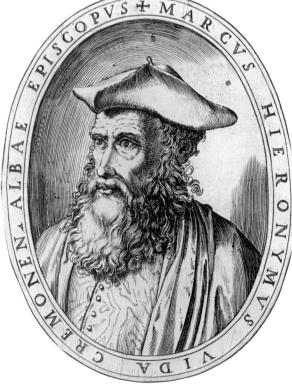

cat. no. 65, only state. Washington, Library of Congress, Rosenwald
Collection

66

Portrait of Francesco Sfondrati
(B. 202) 1582-1584

Engraving. 147 x 113 mm. (oval) (after Antonio Campi) Found on page xxxj, book three, of the *Cremona Fedelissima*.

Literature: Calvesi/Casale 85.

States:

	B	CC
I	I	I

Around oval: FRANCISCVS SFONDRATVS CREMONEN. SANCTAE ROMANÆ ECCLESIÆ CARDINALIS.

Sfondrati (1493-1550) was a Milanese nobleman who received his law degree from the University of Padua in 1520. In his teaching career he worked for Francesco Sforza (cat. no. 75) in Milan and later for Charles V (cat. no. 86). When his wife died in 1535 he became an ecclesiastic. He was the Bishop of Sarno, then Archbishop of Amalfi, and in 1544 he was elevated to the cardinalate. In that year he helped to obtain the Peace of Crèpy between the pope and Charles V. He ended his career as the Bishop of Cremona. Among his writings is a heroic Latin poem *De raptu Helenae,* published in 1559. Campi took the portrait from an "effigia naturale."[1]

1 *Cremona Fedelissima,* book three, p. xxx.

67

Portrait of Ponzino Ponzoni
(B. 203) 1582-1584

Engraving. 148 x 115 mm. (oval) (after Antonio Campi) Found on page lviij, book three, of the *Cremona Fedelissima*.

Literature: Calvesi/Casale 86.

States:

	B	CC
I	I	I

Around oval: PONZINVS PONZONVS CIVIS ET DOMINVS CREMONAE.

According to the inscription Ponzino Ponzoni was a *signore* of the city of Cremona. It has not been possible to learn more about him. Antonio Campi took his likeness from an "effigia naturale."[1]

1 *Cremona Fedelissima,* book three, p. lviij.

68

Portrait of Nicolo Sfondrati
(B. 204) 1582-1584

Engraving. 149 x 115 mm. (oval) (after Antonio Campi) Found on page lxvj, book three, of the *Cremona Fedelissima*.

Literature: Erica Tietze-Conrat, "Notes on Portraits from Campi's 'Cremona Fedelissima'" *Raccolta Vinciana,* 17, part 1 (1954): 256-260; Calvesi/Casale 87.

States:

	B	CC
I	I	I

Around oval: NICOLAVS SFONDRATVS CARDINALIS ET EPISCOPVS CREMONEN. FRANCISCI CARD. FIL

According to the inscription, Nicolo Sfondrati was a bishop of Cremona and a cardinal. Tietze-Conrat suggested the origin of Campi's drawing was a painting by Bernardino Campi because Lamo (see cat. no. 127) discussed a portrait by Bernardino of Nicolo Sfondrati.

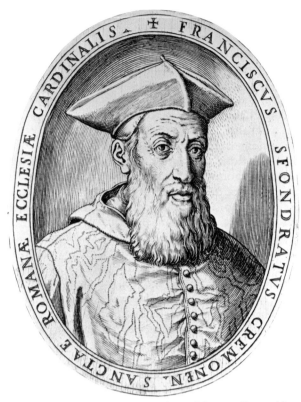

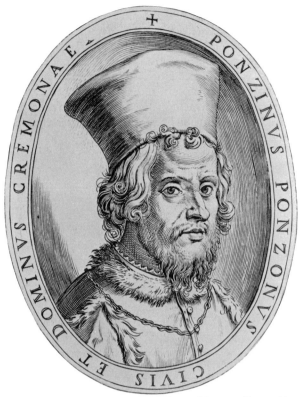

cat. no. 66, only state. Washington, Library of Congress, Rosenwald Collection

cat. no. 67, only state. Washington, Library of Congress, Rosenwald Collection

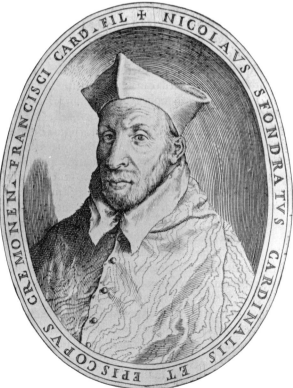

cat. no. 68, only state. Washington, Library of Congress, Rosenwald Collection

69

Portrait of Gian Galeazzo Visconti
(B. 205) 1582-1584

Engraving. 150 x 115 mm. (oval) (after Antonio Campi) Found on p. 90, book four, of the *Cremona Fedelissima*.

Literature: Calvesi/Casale 88.

States:

	B	CC
I	I	I

Around oval: IO. GALEATIVS GALEATII VICECOM. FIL. MED DVX PRIMVS.

Copies: 1. Engraving by LeBlanc in the same direction. 192 x 140 mm. Rectangular plate. Oval is set within a decorative border. Around the oval is IONNES GAEACIVS VICECOMES. Found on page 104 of Paolo Giovio, *Le Vite de i Dodici Visconti che Signoreggiarono Milano* (Milan, 1645).

Gian Galeazzo Visconti (1351-1402), the first Duke of Milan and the most powerful of Visconti rulers, attempted to unify Italy in the fourteenth century by capturing Padua, Bologna, Pavia, Pisa, Siena, and Perugia. This very strong personality died during the plague. Campi said that this portrait comes from an effigy of which there were many in the Certosa.[1]

1 *Cremona Fedelissima,* book four, p. 90.

70

Portrait of Caterina Visconti
(B. 206) 1582-1584

Engraving. 150 x 116 mm. (oval) (after Antonio Campi) Found on p. 91, book four, of the *Cremona Fedelissima*.

Literature: Calvesi/Casale 89.

States:

	B	CC
I	I	I

Around oval: CATHERINA BERNABOVIS VICECOM. F. IO. GALEATII VICECOM. VX.

Caterina Visconti was the wife of Gian Galeazzo Visconti (cat. no. 69). Like the portrait of her husband, this also was taken from an effigy, in this case a marble portrait in the Certosa in Parma.[1]

1 *Cremona Fedelissima,* book four, p. 91.

71

Portrait of Giovanni Maria Visconti (B. 207) 1582-1584

Engraving. 147 x 118 mm. (oval) (after Antonio Campi) Found on p. 92, book four, of the *Cremona Fedelissima*.

Literature: Calvesi/Casale 90.

States:

	B	CC
I	I	I

Around oval: IOANNES MARIA VICECOMES IO. GAL. FIL. MEDIOL. DVX.

Copies: 1. Engraving by LeBlanc in the same direction. 195 x 140 mm. An oval within a decorative border. Around oval: IONNES MARIA VICECOMES. Found on p. 115 of Paolo Giovio, *Le Vite de i Dodici Visconti che Signoreggiarono Milano* (Milan, 1645).

Giovanni Maria Visconti (1388-1412) was the incompetent and cruel son of Gian Galeazzo Visconti (cat. no. 69). He lost all the territories gained by his father and was eventually assassinated. Campi took his likeness from a sculpture in the Certosa.[1]

1 *Cremona Fedelissima,* book four, p. 92.

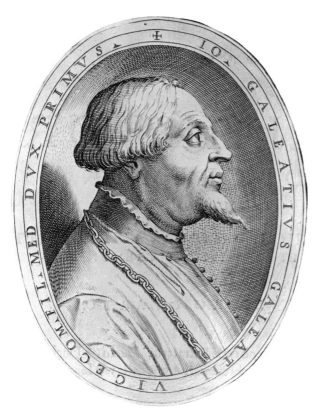

cat. no. 69, only state. Washington, Library of Congress, Rosenwald
Collection

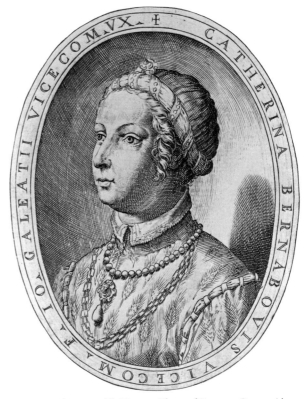

cat. no. 70, only state. Washington, Library of Congress, Rosenwald
Collection

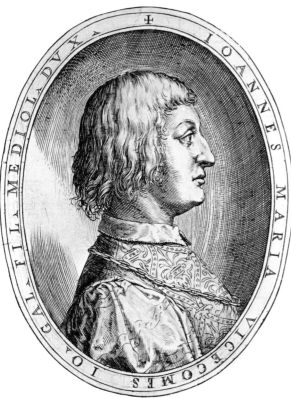

cat. no. 71, only state. Washington, Library of Congress, Rosenwald
Collection

72

Portrait of Antonia Malatesta
(B. 208) 1582-1584

Engraving. 147 x 115 mm. (oval) (after
Antonio Campi) Found on page 93, book four,
of the *Cremona Fedelissima*.

Literature: Calvesi/Casale 91.

States:

	B	CC
I	I	I

Around oval: ANTONIA MALATESTA MALATESTÆ
CÆSENÆ PRINCIPIS F. IO. MARIÆ VICECOM. VX.

Antonia Malatesta was the wife of Giovanni Maria Visconti (cat. no. 71).
Campi found her likeness in an effigy in the Certosa, along with that of
her husband.[1]

1 *Cremona Fedelissima,* book four, p. 93.

73

Portrait of Filippo Maria Visconti
(B. 209) 1582-1584

Engraving. 149 x 116 mm. (oval) (after
Antonio Campi) Found on page 94, book four,
of the *Cremona Fedelissima*.

Literature: Calvesi/Casale 92.

States:

	B	CC
I	I	I

Around oval: PHILIPPVS MARIA VICECOMES IO.
GAL. FIL. MEDIOL DVX.

Copies: 1. Engraving by LeBlanc in the same
direction. 192 x 139 mm. An oval in a decora-
tive border of a rectangular plate. Around the
oval: PHILIPPVS MARIA VICECOMES. The engrav-
ing is found on pp. 120 and 126 of Paolo
Giovio, *Le Vite de i Dodici Visconti che
Signoreggiarono Milano* (Milan, 1645).

Filippo Maria Visconti (1392-1447), the second son of Giovanni
Galeazzo Visconti (cat. no. 69), was the count of Pavia and succeeded to
the duchy of Milan when his brother Giovanni Maria (cat. no. 71) was
assassinated. By political marriage he reconstructed the family's fortune
and the army. His fights with Florence and Venice lost him Brescia and
Bergamo, and his territory was lost at his death due to the lack of a male
heir. Campi reported that the effigy was taken from a medal belonging
to Prospero Visconte, a Milanese nobleman.[1]

1 *Cremona Fedelissima,* book four, p. 94. It still exists. Reproduced in Gonzalo Alvarez
Garcia, *Gli stemmi della Signoria Viscontea del Comune di Milano* (Milan, 1972), 30,
fig. 12.

74

Portrait of Beatrice de Tenda
(B. 210) 1582-1584

Engraving. 151 x 116 mm. (oval) (after
Antonio Campi) Found on page 95, book four,
of the *Cremona Fedelissima*.

Literature: Calvesi/Casale 93.

States:

	B	CC
I	I	I

Around oval: BEATRIX TENDA PHILIPPI MARIAE
VICECOM. VX.

Beatrice de Tenda (1372-1418), the wife of Filippo Maria Visconti (cat.
no. 73), was executed by him for adultery, although earlier she had a
great influence on him. She is the subject of numerous poems and
stories. The effigy was taken from the "Prontuario delle Medaglie."[1]

1 *Cremona Fedelissima,* book four, p. 95.

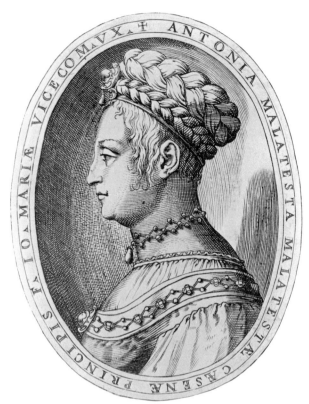

cat. no. 72, only state. Washington, Library of Congress, Rosenwald Collection

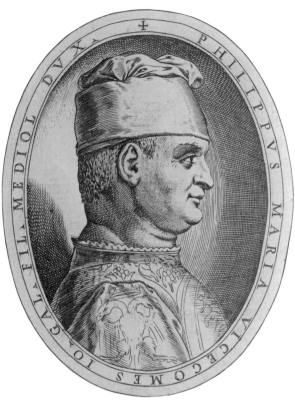

cat. no. 73, only state. Washington, Library of Congress, Rosenwald Collection

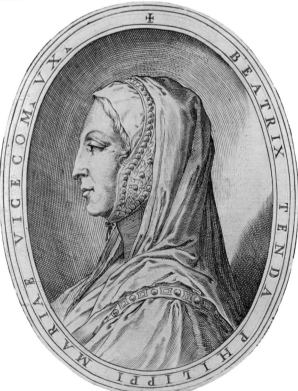

cat. no. 74, only state. Washington, Library of Congress, Rosenwald Collection

75

Portrait of Francesco Sforza
(B. 211) 1582-1584

Engraving. 150 x 115 mm. (oval) (after
Antonio Campi) Found on page 96, book four,
of the *Cremona Fedelissima*.

Literature: Calvesi/Casale 94.

States:

	B	CC
I	I	I

Around oval: FRANISCVS I. SFORTIA VICECOM.
MED. DV X.

Francesco Sforza (1401-1466) was promised the duchy of Milan when he
married Filippo Maria Visconti's (cat. no. 73) illegitimate daughter
Bianca (cat. no. 76). At his marriage he received Pontremoli and Cre-
mona as dowry, but he had to fight to win the succession to the duchy
and finally did succeed in 1450. His children were trained under men of
letters. Campi copied the portrait from a medal belonging to Prospero
Visconti of Milan.[1]

1 *Cremona Fedelissima,* book four, p. 96.

76

Portrait of Bianca Maria Visconti
(B. 212) 1582-1584

Engraving. 149 x 115 mm. (oval) (after
Antonio Campi) Found on page 97, book four,
of the *Cremona Fedelissima*.

Literature: Calvesi/Casale 95.

States:

	B	CC
I	I	I

Around oval: BLANCA MARIA VICECOM PHILIP.
MA. FIL. FRAN. I. SFORTIÆ VX.

Bianca Maria (1425-1468) was the daughter of Filippo Maria Visconti
(cat. no. 73) and the wife of Francesco Sforza (cat. no. 75). Campi said
that the drawing was taken from a painting from nature in S. Agostino
in Cremona by Bonifacio Bembo, a Cremonese artist.[1]

1 *Cremona Fedelissima,* book four, p. 97.

77

Portrait of Galeazzo Maria Sforza
(B. 213) 1582-1584

Engraving. 149 x 115 mm. (oval) (after
Antonio Campi) Found on page 98, book four,
of the *Cremona Fedelissima*.

Literature: Calvesi/Casale 96.

States:

	B	CC
I	I	I

Around oval: GALEATIVS MARIA SFOR.
VICECOM. FRANC. FIL. MED. DVX.

Galeazzo Maria Sforza (1444-1476) was the son of Francesco Sforza (cat.
no. 75) and an able ruler. A patron of the arts and letters, he also wanted
to make his duchy a kingdom. He was eventually murdered, leading to
the end of the Sforza rule in Milan. According to Campi, the effigy
comes from a panel in the Duomo in Milan.[1]

1 *Cremona Fedelissima,* book four, p. 96.

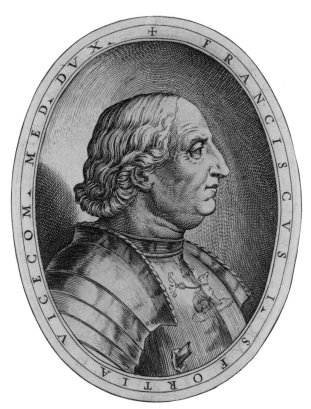

cat. no. 75, only state. Washington, Library of Congress, Rosenwald
Collection

cat. no. 76, only state. Washington, Library of Congress, Rosenwald
Collection

cat. no. 77, only state. Washington, Library of Congress, Rosenwald
Collection

78

Portrait of Bona Filiberti
(B. 214) 1582-1584

Engraving. 148 x 115 mm. (oval) (after
Antonio Campi) Found on page 99, book four,
of the *Cremona Fedelissima*.

Literature: Calvesi/Casale 97.

States:

	B	CC
I	I	I

Around oval: BONA FILIBERTI SABAVDIAE DV.
FIL. GALEATTI MA. SFOR VIC. XV.

Bona Filiberti of Savoy was the wife of Galeazzo Maria Sforza (cat.
no. 77). Campi took her image from the painting next to her husband's
in the Duomo in Milan.[1]

1 *Cremona Fedelissima*, book four, p. 99.

79

*Portrait of Gian Galeazzo
Maria Sforza*
(B. 215) 1582-1584

Engraving. 150 x 115 mm. (oval) (after
Antonio Campi) Found on page 100, book four,
of the *Cremona Fedelissima*.

Literature: Calvesi/Casale 98.

States:

	B	CC
I	I	I

Around oval: IO. GALEATIVS MARIA GALEATII
MAR. ET BONÆ. FIL. MED DVX.

Gian Galeazzo Maria Sforza (1469-1494) was the son of Galeazzo Maria
Sforza (cat. no. 77). Not strong in mind or body, he died young, but
earlier (c. 1479-1480) power passed to his uncle, Lodovico il Moro (cat.
no. 81), who tried to retain the faltering duchy. Antonio Campi was
influenced in this effigy by gold and silver coins.[1]

1 *Cremona Fedelissima*, book four, p. 100.

80

Portrait of Isabella of Aragon
(B. 216) 1582-1584

Engraving. 151 x 116 mm. (oval) (after
Antonio Campi) Found on page 101, book four,
of the *Cremona Fedelissima*.

Literature: Calvesi/Casale 99.

States:

	B	CC
I	I	I

Around oval: ISABELLA ARAGONIA ALPHONSI
REG. FIL. IO. GALEATII MA. VX.

Isabella of Aragon was married to Gian Galeazzo Maria Sforza (cat.
no. 79) in 1489. She was the granddaughter of Ferdinand I of Naples.
Campi took the effigy from "una medaglia di metallo."[1]

1 *Cremona Fedelissima*, book four, p. 101.

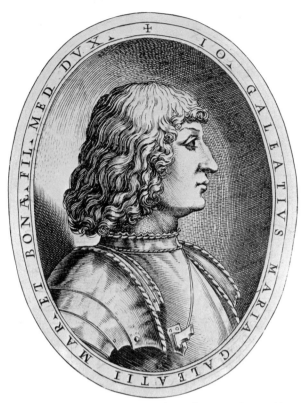

cat. no. 78, only state. Washington, Library of Congress, Rosenwald
Collection

cat. no. 79, only state. Washington, Library of Congress, Rosenwald
Collection

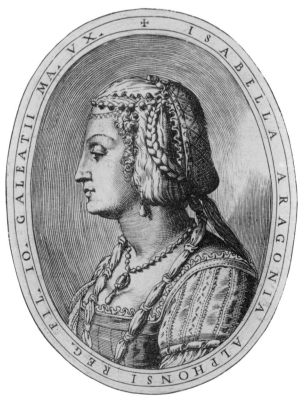

cat. no. 80, only state. Washington, Library of Congress, Rosenwald
Collection

81

Portrait of Lodovico Maria Sforza
(B. 217) 1582-1584

Engraving. 147 x 115 mm. (oval) (after Antonio Campi) Found on page 102, book four, of the *Cremona Fedelissima*.

Literature: Calvesi/Casale 217.

States:

	B	CC
I	I	I

Around oval: LVDOVICVS MARIA SFORTIA VIC. FRANC. SFOR. FIL. MED. DVX.

82

Portrait of Beatrice D'Este
(B. 218) 1582-1584

Engraving. 150 x 115 mm. (oval) (after Antonio Campi drawing in the British Museum) Found on page 103, book four, of the *Cremona Fedelissima*.

Literature: Calvesi/Casale 101.

States:

	B	CC
I	I	I

Around oval: BEATRIX ESTENSIS HERC. FERR. DV. FIL. LVDOVICI VX. +

83

Portrait of Massimiliano Sforza
(B. 219) 1582-1584

Engraving. 150 x 116 mm. (oval) (after Antonio Campi) Found on page 104, book four, of the *Cremona Fedelissima*.

Literature: Erica Tietze-Conrat, "Notes on Portraits from Campi's 'Cremona Fedelissima'" *Raccolta Vinciana*, 17, part 1 (1954): 223-225; Calvesi/Casale 102.

States:

	B	CC
I	I	I

Around oval: + MAXIMILIANVS SFORTIA VICECOM. LVD. FILIVS MEDIOL. DVX.

Lodovico Maria Sforza, known as Lodovico il Moro (1451-1508), attempted to keep control of the faltering duchy of Milan. In 1491 he married Beatrice d'Este (cat. no. 82), and together they were great patrons of the arts. Lodovico encouraged Charles VIII of France to invade Italy, thus beginning a series of devastating wars. The purpose was to displace Gian Galeazzo Sforza (cat. no. 79) and rule Milan himself. Maximilian I secretly invested Lodovico il Moro with the duchy of Milan in 1494, but he was driven from power by Louis XII in 1499 and died a prisoner. Antonio Campi's image for this portrait was a painting on the high altar of S. Ambrosio al Nemo in Milan, the so-called anonymous *Pala Sforzesca*, now in the Brera.[1]

1 *Cremona Fedelissima*, book four, p. 102. Reproduced in Antonio Morassi, *La Regia Pinacoteca di Brera* (Rome, 1934), 76.

This portrait of Beatrice d'Este (1475-1497), sister of Isabella and wife of Lodovico il Moro (cat. no. 81), comes from the same unattributed painting which also portrays her husband—the *Pala Sforzesca*, formerly on the main altar of S. Ambrosio al Nemo in Milan and now in the Brera.[1] Antonio Campi's drawing for this engraving in the British Museum (fig. 82a)[2] is much larger than Agostino's print as are all the extant drawings for the book (figs. 85a, 91a, 92a). This affords us an insight into Agostino's working methods.[3] Not only did he not reverse his preparatory studies very often, but he transferred them in reverse, free hand, to the plate.[4] The results are engravings which are not just purely reproductive but are also imaginative.

1 *Cremona Fedelissima*, book four, p. 103. The painting is reproduced in Antonio Morassi, *La Regia Pinacoteca di Brera* (Rome, 1934), 76.

2 Inv. no. 1874-8-8-5. Black chalk. Inscriptions in black chalk and brown ink. 286 x 211 mm.

3 For a discussion of Agostino's working methods, see the Introduction.

4 The most obvious of these is Agostino's 1582 *Holy Family with Saints Catherine and Anthony* (cat. no. 103).

Massimiliano Sforza (1493-1530), the son of Lodovico il Moro (cat. no. 81), took refuge in Germany when the duchy of Milan was overtaken by the French. In 1512 his position was restored to him by the Swiss, but in 1515 he surrendered his rights to the duchy to Francis I after the battle of Mangano. According to Campi, the image is taken from an oil painting by Leonardo da Vinci in the house of Francesco Melzi (d. 1570) in Milan.[1] If by Leonardo, the portrait is lost.[2]

1 *Cremona Fedelissima*, book four, p. 104.

2 See Tietze-Conrat, p. 225.

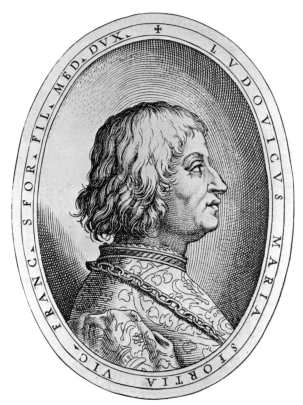

cat. no. 81, only state. Washington, Library of Congress, Rosenwald Collection

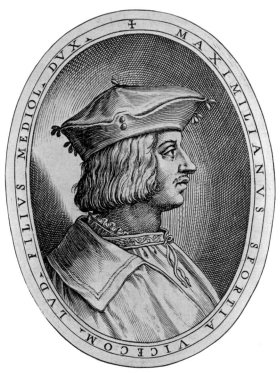

cat. no. 83, only state. Washington, Library of Congress, Rosenwald Collection

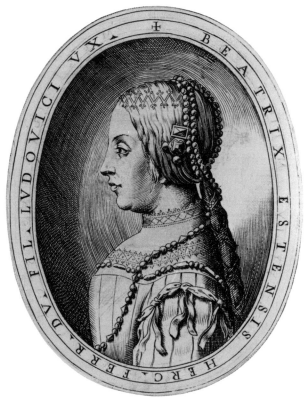

cat. no. 82, only state. Washington, Library of Congress, Rosenwald Collection

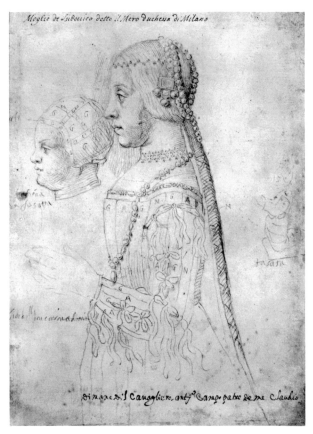

fig. 82a. Antonio Campi, *Portrait of Beatrice d'Este*. London, The British Museum

84

Portrait of Francesco Maria Sforza
(B. 220) 1582-1584

Engraving. 150 x 116 mm. (oval) (after
Antonio Campi) Found on page 106, book four,
of the *Cremona Fedelissima.*

Literature: Erica Tietze-Conrat, "Notes on
Portraits from Campi's 'Cremona Fedelissima,'"
Raccolta Vinciana, 17, part 1 (1954): 255;
Calvesi/Casale 103.

States:

	B	CC
I	I	I

Around oval: + FRANCISCVS II. SFORTIA VIC.
LVDOVICI FIL. DVX.

85

Portrait of Christina of Denmark
(B. 221) 1582-1584

Engraving. 148 x 114 mm. (oval) (after
Antonio Campi drawing in British Museum)
Found on page 107, book four, of the *Cremona
Fedelissima.*

Literature: Calvesi/Casale 104.

States:

	B	CC
I	I	I

Around oval: + CHRISTIERNA DANIAE REGIS
FIL. FRANC. II. SFORTIÆ VX.

Copies: Engraving in reverse. 150 x 115 mm.
cat no. 220.

86

Portrait of the Emperor Charles V
(B. 222) 1582-1584

Engraving. 150 x 115 mm. (oval) (after
Antonio Campi) Found on page 108, book four,
of the *Cremona Fedelissima.*

Literature: Erica Tietze-Conrat, "Notes on
Portraits from Campi's 'Cremona Fedelissima,'"
Raccolta Vinciana, 17, part 1 (1954): 255.

States:

	B	CC
I	I	I

Around oval: IMP. CAES. CAROLVS V. AVG. ET
MLI. DVX. +

Francesco Maria Sforza (1495-1535), the second son of Lodovico il Moro
(cat. no. 81), became the ruler of the duchy of Milan after the defeat of
the French at Bicocca in 1522. He died without male heir. Campi re-
lated that the image was taken from a painting by Titian in the collec-
tion of Mario Amigone, a Milanese.[1] Vasari and Ridolfi mentioned this
lost original of which in 1954 there was a copy in a private collection in
Vienna.[2]

1 *Cremona Fedelissima,* book four, p. 106.

2 Tietze-Conrat, p. 255.

Christina of Denmark was the wife of Francesco Sforza (cat. no. 84).
Campi said that the drawing was taken from an oil painting in the
collection of Don Antonio Londonio, president of the "Magistrato Or-
dinario di Milano."[1] His drawing for the print is in the British Museum
(fig. 85a),[2] and is the closest of any of his drawings to Agostino's fin-
ished engraving.[3] It was executed in an engraver's technique, and details
(such as the decoration of the bonnet) are indicated for use by the en-
graver. Agostino followed Campi's shading and his hatching more
closely than he did in the other engravings for which drawings exist.
Unfortunately, the date in the lower right of the drawing is indeciper-
able, but due to the fidelity with which Agostino copied the sheet, one
assumes that this was one of the earlier portraits engraved for the *Cre-
mona Fedelissima.* The drawing, like the others extant, is larger than
Agostino's finished print. The sheet was squared on the verso with black
chalk in order to transfer the image in reverse to the plate, resulting in
the image of the engraving being in the same direction as the drawing.

1 *Cremona Fedelissima,* book four, p. 107.

2 Inv. no. 1881-6-11-133. Black chalk with inscriptions in black chalk. Squared for
transfer on the verso in black chalk. Lower edge: *Christianna duchessa di Milano et di
Parma.* Below that a date: *15—.* At right of head: *la camp(?) bianchal vermilia di oggi dil
tira al mezzo riogo(?)l li capelli di color dilcastagna.* Lower right: *robone(?) dil pelle di lupol
cremono(?)* 367 x 257 mm.

3 See cat. nos. 82, 91-92.

Campi's portrait of Charles V (1500-1558) was taken from a painting by
his brother Giulio Campi made the year Charles came to Cremona to
take possession of the state of Milan.[1] Tietze-Conrat noticed the influ-
ence of Titian's portrait of Charles V on this image.[2]

1 *Cremona Fedelissima,* book four, p. 110.

2 The Titian portrait is now in the Prado, Madrid, and is reproduced in Harold E.
Wethey, *The Paintings of Titian. II. the Portraits* (London, 1971), pl. 141.

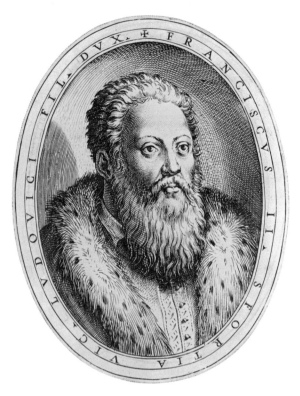

cat. no. 84, only state. Washington, Library of Congress, Rosenwald
Collection

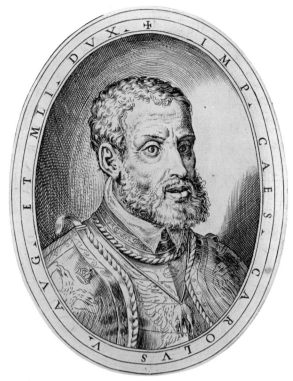

cat. no. 86, only state. Washington, Library of Congress, Rosenwald
Collection

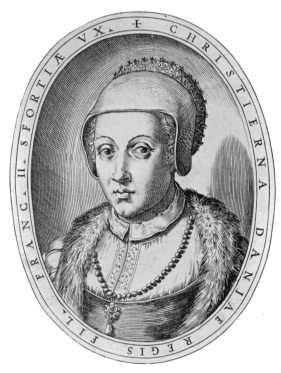

cat. no. 85, only state. Washington, Library of Congress, Rosenwald
Collection

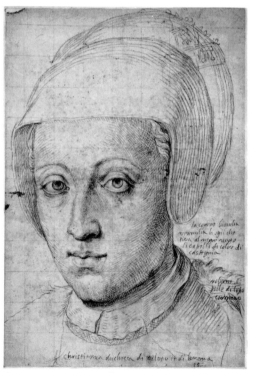

fig. 85a. Antonio Campi, *Portrait of Christina of Denmark.*
London, The British Museum

87

Portrait of Isabella of Portugal
(B. 223) 1582-1584

Engraving. 150 x 116 mm. (oval) (after
Antonio Campi) Found on page 111, book four,
of the *Cremona Fedelissima*.

Literature: Calvesi/Casale 106. Erica
Tietze-Conrat, "Notes on Portraits from
Campi's 'Cremona Fedelissima,'" *Raccolta
Vinciana*, 17, part 1 (1954): 255.

States:

	B	CC
I	I	I

Around oval: ISABELLA EMANVELIS LVSITANIÆ
REGIS F. CAROLI V. IMP. MAX. VX. +

Isabella of Portugal was the wife of Charles V (cat. no. 86). According to
Campi, the image was taken from a work after Francesco Terzo, a Ber-
gamesque painter.[1]

1 *Cremona Fedelissima*, book four, p. 111. Francesco Terzo is the inventor of the compo-
sition of the *Memorial Portrait of Carlo Borromeo* (cat. no. 132).

88

Portrait of Philip II of Spain
(B. 230) 1582-1584

Engraving. 149 x 115 mm. (oval) (after
Antonio Campi) Found on page 112, book four,
of the *Cremona Fedelissima*.

Literature: LeBlanc 231; Calvesi/Casale 107.

States:

	B	CC
I	I	I

Around oval: PHILIPPVS II. HISPANIAR ET
LVSITANIAE. REX DIVI CAROLI V. IMP. F. MED. DVX. +

Copies: 1. Engraving of full figure in reverse.
Face is taken from this engraving. (MMA)

Philip II (1527-1598), to whom the *Cremona Fedelissima* is dedicated,
became king of Spain in 1566. He was the son of Charles V (cat. no. 86)
and Isabella of Portugal (cat. no. 87). Spain attained its greatest expan-
sion under him. He was given the duchy of Milan by his father Charles
V in 1540 and then the kingdoms of Naples and Sicily in 1554. As the
current ruler of Cremona, it was fitting that the *Cremona Fedelissima* be
dedicated to him.

Antonio took this portrait from a painting in the collection of Carlo
Emanuello, Duke of Savoy.[1]

1 *Cremona Fedelissima*, book four, p. 114. This portrait is inserted in the portrait oval of
cat. no. 57 in the edition of 1645.

89

Portrait of Maria of Portugal
(B. 225) 1582-1584

Engraving. 148 x 116 mm. (oval) (after
Antonio Campi) Found on page 116, book four,
of the *Cremona Fedelissima*.

Literature: Calvesi/Casale 108.

States:

	B	CC
I	I	I

Around oval: MARIA IOAN. REG. PORTVG. F.
PHILIPPI HISP. REG. VX. I. +

The four wives of Philip II appear on two facing pages of the *Cremona
Fedelissima*, pp. 116-117. Maria of Portugal, Philip's first wife, was his
cousin and married him in 1543. She died in 1545 giving birth to a son
Don Carlos. Campi used the portraits of Maria and Philip's other three
wives in the collection of Pietro Antonio Lonato the "Commissario
General degli esserciti di S.M.C. in Lombardia, et in Piemonte."[1]

1 *Cremona Fedelissima*, book four, p. 118.

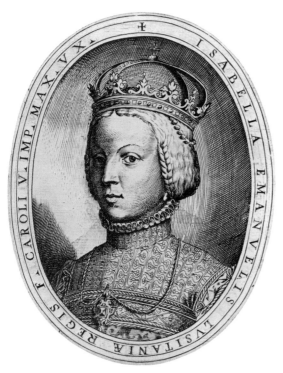

cat. no. 87, only state. Washington, Library of Congress, Rosenwald
Collection

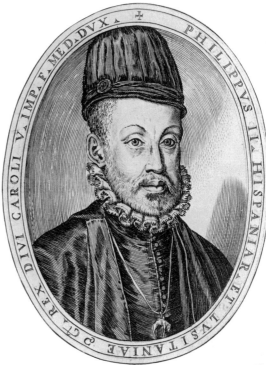

cat. no. 88, only state. Washington, Library of Congress, Rosenwald
Collection

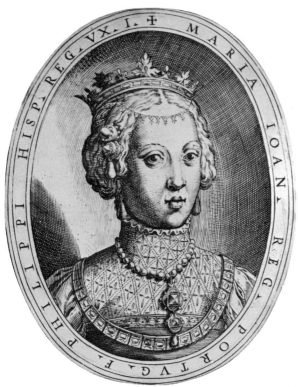

cat. no. 89, only state. Washington, Library of Congress, Rosenwald
Collection

90

Portrait of Mary, Queen of England
(B. 226) 1582-1584

Engraving. 147 x 116 mm. (oval) (after Antonio Campi) Found on page 116, book four, of the *Cremona Fedelissima.*

Literature: Calvesi/Casale 109.

States:

	B	CC
I	I	I

Around oval: MARIA ANGLIAE REGINA PHILIPPI HISP. REG. VX. II. +

91

Portrait of Elizabeth of Valois
(B. 227) 1582-1584

Engraving. 148 x 116 mm. (oval) (after Antonio Campi drawing in Christ Church, Oxford) Found on page 117, book four, of the *Cremona Fedelissima.*

Literature: Calvesi/Casale 110.

States:

	B	CC
I	I	I

Around oval: ISABELLA HENRICI II. GALLIÆ REG. FRAN. F. PHILIPPI HISP. REG. VX. III.

92

Portrait of Anna of Austria
(B. 228) 1582-1584

Engraving. 148 x 116 mm. (oval) (after Antonio Campi drawing in Christ Church, Oxford) Found on page 117, book four, of the *Cremona Fedelissima.*

Literature: Calvesi/Casale 111.

States:

	B	CC
I	I	I

Around oval: ANNA MAXIMILIANI II. ROM. IMP. F. PHILIPPI HISP. REG. VX. IIII. +

Mary was the second wife of Philip II; they were married in 1554, and Philip joined her in reigning over England. She died without children in 1558. According to Byam Shaw, in 1966 the drawing for this print was at Wildenstein & Co., New York, attributed to Antonio Moro.[1]

1 James Byam Shaw, *Drawings by Old Masters at Christ Church Oxford* (Oxford, 1976), under no. 1114. This writer has been unable to locate the sheet.

Elizabeth of Valois was the daughter of Henry II of France. Her marriage to Philip II in 1559 ended the generation of wars between France and Spain. Before she died in 1568, she bore Philip two daughters: Isabella Clara Eugenia and Catherine Micaela.

Antonio Campi's drawing in Christ Church (fig. 91a)[1] from which this print derives is much larger than the engraving by Agostino. It is also in reverse, unlike the other extant drawings by Campi (figs. 82a, 85a, 92a). Agostino must have squared the drawing to reduce its size and then made another drawing to be transferred to the plate. He changed the direction of the shading employed by Campi and increased the contrast between light and dark in the drawing. Agostino added a crown, elongated the features of the sitter, and idealized her face, giving her a more regal and elegant appearance.

1 Inv. no. 1613. Black chalk. Laid down. 366 x 261 mm. Squared in black chalk. Discussed and reproduced in James Byam Shaw, *Drawings by Old Masters at Christ Church Oxford* (Oxford, 1976), cat. no. 1114, plate 680.

Anna of Austria, the daughter of Maximilian II, was Philip II's fourth wife, and also his cousin. They married in 1570, and their son became Philip III.

The Christ Church drawing by Campi (fig. 92a)[1] allows us a further insight into Agostino's working methods.[2] The drawing appears to have been squared on the verso rather than on the recto of the sheet, and Agostino probably was able to see the image through the sheet.[3] He probably transferred the drawing by squaring directly onto the plate, without an intermediate drawing. In this way, the final image of the engraving appears in the same direction as Campi's drawing. Agostino retained the shading of the original (unlike cat. no. 91), but he changed several of its aspects. First, he gave Anna a crown, enhancing her regal aspects, and, second, he played down the mole on the bridge of her nose, further idealizing her appearance.

1 Inv. no. 1612. Black chalk. Laid down. 374 x 266 mm. Squared from the verso in black (or blue?) chalk. Discussed and reproduced in James Byam Shaw, *Drawings by Old Masters at Christ Church Oxford* (Oxford, 1976), cat. no. 1115, plate 681.

2 See Introduction for a discussion of Agostino's working methods.

3 Since the drawing is laid down, it is difficult to analyze where the chalk squaring is, although it appears not to be over the drawing.

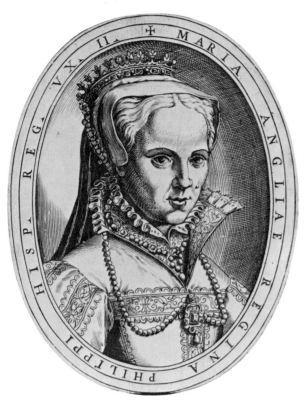

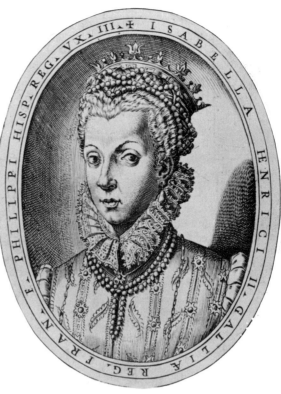

cat. no. 90, only state. Washington, Library of Congress, Rosenwald Collection

cat. no. 91, only state. Washington, Library of Congress, Rosenwald Collection

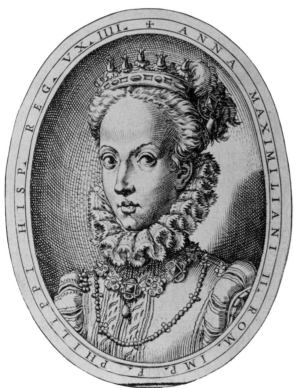

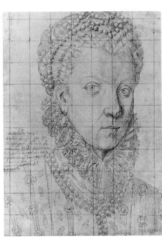

fig. 91a. Antonio Campi, *Portrait of Elizabeth of Valois.* Oxford, Christ Church

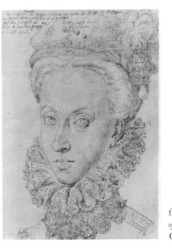

cat. no. 92, only state. Washington, Library of Congress, Rosenwald Collection

fig. 92a. Antonio Campi, *Portrait of Anna of Austria.* Oxford, Christ Church

93

Coat of Arms of Cardinal Vincenzo Lauri
(B. 173) 1582-1585

Engraving. 102 x 80 mm.

Literature: Heinecken p. 643, no. 21; LeBlanc 260; Bodmer 1940, p. 51.

States:

I	$\dfrac{B}{I}$

Around oval: VINCENTIVS LAVRVS S.R.E. CARD. AMPLISSIMVS. (Alb)

cat. no. 93, only state. Vienna, Graphische Sammlung Albertina

This engraving and the following (cat. no. 94)[1] are found in only one impression each, at the Albertina. Stylistically, they belong with the portraits of the *Cremona Fedelissima* (cat. nos. 57, 60-92).[2] Although somewhat smaller in format, each print is surrounded by an oval border with an inscription around it. The placement of the similar cartouches on a shaded background are reminiscent of Agostino's earlier *Coat of Arms of Cardinal Fieschi* (cat. no. 30).

Vincenzo Lauri, from Calabria, was made a cardinal by Gregory XIII, who was pope from 1572-1585.[3]

1 These engravings appear almost as pendants; however, they were probably made at the same time for different families, to be used separately. Yet, Agostino still conceived of them together.

2 Bodmer also dated the prints 1583-1585.

3 Vincenzo Lauri (1523-1592) was mentioned by Ciaconi IV, pp. 90-94. Berton, however, did not list any Lauri cardinals.

94

*Coat of Arms of Marchese
Emmanuele Filiberti Molazani*
(B. 174) 1582-1585

Engraving. 112 x 80 mm.

Literature: Heinecken p. 643, no. 23; LeBlanc 262.

States:

	B
I	1

Around oval: EMANVUEL PHILIBERTVS DE
NIGRO MARCHIO MOLAZANI. + (Alb)

cat. no. 94, only state. Vienna, Graphische Sammlung Albertina

It has not been possible to locate the name of Molazani in any biographies. Yet, the relation of this print to the previous engraving (cat. no. 93) places it in the same period.

95*

Dog

(B. 259) 1582-1585

Engraving. 156 x 122 mm.

Literature: Malvasia p. 83; Oretti p. 832; Heinecken p. 640, no. 7; Nagler 1835, p. 399; Nagler I, no. 305; Bolognini Amorini p. 59; LeBlanc 139; Foratti pp. 177-178; Petrucci p. 132; Bodmer 1940, p. 71; Calvesi/Casale 42; Bertelà 291-293.

States:

	B	CC
I	1	—

A margin line lightly indicated. A castle lightly indicated between the dog's legs. (BM, Dres)

II	2	—

As state I, but with the inscription lower right below back paw: *A. Caraza f.* (Alb, Bo, Br, Dres, LC, Ro, and others)

III	—	1

As state II, but castle has been burnished out and margin line partially burnished out. (Alb, BM, BN, Bo, Ham, MMA, Ro, and others)

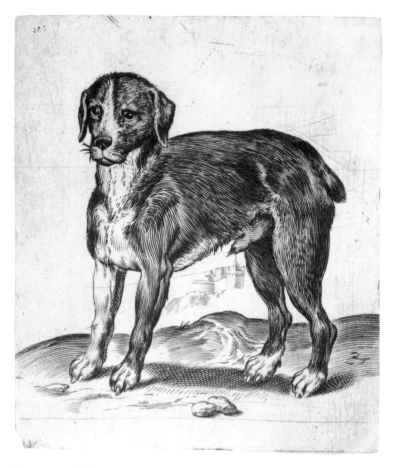

Due to the differences in inking and condition of various impressions of this rather common print, it has been difficult to ascertain exactly in which order the states come; consequently, the critics have differed as to their opinion of the relationship of the states. Writers have also differed as to the authenticity of this engraving, and when accepting it, they have differed as to its dating. Heinecken and Bodmer rejected the print, yet other critics have accepted it. Malvasia believed that the engraving was made in Agostino's early style and that it represented a likeness of the artist's dog. Petrucci followed him in this thinking and dated the print before 1570; that is, before Agostino was fifteen years old. On the other hand, Bartsch said that the print was very late in Agostino's career. Calvesi/Casale dated it c. 1582 or before but gave no reasons for this dating.

Whether the dog represented belonged to Agostino is inconsequential, although there is a definite sympathy shown by the artist toward the forlorn, though charming animal. The attribution to Agostino is fitting if one compares the thickly rendered, curved burin strokes with those on the helmet in the title page to the *Cremona Fedelissima* (cat. no. 56), with the hair of *Giovanni Tommasso Constanza* (cat. no. 96), or with the cloak of the man portrayed in cat. no. 144. No other artist at this time was able to exhibit such a rich depth to his shading by the simple juxtaposition of closely spaced burin strokes.

It is evident why Malvasia believed this engraving to have been executed early in Agostino's career. The dog is standing awkwardly on a simple ground plane, and the castle in the background is poorly related to the animal in the foreground. If the simply rendered head with its flat

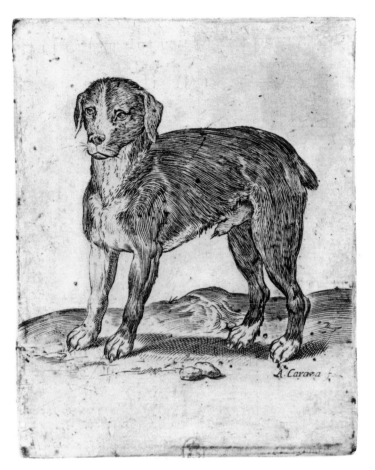

cat. no. 95, state I. London, The British Museum
(left)

cat. no. 95, state III. Paris, Bibliothèque Nationale
(right)

features is compared with the *Study of a Dog*[1] for the 1599-1600 paint-
ing of an *Allegorical Subject* in the Museo di Capodimonte in Naples,[2]
one realizes Bartsch's error in placing this print late in Agostino's career.
In the drawing from the 1590s, Agostino successfully rendered the vol-
umetric aspects of the dog's head in space, and the soft strokes employed
emphasize the furriness of the dog's mane. In the print, however, the
short-haired dog does not appear to have a plastically rendered form, and
the fur is less tangible. Yet, placing this print during Agostino's first
decade of work, as did Malvasia, does not take into account the use of
closely placed hatching, which Agostino did not seem to employ before
1582. Moreover, the artist must have seen his mistake in placing the
castle between the dog's legs and removed it before he signed the print
in the second state. In addition, the type of hatching employed is closest
to the other prints here attributed to this period in the 1580s. Another
dog, more fully understood in space, appears in Agostino's *Martyrdom of
Saint Justina* (cat. no. 105), its plasticity suggesting that this print may
predate the Venetian sojourn.

*The engraving in the exhibition comes from the Metropolitan Museum of Art, New
York, Harris Brisbane Dick Fund, 1953.

1 Staatliche Museen Preussischer Kulturbesitz, Kupferstichkabinett, Dahlem (Berlin),
inv. no. KdZ 17948 recto, 244 x 308 mm., black chalk with white heightening on blue
paper. Reproduced and discussed in Berlin Kupferstichkabinett. *Vom Späten Mittelalter bis
zu Jacques Louis David* (Berlin, 1973), cat. no. 124.

2 Reproduced *Mostra-Dipinti*, pl. 45.

96

Portrait of Giovanni Tommasso Constanzo

(B. 142) c. 1582-1585

Engraving. 180 x 124 mm. (sheet: Alb)

Literature: Heinecken p. 629, no. 19; Gori Gandellini p. 313, no. VIII; Nagler 1835, p. 398; Joubert p. 345; LeBlanc 228; Bodmer 1940, p. 59.

States:

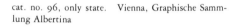

	B
I	I

Around oval: IO. THOMAS CONSTANTIVS ANN. AGENS XXVII. + (Alb)

cat. no. 96, only state. Vienna, Graphische Sammlung Albertina

This portrait is known in only one impression, in the Albertina. Unfortunately, it has not been possible to locate in the biographies any mention of Constanzo, who, according to the inscription, was twenty-seven at the time of this portrait.[1] Although there is some stylistic connection between this portrait and portraits by Agostino from the late 1580s and 1590,[2] and although Bodmer dated this print in the second half of the 1580s, it is the opinion of this writer that the portrait belongs to the period of the *Cremona Fedelissima* (cat. nos. 56-92). The representation of the man surrounded by an oval with inscription and his costume connect him with the portraits in that book. The armor surrounding the portrait is reminiscent of the armor on the title page of Campi's volume, and the placement of the decoration against a background of crosshatching is much like Agostino's other works from this period.[3] The result is that of a tableau placed in a shallow box. It seems fitting then to date this print around the middle of the 1580s.

1 Constanzo must have been some kind of military man, as evidenced by his costume and the arms surrounding the portrait. Joubert misread the age as twenty-two.

2 Especially with the *Portrait of Ferdinand, the Grand Duke of Tuscany* (cat. no. 151), *Portrait of Giovanni Battista Pona,* 1590 (cat. no. 175), and the *Portrait of a Man* (cat. no. 144). But each of these portraits, even the very simply rendered one of Pona, evidences more sophistication in the burin technique and in the presentation of the sitter.

3 Especially the *Coat of Arms of Cardinal Fieschi* (cat. no. 30) and the title page to the *Cremona Fedelissima* (cat. no. 56).

97

The Virgin Annunciate
(B. 35) C. 1581-1584

Engraving. 213 x 162 mm.

Literature: Heinecken p. 634, no. 31; LeBlanc 11; Bodmer 1940, p. 71.

States:

	B
I	1

Before letters (Alb, BN, Br)

II	2

Lower left: *frari⁵. bertelli.* (Alb, Dres, MMA)

III	—

Something written and burnished out to right of book (Frankfurt)

cat. no. 97, state I. Paris, Bibliothèque Nationale

Bodmer rejected this print, but the earlier critics who cited it accepted it as a work of Agostino's. The address of the Bertelli brothers suggests that the work may have been published in Venice in 1582 or in Rome in 1583, although the address coming in the second state may mean that it was published sometime after its execution.[1] Stylistically, the print, which must belong to Agostino, could come at any period during the first half of the 1580s. Probably reflecting his own composition, the engraving is akin to most of the works produced at this period. The puffy hands were seen earlier in Agostino's signed *Tobias and the Angel* (cat. no. 26), and the way in which the figure is placed within a box recurs in other engravings from this time.[2] Morphologically, the Virgin's face reflects the Madonna in the *Adoration of the Shepherds* of 1581 (cat. no. 28). Also close in figural type but on a reduced scale is the Virgin in the 1581 print of *The Madonna* (cat. no. 47). This style is used throughout the first half of the 1580s and can be evidenced in the series of apostles dated 1583 (cat. nos. 109-123). An interesting technique which Agostino employed here and in some other prints from the 1580s is the added burin strokes to the left of the Virgin to indicate a cracking or blemish in the wall. Similar touches are added to the *Portrait of Caterina Sforza* (cat. no. 55) and to the *Portrait of a Man* (cat. no. 144), touches of originality which give the scenes a more naturalistic quality.

1 See Appendix I for a discussion of the publishers of the Bertelli family and their connections with the Carracci.

2 E.g., in cat. nos. 30 and 56.

98*

Madonna and Child on the Clouds
(B. 32) 1582

Engraving. 153 x 118 mm. (after Federico Barocci etching, Bartsch XVII, 3.2)

Literature: Malvasia pp. 81, 270, 293; Oretti p. 823; Heinecken p. 632, no. 12; Joubert p. 347; Bolognini Amorini p. 58; Mariette II, 41; Nagler I, no. 651(2); LeBlanc 21; Petrucci p. 136, p. 143, note 33; *Mostra-Dipinti* p. 72; Calvesi/Casale 41; Ostrow 24; Bertelà 158; Pillsbury and Richards 78.

States:

	B	CC	Ost
I	I	I	I

Lower left: *Agu. fe. 1582.* In margin: *Fede. Baro. in. Hora. Ber. For.* (Alb, BM, Bo, Br, Dres, MMA, and others)

II	—	—	—

Recut. Agostino signature burnished and crossed out. Inscription in margin changed to lower left: *Fed: Barozi. inv.* Lower center: MATER AMABILIS. Lower right: *Ag. Carazi de-lineau/ Ale: a Via rest.* Lower left crosshatched instead of hatched. (Ro)

Copies: 1. Etching by Raphael Sciaminossi (Bartsch XVII, 220. 33) 1613. 2. Alessandro Vaiani (Petrucci p. 143, note 33).

According to Malvasia, Barocci was very unhappy with Agostino's interpretation of his print (fig. 98a)*. Malvasia believed that jealousy was at the root of this displeasure,[1] but it could have been due to Agostino's lack of sensitivity to the atmospheric and painterly style of Barocci. Agostino was very literal in his translation of Barocci: the same forms are apparent, but the sense of atmosphere is missing due to the emphasis on linearity and contour in Agostino's sheet. Barocci was very popular with the Carracci during this period, and this print was especially well liked. Annibale copied it in 1582 (Annibale cat. no. 3), and even Lodovico may have interpreted a similar composition.[2] In Agostino's case, his style emphasized solidity of form rather than movement of light and atmosphere.

As usual, Agostino transposed the original in a similar direction, probably copying rather than tracing the print he used. Consequently, the freedom of choice in contour was easier to achieve.

Although there is no problem with the date of the engraving by Agostino, there is a question as to where it was executed. The publisher's address, found in the first state may indicate that Agostino was in Venice when he made the print. Orazio Bertelli signed other prints by Agostino, but these were made in Rome in 1583 where we know Bertelli was active.[3] The Bertelli family had branches in Venice and Rome; therefore Orazio Bertelli may have been working in Venice in 1582. Conversely, Agostino may have made the sheet prior to his trip to Venice and allowed Bertelli to publish it after his arrival. In burin technique it is closest to the Venetian works and was most likely executed in that city.[4]

1 Malvasia p. 293 said that Agostino improved upon Barocci's design. He discussed it in relation to the *Aeneas and Anchises* (cat. no. 203) which displeased Barocci.

2 Lodovico's painting of *San Vincenzo* (fig. 140a) in the collection of the Credito Romagnolo, Bologna, represents the Madonna and Child on the clouds after Barocci in the upper right hand portion. This painterly version comes from Barocci's drawing in the British Museum (inv. no. 1873-12-13-1937, reproduced Carlo Volpe, "Gli inizi di Ludovico Carracci," *Paragone*, 27, no. 317-319, September, 1976, pp. 115-129, pl. 88a) and could well also date c. 1582, as do this print and Annibale's. For further discussion see the Introduction, p. 38.

3 See Appendix I for a discussion of the Bertelli family as publishers of Carracci prints.

4 Cf., e.g., cat. no. 107 of the *Crucifixion* after Veronese.

cat. no. 98, state I. New York, The Metropolitan Museum of Art, Harris Brisbane Dick Fund, 1917 (top)

fig. 98a. Federico Barocci, *Madonna and Child on the Clouds.* The Cleveland Museum of Art, Gift of The Print Club of Cleveland (bottom)

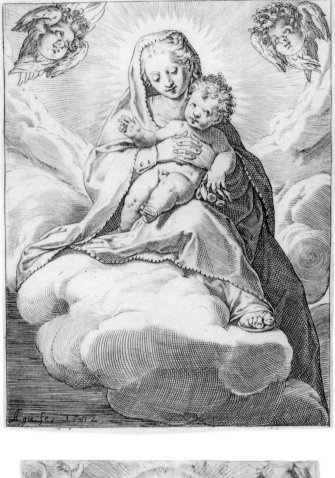

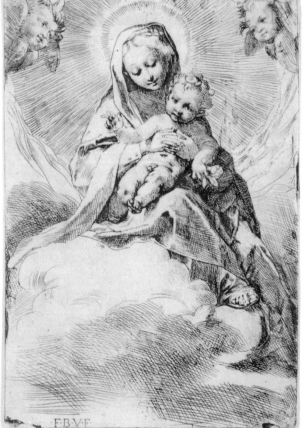

191 AGOSTINO

99*

Madonna and Child on the Clouds
(B. 36) 1582

Engraving. 248 x 176 mm. (sheet: Dresden) (addition to Marcantonio school? engraving after Raphael: Bartsch XIV. 60, 53)

Literature: Malvasia pp. 79, 294; Oretti p. 810; Heinecken p. 643, no. 30; Gori Gandellini p. 314, no. XVIII; Bolognini Amorini p. 56(?); LeBlanc 12; Petrucci p. 133; Bodmer 1940, p. 71; Calvesi/Casale 129.

States:

	B	CC
I	I	I

As reproduced. (Alb, Ber, Dres, MMA, PAFA, Ro) (Additions to Bartsch XIV, 60. 53 state 2)

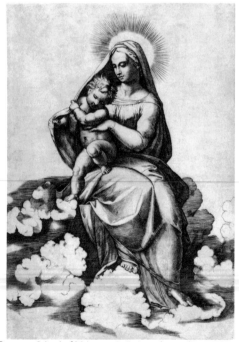

fig. 99a. School of Marcantonio Raimondi, *Madonna and Child on the Clouds.* Vienna, Graphische Sammlung Albertina

This is the only example in Agostino's oeuvre in which he took another artist's engraving and added to it. Agostino's contributions to this plate are the clouds above the center of the composition and the two cherubs at either side. He worked on the second state of the original print which carried the inscription: *Raf. Vrb. in.* (fig. 99a). The composition is by a member of the Marcantonio school after the *Madonna di Foligno* in the Vatican by Raphael.[1] Malvasia attributed the additions to Agostino, but he also believed, incorrectly, that Agostino had altered the figure of the Madonna on the earlier plate. Bodmer doubted the sheet. Calvesi/Casale accepted the additions as Agostino's.

According to Petrucci, Agostino was not an innovative artist and followed the style of the school of Marcantonio.[2] His interest in Marcantonio and Roman printmaking is apparent here, but the contrast in burin techniques points out that Agostino was not part of the Marcantonio tradition. The Marcantonio follower used a very fine burin line and regular, straight-line hatching and crosshatching, seldom curving the burin unless forced to.[3] The result is an undistinguished surface pattern without much differentiation of light and shade. Agostino's additions to the print are in marked contrast to the existing forms. His clouds are made up of many curvilinear lines, each varying in size and depth. The burin is thicker and therefore contrasts more with the white of the paper, giving the print an increased emphasis on light and shade. Hatching is farther apart, lightening the spaces between and again placing more emphasis on light and shade. Obviously, Agostino was not attempting to emulate the style of Marcantonio but to improve and change it. He did not emerge from this tradition but from the tradition of Cort's style, in which the integrity of the line itself with its variation of swelling and tapering overcomes the regularity of hatching inherent to the Marcantonio school.

Calvesi/Casale correctly dated this print c. 1582, comparing it with the signed and dated print of the same year after Barocci (cat. no. 98). The burin technique, simple and strong, appears in most of his works of 1582, Agostino's most productive year. Whether this print was executed before or after his Venetian trip is unimportant, although its proximity with cat. no. 98 suggests it comes after the trip. What is evident is that his style became individual in this year and his burin work stronger.

*Engraving in exhibition comes from The Philadelphia Museum of Art, the Academy Collection.

1 There are two versions of the Marcantonio print. The earlier, Bartsch XIV. 58.52, is attributed to Marcantonio himself. The second version, variously attributed to Marcantonio or to a follower (fig. 99a) exists in two states. The second one carries the inscription: *Raf. Vrb. in.* and is the state of the plate which Agostino used.

2 Petrucci, pp. 132-133.

3 This is a tradition from which the works of Domenico Tibaldi come. After Tibaldi was exposed to Cort that tradition in Bologna changed. The *Rest on the Flight into Egypt* by Tibaldi (Bartsch XVIII, 12.1 fig. G) is an example of this first style employed by the artist.

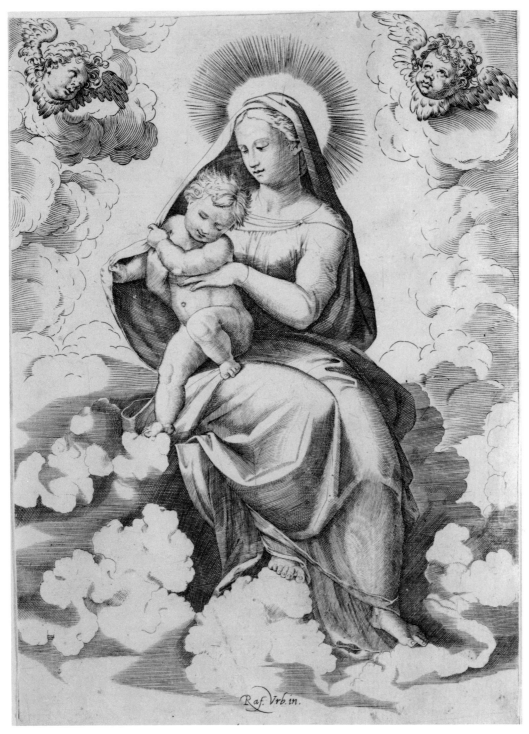

cat. no. 99, only state. New York, The Metropolitan Museum of Art, Harris Brisbane Dick Fund, 1927

100*

Print for the Confraternity of the Name of God
(B. 108) 1582

Engraving. 503 x 361 mm.

Literature: Malvasia p. 76; Oretti p. 795; Heinecken p. 632, no. 8; Gori Gandellini p. 314, no. XXIV; Nagler 1835, p. 397; Bolognini Amorini p. 55; LeBlanc 93; Bodmer 1939, p. 140; Calvesi/Casale 38; Ostrow 29.

States:

	B	CC	Ost
I	I	I	I

Various inscriptions in roundels at sides and bottom and cartouche below kneeling saints. In oval within arms below: CONFRATERNIT./DEL SANTISSIMO NOME/D'IDDIO NELL' ORATORIO/DI S. MARIA DELLA PACE/ IN S. GIOANNI ET PAOLO./ MDLXXXII. And lower center: *Luca Bertelli formis 1582*. (Alb, Par, U)

Preparatory Drawings: *1. Louvre 7112 for composition (fig. 100a)

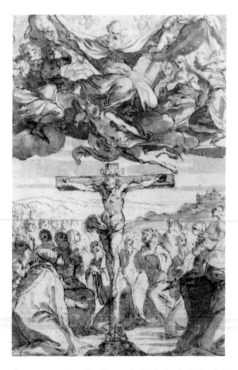

fig. 100a. Agostino Carracci, *Study for the Print of the Confraternity of the Name of God*. Paris, Cabinet des dessins du Musée du Louvre

Although this print is dated but not signed, it has traditionally been attributed to Agostino. The crowded composition, with its awkwardly treated figures, was very ambitious for Agostino at this time, yet one could compare it with the *Frieze to Accompany a Map of the City of Bologna* (cat. no. 29), which is similar in its multitudinous compartments.[1] In addition, the simply executed forms are similar to Agostino's *santini* (cat. nos. 40-49) of the year before. The Madonna is especially reminiscent of the *Virgin Annunciate* from that series (cat. no. 41).

Since the publisher Luca Bertelli was active in Venice during this period[2] and since the confraternity was located in a Venetian church, this engraving must have been made by Agostino on his trip to Venice in 1582.

A drawing made as an early thought for the composition[3] (fig. 100a) indicates that Agostino was working on different ideas for the design, even considering a rectangular format and an emphasis on the suffering of Christ, and confirms the suspicion that the invention was his and not another artist's. The drawing is stylistically close to other early drawings by Agostino: the forms are indicated quickly and lack the substantial volume characteristic of his later works. An emphasis on movement is apparent here, whereas in later works, the artist seemed more interested in the placement of solid forms in space. This movement is emphasized by the shimmering blotches of wash and by the quickly drawn outlines of the figures, which lack fully defined contours.

1 The composition represents the pope and Venetian senate praying to the Virgin, who sits on the clouds with the Christ Child accompanied by saints Dominic, Thomas Aquinas and two martyrs. She intercedes on behalf of the confraternity with God who is enthroned above with angels. On either side of the oval composition are the four cardinal virtues; in the spandrels at the four corners are the four Evangelists; above are figures who represent the three theological virtues.

2 See Appendix I for a discussion of Bertelli.

3 Louvre 7112. Pen and brown ink and wash. Laid down. 265 x 176 mm. Bibliography and collections found in Bacou, no. 16. There is an eighteenth-century etching after this drawing (in reverse) in Dresden. It measures 265 x 171 mm.

cat. no. 100, only state. Florence, Gabinetto disegni e stampe degli Uffizi

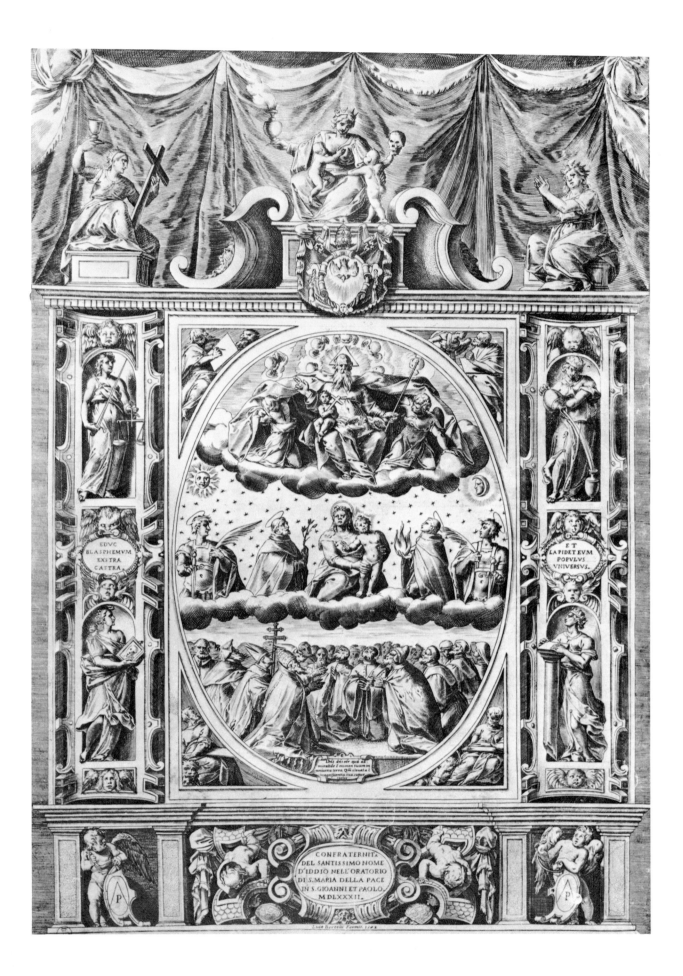

EDVC
BLASPHEMVM
EX STRA
CASTRA.

ET
LA PIDET EVM
POPVLVS
VNIVERSVS.

CONFRATERNITA
DEL SANTISSIMO NOME
D'IDDIO NELL'ORATORIO
DI S.MARIA DELLA PACE
IN S.GIOANNI ET PAOLO.
MDLXXXII.

195 AGOSTINO

IOI

The Temptation of Saint Anthony (B. 63) 1582

Engraving. 498 x 327 mm. (after Jacopo Tintoretto painting in S. Trovaso, Venice)

Literature: Bellori p. 115; Malvasia pp. 76, note 1, and 270; Oretti p. 795; Mariette ms. II, 81; Basan p. 110; Strutt p. 181; Heinecken p. 635, no. 52; Gori Gandellini p. 319, no. XXXIV; Joubert p. 348; Nagler 1835, p. 393; Bolognini Amorini p. 55; Mariette III, 66; LeBlanc 56; Andresen 7; Foratti p. 171; Kristeller p. 283; Pittaluga p. 343; Petrucci p. 137; *Mostra-Dipinti* p. 72; Calvesi/Casale 36; Ostrow 28; Bertelà 178; Boschloo p. 180, note 7.

States:

	B	CC	Ost
I	I	I	I

Lower left: *Iacobi Tintorettis pictoris/ Veneti prestantissimi/ inventum.* Lower center: *Antonius, cum Demones vario sub aspectu ipsum infestantes/ perpetua patientia superasset, viso Domino confortantur.* Lower right: *Lucæ Berteli For./ Anno* · M·D·L·XXXII. (Alb, BM, Br, Dres, MMA, Ro, and others)

| II | — | — | — |

The address of Bertelli burnished out at right. At right of inscription in center: *Giacomo Franco Forma.* (Ber, Bo, PAFA, and others)[1]

This dated but unsigned engraving was doubted only by Zanotti in his notes to Malvasia's volumes. He gave the print to Cornelis Cort; such an attribution is impossible since Cort died in 1578. One copy of this print is found in the Tibaldi album at the Albertina.

Although much of Agostino's manner of 1581 is still evident here in the delicacy of the burin strokes, Ostrow noticed that the swirling clouds became hallmarks of Agostino's Venetian works. Moreover, the face of the temptress at right is related to the figures in the *Allegory of the Psalm of David* (cat. no. 11). Also the right arm of St. Anthony steeped in shadow is reminiscent of the limbs of Christ and St. John the Baptist in the *Baptism of Christ* (cat. no. 23).

The drama of Tintoretto's scene (fig. 101a) has been toned down. There is less contrast of light and dark, but rather an overall bland tonal value in the print. This aspect of the engraving leads us to conclude that it was one of the first prints Agostino made after a Venetian artist on his first trip to Venice.[2]

1 Heinecken, Andresen, and Bertelà also noted this second state.

2 Boschloo noted the relationship of the figure of Saint Anthony with that of Christ in Annibale's painting of the *Baptism of Christ* in S. Gregorio, Bologna of 1585 (Boschloo fig. 8). For the continuing relationship of Annibale and Agostino and their interdependence, see the Introduction.

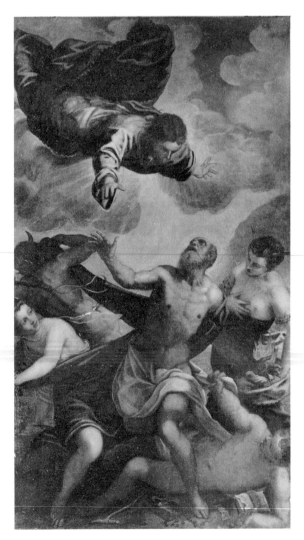

fig. 101a. Jacopo Tintoretto, *The Temptation of Saint Anthony*. Venice, San Trovaso

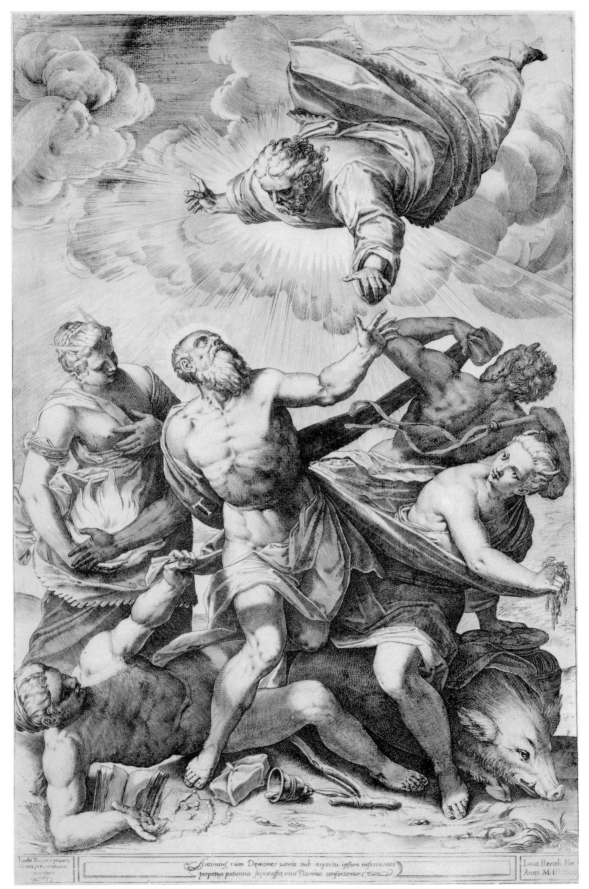

197 AGOSTINO

102

Pietà
(B. 102) 1582

Engraving. 407 x 286 mm. (after Paolo
Veronese painting in the Hermitage, Leningrad)

Literature: Bellori, p. 115; Malvasia pp. 76,
270; Oretti p. 797; Mariette ms II, 57; Basan
p. 111; Strutt p. 181; Nagler I, 652(2); Nagler
1835, p. 393; Heinecken p. 631, no. 28;
Bolognini Amorini p. 55; LeBlanc 51; Andresen
16; Foratti p. 170; *Mostra-Dipinti* p. 72;
Calvesi/Casale 33; Ostrow 27; Bertelà 215.

States:

	B	CC	Ost
I	1	1	1

Lower left: *Agu. Car. fe.* Lower left toward
center: *Paolo Calliarj Veronese inve./ Oratio
Bertelli for. 1582.* (Alb, BM, BN, Bo, Br,
MMA, and others)

	B	CC	Ost
II	2	—	2

This last erased and in its place: *Paulli Caliarij
Opus/ Giacomo Franco Forma.* (Alb, Br,
Philadelphia, Ro, and others)

	B	CC	Ost
III	—	—	—

The *Giacomo Franco Forma* burnished out (Dar,
Stu)

Copies: 1. Engraving in reverse. 418 x
290 mm. Toward left lower: *Tinthoret Invent.* In
margin an inscription beginning with MORTVVS
HEV MORTIS. . . . (Ber, Dres)

No one has doubted this signed and dated engraving, which exemplifies
the new emphasis in Agostino's work on contrast of light and shade and
a new use of the paper for bright highlights. Also, the forms and limbs
are less awkward here and the burin thicker. Veronese's original compo-
sition (fig. 102a)[1] is enlarged to include a tree at right and a distance
beyond. Figures are not enclosed in a confining space but breathe in the
open air. It is this kind of change which marks Agostino as an "original"
reproductive engraver. Rather than copy a composition directly, he at-
tempted to imbue it with his own personality, changing and interpreting
so as to expand the forms in space.

This is one of six paintings by Veronese which Agostino engraved
in 1582 (cat. nos. 102-107), suggesting that Agostino and Veronese had
arranged a successful business relationship, the latter obviously pleased
with Agostino's work.

1 Leningrad, Hermitage. The painting is usually dated late in Veronese's career,
c. 1580, and thought to have been done for the church of SS. Giovanni e Paolo in
Venice.

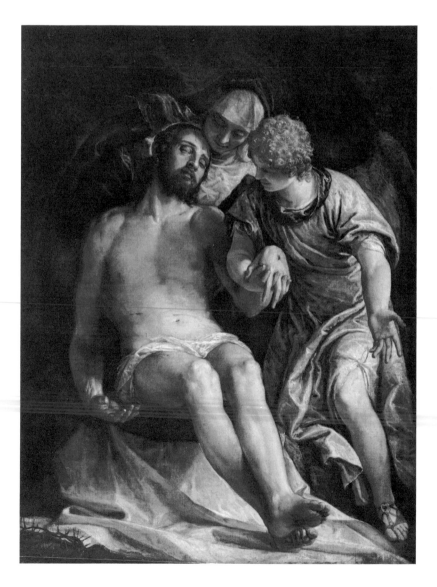

fig. 102a. Paolo Veronese, *Pietà.* Leningrad, The
Hermitage

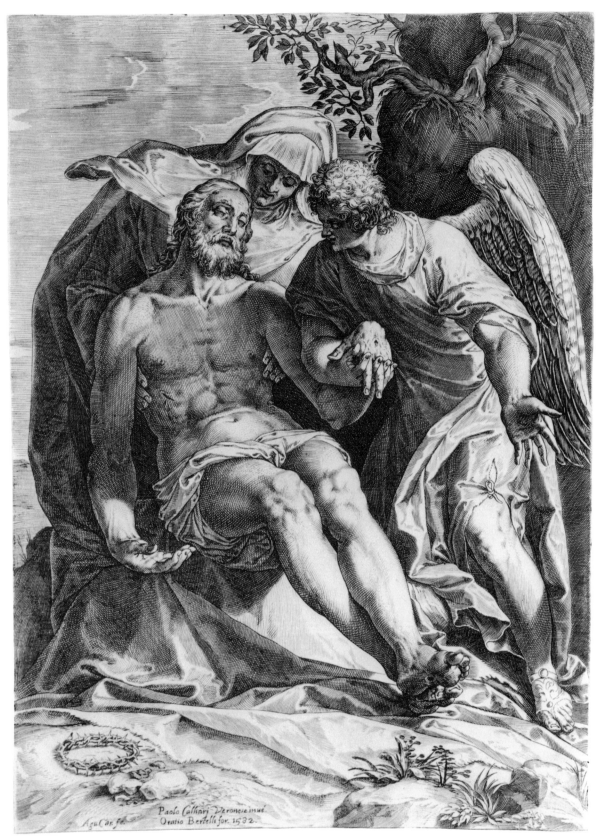

Paolo Calharj Deronese inue.
Oratio Bertelli for. 1582.

Agu Car fe.

cat. no. 102, state I. The Baltimore Museum of Art, Garrett Collection

103*

Holy Family with Saints John the Baptist, Catherine, and Anthony Abbot
(B. 96) 1582

Engraving. 487 x 316 mm. (after Paolo Veronese painting in S. Francesco della Vigna, Venice)

Literature: Malvasia pp. 76, 270; Bellori p. 115; Oretti p. 796; Basan p. 111; Strutt p. 181; Heinecken p. 632, no. 7; Gori Gandellini p. 319, no. XXI; Nagler I, 316(1); Joubert p. 348; Bolognini Amorini p. 55; Mariette II, 32, 55; LeBlanc 33; Kristeller p. 283; Calvesi/Casale 31; Bertelà 211; Boschloo pp. 23, 186, note 29.

States:

	B	CC
I	–	–

Unfinished. As reproduced. (BM)

	B	CC
II	1	1

Something written and burnished out lower right. Reads as: *Paulli Caliarij Veronensis inven: 1582.* On wheel at St. Catherine's feet: *A.C.F.* Lower center toward right: *Paulli Caliarij Veronensis opus in/ Ecclesia sancti Francisi aviniae.* (Alb, BN, Bo, Br, Dres, NYPL, and others)

	B	CC
III	–	–

Added lower right: GIACOMO FRANCO FORMA. (Ber, Bo, MMA, Ro, and others)

Copies: 1. Engraving in same direction. 505 x 338 mm. Lower edge: *Paulli Caliarij Veronensis opus in/ Ecclesia sancti Francisi.* Lower right: *Batista da parma. formis. romae.* (Par). 2. Engraving in reverse. 300 x 196 mm. Dated 1609. Lower center: *P. Veronees. Inve.* (sheet: Par)

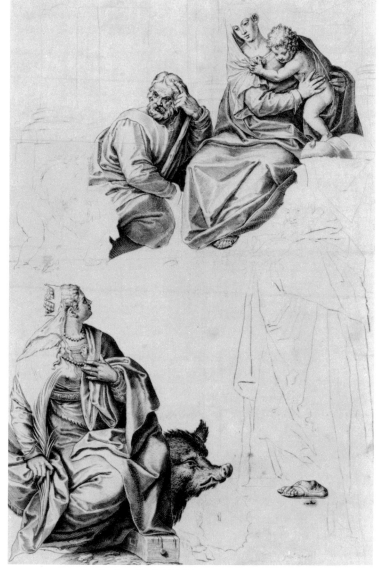

cat. no. 103, state I. London, The British Museum

Although this is a signed and dated engraving, it was not included in Ostrow's list.[1] Everyone else discussing the print wholeheartedly accepted it, with justification. This is one of six prints Agostino made after Veronese in Venice in 1582 (cat. nos. 102-107). Obviously, the artist's use of *colore* attracted Agostino as did his sumptuously depicted Venetian costumes. In this print, Agostino translated the shimmering draperies of Veronese's paintings better than any artist to date. The highlights of Veronese's painting (fig. 103a) have been preserved as have the textural nuances of the garments and the architectural stone.

Although the direction and angle of St. Joseph's head are different in the engraving, most other features of the composition reiterate Veronese's original. As with most of his prints after paintings, Agostino retained the direction of the original composition. As usual, though, he tightened the composition, in this case by cutting off a part of the upper portion, giving less space between the figures and the top. He also, almost imperceptibly, brought the figures closer together and cut a small part off each side of the composition. In addition, the Virgin is given a

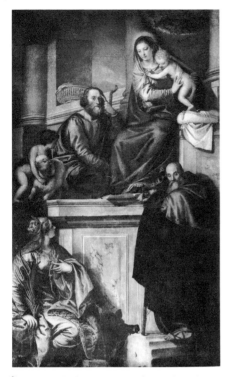

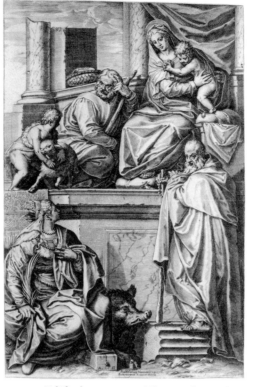

fig. 103a. Paolo Veronese, *Holy Family with Saints Catherine and Anthony Abbot*. Venice, S. Francesco della Vigna (above)

cat. no. 103, state II. Paris, Bibliothèque Nationale (above right)

more solidified structure. The result is a less elongated and more compact composition.

The first state of this print, found at the British Museum, does more to tell us about Agostino's working methods on the copperplate than does his unfinished *St. Jerome* of 1602 (cat. no. 213), the only other engraving by the artist to have a pull taken so early in the conception of the composition. If Agostino worked from a preparatory drawing, it is not known. He may have used one of his own to transfer the main outlines to the plate. But what we see in the unfinished state of the plate is that Agostino drew in free hand (with drypoint) the general outlines of the figures on the copper. He then went over whichever portion he wished to fill out in detail, not especially figure by figure or portion by portion, but rather in what can only be judged a random fashion. Instead of finishing one entire figure, he worked on different small areas, such as St. Anthony Abbot's foot. He seems to have left the background for last, although in the *St. Jerome* he also worked on the background at the same time as on the main figures. In other words after outlining the general composition free hand, Agostino worked on completing it in a rather haphazard way. From the outset, it seems that he had a mental image of the completed composition and the placement of the lighting. Once the bare outlines were sketched in, he could take any part and complete it without destroying the early concept of the finished engraving. This means that Agostino had an excellent visual idea of the completed engraving from the very beginning.[2]

*Engraving in the exhibition comes from Prints Division, The New York Public Library, Astor, Lenox, and Tilden Foundation.

1 Strutt mistook the date for 1583.

2 Boschloo suggested that Annibale in his painting *Madonna and Child Enthroned with Saints* in the Pinacoteca, Bologna, of 1593, was influenced by this print. (Boschloo fig. 44). He pushes the connection too far.

104*

The Mystic Marriage of Saint Catherine
(B. 98) 1582

Engraving. 505 x 344 mm. (after Paolo Veronese painting in the Accademia, Venice, but in c. 1575 in the church of Sta. Caterina, Venice)

Literature: Boschini p. 755; Malvasia p. 76; Bellori p. 115; Oretti p. 795; Basan p. 111; Strutt p. 181; Heinecken p. 636, no. 64; Joubert p. 348; Bolognini Amorini p. 55; Nagler 1835, p. 393; Mariette II, 54; Nagler I, 652 (1); LeBlanc 77; Andresen 15; Foratti p. 170; Bodmer 1939, pp. 140-142; *Mostra-Dipinti* p. 72; Calvesi/Casale 35; Ostrow 25; Bertelà 213.

States:

	B	CC	Ost
I	1	1	1

Lower left: *Paulli Caliarij Veronensis Opus / in ecclesia D. Caterinæ Venetijs.* Lower right: *Aug. Car. fe. 1582.* (Alb, BM, BN, Bo, Br, LC, and others)

	B	CC	Ost
II	2	2	2

As in state I but with the address *Giacomo Franco forma* added below.[1]

Copies: 1. Engraving in same direction. 498 x 349 mm. (sheet: Alb) In margin: DIVINI · FELIX· VIRGOCAPEPIGNUS. . . . *Romae batissa Daparrma formis. 1585* (or 1588). (Alb). 2. Engraving in reverse without letters. 524 x 350 mm. (sheet: Alb). 3. Engraving in reverse. 478 x 350 mm. In margin: *Sainte Catherine Epouse de Jesus Christ.* Lower left: *Jean Batiste Bonnart ex au Coq.* (Par). 4. Etching in same direction 285 x 207 mm. (sheet: Ber). Without letters. Crude.

No one has doubted this signed and dated engraving. Bartsch correctly believed it to be one of Agostino's most successful prints but criticized the equality of the lines employed. Agostino changed little of the original composition (fig. 104a), and he successfully rendered the shimmering effects of the sumptuous materials characteristic of Veronese, although changing the patterns of the brocade. The moving clouds with their spiral effects first appeared in this year in prints by Agostino after Veronese and became a trademark of his engravings in the following years.[2]

There is a drawing in the Isabella Stewart Gardner Museum in Boston[3] which is probably a copy by a follower of Veronese after a preparatory drawing for the painting by Veronese. Although Agostino's engraving is closer to the painting than to this drawing, he would have had access to one of Veronese's sketches for the work, and he probably worked after a lost drawing for the composition.

It is well known that Annibale's painting, the *Madonna of Saint Matthew* in Dresden, is based on Veronese's *Mystic Marriage of Saint Catherine.*[4] Perhaps Annibale was drawn to the painting through Agostino's engraving of the composition, as he was influenced by so many other prints by his brother. Of course, when Annibale's painting was executed, in 1588, the artist knew the painting in the original.

1 Andresen mentioned a third state of the print in which the *Giacomo Franco forma* is burnished out. Yet, he did not note the first state and thus may have reversed states I and II.

2 See, e.g., the *Harmony of the Spheres* (cat. no. 153).

3 Inv. B1430. Reproduced in *Drawings Isabella Stewart Gardner Museum,* ed. by Rollin van N. Hadley (Boston, 1968), 24, no. 11.

4 Posner 45a. Posner I, p. 45 and Dempsey, p. 21.

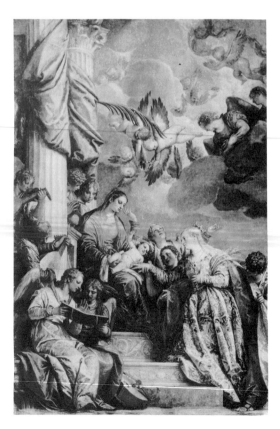

cat. no. 104, state I. Washington, The Library of Congress (right)

fig. 104a. Paolo Veronese, *The Mystic Marriage of Saint Catherine.* Venice, Accademia (left)

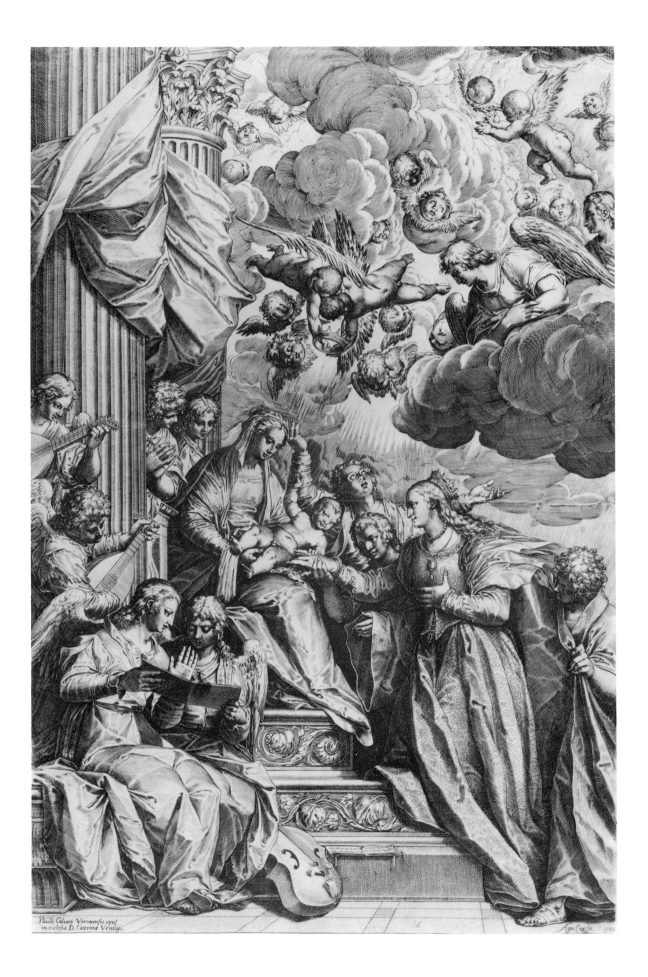

Paulli Caliary Veronensis opus
in ecclesia D. Caterinæ Venetijs.

Agu. Car. fc. 1582

203 AGOSTINO

105*

The Martyrdom of Saint Justina of Padua
(B. 78) 1582

Engraving on two sheets. Upper 451 x 592 mm. (sheet: Balt) Lower 459 x 592 mm. (sheet: Balt) (After Paolo Veronese painting in Sta. Giustina, Padua)

Literature: Baglione pp. 105, 390; Bellori p. 115; Malvasia pp. 75-76; Oretti p. 794; Mariette ms. II, 92; Basan p. 111; Strutt p. 181; Nagler 1835, p. 393; Heinecken p. 636, no. 67; Gori Gandellini p. 319, no. XXIV; Joubert p. 348; Bolognini Amorini p. 55; Mariette II, 56; Nagler I, 1380 (3); LeBlanc 79; Andresen 13; Foratti p. 169; Bodmer 1939, p. 140; *Mostra-Dipinti* p. 72; Calvesi/Casale 34; Ostrow 26; Bertelà 197.

States:

	B	CC	Ost
I(?)	—	—	—

Without letters (Alb)[1]

II	1	1	1

n center lower: *Cum Privilegijs/ Sumi Pontificis Caes Maestatis Regis Catholici et Senatus Veneti.* In margin inscription beginning: CLAR. ᴹᴼ VIRO IACOBO CONTARENO/ . . . and ending: *Venetijs Kal. Iun.* MDLXXXII *Clmae D.V. Addictissimi Lucus Bertellus, et socius Aug.s Car. fe.* (Bo, Frankfurt, U)

III	2	—	—

The *et socius* crossed out. (BN, Bo, Br)

IV	—	—	2

Iocobus Franco. excudit in Frezzaria. substituted for *Lucus Bertellus.*[2] (Balt, BM, and others)

V?	—	—	—

Romae apud Carolum Losi Anno 1773[3]

Copies: 1. Engraving in same direction. Upper sheet: 440 x 562 mm. Lower sheet: 438 x 558 mm. Similar inscription in margin; no inscriptions above margin. (Ro)

There is a drawing for this painting by Veronese in Chatsworth.[4] Agostino's engraving varies from the drawing and the painting; therefore he must have used an intermediate study by Veronese. Some of the differences from the painting are as follows: Agostino added trees to the background at left; he changed the composition from an arched top to a rectangular format; the dog faces in the opposite direction; he defined the figures and their faces more clearly than was done in the painting. In all, Agostino tightened Veronese's original composition.

Bodmer noted that the date on this engraving is January 1582 and concluded that Agostino had been in Venice as early as 1581. Ostrow did not believe that this proved the artist was there that early; however, one would assume that a print of this size and complexity would have taken Agostino some time to execute. If the privilege of the Venetian senate was given in January, it may mean that Agostino was in fact in Venice working on this print earlier than the first month of 1582.

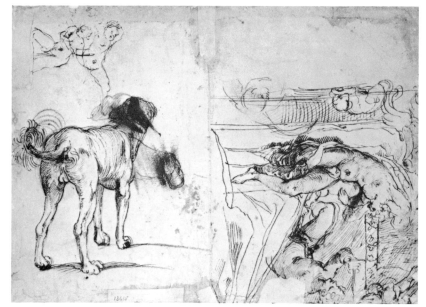

fig. 105a. Agostino Carracci(?), *Various Studies.* Florence, Gabinetto disegni e stampe degli Uffizi

There is a drawing in the Uffizi (fig. 105a),[5] whose attribution is puzzling; it relates to this engraving but must date somewhat later. On the verso of the sheet, reproduced here, are various studies drawn in an engraver's technique typical of Agostino. The bodily type, stance, and linear contours of the dog on this sheet reflect the dog in the engraving at the bottom of the steps. The drawing has been ascribed to Annibale as a study for a dog in his painting *Vision of Saint Eustace* in Naples.[6] However, one can also relate it to a painting of a *Landscape with a Hunting Scene,* also by Annibale, in the Louvre.[7] The common source for these painted animals may be this drawing, which does not relate stylistically to Annibale's compositional study for the painting in the Louvre.[8] Moreover, on the recto of the sheet is a reclining Christ figure, always regarded as Annibale's study for his 1585 *Pietà* in the Galleria Nazionale in Parma.[9]

Boschloo pointed out that Annibale was influenced in this drawing, and thus in the painting, by Agostino's engraving of the *Pietà* after Michelangelo (cat. no. 9).[10] To complicate matters further, there is a

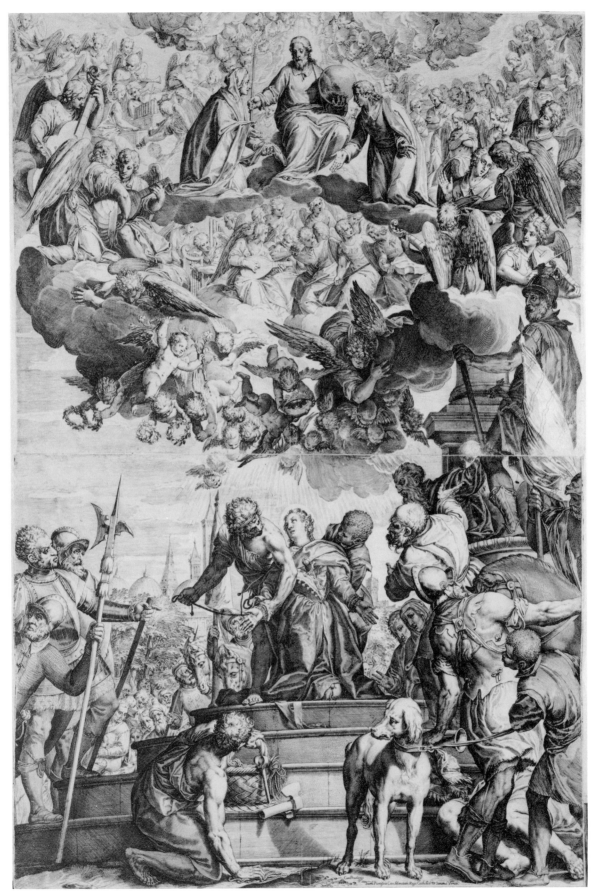

cat. no. 105, state IV. The Baltimore Museum of Art, Garrett Collection

painting of the *Pietà* by Agostino in Leningrad, which closely follows Annibale's Parma painting.[11] Considering the influence of Agostino's engraving on the figure of Christ in Annibale's painting, the proximity of the drawing style of the verso of this sheet to Agostino's pen and ink drawings, and Agostino's painting of the *Pietà* related to Annibale's, it seems possible that this drawing is entirely by Agostino's hand. The recto of the sheet, stylistically, falls within the range not only of those drawings attributed to Annibale during this period, but also of those done by Agostino.[12] There is the possibility that Agostino copied Annibale's painting and reversed the image for his own painting, at the same time incorporating elements of the position of the body from his own engraving.[13] Or, conversely, Annibale copied the pose of Agostino's drawing for his painting. He would then also have employed Agostino's dog with the wagging tail for his paintings the *Vision of Saint Eustace* and the *Landscape with a Hunting Scene.*

Although, due to the strong connections of this drawing with Annibale's paintings, one cannot securely attribute its execution to Agostino, the close working relationship between the brothers does not preclude, but in fact suggests, that drawings were made by one artist and employed for projects by another.[14]

1 This writer has not seen the print in the Albertina which, according to the Albertina catalogue, exists in that print collection. The engraving comes in very worn impressions and in poor condition, probably due to its large size.

2 Andresen noted states II, III, and IV.

3 According to Paolo Ticozzi, *Paolo Veronese e i suoi incisori,* Venice, Museo Correr, July-August, 1977, no. 2.

4 Inv. no. 231. 470 x 231 mm. For reproduction and bibliography see Cini Foundation, *Disegni veronesi del Cinquecento* (Venice, 1971), 60, no. 65.

5 Inv. no. 12418F. verso. Pen and brown ink over red chalk. 297 x 412 mm. See Posner II p. 14, under cat. no. 27. Further discussion and bibliography in *Mostra-Disegni* no. 90.

6 Posner 27. See also *Mostra-Disegni,* cat. no. 90.

7 Posner 43. The connection has not been noted previously.

8 Posner 44b. There is an openness of the contours, a freedom of the pen in the Louvre drawing as opposed to the more careful rendering of contours, more mechanical hatching and reinforcement of lines in the Uffizi sheet.

9 Inv. no. 12418 recto. 412 x 297 mm. Red chalk. The painting is reproduced in Posner, 24a; the drawing 24b. In Boschloo, fig. 13. See also *Mostra-Disegni,* cat. no. 90.

10 Boschloo p. 13, p. 181, note 12.

11 Attributed by Roberto Longhi, "Annibale, 1584?" *Paragone* 8, no. 89 (May, 1957): 33-42, reproduced pl. 19. It was questioned by Ostrow, cat. no. II/ 5, pp. 407-409 but accepted by Posner II p. 13, under cat. no. 24. This writer knows it only in photographs, and accepts it on that basis. It related very well with Agostino's *Madonna and Child and Saints* of 1586 in the Galleria Nazionale in Parma (*Mostra-Dipinti,* pl. 37).

12 See, e.g., Wittkower 27, and *Mostra-Disegni* cat. no. 54, pl. 16 from the Uffizi.

13 It does not seem to this writer that Agostino made the drawing as a preparatory sheet for his engraving of the *Pietà* (cat. no. 9) since the relationship is closest to Annibale's painting and not Michelangelo's sculpture.

14 This working relationship and use of drawings by the family is well known. See especially the drawings for the Palazzo Fava (Posner 15k) and Palazzo Magnani (Posner 52j and 52k).

106*

The Madonna Protecting Two Members of a Confraternity (B. 105) 1582

Engraving. 299 x 216 mm. (after Paolo Veronese)

Literature: Bellori p. 115; Malvasia pp. 78, 368; Oretti pp. 803-804; Mariette ms. 25; Heinecken p. 633, no. 22; Gori Gandellini p. 319, no. XXII; Joubert p. 344; Bolognini Amorini p. 56; LeBlanc 90; Foratti p. 170; Pittaluga p. 343; Bodmer 1939, p. 140; Calvesi/Casale 32; Bertelà 216.

States:

	B	CC
I	–	–

Before letters (Alb)

	B	CC
II	–	–

Lower right: *Horatio/ Bertelli. for.* (Alb)

	B	CC
III	1	1

As state II but with the following in the margin: *Color che unīti in charita perfetta/ Menan quà giù vivendo.i giorni èl'hore,/ Fratelli in Christo, dalla sua diletta,/ Madre, raccolti son con santo amore;/ Ella gli custodisce ella gli accetta/ Come suoi figli, et mette in somo honore;/ Ella del mondo à lor dona vittoria,/ E in Ciel gli tira à là beata gloria./ Horatio/ Bertelli/ for.* (Alb, BM, BN, Bo, Br, MMA, Ro, and others)

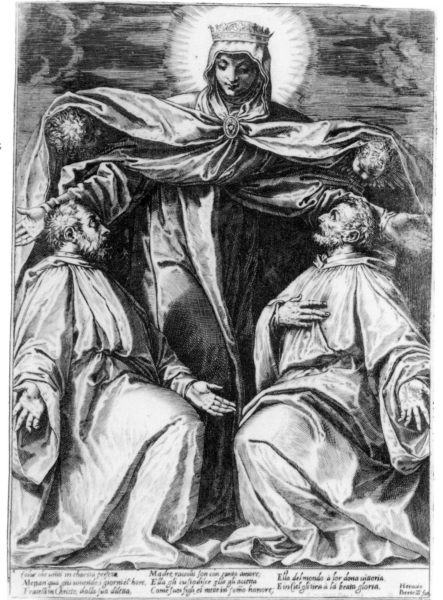

cat. no. 106, state III. Vienna, Graphische Sammlung Albertina

The style of this engraving and its proximity to Agostino's works done in Venice, indicates that it was executed by him in 1582. Besides, the address of Bertelli would imply a Venetian provenance. The lost painting by Veronese which the print reproduces was, according to Malvasia, in the collection of a Sig. Basenghi in Parma. He believed that Agostino did the engraving after the painting, which was of the same size, when he was in Parma. The address of Bertelli would discredit this supposition, however. Bartsch believed that the verses were also those of Agostino.

*Engraving in the exhibition from the Philadelphia Museum of Art, The Academy Collection.

107*

The Crucifixion
(B. 21) 1582

Engraving. 303 x 220 mm. (after Paolo Veronese painting in S. Sebastiano, Venice)

Literature: Malvasia p. 77; Oretti pp. 800-801; Mariette ms. II, 55; Heinecken p. 631, no. 23; Nagler I, 2254; Bolognini Amorini p. 56; LeBlanc 46; Foratti p. 169; Kristeller p. 283; Bodmer 1939, p. 140; Calvesi/Casale 30; Bertelà 151; Boschloo pp. 10, 179, note 4.

States:

	B	CC
—	I	—

Lower left: *Hora Ber. for.* Lower right: *Pao. Ver. in.*

—	—	I

As above with *Carrazzi fe.* lower left.

I	—	—

As above but with *Carrazzi fe.* hatched out[1] (Alb, BM, Bo, Br, MMA, Ro, and others)

Copies: 1. Engraving in reverse. 211 x 150 mm. (sheet: Par). Lower left: *Marco Sadeler excudit.*

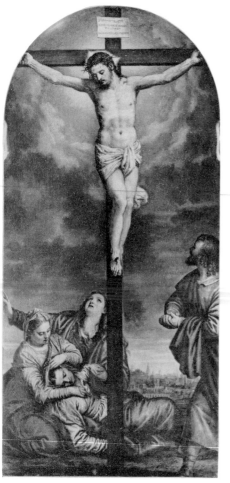

Every critic except Zanotti[2] has attributed this print to Agostino, and most have dated the engraving to 1582 when Agostino was in Venice. Only Foratti suggested the date c. 1581. The broad use of the burin, the proximity of style with other Venetian works,[3] and the address of Bertelli imply that this engraving does indeed belong to the first Venetian trip by Agostino.

As with the *Martyrdom of Saint Justina* (cat. no. 105), Agostino changed the Veronese arched composition (fig. 107a) into a rectangular one. He also expanded the format at left and brought the cross closer to the protagonists in the lower part of the composition. Figures are less elongated. These differences from the painting could be accounted for by a lost Veronese drawing which Agostino followed, but it is more likely that Agostino wished to interpret the scene in a more solid, triangular form. This solidifying of forms and compositions is a characteristic of the artist.[4]

1 The states noted by Bartsch and Calvesi/Casale are probably the same as the one here designated state I. Since the *Carrazzi fe.* is hatched out in all known versions, Bartsch probably did not notice the signature. On the other hand, the hatching is evident in Calvesi/Casale's reproduction of the print, and the authors merely failed to mention it.

2 Zanotti attributed the engraving to Cort.

3 The engraving is closest to cat. no. 106 but is also very close to the *Pietà* after Veronese (cat. no. 102).

4 The importance of this print and Veronese's painting for Annibale's early paintings, especially the *Crucifixion* in Bologna's S. Maria della Carità of 1583, has been noted by various critics, notably Boschloo and Bissell (R. Ward Bissell, review of Posner in the *Art Bulletin,* 56 [1974]: 131). For further discussion on Agostino's influence on Annibale, see the Introduction.

fig. 107a. Paolo Veronese, *The Crucifixion.* Venice, S. Sebastiano

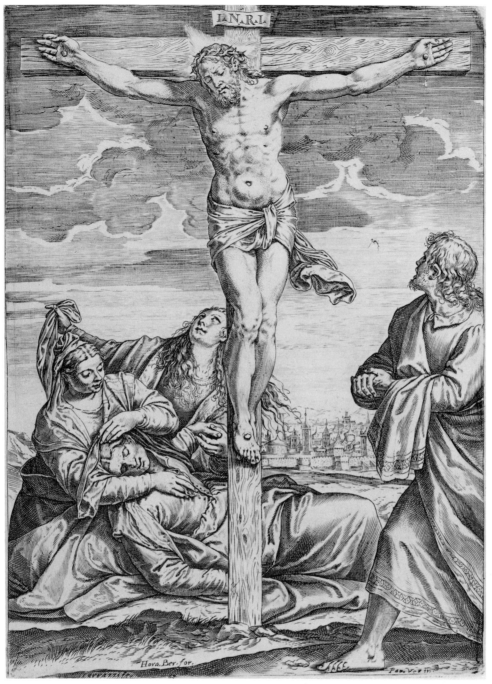

I.N.R.I.

Hova. Ber. for.

cat. no. 107, only state. New York, The Metropolitan Museum of Art, The Elisha Whittelsey Fund, 1959

108

Saint Paul Raising Patroclus
(B. 85) 1583

Engraving. 256 x 190 mm. (after Antonio Campi fresco in S. Paolo, Milan?)

Literature: Malvasia p. 79; Oretti p. 810; Heinecken p. 634, no. 39; Gori Gandellini p. 319, no. XXVII; Nagler I, 647 (1); Joubert p. 348; Bolognini Amorini p. 56; Mariette II, 43; Nagler 1835, p. 397; Zani part II, 9, p. 282; LeBlanc 71; Bodmer 1940, p. 41; *Mostra-Dipinti* p. 73; Calvesi/Casale 74; Ostrow 32.

States:

	B	CC	Ost
I	1	1	1

Lower left: *1583.* AN.CAM.IN. Lower right: *Ago. Car. f.* In margin: D·PAVLI·MYRACVLVM· IN·NERONIS·PALATIO·FACTVM·[1] (Alb, BMFA, BN, Br, Dres, Ro, and others)

II	2	2	2

As in state I but with *Pietro Stefanone for.* Lower left (Alb, BM, Ham, MMA, and others)

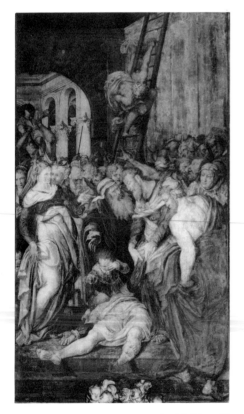

fig. 108a. Antonio Campi, *Saint Paul Raising a Young Man.* Milan, S. Paolo

Malvasia said that this print was executed as proof of Agostino's ability to take on the task of the portraits for the *Cremona Fedelissima* (cat. nos. 56-92). Most critics have assumed this allegation to be true, since they believed that the *Cremona Fedelissima,* first published in 1585, was probably begun in 1583.[2] As has been shown here (cat. nos. 55 and 56), the *Cremona Fedelissima* was actually begun in 1582, probably before Agostino's Venetian trip. Although this print was not done as a trial to obtain the commission for the *Cremona Fedelissima,* Agostino was still working for Antonio Campi in 1583,[2] and it is therefore not unusual that he would execute this engraving for him.

Ostrow noted that since this is the only engraving known after Campi's fresco (fig. 108a), it proves that Agostino was in Milan in 1583. But, a cursory comparison between fresco and engraving reveals that Agostino probably worked from a preparatory drawing by Campi. When Agostino worked in a reproductive style, he did not normally depart so drastically from the original. In this case, Campi's fresco portrays the scene indoors or in a confined space, without the architectural background, with a crowd of assorted onlookers, etc. In fact, Agostino's engraving does not purport to be after Campi's fresco, only after a work by Campi. This work, probably related to the fresco, is not currently known. Agostino probably did travel to Milan during his peripatetic years in the 1580s but not to engrave this fresco.[3]

1 Nagler I, 647(1) reported an earlier state without letters.

2 See discussion before cat. no. 56.

3 The title of this engraving is usually given as *Saint Paul Raising Eutichus,* a mistake that was first made by Gori Gandellini and Heinecken. Before that the name of the young man was not mentioned. As the inscription states, the miracle represented takes place in front of the house of Nero. According to Voragine's *Golden Legend,* Saint Paul revived a young man named Patroclus, a favorite of Nero, who had climbed on a palace window to hear Paul preach, fell to the ground, and was killed. (Information supplied by David Steel.)

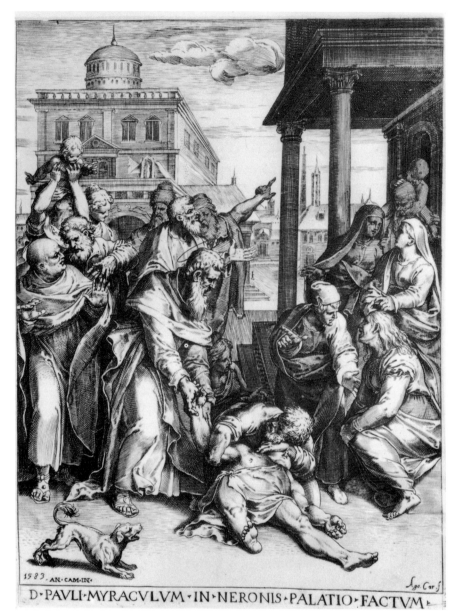

D·PAVLI·MYRACVLVM·IN·NERONIS·PALATIO·FACTVM·

cat. no. 108, state I. Vienna, Graphische Sammlung Albertina

109-123*

The Savior, the Virgin Mary, Saint John the Baptist, and the Twelve Apostles
(B. 48-62)

Engravings. Fifteen subjects on five plates (see individual entries for sizes and states)

Literature: Bellori p. 116; Malvasia pp. 83, 266; Oretti p. 834; Mariette ms. II, 59; Heinecken p. 634, no. 35; Nagler 1835, p. 396; Bolognini Amorini p. 59; Nagler I, 296 (12); Mariette III, 93-107; LeBlanc 94-108; Calvesi, *Commentari*, p. 263; Calvesi/Casale 59-73; Ostrow 31 A-N; Bertelà 163-177; Boschloo p. 196, note 19.

Preparatory Drawings: See individual entries.

Copies: 1. By Frans Aspruck, 1601. A set of thirteen punched and engraved plates (Hollstein 1-13) of the Savior and the twelve apostles: after cat. nos. 110, 112-123. Upper left: *A.C.* Upper right: *F.O.A.* Inscriptions in haloes sometimes differ from originals by Agostino. Each print numbered, from 1 to 13. In reverse of originals. Inscriptions in margins varying in length. 2. Seventeenth-century engravings. Northern European. Same direction as originals. Without writing in haloes but with name of saint and number in margin. Addition of other saints to this set besides Agostino's apostles.

In making an engraved set of the apostles, Agostino followed a long tradition in fifteenth- and sixteenth-century printmaking in both Italy and northern Europe. Most famous among the early series of apostles was Martin Schongauer's of c. 1480, which Boschloo believed was influential on Agostino's prints.[1] Although Agostino would certainly have known Schongauer's prints, as well as the numerous other apostles series from the north such as those by Albrecht Dürer, Lucas van Leyden, Hans Baldung Grien, Hans Sebald Beham, and Lucas Cranach the Elder, to name a few,[2] there is no reason to believe that stylistically any of these prints influenced our artist. In fact, the detailed, crisp drapery style of most of these works is foreign to Agostino's simplified, flowing robes adorning his figures. Closer to home, Agostino would have known Marcantonio Raimondi's engraved set of the apostles, after Raphael, and its numerous copies.[3] By virtue of the simplified drapery style, these come nearer to Agostino's conception than do those of the north. The etched set of apostles after Parmigianino by the Master FP, and the chiaroscuro woodcut set, also after Parmigianino, would have interested Agostino for their clarity of presentation.[4] It is also possible that Agostino looked to Parmigianino when portraying the ragged, wind-swept locks of St. Thomas (cat. no. 113). Agostino's designs, like Parmigianino's, took advantage of a variety of poses and movements.

As in some of the series before his, Agostino portrayed his figures in a simplified landscape setting but embellished the skies with moving clouds. Unlike any of the previous series, which variously included between twelve and fourteen prints, sometimes with the figure of Christ, Agostino's series numbered fifteen individual figures. He portrayed not only Christ and the twelve apostles, but also added the Mother of Christ and Saint John the Baptist.

Although Bellori discussed a 1590 edition for this series, and Calvesi believed there may have been an unknown second edition,[5] there seems no reason to doubt the date of 1583 found on the print of *St. John* (cat. no. 117). Moreover, the address of the publisher Orazio Bertelli may indicate that Agostino was still in Venice this year, or at least at the beginning of the year. It is known that he was back in Bologna by 1584 when he was working on the Palazzo Fava frescoes.[6]

There are several drawings of saints' heads which may be connected with this series, but there are no full figure studies yet known. Wittkower connected three sheets in the Uffizi (figs. 109c, 116b, 122a)[7] and a drawing in Windsor (fig. 113a)[8] with the apostle engravings. Although not of a high quality and in a small format, the Uffizi drawings are probably by Agostino. Two of the pen sketches relate directly to the engravings (*St. Andrew,* cat. no. 116, fig. 116b and *St. Philip* cat. no. 122, fig. 122a), the third probably being a discarded pose (fig. 109c). The Windsor drawing noted by Wittkower (fig. 113a), in the same direction as the *St. Thomas* (cat. no. 113), is most likely a study for that engraving and not a copy after it. The short, fussy strokes apparent in all four of these drawings are seen in other Agostino drawings of the period and thus suggest his authorship.

Three other drawings relate loosely to the apostles series: a large sheet in Turin from the same model as the *St. Andrew* (fig. 116a)[9] and drawings in Vienna (fig. 109a) and Windsor* (fig. 109b).[10] The sheet in Vienna is there attributed to Lodovico Carracci but in hatching tech-

nique is much closer to Agostino. The turbaned head represented could not be that of an apostle, but stylistically it belongs in this period and comes closest to the other drawings mentioned here. The drawing in Windsor could have been an early thought for an apostle such as Simon (cat. no. 121), whose pose and flowing beard are similar. In any case, the curlicues for hair, the quickly executed hatching, and the sharply drawn features of the head are characteristic of this period in Agostino's career when his drawing style was often dependent on Parmigianino.[11] Agostino must have made many of these heads and discarded them in trying to work out his compositions. This indicates that the series of apostles, as most critics believe, was indeed Agostino's invention and not of a reproductive nature.

The fifteen prints in this series were made on five plates, each with three figures. Since they are normally found cut into separate sheets containing one figure, each figure is here given a catalogue number. Bartsch also numbered them in this fashion. Since they are rarely found together and there is a border around each figural composition, it is likely that Agostino intended them to be separated. The use of one small plate per three apostles was probably expedient and less costly.

1 Bartsch VI, 136-138.34-45 (twelve prints). Boschloo discussed the connection in relation to his suggestion that Agostino introduced northern elements into his prints which later influenced his brother Annibale. Zanotti suggested that there may have been Venetian sources for the prints, but what he meant is unknown.

2 Lucas van Leyden: Bartsch VII, 387-390. 86-99 (fourteen prints). Albrecht Dürer: Bartsch VII, 64-68. 46-50 (four prints). These prints were probably meant to be part of a series of twelve. They date from 1514-1526. Hans Sebald Beham: Bartsch VIII, 134-137.43-54 (twelve prints). Hans Baldung Grien: Hollstein II, 101.67-78 (twelve prints). Hollstein II, 102-103.79-91 (thirteen prints). Lucas Cranach the Elder: Hollstein II, 30-33.31-44 (fourteen woodblocks).

3 Bartsch XIV, 74-78.64-76 (thirteen prints). Copies in reverse: Bartsch XIV, 79-82.79-91. For other copies see Bartsch XIV, pp. 111ff.

4 Master FP: Bartsch XVI, 19-22.1-13. Twelve chiaroscuro woodcuts (Antonio da Trento?): Bartsch XII, 69-70.1-12. See also the two prints by Parmigianino himself: Bartsch XVI, 16.8-9. 5 Calvesi, *Commentari*, p. 263.

6 Calvesi/Casale suggested that these engravings are close stylistically to the Fava frescoes, but, although they are almost contemporary, there seems no real basis for connecting them. See Appendix I for information on Orazio Bertelli.

7 Wittkower 156. Uffizi drawings: 3871s: 76 x 73 mm. Pen and brown ink. Incised. Laid down. 3872s: 80 x 63 mm. Pen and brown ink. 3873s: 79 x 75 mm. Pen and brown ink. Laid down. Also noted by Ostrow p. 519. Ostrow accepted 3872s and 3873s but rejected 3871s. 3871s is here questioned.

8 Inv. no. 2278. Wittkower 156. Pen and brown ink on grayish green paper. 171 x 129 mm. Laid down. The technique looks forward to some of Guido Reni's early drawings. Also accepted by Ostrow p. 519.

9 Inv. no. 16069. 362 x 273 mm. Black chalk with white heightening on brown paper. Laid down. Aldo Bertini, *I disegni italiani della Biblioteca Reale di Torino*, Rome, 1958, cat. no. 86. The pose, common in Agostino, was used for the lost profile of the apostle toward the left in Agostino's *Assumption* in the Pinacoteca Nazionale in Bologna (reproduced *Mostra-Dipinti* plate 42). There are also two other similar drawings of heads at Turin in the same technique (Bertini 87-88).

10 Inv. no. 1895. Wittkower 150. Pen and brown ink. 168 x 124 mm. Laid down. (Windsor sheet). Inv. no. 2092. 124 x 86 mm. Pen and brown ink. (Albertina sheet).

11 See especially a drawing such as the *Holy Family* at Windsor Castle. Wittkower 113, plate 25. This early connection with Parmigianino suggests the possible influence of the series of apostles after that artist.

109-111*

Saint John the Baptist
(B. 50) 1583

Salvator Mundi
(B. 48)

The Virgin Mary
(B. 49)

Engraving. 107 x 194 mm.

States:

	B	CC	Ost
I	I	I	I

As reproduced.

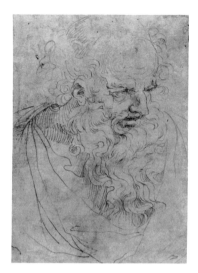

fig. 109a. Agostino Carracci, *Bearded Man.* Vienna, Graphische Sammlung Albertina

fig. 109b. Agostino Carracci, *Head of an Old Man.* Windsor Castle, Royal Library, Her Majesty Queen Elizabeth II

fig. 109c. Agostino Carracci(?), *Head of a Man.* Florence, Gabinetto disegni e stampe degli Uffizi

112-114*

Saint Bartholomew
(B. 56) 1583

Saint Thomas
(B. 58)

Saint Peter
(B. 51)

Engraving. 105 x 190 mm.

States:

	B	CC	Ost
I	I	I	I

As reproduced.

Preparatory Drawings: Windsor Castle 2278. Wittkower 156. For cat. no. 113 see discussion before cat. no. 109.

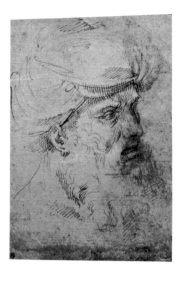

fig. 113a. Agostino Carracci, *Head of a Man.* Windsor Castle, Royal Library, Her Majesty Queen Elizabeth II

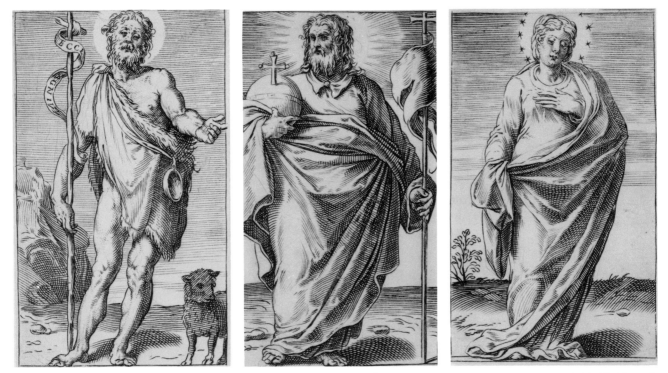

cat. no. 109, only state. New York, The Metropoli-
tan Museum of Art, Harris Brisbane Dick Fund, 1953

cat. no. 110, only state. New York, The Metropoli-
tan Museum of Art, Harris Brisbane Dick Fund, 1953

cat. no. 111, only state. New York, The Metropoli-
tan Museum of Art, Harris Brisbane Dick Fund, 1953

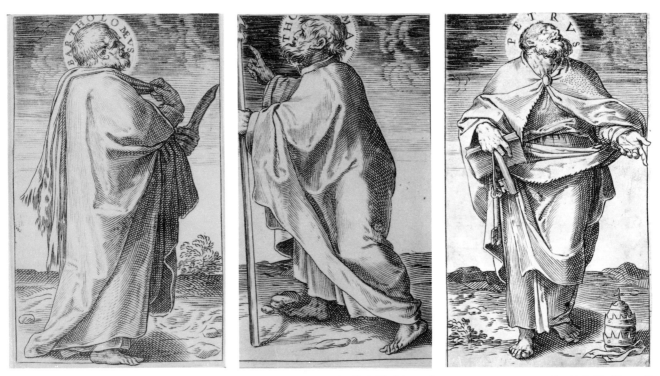

cat. no. 112, only state. New York, The Metropoli-
tan Museum of Art, Harris Brisbane Dick Fund, 1953

cat. no. 114, only state. New York, The Metropoli-
tan Museum of Art, Harris Brisbane Dick Fund, 1953

cat. no. 113, only state. New York, The Metropoli-
tan Museum of Art, Harris Brisbane Dick Fund, 1953

115-117*

Saint Matthew
(B. 57) 1583

Saint Andrew
(B. 52)

Saint John
(B. 54)

Engraving. 105 x 93 mm.

Literature: LeBlanc 103, 98, 100; Calvesi/
Casale 68, 69, 70; Ostrow 31 I, E; Bertelà 172,
167, 169.

States:

	B	CC	Ost
I	I	I	I

On section of St. John at right in lower left:
Oratio Bertelli. Form. Lower right: *1583*

Preparatory Drawing: Uffizi 3873s for cat. no.
116. (fig. 116b). See discussion before cat. no.
109.

118-120*

Saint James Minor
(B. 59) 1583

Saint James Major
(B. 53)

Saint Mattias
(B. 62)

Engraving. 108 x 192 mm.

Literature: LeBlanc 105, 99, 108; Calvesi/
Casale 62, 63, 73; Ostrow 31 K, 31 F, 31N;
Bertelà 174, 168, 177.

States:

	B	CC	Ost
I	I	I	I

As reproduced.

The inscription on this plate is the basis for the 1583 dating of the
entire series. Orazio Bertelli's address suggests that the prints were made
in Venice and that Agostino was still there at the beginning of this
year.[1]

1 See Appendix I for a discussion of the Bertelli family and Orazio.

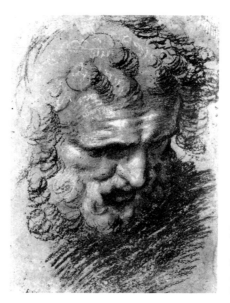

fig. 116a. Agostino Carracci, *Head of a Man.*
Turin, Biblioteca Reale

fig. 116b. Agostino Carracci(?), *Head of
a Man.* Florence, Gabinetto disegni e stampe
degli Uffizi

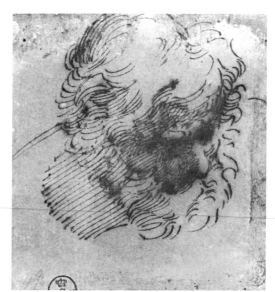

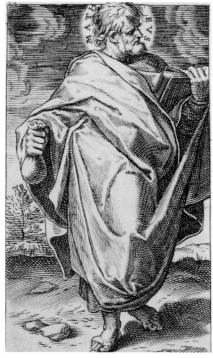

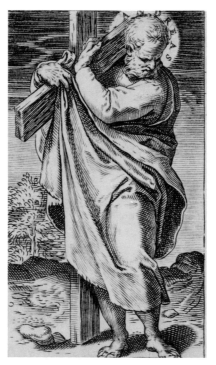

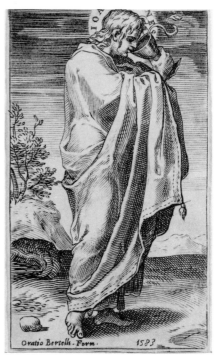

cat. no. 115, only state. New York, The Metropolitan Museum of Art, Harris Brisbane Dick Fund, 1953

cat. no. 116, only state. New York, The Metropolitan Museum of Art, Harris Brisbane Dick Fund, 1953

cat. no. 117, only state. New York, The Metropolitan Museum of Art, Harris Brisbane Dick Fund, 1953

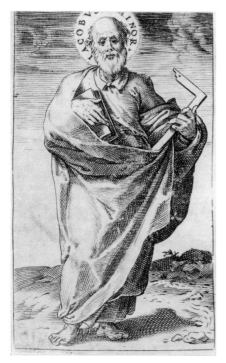

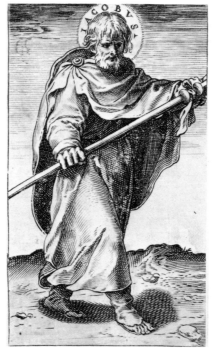

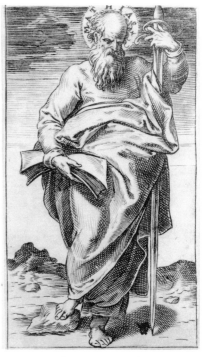

cat. no. 118, only state. New York, The Metropolitan Museum of Art, Harris Brisbane Dick Fund, 1953

cat. no. 119, only state. New York, The Metropolitan Museum of Art, Harris Brisbane Dick Fund, 1953

cat. no. 120, only state. New York, The Metropolitan Museum of Art, Harris Brisbane Dick Fund, 1953

121-123*

Saint Simon
(B. 60) 1583

Saint Philip
(B. 55)

Saint Judas Thadeus
(B. 61)

Engraving. 110 x 195 mm.

Literature: LeBlanc 106, 101, 107; Calvesi/
Casale 65, 66, 67; Ostrow 31 L, 31 G, 31 M;
Bertelà 175, 170, 176.

States:

	B	CC	Ost
I	1	1	1

As reproduced.

Preparatory Drawings: Uffizi 3872s for cat. no.
122 (fig. 122a). See discussion before cat.
no. 109.

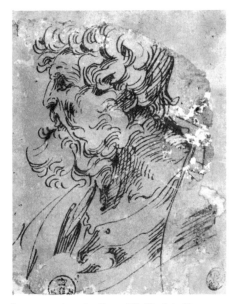

fig. 122a. Agostino Carracci(?), *Head of a Man.*
Florence, Gabinetto disegni e stampe degli Uffizi

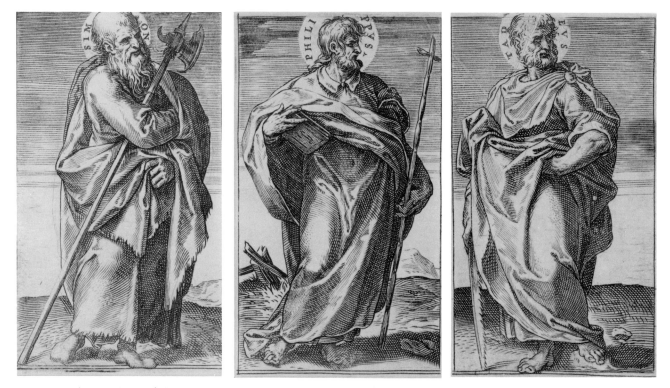

cat. no. 121, only state. New York, The Metropolitan Museum of Art, Harris Brisbane Dick Fund, 1953 cat. no. 122, only state. New York, The Metropolitan Museum of Art, Harris Brisbane Dick Fund, 1953 cat. no. 123, only state. New York, The Metropolitan Museum of Art, Harris Brisbane Dick Fund, 1953

124

Saint Francis Receiving the Stigmata
(B. 65) c. 1583

Engraving. 114 x 88 mm.

Literature: Oretti p. 838; Heinecken p. 635, no. 48; Mariette III, 120; LeBlanc 57; Bodmer 1939, p. 138; Petrucci p. 138; Calvesi/Casale 53; Bertelà 180.

States:

	B	CC
I	1	1

As reproduced. (Alb, BM, BN, Bo, Br, MMA, Ro, and others).

Copies: Contemporary engraving. (MMA).

Bodmer dated this print to the year 1581, and Calvesi/Casale believed it to belong to the following year. Its relative sophistication when compared with Agostino's *santini* of 1581 (cat. nos. 40-49) indicates that it must date after them. The landscape, although simple, corresponds in type to the apostles of 1583 (cat. nos. 109-123), and the face of Saint Francis is also close to those figures. It seems likely that this print and the following two (cat. nos. 125 and 126) date from the same period. The proximity in size and composition to the *Saint Jerome* (cat. no. 125) suggests that these engravings may have been meant as pendants.

125*

Saint Jerome
(B. 73) c. 1583

Engraving. 115 x 84 mm.

Literature: Mariette ms. II, no. 13?; Heinecken p. 634, no. 42; Mariette III, 127; LeBlanc 66; Bodmer 1939, p. 138; Calvesi/Casale 55; Bertelà 187; Boschloo p. 29.

States:

	B	CC
I	1	1

As reproduced. No inscriptions. (Alb, BM, BN, Bo, Br, MMA, Ro, and others).

As discussed in cat. no. 124, this print dates from c. 1583 and is comparable to the apostles series (cat. nos. 109-123). As with the *Saint Francis* (cat. no. 124), to which this may be a pendant, Bodmer dated the sheet 1581 and Calvesi/Casale c. 1582. Bartsch noted that the engraving was done with little care; on the contrary, the carefully contrived composition and the new understanding of the form against the background as well as the better portrayal of appendages show that Agostino had lavished a great deal of time on this print.

The print is very much like Annibale's early engraving of *St. Jerome* (Annibale cat. no. 4) and may have influenced it, as Boschloo suggested.

126

Saint Francis Adoring the Crucifix
(B. 66) c. 1583

Engraving. 122 x 92 mm.

Literature: Malvasia p. 84; Mariette ms. II, no. 63; Heinecken p. 635, no. 49; Nagler I, 1381 (2); Mariette II, 61; III, 121; LeBlanc 58; Bodmer 1939, p. 138; Calvesi/Casale 54; Bertelà 82.

States:

	B	CC
I	—	—

Before letters (Alb, Ber, BM, BN, Stu)

	B	CC
II	1	1

Lower center: *Aug. Carax/fe* (Alb, Bo, Dres, Fitzwilliam Museum, MMA, Par)

As discussed in cat. no. 125, this print is dated by Bodmer 1581 and by Calvesi/Casale c. 1582. Its relationship to cat. nos. 124 and 125 and to the apostles series (cat. nos. 109-123) place it securely after the early prints of 1581. As with cat. no. 125, the new understanding of forms in space and in relation to the background suggests that a more mature Agostino executed this print in 1583.

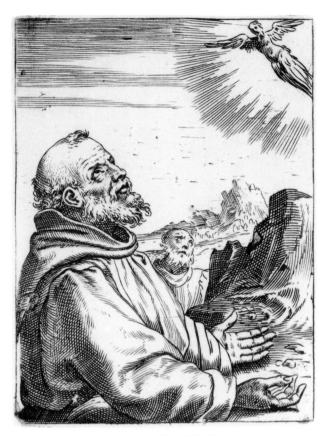

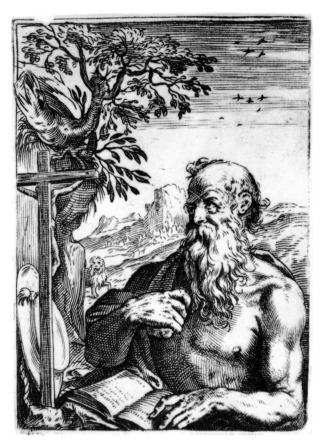

cat. no. 124, only state. London, The British Museum

cat. no. 125, only state. London, The British Museum

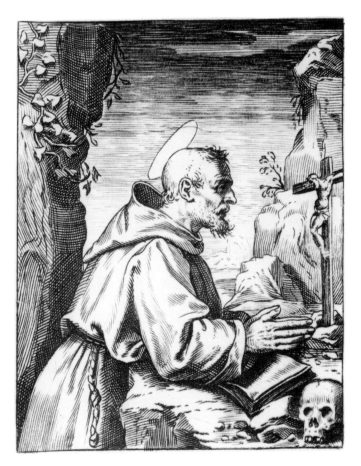

cat. no. 126, only state.
London, The British Museum

127*

Portrait of Bernardino Campi
(B. 139) 1584

Engraving. 150 x 118 mm.

Literature: Nagler 1835, p. 398; LeBlanc 225; Foratti p. 178; Bodmer 1940, p. 58; Calvesi/ Casale 114; Bertelà 248; Boschloo pp. 46, 202, note 22.

States:

	B	CC
I	1	1

Below: BERNARDINVS CAMPVS PICTOR./ CRE-MONENSIS. (Alb, BM, Bo, Ham, Houghton)

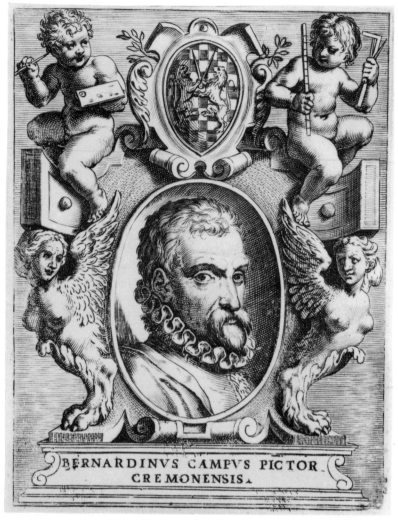

cat. no. 127, only state. Vienna, Graphische Sammlung Albertina

The date of this print is known since it forms the frontispiece to the book by Alessandro Lamo, *Discorso intorno all scoltura, et pittura fatte da Bernardino Campo,* edited by G. B. Trotto and published by Cristoforo Draconi in Cremona in 1584. Not only the engraving but also the book by Lamo is very rare. In several copies of the book, the engraving is missing, and in several print rooms the engraving is found apart from the book.[1] None of the extant impressions is very good. The fact that this print is part of a book published in Cremona and that the portrait is of Bernardino Campi (1522-1591), perhaps Antonio Campi's cousin,[2] implies that Agostino either was in Cremona again in 1584—perhaps still working on the portraits of the *Cremona Fedelissima*—or was otherwise involved with the Campi family at this period.

*Engraving in exhibition from Houghton Library, Harvard University, Gift of Philip Hofer.

1 The Ambrosiana in Milan and the Biblioteca Palatina in Parma each own a copy of the book without this frontispiece. The copies of the engraving found at the Albertina, Bologna, and Hamburg are separated from the book.

2 Bernardino's relationship to the other members of the Campi family is not known, but he seems to have been a distant relative. (See Aurelia Perotti, *Pittori Campi da Cremona,* Milan, [n.d.], p. 105).

128*

Coat of Arms of Giacomo Boncampagni, Marchese of Vignola

(B. 165) c. 1582-1585

Engraving. 112 x 133 mm.

Literature: Malvasia p. 83; Heinecken p. 642, no. 15; Bolognini Amorini p. 59; Nagler 1835, p 398; LeBlanc 253; Bodmer 1940, p. 51; Calvesi/Casale 116; Bertelà 264.

States:

	B	CC
I	I	I

As reproduced with inscriptions in banners: CVSTODITA/ MNI/ SO/ IN DRA/ CO/ NE./ HOS TIBI NVNC TENERO AFFERT TVA VINEA FRVCTVS.[1] (Alb, BM, BN, Bo, Br, Ham)

cat. no. 128, only state. London, The British Museum

Bartsch felt that this charming print was one of Agostino's most beautiful works. Bodmer dated it c. 1583-1585, reasoning that Giacomo Boncampagni (1548-1612) became marchese of Vignola in 1577 and the Duke of Sora in 1582.[2] Giacomo was also the son of Pope Gregory XIII who reigned from 1572-1585. Besides these external reasons for dating this engraving to the early to mid-1580s, stylistically it belongs during this period. The *putti* resemble those in other works of these years such as those in the *Memorial Portrait of Carlo Borromeo* (cat. no. 132) of 1585 and those in the *Portrait of Bernardino Campi* of 1584 (cat. no. 127). Moreover, the *putti* are reminiscent of the apostles series (cat. nos. 109-123) of 1583 and the other saints here attributed to the same period (cat. nos. 124-126).

1 The letters in the banner entwined around the wreath read: "In somni Custodita Dracone."

2 Filippo Bianchi, *Trattato de gli Huomini Illvstri di Bologna* (Ferrara, 1590): 62, is the earliest source in which a biography of Giacomo Boncampagni is found. Boncampagni was also made the head of the territories of Arpino and the Rocca di Secca in 1583. There were numerous other properties bought for him by Gregory XIII. Biographies are also found in Dolfi p. 199 and Litta, vol. 3, tavola 2.

129

Saint Malachy
(B. 84) c. 1584-1586

Engraving. 239 x 169 mm. (sheet: BN)

Literature: Nagler 1835, p. 396; Mariette ms.
II, 85; Heinecken p. 636, no. 58; LeBlanc 70.

States:

	B
I	I

In cartouche above: PROVINCIA/HIBERNIAE.
Below image of saint: *S. Malachias Epus Hiber-
niae.* (Alb, BN)

This print and the following of the *Holy Trinity* (cat. no. 130) were not connected stylistically or compositionally by Bartsch. Their rarity has precluded their publication by modern critics. With the discovery of a third, obviously related engraving (cat. no. 131) it becomes evident that Agostino was planning a series of religious prints. The cartouches of each are similar, although interestingly diverse, and the measurements are also close. In addition, on the plaque at the top of each is found *Provincia. . . .* The compositions set within elaborate borders suggest that the works were meant as frontispieces or, more likely, as chapter headings for a book. The rarity of the pieces[1] may indicate that these prints were part of a book of saints or similar religious volume that was indeed published, and that these few extant prints were removed from the books. Unfortunately, if such a book exists, it is unknown to this author.

Stylistically, the engravings can be compared with dated works from c. 1584-1586. The sleek, attached winged female forms on the sides of the *St. Malachy* cartouche are related to the elegant sylphlike boys that hold the wreath on the title page of the *Vita di Cosimo de'Medici* of 1586 (cat. no. 135). In all of the similar title pages and illustrations of this period (cat. nos. 127, 130-132, 136) there is an emphasis on light, which Agostino accomplished by allowing more of the white of the paper to appear. It is probable that after Agostino's experience with the *Cremona Fedelissima* and his making of coats of arms for various cardinals, he became adept at inventing unusual frames. It is certainly true that the most interesting Italian title pages and illustrations from this period are by Agostino.[2]

1 Cat. no. 129 is found at the Albertina and the Bibliothèque Nationale in Paris. Cat. no. 130 is found only at the Albertina and cat. no. 131 is found only at the Bibliothèque Nationale.

2 See especially the *Portrait of Cosimo de' Medici* in which the cartouche alone was executed by Agostino (cat. no. 136), the *Portrait of Bernardino Campi* (cat. no. 127), and the very elegant and simplified *Vita di Cosimo de' Medici* (cat. no. 135).

PROVINCIA HIBERNIAE

S. Malachias Epūs Hiberniæ

cat. no. 129, only state. Paris, Bibliothèque Nationale

130

The Holy Trinity
(B. 92) c. 1584-1586

Engraving. 239 x 174 mm. (sheet: Alb) (after Cornelis Cort engraving: Bierens de Haan 111).

Literature: Malvasia p. 79; Oretti p. 811; Heinecken p. 634, no. 34, p. 644, no. 4; Gori Gandellini p. 319, no. XXV; LeBlanc 86.

States:

	B
I	1

In plaque above: PROVINCIA/TRINITATIS. In margin below frame: *Beata sit Sctā. et individua Trinitas.* (Alb)

Bartsch noted that this engraving is after a work by Titian but did not realize that the direct precedent for it is Cornelis Cort's engraving after Titian's *Triumph of The Trinity* in the Prado, Madrid.[1] Agostino copied the upper portion of Cort's 1566 engraving (fig. 130a) and executed it in reverse. He changed the rays of light above God the Father's and Christ's heads to a triangle of light above the former and a halo above the latter. Bartsch was correct in suggesting that the ornamental decoration of the border was Agostino's own. As explained in cat. no. 129, the kind of frame executed is similar to others by the artist.

Heinecken was on the right track when he listed this engraving as a frontispiece. When considered along with the two related prints (cat. nos. 129, 131), it is evident that these prints were meant as book illustrations.

There is a note on the Albertina print dating this sheet c. 1580. As explained in cat. no. 129, the stylistic similarities with other prints of the period c. 1584-1586 imply that this work also comes from that period. In addition, the morphological comparisons of the figure of Christ with that of the same figure in Agostino's 1582 print of the *Martyrdom of Saint Justina* (cat. no. 105), after Veronese, indicate that Agostino had a prototype from which to work.

1 Reproduced in Harold E. Wethey, *The Paintings of Titian, I. The Religious Paintings* (London, 1969), pl. 105.

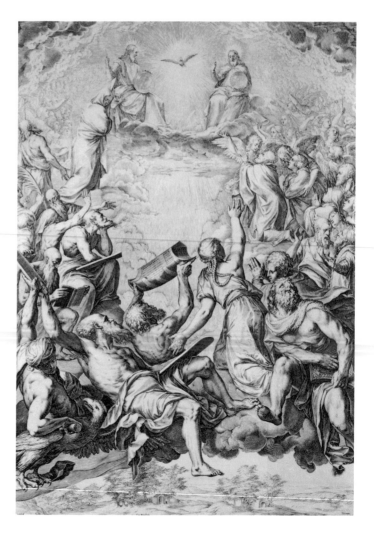

fig. 130a. Cornelis Cort, *The Triumph of the Trinity.* London, The British Museum

cat. no. 130, only state. Vienna, Graphische Sammlung Albertina

131

Saint Francis of Quito Preaching

Engraving. 245 x 168 mm. (sheet: BN)

Literature: Mariette ms. II, no. 64.

States:
I

In plaque above: PROVINCIA S.^{TI} FRANC. DE QUITO. (BN)

Preparatory Drawings: 1. Louvre 7114. Pen and ink. 279 x 186 mm. Laid down. Lower left: *Antonio Carracci* Lower right: *Ce . . . gravé par Aug.ⁿ avec 2. autres pieces dans l'histoire/ de l'ordre des françois. Ce dernier vien du Prince/ Dom Luis.* Lower right: *129.* Writing from verso (illegible) shows through. Unpublished.[1]

This print, hitherto unpublished,[2] completes the series of chapter headings for a book, unknown or unfinished.[3] Quito (in Ecuador), founded in 1545, was one of the first dioceses in the New World. This, with the little-known St. Malachy from Ireland, indicates that the arcane subject matter of the book may have been commissioned by a religious order.[4] In post-Tridentine Italy, such a book could have been written to spread information on the good works of the missionary orders.

The drawing in the Louvre by Agostino is in reverse of the print (fig. 131a), and most of the outlines were followed in the engraving. Although the inscription on the drawing attributes it to Antonio Carracci, the style is typical of Agostino in the 1580s.

1 On the verso of the mat, in a different hand from the writing on the recto: *Dessein d'Augustin Carache quel a gravé et setrouve dans l'histoire del ordre des francois. dans laquelle il y/ a encore deux autres Estampes aussi graves par Augustin/ Ce dessein vien du Cabinet du Prince Dom Louis.*

2 Mariette attributed the print to Agostino, but it was not published in the *Abecedario.*

3 See cat. nos. 129-130.

4 The inscription on the drawing indicates that the works were indeed made for a confraternity or religious order. It is possible, too, that they were made for a history of the Franciscan order. The saint here represented may in fact be Saint Francis of Assisi. On the other hand, it would be difficult to understand where St. Malachy would fit into this scheme.

fig. 131a. Agostino Carracci, *Saint Francis of Quito Preaching.* Paris, Cabinet des dessins du Musée du Louvre

PROVINCIA S.^{TI} FRAN.^{CI} DE QVITO.

cat. no. 131, only state. Paris, Bibliothèque Nationale

132*

Portrait of Carlo Borromeo
(B. 138) 1585

Engraving. 481 x 341 mm. (after Francesco Terzo)

Literature: Mariette ms. 12; Heinecken p. 636, no. 57; Nagler 1835, pp. 393, 394; LeBlanc 224; Foratti p. 175; Bodmer 1940, p. 43; Calvesi/Casale 117; Bertelà 247.

States:

	B	CC
I	1	–

In margin above: LVCE SALE ET PRECIBVS VITA ASPERIORE RAPACES IPSE LVPOS ARCENS DVCIS AD ASTRA GREGEM. Various inscriptions in banners, on walls, in plaques, etc., in elaborate framework around portrait. In margin below nine lines telling the virtues of Carlo Borromeo, beginning with: *Le virtù del Car.^le Borrome came raggi di lucidissimo sole, . . .* At end *D.V.A. Ser.^ma* humiliss.° *Ser.^re/ Francesco Terzo.* CON PRIVILEGIO DI S.S^TA T DEL RE CATH.^CO ET DELLA DIG.^RIA DI VINETIA CHE PER ANI XII NON SI POSSA/ RISTAMPAR IN MODO ALCVNO. MDLXXXV. (Alb, Bo, Br)

II	2	–

The same as state one but with *Aug. Car. f.* lower right above margin. (Ber, BN)

Although not signed until the second state, there has never been any doubt as to the authenticity of this print. Moreover, the style of the engraving is consistent with Agostino's other works. Bodmer suggested that the elaborate cartouche is typical of Venetian Renaissance architecture,[1] but the facade does not reflect any known Venetian works. The connection with Venice does remain, however, since the Venetian senate extended the *privilegio* to publish the engraving for twelve years. It is possible that the print was in fact executed in Venice in 1585 and that Agostino was in the city in that year; the following print after Veronese (cat. no. 133), also dated 1585, suggests such a trip.

The composition of this elaborate illustration belongs to Francesco Terzo (c. 1523-1591), an artist from Bergamo who made drawings for use by printmakers.[2] Like the title page for the *Cremona Fedelissima* (cat. no. 56), the presentation of this composition resembles that of a stage setting instead of the old book illustration designs. Since the inventor of the title page to the *Cremona Fedelissima* was Antonio Campi, from Cremona, it may be that this new kind of tableaulike illustration is Lombard in origin.[3] The allegorical and religious figures portrayed proclaim the virtue of Borromeo, who had died the year before, as does the Italian inscription in the margin. At either side of the pedestal are representations of the good shepherd who protects his flock from wolves, and below the portrait are the words *Bonvs Pastor.* At either side of the oval portrait are cherubs who hold the cardinal's hat and staff and the bishop's miter and crosier, indicating he was equally a cardinal of the Church and a bishop of his flock—the diocese of Milan. Above, personifications of Faith and Victory reflect those qualities in Borromeo. Above, at center, are figures (representing the Church) who admonish one to pray and fast, like the cardinal. Behind is a picture of a town on a hill (suspiciously like Terzo's Bergamo) with the words from Matthew 5, verse 14: "it cannot be hidden,"[4] meaning that Borromeo's virtues and faith are apparent to all.

Very few of these prints are extant, indicating that it must have been popular and widely distributed. Due to his strict lifestyle, his work at the Council of Trent, and his concern for the people of his diocese, Borromeo's effigy would have been in demand.[5]

*The engraving in the exhibition is from the Graphische Sammlung Albertina, Vienna.

1 C. Douglas Lewis has noted to the author that the Venetian connection is tenuous.

2 Terzo was not only an artist but also a member of the literati. For this reason alone, he and Agostino would have had much in common. Moreover, he did some work for the Medici in relation to the 1589 marriage of Ferdinando and Christine of Lorraine. If Agostino was also there in that year, they would have been in contact (see cat. nos. 153-154). Terzo spent his last years in Rome, where he died in 1591. Little is written on him. See Thieme-Becker vol. XXXII, pp. 546-548. See also cat. no. 87.

3 For more on this development see the Introduction p. 5c and the discussion before cat. no. 56.

4 "Ye are the light of the world. A city that is set on a hill cannot be hid." Thomas McGill kindly translated the Latin on this engraving and found the reference to Matthew.

5 Foratti suggested that the portrait of Borromeo in the oval is connected with a painting in Leningrad, the Hermitage, there attributed to Annibale, but in truth by Agostino. This writer has not located the painting.

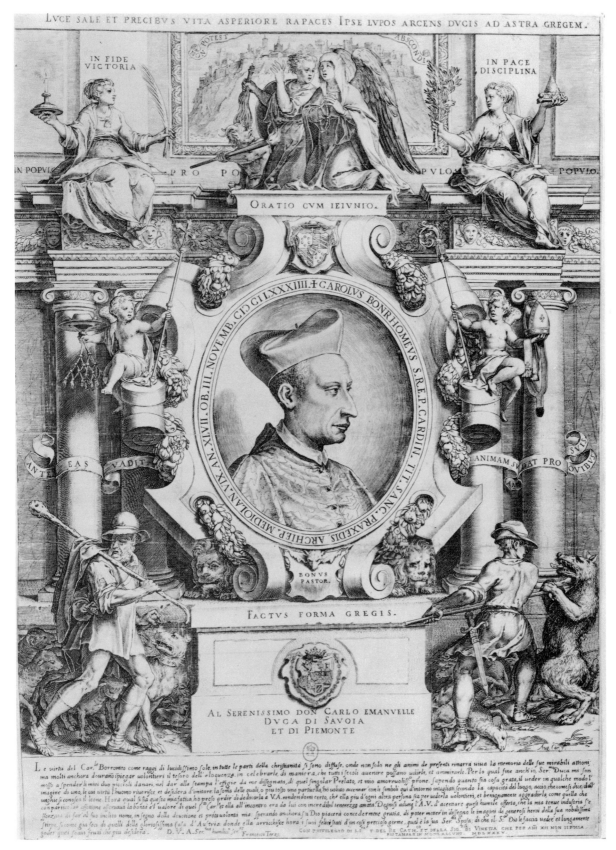

LVCE SALE ET PRECIBVS VITA ASPERIORE RAPACES IPSE LVPOS ARCENS DVCIS AD ASTRA GREGEM.

IN FIDE VICTORIA

IN PACE DISCIPLINA

ORATIO CVM IEIVNIO.

ANTE EAS VADIT

ANIMAM SVBAT PRO OVIBVS SVIS

BONVS PASTOR.

FACTVS FORMA GREGIS.

AL SERENISSIMO DON CARLO EMANVELLE
DVCA DI SAVOIA
ET DI PIEMONTE

cat. no. 132, state II. Paris, Bibliothèque Nationale

133*

The Mystic Marriage of Saint Catherine
(B. 97) 1585

Engraving. 312 x 230 mm. (after Veronese painting in the Institute of Arts, Detroit)

Literature: Bellori p. 115; Malvasia pp. 77-78; Oretti pp. 802-803; Heinecken p. 636, no. 65; Gori Gandellini p. 319, no. XXIII; Bolognini Amorini p. 56; Nagler 1835, p. 397; Mariette II, 31?, 53; LeBlanc 76; Disertori p. 262; Bodmer 1940, pp. 43-44; Petrucci p. 136; Petrucci 1953, no. 235; *Mostra-Dipinti* pp. 78, 143; Calvesi/Casale 118; Ostrow 34.

States:

	B	CC	Ost
—	1	—	—

Lower right above margin: *1586*

	B	CC	Ost
I	—	—	1

Lower right above margin: *1585* (Alb, BM, BMFA)

	B	CC	Ost
II	2	1	—

As state I but with *Pauli Calliari inven.* lower right in margin. (Alb, BM, BN, Br, Dres, Fogg)

	B	CC	Ost
III	3	2	—

As state II but with *Agustino Caraci* lower right and *Antonius Carensanus fo.* below. These are weak. (Ber, Bo, Ham, MMA, Ro, and others)

	B	CC	Ost
IV	—	3	—

As above but sex of the Christ Child and flying angel have been covered by a leaf. (Rome: Calcografia Nazionale)

*Plate extant at the Calcografia Nazionale, Rome (Inv. 235). The verso is cat. no. 134.

Copies: Engraving in same direction. 292 x 231 mm. (sheet: Par) Lower right: *Nicolas. valegii formis. Vent.* (Par)

Bartsch, followed only by Bodmer and Cavalli *(Mostra-Dipinti),* mistook the date to read 1586 instead of 1585. Because the composition is after one by a Venetian artist, Calvesi/Casale proposed another trip to Venice in 1585, but Ostrow felt that there was not enough evidence to accept such a trip. The painting by Veronese (fig. 133a) was not mentioned specifically as being in the artist's studio at his death, but conjecture has placed it there. It could have been in another city, and is only traceable to the nineteenth century.[1] However, if one were to accept that the Carlo Borromeo portrait was executed in Venice in 1585, there is a possibility that both of these works were engraved on a second trip to the city by Agostino in this year. But without further evidence, this must still remain conjecture.

Although the signature appears only in the third state, and Ostrow correctly called it apocryphal, there has never been any doubt as to the attribution of this work. It is close stylistically to the engravings after Veronese which are signed and dated 1582 (cat. nos. 102-105). Obviously, Agostino's interest in the Venetian artist had not waned in the intervening three years.

1 See Ostrow, pp. 528-529, for a discussion of the provenance of the painting and his view of Agostino's travels at the time. Although the painting has been attributed to Veronese's studio, the fact that Agostino engraved it as his strengthens the contention that Veronese accepted responsibility for the work.

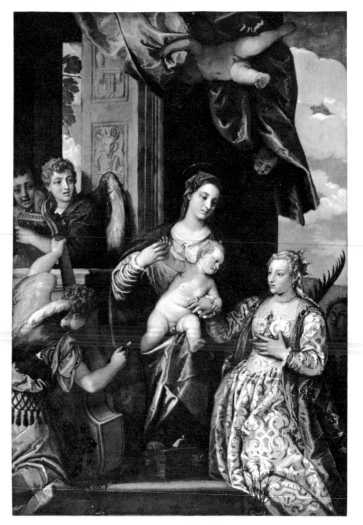

fig. 133a. Paolo Veronese, *The Mystic Marriage of Saint Catherine.* The Detroit Institute of Art, Gift of Mr. and Mrs. Walter O. Briggs

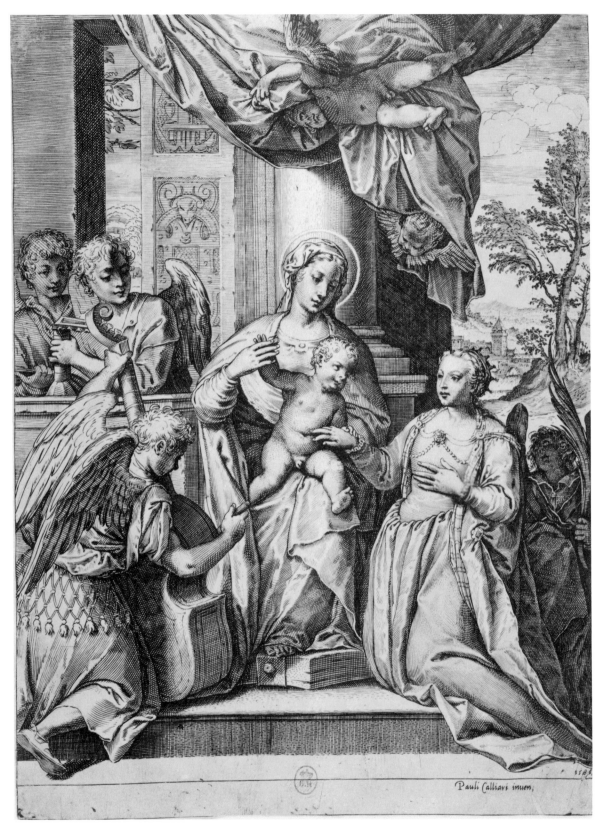

Pauli Calliari inuen.

cat. no. 133, state II. Paris, Bibliothèque Nationale

134*
Various Studies
c. 1585

Engraving. 312 x 230 mm.

Literature: Calvesi/Casale 119.

States:

	CC
	I
I	1

As reproduced. No inscriptions. (Calcografia Nazionale, Rome)

*Plate extant in the Calcografia Nazionale, Rome (Inv. 235R). Recto is cat. no. 133.

cat. no. 134, copperplate. Rome, Istituto Nazionale per la Grafica—Calcografia

cat. no. 134, only state. Rome, Istituto Nazionale per la Grafica—Calcografia

The print, known only in impressions from the Calcografia Nazionale in Rome, is indicative of the artist's working method; he tried the burin on the plate and made various studies before doing a complete design on the other side of the plate. The practice was common during the period and can also be seen in Annibale's prints (Annibale, cat. nos. 5-10) when the plates are extant.

It is interesting to note that the face here is much like some of the heads in the *Lascivie*, e.g., cat. nos. 176-190, although those are dated here in the early 1590s. Closer yet is the head of the Madonna in the *Madonna of Saint Jerome* (cat. no. 142) of 1586.[1]

1 The pocking of the plate appears at first to be from an etching mordant, but there is no evidence that any of the plate was etched or placed in an acid bath. More likely, it is damage from corrosion caused by the atmosphere.

135-139

Engravings to illustrate the Vita di Cosimo de' Medici, 1586

135

Title Page for the Vita di Cosimo de' Medici (B. 262) 1586

Engraving. 263 x 178 mm. (sheets in volume 309 x 214 mm.)

Literature: Malvasia p. 78 & note 4; Oretti p. 807; Heinecken p. 643, no. 1; Gori Gandellini p. 316, no. LIV; LeBlanc 222; Graesse IV, p. 376; Ostrow 36; Mortimer no. 276; Bertelà 296.

States:

	B	Ost
I	1	1

In oval: VITA/ DI/ COSIMO/ DE'/ MEDICI,/ PRIMO/ GRAN DVCA/ DI/ TOSCANA,/ *Descritta/ da/ Aldo Mannucci.* In margin lower left: IN BOLOGNA. Lower right: MDLXXXVI (Alb, BM, BN, Bo, Dres, Ham, and others)

| II | — | — |

Title in oval changed to GEOMETRIA/ PRATTICA. . . . In margin lower left: IN ROMA. Lower right: MDCII. Center: *Appresso Giovanni Martinelli/Con licenza de superiori.* Also *Ristampata con privilegio.* . . . Arms below changed. Reworked. (BN)

The following four engravings were made to illustrate Aldo Manuzio's *Vita di Cosimo de' Medici,* published in Bologna in 1586. Although there are some ornamental woodcuts in the book, probably by an unknown artist-craftsman, there are only five engravings in the volume: the four attributed to Agostino—a title page, a portrait of Cosimo de' Medici, an ornamental letter, and a decorative vignette—and a portrait of Francesco de' Medici (fig. 136a), here attributed to Martin Rota. There has been some question as to the author of the *Portrait of Cosimo de' Medici* (cat. no. 136), here attributed partially to Martin Rota, but the remaining engravings have always been given to Agostino.

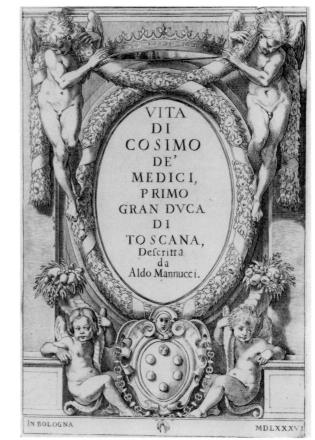

The elegant, mannered tendency of the elongated figures holding the swag of fruit seems to appear in Agostino's work of this time. Similarly executed are the winged female forms on the cartouche of the *Saint Malachy* (cat. no. 129), types also seen later in Agostino's painting of the *Assumption* in the Pinacoteca Nazionale in Parma.[1] The *putti* holding the cornucopias are similar to the ones in the *Memorial Portrait of Carlo Borromeo* (cat. no. 132). Ostrow compared the sheet to the *Cordons of Saint Francis* (cat. no. 141) of the same year.

In his notes to Malvasia, Zanotti claimed that the composition was patterned after some "dry Florentine." Ostrow was correct in refuting this allegation and calling the design Agostino's own. The placement of the figures against a backdrop and highlighting them as if they were in an enclosed box is typical of Agostino's compositions during the 1580s.[2]

1 Reproduced *Mostra-Dipinti,* pl. 42. Dated in the early 1590s.

2 See, for example, the *Arms of Cardinal Fieschi* (cat. no. 30).

136*

Cartouche Surrounding a Portrait of Cosimo de' Medici
(B. 140) 1586

Engraving. 273 x 191 mm.

Literature: Malvasia p. 79; Oretti p. 808; Mariette ms. 20; Heinecken p. 628, no. 3; Gori Gandellini p. 313, no. V; Joubert p. 345; Bolognini Amorini p. 56; LeBlanc 242; Bodmer 1940, p. 58; Calvesi/Casale 27; Mortimer 276; Bertelà 249.

States:

	B	CC
I	–	I

Before letters (Alb, Bo)

	B	CC
II	I	2

Letters around oval above portrait: COSMVS MEDICES MAG. DVX ETRVRIÆ·I. (Alb, BN, Dres, MMA, and others)

fig. 136a. Martin Rota(?), *Portrait of Francesco de' Medici.* Cambridge, Houghton Library, Harvard University

Malvasia attributed this entire engraving—portrait and surrounding cartouche—to Agostino Carracci. Bartsch did not feel that the portrait could be securely attributed to Agostino, since its style was very close to Martin Rota. He did believe that the ornaments were by Agostino, c. 1581. Calvesi/Casale confusingly attributed the entire work to Agostino, even though they said that the portrait was done separately from the ornament. They added that the portrait could have actually been an early proof of an engraving by Annibale when he worked with Agostino on the *Cremona Fedelissima.* There is absolutely no basis for this assumption.

Even the most casual observer notices that there is a technical and stylistic disparity between the portrait and the surrounding ornamental cartouche. However, although it appears that the two parts were executed by separate hands, there is but one plate on which the entire print was made. There could be two explanations for this: 1) the portrait was executed on a large plate and left unfinished for some reason or 2) the cartouche was made first, leaving the portrait to be executed by another artist. The stylistic diversity of the two parts, with a more archaic style for the portrait, speaks for the first explanation. Agostino was probably called in to finish the ornamental cartouche after the first artist abandoned the project due to other commitments or death. The style of the portrait, with its delicate and closely spaced hatching, harsh contours and contrasts of the features, and emphasis on the costume, is characteristic of an artist working in a northern ambience, such as Martin Rota. Most closely akin to this portrait is one by Rota dated 1575 of Ferdinand I (Bartsch XVI.268, 68). The same characteristics found in the Cosimo portrait are found in the earlier print. Rota was born in Sebenico (Dalmatia) but spent most of his life in Venice and Rome. He left for Vienna in 1572 and died before 1583.[1] Since Rota was in Italy most of his life and since he did do a portrait of Cosimo de' Medici in 1568 (Bartsch XVI, 273.85), there is no reason to doubt that he could have executed this print sometime before his death in 1583. Since there are no such frameworks surrounding any of Rota's known prints,[2] perhaps it was left unfinished to accommodate an ornamental framework by another artist.

When Agostino was given the partially completed plate, he must have burnished out portions of the lower part of the costume to accommodate the heads of the two *putti.* The style of the cartouche is typical of Agostino's works in the early 1580s, and there is no reason to doubt that he would have been asked to make the framework after his successes with the *Cremona Fedelissima* and his coats of arms, probably in circulation by that time. The broad burin technique is like that of Agostino after 1582, and the figures of the winged female forms recall similar types on the frontispiece to the *Cremona Fedelissima* (cat. no. 56). Moreover, the *putti* come from the same mold as those in the *Arms of Cardinal Fieschi* (cat. no. 30) and the *Frieze to Accompany a Map of the City of Bologna* (cat. no. 29). These comparisons are with engravings made by Agostino in the early 1580s, and there is a possibility that Agostino worked on this book prior to its publication in 1586.

A second portrait in the volume, of Francesco de' Medici (fig. 136a), is consistent stylistically with Rota's portrait of Cosimo, and in a finer burin technique than Agostino's in the framework for the portrait

cat. no. 136, state II. Cambridge, Houghton Library, Harvard University

of Cosimo de' Medici. In addition, the surrounding personifications appear to be by the same hand. It is likely then that the *Portrait of Francesco de' Medici* is also by Martin Rota.

1 See Appendix II for a further discussion of Martin Rota and for a bibliography. Lamberto Donati, "Alcuni disegni sconosciuti di Martino Rota," *Archivio storico per la Dalmazia,* anno V, vol. X, fasc, 57 (Dec., 1930): 422 mentioned that many portraits by Rota were published after his death and cites the *Cosimo de' Medici,* finished by Agostino, as one of them.

2 Unless we accept fig. 136a as Rota's.

137

The Letter A with an Eagle
(B. 264) 1586

cat. no. 137, only state. Cambridge, Houghton
Library, Harvard University

Engraving. 50 x 53 mm.

Literature: Heinecken p. 643, no. 10; LeBlanc
140; Mortimer 276.

States:

	B
I	1

As reproduced. No inscriptions. (Alb, BM,
BN, MMA, and others)

The engraving is found on the dedication page of the *Vita di Cosimo de'
Medici.* As it is stylistically consistent with Agostino's works and is part
of this book, it seems natural that it was also executed by him.

138

Oval Vignette with Sun and
Moon and Crowns
(B. 267) 1586

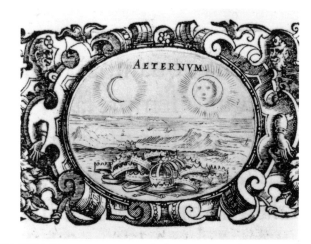

cat. no. 138, only state. Cambridge, Houghton Library, Harvard
University

Engraving. 40 x 51 mm. (oval) (Image of
woodcut within which it is set: 157 x 52 mm.)

Literature: Heinecken p. 641, no. 14, p. 643,
no. 2; LeBlanc 143; Bodmer 1940, p. 58;
Mortimer 276.

States:

	B
I	1

At top: AETERNVM (Alb, BM, MMA, and
others)

Bartsch believed that this print was after an invention of another artist.
The simplicity of the composition was certainly within Agostino's capa-
bilities, but without the preparatory drawing one cannot say who the
inventor was. Bodmer compared the sheet with the *Headpiece in the Form
of a Fan* (cat. no. 193). Although there are oval designs on that engrav-
ing, there is no other apt comparison with the sheet.

139

Pastoral Scene for the Title Page of Horace's Odes
(B. 268) 1586

Engraving. 52 x 83 mm.

Literature: Heinecken p. 643, no. 6; LeBlanc 144.

States:

	B
I	1

As reproduced. No inscription. (Alb, BM, Bologna: Biblioteca Universitaria)

cat. no. 139, only state. London, The British Museum

As Bartsch pointed out, this rare print formed part of the title page to the Odes of Horace, *De Laudibus Vitae Rusticae . . .,* edited by Aldo Manuzio and published in Bologna in 1586. Although Bartsch and LeBlanc were the only critics to mention this print, its style is close to the backgrounds in other Agostino works,[1] and it must be by him. It may have been ignored by other writers due to its rarity. As in the preceding engraving (cat. no. 138), Agostino worked in a simplified manner when tackling compositions on a small scale.

1 Cf., e.g., the print of the *Carroccio* in the *Cremona Fedelissima* (cat. no. 59).

140*

Saint Francis Receiving the Stigmata
(B. 68) 1586

Engraving. 453 x 317 mm. (partially after Lodovico Carracci painting in the Credito Romagnolo, Bologna)

Literature: Bellori p. 116; Malvasia p. 76; Strutt p. 181; Heinecken p. 635, no. 46; Gori Gandellini p. 314, no. XXV; Joubert p. 344; Bolognini Amorini p. 55; Mariette II, 60?; III, 128; Nagler 1835, p. 393; Nagler I, 296 (13); LeBlanc 60; Andresen 9; Disertori pp. 262, 264; Bodmer 1940, p. 45; Petrucci 1953, cat. no. 315; *Mostra-Dipinti* p. 78; Calvesi/Casale 121; Ostrow 37; Bertelà 184; Carlo Volpe, "Sugli inizi di Lodovico Carracci," *Paragone,* no. 317-319 (July-September, 1976): 124.

States:

	B	CC	Ost
I	1	1	1

Lower left: *Agostino Caracci forma Bologna 1586* with 8 on its side. On scroll: *Ego enim stigma/ta domini inri/ Iesu Christi in/corpore meo porto.* In margin: SIGNASTI DOMINE SERVM TVVM FRANCISCVM, SIGNIS REDEMPTIONIS NOSTRAE. (Alb, BM, BN, Bo, Br, MMA, U, and others)

II	2	2	2

As state I but with *et nunc apud Phillipu Thomassinù, Rome* after *Bologna, 1586.* (BN, Bo, Dres, MMA, and others)

III	3	3	3

As state II but with *Gio: Iacomo de Rossi alla pace formis 1649* added after *1586.* Very weak. (Alb, Ber, BN, Dres, Philadelphia, Ro, and others)

Plate extant in the Calcografia Nazionale, Rome.

Copies: 1. Etching in reverse. No inscriptions. 199 x 134 mm. (sheet: Ber)

Writers differ as to whether the original design of this engraving, published by Agostino himself in 1586, is by Cornelis Cort or Agostino. Bellori, Strutt, Gori Gandellini, and Ostrow believed it to be Agostino's invention, but Ostrow added that it was close to a Muziano prototype often engraved by Cort. However, Volpe related much of the landscape behind Saint Francis to the landscape in a painting he attributed to Lodovico of *San Vincenzo* (fig. 140a) in the Credito Romagnolo, Bologna. As discussed under cat. no. 98, this painting could belong to Lodovico's oeuvre and have been painted c. 1582. Although the landscape is reproduced in the same direction by Agostino, this is usual for his mode of working. The figure of Saint Francis is somewhat reminiscent of Federico Barocci's *Il Perdono,*[1] but this pose probably belongs to Agostino.

A continuing interchange of drawings and compositions seems to have taken place among the Carracci throughout their careers.[2] It is probable that many of Agostino's engravings thought to be of original invention stem from ideas circulating in the Carracci academy and among the Carracci cousins. Conversely, it is known that Agostino's engravings were influential on his brother's paintings.[3]

The *Saint Francis Receiving the Stigmata* was published in Bologna by Agostino probably before his trip to Parma in the same year. He remained there until 1587.[4]

*Engraving in exhibition from the Cleveland Museum of Art, James Parmelee Fund.

1 Emiliani, pl. 76.

2 See cat. no. 98 and Annibale cat. no. 19.

3 See, e.g., cat. no. 105.

4 See cat. nos. 142-143. As noted in Appendix I, Agostino published at least three of his own prints.

Bodmer listed six drawings which he called preparatory to this engraving. The two drawings in the Louvre (Inv. 7437, 7120) are not by Agostino and not connected in any way with this print. The Munich drawing (Inv. 11782) of a landscape is not by Agostino nor close to this composition. The Uffizi drawing (Inv. 3853) is not by Agostino, but rather a poor copy after Barocci. The Berlin sheet (KdZ 16317) is a poor copy after Agostino's print.

fig. 140a. Lodovico Carracci, *San Vincenzo.* Bologna, Credito Romagnolo

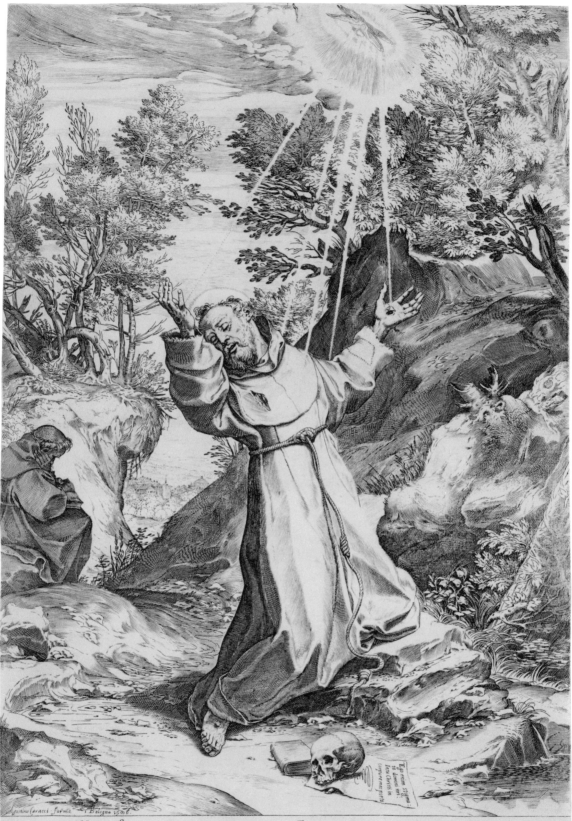

SIGNASTI DOMINE SERVM TVVM FRANCISCVM, SIGNIS REDEMPTIONIS NOSTRÆ.

cat. no. 140, state I. New York, The Metropolitan Museum of Art, Harris Brisbane Dick Fund, 1926

141

The Cordons of Saint Francis
(B. 109) 1586

Engraving. 521 x 344 mm. (sheet: Alb)

Literature: Bellori p. 116; Malvasia pp. 76, 287; Oretti p. 795; Mariette ms. II, 65; Basan pp. 109-110; Strutt p. 181; Heinecken p. 635, no. 47; Gori Gandellini p. 314, no. XXVI; Joubert p. 344; Bolognini Amorini p. 55; Nagler 1835, p. 393; Nagler I, 647 (2); LeBlanc 62; Andresen 17; Bodmer 1940, pp. 44-45;[1] *Mostra-Dipinti* p. 78; Calvesi/Casale 120; Ostrow 35; Bertelà 217.

States:

	B	CC	Ost
I	I	I	I

Above: *Ecco figli, ch'à pieno/ Sparge l'almo sereno,/ Gracia cosi felice/ Che in lei bear' vilice.* Middle right: *E noi puir lieti siamo/ Che libertà aspettiamo.* In orb: *Madre felice hor godi/ de tuoi preciosimo*[di]. Below on pedestal: *Quindi ne trae 'alma/ Lo scarco di Sua Salma.* Below that: *Eccovi aperto à pieno/ dela pietade il seno.* In vault: QVESTO E DI SANTO CHIESA IL GRAN TESORO. The rest is found in Bartsch. Lower left: *Ago:Car:for:.* Lower right: *Bol.*[e] *1586.* Above margin at left: *Con privilegio.* (Alb, BM, BN, Bo, Br, Ro, and others)

Preparatory Drawings: 1. *Kneeling Pope* Ashmolean Inv. no. 142. 273 x 182 mm; Red chalk. (fig. 141a). Literature: Parker 142; Ostrow p. 532.

Copies: 1. Engraving in the same direction. 503 x 333 mm. (image: BN); Lower left: *Gul. Ru. formis.* instead of *Ago. Car. for.* Lower left: *C. Cart. fe.* By Cristoforo Cartaro. 2. Engraving in same direction. 504 x 342 mm. (sheet: Par.). Lower right: *Cami. Graffico Ed Roma. Baptista Parmen. Formis./1587.* (Alb, Par). 3. Engraving in same direction and with same inscriptions. Lower left: *Cum privi.* Without Agostino's name. Lower right: *Bol. 1586.* 499 x 337 mm. (sheet: Alb)

This very elaborate composition and iconography are probably Agostino's invention and suggest that in 1586, he was working in an independent manner, producing complicated, intricate designs. Ostrow noted this print as the first in which Agostino's independent style caught up with his reproductive style.[2]

The print is dedicated to a Nicolo Cicaglia from Correggio and suggests that Agostino made the print while in Parma in 1586, the year he was so interested in reproducing the works of Correggio.

There is only one drawing connected with this print, although two others have been mentioned in relation to it.[3] That drawing is of a *Kneeling Pope* (fig. 141a), in reverse of the engraving. It shows an advanced stage of the design when Agostino was working on the individual figures to be placed in the composition. The form is almost the same as that finally executed.[4]

The unusual iconography of this print has not been discussed but can be reconstructed by reading a little-known devotional work by Nicolas Aubespin, written in 1608, *La Cordeliere ov Tresor des Indulgences du Cordon S.*[t] *Francois.*[5] In a bull of Sixtus V, who is shown in the lower left opening the door to the treasures of the Church, issued December 30, 1585, the pope instituted the Confraternity of the Cordons of St. Francis and granted a plenary indulgence to all members, male or female. Sixtus V was a member of a Franciscan order, and his favoring this confraternity is not surprising. Thus, in the print St. Francis is handing Christ the cordons, which signify the wearer's tie with Christ and faith in His redemption. Those gathered around the altar are members of the Confraternity of the Cordons of St. Francis who agree to wear the cordon and will receive the indulgences proclaimed by Sixtus. In the middle ground at right are those faithful from the confraternity who are going directly to Heaven, as the jaws of Purgatory release them. The print was probably commissioned to commemorate Sixtus V's recent decree.

Around Saint Francis are Franciscan saints. Perhaps the circular coat of arms carried by Christ with the motif of crossed arms is the emblem of the confraternity. If so, the coat of arms at lower left in the print could be that of the patron Cicaglia as a member of the confraternity. The coat of arms in the lower center is that of Sixtus V. The figures around the altar, including the rulers, cardinals, and bishops, probably do not represent actual personages, since Aubespin emphasized that all faithful, whether kings, queens, clergy, or laymen, were welcome to join the confraternity.

1 Bodmer mistook the Bartsch number as 106 instead of 109.

2 See the Introduction for a discussion and refutation of Ostrow's theory.

3 Bodmer (followed by Calvesi/Casale) attributed a drawing in Frankfurt, Städelisches Institut (Inv. no. 4080, here fig. 141b, pen and brown ink and wash over black chalk. 462 x 330 mm., Laid down. Insc. lower center: *Carracio.*) as a compositional study for the sheet. Not only is the drawing not close to this print compositionally, it is not at all in Agostino's style. It is probably by Filippo Bellini, who lived from 1550/55-1604. For stylistic comparisons see the article on "Filippo Bellini da Urbino della Scuola del Baroccio," by Catherine Monbieg-Goguel in *Master Drawings,* 13 (Winter, 1975): 347-370. The two-part composition is also typical of his style.

Another drawing for *St. Francis* in the Uffizi (Inv. no. 12380 F, 237 x 148 mm. Pen and brown ink and wash) is connected with the engraving. It is doubtful, however, that this sheet is by Agostino: the use of dark wash and chiaroscuro shading is more

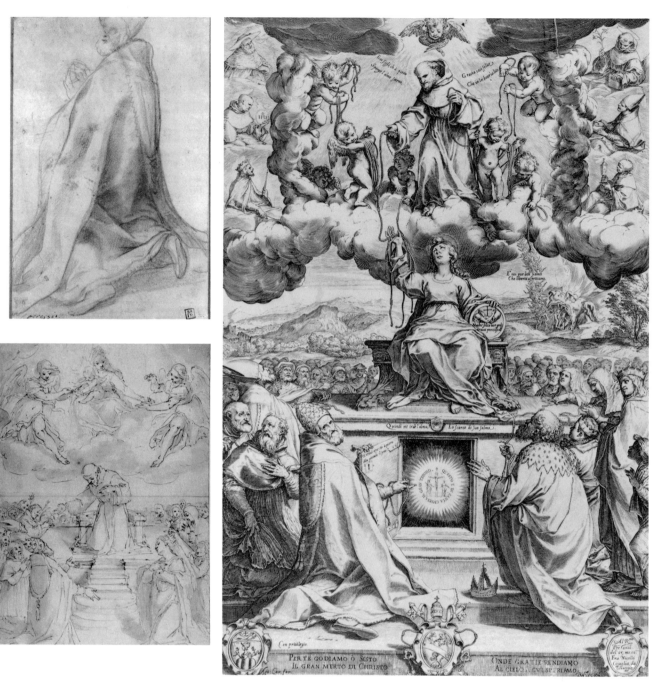

cat. no. 141, only state. Paris, Bibliothèque Nationale

fig. 141a. Agostino Carracci, *A Kneeling Pope*. Oxford, Ashmolean Museum

cat. no. 141b. Filippo Bellini, *The Indulgences of Saint Francis*. Frankfurt, Städelisches Institut

dramatic than anything seen in his work. Moreover, the use of short pen strokes for contours is foreign to his style. It is probably a copy after the print.

4 There exists a painted copy of this print by Guglielmo Caccia, found in S. Francesco in Moncalvo (reproduced by Giovanni Romano, *Casalesi del Cinquecento*. Turin, 1970, fig. 84.)

5 David Steel brought the book to the writer's attention. It was published in Paris, and there is a copy in the Bibliothèque Nationale.

142

The Madonna of Saint Jerome
(B. 95) 1586

Engraving. 481 x 329 mm.[1] (after Cornelis Cort engraving, Bierens de Haan 50, after Correggio painting in Pinacoteca Nazionale in Parma)

Literature: Baglione pp. 105, 390; Bellori p. 115; Malvasia pp. 76, 267, 270; Oretti p. 796; Mariette ms. II, 30; Basan p. 110; Strutt pp. 180-181; Heinecken p. 633, no. 16; Gori Gandellini p. 318, no. IX; Joubert p. 347; Bolognini Amorini p. 55; Nagler 1835, p. 393; Nagler I, 1379 (2); LeBlanc 32; Andresen 14; Foratti p. 173; Bodmer 1940, p. 44; *Mostra-Dipinti* p. 78; Calvesi/Casale 122; Ostrow 38.

States:

	B	CC	Ost
I	1	—	—

Unfinished and before letters. Part of the lion mane is still white. (Alb, U)

	B	CC	Ost
II	2	1	1

Above portions finished. Lower right: *Aug. Car. Bonon. ºincidit et impressit:/ 1586.* In margin: TYBERIO DELPHINO PHISICÆ PERITISS.º ET C./ OPTIME MERITO/ INVENTIONEM HANC EXIMII PICTORIS ANTONII CORREGIENSIS GRATI ANIMI ERGO DICAT SACRATQ. /AVGVSTINVS CARRATIVS. (Alb, Ber, BM, and others)

	B	CC	Ost
III	3	2	2

As in state II but with *Venetiis Donati Rascicotti formis* lower right (Alb, BM, Bo, Br, MMA, and others)

	B	CC	Ost
IV	—	—	—

Instead of address in state III: *Venetiis Doina et Valegio formis.* Very weak. (BN, Bo, Dar, Dres, and others)[2]

Copies: 1. Engraving in same direction by Cristoforo Cartaro. 458 x 328 mm. (sheet: PAFA) Lower right: *C. Cart. fe.* In margin: INVENTIONEM HANC EXIMII ANTONII CORREGIENSIS GRATI ANIMI ERGO DICAT SACRATQ:/ *Baptistue parmiensis for. Romae 1586.* (This may in fact also be after the Cort engraving, as noted by Bierens de Haan). 2. Engraving in same direction. Signed lower right: *Franciscus Villamenae Fecit 1586.* 468 x 323 mm. (sheet: Stu). Long inscription in margin. 3. Engraving in reverse (MMA)

Malvasia said that this is a reproduction of Cort's engraving (fig. 142a) and was made in competition with him. Ostrow refuted Malvasia's statement by insisting that Agostino would not compete with an artist who had been dead for eight years. He also believed that Agostino's print was executed after the original canvas by Correggio, found in the sixteenth century in the church of S. Antonio in Parma but today in the Galleria Nazionale in Parma (fig. 142b). But a comparison of Agostino's print with both Cort's engraving and with the original Correggio canvas indicates that Malvasia was correct. The trees, landscape, light and shade, and morphology depend on a knowledge of Cort's print.[3] Malvasia could also have been right in suggesting that the engraving was made in competition with Cort's artistic abilities. Agostino may have been trying to prove that he was superior to the Fleming who had taught him so much through his prints. If not done in competition, the engraving points out Agostino's continued admiration for Cort.

Ostrow believed the print to be after the original canvas because he was sure of a 1586 trip by the artist to Parma. In fact, the prints of the *Cordons of St. Francis* (cat. no. 141) and of *Ecce Homo* (cat. no. 143) prove almost conclusively that Agostino was in Parma in that year and the next. Perhaps his trip to Parma and his confrontation with the original by Correggio prompted him to reproduce the composition in engraving. Since the painting was probably in a dark church interior and because Agostino usually worked after drawings, it may have been a convenience to use Cort's engraving as a model.

1 The plate was originally larger. The impression in the Uffizi of the proof state shows a border with scratchings where the artist was trying his burin. That plate measures 488 x 331 mm. The copper must have been cut down after that since many of the impressions of state II exhibit a plate mark.

2 Nancy Ward Neilson suggested the existence of a fifth state, unknown to this writer, with the address removed.

3 Bierens de Haan (no. 50) also called Agostino's print a copy after Cort.

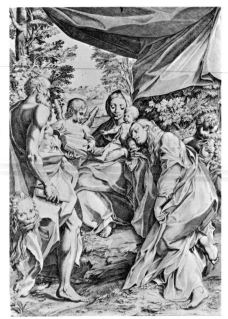

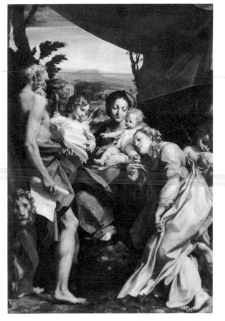

fig. 142a. Cornelis Cort, *The Madonna of Saint Jerome.* London, The British Museum

fig. 142b. Correggio, *The Madonna of Saint Jerome.* Parma, Galleria Nazionale

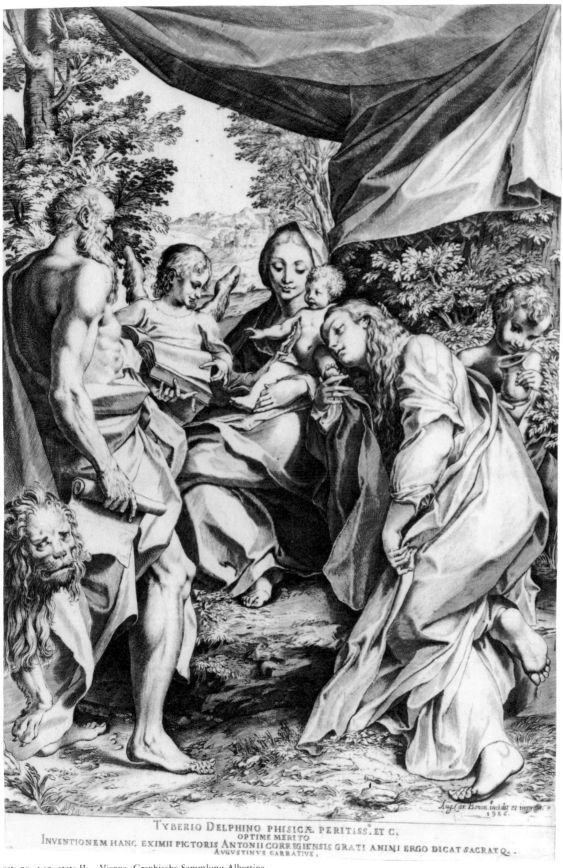

TYBERIO DELPHINO PHISICÆ PERITISS. ET C.
OPTIME MERITO
INVENTIONEM HANC EXIMII PICTORIS ANTONII CORREGIENSIS GRATI ANIMI ERGO DICAT SACRAT Q.
AVGVSTINVS CARRATIVS.

cat. no. 142, state II. Vienna, Graphische Sammlung Albertina

143

Ecce Homo
(B. 20) 1587

Engraving. 375 x 267 mm. (after Correggio painting in National Gallery, London)

Literature: Baglione pp. 105, 390; Bellori p. 115; Malvasia pp. 77, 270; Oretti p. 798; Mariette ms. II, 53; Basan p. 110; Strutt p. 181; Heinecken p. 630, no. 18; Gori Gandellini p. 318, no. X; Joubert p. 347; Bolognini Amorini p. 55; Nagler 1835, p. 393, Nagler I, 1379 (1); Mariette II, 44; LeBlanc 45; Andresen 3; Foratti p. 172; Pittaluga p. 344; Bodmer 1940, p. 44; *Mostra-Dipinti* p. 78; Calvesi/Casale 123; Ostrow 39; Bertelà 150.

States:

	B	CC	Ost
I	I	I	I

On parapet: *Ill.:ᵐᵒer Rᵐᵒ D.D.no. Henrico Caetano S.R.E. / Card: amplissimo Bon: Legº. / dicatum.* In margin: ILLA DEI SOBOLES CERTÆ DVX ILLE SALVTIS MVNDI OPIEEX NOSTROQVEʳⁿᵒ PRO CRIMINE PASSVS. Below that lower left: *Ant: Correg: inven: Parma in Aedibus Pratorum.* Center: *1587.* Right: *Aug: Car: Bon: inc: excu:* (Alb, BM, Bo, Br, MMA, Ro, and others)

| II | — | — | — |

Along bottom below image: PSF (Ber, Dres, PAFA, and others)

Copies: 1. Engraving in reverse. 370 x 267 mm. No inscriptions. (Ber). 2. Engraving in reverse. 407 x 189 mm. (sheet: Dres). In margin same inscription as original except VNO on same line. At lower right: *Muette ExxA Lille.* (Dres)

This large engraving approximates the size of the original painting by Correggio (fig. 143a), today in the National Gallery, London, but in 1587 in the Prato collection, as indicated by the inscription.[1] Bodmer believed that since the print was dedicated to the papal legate in Bologna, it was finished in Agostino's native city. Ostrow refuted this theory on the basis that Bodmer supposed that Agostino went from Venice to Parma and back to Bologna in 1586-1587. Ostrow contended that the print was executed only in Parma. These seem very fine points that are not conclusive. Agostino could have dedicated the print as easily in Parma as in Bologna. It seems safe to assume that he was in Parma in 1586 due to his interest in Correggio and his dedication of the *Cordons of St. Francis* (cat. no. 141) to a person from the town of Correggio.[2] He then executed the *Ecce Homo* either during that year or in 1587, the year in which it is dated. After finishing this he returned to Bologna for a time and was next in Venice in 1588/1589.

Ostrow placed this print at the beginning of what he called Agostino's academic style. It is true that it is harsher than his earlier prints and that the hatching is tighter than usual. However, the original by Correggio reflects the same hard qualities as the print.

1 The inscription locates Correggio's painting in the house of the Pratori in Parma. Malvasia, p. 270, said that the painting "che già si trovavano dello Studio famoso del signor Basenghi, e che poi della stessa grandezza si mirabilmente intagliò in rame. . . ."

2 The *Madonna of Saint Jerome* (cat. no. 142) may also have been dedicated to a person from Correggio, as noted by the letter *C* after the dedicatee's name.

fig. 143a. Correggio, *Ecce Homo.* Reproduced by courtesy of the Trustees, the National Gallery, London

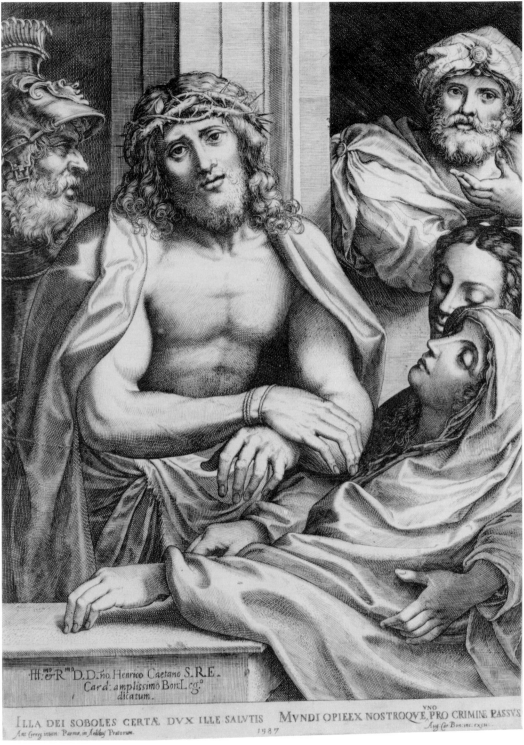

HI.^{mo}&R.^{mo} D.D. no. Henrico Caetano S.R.E.
Card: amplissimo Bon.Leg°
dicatum.

VNO
ILLA DEI SOBOLES CERTÆ DVX ILLE SALVTIS MVNDI OPIFEX NOSTROQVE PRO CRIMINE PASSVS
Ant Corregimuen: Parma in Ædibus Prætorum. 1587 Aug.Car Bon:inc:exsu.

cat. no. 143, state I. New York, The Metropolitan Museum of Art, Harris Brisbane Dick Fund, 1953

144*

Portrait of a Man
(B. 156) 2nd half 1580s

Engraving. 258 x 193 mm.

Literature: Malvasia p. 79; Oretti p. 808;
Mariette III, 147; Heinecken p. 628, no. 23;
LeBlanc 226; Nagler I, 652 (3); Bodmer 1940,
p. 59.

States:

	B
I	I

Lower right: *Agu. Car.* (Alb, BM, BN, Br,
Dres, Ham, NGA)

Bodmer dated this portrait in the second half of the 1580s. Although the oval within a frame which appears to be chipped is extremely close to the 1582 *Portrait of Caterina Sforza* (cat. no. 55), Bodmer was correct in placing the engraving later in the decade. The burin technique is further developed in the drapery and in the face, portraying the tactile qualities of the fur and of the beard and hair. The strong contrast of light and shade was not seen in Agostino's work at the time of the *Caterina* portrait, before his first trip to Venice in 1582. Obviously, Agostino returned to the earlier portrait for his composition, but he developed it further.

The identification of the sitter is difficult to determine. The costume indicates a man of wealth and position, possibly a doctor or professor. On two of the existing impressions the sitter is identified as Pietro Antonio Tolentino, a Cremonese.[1] On a photograph in the Witt Library, the man is identified as Cevalius or Sevalius. On the impression in the National Gallery, Washington, Hind suggested that the sitter was Paolo Veronese. Unfortunately, the first two names have been impossible to locate in biographies of the period, and the only known likenesses of Veronese indicate that this portrait is not of him.[2]

1 Around the oval in contemporary handwriting on the British Museum example is found: *Pietro Antonio Tolentino. Canonicho Cremonese.* An inscription on the verso, of the Hamburg sheet, probably of nineteenth-century origin, says *Pietro Antonio Tolentino, Canonico Cremonese/Antiquario.* The costume does not seem to be that of a prelate. Oretti identified the subject as a doctor.

2 Veronese was born in 1528 and would have been older than the person portrayed, even if the print were executed in 1582, when Veronese was fifty-four years old. Of course, Agostino would have known Veronese and could possibly have done a portrait of him.

cat. no. 144, only state. Washington, National Gallery of Art, Rosenwald Collection

145*

Portrait of Titian
(B. 154) 1587

Engraving. 327 x 236 mm. (after Titian
Self-Portrait, Staatliche Museum, Berlin)

Literature: Bellori p. 115; Malvasia p. 77; Oretti
p. 800; Mariette ms. 8; Basan p. 110;
Heinecken p. 628, no. 11; Gori Gandellini
p. 313, no. XII; Joubert p. 345; Bolognini
Amorini p. 56; Nagler 1835, p. 393; LeBlanc
244; Andresen 20; Foratti p. 174; Kristeller
p. 283; Pitttaluga p. 349; Bodmer 1940,
pp. 45-46; Petrucci p. 42, note 154, p. 142,
note 28; *Mostra-Dipinti* p. 78; *Mostra-Disegni*
no. 255; Calvesi/Casale 124; Bertelà 257.

States:

	B	CC
I	–	–

Before inscriptions. Background unfinished at
left. (BM)

II	1	1

In margin: ILL.mo ET R.mo D. DNO. HENRICO
CAETANO S.R.E. CARD. AMPL.mo BON.AE
LEGATO/ EXIGVVM HOC MVNVS IMAGINIS
TITIANI PICT. CVIVS NOMEN ORBIS CONTINERE
NON VALET SVBMISSE DICAT SACRATQVÈ/
HVMILL.s DEDIT.s Q.SERVVS AVGVST.
CARRATIVS. Lower right in margin: *1587* (Alb,
BN, Bo, Dres, Ham, NGA, and others)

III	2	2

Hatching at top burnished out to form upper
margin with inscription: TITIANI VECELLI
PICTORIS CELEBERRIMI AC/ FAMOSISSIMI VERA
EFFIGIES. (Alb, Ber, BN, Bo, Dres, and others)

IV	–	–

Reworked. Weak, late. (BN)

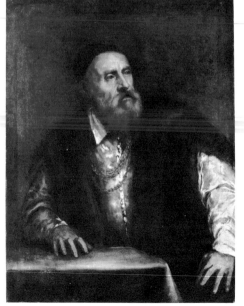

Probably Agostino's most famous print, this portrait shows the artist at
his most brilliant. Gori Gandellini incorrectly believed the engraving to
be after Agostino's own design; rather, it follows the self-portrait by
Titian (fig. 145a), now in Berlin, but in the 1580s in Venice.[1] Zanotti,
ignoring the signature and date on the print, attributed it to Cort.
Bodmer believed that it was executed in 1586 on the trip to Venice he
proposed and that it was finished in Bologna, since it is dedicated to the
papal legate in Bologna, Cardinal Caetano. The trip would have had to
have been in 1585, however, since Agostino's print after Veronese (cat.
no. 133) is dated that year. But, as Ostrow pointed out, this inscription
does not necessarily prove a 1585 trip to that city.[2] Yet, this print must
have been conceived after Agostino saw the Titian portraits in Venice,
and perhaps it indicates that the artist was in Venice in 1587.[3] We do
know that he was there the following year (cat. no. 146). There is no
reason why he could not have dedicated the print while he was in Venice
to the papal legate and sent it to Bologna.

If one compares this portrait with Marcantonio's print of *Aretino*
after Titian (Bartsch XIV, 374.513), it is evident how far Agostino had
traveled from the Roman school of the early to mid-sixteenth century.
He portrayed the sensuous qualities of the fur and satin vest by spacing
his burin strokes farther apart and by employing a larger burin than the
followers of Marcantonio. He also varied the spaces between the strokes
and used a swelling line when necessary. The repertoire of strokes used
here was developed by Agostino after his first trip to Venice in 1582,
and by 1587 he had proved he was a master of the technique. The
differences between this engraving and those of Marcantonio's school
suggest that Pittaluga was incorrect when she said that Agostino was a
mere follower of the Roman technique of engraving.[4]

1 Berlin-Dahlem, Staatliche Gemäldegalerie. Harold E. Wethey, *The Paintings of
Titian. II. The Portraits* (London, 1971), pl. 209, and cat. no. 104 for dating and
provenance. The print is in reverse of the painting. Calvesi/Casale mentioned several
other portraits of Titian that Agostino may have used, but it appears that the Berlin
portrait was his main source. 2 See cat. no. 133.

3 Of course, Agostino would have known Britto's woodcut portrait of Titian (Wethey,
pl. 208), as suggested by Calvesi/Casale. Both are in the same direction. But, he could
not have conceived the intense expression of the eyes and the reproduction of the skin
lines without having known the original Titian painting. 4 Pittaluga p. 338.

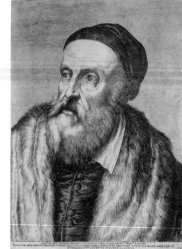

cat. no. 145, state II. Washington, National
Gallery of Art, Rosenwald Collection

fig. 145a. Titian, *Self-Portrait*. Berlin (Dahlem),
Staatliche Museen Preussischer Kulturbesitz,
Gemäldegalerie

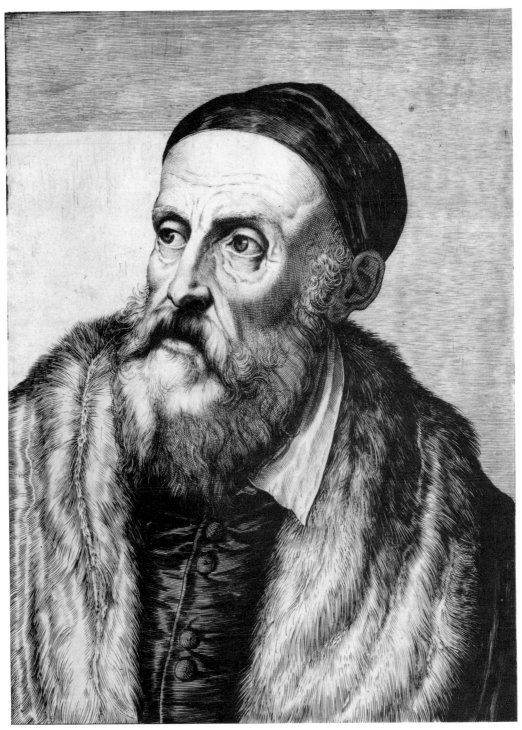

cat. no. 145, state I. London, The British Museum

146*

The Madonna Appearing to Saint Jerome
(B. 76) 1588

Engraving. 423 x 298 mm. (after Tintoretto painting in the Accademia, Venice)

Literature: Baglione p. 390; Bellori p. 115; Malvasia p. 76; Oretti p. 797; Mariette ms. II, 72; Basan p. 110; Strutt p. 181; Heinecken p. 635, no. 45; Gori Gandellini p. 319, no. XXXIII; Joubert p. 348; Bolognini Amorini p. 55; Nagler 1835, p. 393; Mariette III, 65; LeBlanc 69; Andresen 12; Kristeller p. 283; Bodmer 1940, p. 46; Petrucci p. 137; *Mostra-Dipinti* p. 80; *Mostra-Disegni* no. 256; Calvesi/Casale 125; Ostrow 40; Bertelà 195-195c; Boschloo 1972, p. 75; Boschloo p. 209, note 25.

States:

	B	CC	Ost
—	—	1?	—

Dated 1587[1]

I			
	I	2	I

In open book at left: *Hoc Iacobi Tintoreti ill. pict. / insigni in vestro sacello (vi/ri pientiss.) egregie coloribus / expressu opūs iam nuo sum / mo studio lineari pitura / desputo typisque anis excus / sum Augustinus Carracius / Bononien universa bea / ti Hieronymi in sancto / Fantino Venetia. confra / ternitati revereter dicatu / obtulit sesequ umiler comendas*. In book at right: *1588* (Alb, BM, Bo, MMA, and others)

II	—	—	—

As state I but with *Cum Privilegi* under book (Alb, Bo, Dres, NYPL, and others)[2]

III	—	—	—

As state II but with *Donati Rascichoti for* in lower margin right of center. (Ber, Bo, Ro, and others)[2]

IV	—	—	—

As state III but with *a. S. Julia/ in Ven:ª apreso Stefano Scolari* lower left. Very weak. (PAFA and others)

Copies: 1. Engraving in reverse. 422 x 297 mm. In margin lower left: *I. Tinturet pinxit.* Center: s. HIERONIME. Right: *Typis Petri Mariette, via Iacobæa, ad Insigne Spei.* (Munich, Par). 2. Engraving in reverse. 295 x 212 mm. Lower right: *Marco Sadeler excudit.* (Par) 3. Engraving in same direction with virtues surrounding composition. 228 x 167 mm. (Par).

If Bellori was correct in seeing a 1587 impression of this print, then Agostino was definitely in Venice by that year, and his *Portrait of Titian* (cat. no. 145) was probably also executed in that city.

Ostrow believed that the hardness of forms indicates that Agostino was entering his "academic" phase. What he termed a harshness is more a further development of Agostino's experimentation with strong contrasts of light and shade begun during his first trip to Venice in 1582. As with the *Portrait of a Man* and *Portrait of Titian* (cat. nos. 144, 145), in this engraving also the artist developed a technique to portray more accurately textural contrasts within the forms.

The popularity of this engraving is evidenced by the numerous states published in the years following the first edition.[3]

1 According to Bellori there was a 1587 edition of the print; however, since he did not mention the 1588 edition, perhaps he mistook the last number to be a 7 instead of an 8. He also mistakenly dated the *Aeneas and His Family Fleeing Troy* (cat. no. 203) 1599 instead of 1595.

2 Andresen noted this state.

3 Boshcloo noted the influence of this print on the composition of Annibale's painting of the *Temptation of Saint Anthony* in the National Gallery, London (Posner 105), of c. 1598. The comparison is striking.

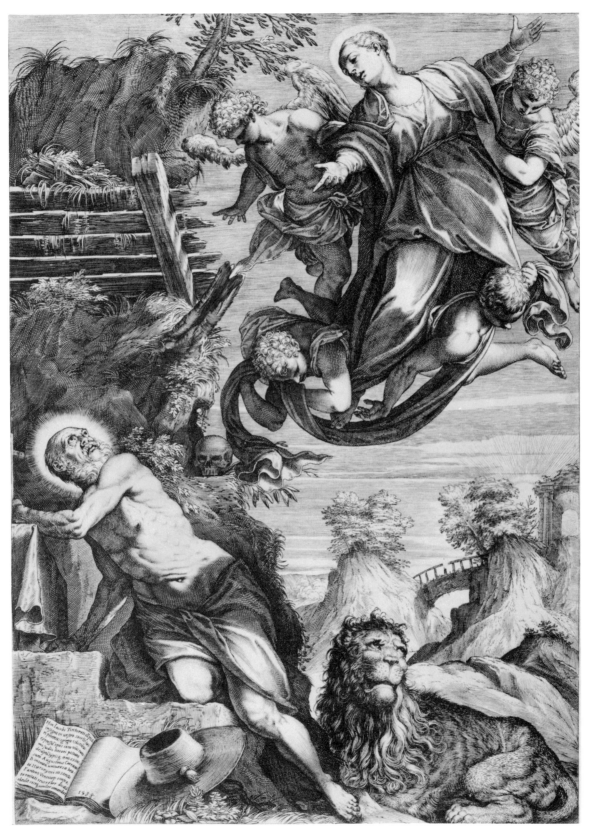

cat. no. 146, state I. Paris, Bibliothèque Nationale

147*

The Crucifixion
(B. 23) 1589

Engraving on three sheets. Left: 510 x 397 mm. Center: 511 x 401 mm. Right: 518 x 399 mm. (after Tintoretto painting in the Scuola di San Rocco, Venice)

Literature: Baglione p. 390; Bellori pp. 110, 115; Boschini pp. 146-147; Malvasia pp. 74-75, 282, 293; Oretti p. 793; Mariette ms. II, 54; Basan p. 110; Strutt p. 181; Heinecken p. 63, no. 21; Gori Gandellini p. 318, no. XIII; Joubert p. 347; Bolognini Amorini p. 55; Nagler 1835, p. 392; Nagler I, 1451; Mariette III, 64; LeBlanc 48; Andresen 4; Foratti p. 171; Kristeller p. 283; Pittaluga pp. 343, 366, note 6; Petrucci p. 137; Bodmer 1940, pp. 49-50; *Mostra-Dipinti* p. 82; *Mostra-Disegni* no. 257; Calvesi/Casale 37; Ostrow 42; Bertelà 153.

States:

	B	CC	Ost
I	–	–	–

The left and right sheets as in state II. The center sheet unfinished. No inscription in margin. RR on banner at left not filled in. Unfinished portions along left and right borders especially in group with thief at right. Along both sides only contours filled in. Shading not finished in several portions. (BM)

	B	CC	Ost
II	I	I	I

Above margin at lower left (left sheet): AVGV. CAR. FE. Above margin lower on center sheet: *cum privilegio Senatus Veneti per annos. 15.* Lower left center sheet: *Jacobus Tintoretus Inventor.* In right sheet lower right above margin: *Venetijs Donati Rascichotti formis/ 1589.* In margin left sheet a dedication to Ferdinando de' Medici and a long inscription beginning with *Cum Jacobus Tinctoretus....* Also signed *Augustinus Carratius.* lower right. Inscription continues in all of three sheets. (Alb, BN, Bo, Br, LC, and others)

Copies: 1. Engraving in reverse on three sheets. Along with long inscription in margin and dedicated to Ferdinand de' Medici. Right sheet: 502 x 398 mm. (sheet). Center: 505 x 400 mm. (sheet). Left: 505 x 399 mm. (sheet) (U).[1] 2. Engraving in reverse on three sheets by Egidio Sadeler. Long inscription in margin beginning with *Ille caput praebet spiris....* Right sheet: 498 x 393 mm. (sheet). Center: 496 x 395 mm. Left: 491 x 392 mm. (sheet). A second state of this print has *Jacobus Tintoretus Inventor* lower left on center sheet added. (BN, MMA, Ro, and others).[2] 3. A French copy with Mariette's address (according to Andresen).

This is probably Agostino's most elaborate engraving, including both his reproductive and original work. It was so popular in his day that Tintoretto himself, according to Boschini, thought it equaled the original (fig. 147a).[3] According to Boschini, Daniel Nis took the plates to Flanders and had them gilt to prevent them from deteriorating further after numerous printings had already been made from them.[4] It is puzzling why Andresen, who said that the plates still existed in his day, did not note the gilding.

The dating of the print has been problematical, although it is signed and dated. The last number of the date has been variously read as a "2" or a "9." Bartsch, Gori Gandellini, and Ostrow correctly read the number as 1589, whereas others, most recently Calvesi/Casale, have argued for a 1582 dating. The last number is in fact a "9," the confusion caused by the misreading of a hatching mark as the lower part of a "2."

There are numerous reasons for attributing this print stylistically to 1589. Most noticeable is that Agostino's technical mastery of the burin is far advanced over even his elaborate works of 1582, such as the *Martyrdom of Saint Justina,* after Veronese (cat. no. 105). Moreover, Agostino appears to have been more interested in the works of Tintoretto in 1588/1589 than he was in 1582.[5] Ostrow believed that Agostino's style became harder and more academic in these works of the late 1580s. Although this may be true in regard to his paintings, it is not so with his engravings. Not until Agostino went to Rome in 1595 did his style reflect a real change in attitude towards his forms. This engraving, like the others of the late 1580s, instead exhibits an increased awareness of the tactile qualities of the forms represented.

According to Bellori, Tintoretto, in appreciation of the beauty of this engraving, acted as godfather to Agostino's son Antonio.[6] It is generally believed that Antonio was born about 1590,[7] strengthening the reading of the date on the print as 1589.

*Engraving in exhibition from the Library of Congress, Washington, D.C.

1 This may be the print mentioned by Boschini as having been made after Agostino's, due to the great fame of the former and to satisfy the demand for the composition:
Ma perché quele do no fu bastante
 De satisfar in general la brama,
 El Valezo anche lu, che ebe gran fama,
 La retagiè con muodo assae galante.
The artist mentioned is Francesco Valesio, active in Venice c. 1611-1643. See more on him as a publisher, Appendix I.

2 Mentioned by Boschini:
Dove che Egidio ghe ne fè da quela
 Un'altra de so man, che molto val.
 Ma infin l'è copia, no l'è original;
 Però l'è de valor, l'è molto bela.

3 Ec. Compare, sta Passion no l'ha intagià
 Quel ecelente e degno Intagiador,
 E valoroso e gran dessegnador,
 Quel'Agustin Carazza nominà?
 C. La ghe xe certo, a tanto l'è ben fata,
 Che la rende stupor grando in efeto;
 E quando el la mostrete al Tentoreto,
 El ghe disse: Agustin, ti ha fato pata.

4 La sapia che la stampa del Carazza,
 Per bona sorte, vegne a capitar
 A Daniel Nis, el qual la fè dorar
 Col dir: no vogio più che i la strapazza.
 E in Fiandra se conserva sto tesoro,
 E sta zogia stimada e riverida,
 La qual quei virtuosi per so guida
 La tien coverta (come ho dito) in oro.

5 Other Agostino prints after Tintoretto from 1588/1589 are the *Madonna Appearing to Saint Jerome* (cat. no. 146), the *Mars Driven Away from Peace and Abundance by Minerva* (cat. no. 148) and *Mercury and the Three Graces* (cat. no. 149).

6 Bellori p. 110: "Dicesi che il Tintoretto vedendo la stampa della sua Crocifissione dipinta nella scuola di San Rocco, se ne compiacque tanto che abbraccio Agostino, à cui essendo nato vn figluolo in Venetia, volle stringersi seco maggiormente, con essergli compare, e lo tenne al Battesimo; che fù Antonio Carracci."

7 For bibliography and information on Antonio Carracci see Luigi Salerno, "L'opera di Antonio Carracci," *Bollettino d'Arte* 41 (1956): 30-37.

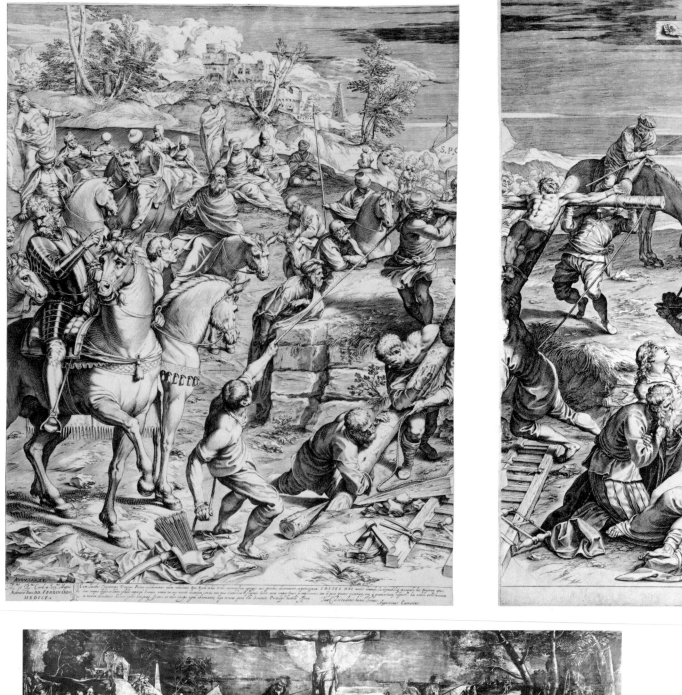

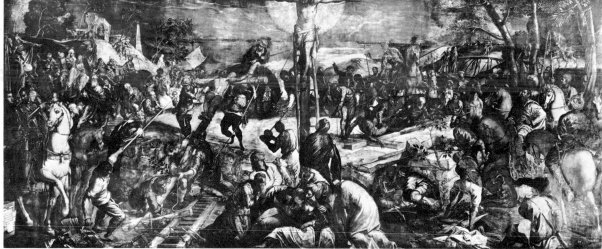

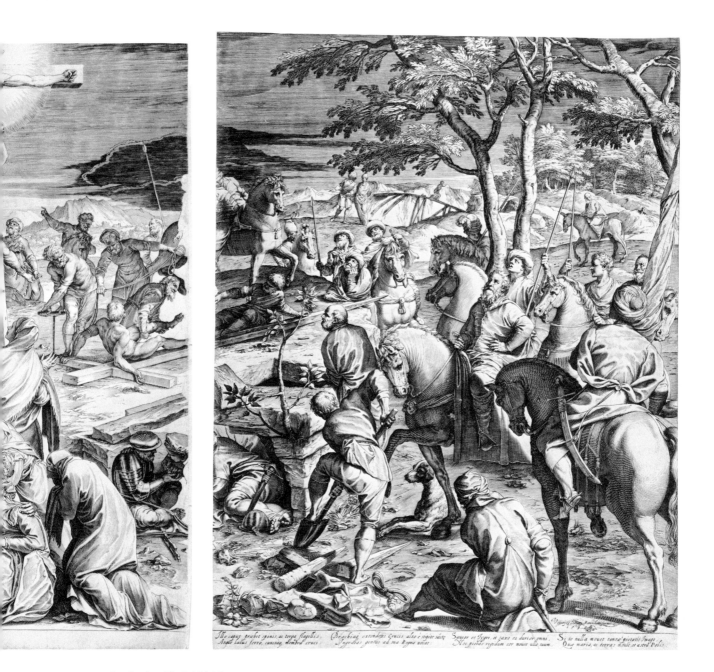

Ille capus probet spinis, ac terga flagellis. (Brachiad extendens Crucis alto e stipite déitz Sanuou et Jovis, et saxo es durior omni. Si te nulla mouet tantæ pietatis Imago,
Atqz latus ferro, cunctaq membra cruci. Ingredias gentes ad sua Regna uocat. Nec pietds rigidum cor mouet ulla tuum. Que maria, et terras nútulit, et astra Polis.

cat. no. 147, state I. London, The British Museum

fig. 147a. Jacopo Tintoretto, *Crucifixion.* Venice,
Scuola di San Rocco

148*

Mars Driven Away From Peace and Abundance by Minerva
(B. 118) 1589

Engraving. 191 x 253 mm. (after Tintoretto painting in the Palazzo Ducale, Venice, fig. 148a)

Literature: Baglione p. 390; Bellori p. 115; Malvasia p. 79, n. 2; Oretti pp. 809-810; Mariette ms. II, 65; Basan pp. 110-111; Strutt p. 181; Heinecken p. 638, no. 8; Gori Gandellini p. 320, no. XXXVI; Joubert p. 348; Bolognini Amorini p. 56; Mariette III, 67; Nagler 1835, p. 394; Nagler I, 296 (6); LeBlanc 109; Foratti p. 170; Pittaluga pp. 343-344; Bodmer 1940, p. 49; Petrucci p. 137; *Mostra-Dipinti* p. 81; Calvesi/Casale 126; Ostrow 43; Bertelà 225; Boschloo p. 31.

States:

	B	CC	Ost
I	1	—	2

Lower right on rock: *A.C.* Lower right: *1589.* Lower left: *Jacobus Tinctoretus pixit.* (Alb)

	B	CC	Ost
II	2	1	1

As state I but *1589* burnished out and *Jacobus Tinctoretus pixit* burnished out and replaced by a similar inscription in smaller letters. Lower: *Sapientia Martem depellente Pax et Abundantia cogaudent.* (BM, BN, Bo, Br, PAFA, and others)

	B	CC	Ost
III	—	—	—

As state II but with *Valegio et Doino forma Venetia.* Recut (Philadelphia)

	B	CC	Ost
IV	—	—	—

This last erased. Very weak. (BN, Ro, and others)

Bodmer dated the print in the late 1580s without having seen the first state with the date 1589. Ostrow confused the first and second states and thought that the year 1589 was added in the second state rather than appearing originally on the first. He still accepted the date as 1589.

The engraving is one of two after Tintoretto paintings in the Palazzo Ducale in Venice (see cat. no. 149). There are four Tintoretto paintings in the Atrio Quadrato, a room in the Palazzo Ducale, but Agostino worked after only two. Similarly, in the early 1590s, he reproduced two paintings by Paolo Fiammingo (?) from a group of four (cat. nos. 191-192); the other two Fiammingo paintings were engraved by Sadeler. Perhaps here, also, another artist was to have engraved the remaining Tintoretto paintings, the *Forge of Vulcan* and the *Marriage of Bacchus and Ariadne.*

The 1589 date is fitting if one compares this sheet with Agostino's other works of the same period. There is a greater complexity in the burin technique at this time and a continued emphasis on sharp contrasts of light and shade. Ostrow criticized these works for their lack of tonal contrasts when compared with the Tintoretto paintings. He also noted that Agostino widened the composition horizontally so that the figures no longer fall into our space but occupy an expanded area, thus denying the tension of Tintoretto's work and adding a spatial clarity.[1]

Zanotti, in his notes to Malvasia, said that he had the plates for this and the following print (cat. no. 149) and that they were worn out.[2]

*Engraving in exhibition from the Museum of Fine Arts, Boston, Bequest of William P. Babcock.

1 There is a drawn copy of this engraving in Spain, reproduced in Alfonso E. Perez Sanchez, *Catálogo de la colección del Instituto Jouellanos de Gijón,* Madrid, 1969, no. 587. Boschloo noted the influence of the composition of this engraving and the postures of the figures on Annibale's painting of *Venus and Adonis* of c. 1590, in Madrid (Posner 46a). The connection is undeniable.

2 Malvasia p. 79, note 2: "Io ne ho i due rami ma consumati."

fig. 148a. Jacopo Tintoretto, *Mars Driven Away from Peace and Abundance by Minerva.* Venice, Palazzo Ducale

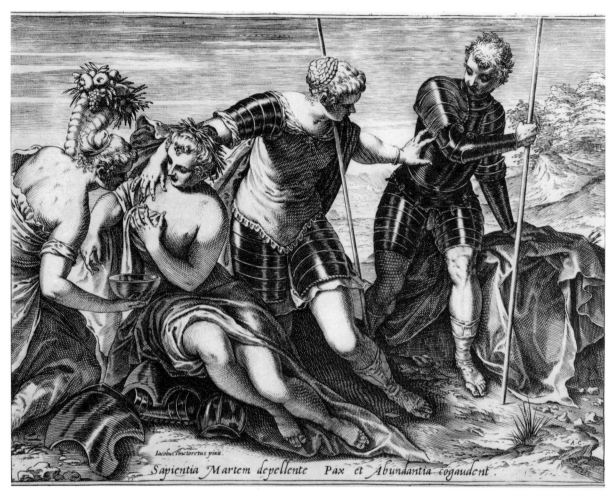

Iacobus Tinctoretus pinxit.

Sapientia Martem depellente Pax et Abundantia cogaudent.

cat. no. 148, state II. London, The British Museum

149*

Mercury and the Three Graces
(B. 117) 1589

Engraving. 203 x 259 mm. (after Tintoretto painting in the Palazzo Ducale, Venice, fig. 149a)

Literature: Baglione p. 390; Bellori p. 115; Malvasia p. 79, n. 2; Oretti pp. 809-810; Mariette ms. II, 164; Basan p. 110; Strutt p. 181; Heinecken p. 638, no. 7; Gori Gandellini p. 320, no. XXXV; Bolognini Amorini p. 56; Mariette III, 68; Nagler 1835, p. 394; Nagler I, 296 (5); LeBlanc 110; Foratti p. 170; Bodmer 1940, p. 49; Petrucci p. 137; Calvesi/Casale 127; Bertelà 224.

States:

	B	CC
I	I	I

Lower right above margin: A.C. Toward bottom right: *Iacobus Tinctoretus pixit.* In margin: *Spectator si scire cupis quid picta tabella est, Est Iouis et Maiae filius, et Charites.* (Alb, BM, BN, Bo, Br, LC, and others)

II	—	—

Something written and burnished out in lower right corner of margin.[1] Weak. (Bo, Dres, U)

III	—	—

Lower right plate corner broken. (Munich, Bologna: Biblioteca Archiginnasio, Milan-Bertelli Collection)

Although undated, this print forms a pair with the *Mars Driven Away from Peace and Abundance by Minerva* (cat. no. 148); both are reproductions of Tintoretto paintings in the same room of the Palazzo Ducale. As in previous engravings, Agostino expanded the composition in this print, enlarging it horizontally to include more landscape background and thus set the figures apart from the viewer. The result in both prints is a balancing of the figures and background and a reduction of the tension of the forms, which in the painting lean precariously into the viewer's space. Moreover, Agostino elongated the figures and hardened their contours, thus solidifying their movement in contrast to the fluidity of movement in the original.[2]

1 It appears that the following was burnished out: *Valegio et Doino forma in Venetia.*

2 There is a drawn copy of this print in the Museum of Fine Arts, Copenhagen (Gernsheim photo no. 73 152). Zanotti owned the plate for this and the former engraving (cat. no. 148) and noted their ruined state (see cat. no. 148).

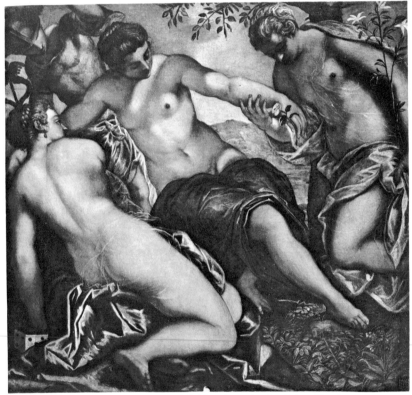

fig. 149a. Jacopo Tintoretto, *Mercury and the Three Graces*, Venice, Palazzo Ducale

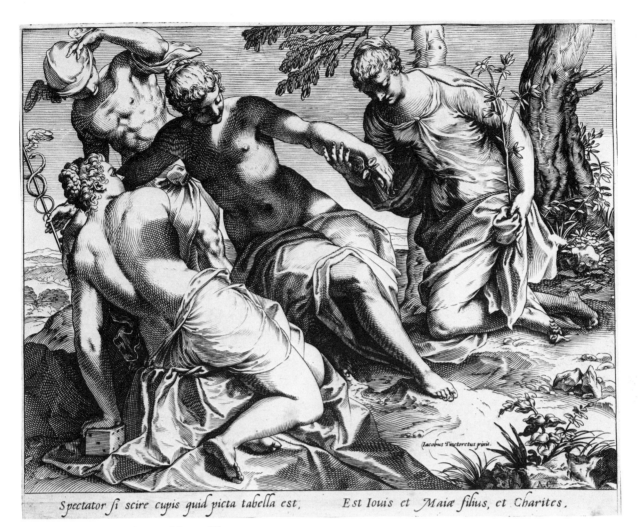

Iacobus Tinctoretus pinit.

Spectator si scire cupis quid picta tabella est, Est Iouis et Maiæ filius, et Charites.

cat. no. 149, state I. Washington, Library of Congress

150

The Madonna and Child Seated on a Crescent Moon
(B. 34) 1589

Engraving. 212 x 169 mm. (after Jacopo Ligozzi)

Literature: Bellori p. 116(?); Malvasia p. 79, note 6; Oretti pp. 812-813; Heinecken p. 633, no. 26; Gori Gandellini p. 319, no. XXXI; Nagler 1835, p. 396; Joubert p. 347; Mariette II, 37; LeBlanc 22; Andresen 5; Bodmer 1940, p. 50; *Mostra-Dipinti* p. 82; Calvesi/Casale 128; Ostrow 44;[1] Bertelà 159.

States:

	B	CC	Ost
I	I	I	I

Lower left: *Iacobus Ligotius inven.* Center lower: ILL.[ME] ET ECCELL.[MAE] PRINCIPI MARIÆ MEDICES. Below that: *1589.* Lower right: *Augustinus Caracius Di.* (Alb, BM, BN, Bo, Br, Dres, MMA, and others)

Copies: 1. Engraving in reverse with same inscriptions. 205 x 158 mm. Very deceptive (Bartsch felt this may have in fact been the original). (Alb, etc.). 2. Engraving in reverse by Raphael Sadeler. With parapet and inscription around oval. Also inscription on parapet. Bowl of fruit on parapet (Par)[2]
3. Engraving in same direction. Around oval: BEATVS . VENTER. QVI. TE. PORTAVIT. ET. VBERA. QVÆ. SVXISTI. Lower left: *Iacobus Ligotius inventor.* Lower right: *Augustinus Caracius.* 207 x 163 mm. (Ber, Par).
4. Engraving in reverse. 216 x 165 mm. Lower left: *Presso Lorenzo Capponi.* Lower right: *in Bologna.* Late. (Par). 5. Engraving in same sense. 142 x 109 mm. Beneath oval: SMARIA. Lower left: *Augustinus Caratius Sc.* (Ber) 6. Engraving in reverse. 206 x 163 mm. Lower left: AF. Lower right: *1672.* (Fitzwilliam).

This is probably the oval composition of the *Madonna and Child* mentioned by Bellori, who thought the invention was Agostino's.

Jacopo Ligozzi (c. 1547-1626), born in Verona, worked at the Medici court beginning c. 1578. This print after Ligozzi indicates that Agostino may have traveled to Florence in 1589. Ostrow suggested that Agostino probably did the engraving in Bologna after a Ligozzi drawing (unknown at this time) and that he may have been introduced to Ligozzi's works by Ulisse Aldrovandi, the Bolognese naturalist who worked at the Medici court and knew both artists.[3] However, the following four prints (cat. nos. 151-154) are connected with the Medici wedding in Florence of 1589 and, with this engraving, offer strong evidence that Agostino was indeed in Florence in that year.

The Ligozzi engraving was extremely popular, as witnessed by the numerous copies after it. The copy (copy no. 1) in reverse, which Bartsch believed could possibly be the original, may be a copy by Agostino made to meet the demand for the composition.

1 Ostrow incorrectly referred to this engraving as B. 18.

2 There is a copy of this engraving in the same direction in Parma: 126 x 102 mm.

3 For information on Aldrovandi see Agostino's portrait after him (cat. no. 207). Ligozzi's work at the Medici court included making drawings of flora and fauna described to him by Aldrovandi. For information on Ligozzi and bibliography, see Florence, Gabinetto disegni e stampe degli Uffizi, *Mostra di disegni di Jacopo Ligozzi* (Florence, 1961).

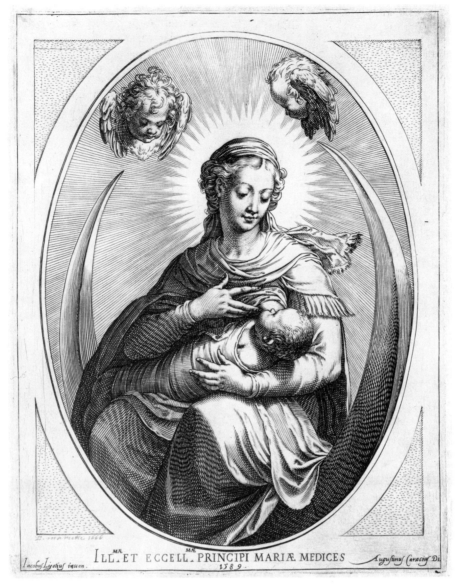

ILL^{MÆ} ET ECCELL^{MÆ} PRINCIPI MARIÆ MEDICES
1589

Iacobus Lichtius inuen. Augustinus Caracius Di

cat. no. 150, only state. London, The British Museum

151

Portrait of Ferdinand, the Grand Duke of Tuscany
(B. 145) c. 1589

Engraving. 262 x 204 mm. (sheet: BM)

Literature: Malvasia p. 78 and note 5; Oretti p. 807; Heinecken p. 628, no. 4; Mariette I, p. 314; LeBlanc 243; Bolognini Amorini p. 56; Foratti p. 175; Bodmer 1940, p. 59.

States:

	B
I	I

In margin: FERD. MED. MAGN. DVX ETRVRIAE III. Arms of the Medici and the Dukes of Lorraine in upper left. (Alb, BM)

II	2

Same as state I but with arms changed. (Alb, BN, Fitzwilliam)

This engraving is pendant to the *Portrait of Christine of Lorraine* (cat. no. 152), whom Ferdinand (1549-1606) married in an elaborate wedding in 1589.[1] Consequently, these two engravings must date from that year or shortly after and were probably made in commemoration of the wedding. The style of the portaits is an elaborate outgrowth of the portraits of the *Cremona Fedelissima* (cat. nos. 56-92). They are much closer, however, to the more recent *Portrait of Titian* (cat. no. 145) and the *Portrait of a Man* (cat. no. 144). As in those, the costumes of the sitters are intricately portrayed, and the tactile quality of the hair is emphasized. In addition, more complicated, almost ornamental, hatching and cross-hatching delineate the features. Much care was obviously taken with this important commission.

The models for the portraits are not known, but it is likely that Agostino was provided with paintings, drawings, or even engravings of the nuptial pair. Since the portrait busts are not the same size, it is obvious that Agostino's models were not pendants. Perhaps that of Christine was a portrait made before her arrival in Florence. If so, Agostino may have been commissioned to do the works in 1589 and provided with the only available portrait models, made by different artists.[2]

1 For descriptions of the wedding recorded in contemporary accounts see the excellent bibliography in Florence, Gabinetto disegni e stampe degli Uffizi, *Feste e Apparati Medicei da Cosimo I a Cosimo II,* by Giovanna Gaeta Bertelà and Annamaria Petrioli Tofani, Florence, 1969, pp. 67-86.

2 Only Zanotti doubted that Agostino was the author of these engravings. Gori Gandellini believed that the prints were after Agostino's own designs.

152

Portrait of Christine of Lorraine
(B. 141) c. 1589

Engraving. 261 x 205 mm.

Literature: Malvasia p. 78 and note 5; Oretti p. 807; Heinecken p. 628, no. 5; Gori Gandellini p. 313, no. IX; Joubert p. 345; Bolognini Amorini p. 56; LeBlanc 238; Foratti p. 174; Bodmer 1940, p. 59; Mariette I, p. 314; Bertelà 250.

States:

	B
I	I

In margin: CHRISTINA LOTARINGIA MAGNA DVC.^A ETRURIÆ. Arms of Medici and Lorraine in upper left. (Alb, BM)

II	2

Same as state I but with arms changed. (Alb, BN, Bo, Fitzwilliam)

See cat. no. 151. Christine of Lorraine lived from 1565 to 1637.

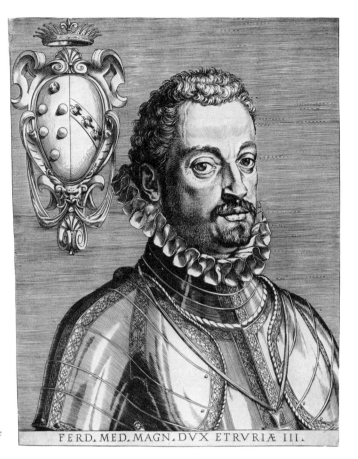

FERD. MED. MAGN. DVX ETRVRIÆ III.

cat. no. 151, state I. London, The
British Museum

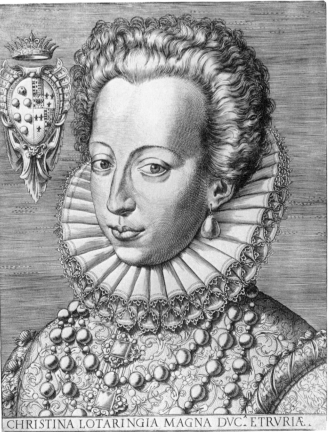

CHRISTINA LOTARINGIA MAGNA DVC. ETRVRIÆ.

cat. no. 152, state I. London, The
British Museum

153*

The Harmony of the Spheres
(B. 121) 1589-1592

Etching and engraving. 243 x 343 mm (after Andrea Boscoli drawing after Bernardo Buontalenti in the Uffizi, fig. 153b)

Literature: Bellori p. 116; Malvasia p. 77; Oretti pp. 799-800; Heinecken p. 640, no. 4; Joubert p. 346; Gori Gandellini p. 316, no. LI; Bolognini Amorini p. 56; Mariette I pp. 313-314; Nagler 1835, p. 398; Nagler I, 316 (3); LeBlanc 161; Foratti p. 176; Kristeller p. 283; Pittaluga p. 348; Aby Warburg, "I costumi teatrali per gli intermezzi del 1589," *Gesammelte Schriften,* 1 (Berlin, 1932): 266, 276; James Laver, "Stage Designs for the Florentine Intermezzi of 1589," *Burlington Magazine,* 60 (June, 1932): 299; Bodmer 1940, p. 62; Petrucci pp. 138, 142, note 29; Calvesi/Casale 168; A. M. Nagler, *Theater Festivals of the Medici 1539-1637,* New York and London, 1964, p. 77; Giovanna Gaeta Bertelà, *Feste e apparati medicei da Cosimo I a Cosimo II,* Florence, Uffizi, 1969, pp. 78-80, no. 37 (with further bibliography); Arthur Blumenthal, *Italian Renaissance Festival Designs,* Madison, 1973, p. 88, no. 37; Bertelà 229, Phyllis Dearborn Massar, "A Set of Prints and a Drawing for the 1589 Medici Marriage Festival," *Master Drawings,* 13, no. 1 (Spring 1975): 12-23.

States:

	B	CC
I	1	1

Lower right: A.C.F. (Alb, BN, Bo, Br, MMA, and others)

	B	CC
II	2	2

As state I but with lower center: *Filippo Suchielli for. Siena* (Ber, BMFA, BN, Dres, and others)

	B	CC
III	—	—

This last address erased. Very weak. (Ber, BN, Chatsworth)

Preparatory Drawings: 1. Windsor 1996 recto (Wittkower 125). Pen and brown ink. 261 x 163 mm. (fig. 153b).[1] 2. Chatsworth 816B. Pen and brown ink. 199 x 278 mm (fig. 153c).*[2]

Together with the print of *Apollo and the Python* (cat. no. 154), this etching records part of the festivities honoring the marriage of Ferdinando I de' Medici and Christine of Lorraine in 1589. Throughout the month of May, the festivities continued, following the entry of Christine into Florence. Through the numerous contemporary records, both written and visual,[3] the elaborate costumes, plays, triumphal arches, mock battles, etc. are vividly brought to life. On May 2 the play *La Pellegrina* by Girolamo Bargagli was performed with six *intermezzi* by Giovanni de' Bardi. The *intermezzi,* considered the most splendid events of the entire festival, were repeated on the sixth and the thirteenth of the month. Bernardo Buontalenti was responsible for the costumes and machines made for the *intermezzi.*

The Harmony of the Spheres records Buontalenti's design, now in the Victoria and Albert Museum (fig. 153a), for the first *intermezzo.*[4] In this part of the *intermezzo,* Necessity holding the spindle of the world is seated, supported by the three Parcae, and is surrounded by the seven planets and Astrea. Beneath are the Sirens, beginning to ascend toward heaven.[5] Although Agostino's print includes all the elements from Buontalenti's drawing, it is embellished with another figure of a Siren and is completely different in feeling. Unlike the elongated forms in Buontalenti's sheet, Agostino's figures, although svelte and willowy, are closer to actual human proportions. In addition, the atmospheric, rising clouds in Buontalenti's drawing have been enlarged and rounded to recall billowing cumulus clouds. The sharp perspective resulting in a swirling vortex in the center of Buontalenti's drawing is flattened out in Agostino's print, negating the discomforting feeling from Buontalenti's sheet. In all, the mannerist traits of the original have been ignored or at the least softened. The reason for the change in attitude of the figures is that Agostino interpreted Buontalenti's design through a copy attributed to Andrea Boscoli. This drawing is similar to the engraving in size, all the same figures are reproduced, and it is in reverse of the etching.[6]

Two drawings by Agostino (figs. 153b, 153c) may be connected with this print. Each represents forms more elongated than normal with Agostino. The swaying, slender proportions of the figures may reflect Agostino's attempt to reconcile his style with that of Buontalenti. The drawing in Windsor (fig. 153c) shows two draped female forms in poses similar to some of the Sirens in the etching. The second, at Chatsworth (fig. 154d),* may also come from this period, although the model's body is more modestly draped, suggesting a study for a saint.

The dating of this print and *Apollo and the Python* (cat. no. 154) has been disputed, but the *terminus post quem* is obviously 1589, the date of the *intermezzi.* Etchings by Epifanio d'Alfiano for the second, fourth, fifth, and sixth *intermezzi* exist, and at least one of them is dated 1592[7]. Six prints by Orazio Scarabelli connected with the wedding festivities are also dated 1592.[8] In all, thirty-two prints commemorating portions of the decorations and festivities are known.[9] They are all generally of the same size and may have been intended for a commemorative volume. All but Agostino's have decorative borders, leading Massar to believe that his were issued separately from the rest.[10] It is probable that Agostino's etchings were made at the same time as his portraits of the bride and groom (cat. nos. 151-152). A range of dating from c. 1589, when Agos-

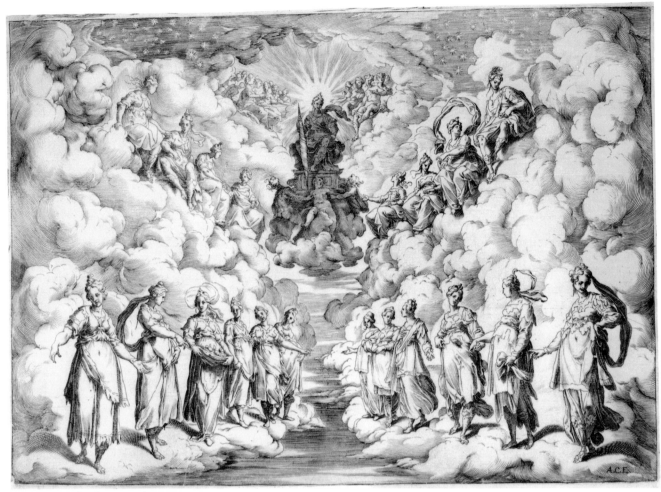

cat. no. 153, state I. Anonymous loan

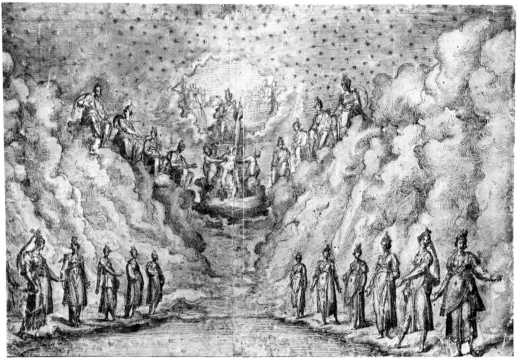

fig. 153a. Bernardo Buontalenti, *The Harmony of the Spheres*. London, Victoria and Albert Museum

tino may have seen the festivities in Florence, to c. 1592/1595 seems tenable. Stylistically, also, one would tend to date the prints in this period, a time when Agostino's work was characterized by a "retrogressive" interest in the elegant and elongated figure type and a delicacy of expression and facial features.[11]

Most unusual about these two prints is Agostino's employment of the etching technique. There could be a variety of explanations for this, including a simple interest in trying out the etching needle. After all, Annibale used etching almost exclusively for his prints. On the other hand, all the other prints having to do with the wedding of Ferdinand and Christine were etchings, and perhaps Agostino was required to use the same technique as the other artists. Morever, he may have been in contact with the other printmakers and wanted to emulate their technique. In support of this thesis is the similarity of style between Agostino's *Harmony of the Spheres* and Cherubino Alberti's etching of a *Festival Chariot Drawn by Bears,* also recording the ceremonies.[12] In any case, after these two prints Agostino abandoned the etching needle, which he handled as if it were the burin.

1 Wittkower called this a late drawing, probably based on the classical profile of a woman's face. However, the curvilinear drapery is characteristic of Agostino's graphic style of the 1580s and not necessarily of the late period.

2 Collection Peter Lely. On the recto is a pen and ink study of the *Rest on the Flight into Egypt.* The verso has an inscription: *Di Agostino Carazo bolognese.*
 A drawing in the O.v. zur Muhlen Sale, Berlin, June, 1912 of the figures of this print was called Agostino Carracci, but is not a study for the print but a copy after it by an unknown artist. (Photograph in the Witt Library, London.)

3 The primary and secondary sources are too numerous to mention here. For a list of these see the Uffizi catalogue (mentioned in the bibliography) pp. 67-75, 237, and the bibliography within until 1969. See also Massar, p. 22, and the most recent account in Blumenthal.

4 Inv. no. E 1186-1931. Pen and brown ink and colored washes. 380 x 555 mm. Poor condition. For literature see Bertelà *Feste.* Numerous drawings by Buontalenti for the costumes of this *intermezzo* and other parts of the festivities are extant in the Biblioteca Nazionale and the Archivio di Stato in Florence. See Warburg pp. 265-266.

5 See Warburg pp. 271 ff. for an interpretation of the iconography.

6 Gabinetto disegni e stampe degli Uffizi Inv. no. 15115 F. Pen and brown ink and black chalk. 266 x 376 mm. Uffizi catalogue, no. 38, fig. 16. First suggested by Tofani in that catalogue as the model used by Agostino.

7 Uffizi catalogue nos. 39, 41 and Massar p. 22, note 3.

8 Uffizi catalogue nos. 36, 42; Massar figs. 3-9, 11, 13.

9 Massar p. 22, note 3.

10 *Ibid.,* p. 12.

11 Cf. especially with the prints from the *Lascivie* (cat. nos. 176-109), *Reciprico Amore* and *Love in the Golden Age* (cat. nos. 191-192) and the *Headpiece in the Form of a Fan* (cat. no. 193).

12 Massar, fig. 1. For a further discussion of Alberti see Appendix II.

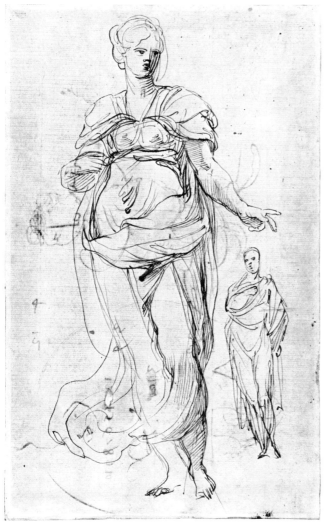

fig. 153b. Agostino Carracci, *Standing Female Figure*. Windsor Castle, Royal Library, Her Majesty Queen Elizabeth II

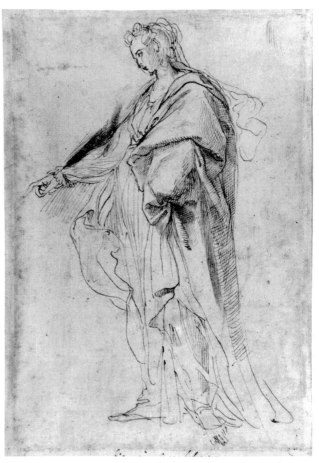

fig. 153c. Agostino Carracci, *Standing Female Figure*. Chatsworth Devonshire Collection, The Trustees of the Chatsworth Settlement

154*

Apollo and the Python
(B. 122) 1589-1592

Etching and engraving. 242 x 345 mm. (after Andrea Boscoli? after Bernardo Buontalenti)

Literature: Bellori p. 116; Malvasia p. 77; Mariette ms. II, 109; Oretti pp. 799-800; Gori Gandellini p. 316, no. LII; Joubert p. 346; Bolognini Amorini p. 56; Heinecken p. 640, no. 4; Mariette I, pp. 313-314; LeBlanc 162; Nagler 1835, p. 398; Foratti p. 176; Kristeller p. 283; Pittaluga p. 348; Warburg p. 266; Laver p. 294; Bodmer 1940, p. 62; Petrucci pp. 138, 142, note 29; Kurz 1951, p. 232; A. M. Nagler p. 84; Bertelà, *Feste,* pp. 81-82, no. 40 (with further bibliography); Calvesi/ Casale 169; Bertelà 230; Blumenthal p. 92, no. 39; Massar p. 12-23.[1]

States:

	B	CC
I	1	1

Lower right: *Carracius fe.* (Alb, BM, BN, Bo Br, MMA, and others)

II	2	2

As state I but with lower left: *filippo Suchielli for Siena.* (Ber, BMFA, BN, Dres, and others)

III	—	—

This last erased. Very weak. (Achenbach Foundation)

Apollo and the Python represents the third *intermezzo* performed for the marriage ceremonies of the wedding of Ferdinand de' Medici and Christine of Lorraine. Further information on the festivities and the part these prints played is given in cat. no. 153. In this scene, Delphic men and women surround the dragon (or python), who was terrorizing them, and call for help. Apollo swoops down from above in readiness to slay the monster. Buontalenti's original design for the *intermezzo* is in the Victoria and Albert Museum in London (fig. 154a).[2] Agostino reversed the design and, as with the *Harmony of the Spheres* (cat. no. 153), broadened the composition to negate the vertical qualities in Buontalenti's work. It is probable that he did so on the basis of an intermediary drawing by Boscoli, as he had in the *Harmony of the Spheres.* That sheet is not known.[3]

1 Complete references given in cat. no. 153.

2 Inv. no. E 1188-1931. 378 x 566 mm. Laid down. Pen and brown ink and wash with watercolor. For literature see Bertelà *Feste.*

3 There are two copies of this print. One, a copy of the python, is in the Pierpont Morgan Library in New York (Inv. 1960.20, attributed to Buontalenti, reproduced Blumenthal p. 91). The other, in the Louvre, attributed to Agostino Carracci, is a free rendering of the background landscape. (Pen and brown ink over red chalk. 267 x 409 mm. Laid down. Unpublished.)

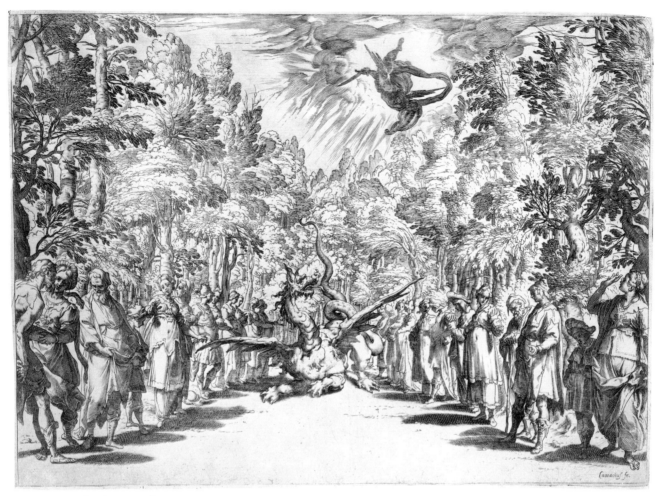

cat. no. 154, state I. Anonymous loan

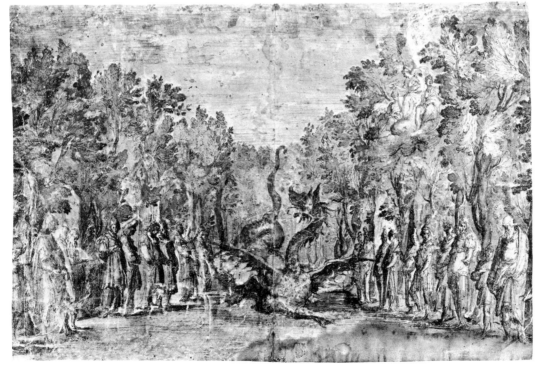

fig. 154a. Bernardo Buontalenti, *Apollo and the Python*. London, Victoria and Albert Museum

155-164*

Engravings for La Gerusalemme
Liberata
(B. 182-191) 1590

Engravings. (after drawings by Bernardo
Castello)

Literature: Bellori 116; Malvasia pp. 81-82,
293; Oretti pp. 825-827, Mariette ms. 3;
Heinecken p. 637, no. 4; Gori Gandellini
p. 317, no. LVI; Cicognara 1112; Bolognini
Amorini p. 58; Nagler 1835, p. 399; Mariette
III, 153-173; LeBlanc 151-160; Foratti
pp. 184-187; Kristeller p. 283; Marchesini
p. 166; Pittaluga pp. 347-348; Brunet V, 665;
Bodmer 1940, pp. 61-62; Graesse, vol. 7,
pp. 32-33; *Mostra-Dipinti* pp. 82-83; Calvesi/
Casale 145-154; Ostrow 45, 45-A.

La Gerusalemme Liberata by Torquato Tasso, finished in 1575, was first
published in its entirety in 1581. The volume under discussion is the
first illustrated version of this already popular tale and was published by
Girolamo Bartoli in Genoa in 1590.[1] According to the introduction to
the text, the illustrations were designed by Bernardo Castello (1557-
1629), and, in fact, there are several preparatory drawings for the vol-
ume extant.[2] The book has twenty-one illustrations, including the title
page and an illustration heading each of the twenty cantos. Of these
engravings, eleven are by Giacomo Franco, all signed.[3] Two others carry
the initials "AC" (cat. nos. 158, 163), and on this basis Bellori and
Malvasia first attributed the remaining nine engravings and the title
page to Agostino Carracci.[4] Practically all writers since that time have
accepted this attribution. Ostrow recently grudgingly accepted the en-
gravings on the basis of the initials on the two prints but emphasized the
extremely low quality of the works and the consistency in style with the
signed Franco sheets. Although the sheets do have a somewhat similar
illustrative style, the works attributed to Agostino do differ from those
by Franco. First of all, Franco consistently employed a technique of dots
for many of his backgrounds, whereas Agostino almost always used ful-
ler, even if short, lines. Franco also elongated his figures and deprived
them of the volume inherent in Agostino's representations. Finally, there
is a greater use of the paper for white highlights in Agostino's works.
Ostrow attempted to give a justification for the consistency of the qual-
ity and style of the prints: the engravings were not done on commission
but as a diversion while Agostino painted the Magnani frescoes, and, as
recounted by Malvasia and Marchesini, an assistant collaborated with the
artist. But, according to Ostrow, Agostino was more interested in paint-
ing during the period c. 1589-1595 and produced relatively few prints.
On the contrary, as can be seen from the chronology advanced in this
catalogue, Agostino continued to occupy himself with printmaking
along with his tasks as a painter.[5]

 The prints must have been executed between 1586, when the draw-
ings by Castello were made, and April 25, 1590, the date of the dedica-
tion of the volume.[6] Ostrow believed that Agostino may have received
the commission when he was in Venice in 1588-1589, since he would
then have been in contact with Giacomo Franco.[7] He would have exe-
cuted them when he returned to Bologna in 1589. But, as witnessed by
the preceding prints, Agostino may also have spent some time in Flor-
ence in 1589. In any case, the engravings were finished before the date
of the publication on April 25, 1590.

 There are several examples of the book on blue paper.[8] It is doubt-
ful that Agostino would have approved of this as the narrative value of
the prints is lost by juxtaposing the complexly engraved lines with the
dark paper. Calvesi/Casale incorrectly suggested that the woodblock ini-
tials and friezes in the book could also have been by Agostino. Without
any other woodcuts by Agostino known, it is doubtful that this
craftsman's job was taken up by him. The book was published in great
quantity and exists today in numerous libraries and print rooms
throughout Europe and America.[9]

1 According to Calvesi/Casale, the only illustration for Tasso previous to this book was Tintoretto's painting of *Tancred Killing Clorinda* of c. 1580. The author's manuscript was circulating since it was finished in 1575, and there are, no doubt, earlier illustrations to it.

2 Two of these are preparatory to Agostino's engravings. See cat. nos. 159, 163. Three others relate to engravings by Giacomo Franco. One in the Palazzo Rosso in Genoa (Inv. no. 1992, red chalk) is connected with the background of the engraving of Canto XVIII. A second, in the Institut Néerlandais, Paris (Inv. no. 1972.-T.46) relates to Canto XI. A third, in the Albertina (Inv. no. 2779) is preparatory for Canto IX. (Vienna, Albertina, *Beschreibender Katalog der Handzeichnungen*, vol. VI, no. 501.) Two other drawings in Berlin (Kupferstichkabinett) by Castello (Inv. K.d.Z. 251843-4, Pacetti Collection, red chalk) relate to two of Agostino's prints, but are not the final preparatory sheets. The first could be an early thought for the two figures in the chariot in the background of Canto X; the second may be an alternate idea for Clorinda wounded in Canto XII. The drawings were classed as anonymous but attributed to Castello by Mary Newcome Schleier. All the above drawings were brought to the attention of the author by Dr. Newcome Schleier.

3 For Cantos I, II, III, IV, V, IX, XI, XIII, XV, XVIII.

4 For the title page and Cantos VI, VII, VIII, X, XII, XVI, XVII, XIX, and XX.

5 See the coats of arms which must fall within this period (cat. nos. 195-199) as well as the series of the *Lascivie* (cat. nos. 176-190).

6 See Mary Newcome, *Genoese Baroque Drawings* (Binghamton, 1972), 57, no. 155 for background and bibliography on Castello's drawings for Tasso, who thanked the artist with a sonnet.

7 Giacomo Franco was not only an artist but active as a publisher. He published several of Agostino's engravings (cat. nos. 26, 101-105). For Franco as a publisher see Appendix I.

8 In the New York Public Library, Spencer Collection. Brunet mentioned several examples on blue paper.

9 Campori (pp. 577-578) attributed some drawings in the Gaburri collection (in 1722) to Agostino as studies for this book: ". . . e particolarmente alcuni pensieri, originali di mano di Agostino *Caracci*, fatti per l'istorie del Tasso, tutti benissimo conservati. . . ."

155

Title Page to La Gerusalemme Liberata *by Torquato Tasso*
(B. 182) 1590

Engraving. 238 x 161 mm. (after Bernardo Castello)

Literature: See previous discussion and Calvesi/Casale 145; Bodmer 1940, pp. 61-62.

States:

	B	CC
I	I	I

In oval above around Tasso portrait: TORQVATO TASSO. In tablet in center: LA GIERVSALEMME/ LIBERATA/ DI TORQVATO TASSO/ *Con le Figure di Bernardo/* CASTELLO;/ *E le Annotationi di Scipio/* GENTILI, *e di Giulio* GVASTAVINI. IN GENOVA. M.D.LXXXX. (Alb, BM, BN, and most libraries and print rooms)

cat. no. 155, only state. Washington, Library of Congress, Rosenwald Collection

cat. no. 156, state I. Washington, Library of Congress, Rosenwald Collection

156

Argantes and Tancred Preparing for Combat
(B. 183) 1590

Engraving. 188 x 141 mm. (after Bernardo Castello)

Illustration to Canto VI of the *Gerusalemme Liberata.*

Literature: See previous discussion and Calvesi/Casale 146.

States:

	B	CC
I	I	I

As reproduced. No inscriptions. (most libraries and print rooms)

| II | — | — |

Lower left: 6 (Dres, Houghton)

See previous discussion.

Although hastily done, the style of the engraving bespeaks Agostino's hand. The angelic figures at the sides of Tasso's portrait carrying symbols of glory and honor are consistent with the usual cherubic forms employed by the artist. The rest of the framework must depend on the lost original by Castello.[1]

1 The city represented in the *trompe l'oeil* window is Genoa, the city of publication.

157

Erminia and the Shepherd
(B. 184) 1590

Engraving. 189 x 142 mm. (after Bernardo Castello)

Illustration to Canto VII of the *Gerusalemme Liberata*.

Literature: See previous discussion and Calvesi/Casale 147.

States:

	B	CC
I	I	I

As reproduced. No inscriptions. (most libraries and print rooms)

II	—	—

Lower right: 7 (Dres, Houghton)

See previous discussion.

cat. no. 157, state I. Washington, Library of Congress, Rosenwald Collection

158

Foraging Party Returning with the Armor of Rinaldo
(B. 185) 1590

Engraving. 189 x 141 mm. (after Bernardo Castello)

Illustration to Canto VIII of the *Gerusalemme Liberata*.

Literature: See previous discussion and Nagler I, 296(9); Bodmer 1940, p. 61; Calvesi/Casale 148; Ostrow 45.

States:

	B	CC	Ost
I	I	I	I

Lower edge toward left: A.C.F.[1] (most libraries and print rooms)

II	—	—	—

Lower left: 8 (Dres, Houghton)

cat. no. 158, state I. Washington, Library of Congress, Rosenwald Collection

This engraving has been attributed to Agostino on the basis of the initialed inscription. See previous discussion for attribution of entire series based on this and cat. no. 163.

1 Bartsch did not see the F. of A.C.F. and reported the inscription erroneously as A.C.

159

*Soldiers Recounting Their
Liberation from Armida by
Rinaldo.
Peter the Hermit Tells the Future
Deeds of Rinaldo.*
(B. 186) 1590

Engraving. 190 x 140 mm. (after Bernardo
Castello drawing in Palazzo Rosso, Genoa)

Illustration to Canto X of the *Gerusalemme
Liberata.*

Literature: See previous discussion and
Calvesi/Casale 149.

States:

	B	CC
I	1	1

As reproduced. No inscriptions. (most libraries
and print rooms)

| II | — | — |

Lower right: *10* (Dres, Houghton)

The preparatory drawing by Bernardo Castello for this illustration is
currently in the Palazzo Rosso in Genoa (fig. 159a) and is one of two
surviving drawings for the engravings by Agostino.[1] Either this was not
the final study for the engraving or Agostino took many liberties in
transferring the drawing to the plate. He changed the position of the
city of Jerusalem in the background, placing it behind the tent of
Godefrey, and balanced that part of the composition with the rolling
clouds in the upper right. There are more protagonists, and their ges-
tures are altered. It may be that Castello's drawing was cut down at the
sides, but it is more likely that there was another sheet which was em-
ployed by the engraver.

1 Inv. no. 1994. Red chalk. 183 x 133 mm. Information from Mary Newcome
Schleier. See also cat. no. 163. For three other drawings by Castello for the engravings
see the discussion before cat. no. 155.

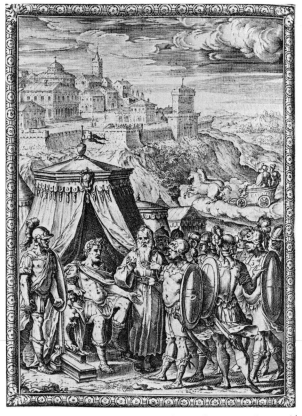

cat. no. 159, state I. Washington, Library of Congress, Rosenwald
Collection

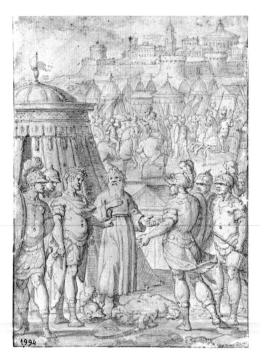

fig. 159a. Bernardo Castello, *Soldiers Recounting their
Liberation from Armida by Rinaldo.* Genoa, Palazzo Rosso

160

Clorinda Dying in the Arms of Tancred
(B. 187) 1590

Engraving. 190 x 143 mm. (after Bernardo Castello)

Illustration to Canto XII of the *Gerusalemme Liberata*.

Literature: See previous discussion and Calvesi/Casale 150.

States:

	B	CC
I	1	1

As reproduced. No inscriptions. (most libraries and print rooms)

II	—	—

Lower right: *12* (Dres, Houghton)

See previous discussion.

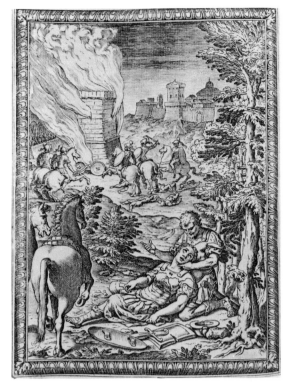

cat. no. 160, state I. Washington, Library of Congress, Rosenwald Collection

161

Rinaldo in the Arms of Armida
(B. 188) 1590

Engraving. 188 x 139 mm. (after Bernardo Castello)

Illustration to Canto XVI of the *Gerusalemme Liberata*.

Literature: See previous discussion and Calvesi/Casale 151.

States:

	B	CC
I	1	1

As reproduced. No inscriptions. (most libraries and print rooms)

II	—	—

Lower Center: *16* (Ambrosiana, Dres, Houghton)

See previous discussion.

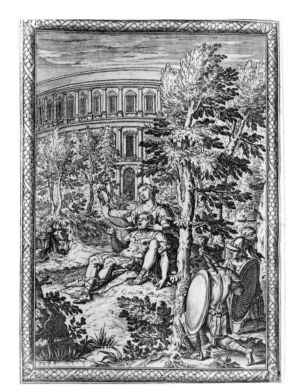

cat. no. 161, state I. Washington, Library of Congress, Rosenwald Collection

162

A Soudan of Egypt Calling his Generals to Arms

(B. 189) 1590

Engraving. 187 x 139 mm. (after Bernardo Castello)

Illustration to Canto XVII of the *Gerusalemme Liberata*.

Literature: See previous discussion and Calvesi/ Casale 152.

States:

	B	CC
I	1	1

As reproduced. No inscriptions. (most libraries and print rooms)

II	—	—

Lower left: *17* (Dres, Houghton)

See previous discussion.

163

Erminia Nursing Tancred's Wounds

(B. 190) 1590

Engraving. 188 x 139 mm. (after Bernardo Castello)

Illustration to Canto XIX of the *Gerusalemme Liberata*.

Literature: See previous literature and Nagler I, 296(10); Bodmer 1940, p. 61; Calvesi/Casale 153; Ostrow 45A.

States:

	B	CC	OST
I	1	1	1

Bottom toward right: A.C.F.[1] Bottom toward left: *Ber. Caste. in.* (most libraries and print rooms)

II	—	—	—

Lower right: *19* (Dres, Houghton, PAFA)

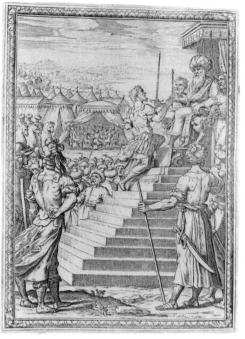

cat. no. 162, state I. Washington, Library of Congress, Rosenwald Collection

The entire group of unsigned prints has been attributed to Agostino on the basis of the inscription on this print and on cat. no. 158. See previous discussion for explanation.

Castello's drawing for this engraving, in reverse, reproduces the moment earlier, when Erminia discovers Tancred lying wounded.[2] The composition is similar, but one suspects that there was another final preparatory drawing which Agostino employed for his engraving.

1 Bartsch incorrectly read inscription as A.C. 2 Location unknown. Red wash with point of brush over red chalk. Photograph from Mary Newcome.

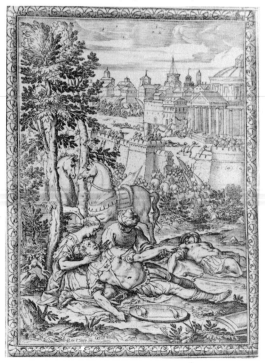

cat. no. 163, state I. Washington, Library of Congress, Rosenwald Collection

164

A Saracen Surrendering His Sword to Godefrey
(B. 161) 1590

Engraving. 184 x 136 mm. (after Bernardo Castello)

Illustration to Canto XX of the *Gerusalemme Liberata*.

Literature: See previous discussion and Calvesi/Casale 154.

States:

	B	CC
I	1	1

As reproduced. No inscriptions. (most libraries and print rooms)

| II | — | — |

Lower left: *20* (Dres, Houghton)

See previous discussion.

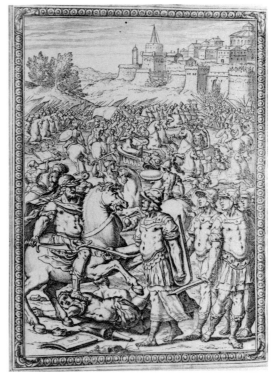

cat. no. 164, state I. Washington, Library of Congress, Rosenwald Collection

165-174

Illustrations to the Ricreationi amorose de gli Academici Gelati di Bologna

1590

Ten engravings.

Literature: Malvasia pp. 83, 294; Oretti p. 831; Nagler 1835, p. 399; Mariette I p. 314-315; LeBlanc 163-180; Cicognara 1831, 1832; Foratti pp. 187-189; Bodmer 1940, pp. 60-61; Mario Praz, *Studies in Seventeenth-Century Imagery,* Rome, 1964, pp. 244-245; Calvesi/Casale 132; Bertelà 279-289.

The *Ricreationi amorose de gli Academici Gelati di Bologna* is a small volume of poetry published by the Bolognese literary Academy of the Gelati (Accademia de' Gelati) in 1590.[1] The book is illustrated with an engraved title page and nine emblems of the authors of each section, all members of the academy.[2] A second enlarged edition of the book was issued in 1597 under the title *Rime de gli Academici Gelati di Bologna.* In this second edition ten more emblems were added (cat. nos. R1-R10) and two deleted (cat. nos. 171-172). Although the prints are not signed, they have been traditionally given to Agostino. Malvasia recounted that Agostino made twelve engravings for this book at the request of his friend Melchiore Zoppio and in exchange was made a member of the academy.[3]

Since Malvasia's mention of the plates, all writers have accepted as Agostino's the entire nineteen emblems from the two editions as well as the title page. Only Mariette correctly attributed just those engravings in the first edition to Agostino. Unfortunately, the other critics, including Bartsch, confused the second edition with the first or confused which emblems are found in which edition. This mistake stems from Malvasia, who attributed twelve engravings to Agostino (there are ten engravings in the first edition and seventeen in the second) without naming which prints he gave to the artist. Bartsch, from whom most later writers took their information, attributed all the prints from the 1597 edition to Agostino but incorrectly called it the 1590 edition. Each succeeding writer has made some similar error in attributing the prints. For example, Heinecken attributed five emblems to Agostino but chose them incorrectly, and Cicognara said that there were fourteen emblems in the second edition. Ostrow made the mistake of saying that the 1597 edition was identical to that of 1590 except that *Il Tardo* (cat. no. 173) and *Il Pronto* (cat. no. 172) were added in the latter volume when, in fact, they were deleted from that edition. To clarify the editions: the title page (cat. no. 165) and the following nine emblems or devices (cat. nos. 166-174) are found in the 1590 edition. Two of these prints (cat. nos. 172 and 173) were removed from the second edition of 1597. In addition, ten new prints were added (cat. nos. R1-R10). It is the opinion of this author that when comparing engravings from both editions, it becomes obvious that the prints added in the second edition are by a separate hand.[4] Although Agostino may have been in Bologna in 1597, he was certainly in Rome in that year, and was therefore perhaps too busy to make the added engravings for the second edition of the book.

Although the prints in the 1590 edition are traditionally given to Agostino, they can also be attributed to him stylistically. The vibrancy with which they have been engraved, even on this minute scale, suggests Agostino's hand. The foliage is characteristic of Agostino's trees and branches, and the simple cartouches exhibit the depth typical of his more elaborate frontispieces. Malvasia was correct in adding them to Agostino's oeuvre.

1 The volume contains a dedication by Melchiore Zoppio (c. 1544-1634) to the Cardinal Protector, followed by poetry by the members of the academy. Each poem is a chapter of the book and is headed by the device of the poet. The book is usually bound with Melchiore Zoppio's *Psafone trattato d'amore,* also published by Giovanni Rossi in Bologna in 1590.

2 The Accademia de' Gelati was a literary academy founded in 1588 by Melchiore Zoppio and Camillo and Cesare Gessi; it met in the Zoppio home. The academy issued at least three volumes of poetry; the present volumes in 1590 and 1597, and another in 1615. See Fr. Pellegrino Antonio Orlandi, *Notizie degli Scrittori Bolognesi e dell'opere loro stampate e Manoscritte* (Bologna, 1714), 31 and Michele Medici, *Memorie storiche intorno le accademie scientifiche e letterarie della città di Bologna* (Bologna, 1852), 50-53.

3 Malvasia, p. 294: ". . . che gran tempo andò che più intagliar non volle, se non quanto non potè negare al suo tanto stimato Dottor Zoppio il rame in dodici, che andò avanti alle rime de'suoi Accademici Gelati, ed a' quali anch'esso fu aggregato Agostino; . . ." and p. 83: "Il frontispicio alle rime de'Gelati, sì alle prime fatte pubbliche del 1590. che alle altre date fuori del 1597. in quella guisa stessa, che'avea loro dipinta la universale impresa(1), l'uno e l'altra gratis e senza ricognizione alcuna, per essere anch'egli ad essi aggregato e intercessione del fondatore Zoppio, al quale fece anche il ritratto della moglie già morta e sepolta, a mente, con un ritrattino di lui stesso in mano; . . ." From this passage, others have assumed that Agostino also invented the *impresa* of the academy.

Agostino does not seem to have been a full member but a member of the "second order." He is listed in only one book by the academy as a member, but not in the regular list. Bologna, Accademia de'Gelati, *Memorie Ritratti ed Impresse de S.S.^{ri} Accademici Gelati di Bologna* (Bologna, 1671), in the introduction names some of the people who belonged to the academy in the past. At the end of the list: ". . Agostino Carracci, ed Agostino Mitelli Pittori Celebri, che fiorirono tra nostri Accademici di secondo Ordine, et molti, e molt'altri, le cui accreditate composizioni in ogni genere di Lettere onorano gli autori, . . ." Faberio, Agucchi, and Malvasia were full members of the academy (see Mahon, p. 136.)

4 See cat. nos. R1-R10 for the reason for rejecting these prints.

165

Title Page to the Ricreationi amorose de gli Academici Gelati di Bologna
(B. 231) 1590

Engraving. 127 x 67 mm.

Literature: Malvasia p. 83; Oretti pp. 830-831; Heinecken p. 641, no. 15 and p. 643, no. 7?; Bolognini Amorini p. 59; Foratti pp. 187-189; Bodmer 1940, pp. 60-61; Calvesi/Casale 132; Ostrow 46; Bertelà 279-280.

States:

	B	CC	Ost
I	1	1	1

In tablet above: RICREATIONI AMOROSE/DE GLI ACADEMICI GELATI/ DI BOLOGNA. In banner: NEC LONGVM TEMPVS 1590 edition. (Alb, Ber, Bo, and others)

II	3	—	2

Title changed to read: RIME/DE GLI ACADEMICI GELATI/ DI BOLOGNA. 1597 edition. (Dres and various major libraries)

III	2	—	3

Plate recut. Title changed to RIME DE I/ GELATI. 1615 edition. (Alb, BN, Bo, Ro, and others)

—	—	—	4

See copy 1.

Copies: 1. Engraving by Lorenzo Tinti in same direction. In tablet: PROSE DE' SIG. ACCADEMICI GELATI/ DI BOLOGNA. In banner: NEC LONGVM TEMPVS. Lower left: *Aug. Carracia Inv.* Lower right: *Lauren Tintus Incisor* (second state of print adds *et Accadem* after *Aug. Carracia Inv.* This engraving forms the frontispiece to Valerio Zani's book of *Prose de' Signori Accademici Gelati di Bologna* (Bologna, 1671). 195 x 135 mm. 2. Engraving by Lorenzo Tinti in book described in copy 1 on first page of introduction. 173 x 115 mm. It is a somewhat free copy of the trees of Agostino's print within a different cartouche carried by *putti*.

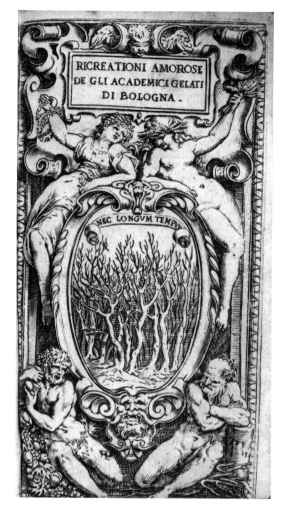

cat. no. 165, state I. Chicago, The Newberry Library

This title page to the *Ricreationi amorose de gli Academici Gelati di Bologna* is found in both the 1590 and 1597 editions of the book but not in the later 1615 edition, which also excludes the *imprese*. The composition was most likely designed by Agostino himself. The figures of the four seasons surrounding the central oval of bare trees (*gelati*) are reminiscent of Agostino's symbolic figures in other title page compositions.[1] Moreover, the depth of the box in which the figures are enclosed is typical of Agostino's book illustrations. The masks on the cartouche reappear in his coats of arms of the forthcoming decade.

1 E.g., those of the *Cremona Fedelissima* (cat. no. 56) and the *Vita di Cosimo de' Medici* (cat. no. 135) in which similar languid reclining figures appear.

166

L'Immaturo (Giovanni Battista Mauritio)

(B. 235) 1590

Engraving. 66 x 65 mm.
Found on p. 5 of *Ricreationi amorose* . . .[1]

Literature: Bodmer 1940, p. 261; Bertelà 284.

States:

	B
I	1

In banner: SESE/ MELIORIBVS/ OFFERT/ L'IMMATVRO/ GIO. BATTISTA MAVRITIO. (Alb, Bo, and others)

cat. no. 166, only state. Chicago, The Newberry Library

Each of the prints in this volume reproduces the *imprese* or emblem of the author of the poem following it. The name given, such as *L'Immaturo,* is the name used for the poet by the academy. In most cases his coat of arms is reproduced, and his Christian name also given, as here.

According to Fantuzzi, Mauritio (d. 1635) studied under Melchiore Zoppio (see cat. no. 174) and took his doctorate in 1609. As a young man he applied himself to Morals and Theology and was among the founders of the Accademia de' Gelati.[2] He was the *principe* (head) of the academy in 1590.[3]

1 And on page 43 of the 1597 edition. 2 Fantuzzi, vol. 5, pp. 371-373.

3 *Memorie,* p. 405.

167

Il Faunio (Paolo Emilio Balzani)

(B. 248) 1590

Engraving. 61 x 65 mm. Found on p. 19 of *Ricreationi amorose* and p. 171 of *Rime de gli Academici.*

Literature: Malvasia p. 83; Oretti p. 831; Heinecken p. 641, nos. 16 and 17; Bertelà 287.

States:

	B
I	—
II	1

Above: PER ARTEM Below: IL FAUNIO and PAULOEMILIO BALZANI. (Alb, Bo, and others) (Found in 1590 edition)

PER ARTEM changed to VTILE DVLCI.[1] (various libraries) (Found in 1597 edition)

cat. no. 167, state I. Chicago, The Newberry Library

The poet Paolo Emilio Balzani was *principe* of the Accademia de' Gelati in 1604.[2]

1 Jacopo Gelli, *Divise-Motti e Imprese di famiglie e personaggi italiani* (Milan, 1928), 503, no. 1741 explained this motto as the need to unite the useful with the sweet. It comes from Horace (Ad. Pis., 343). Gelli noted the utility and delight of poetry.

2 Mazzuchelli, vol. II, p. 194 listed where Balzani's poems appear. *Memorie,* p. 405 listed him as *principe* in 1604.

168

L'Intento (Camillo Gessi)
(B. 245) 1590

Engraving. 63 x 64 mm. Found on p. 30 of *Ricreationi amorose* and p. 149 of *Rime de gli Academici*.

Literature: Bertelà 285.

States:

	B
I	I

PER VADA MOSTRAT ITER/ L'INTENTO/ CAMI GESSI. (Alb, Bo, and others)

cat. no. 168, only state. Chicago, The Newberry Library

Camillo Gessi was an important literary figure in Bologna in the late sixteenth century and *principe* of the Accademia de' Gelati in 1594.[1] He was one of the founders of the academy with his brother Cesare and Melchiore Zoppio.

1 See Dolfi p. 340, for information on Gessi, and *Memorie* p. 405.

169

Il Tenebroso (Francesco Maria Caccianemici)
(B. 234) 1590

Engraving. 66 x 65 mm. Found on p. 31 of *Ricreationi amorose* and p. 31 of *Rime de gli Academici*.

Literature: Bertelà 283.

States:

	B
I	I

IN APRICVM PROFERET/ IL TENEBROSO/ FRAN. MARIA CACCIANEMICI. (Alb, Bo, and others)

Copies: 1. Loose copy in the *Memorie e Imprese* volume (see copy 1 of cat. no. 165) of 1672. Tinti was inspired by this, although he did not directly copy it.

cat. no. 169, only state. Chicago, The Newberry Library

Caccianemici (born 1567) was a member of the famous pontifical house of Caccianemici and an illustrious poet of his era. One of his books, published in 1608, was entitled *Rime di Francesco Maria Caccianemici, nell' Accademia dei Gelati il Tenebroso.*[1] He was *principe* of the academy in 1595 and 1611.[2]

1 Fantuzzi, vol. III, pp. 3-4. 2 *Memorie,* p. 405.

170

L'Incolto (Vincenzo Fabretti)
(B. 233) 1590

Engraving. 64 x 65 mm. Found on p. 39 of
Ricreationi amorose and p. 18 of *Rime de gli Aca-
demici.*

Literature: Malvasia p. 83; Oretti p. 831;
Heinecken p. 641, no. 19; Bodmer 1940, p. 61;
Bertelà 282.

States:

	B
I	I

SPONTESVA/ L'INCOLTO/ VINCENZO FABRETTI.
(Alb, Bo, and others)

cat. no. 170, only state. Chicago, The Newberry Library

Vincenzo Fabretti, about whom little is known, was *principe* of the
Accademia de' Gelati in 1591.[1]

1 *Memorie,* p. 405.

171

L'Improviso (Cesare Gessi)
(B. 246) 1590

Engraving. 65 x 65 mm. Found on p. 51 of
Ricreationi amorose and p. 151 of *Rime de gli
Academici.*

Literature: Bertelà 286.

States:

	B
I	I?

NON EXPECTATAS DABIT/ L'IMPROVISO/ CESA
GESSI. (Alb, Bo, and others) Found in 1590
edition.

II	—

Name recut to read CESARE GESSI. (Various
libraries) Found in 1597 edition.

cat. no. 171, state I. Chicago, The Newberry Library

Cesare Gessi became a doctor in 1573 and *principe* of the Accademia de'
Gelati in 1592.[1] Gelli explained his *imprese* as reading, "it will produce
unexpected things." The poet takes a trunk of the frozen tree of the
Gelati Academy and makes it into the pole of Romulus, which would
produce the flowered greenery of his genius by virtue of his participation
in the Accademia de' Gelati.[2] With his brother Camillo and Melchiore
Zoppio, Gessi was one of the founders of the Accademia de' Gelati in
1588.

1 Filippo Bianchi, *Trattato de gli Huomini Illvstri di Bologna* (Ferrara, 1590), 111, and
Memorie, p. 405.

2 Gelli, no. 1287.

172

Il Pronto (Lelio Testa)

1590

Engraving. 65 x 66 mm. Found on p. 56 of the *Ricreationi amorose.*

Literature: Bodmer 1940, pp. 60-61; Bertelà 288.

States:

I

IN VTRVNQ/ IL PRONTO/ LELIO TESTA. (Alb, Bo, and others)

cat. no. 172, only state. Chicago, The Newberry Library

This print went unnoticed by Bartsch because it is missing from the 1597 edition, the one he used in describing the *imprese* of the volumes. Bodmer did note it but said it was added in the 1597 edition. As mentioned in the discussion to this series, *Il Pronto* and the following print, *Il Tardo* (cat. no. 173), were deleted from the 1597 edition, perhaps because these members of the academy had died or were no longer participants in the organization. Little is known about Lelio Testa, and *Il Tardo*'s real name is unknown.

173

Il Tardo

(B. 249) 1590

Engraving. 67 x 64 mm. Found on p. 62 of the *Ricreationi amorose.*

Literature: Malvasia p. 83; Oretti p. 831; Heinecken p. 641, no. 20; LeBlanc 181; Bodmer 1940, pp. 60-61; Bertelà 289.

States:

	B
	I
I	

PRAESENS IN TEMPVS/ IL TARDO. (Alb, Bo, and others)

cat. no. 173, only state. Chicago, The Newberry Library

Malvasia believed that this was the most beautiful print of the series, and indeed the flowing branches of the tree do lend a rhythmic movement to the composition. Bartsch did not find the print in the edition he was using (the 1597 edition) but believed, correctly, that the print was connected with the series. As noted already, this engraving was taken out of the second edition of the book. Bodmer incorrectly stated that this print was added to the second edition.

174

Il Caliginoso (Melchiore Zoppio)
(B. 232) 1590

Engraving. 65 x 66 mm. Found on p. 64 of *Ricreationi amorose* and p. 1 of *Rime de gli Academici.*

Literature: Bertelà 281.

States:

	B
I	I

MVNERIS HOC TVI/ IL CALIGINOSO/ M/Z. (Alb, Bo, and others)

cat. no. 174, state I. Chicago, The Newberry Library

Melchiore Zoppio was the cofounder of the Accademia de' Gelati, which met in his house in Bologna. He was *principe* of the organization in 1593, 1597, 1603, 1608, and 1618.[1] In 1579 Zoppio received his doctorate in philosophy and medicine and in 1581, in logic.[2] He was one of the most influential men of letters in Bologna during this period and, according to Malvasia, a friend of Agostino Carracci.[3] In 1634 the Accademia de' Gelati prepared a solemn funeral for him.

1 *Memorie,* p. 405.

2 Fantuzzi, vol. 8, pp. 303-307 is the most complete account of Zoppio's life and writings. He was also mentioned by Bianchi p. 111.

3 Malvasia pp. 83, 294. See discussion on this series for quotations.

175*

Portrait of Giovanni Battista Pona

(B. 150) 1590

Engraving. 111 x 89 mm. Found in *Diatribae de rebus philosophicus* and in *Liber singvlaris carminum*.

Literature: Malvasia p. 83; Oretti p. 834; Heinecken p. 628, no. 13; Bolognini Amorini p. 59; Nagler 1835, p. 398; Nagler I, 326(2); LeBlanc 239.

States:

	B
J	I

Lower right: A.C.F. Around oval: IO BAPTISTA PONA PHILOSOPH ET MEDICVS VERONENSIS ÆTATIS ANNORVM XXXI. (Alb and various libraries)

cat. no. 175, only state. Chicago, The University of Chicago, The Joseph Regenstein Library

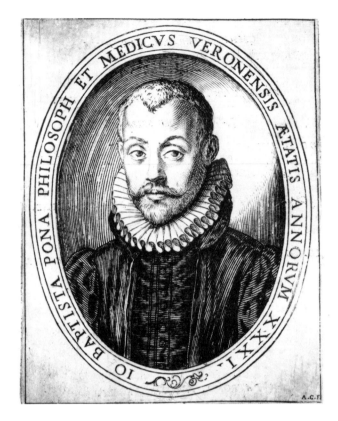

Possibly due to its assumed rarity, this portrait of Giovanni Battista Pona[1] (b. 1558) has seldom been discussed in the literature. Malvasia was the first to attribute the portrait to Agostino, others following suit. No writer attempted to date the work, and modern critics have been silent about it. The print is not as rare as supposed; it is found not only in the Albertina as a single sheet but is also extant in several libraries as frontispieces for two of Pona's books. The volumes, *Diatribae de rebus philosphicus* and *Liber singularis carminum,* were published in Verona in 1590. Pona, who is not well known today, was a member of a Veronese family of scientific and literary repute. He was famous in his time as an author of many philosophic and poetic works and as a doctor of medicine.

The inscription on the portrait indicates that it was made during Pona's thirty-first year. Since he was born in 1558, Pona's portrait could date to either 1589 or 1590, when the two books containing it were published. The style of the engraving is similar to Agostino's earlier simplified portraits, such as the *Portrait of a Man* (cat. no. 144) and the *Portrait of Giovanni Tommaso Costanza* (cat. no. 96). If the date of this engraving were not secure, one would tend to place it earlier in the 1580s, closer to the portraits in the *Cremona Fedelissima* (cat. nos. 56-92). However, the purpose of this sheet as an author portrait in a book called for a simplicity of execution rather than an elaboration of cartouche elements.

Since this portrait was destined to illustrate a book, one wonders if other portraits by Agostino, considered rare at present, will also eventually be found as book illustrations.[2]

1 Information on Pona can be found in G. B. Crollalanza, *Dizionario Storico-Blasonico delle Famiglie nobili e notabili italiane estinte e fiorenti* (Pisa, 1888), vol. 2, p. 359.

2 Especially the portraits of Costanza (cat. no. 96) and the *Portrait of a Man* (cat.no. 144).

176-190

The So-called Lascivie
(B. 114, B. 123-136) c. 1590-1595

Literature: Bellori p. 116; Malvasia p. 281;
Mostra-Dipinti p. 146; Nagler 1835, p. 398.
(See individual prints for other bibliography.)

These fifteen prints of mythological and biblical subjects form a series which has been called the *Lascivie* because of their specific sexual references. They have been lumped together by writers even though they are dissimilar in subject matter and often in format. Thirteen of the engravings (cat. nos. 176-188) are also extremely close in size, varying from 140 to 156 mm. in height and 99 to 117 mm. in width. The other two prints, which are larger, are included here because the *Satyr Mason* (cat. no. 189), due to its sexual content, has always been included in any discussion of the *Lascivie,* and the *Ogni cosa vince l'oro* (cat. no. 190), although not grouped with this series by Bartsch, is close in style and subject matter. Whether Agostino meant these all to be a series is unknown, since the only common ground they share is their erotic intent, whether the subject matter is biblical (*Lot and his Daughters,* cat. no. 177) or mythological (*Venus Punishing Profane Love,* cat. no. 182).

According to Malvasia, this series of prints caused the wrath of Pope Clement VIII (1592-1605), who rebuked Agostino for his lack of decorum.[1] Clement's interest in these engravings may aid in determining their date. First of all, none of the works exhibit any influence of Agostino's second Roman trip, which began in late 1594; thus a *terminus ante quem* of 1595 is appropriate. After 1595 Agostino's figures became fuller and features took on a sculpturesque quality, influenced by classical forms. In addition, all dated prints after that year exhibit an interest in the virtuosity of the burin.[2] The tower in the background of *Ogni cosa vince l'oro* (cat. no. 190) may represent the campanile in St. Mark's square in Venice, suggesting that Agostino made the prints on his first or second Venetian trip in 1582 or 1589. Although the campanile is Venetian in origin, it does not necessarily mean that Agostino made the prints in that city, only that he recorded what he had seen. The interest in the intensity of light, however, does suggest that the lessons of Venice were still much in the mind of the artist. As Bodmer noted, the style of these works is close to many engravings executed between 1584 and 1587.[3] But, if Clement VIII chastised Agostino for these works, he must have done so after his accession to the papacy in 1592. If the prints had been in circulation, openly or clandestinely for many years, it is doubtful that Clement's rebuke would have had much effect. It is more likely that his pronouncement to Agostino took place shortly after the prints were put into circulation, to denounce them as unacceptable for the religious public. A dating of c. 1590/1592-1595 appears to be proper, then, for the execution of the series.

In spite of Clement's admonition, Agostino's *Lascivie* seem to have been widely circulated, as judged by the numerous examples in poor condition, indicative of overuse of the plate. The Counter-Reformation in Italy seems not to have assuaged the desire for sexually explicit art, which had a long tradition in both Italy and the north in the sixteenth century. In Germany, the moralizing gloss of prints by such artists as Hans Sebald Beham and Hendrik Aldegrever did not overshadow the erotic nature of some of their works.[4] In Italy, engravers made mythological prints of the loves of the gods, which had a frankly prurient content. The most famous, indeed infamous, of these was Marcantonio's 1524 series of engravings after drawings by Giulio Romano.[5] According to Vasari, the prints, called *I modi,* were sold surreptitiously until Pope Clement VII found out about the works and sent Marcantonio

to prison.[6] The artist was released when he promised to destroy the plates and all examples of the prints he could find. He seems to have been fairly successful at removing traces of these works, as the only known examples, those in the British Museum, have been remarkably bowdlerized.[7]

Marcantonio's series, although the most explicitly sexual, was not the only one of its kind in Italy. Bonasone did a group of prints after Perino del Vaga, some of which approached Marcantonio's in tone.[8] Marco da Ravenna, Eneo Vico, and later Giorgio Ghisi also made lascivious works that must have been popular.[9] But, due to the admonitions of the Council of Trent, works of this nature fell off in the second half of the sixteenth century in Italy, only to be revived by Agostino's engravings, which caused another Clement some distress. But, the vigilance of the Church had slackened somewhat even before the *Lascivie*. In *La Gerusalemme Liberata* and other epics of the period, romantic themes thinly veiled in religious guise gained popularity. It was in this atmosphere that Agostino must have felt confident to produce his works.

1 Malvasia p. 281: "Basterà solo il dir per ora, ch'elleno furono così accette per tutto il mondo le sue carte, che le commissioni che da tutte le parti venivano e gli dispacci, arricchirono il Tibaldi, il Bertelli, il Rosigoti ed altri impressori, che gareggiavan fra di loro in levarlo con grosse provigioni, e finalmente a gran prezzo comperarono i suoi rami. E questa in gran parte ancora fu la cagione perch'egli pubblicasse que'lascivi gesti, a traboccar anche ne'quale si vide sotto Papa Clemente unirsi l'indegno conciliabolo della più fiera matite, del più intelligente bolino e della più satirica penna, che a quei tempi avesse grido; il perchè di così giusto sdegno s'accese il Santo Pontefice, che infelici loro, se al meritato castigo con volontario esilio non si sottraevano: che se in vece di riprensione, non n'avesse incontrato egli applauso, e quel ch'è più, una esorbitante ricompensa, ch'era poi la scusa ch'ei n'adduceva a Lodovico, quando dichiarandosene tanto mortificato, malamente ne lo sgridava, avrebbe tralasciato di più pubblicarne. Non n'andò però senza castigo il principal motore, e fu il Rosigotti, che quasi d'ascoso, con riputazione e rigorosissimo prezzo le dava a chi dovea piuttosto e potea vietarlo, se non punirne; perchè da quel tempo che tal mercatura intraprese, mai più goder potette un'ora di bene e diede in mille disastri; e giurava da quell'ora in poi essersi sempre sentito roder dentro dal tarlo della coscienza, massime per aver promesso tante volte a'Confessor abbruciar dette carte, ed abolirne i rami, nè mai averlo eseguito, per l'avarizia ed avidità del guadagno."

2 Cf., e.g., cat. nos. 203-204.

3 Bodmer 1940, p. 47. Calvesi (*Mostra-Dipinti* p. 146) dated the series in the late 1580s.

4 For example, see Beham's prints of *Death and the Three Sorceresses* (Bartsch VII, 176.151), *Three Women at a Bath* (Bartsch VII, 203.208) as well as several others. Aldegrever's *Nun and Monk* (Bartsch VIII, 413.178) was certainly anti-Catholic in intent, but definitely of an erotic nature.

5 Bartsch XIV, 186-187.231.

6 Vasari, V, p. 418.

7 The prints are cut to exclude almost all but the heads. Even then, the imagination fills in much of the missing scene. There are copies extant which probably reproduce Marcantonio's lost compositions.

8 Bonasone did several mythological and erotic prints after Perino. (Bartsch XV, 137.97, and XV, 72-77.9-23).

9 Marco da Ravenna, see, e.g., Bartsch XIV, 254.338. The most famous Eneo Vico of this type is the print of *Mars and Venus* after Parmigianino (Bartsch XV, 294.27) which went through three states, entirely negating the early composition. Parmigianino's mythological works were always of an erotic nature and would have been known to Agostino. The Ghisi print of *Mars and Venus* is undescribed by Bartsch.

176*

Susanna and the Elders
(B. 124) C. 1590-1595

Engraving. 154 x 110 mm.

Literature: Previous discussion and Malvasia
p. 80; Oretti p. 822; Heinecken p. 639, no. 11;
Gori Gandellini p. 315, no. XXXIX; Joubert
p. 346; Bolognini Amorini p. 57; Nagler 1835,
p. 398; Mariette II, 23/5; LeBlanc 6; Bodmer
1940, p. 48; Petrucci p. 138; Louis Dunand,
"A Propos d'une estampe rare du Musée des
Beaux-Arts de Lyon appartenant a la suite du
'Lascivie' d'Augustin Carrache," *Bulletin des
Musées Lyonnais* (1957): 6, 16; Calvesi/Casale
136; Bertelà 232.

States:

	B
I	1

As reproduced. No inscriptions. (Alb, BN, Bo,
Br, MMA, and others)

Copies: 1. Engraving in reverse. 151 x
107 mm. (Alb, Bo, and others). 2. Etching in
same direction. In a roundel. 97 x 80 mm.
Nineteenth century. (Par). 3. Engraving in
reverse. 155 x 107 mm. Lower right: A D (D is
backwards and under the A). 4. Engraving in
reverse. 152 x 108 mm. Close to copy 1, but
harsher. (Dres). 5. Etching in reverse. 150 x
112 mm. (sheet). Fluffy trees. (Ashmolean).
6. Etching in the same direction published by
Bouchard and Gravier 1786. In margin: *La
Chaste Susane.* (Photo: Witt Library).

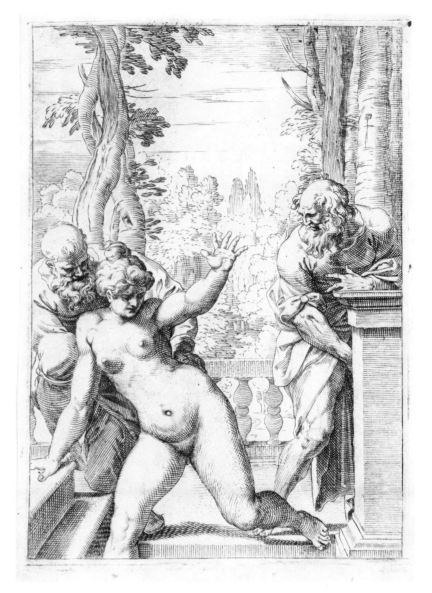

cat. no. 176, only state. New York, The Metropolitan Museum of Art, Gift of Henry Walters, 1917

The cipher on the tree at right is unusual for Agostino and is seen in
another print in this series (cat. no. 187). Its meaning is unknown.

177*

Lot and his Daughters
(B. 127) c. 1590-1595

Engraving. 156 x 113 mm.

Literature: Malvasia p. 80; Oretti p. 822;
Heinecken p. 636, no. 13; Gori Gandellini
p. 315, no. XLI; Joubert p. 346; Bolognini
Amorini p. 58; Nagler 1835, p. 398; Mariette
II, 27-9; LeBlanc 5; Bodmer 1940, p. 48; Louis
Dunand, "A Propos d'une estampe rare du
Musée des Beaux-Arts de Lyon appartenant a la
suite du 'Lascivie' d'Augustin Carrache,"
Bulletin des Musées Lyonnais (1957): 16;
Calvesi/Casale 138; Bertelà 237.

States:

	B
I	1

As reproduced. No inscriptions. (Alb, BN, Bo,
Br, Dres, MMA, and others)

Copies: 1. Etching in reverse. In margin: *Hercole
il grand Eroe s'invaghisce di Iole.* 174 x 117 mm.
(Alb). 2. Engraving in reverse. 152 x 109 mm.
(sheet: Dres).[1]

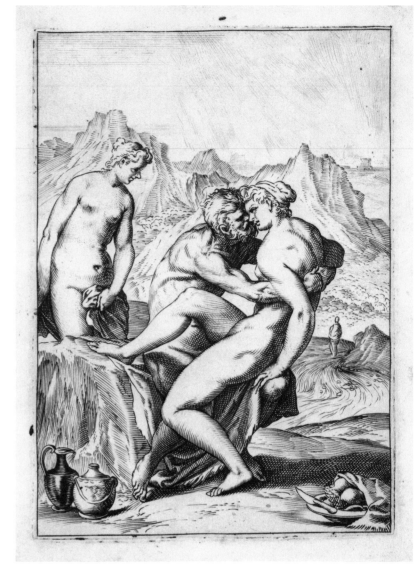

cat. no. 177, only state. New York, The Metropolitan Museum of Art, Gift of Henry Walters, 1917

See discussion before cat. no. 176.[2]

1 There is a pen and ink copy of this engraving in Copenhagen (Kongel. Kobberstik-
samling) attributed to Rubens. It is reproduced in Michael Jaffé, *Rubens and Italy,* 1977,
fig. 64.

2 David Steel pointed out the sexual significance of the knife and fruit in the basket in
the lower right.

178*

Orpheus and Eurydice
(B. 123) c. 1590-1595

Engraving. 140 x 101 mm.

Literature: Malvasia p. 82; Bellori p. 116; Oretti p. 828; Heinecken p. 639, no. 16; Gori Gandellini p. 315, no. XLIV; Bolognini Amorini p. 58; Mariette II, 35-17; Nagler 1835, p. 398; LeBlanc 117; Foratti p. 173; Bodmer 1940, p. 47; Petrucci p. 138; Calvesi/Casale 135; Bertelà 231; Louis Dunand, "A Propos d'une estampe rare du Musée des Beaux-Arts de Lyon appartenant a la suite du 'Lascivie' d'Augustin Carrache," *Bulletin des Musées Lyonnais* (1957): 12, 15.

States:

	B
I	—

Without letters (Alb)

| II | I |

Lower right: *Venetiis Donati Rascicotti formis.* (Alb, BN, Bo, Dres, MMA, and others)

Copies: 1. Contemporary engraving in reverse (Ciamberlano?). 149 x 117 mm. (Alb, Br, and others). 2. Etching in same direction. 230 x 193 mm. Some trees in upper left corner. Lower left: *Ann. C.* According to note at Albertina: by Mich Corneille. (Alb, BN). 3. Engraving in reverse. 142 x 102 mm. Lower left: a monogram of an s with a vertical slash. (Achenbach). 4. Etching in reverse. 176 x 119 mm. In margin: *Orfeo riottiene fuori dell'Inferno Euridice/ la Sua amanta Donna.* (Alb). 5. Etching in reverse. 95 x 76 mm. In roundel. Nineteenth century. (Par). 6. Engraving in reverse. Close to copy 1. 152 x 107 mm. (sheet: Dres). 7. Etching and engraving in reverse. Close to copies 1 and 6 but cruder. 148 x 107 mm. (sheet: Dres). 8. Etching in reverse. 159 x 110 mm. In margin: *Orphée perdant sa femme Eurydice pour la/ Seconde fois.* Lower left: *Carache. in.* Published by Bouchard and Gravier 1786 (Photo: Witt Library).

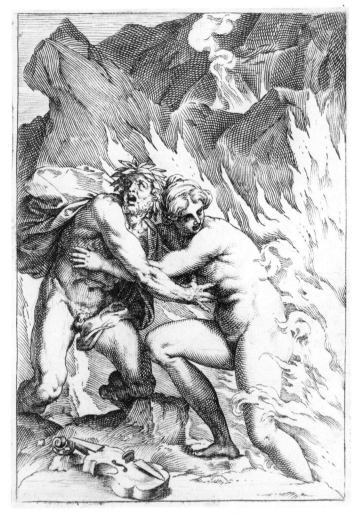

cat. no. 178, state I. Vienna, Graphische Sammlung Albertina

The address of Rascicotti could have led Bodmer to believe that these prints were executed in Venice. However, as can be seen now, that inscription is found only in the second state. Consequently, one does not know when Rascicotti came into possession of the plate.

*Engraving in exhibition from the Metropolitan Museum of Art, New York, Gift of Henry Walters, 1917

179*

Andromeda
(B. 125) c. 1590-1595

Engraving. 152 x 108 mm.

Literature: See previous discussion and Malvasia
p. 80; Oretti p. 822; Heinecken p. 639, no. 9;
Gori Gandellini p. 315, no. XXXVII; Joubert
p. 346; Bolognini Amorini p. 57; Mariette II,
33-15; Nagler 1835, p. 398; LeBlanc 118;
Bodmer 1940, p. 48; Louis Dunand, "A Propos
d'une estampe rare du Musée des Beaux-Arts de
Lyon appartenant a la suite du 'Lascivie'
d'Augustin Carrache," *Bulletin des Musées
Lyonnais* (1957): 11; Calvesi/Casale 137;
Bertelà 234.

States:

	B
I	1

As reproduced. No inscriptions. (Alb, BN, Br,
Bo, Dres, MMA, and others)

Copies: 1. Engraving in reverse. 147 x 116 mm.
Very close. (Alb, Br, Bo, Dres, Ro). 2. Engrav-
ing in reverse. 152 x 110 mm. Close to copy 1
but with more hatching. (Dres)

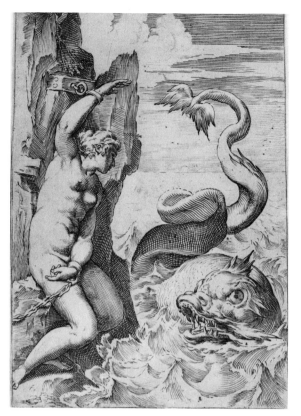

cat. no. 179, only state.
New York, The Metropolitan
Museum of Art, Gift of
Henry Walters, 1917

See discussion before cat. no. 176.

180*

Andromeda or Hesion
(B. 126) c. 1590-1595

Engraving. 150 x 99 mm.

Literature: Malvasia p. 80; Oretti p. 822;
Heinecken p. 639, no. 10; Gori Gandellini
p. 315, no. XXXVIII; Joubert p. 346;
Bolognini Amorini p. 57; LeBlanc 119; Bodmer
1940, p. 48; Louis Dunand, "A Propos d'une
estampe rare du Musée des Beaux-Arts de Lyon
appartenant a la suite du 'Lascivie' d'Augustin
Carrache," *Bulletin des Musées Lyonnais* (1957):
6, 11; Bertelà 236.

States:

	B
I	1

As reproduced. No inscriptions. (Alb, Bo, Br,
Dres, MMA, and others)

Copies: 1. Engraving in reverse. 152 x 104 mm.
(Dres, Br). 2. Engraving in reverse. 139 x
96 mm. (sheet: Alb). 3. Etching in reverse.
179 x 118 mm. In margin: *Andromeda esposta al
Mostro marino.* (Alb). 4. Engraving in reverse.
147 x 109 mm. (sheet: Dres). Close to copy 1.
5. Etching in reverse. 166 x 113 mm. (sheet).
In margin: *Andromede.* Lower left: *Aug. Carracci
Pinx.* Published by Bouchard and Gravier. 1786
(Witt Library).

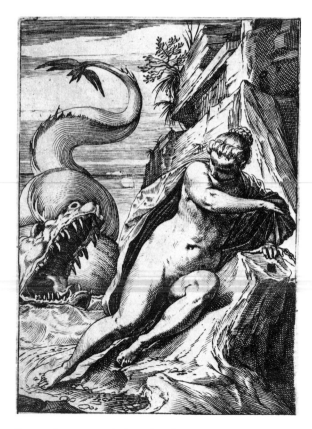

cat. no. 180, only state.
Prints Division,
The New York Public
Library, Astor, Lenox and
Tilden Foundations

Dunand suggested that this figure represents Hesion rather than An-
dromeda. The former was bound to a rock by one rather than two hands.

181*

Venus or Galatea Supported by Dolphins

(B. 129) c. 1590-1595

Engraving. 151 x 108 mm.

Literature: Malvasia pp. 80, 293; Oretti p. 820; Heinecken p. 638, no. 3; Gori Gandellini p. 315, no. XXXI; Joubert p. 345; Bolognini Amorini p. 57; LeBlanc 112; Petrucci p. 138; Louis Dunand, "A Propos d'une estampe rare du Musée des Beaux-Arts de Lyon appartenant a la suite du 'Lascivie' d'Augustin Carrache," *Bulletin des Musées Lyonnais* (1957): 129; Calvesi/Casale 140; Bertelà 239.

States:

I	B
	1

As reproduced. No inscriptions. (Alb, Bo, Br, Dres, NGA, and others)

Preparatory drawings: There was a drawing for this print formerly in the Prince de Ligne collection, in red chalk. See Adam Bartsch, *La collection des dessins originaux de feu le Prince Charles de Ligne,* Vienna, 1794, p. 90. He noted another one in the Gallerie Gabburi, 1722.

Copies: 1. Print in reverse in "maniere noire," (mezzotint?). *Galatea Carati inv.* Exaggerated features. Mentioned in Dunand, p. 17. 2. Engraving in reverse. 149 x 114 mm. (Alb and others). 3. Aquatint in brown in same direction. 160 x 118 mm. Lower left: *Pierron. Imp.* + *Montfaucon.* 1. Center: A. CARRACHE. Lower right: *Péquégnot. sc.* (BN) 4. Engraving in reverse. 147 x 104 mm. Without clouds. (Alb, Achenbach). 5. Engraving in reverse. 146 x 105 mm. (sheet: Par). Very close to copy 2 but with more shading. 6. Engraving in reverse. 161 x 119 mm. Empty margin. (Ber, Br). 7. Etching in reverse. 185 x 122 mm. In margin: *Venus sur les eaux.* Lower left: *Aug. Carrache Pinx.* Published by Bouchard and Gravier, 1786 (Witt Library).

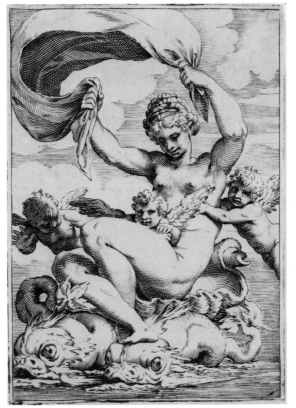

cat. no. 181, only state. Washington, National Gallery of Art, Ailsa Mellon Bruce Fund

This print is certainly influenced by Raphael's *Triumph of Galatea* in the Farnesina[1] but probably through Marcantonio's print of it (Bartsch XIV. 262, 350),[2] as Agostino had not been in Rome for many years when he executed this engraving. The two dolphins, the sea shell, and the billowing drapery held by the goddess all hark back to Raphael's composition, but without further attributes there is no way to decide whether the figure represents Venus or Galatea.

1 Reproduced Adolf Rosenberg, *Rafael des Meisters Gemälde* (Stuttgart, Berlin, and Leipzig, 1923), 116.

2 Reproduced Lambert-Oberthür p. 26, no. 130.

182*

Venus Punishing Profane Love
(B. 135) c. 1590-1595

Engraving. 154 x 112 mm.

Literature: Oretti p. 821; Heinecken p. 639, no. 6; Gori Gandellini p. 315, no. XXXIV; Joubert p. 345; Bolognini Amorini p. 57; LeBlanc 114; Louis Dunand, "A Propos d'une estampe rare du Musée des Beaux-Arts de Lyon appartenant a la suite du 'Lascivie' d'Augustin Carrache," *Bulletin des Musées Lyonnais* (1957): 18-19; Calvesi/Casale 143; Bertelà 245.

States:

	B
I	1

As reproduced. No inscriptions. (Alb, BN, Bo, Br, Dres, MMA, and others)

Copies: 1. Engraving in reverse. 157 x 111 mm. (sheet: Par) Venus' face covered by strong shade. 2. Engraving in reverse. 154 x 110 mm. With five Italian verses. (Br, Dres, and others). 3. Engraving in reverse. Trees only lightly indicated (Dunand, p. 19). 4. Engraving in same direction. 141 x 118 mm. (sheet: Ro). With opossum in tree at right turning around himself. 5. Etching in reverse. 174 x 128 mm. In margin: *Venere castiga Cupido per il suo incarito ferir.* (Alb). 6. Engraving in reverse. 150 x 116 mm. (sheet: Alb). 7. Engraving in reverse. 175 x 123 mm. (sheet: Par). Lower right: *Pet. Over. ex.* In margin: *Quae flagras vitio, puerum cur. inipia flagro Proscindi.[8] pharetra, viribus, orbus erit.* 8. Engraving in same direction. 105 x 88 mm. No background. Fine burin technique (Ber). 9. Etching in reverse. 152 x 112 mm. Lower left: *37.* Feathery technique. (Ashmolean). 10. Etching in reverse. 157 x 123 mm. In margin: *Venus.* Lower left: *aug. Carache in.* Published by Bouchard and Gravier, 1786 (Witt Library).

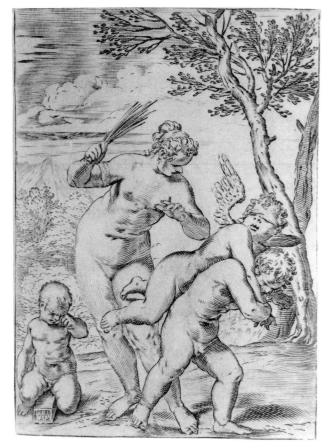

cat. no. 182, only state. Philadelphia Museum of Art, The Academy Collection

See discussion before cat. no. 176.

183*

The Three Graces

(B. 130) c. 1590-1595

Engraving. 154 x 110 mm.

Literature: See discussion and Malvasia p. 80;
Oretti p. 822; Heinecken p. 639, no. 12; Gori
Gandellini p. 315, no. XL; Joubert p. 346;
Bolognini Amorini p. 57; Mariette II, 34-16;
Nagler 1835, p. 398, LeBlanc 111; Louis
Dunand, "A Propos d'une estampe rare du
Musée des Beaux-Arts de Lyon appartenant a la
suite du 'Lascivie' d'Augustin Carrache,"
Bulletin des Musées Lyonnais (1957): 17;
Bertelà 240.

States:

	B
I	1

As reproduced. No inscriptions. (Alb, BN, Bo,
Br, Dres, MMA, and others)

Copies: 1. Etching in reverse. 175 x 117 mm. In
margin: *L'Imagine delle tre Grazie/Deè della
Conversazione, Sociabilita, ed Amicizia.* (Alb).
2. Engraving in reverse. 157 x 109 mm.
(Br, Dres).

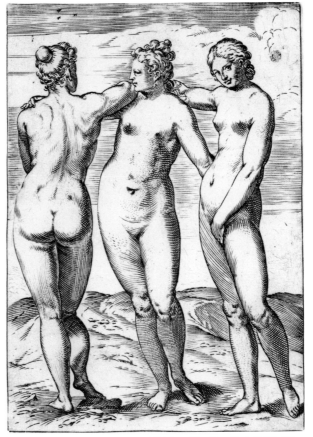

cat. no. 183, only state. Prints Division, The New York Public Library,
Astor, Lenox and Tilden Foundations

This print was probably influenced by Marcantonio's *Judgment of Paris*
after Raphael (Bartsch XIV, 197.245).[1]

[1]Reproduced in Lambert-Oberthür, p. 24, no. 114.

184*

A Satyr Approaching a Sleeping Nymph

(B. 128) c. 1590-1595

Engraving. 151 x 106 mm.

Literature: See discussion and Malvasia p. 80; Oretti pp. 820-821; Mariette ms. 20; Heinecken p. 638, no. 1; Gori Gandellini p. 315, no. XXXII; Joubert p. 345; Bolognini Amorini p. 57; Mariette II, 26-28; LeBlanc 122; Bodmer 1940, p. 48; Louis Dunand, "A Propos d'une estampe rare du Musée des Beaux-Arts de Lyon appartenant a la suite de 'Lascivie' d'Augustin Carrache," *Bulletin des Musées Lyonnais* (1957): 16; Bertelà 238.

States:

	B
I	1

As reproduced. No inscriptions. (Alb, Bo, Br, Dres, MMA, and others)

Copies: 1. Engraving in same direction. 148 x 98 mm. (Achenbach Foundation). 2. Engraving in reverse. 155 x 109 mm. Close to original but with more shading. (Alb and others). 3. Etching in reverse. 168 x 112 mm. In margin: *Un Satiro s'acorge d'una Ninfa in riposa.: per prenderne parte.* (Alb). 4. Etching in reverse. 165 x 124 mm. In margin: *Venus et un Satyre.* Lower left: *Aug. Carracci Pinx.* Published by Bouchard and Gravier, 1786 (Witt Library).

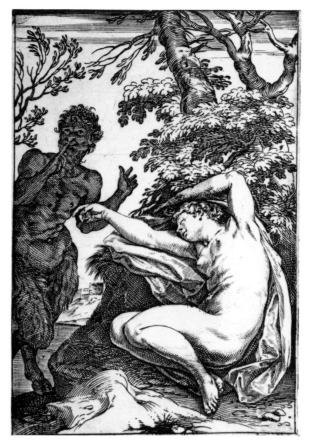

cat. no. 184, only state. Prints Division, The New York Public Library, Astor, Lenox and Tilden Foundations

See discussion before cat. no. 176.

185*

Satyr Looking at a Sleeping Nymph

(B. 131) c. 1590-1595

Engraving. 152 x 117 mm.

Literature: Malvasia p. 80; Oretti p. 819;
Heinecken p. 638, no. 4; Gori Gandellini
p. 315, no. XXXIII; Joubert p. 345; Bolognini
Amorini p. 57; Mariette II, 28-11?; LeBlanc
123; Louis Dunand, "A Propos d'une estampe
rare du Musée des Beaux-Arts de Lyon
appartenant a la suite du 'Lascivie' d'Augustin
Carrache," *Bulletin des Musée Lyonnais* (1957):
1-20, p. 17; Bertelà 241.

States:

	B
I	1

As reproduced. No inscriptions. (Alb, Bo, Br,
Dres, MMA, and others)

Copies: 1. Etching in reverse. In margin: *Un
Satiro s'invaghisce d'una Ninfe, che dorme.* 174 x
124 mm. (Alb). 2. Engraving in reverse. 152 x
117 mm. (Br, Dres, Par). 3. Engraving in
reverse. 168 x 112 mm. (sheet: Milan: Raccolta
delle stampe). 4. Etching in reverse. 162 x
141 mm. (sheet: Witt Library). In margin:
Venus et un Satyre and lower right: *Aug.
Carracci/Pinxit.* Published by Bouchard and
Gravier, 1786. 5. Engraving in reverse. 154 x
113 mm. Close to copy 2. (Dres).

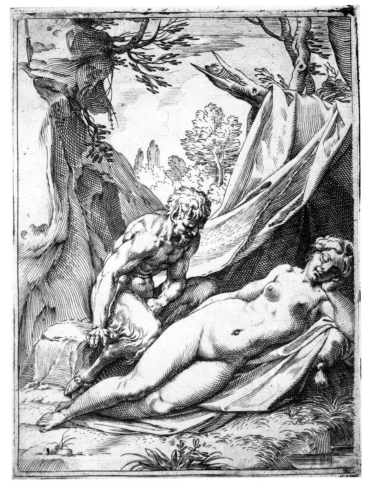

cat. no. 185, only state. London, The British Museum

See discussion before cat. no. 176.

186*

A Satyr Whipping A Nymph
(B. 133) c. 1590-1595

Engraving. 152 x 107 mm.

Literature: See discussion and Malvasia p. 82;
Oretti p. 828; Heinecken p. 639, no. 15; Gori
Gandellini p. 315, no. XLIII; Joubert p. 345;
Bolognini Amorini p. 58; Nagler 1835, p. 398;
Mariette II, 32-14; LeBlanc 124; Bodmer
1940, p. 48; Louis Dunand, "A Propos d'une
estampe rare du Musée des Beaux-Arts de Lyon
appartenant a la suite du 'Lascivie' d'Augustin
Carrache," *Bulletin des Musées Lyonnais* (1957):
18; Calvesi/Casale 142; Bertelà 243.

States:

	B
I	1

As reproduced. No inscriptions. (Alb, BN, Bo,
Br, Dres, MMA, and others)

Copies: 1. Engraving in same direction. 162 x
126 mm. Early seventeenth century. No sky in
background. Finer burin technique. Leafier
branches to trees. (Ber, BMFA). 2. Engraving
in reverse. 115 x 110 mm. (sheet: Alb, Bo,
Dres). 3. The satyr alone in reverse by Odoardo
Fialetti (Dunand, p. 18). 4. Etching in reverse.
170 x 126 mm. In margin: *Il Satiro geloso
battendo intinorisce la sua amata/ Donna per non
tradirlo.* (Alb). 5. Etching in same direction.
95 x 73 mm. In a roundel. Nineteenth century.
(Par). 6. Engraving in the same direction.
152 x 110 mm. Background unfinished.
(Fitzwilliam).

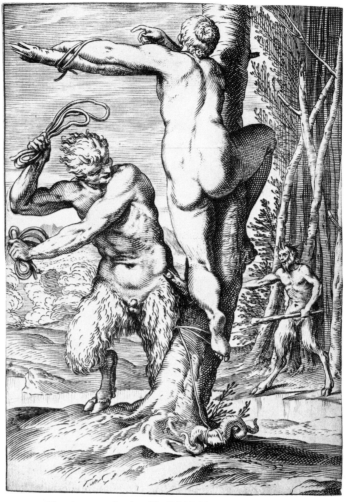

cat. no. 186, only state. London, The British Museum

See discussion before cat. no. 176.

187

A Satyr and Nymph Embracing
(B. 134) c. 1590-1595

Engraving. 150 x 102 mm. (sheet: Ber)

Literature: Bolognini Amorini p. 57; Oretti
p. 822; Mariette I, p. 316; LeBlanc 125; Louis
Dunand, "A Propos d'une estampe rare du
Musée des Beaux-Arts de Lyon appartenant a la
suite du 'Lascivie' d'Augustin Carrache,"
Bulletin des Musées Lyonnais (1957): 12, 18;
Calvesi/Casale p. 42; Bertelà 244.

States:

	B	CC
I	–	–

As reproduced. No inscription. (BM)

	B	CC
II	1	1

Lower right: *1559.* (Alb, Ber, Bo, Milan:
Raccolta delle stampe)

Copies: 1. According to Calvesi/Casale there is a
copy in the Raccolta delle stampe in Milan, but
it is unknown to this author. There is an
original in that collection.

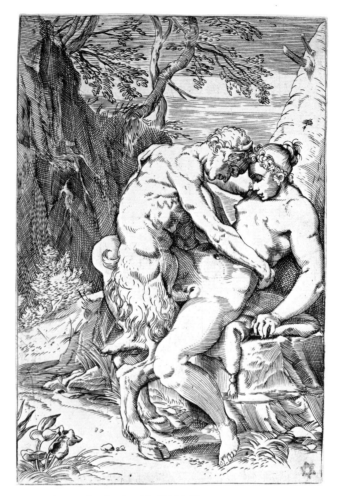

cat. no. 187, state I. London, The British Museum

According to Calvesi/Casale the date "1559" found on the print is a mistake and should have read "1589" or "1599." Dunand, following Mariette, stated that the date was placed on the sheet by the artist to give the impression that the work was not by him. But, now that a first state of the print without the erroneous date has been found, it could be assumed that a publisher later placed the date on the sheet in ignorance of its actual execution date. On the other hand, Agostino himself, after having been rebuked by the pope, may have felt it necessary to disavow authorship of the engraving. On the trunk of the tree is the same unusual cipher as on another print in the series (cat. no. 176).

188

Nymph, Putto, and Small Satyr
(B. 132) c. 1590-1595

Engraving. 153 x 106 mm.

Literature: See discussion and Malvasia p. 80; Oretti pp. 821-822; Heinecken p. 639, no. 7; Gori Gandellini p. 315, no. XLV; Joubert p. 346; Bolognini Amorini p. 57; Nagler 1835, p. 398; LeBlanc 128; Louis Dunand, "A Propos d'une estampe rare du Musée des Beaux-Arts de Lyon appartenant a la suite du 'Lascivie' d'Augustin Carrache," *Bulletin des Musées Lyonnais* (1957): 17-18; Calvesi/Casale 141; Bertelà 242.

States:

	B
	—
I	I

As reproduced. No inscriptions. (Ber, Dres, and others)

Copies: 1. Engraving in reverse. 151 x 107 mm. Very deceptive. See discussion. (Alb, BM, Br, Dres, and others). 2. Etching in reverse. 156 x 111 mm. In margin: *Venus Aug. Carrache.jn.* Published by Bouchard and Gravier, 1786 (Witt Library).

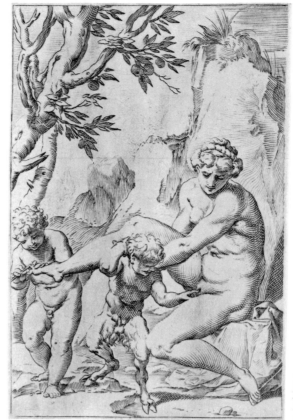

cat. no. 188, only state. Berlin (Dahlem), Staatliche Museen Preussischer Kulturbesitz, Kupferstichkabinett

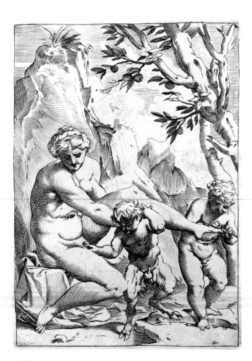

fig. 188a. Anonymous copy of cat. no. 188. London, The British Museum

All writers from Bartsch on have confused the copy of this engraving in reverse (copy no. 1) with the original, which they believed to be the copy. First of all, when comparing the original with the copy (fig. 188a), it is apparent which is by Agostino. The harsh tones and expression of the nymph's face in the copy are unlike the typical sweetened expression in the original. The same holds true for the *putto* and small satyr. Moreover, there is mechanical hatching on the copy, especially in the nymph's legs. The copyist also misunderstood the placement of the nymph's left arm, and it appears a misshapen appendage rather than the supporting arm it is in Agostino's original.

In their discussion of the print, Calvesi/Casale dated the engraving c. 1599 and compared it with Agostino's dated print from that year of *Omnia vincit Amor* (cat. no. 210). They also believed it to be influenced by the fresco of *Roxanne and Alexander* on the vault of the Farnese Gallery by Annibale.[1] This dating of the print is far too late. In all of Agostino's works after 1595 there is a volumetric conception of form, not in evidence here. Classical sculpture influenced these late works, with figures often given features from antique works. These traits are evident in the print of the *Omnia vincit Amor* but are missing here. It is also possible that Annibale looked at Agostino's print for inspiration for his figure of Roxanne on the Farnese ceiling of several years after this print. It is, in fact, in the same direction.[2]

1 Reproduced in Posner, plate 111s.

2 There is a copy in pen and ink of portions of this print in the Palazzo Rosso in Genoa (Inv. 1911): on the head of the nymph and studies of the satyr's legs. They are in the same direction as the engraving.

189

The "Satyr Mason"
(B. 136) c. 1590-1595

Engraving. 201 x 134 mm.

Literature: See discussion and Malvasia p. 81;
Oretti p. 820; Mariette ms. II, 107; Heinecken
p. 638, no. 2; Gori Gandellini p. 315,
no. XLVI; Joubert p. 346; Mariette II, 30/12?;
Nagler 1835, p. 398; Nagler I, 296(21);
LeBlanc 126; Andresen 19; Bodmer 1940,
p. 47; Louis Dunand, "A Propos d'une estampe
rare du Musée des Beaux-Arts de Lyon
appartenant a la suite du 'Lascivie' d'Augustin
Carrache," *Bulletin des Musées Lyonnais* (1957):
8-9, note 11; Bertelà 246.

States:

	B
I	1

As reproduced. No inscriptions. (Alb, Ber,
BM, Bo, Br, Chatsworth)

Copies: 1. One mentioned by Andresen and
Dunand in the Cabinet des Estampes,
Paris—with a bird in cage suspended at right,
covered with hatching. Half the original.
2. Engraving in reverse. 200 x 136 mm.
(Dres).

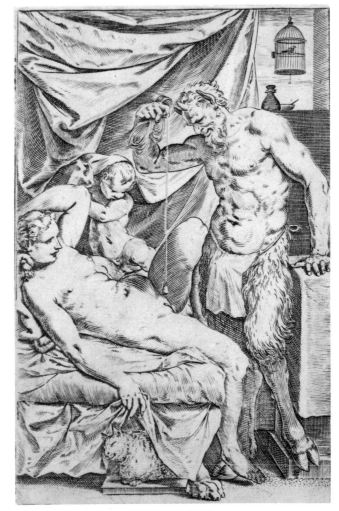

cat. no. 189, only state. London, The British Museum

Bodmer added this print to his series of the *Lascivie* because of its similar
subject matter and dated it as he did the entire series, c. 1584-1586.
Dunand, on the other hand, correctly noted its larger size and discussed
it separately from the other prints. It is included here with the *Lascivie*
by nature of subject matter, the significance of which has not been inter-
preted.[1]

1 According to Dunand, the composition was inspired by a scene of the same subject,
designed by W. Haecht and engraved in 1578 by Jerome Wiérix. The print is unknown
to the author.

190*

Ogni cosa vince l'oro
(B. 114) c. 1590-1595

Engraving. 213 x 162 mm.

Literature: Malvasia p. 80; Oretti pp. 814-815; Heinecken p. 639, no. 17; Gori Gandellini p. 316, no. XLVII; Joubert p. 346; Bolognini Amorini p. 57; Nagler I, 296 (20); LeBlanc 245; Bodmer 1940, p. 47; Calvesi/Casale 144; Dunand pp. 6, 8; Bertelà 221.

States:

	B	CC
I	I	I

As reproduced. (Alb, Ber, Bo, Dres, MMA, and others)

Copies: 1. Margin copied by Luca Ciamberlano and found in the series *Libri dei Disegni* (Bartsch XVIII, 165.50). 2. Engraving in reverse. 177 x 153 mm. Lower right: *Gillis van. Breen. Sculpt.* Lower center: *Visscher excu.* (BN). 3. Etching in reverse. 127 x 101 mm. (Sheet:Alb). Lower right a monogram: *Aug. Car. inv.* 4. Engraving in reverse. 110 x 82 mm. In margin: TVRPE SENEX MILES, MAGÉ TVRPE SENILIS AMATOR. Lower right above margin: 17. (Dres). 5. Engraving in reverse. 218 x 166 mm. Lower right: *Gillis van Breen Schulpt. et excude.* Verses in margin. (Alb). 6. Etching in reverse. 129 x 99 mm. Lower left: *Agust. Car. in.* Lower right: a monogram with the letters FACI superimposed on each other. 7. Engraving in reverse. 102 x 90 mm. (Alb).

As with cat. no. 189, this print is in a larger format than the other *Lascivie,* but fits into the series by virtue of its subject matter. Bodmer dated the sheet c. 1584-1587 and noted that since the tower could represent the campanile of St. Mark's in Venice, the print could have been influenced by Agostino's 1582 Venetian trip. Although the figure of Amor in the right is very close to many of Agostino's *putti* of the mid 1580s, the print is close enough to others in the series to place it later in the artist's career. Agostino's style does not seem to have changed drastically between c. 1585 and 1595 when he went to Rome.

The rebus in the margin translates as "ogni (unghie) cosa (coscia) vin (vino) c (pronounced *ci*) l' oro." Perhaps the figures in the left background are also meant to add something to the message in the margin; however, it has not been interpreted yet. Rebuses and picture games were popular in the sixteenth century, and Agostino was a famous inventor of such intellectually stimulating designs, which were circulated in the Carracci Academy and among friends. He drew many abbreviated forms to be deciphered by the viewers.[1] It is possible that many of the engravings in this series are in reality cleverly disguised conceits made for the intellectually initiated.[2]

1 See Malvasia on this, p. 335. Some of the earlier images in Italian art in this mode were influenced by emblems and even hieroglyphs. See, e.g., Lorenzo Lotto's *Portrait of a Man* in El Paso, Texas (Reproduced Piero Bianconi, *All the Paintings of Lorenzo Lotto,* New York, 1963, vol. 1, pl. 185) and his *Portrait of Lucina Brembate* in the Accademia Carrara, Bergamo (Reproduced Biaconi pl. 53) with rebuses and hieroglyphic images. See also Bartolomeo Passarotti's *Merry Company* in a private collection (Posner, 1, fig. 11) with a rebus along the bottom, as well as his *Family Group* in the Galleria Colonna, Rome (reproduced Heinrich Bodmer, "Un ritrattista bolognese del cinquecento, Bartolomeo Passarotti," *Il comune di Bologna,* 21, no. 2, 1934, p. 11, fig. 3), also with a rebus along the bottom. It is possible that his famous *Butcher Shop* in the Galleria Nazionale, Rome (Posner, 1, fig. 8) may also contain a rebus on the slaughtering table. Emblem books were also popular and influential among artists during the period. The most famous was Andrea Alciati's *Emblemata* published in 1531. Agostino, of course, worked on Bocchi's *Symbolicarum* . . . (see cat. no. 1), and he would have been well informed about this trend in Italian art. Some of the above works were discussed in a Folger Institute seminar in Washington, D.C., in 1977 by Charles Dempsey. It is hoped that his work on the complicated and fascinating use of hieroglyphs and emblems in fifteenth- and sixteenth-century art will be published.

2 See cat. no. 177, note 2. Indeed, the meaning of the "Satyr Mason" must involve some kind of conceit. The *Satyr Whipping a Nymph* (cat. no. 186) with the image of the horn indicates a conceit of the satyr *cornuto.* Many of the prints, especially cat. no. 187, contain sharp-edged phallic forms as branches of the trees. David Steel pointed out many of these hidden metaphors.

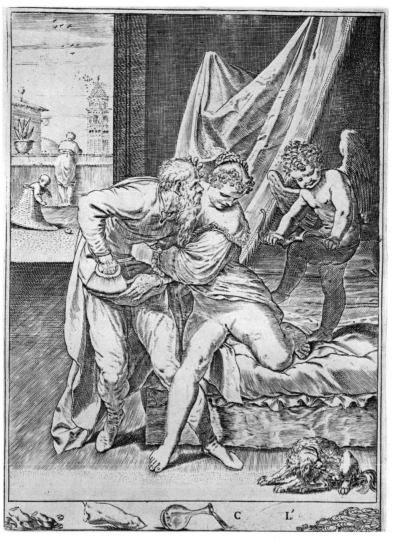

cat. no. 190, only state. London, The British Museum

191

Reciprico Amore
(B. 119) c. 1589-1595

Engraving. 225 x 304 mm. (after painting by Paolo Fiammingo? in the Kunsthistorisches Museum, Vienna)

Literature: Malvasia p. 78; Oretti p. 806; Heinecken p. 639, no. 20; Gori Gandellini p. 316, no. XLIX; Joubert p. 346; Bolognini Amorini p. 56; LeBlanc 116; Bodmer 1940, pp. 62-63; Kurz 1951, pp. 223 ff; Louis Dunand, "A Propos d'une estampe rare du Musée des Beaux-Arts de Lyon appartenant a la suite du 'Lascivie' d'Augustin Carrache," *Bulletin des Musées Lyonnais* (1957): 13; *Mostra-Dipinti* pp. 145-146; Calvesi/Casale 158; Ostrow (under) III, 7; Bertelà 227.

States:

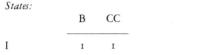

	B	CC
I	1	1

In margin: *Del reciproco Amor, che nasce e viene/ Da pia cagion di virtuoso affetto.* At right: *Nasce à l'alme sincere almo diletto,/ che reca, à l'huom letitia e'l trahe di pene.*

Reciprico Amore and its pendant, *Love in the Golden Age* (cat. no. 192), are reproductive engravings in reverse after paintings of the same subjects in the Kunsthistorisches Museum, Vienna (figs. 191a, 192a), which have been ascribed in this century to an anonymous Venetian artist c. 1600, to Paolo Fiammingo, and to Agostino Carracci.[1] Kurz was the first to attribute the painted works to Agostino, followed by Calvesi in the *Mostra-Dipinti.* Various opinions regarding Agostino's participation were put forth in the reviews of the Carracci exhibition, but Ostrow, who summed up the history of the attributions, clearly rejected the paintings from Agostino's oeuvre. This writer is also of the opinion that the paintings are not from Agostino's hand.[2]

The paintings under discussion are part of a series of four in Vienna, each describing allegories of love. The two which complete the set represent *Amor Lethe* and *Castigo d'Amore.*[3] The iconography, which depends on Vincenzo Cartari's *Le imagini de i dei de gli antichi,* is interpreted by Otto Kurz in his excellent article on the paintings.

The paintings are reproduced in four engravings—the present two by Agostino and two signed by Sadeler after the paintings *Amor Lethe* and *Castigo d'Amore.*[4] Malvasia first mentioned the engravings, erroneously attributing the invention of the compositions to Agostino.[5] Since he did not make note of the paintings now in Vienna, it is doubtful that he knew them as the source of the prints.

The engravings differ from the paintings in several respects. They are expanded on the sides, leading Kurz to believe that the paintings have been cut down.[6] In addition, the deep landscape in *Reciprico Amore* has been contracted and the action in the deep background brought forward. In *Love in the Golden Age* (cat. no. 192), the background landscape of a receding stream has been eliminated and the protagonists in the foreground and middle grounds brought closer to the center of the composition. The result in both engravings is an integration of figures and landscape, missing in the paintings.[7]

Bodmer, Kurz, and Calvesi/Casale dated the engravings correctly to the late 1580s or very early 1590s. They are dated here c. 1589-1595 due to their relationship with other engravings of that period. As observed here, Agostino's style does not change drastically during the period of the late 1580s and early 1590s. The *putti* in these prints recall those done by Agostino as early as 1581,[8] but the burin technique is closer to works after the 1589 Venetian experience, in which hatching became more complicated and compositions fuller. Calvesi/Casale compared the prints to those in the *Gerusalemme Liberata* of 1590, but a more fitting comparison, already brought forward by Kurz, is with the engraving of a *Headpiece in the Form of a Fan* (cat. no. 193), which probably dates from the same period.[9]

1 Inv. nos. 2360, 2361 as A. Carracci? For a history of the paintings see Kurz, 1951, pp. 221-223. Little more is given by Calvesi (*Mostra-Dipinti* pp. 145-146). Ostrow listed all the opinions on the paintings after the *Mostra* in Bologna, found mostly in reviews of the exhibition.

2 Ostrow's characterization of the style of the paintings and reasoning why they are not by Agostino is well thought out and convincing.

3 Inv. nos. 2362, 2363 as A. Carracci? Reproduced in Kurz 1951, pl. 44a, 45a.

4 Reproduced in Kurz 1951, pl. 44b, 45d. The first name of the artist is not given, and since the Sadeler family is large, one cannot be secure as to the attribution of these

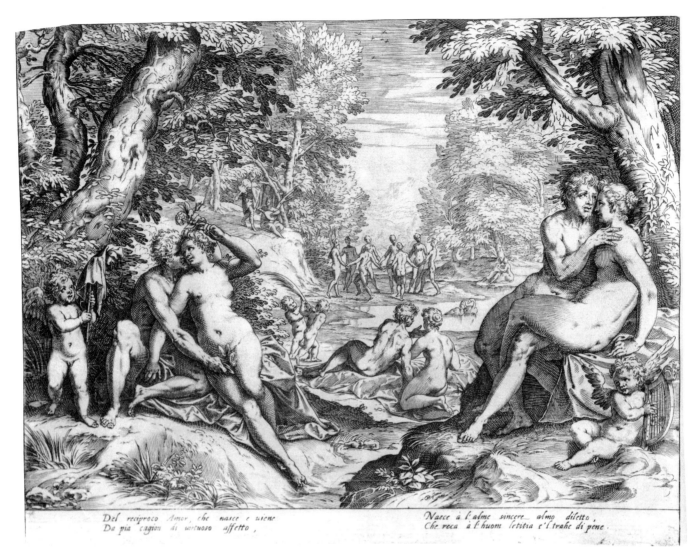

Del reciproco Amor, che nasce e uiene Nasce à l'alme sincere almo diletto,
Da pia cagion di uirtuoso affetto, Che reca à l'huom letitia e'l trahe di pene.

cat. no. 191, only state. The Baltimore Museum of Art, Garrett Collection

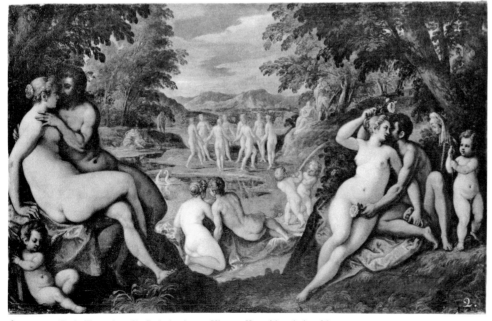

fig. 191a. Paolo Fiammingo(?), *Reciprico Amore*. Vienna, Kunsthistorischen Museum

two prints, although Egidio Sadeler's name is most often given.

5 Malvasia p. 78: "Il secolo d'oro, . . . con la sua compagna, da lui stesso tagliate:
. . . che con tre altre compagne, sua invenzione, similmente intagliate dal Sadeler, co-
munemente son dette: le carte degli amore: gli amori de' Carracci."

6 If they were indeed cut down, it was not by much. The expansion at the sides was
normal procedure for an engraver.

7 The compositional differences between paintings and engravings, with less contrast
between extremely large and extremely small figures, is another indication that paintings
and engravings are by different hands.

8 See especially cat. nos. 29-30.

9 These prints are among the few examples of those in which Agostino reversed the
image of the original composition. This is the second case in which Agostino engraved
two of a series of four paintings by a Venetian (?) artist. See cat. nos. 148-149 after
Tintoretto. It is interesting to compare these prints with those of *The Ages of Man,* done
under Goltzius' direction, especially the print of the *Golden Age* (Bartsch III, 104.3) in
which there is a similar composition, divided in two with a deep background and figures
reclining throughout. The prints are dated 1589 and 1590. The compositions of the
Vienna paintings, so like those of Goltzius, suggest a northern artist as the author. The
rich color of the paintings, of course, indicates someone familiar with Veronese and
Tintoretto. Perhaps then Paolo Fiammingo (Pauwels Franck, Antwerp 1540-Venice
1596) is the best candidate for the authorship of these paintings.

192

Love in the Golden Age or The Fruits of Love
(B. 120) c. 1589-1595

Engraving. 218 x 290 mm. (after painting by Paolo Fiammingo? in the Kunsthistorishes Museum, Vienna)

Literature: Malvasia, p. 78; Oretti p. 806; Heinecken p. 639, no. 19; Gori Gandellini p. 316, no. XLVIII; Joubert p. 346; Bolognini Amorini p. 56; LeBlanc 120; Kurz 1951, pp. 223 ff.; *Mostra-Dipinti* pp. 145-146; Calvesi/Casale under 158; Bertelà 228.

States:

	B
I	1

In margin lower left: *Come la palma indicio è di vittoria, / Cosi d'Amor conveniente è il frutto.* Lower right: *Quella dolcezza; da cui vien produtto: Il seme, onde Natura, è 1 ciel si gloria.* (Alb, Ber, BN, Bo, MMA, and others)

See the discussion for cat no. 191.

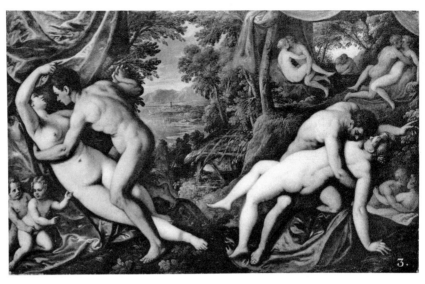

fig. 192a. Paolo Fiammingo(?), *Love in the Golden Age.* Vienna, Kunsthistorischen Museum

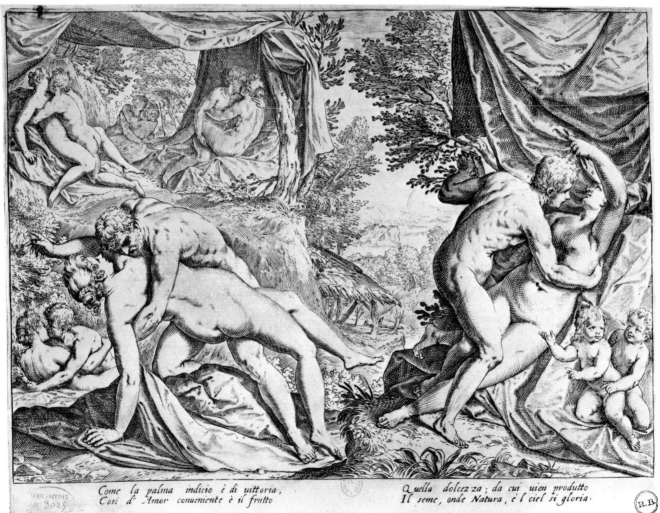

Come la palma indicio è di vittoria,
Cosi d'Amor conveniente è il frutto

Quella dolcezza; da cui vien produtto
Il seme, onde Natura, è l ciel si gloria.

cat. no. 192, only state. Paris, Bibliothèque Nationale

193*

A Headpiece in the Form of A Fan
(B. 260) c. 1589-1595

Engraving. 372 x 251 mm.

Literature: Bellori p. 116; Malvasia p. 77; Oretti pp. 798-799; Heinecken p. 640, no. 5; Gori Gandellini p. 316, no. LIII; Bolgnini Amorini p. 55; Nagler 1835, p. 399; Nagler I, 296 (22); LeBlanc 129; Foratti p. 176; Bodmer 1940, p. 58; Kurz 1951, p. 232; *Mostra-Disegni* no. 254; Calvesi/Casale 134; Bertelà 293.

States:

	B	CC
I	1	1

Before letters. (Alb, Ber, BN, Cleveland, Dres, and others)

	B	CC
II	2	2

Lower left: *August. Carazza Inv. e fe.* (Alb, BM, Bo, Br, NGA, and others)

Preparatory drawings: 1. Private Collection, England.* Pen and ink over red and black chalk. Incised. 300 x 237 mm.[1]

Copies: 1. Engraving in same direction. 346 x 250 mm. The three ovals of the original are missing and a different one with dancing nymphs from cat. no. 191 is added lower right. (Bo)

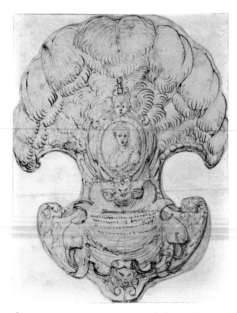

fig. 193a. Agostino Carracci, *Study for "Headpiece in the Form of a Fan."* Private Collection, England

Bellori was the first to mention this sheet but seems to have been describing the copy rather than the original. Both Bodmer and Mahon (*Mostra-Disegni*) dated the engraving in the mid 1580s; Bartsch earlier had believed the print to be in Agostino's youthful manner. Bodmer compared the landscape in the oval in the headpiece with the *Oval Vignette with Sun and Moon and Crowns* in the *Vita di Cosimo de' Medici* (cat. no. 138). The only salient comparison there is that each is done in an oval; otherwise the landscapes are quite different, this one being far more complicated. Calvesi/Casale correctly noted the similarity of the manner in the three ovals at right with the illustrative prints by Agostino in the *Gerusalemme Liberata* (cat. nos. 155-164) of 1590, and Kurz compared the work with the previous two engravings (cat. nos. 191-192). Moreover, the delicacy of the burin in the landscape backgrounds is most characteristic of Agostino's manner from the 1590s into his Roman period and to the end of his life. On the other hand, the classically inspired facial types of the Roman period are missing, implying that this print must predate 1595.

The drawing in a private collection, England (fig. 193a)* was rejected by Bodmer but accepted by Mahon in the *Mostra* catalogue. It is incised for transfer and in reverse of the engraving. Also, the measurements of the fan in the drawing are close to those in the engraving. Agostino needed to transfer only the most basic contours to the plate to give himself a general idea of the composition. From what we have seen of his working methods, this is typical. After transferring these lines, Agostino would have worked out the rest of the composition on the plate without the need of the drawing for reference.[2] Bodmer may have rejected this drawing on the basis of its quickly executed manner, but Agostino was not always meticulous with his drawing style. Sometimes simple indications alone were necessary.

Mahon's dating of the engraving to the mid 1580s may have been based on the style of the drawing, which is closest to works in the early 1580s.[3] But Agostino's pen style remained loose throughout his career, and even after 1595 was used as an alternate style to his more meticulous Roman manner.

This engraving has always been interpreted as representing a fan, but it must be something else. There is no handle for a fan, and the user could not very well hold on to the cumbersome center of the piece. Also, no explanation has been offered for the three ovals in the lower right-hand corner and the indication for a fourth oval in the lower left. H. Diane Russell has suggested that perhaps the object was meant as a headpiece to be cut out and worn in a festival. Then, each of the scenes in the ovals could be alternated with the landscape oval on the headpiece at will. Jacques Callot made such engravings to be cut up and used in festivals, the best example being his well-known *Fan*. Moreover, the form does resemble some of the headpieces and helmets worn in festivals during the period.[4]

If the form was destined as a festival headpiece, for which festival was it made? The only one with which we know for certain that Agostino was connected was the incredibly sumptuous marriage feast of Ferdinand de' Medici and Christine of Lorraine of 1589.[5] If made that early, and stylistically it is possible, this engraving may have been used in one of the processions or possibly in one of the plays or *intermezzi*. The

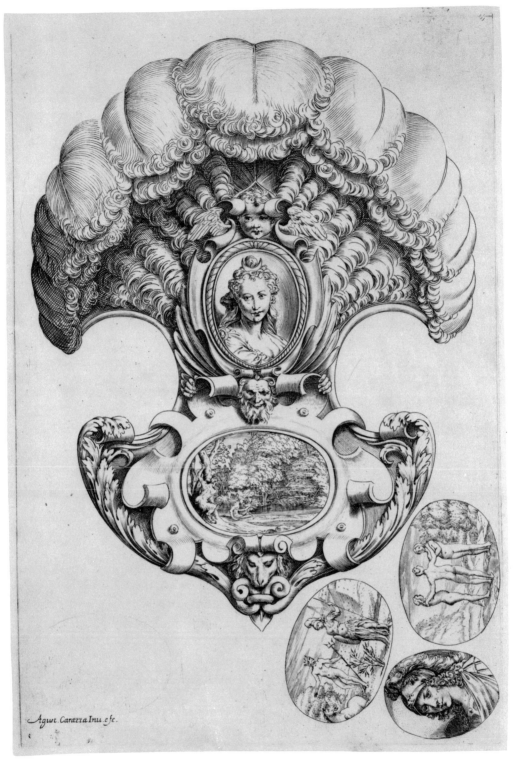

Aguſt. Carazza Inu. e fe.

cat. no. 193, state II. Washington, National Gallery of Art, Ailsa Mellon Bruce Collection

311 AGOSTINO

headpieces on some of the figures in the *Harmony of the Spheres* (cat. no. 153), especially the seated figure on the far right, are similar in form to this headpiece. Without any documentation, however, the function of this engraving must remain conjecture.[6]

1 The form of the headpiece has been cut out and is laid down on another sheet. Inscribed: *Donna mentre i begli occhi* by the artist. Collections: Henry Reitlinger, Maurice Rosenheim. Literature: Tancred Borenius, "Drawings and Engravings by the Carracci," *The Print-Collector's Quarterly,* 9 (1922): 114, reproduced p. 111; Bodmer 1940, p. 58, note 1; *Mostra-Disegni,* no. 47.

2 Agostino's working methods are discussed in the Introduction. See also cat. no. 103 state I for an example of the free-flowing lines Agostino used to transfer his designs to his plates.

3 It is similar in its loose handling to the *Communion of St. Francis,* a study for the painting in Dulwich. Both are reproduced in Michael Jaffé, "Some Drawing by Annibale and by Agostino Carracci," *Paragone,* 83 (1956), pl. 10-11.

4 Oral communication. For information on the use of Callot's *Fan* in festival activities see H. Diane Russell, *Callot: Prints and Related Drawings,* National Gallery of Art, Washington, D.C., 1975, cat. no.67.

5 See cat. nos. 153-154.

6 A drawing in Windsor Castle* (Wittkower 185, discussed in the Introduction, fig. S), is compositionally related to this print. In it also is a landscape oval in an elaborate surrounding cartouche. Although the Windsor drawing was probably made for a book illustration, it is possible that it is connected with the same project as the *Headpiece in the Form of a Fan.* Although Wittkower dated the drawing to the Roman period, it is probable that the sheet dates from the same period as the present engraving. Wittkower's dating of the sheet was based on the profile head on the verso, which he believed to be Roman in style. On the contrary, the head does not contain the typical classical and sculpturesque features of Agostino's forms after 1595. In addition, the connection, as noted by Wittkower, with the drawing in the Art Institute of Chicago (Inv. 22.19, reproduced in Nancy Ward Neilson, *Italian Drawings Selected from Mid-Western Collections,* 1972, cat. no. 20), which also appears to be earlier than the Roman period, strengthens the dating of the sheet to the period in the late 1580s and early 1590s.

194

Portrait of Pope Innocent IX
(B. 149) 1591

Engraving. 259 x 204 mm.

Literature: Malvasia p. 79 and note 1; Oretti p. 808; Mariette ms. 13; Heinecken p. 629, no. 27; Bolognini Amorini p. 56; Nagler 1835, p. 394; Nagler I, 296(7); LeBlanc 237; Bodmer 1940, pp. 63, 68; *Mostra-Dipinti* p. 83; Bertelà 253.

States:

	B
	—
I	1

In cartouche upper right: INNOCENTIVS IX/ PONT. MAX./ PATRIAE SPENDOR/ BONORV̄. REFVGIVM/ AC/ REIPVB. CHRISTIANAE/ SALVS ET GAVDIV̄./ CREATVS / III. CAL NOVEM./ M.D.XCI. Lower right: A.C.F. (Alb, Bo, Br, Dres, and others)

—	2?

Arms at left changed to those of Paul V. Inscription changed to read: *Paulus V. Pont. Max. 1605.*

Copies: 1. Of the coat of arms only (cat. no. R40).

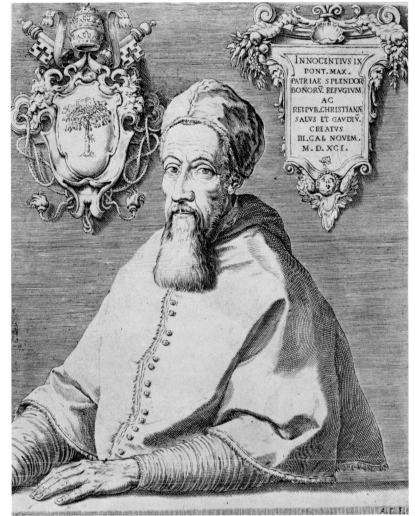

cat. no. 194, only state. New York, The Metropolitan Museum of Art, Harris Brisbane Dick Fund, 1927

Innocent IX, from the Bolognese family of the Fachenetti, reigned briefly as pontiff during the year 1591. It seems fitting that the Bolognese Agostino, whose monogram appears in the lower right-hand corner, would be asked to engrave his portrait that year. Malvasia mentioned the existence of a second proof from the year 1605, in which the arms and inscription were changed to accommodate the reigning pope, Paul V. This state was doubted by Bartsch, and it has not yet come to light.[1]

The burin technique is characteristic of Agostino, as is the style of the features of the pope, penetrating and simplified, and the simply executed left hand. The print has never been doubted.

1 Heinecken said that both portraits (of Innocent IX and Paul V) were published in 1605, and that the engraving was unfinished by Agostino and completed by another hand. What impression he knew is unknown.

195

Coat of Arms of a Duke of Mantua
(B. 172) 1590-1595

Engraving. 142 x 191 (sheet: BM)

Literature: Malvasia p. 80; Oretti pp. 815-816; Heinecken p. 643, no. 22; Bolognini Amorini p. 57; Nagler 1835, p. 399; LeBlanc 261; Calvesi/Casale 160; Bertelà 269.

States:

	B	CC
I	1	1

Below crown: FIDES. (Alb, Ber, BM, BN, Bo, Ro)

Malvasia first attributed this print to Agostino, and it has never been questioned. Bartsch noted the similarity of the escutcheon on cat. no. R31, which he also attributed to Agostino, but which is here given to Francesco Brizio. Calvesi/Casale dated the present engraving near the *Coat of Arms of Cinzio Aldobrandini* (cat. no. 202), which is dated here 1594. A note at the Albertina dates this engraving 1593-1594. Since it is not possible to know which duke's arms are here represented, an exact dating is not possible.[1] A rather broad dating of 1590-1595 is given here because no elements of Agostino's Roman style are prevalent, yet the tightly cropped, closely spaced crosshatching used to form intense shadows seems to appear after 1589. Moreover, the figures of Abundance on the left and Peace on the right, with their tight drapery folds, are similar to figures in the illustrations to the *Gerusalemme Liberata* of 1590 (cat. nos. 155-164).[2]

1 The Duke of Mantua whose arms appear here could be Vincenzo Gonzaga, who became Duke in 1587.

2 There is a pen and ink copy of this engraving in the same direction in the Museo del Prado in Madrid (Inv. F.D. 1327).

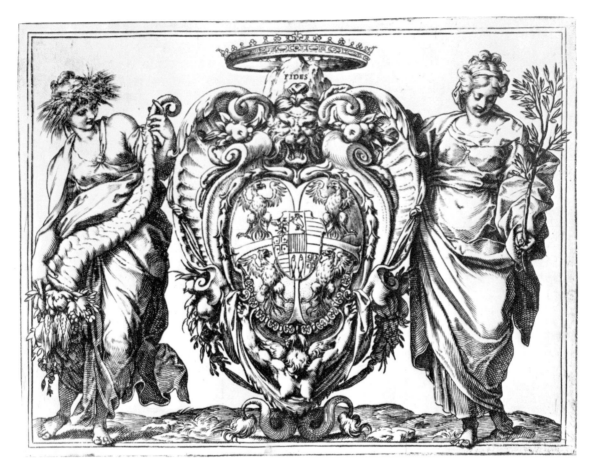

cat. no. 195, only state. Vienna, Graphische Sammlung Albertina

196*

Coat of Arms of Cardinal Fachenetti

(B. 171) c. 1590-1595

Engraving. 225 x 294 mm.

Literature: Malvasia p. 78 and note 2; Oretti pp. 804-805; Heinecken p. 643, no. 18, 19; Bolognini Amorini p. 57; Nagler 1835, p. 398; LeBlanc 259; Bodmer 1940, p. 63; Calvesi/Casale 164; Bertelà 268.

States:

	B	CC
I	I	—

Within escutcheon a tree. Around it the words: DVM SIDERA PRÆPETE PENNA. (Alb)

II	—	I

Same as state I but with a griffin within the escutcheon. (Alb, BN, Bo)

III	—	—

Same as state I except with three starlike circles on three lines. Inscription deleted.[1] (BN)

Preparatory Drawings: 1. British Museum Inv. no. P.p. 3-9. Pen and brown ink and wash over red chalk. Background in blue wash. 231 x 293 mm. (fig. 196a).*[2]

Copies: 1. Woodcut. Title page to Carlo Ruini's *Dell'anotomia et dell' infirmita dell' cavallo,* Bologna, 1598. 2. Engraving. 224 x 284 mm. (sheet: Dres). Copy of the cartouche with the Victories but with elaborate alterations. The coat of arms is replaced with a figure of Velociori and the Victories hold wreaths with portrait medallions. Cardinal's hat deleted. Lower center: *C. Audran Fecit.*

Bartsch believed this to be one of Agostino's most beautiful coats of arms. It was obviously of great commercial value since various states exist with different coats of arms within the cartouche. Bodmer placed this print c. 1591, and stylistic as well as documentary evidence supports this date in the first half of the 1590s. There does not appear to be any Roman influence; the figures are full bodied but lack the classical profiles so evident in Agostino's work after 1595. In addition, the mannered use of the burin found continually after 1595 is here lacking. The dramatic use of strong light and shade in the preparatory drawing in the British Museum (fig. 196a)* is characteristic of Agostino's drawings until the late nineties. After his trip to Rome, the drawings, mainly in pen and ink, offer less contrast than apparent here. The sheet, indented for transfer and in reverse, as with the artist's other preparatory sketches, merely outlines the main forms to be transferred to the copperplate. Changes were then made in the decorative side ropes to balance the composition, and the details were drawn in directly on the plate.

The arms of state I are those of a cardinal from the Bolognese Fachenetti family. Giovanni Antonio Fachenetti, created cardinal in 1583, became Pope Innocent IX in 1591. During his short reign he created only two cardinals, one of whom was Antonio Fachenetti, whose arms these probably are.[3] Antonio died in 1606. If the arms are those of Antonio, a date close to the time of his election to the cardinalate would be fitting.

Ciaconi mentioned only one cardinal from the Franciotti family, whose coat of arms appears on the second state of this print. He was Marc Antonio who was raised to the purple in 1634 by Urban VIII and died in 1666. If he is the cardinal whose arms appear here, then this state was changed after Agostino's death.[4] The fine burin strokes of the griffin are foreign to the rest of the cartouche and appear in Agostino only after 1595, but they are characteristic of many of his followers.

The coat of arms on state III of this print has not been identified. It could possibly be for a member of the Pallotta family, whose arms are similar to this.[5] In any case, it is much weaker than the first two states and not by our artist.

1 Bodmer noted this third state but not the other two.

2 Indented for transfer. Collection: Marquis de Lagoy (Lugt 1710). Laid down. Some holes. Vertical crease center. Unpublished.

3 The other Fachenetti mentioned by Ciaconi was created cardinal by Urban VIII (1623-1644) and is thus not relevant to this discussion. For information on Fachenetti cardinals see Berton p. 888, Ciaconi IV, 621 and Ciaconi IV, 247-248.

4 See Ciaconi IV, 597-8 for information on Marc Antonio Franciotti.

5 Giovanni Evangelista Pallotta (1548-1620) was made cardinal by Sixtus V in 1587 (Ciaconi IV, 179-180). Giovanni Battista Palotta was raised to the purple in 1629 and died in 1668 (Ciaconi IV, 579-580). If state II represents the arms of Marc Antonio Franciotti and was done after 1634, then state III could represent Giovanni Battista Pallotta, made cardinal in 1629.

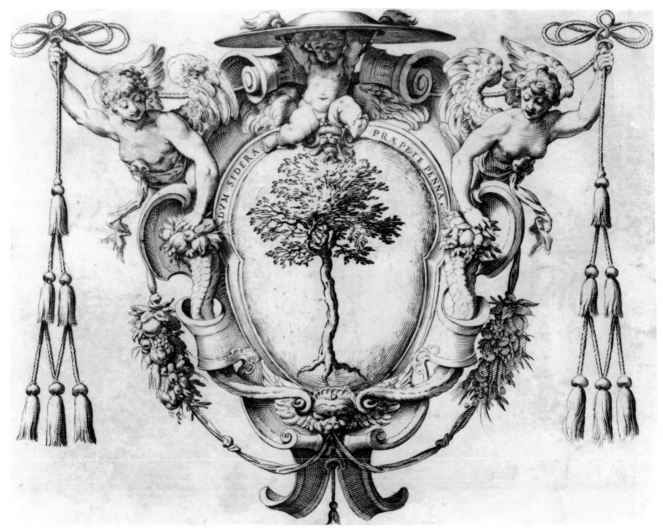

In the coat of arms, the inscriptions read:

DVM SIDERA ... PRÆPETE PENNA.

cat. no. 196, state I. Vienna, Graphische Sammlung Albertina

fig. 196a. Agostino Carracci, *Study for the Coat of Arms of Cardinal Fachenetti*. London, The British Museum

317 AGOSTINO

197

Coat of Arms of a Cardinal of the Sampieri Family
(B. 177) 1590-1595

Engraving. 141 x 107 mm.

Literature: Malvasia p. 82 and note 2; Oretti
p. 828; Heinecken p. 643, no. 28; Bolognini
Amorini p. 58; Nagler 1835, p. 399; LeBlanc
265; Bodmer 1940, p. 64; Calvesi/Casale 165;
Bertelà 273.

States:

	B	CC
I	–	–

Cartouche empty. (Alb)

	B	CC
II	1	1

With rearing dog within cartouche. (Alb, BN,
Bo, Br, MMA, and others)

cat. no. 197, state II. Vienna, Graphische Sammlung Albertina

No Sampieri cardinal, whose arms appear in state II, is mentioned by
any of the biographers. Both Bodmer and Calvesi/Casale dated the en-
graving c. 1593-1594/1595. This seems a fitting date if one compares
the tassels of the cardinal's hat with those in other coats of arms of the
period.[1] The simplicity of the cartouche and the arms within reflect
Agostino's work on the *Lascivie* of the same period (cat. nos. 176-190).

1 See cat. nos. 196, 198, and 200.

198

Coat of Arms of Cardinal Cinzio Aldobrandini

(B. 161) c. 1593-1595

Engraving. 249 x 318 mm.

Literature: Malvasia p. 77; Oretti p. 801; Heinecken p. 642, no. 10; LeBlanc 248; Disertori p. 261; Bodmer 1940, p. 63; Petrucci 1953, cat. no. 358; Calvesi/Casale 162; Bertelà 260.

States:

	B	CC
I	1	1

Without letters (Alb, BM, BN, Bo, Dres, Ham, Ro)

II	2	2

At lower left: *ludovico Carace in et fecit.* At right: *Si Stampano in Roma da Gio. Iacomo de Rossi alla pace.* (Alb, Br, NYPL, and others)

Plate extant in the Calcografia Nazionale, Rome (see cat. no. 199)

Copies: 1. Cat. no. 232. See discussion there. 2. Engraving. 240 x 284 mm. (sheet: Bo). A free variant of this engraving and of cat. no. 232 with the arms of Cardinal Erminio Valenti. Bertelà 262.

The second state of the print incorrectly attributes the execution of the engraving to Lodovico Carracci. It is possible that the design was originally that of Agostino's cousin since Lodovico did do designs for coats of arms, including one executed by Agostino (cat. no. 202).[1] The coat of arms is probably that of Cinzio Aldobrandini, who was created cardinal in 1593 and died in 1610. Other cardinals of the period from the family were Ippolito, who was cardinal from 1586 until his elevation to the papacy in 1592, and Pietro, who became cardinal in 1595. Since the execution of this print seems to have preceded Agostino's 1595 trip to Rome, these are probably Cinzio's arms. The two heads in the volutes reflect those in such prints of the pre-1595 period as the *Lascivie* (cat. nos. 176-190) and the *Apollo and the Python* (cat. no. 154). They lack the classical features of such a head as that of *St. Francis* of 1595 (cat. no. 204), executed after Agostino went to Rome. Moreover, the burin technique, although complicated, lacks the virtuosity and mannered quality of some of the prints after 1595.

Cat. no. 232 is a variant of this print and, as explained in that discussion, may also be by Agostino.

1 There are many engravings after coats of arms by Lodovico. See the ones by Brizio especially, reproduced in Bertelà 44-46, 49-53.

cat. no. 198, state I. London, The British Museum

199

Various Studies

c. 1593-1595

Engraving. 250 x 322 mm.

Unpublished.

States:

I

As reproduced.

Plate extant in the Calcografia Nazionale, Rome. Verso of cat. no. 198.

This engraving was first printed by the Calcografia Nazionale in 1978. As on the versos of Agostino's other extant plates (cat. nos. 13, 14, 134), the artist used this side to try out the burin, in this case for the tassels of the recto and other studies. What is most noticeable about the burin work here is its simplicity and halting quality, leading one to wonder if parts of the print are the work of another artist. Yet, the head at right is very much in Agostino's manner. He employed the burin conservatively: the volume of the head is shown by the curve of a single line. Consequently, one is inclined to accept these studies as from Agostino's hand.

cat. no. 199, only state. Rome, Istituto Nazionale per la Grafica—Calcografia

200

Coat of Arms of Cardinal Peretti (B. 176) c. 1590-1595

Engraving. 227 x 300 mm.

Literature: Malvasia, pp. 78, 83; Oretti pp. 806 and 832; Heinecken p. 643, no. 25; Bolognini Amorini p. 56; Nagler 1835, p. 399; LeBlanc 264; Bodmer 1940, p. 51; Calvesi/Casale 163; Bertelà 271, 272.

States:

	B	CC
I	1	1

Within cartouche the arms of the Peretti family. Above cardinal's hat: META OLIMPO. Above lion with wheel below cartouche: OPE TVA. (BN)

II	–	–

OPE TVA changed to FER OPEM. (Alb, Bo, Br)

III	2	2

META OLIMPO burnished out. Arms of Peretti family changed to arms of Paleotti family. Two bears playing in place of lion with wheel. (BN)

IV	–	–

As state III but without letters. (Alb, BN, Bo, Dres, Ham)

V	–	3

Heraldic devices elaborated. Two bears substituted by head of an angel. (Alb, Bo)

Bodmer dated this engraving c. 1587, and Calvesi/Casale placed it c. 1594. The proximity of the design to that of cat. no. 198 suggests that it was executed about the same period. The only Peretti cardinal who would appear to be applicable to this coat of arms would be Alessandro, who was created cardinal in 1585 by Sixtus V and who died in 1623.[1] The third state of the print represents the arms of the Paleotti family and could conceivably be those of Gabriele Paleotti (1522-1597), the only Paleotti cardinal in the biographies.[2] That would place a *terminus ante quem* on this state of 1597, and the *terminus post quem* of the first state as 1585. It does seem fitting, however, to place the first state within Agostino's pre-Roman period of the 1590s when the features of his figures lack the classical profiles so evident after 1595.

1 Ciaconi listed four Peretti cardinals: 1) Francesco Felix Peretti, who was created cardinal under Pius V and died in 1585, 2) Alessandro, who became cardinal in 1585 (Ciaconi IV, 147), 3) Andrea Barone Peretti, who became a cardinal under Clement VIII in 1596 and died in 1629 (Ciaconi IV, 311-12), and 4) Francesco, who was created cardinal under Urban VIII (Ciaconi 610-611).

2 Cardella V pp. 102 ff. See the Introduction.

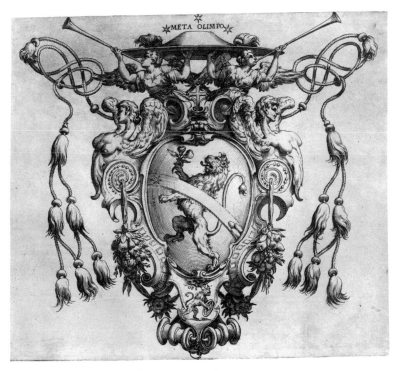

cat. no. 200, state I. Paris, Bibliothèque Nationale

201*

Coat of Arms of a Bishop
(B. 159) mid 1590s

Engraving. 182 x 240 mm.

Literature: Malvasia p. 79; Oretti p. 812;
LeBlanc 269; Heinecken p. 642, no. 7;
Bodmer 1940, p. 51; Calvesi/Casale 115;
Bertelà 258.

States:

	B	CC
I	1	1

Arms within the cartouche (Alb, BN, Bo)

	B	CC
II	2	2

Arms effaced and plate is abraded. Along lower
edge: P.S.F. (Alb, BM, BN, Bo, Br, Dres,
MMA, Ro)

Bodmer dated this sheet in the late 1580s. Calvesi/Casale dated it
c. 1584 noting that the *stemmi* were reminiscent of those in the *Cremona
Fedelissima.* It is not evident to which parts of the *Cremona Fedelissima*
they referred, but there does not seem to be any connection with that
book. The very rotund cherubs suggest that the engraving may have
been done after Agostino arrived in Rome, yet the cartouche itself re-
flects the other coats of arms dated here to the early 1590s. The mask at
bottom appears in similar form on many of the coats of arms and also on
the *Headpiece in the Form of a Fan* (cat. no. 193). The second state of the
print bears the address of Pietro Stefanoni, who was born in Vicenza and
began publishing works in Rome in the first decade of the seventeenth
century.[1] The arms represented are not as yet known.

*Engraving in exhibition from Graphische Sammlung Albertina, Vienna.

1 See Appendix I.

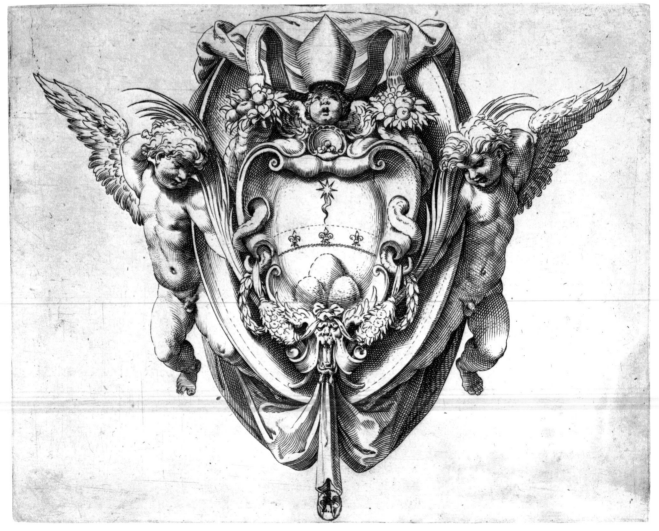

cat. no. 201, state I. Paris, Bibliothèque Nationale

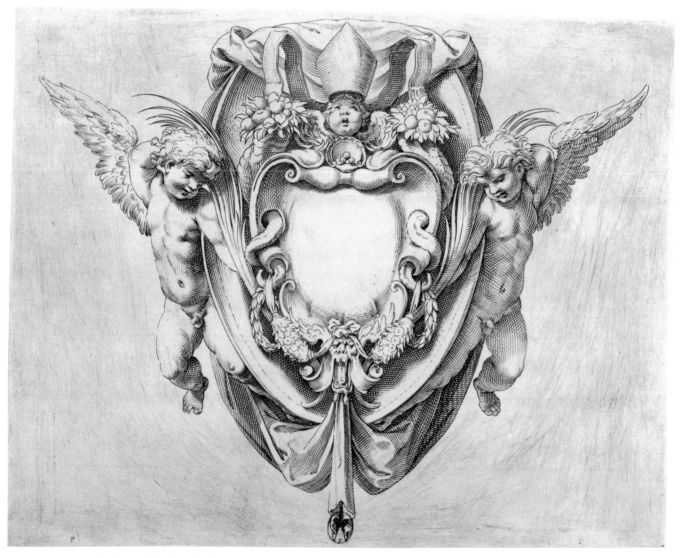

cat. no. 201, state II. Paris, Bibliothèque Nationale

323 AGOSTINO

202*

Coat of Arms of Cardinal Cinzio Aldobrandini
(B. 160) 1593-1594

Engraving. 152 x 202 mm. (after Lodovico Carracci drawing in the Plantin Moretus Museum, Antwerp)

Literature: Malvasia p. 77 or pp. 80-81; Oretti p. 815; Heinecken p. 642, no. 12; Bolognini Amorini p. 56; Nagler 1835, p. 398; Nagler I, 296 (8); LeBlanc 247; Bodmer 1940, p. 63; Calvesi/Casale 159; Bertelà 259.

States:

	B	CC
I	1	1

Arms of Aldobrandini in cartouche. Lower left: A.C. (Alb, BM, BN, Bo, Br)

II	2	–

Arms changed as reproduced. (Alb)

fig. 202a. Broadsheet with cat no. 202. Bologna, Pinacoteca Nazionale

Since it is monogrammed in the first state at left: *A.C.*, this engraving has never been disputed. The arms represented are those of Cinzio Aldobrandini, who was raised to the purple in 1593 and died in 1610. Calvesi/Casale discovered the commemorative sheet on which this engraving appeared in Bologna (fig. 202a); it was published on April 12, 1594. The secure dating of this print forms a basis for dating the other coats of arms which are stylistically similar to it (cat. nos. 195-200). Stylistically, the sharp profiles of the figures of Prudence and Justice which flank the cartouche and the hard drapery folds reflect most of the works from this period.[1] The second state of the print bears an unidentified coat of arms and may postdate Agostino's activity.

John Gere has pointed out an unpublished drawing in the Plantin Moretus Museum[2] (fig. 202b), which he connected with this engraving. The drawing, in reverse of the engraving, is close enough in size and composition to have been the drawing which Agostino used for this print. It is not indented for transfer. But, stylistically, this sheet does not seem to belong to Agostino's hand but to that of his cousin Lodovico. The emphasis on tonal rather than linear indications is typical of Lodovico's style. Moreover, the short strokes to delineate contours are foreign to Agostino, who tended to emphasize the contours of his forms rather than break them up as is done here. In addition, the features of the figure of Justice in the drawing are typical of Lodovico's female forms, whose faces tend to be triangular with pointed chins.[3] As discussed earlier,[4] Lodovico made designs for coats of arms; therefore, it would not be unusual for Agostino to make an engraving from a drawing by his cousin. The date is also fitting, when the three Carracci were still working together in Bologna.

The example of this engraving in Bologna (fig. 202a) appears on an interesting document of the period: an announcement of the public disputation of a thesis to be held at the Collegio di Monte Alto on April 12, 1594. The student defending the thesis was Marcellus Tranquillus Bodiensis, whose patron was Cinzio Aldobrandini. It is possible that Aldobrandini made a trip to Bologna for the occasion.[5]

1 Cf. cat. nos. 177, 183, 191-193.

2 Inv. no. 1333:D. XVI, 14 as Zuccaro. 147 x 200 mm. Presumably in pen and (brown?) ink and wash. The author knows the drawing only in a photograph.

3 See, e.g. Wittkower 12, 16, 28. Ellesmere sale 6-11, 14, 17, 18.

4 Cat. no. 198, note 1.

5 Thomas McGill kindly translated the document for the author.

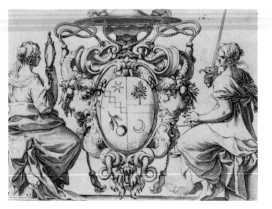

cat. no. 202, state II. Vienna, Graphische Sammlung Albertina

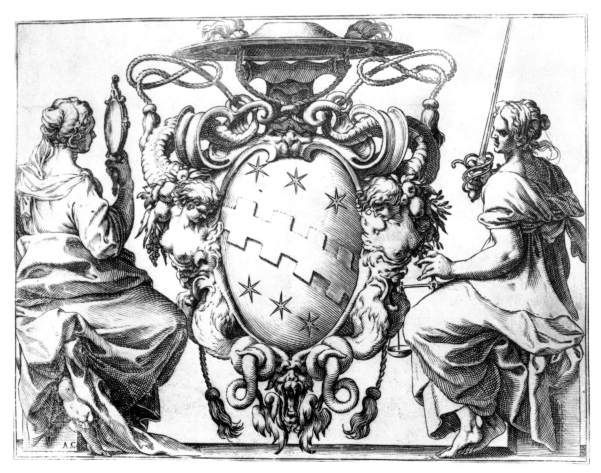

cat. no. 202, state I. Vienna, Graphische Sammlung Albertina

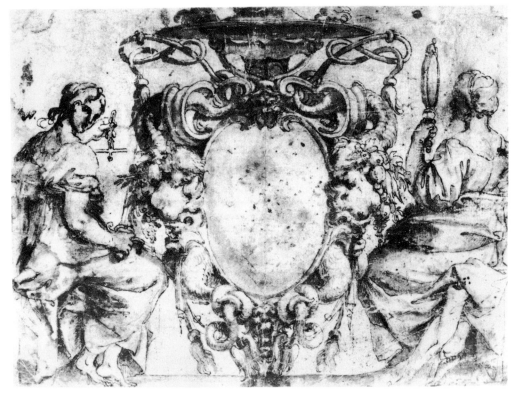

fig. 202b. Lodovico Carracci, *Coat of Arms.* Antwerp, Plantin-Moretus Museum

203*

Aeneas and his Family Fleeing Troy
(B. 110) 1595

Engraving. 404 x 527 mm. (after Federico Barocci painting of 1587-1589 formerly in Prague).

Literature: Bellori p. 115; Malvasia pp. 76, 293; Oretti p. 794; Mariette ms. II, 50; Basan p. 111; Strutt p. 181; Heinecken p. 637, no. 1; Gori Gandellini p. 320, no. XXXVII; Joubert p. 347; Bolognini Amorini p. 55; Nagler 1835, p. 392; Mariette I, p. 69; Nagler I, 647 (3); LeBlanc 182; Andresen 18; Kristeller p. 283; Bodmer 1940, p. 64; Petrucci p. 136; *Mostra-Dipinti* p. 85; Harald Olsen, *Federico Barocci,* Copenhagen, 1962, pp. 181-182; Calvesi/Casale 172; Ostrow 48; Bertelà 218; Emiliani p. 153 and cat. no. 359; Pillsbury and Richards no. 80.

States:

	B	CC	Ost
I	1	1	1

Lower left above margin: *Typis Donati Rasecottij.* Lower left in margin: *Federicus/ Barocius/ Urbinas/ inven:.* Inscription in margin of four sections beginning with ODOARDO FARNESIO/ *Cardinali Amplissimo.* and ending with *Te canit ecce Orbis, carus es et superis.* Lower left in margin: *Augustinus Carracci⁸.* Lower right in margin: *Aᵘgo. Car./ Fe/ 1595.* (Alb, Ber, BM, BN, Bo, Dres, MMA, Ro, and others)

Preparatory Drawings: 1. Windsor Castle 2343 (Wittkower 99). Oil on paper. 338 x 461 mm. Incised. (fig. 203a).

Copies: 1. Engraving by Raphael Guidi in reverse. 403 x 515 mm. Lower left: *Federicus/ barocius/ Urbinas/ inven.* Lower right: *Raphael Guidi Fe.* (Victoria and Albert Museum, London).

Federico Barocci painted two versions of this subject. The first, now lost, was executed between 1586 and 1589 and destined for the court of Rudolf II at Prague.[1] The second, in the Galleria Borghese, was signed and dated by Barocci in 1598 (fig. 203b). Thus, Agostino's 1595 print was a reproduction of the earlier version or of a cartoon for the painting.[2] Agostino's oil monochrome study in Windsor Castle for the print (fig. 203a) is his only extant preparatory study in oil for an engraving although he often used oil studies in preparation for paintings. It may be that since this study is in oil, Agostino was basing it on a highly worked up cartoon by Barocci; cartoons were often elaborately executed in ink, chalk, and body color. Since the paper of Agostino's oil monochrome would have been too thick to transfer the lines to the copperplate, the incising on the study was perhaps used to transfer it to a sheet of tracing paper placed over the oil monochrome. Moreover, the drawing is in the same direction as the print, and another intermediate study may have been necessary to keep the original direction of the study, which is the same as the painting.

Malvasia, in his characteristically proud tone, noted that this print was not made for commercial purposes but to please the artist and to experiment with the burin. He said that Agostino sent two copies to Barocci, who, since they surpassed the original, was displeased with them.[3] Ostrow suggested that Odoardo Farnese's name on the print may indicate it was done at his request. He also believed that it may have been engraved in Bologna after Agostino's return there from Rome in 1595. Since Odoardo Farnese was a cardinal living in Rome at the time, there is no reason to believe that the print was executed in Bologna. It seems more likely that the cardinal took advantage of Agostino's presence in Rome to commission the engraving.

Only Bodmer commented on the strong relationship of this print with Goltzius' work, suggesting an influence from the Netherlandish artist. As discussed in the Introduction, Agostino may have met Goltzius when the latter visited Italy in 1591. In any case, Agostino would have known Goltzius' prints, for he was well known in Italy by the time he made the journey.[4] It is interesting to note that this influence from Goltzius—in the exaggerated musculature, the sharp contrasts of light and shade, and the virtuousity of the handling of the burin—did not become evident in Agostino's art until this year. The new style, however, remained with Agostino until his death. He even copied a print by Goltzius c. 1599.[5]

Although Bartsch believed this work to be one of Agostino's finest, a modern view would tend to discount it as overworked and lacking in originality. It is an example of Agostino at the height of his technical virtuosity in which numerous burin strokes are contrasted for the sake of style alone.

*Engraving in exhibition from the Cleveland Museum of Art, Gift of Mr. and Mrs. Austin Hauxhurst.

1 Emiliani, nos. 163-166. See also Pillsbury and Richards no. 54 for a history of the paintings.

2 Wittkower believed that the print was after Barocci's second version of the painting, which he said was executed at least three years before it was dated (Wittkower 99). However, one must agree with Pillsbury and others before him that the print is probably after a lost *modello* for the first version. Two drawings by Barocci are extant for the earlier

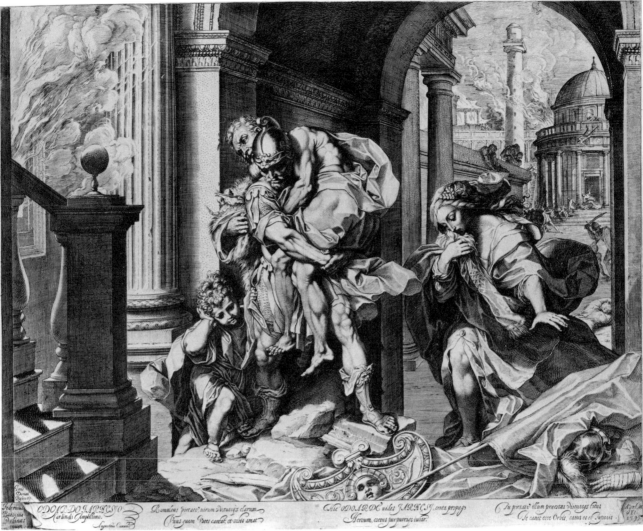

cat. no. 203, only state. Berlin (Dahlem), Staatliche Museen Preussischer Kulturbesitz, Kupferstichkabinett

cat. no. 203a. Agostino Carracci, *Aeneas and his Family Fleeing Troy.* Windsor Castle, Royal Library, Her Majesty Queen Elizabeth II

version: one in Cleveland (Pillsbury and Richards 54) and one in the Louvre (Inv. no. 35774, reproduced in Roseline Bacou *Cartons d'artistes du XVᵉ au XIXᵉ siècle,* Paris, 1974, p. 19, no. 14, pl. IX).

It is not impossible that Agostino saw the painting by Barocci which was executed in 1587-1588 (commissioned in 1586), sent to Rome, and in 1589 shipped to Prague (see Wittkower 99 and Pillsbury 54). Artists of the sixteenth century probably traveled more than we give them credit for, and certainly not every trip was recorded. On the other hand, it seems more likely that Agostino did work after a lost *modello.* Bellori mistook the date on the print to read 1599, probably assuming it was a reproduction of the Galleria Borghese painting.

3 Malvasia p. 293: "Ma famosa oltremodo fu poi la gran carta dell'Anchise di Federico Baroccio, nella quale si soddisfece totalmente operandovi, non come nelle più per divertimento e per servir ad altri, ma per istudio e per compiacere a se stesso in provarsi pure quanto far si potesse col bolino. Venne però questo suo gusto amareggiato in gan parte dalla mala corrispondenza di quell'autore, al quale con umanissima lettera, che lo pregava a gradire in quella fatica la stima ch'ei faceva del suo merito e della sua virtù, e scusare se colla debolezza del taglio avess'egli pregiudicato al valore della pittura, mandandogliene due copie, ebbe così risentita ed indiscreta risposta che giurava il pover uomo non aver mai a'suoi giorni incontrata simil mortificazione. Che ciò accader potesse per gelosia di Federico, conoscendo chiaramente che più intesa ed aggiustata saria per dirsi la carta stampata dell'originale dipinto, come una è delle voci che corre, non credo; quando per simil rispetto non si alterò già il Tintoretto della Crocefissione, e d'altre sue opere con più diligenza, per non dir meglioramento, dallo stesso tagliate; nè di Marcantonio, Alberto Duro, che anzi cangiò l'odio in amore, cedendo lo stesso interesse all'onore, che conobbe esser per arrecargli i rintagli del bravo Bolognese, tanto de'suoi originali migliori."

4 Carel van Mander, *Dutch and Flemish Painters Translation from the Schilderboeck* (New York, 1936), 359-360.

5 Cat. no. 211. For the complicated relationship between Agostino and Goltzius see the Introduction.

cat. no. 203b. Federico Barocci, *Aeneas and his Family Fleeing Troy.* Rome, Galleria Borghese

204*

Saint Francis Consoled by the Musical Angel
(B. 67) 1595

Engraving. 308 x 342 mm. (after Francesco Vanni print: Bartsch XVII, 196.3).

Literature: Baglione p. 390; Bellori p. 116; Malvasia pp. 77, 293; Oretti pp. 801-802; Mariette ms. II, 62; Basan p. 111; Strutt p. 181; Heinecken p. 635, no. 51; Bolognini Amorini p. 56; Nagler 1835, p. 393; Mariette III, 70; Nagler I, 2253; LeBlanc 59; Andresen 8; Bodmer 1940, p. 66; Petrucci p. 136; *Mostra-Dipinti* p. 85; Pamela Askew, "The Angelic Consolation of St. Francis of Assisi in Post-Tridentine Italian Painting," *Journal of the Warburg and Courtauld Institutes,* 32 (1969): 300 and note 90; Calvesi/Casale 171; Ostrow 47; Bertelà 183; Boschloo p. 196, note 17.

States:

	B	CC	Ost
—	—	—	1

Lower, left of center: *Franc.ᵃ Vannius Sen./ Inventor.* Lower right: *Car. fe./ 1595.*

I			
	1	1	2

As above but with verses in the margin beginning with *Desine dulciloquas Ales . . .* and ending with *huius amasse lyra.* Lower right in margin: *Joannes Philippus Ricciuse Societate/ Iesu.* (Alb, BM, BN, Bo, Br, MMA, Ro, and others)

II			
	—	—	—

As above but with *Gio. Marco Paluzzi Formis Romae,* lower right (Dres, PAFA)[1]

Preparatory Drawings: 1. Stuttgart Staatsgalerie. 220 x 331 mm. Pen and brown ink and wash. (fig. 204b).*[2]

Copies: 1. Engraving published by Theodore Galle in same direction with landscape changed to show St. Francis in wilderness. Haloes on St. Francis and angel highly visible. Fruit enframes print. Inscription in double lines, and *Theodorus Galle excudit.* (MMA) 2. Engraving in same direction. 286 x 237 mm. (image: Ro). Lower left: *Franc.ᵃ Vannius Sen/ Inventor.* 3. Engraving in same direction. 213 x 157 mm. (Sheet). Unfinished (Milan: Raccolta delle stampe). 4. Engraving in same direction without angel. 260 x 197 mm. Lower left: *F. Vannis. sen./ Inventor.* In margin: MIHI VIVERE CHRISTVS EST ET MORI. LVCRVM/ *Donato Supriano Roma* (Par). 5. Engraving in same direction. 293 x 233 mm. (image). Same verses in margin with *Franˢ Vannus Sen Inventor* above. In center of margin: S. FRANCISC.ˢ Lower left in margin: *Tommaso moneta for.* (Par). 6. Engraving in same direction. 172 x 125 mm. Lower left: *Chez Landry.* In margin: S. FRANCISCVS. Lower right in margin: *Vanius pinxit* (Par). 7. Engraving in

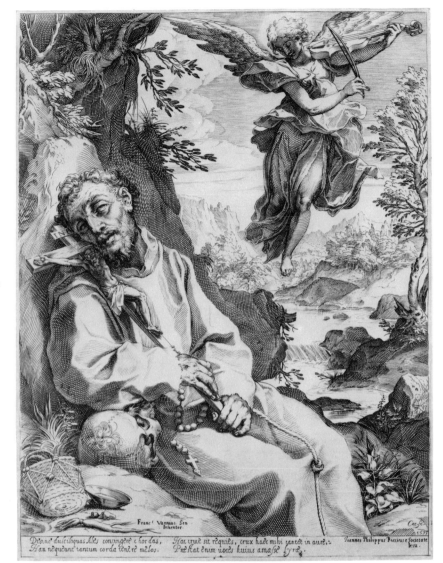

cat. no. 204, state I. Washington, National Gallery of Art, Ailsa Mellon Bruce Fund

Every source except Zanotti, who attributed the sheet to Cort, agreed that this signed and dated print belongs to Agostino. It must have been a popular work since it is found in numerous rather good impressions.

This is one of the few prints in which Agostino veered far from the original. Vanni's print (fig. 204a), after which this is taken, is in the opposite direction and shows only the saint in ecstasy lying against a rock as a small angel consoles him with the violin. Agostino enlarged the theme by placing the saint to the side of a deep landscape, as interesting to the viewer as are the saint and angel. He transformed the small cherubic angel into a fully grown one who flies down from heaven playing his instrument. More movement has been given to the composition, and the enlarged angel plays a dominant role in the scene.

The exact model for Agostino's print is disputed, and Bellori indicated it was a painting by Vanni, not a print. Malvasia referred to Vanni's etching as the work reproduced but altered by Agostino. There is a painting attributed to Vanni of this subject, but, as noted by Askew, it hardly seems to be strong enough to have been Agostino's model.[3] According to Askew, Agostino looked to a painting of the same subject

reverse of St. Francis only. 192 x 133 mm. (image) (Par). 8. Etching in reverse 300 x 237 mm. (Sheet). In margin: VIVO AVTEMIAM NON EGO; VIVIT VERO IN ME CHRISTVS (Stuttgart Staatsgalerie). 9. Engraving in reverse by Francesco Carracci? (Francesco cat. no. 2). 176 x 132 mm. Lower left: *fcF* (NGA).

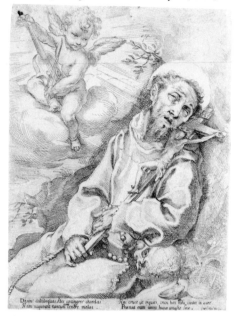

fig. 204a. Francesco Vanni, *Saint Francis Consoled by the Musical Angel*. London, The British Museum

fig. 204b. Agostino Carracci, *Study for "Saint Francis Consoled by the Musical Angel."* Staatsgalerie Graphische Sammlung

by Annibale. That painting, in the collection of Denis Mahon and indeed extremely close to Agostino's engraving, is now attributed to Guido Reni as inspired by Agostino's print.[4] Moreover, Agostino signed his engraving and attributed the invention to Francesco Vanni. In fact, the position of the saint, swooning against the rock, is in reverse of the etching. Agostino, who knew Vanni since their days together in Passerotti's studio, made another engraving after the artist about the same time (cat. no. 205).[5]

A drawing in Stuttgart (fig. 204b),* first connected with this print by Calvesi/Casale when it was still in the Ellesmere collection, appears to be an early thought for the engraving. The recto of the drawing contains an unrelated *Pietà,* and the image of the weeping St. John is repeated at lower left on the verso. Also in the lower left of the verso is a quickly executed sketch of *Saint Francis Consoled by the Musical Angel,* which differs little from Agostino's engraving. At this point Agostino was imagining the final version already in reverse to Vanni's original, rather than copying it unchanged. It seems, however, that this is the first thought for that larger angel, for above in the upper left (upside down) is a small angel without a violin but in the attitude of playing an instrument, as in the final version. We are thus confronting one of Agostino's earliest thoughts for his transformation of Vanni's print. Both recto and verso of this drawing exhibit a nervous and rapid drawing technique unusual for Agostino. Yet, the florid pen strokes of the writing on the verso are characteristic of the artist, and the grimacing mask in the upper left appears on several other authentic drawings by Agostino.[6]

At this period, c. 1595, Agostino began to mark a sharp division between his foreground and background landscapes by using thicker lines in the foreground. Morever, the background landscapes of his prints from this time onward exhibit a delicacy of handling foreign to earlier works.[7]

1 Andresen listed as his state 2 the inscription: *Jacintus Parizenius formis Romaes.* Such a state is unknown to this writer.

2 For a complete bibliography and collections of this drawing see Ellesmere sale no. 23, and Stuttgart Staatsgalerie, *Italienische Zeichnungen 1500-1800,* 1977, pp. 110-111, cat. no. 225. The recto of the sheet is reproduced in both publications.

3 Askew p. 300, note 90. The painting, in the Galleria Pitti in Florence, is reproduced in Venturi IX[7], fig. 600. The writer knows it only through photographs.

4 Askew pp. 299-300. As Askew pointed out, the subject matter is not the Ecstasy of Saint Francis but a later episode in his life when he had a vision of a musical angel. See Askew pp. 298 ff. The painting in the Mahon collection is reproduced in Thomas Agnew and Sons, London, *England and the Seicento,* November 6-December 7, 1973, London, no. 42, with bibliography. The attribution is also accepted by Denis Mahon.

5 Francesco Vanni was in Passerotti's studio from 1575 to 1577; Agostino was there in 1577, the year he made a drawing of Tiburzio Passerotti. See Ostrow p. 563. For interesting connections between Francesco Vanni and the Carracci, see Dempsey pp. 7-9.

6 E.g., Wittkower 185 in Windsor Castle (Introduction fig. S) and the Art Institute of Chicago 22.19 (see cat. no. 193, note. 6).

7 See especially cat. nos. 207 and 208.

205

Saint Jerome
(B. 74) c. 1595

Engraving. 196 x 147 mm. (After Francesco Vanni).

Literature: Baglione p. 390; Malvasia pp. 80, 293; Oretti p. 816; Basan p. 109; Heinecken p. 635, no. 44; Gori Gandellini p. 319, no. XXXII; Bolognini Amorini p. 57; Nagler 1835, p. 393; Nagler I, 644, 645; Mariette III, 69; LeBlanc 67; Andresen 10; Bodmer 1940, p. 66; Petrucci p. 134; Calvesi/Casale 174; Bertelà 189.

States:

	B	CC
I	1	—

Lower right to right of cross: *Ago. fe.* In margin at right: *Franciscus / Vannius / inven.* (Alb, BM)

	B	CC
II	2	1

As state I but with the following added in margin: *Quotidie morimur, quotidie commutamur, / et tamen sternos nos esse credimus. § Mateo flo. for.* (Alb, BN, Bo, Br, Dres, Ro, and others)

Copies: 1. Engraving in reverse, unfinished at top, with writing as in original. 194 x 148 mm. Two states exist. State 1 without *Ago. C. In* at left; state II with this inscription. (Ber, Ro, and others). 2. Engraving in reverse with background eliminated. 142 x 195 mm. (sheet) (Bo). 3. Engraving in same direction. 180 x 135 mm. Same inscription but with *Crestien / Eeurtault / fecit* lower right (NYPL). 4. Engraving in reverse. In margin: *S. Hieronymus Strid niensis / doctor Ecclesiae.* 5. Engraving in reverse. 191 x 146 mm. In center margin: SANCTVS HIERONYMVS. Lower left: *Ioan Galle excudit.* Lower right: *Franciscus Vannius inventor.* (Fogg). 6. Engraving in same direction. 197 x 148 mm. In margin: GIROLAMO DOT. Lower right, not in margin: .N.N. 7. Engraving in reverse, very close to copy 1, but without *Matteo flo. for.* and *Franciscus Vannius inven.* Finer lines. 197 x 142 mm. (sheet: Ro). 8. Engraving in the same direction. 182 x 173 mm. (image). In margin: DEDICATO. / AL MERITO DELLE RRMM *c* DELLA SS. TRINITA *da.* Lower left: *1707. Bono.* Lower right: *Ioseph. M. Viaggi. Sculp^{er}* (Par).

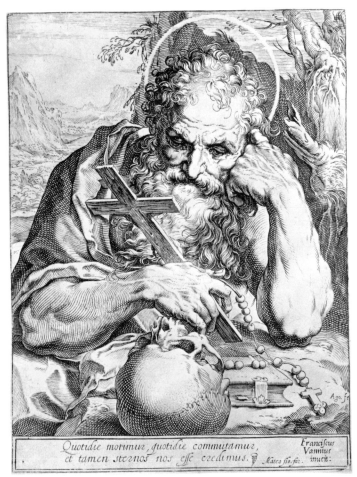

cat. no. 205, state II. New York, The Metropolitan Museum of Art, Harris Brisbane Dick Fund, 1953

Both Bodmer and Calvesi/Casale dated this print c. 1596. Because of its stylistic proximity to cat. no. 203, *Aeneas and his Family Fleeing Troy,* and because it is also after a work by Vanni (as yet unknown), as is the 1595 *St. Francis Consoled by the Musical Angel* (cat. no. 204), a dating of c. 1595 or soon after seems in order. As noted in cat. no. 203, at about this time Agostino was influenced by the works of Hendrick Goltzius, and his working of the plate to effect the same virtuosity of technique is apparent here.[1]

1 For the relationship of Goltzius and Agostino, see the Introduction.

206

Portrait of Francesco Denaglio
(B. 143) 1596

Engraving. 268 x 192 mm. (sheet: BM)

Literature: Malvasia p. 79, and note 5; Oretti
p. 812; Heinecken p. 629, no. 23; Nagler
1835, p. 398; LeBlanc 230; Foratti p. 174;
Bodmer 1940, p. 59; Calvesi/Casale 113;
Bertelà 251.

States:

	B	CC
I	1	1

Oval around portrait without inscription. In
margin: *Divini hac vultum pra[e]sit pictura Poeta/
Veram animi claudit totum opus effigiem.* (Alb,
BM, BN)

	2	2
II		

Around oval: FRANCISCVS DENALIVS I.V.D.
REGIENSIS ANN. ÆT. SVÆ. LXIII. In margin a
different inscription from state I reading: *Hac
vultum Authoris pra[e]sit pictura; sed alman/
Effigiem rectae mentis adumbrat opus.* (Alb, BM,
Bo, Br, and others).

Copies: 1. By Fabri (according to Zanotti).
2. By Laurenti (according to Zanotti).

Francesco Denaglio (1533-1619) was a member of the literati and also a
doctor of law. He published many Latin poems and six books on law and
poetry. Born in Reggio Emilia, he worked in several other Emilian
towns including Parma and Correggio.[1]

Bodmer dated this print in the late 1580s, while Calvesi/Casale
preferred an earlier dating near the portraits of the *Cremona Fedelissima*.
But if we are to believe the inscription on the print, albeit in the second
state, this engraving was made when Denaglio was sixty-three years of
age, that is, in 1596. The age of the sitter does appear to be that of a
man in his early sixties rather than one in his late forties or early fifties,
as Calvesi/Casale's or Bodmer's datings would indicate. Moreover, the
almost flamboyant burin work of the curly hair is typical of Agostino in
his late period. In addition, the classically conceived and simply ren-
dered cartouche holding the oval portrait is reminiscent of the coats of
arms by Agostino in this decade.[2] In 1596 a book by Francesco Denaglio
entitled *Clariss. J.V.D. Regiensis ac Praesidis & perillustris Collegii excellen-
tissorum DD. Doctorum Regii, Caesareique . . .* was published in Reggio,
an example of which has not been seen by this writer. There is a possibil-
ity that Agostino's portrait was executed to be included as an author
portrait in this book, a practice already evident in Agostino's oeuvre.[3]

1 For information on Denaglio's life see Tiraboschi, vol. 2, pp. 210-220.

2 See, e.g., cat. nos. 195-202.

3 See the *Portrait of Giovanni Battista Pona* of 1590 (cat. no. 175).

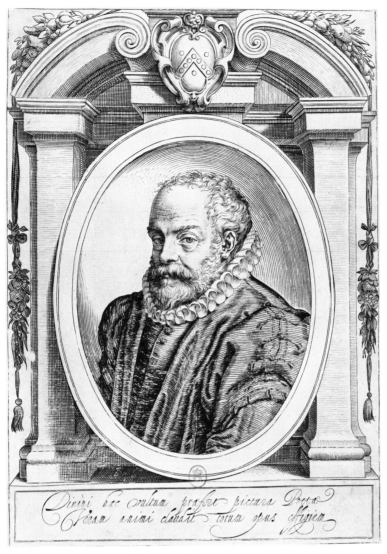

cat. no. 206, state I. Paris, Bibliothèque Nationale

207*

Portrait of Ulisse Aldrovandi
(B. 137) 1596

Engraving. 151 x 114 mm. (oval)

Literature: Malvasia p. 83; Oretti pp. 829-830; Mariette ms. 23; Heinecken p. 628, no. 9; Gori Gandellini p. 313, no. X; Joubert p. 345, Bolognini Amorini p. 59; LeBlanc 223; Foratti p. 157; Kristeller p. 283; Bodmer 1940, pp. 66-68; Ostrow pp. 397-398, note 8.

States:

	B	Ost
I	–	I

Around oval: VLYSSES ALDROVANDVS BONONIENSIS ANNO ÆTATIS LXXIIII (BM, BN, Dres)

II	I	–

LXXIIII changed to LXXVIII (Ber, Bo, Br, MMA, and others)

Copies: 1. Engraving in reverse by DeLarmessing. 188 x 139 mm. In margin: VLYSSES. ALDROVADVS. Lower left: *DeLarmessing (?) Sculpsit.* Published in Isaac Bullart, *Academie des sciences et des arts,* Amsterdam, 1682, vol. 2, p. 109.

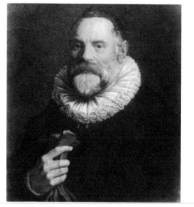

fig. 207a. Attributed to Agostino Carracci, *Ulisse Aldrovandi.* Bergamo, Accademia Carrara di Belle Arti

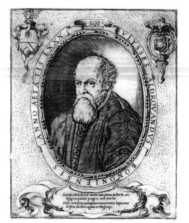

fig. 207b. Giovanni Valesio, *Ulisse Aldrovandi.* Washington, Library of Congress

Ulisse Aldrovandi (1522-1604/1605) was professor of natural history at Bologna and a noted botanist, among whose writings was an encyclopedia of natural history. He is considered a pioneer in the methodology of studying natural objects based on observation and experiment. We also know from Malvasia that he was a friend to Agostino Carracci.[1] There is an oil portrait of Ulisse Aldrovandi in the Accademia Carrara, Bergamo, which has been attributed to Agostino Carracci from the period 1584-1586 (fig. 207a).[2] The present portrait, as is apparent in the inscription AETATIS LXXIIII and the obvious age of the sitter, comes from a period later in Aldrovandi's life. Bodmer may have known the first state of the print since he dated it c. 1596. In the first state the age of Aldrovandi is registered as seventy-four, placing the print in the year 1596. Mariette mentioned that the engraving was used as a frontispiece, and indeed the second state is found in the 1606 edition of Aldrovandi's *Opera Omnia*, a thirteen-volume series first issued in 1599.[3] It seems likely that the original purpose of Agostino's portrait was to adorn a frontispiece and that the book, originally intended to be published in 1596, was delayed for three years; consequently the age of the sitter was also advanced three years to seventy-seven.

No writer has attributed the surrounding framework to Agostino, although Bodmer hinted that it might be his. Bartsch attributed the cartouche to Brizio, as did Heinecken before him.[4] The signature *Io: Corn. VVtervver. M.D. faciebat* on the framework is of little help, since this artist is currently unknown to us. Moreover, although the hands involved in the portrait and framework are diverse, the framework is not that similar to works by Brizio. In fact, the artist of this imaginative piece, which portrays many of Aldrovandi's scientific interests, is Giovanni Valesio (c. 1579-1623), a Bolognese artist. Another portrait of Aldrovandi, signed by Valesio and executed in 1602 (fig. 207b), is surrounded by a cartouche which is obviously by the same hand as that around the Agostino portrait of the naturalist. In addition, the initials I.C.W. occur here and must belong to the mysterious VVtervver, who may have been a publisher of Valesio's works. This Aldrovandi portrait is found in the 1602 edition of the author's *Ornithologiae*. In addition, coats of arms with the same intricate strapwork and odd animal forms are normally attributed to Valesio.[5]

The style of Agostino's portrait reflects his continued refinement of technique in the 1590s. The burin work is delicate in the facial area and contrasts well with the bolder work in the fur and on the robe. Although little changed from his more elaborate portrait of Titian of the year 1587, this portrait reflects an intimate knowledge of the sitter, unlike the portrait of Titian. This sheet exhibits a more penetrating analysis of the face than the earlier oil portrait of Aldrovandi of 1584-1586; the piercing gaze demonstrates that the man was a keen observer.

*Engraving in exhibition from the Library of Congress, Washington, D.C.

1 For an early biography of Aldrovandi see Fantuzzi, vol. 1, pp. 165-190. For his connection with Agostino see Malvasia p. 336.

2 Inv. no. 373. See Ostrow, pp. 396-398, cat. no. II/2 for the background of the attributions of this painting which Ostrow gave to Agostino. This writer knows the work only through photographs and reserves judgment as to its authenticity.

3 This writer has not found the frontispiece in the 1599 edition of the work, only in an example of the 1606 edition.

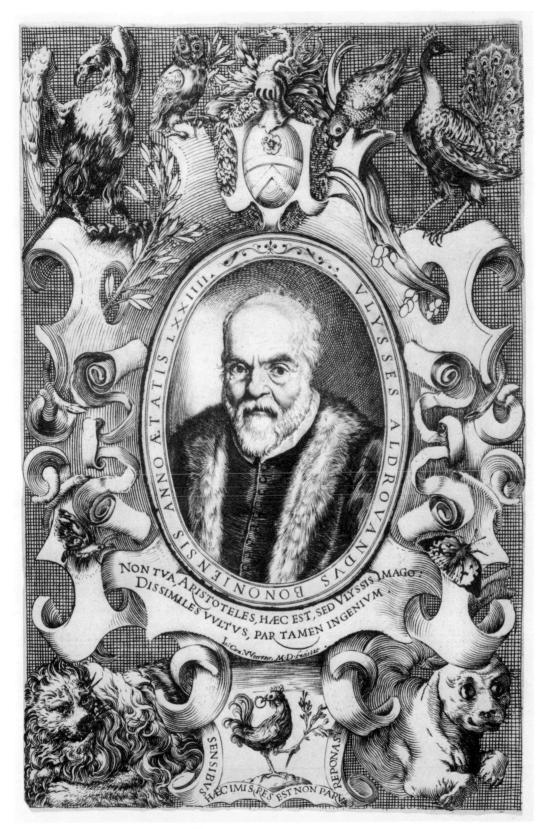

ANNO ÆTATIS LXXIIII

VLYSSES ALDROVANDVS BONONIENSIS

NON TVA ARISTOTELES, HÆC EST, SED VLYSSIS IMAGO
DISSIMILES VVLTVS, PAR TAMEN INGENIVM

Lo: Cra. VVeertder, M.D. faciebat

SENSIBVS HÆC IMIS RES EST NON PARVA REPONAS

cat. no. 207, state I. London, The British Museum

4 Heinecken believed that the work was after a design by Lodovico Carracci. This
seems doubtful as the style of the framework accords with other engravings by Valesio.

5 For examples see Bertelà 978-980.

335 AGOSTINO

208*

Holy Family
(B. 43) 1597

Engraving. 226 x 169 mm.

Literature: Bellori p. 116; Malvasia pp. 79-80; Mariette ms II, no. 39?; Oretti pp. 813-814; Heinecken p. 633, no. 19; LeBlanc 26; Nagler 1835, p. 396; Mariette III, 75; Andresen 6; Bodmer 1940, p. 67; *Mostra-Dipinti* p. 91; Calvesi/Casale 175; Ostrow 50; Bertelà 162.

States:

	B	CC	Ost
I	–	–	–

No markings. (BM, Chatsworth)

	B	CC	Ost
II	I	I	I

Lower left: *1597* (Alb, BM, BN, Bo, Br, MMA, Ro, and others)

	B	CC	Ost
III	–	–	–

As state II but with *Si Stampa da Matteo Giudici alli Cesarini* toward bottom right (Ber, Dres)

	B	CC	Ost
IV	–	–	–

The Giudici address burnished out. After 1597: *Anib.ᵉ Caraci Pinze*. Lower right: *AguS°. Caracⁱ Incidⁱ* (Ber, Madrid: Bibliotheca Nazionale)

Preparatory Drawings: 1. Private Collection. Pen and brown ink and wash over red chalk 289 x 211 mm. (Fig. 208a). *Formerly in the Ellesmere Collection.[1]

Copies: 1. Engraving in reverse. 227 x 174 mm. (sheet: Dres). In margin: *Maria Mater gratiæ* (Dres). 2. An anonymous copy (according to Heinecken).

LeBlanc is the only writer who did not attribute this work to Agostino but gave it to an anonymous artist. Bodmer noted that it is the first instance of Agostino's exhibiting influence from Michelangelo and Raphael in his graphic works. This is hardly the case since Agostino had done engravings after Michelangelo early in his career,[2] and many of his drawings of this period are pervaded with Raphaelesque mannerisms. Yet, the classically inspired forms of this engraving indicate how much the sculpture of Rome and the paintings of Raphael have influenced its creation. The figure of Christ, especially, may have been taken from an ancient sculpture. Moreover, the aquiline nose of the Madonna occurs in Agostino's works after his 1595 journey to Rome. This influence could also have been amplified by the severe classicism exhibited by his brother Annibale at this time, the period of the Farnese ceiling. The same stylistic tendencies are apparent in Agostino's paintings of the period, for example in the *Holy Family with Saints John the Baptist and Margaret* in Naples[3] (fig. 208b).

Calvesi/Casale saw the relationship between the drawing of a Holy Family formerly in the Ellesmere Collection (fig. 208a)* and the engraving. This connection is not purely casual. Although it appears that Agostino may first have been considering a satyr family (note the legs of the Christ Child in the drawing), the traditional placement of the St. Joseph behind the Virgin and her relationship with him indicates he changed his mind and sketched a Holy Family. Like Agostino's quickly executed study for *St. Francis Consoled by the Musical Angel* (fig. 204a) for his print after Vanni (cat. no. 204), the direction of this composition is the same as in the final engraving. Although Agostino rearranged the position of the Madonna and Child, he retained the main elements of the figural composition, which fills most of the sheet in both drawing and print. Thus this drawing, with its compositional as well as stylistic similarities with the print, is an early thought for it. After this sheet, the artist probably made another study closer to the final version, either in reverse to be transferred directly to the plate or in the same direction to be transferred by means of another drawing on tracing paper.

*Engraving in exhibition lent by the Trustees of the British Museum, London.

1 See the Ellesmere sale, no. 31 for literature and exhibitions.

2 See cat. nos. 9 and 10.

3 Naples, Museo di Capodimonte no. 23217. Both Calvesi/Casale and Ostrow noted this relationship. *Mostra-Dipinti* 47, Ostrow I/21. Actually, this painting must date from c. 1600-1602, as proposed by Ostrow. The provenance of the Palazzo del Giardino in Parma indicates it comes from Agostino's Parmesan period. A magnificent drawing in pen and brown ink in Stockholm (Inv. no. 983, 985/1863, fig. 208c), known to this author only in photographs, is a study for the painting in Naples. The figure of the Christ Child is almost the same in reverse as that in the drawing in a private collection (fig. 208a), including the almost hooflike foot. In painting the *Holy Family with Saints John and Margaret*, it is evident that Agostino had in mind the composition of his 1597 *Holy Family*. The drawing is attributed to Annibale Carracci in the catalogue, Stockholm, Nationalmuseum, *Dessins du Nationalmuseum de Stockholm,* 1970, no. 23. See this entry for collections and previous exhibitions.

fig. 208a. Agostino Carracci, *Holy Family(?).* Anonymous Loan

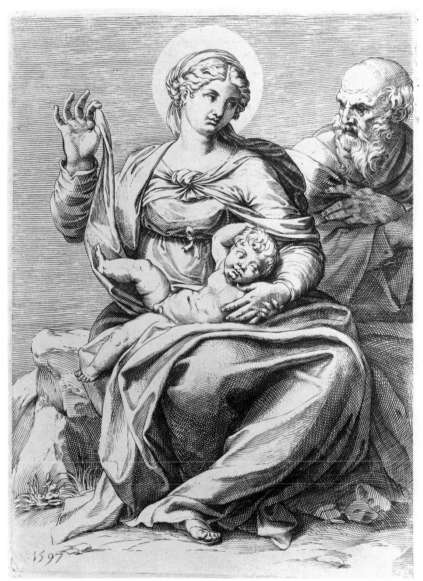

cat. no. 208, state II. Vienna, Graphische Sammlung Albertina

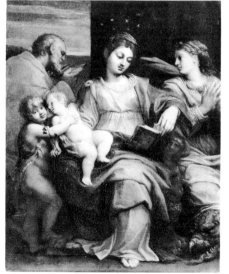

fig. 208b. Agostino Carracci, *Holy Family with Saints John the Baptist and Margaret.* Naples, Museo Nazionale di Capodimonte

fig. 208c. Agostino Carracci, *Holy Family with Saints John the Baptist and Margaret.* Stockholm, Nationalmuseum

209*

Pietà
(B. 101) 1598

Engraving. 122 x 160 mm. (after Annibale Carracci engraving, Annibale cat. no. 18)

Literature: Heinecken p. 631, no. 29; Nagler 1835, p. 397; LeBlanc 50; Nagler I, 1380(2); Petrucci p. 144, note 59; Bodmer 1940, p. 67; *Mostra-Dipinti* p. 91; Ostrow 51.

States:

	B	Ost
I	—	1

On rock at right: *1598*. Lower right: *Aug. Car. F.* (Alb, BN, Br, Ro, and others)

II	1	2

As state 1 but with *Si stampa da Matteo Giudici alli Cesarini* lower left. (Alb, Ber, Br, Dres, NYPL, Ro)

Copies: 1. Engraving in the same direction. 122 x 145 mm. Lower left: *S Stampa da Matteo Giudici alle Cencinne*(?). On rock: *1598*. At lower right: *A. Caraci*. Deceptive. (Bo).
2. Etching in the same direction. Lower left: *Aug. Car. F. L.N.* 126 x 164 mm. (PAFA).
3. Engraving in reverse. 125 x 160 mm. Inscription in reverse lower right: A.C.I.F. and left: ANT. MAR. CARD. SALV. *1598*. Silver plate extant in Museo di Capodimonte, Naples.

As witnessed by the many state changes the plate went through and the numerous copies after it, Annibale Carracci's *Christ of Caprarola* (Annibale cat. no. 18) of 1597 was extremely popular. His brother was probably one of the first artists to copy the print, but to judge from the few extant impressions, Agostino's copy was hardly as popular as the original. The difference between the two prints is a study in the difference of temperament between the two artists. In Annibale's etching and drypoint, the delicate, broken strokes lend a movement and atmospheric rendering (aided by the broken ground of the plate in the area of the sky) to the composition, and the tenderness of facial expression adds a pathos to the scene. Agostino's version, on the other hand, solidifies the movement, removes the atmospheric quality, and by the harsh contrast of light and shade, presents a frozen sculptural group. Although a comparison of the two works leaves no doubt as to the superiority of Annibale's vision, Agostino's engraving should not be dismissed as purely reproductive. As with his other works, his goal was different from his brother's: his forte was not the expression of emotions but the expression of his technical mastery with the burin.

*Engraving in exhibition from the Hamburger Kunsthalle, Kupferstichkabinett.

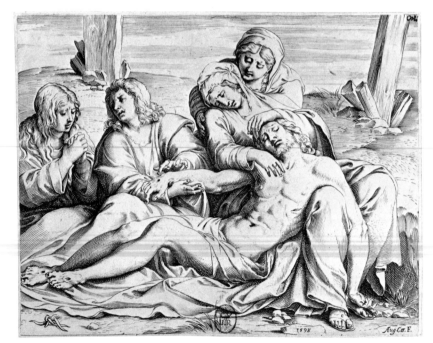

cat. no. 209, state I. Paris, Bibliothèque Nationale

210*

Omnia vincit Amor
(B. 116) 1599

Engraving. 126 x 187 mm.

Literature: Bellori p. 116; Malvasia p. 80; Oretti p. 818; Heinecken p. 637, no. 6; Gori Gandellini p. 316, no. L; Joubert p. 346; Bolognini Amorini p. 57; Nagler 1835, p. 394; Nagler I, 296 (4); Mariette ms. II, 22/4; LeBlanc 115; Foratti p. 161; Bodmer 1940, p. 68; Petrucci p. 134; *Mostra-Dipinti* p. 91; Wittkower p. 112 under cat. no. 94; *Mostra-Disegni* 259; Calvesi/Casale 177; Martin p. 56; Ostrow 53; Bertelà 223.

States:

	B	CC	Ost
I	I	I	I

Center toward top: *omnia vincit Amor.* Lower right above margin: *1599 A.C. IN.* Below margin along bottom: P S F. Above margin line top center: 7. (Alb, BN, Br, Bo, Dres, MMA, and others)

Preparatory Drawings: 1. Frankfurt Städelisches Institut, 4059. 135 x 189 mm. Pen and brown ink (fig. 210a).[1]

Copies: 1. Etching in reverse. 124 x 180 mm. (image without inscription: MMA). Lower left: *A. Carache In.* Lower right: *Cessius sculp.* Below that: *Omnia vincit Amor.* Below that an inscription beginning with *Par un ordre Superieur et surnaturel, . . .* Lower left: *Iacomo Rossi Rom.* (MMA). 2. Etching in reverse. 125 x 187 mm. Similar inscription above. Lower center: *A. Carat'in.* (A first state of this in Berlin is without inscriptions). (BM). 3. Etching in reverse. 133 x 188 mm. Lower left: *A. Carats in.* Center: *omnia vincit Amor.* Lower right: *A. Bloteling ex.* (Alb). 4. Etching in the same direction. 129 x 194 mm. Lower center: A.C. (BN). 5. Etching in reverse. 186 x 238 mm. Lower left: *Anibale Carac. in.* Very crude. (Dres). 6. Etching in reverse. 127 x 184 mm. No inscriptions (Dres). 7. One with *Annibale Caraz in.* (according to Heinecken). 8. Etching in reverse in an oval within a rectangle. 99 x 115 mm. Lower left: A CARACHE *in.* (Dres). 9. Etching in reverse. 183 x 232 mm. Trees have lost any style similar to Carracci. Lower left: *Anibale Carac. in.* Crude. Similar (or same?) as copy no. 5 (Alb). 10. Etching of satyr and *putto* in reverse. 113 x 79 mm. Lower center: AC IN (with N backwards). (Alb). 11. Etching in reverse. 126 x 185 mm. (sheet: Alb). Lower left: A·C·IN (Alb). 12. Etching and engraving in reverse. 127 x 186 mm. Upper center: *Omnia vincit amor.* Lower left: *S. Savry.* Lower center: *A. Carrat. in.* Lower right: sˢF. (Ashmolean Museum).

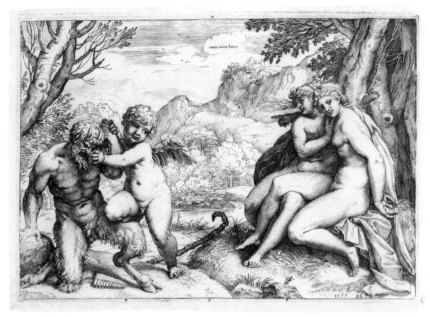

cat. no. 210, only state. Washington, National Gallery of Art, Ailsa Mellon Bruce Fund

Martin has pointed out that the two nymphs to the right in this engraving are taken from Annibale's painting of a *Landscape with Diana and Callisto* of c. 1598/1599 in the collection of the Duke of Sutherland.[2] In fact, even the composition of *Omnia vincit Amor* is remarkably similar to Annibale's painting with two sets of protagonists flanking a deep landscape.[3] Thus, Bartsch was incorrect in believing that this design was Agostino's invention. It is, as with his engraving after Vanni of *Saint Francis Consoled by the Musical Angel* (cat. no. 204), based on another artist's work and revitalized by the addition of ideas of his own invention.

A drawing for this print (fig. 210a), in reverse, was probably one of the final studies for the composition. Yet, even at this late stage, Agostino made some significant changes in the work. In the drawing, the satyr appears to be more in control of Amor than in the print where Amor is obviously triumphant (omnia vincit Amor). Also in the drawing two satyrs lurk behind the trees at left in anticipation of capturing the nymphs with a rope. They are deleted in the engraving. In the drawing, Agostino made distinct divisions between the two sides of the composition with a hiatus occurring in the center reflected in the distant mountain pass. In the engraving, the two sides of the composition have been united not only by the continuation of the mountain range in the distance but also by the glance of Amor in the direction of the nymphs. Although the drawing is not incised, it could very well have been Agostino's final sheet for the print. As discussed in cat. no. 103, the artist was so adept at transferring his designs to the plate that he could do it free hand. Perhaps in this instance, Agostino used the drawing as a guide and finished the composition directly on the plate. If so, it again exhibits the artist's control and virtuosity with the burin in creating his compositions.

Bodmer connected this print with the *Lascivie*, and it may be that Agostino was planning another series along the same lines. Justification

for this thesis is based on the print *Sine Cerere et Baccho Friget Venus* (cat. no. 211), of the same period, and on a drawing in Windsor Castle of *Venus, Vulcan, and Cupid* (fig. 210b).*[4] *Sine Cerere et Baccho Friget Venus* reflects a similar kind of subject, although the composition and format are different. The Windsor drawing is obviously from the same period as the drawing in Frankfurt (fig. 210a) and in the same engraver's technique of carefully executed crosshatching accompanied by dots. It seems likely that Agostino intended to engrave this composition but never got around to it. It was eventually engraved by Pietro del Po (Bartsch XX, 256.32). Another drawing of *Cupid Carrying the Sword of Mars* (fig. 210c),* in the Ashmolean, is also connected with these works by virtue of style and subject.[5] In fact, Cupid's features reflect those of the same figure in reverse in this engraving. Although Agostino may have been planning a series of loves of the gods at this period, it is also true that he was involved with the mythological paintings of the Palazzo Farnese ceiling and may have been working out his ideas for them.[6]

1 Literature: Bodmer 1940, p. 68; *Mostra-Disegni* under 259.

2 The painting is reproduced in Posner, no. 112. See also Agnew & Sons, *England and the Seicento* (London, 1973), no. 17.

3 This compositional technique was of course not new to Agostino, who used it quite successfully in his painting of the *Last Communion of St. Jerome* of c. 1592/1593 in the Pinacoteca Nazionale, Bologna (Inv. 461). The painting is reproduced in *Mostra-Dipinti*, no. 39. See also cat. nos. 191-192; which are reproductive prints.

4 Inv. no. 2303 (Wittkower 101). 172 x 274 mm. The format is larger than Agostino's engraving.

5 Parker 151. Pen and brown ink. 106 x 145 mm.

6 It should be noted that the drawings in Windsor and the Ashmolean are not dated and could have been done while Agostino was still active in the Farnese palace, or they could belong to a slightly later period when he was working at the Palazzo del Giardino in Parma where he did a mythological series of *Peleus and Thetis*. See Jaynie Anderson, "The 'Sala di Agostino Carracci' in the Palazzo del Giardino," *Art Bulletin,* 52 (March, 1970): 41-48.

Calvesi/Casale mentioned a painting of the composition of this engraving, implying it is by Agostino, exhibited in Manchester in 1957 in an exhibition of "Art Treasures." There was an exhibition *Art Treasures—A Centenary Exhibition* in the Art Galleries of Manchester in that year, but, according to the catalogue, no painting with this subject was in it. Perhaps this is the same painting as the one in Apsley House (Evelyn Wellington, *A Descriptive & Historical Catalogue of the Collection of Pictures and Sculpture at Apsley House, London,* London, 1901, vol. 1, p. 62, no. 113), a painted version of the engraving.

Wittkower (p. 111-112, cat. no. 94) discussed the use of this subject in the Carracci.

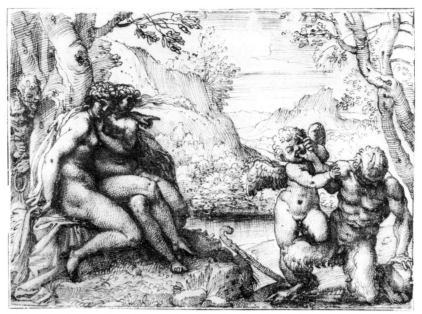

fig. 210a. Agostino Carracci, *Omnia vincit Amor.* Frankfurt, Städelisches Institut

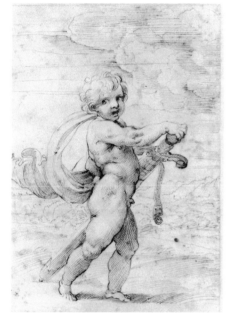

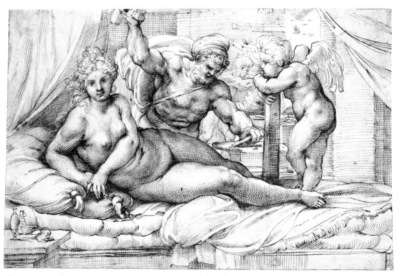

fig. 210c. Agostino Carracci, *Cupid Carrying the Sword of Mars,* Oxford, Ashmolean Museum

fig. 210b. Agostino Carracci, *Venus, Vulcan and Cupid.* Windsor Castle, Royal Library, Her Majesty Queen Elizabeth II

211*

Sine Cerere et Baccho Friget Venus

(B. 115) 1599

Engraving. 220 x 154 mm. (after Hendrick Goltzius engraving, Bartsch III, 78.257)

Literature: Baglione p. 390?; Mariette ms. 21/3 and 161; Heinecken p. 639, no. 14; Nagler 1835, p. 394; LeBlanc 113; Mariette II, 21/3; Bodmer 1940, p. 71; Petrucci p. 138; Bertelà 222.

States:

	B
I	I

In margin: SINE CERERE ET BACCHO FRIGET VENVS. (Alb, BM, BN, Bo, Br, Dres, MMA, and others)

Copies:[1] Engraving in the same direction. 222 x 162 mm. Toward bottom right: *Alissandro Fabri Formis.* In margin verses in two sets of four lines beginning with *Mentre la vaga dea dal caldo sgombra.* . . . (Berlin).

This print has not been discussed in detail in the literature, although Bartsch justifiably believed it to be one of Agostino's most beautiful prints. Bodmer, on the other hand, rejected its authenticity. There is no basis for this denial of Agostino's authorship for the features of the sleeping Cupid are typically those of our artist.[2] The format is close to several of the *Lascivie* engravings, but this print dates after Agostino's trip to Rome. The delicacy of the background landscape is akin to that in *Omnia vincit Amor* (cat. no. 210), and the classically inspired features of Venus as well as her full-bodied figure are elements of Agostino's style after c. 1595.

It has been assumed by both Carracci and Goltzius scholars that this print was the model for an engraving of the same subject by Hendrick Goltzius (fig. 211a).[3] That print has been dated by Reznicek and Strauss c. 1590. If the Goltzius engraving dates from that period and, as suggested here, Agostino's work comes at the end of the decade, it is Agostino who copied Goltzius' composition. In fact there is no secure basis for advancing the opposite case. If Goltzius met Agostino when he was in Italy in 1591, he may have left this print with him. In any case, Agostino could have easily obtained a copy of it. Goltzius' composition, arranged cleverly to take advantage of the round format (Cupid's legs and arms especially reiterate the curve), was transformed by Agostino to fit into a rectangular framework. In addition, the subject matter, thought to be first found in Agostino's print, was popular in Goltzius' and other northern artists' oeuvres in the late sixteenth and early seventeenth centuries.[4] Thus, it seems likely that Goltzius and not Agostino invented the composition.[5]

*Engraving in exhibition from the Museum of Fine Arts, Boston, Harvey D. Parker Collection.

1 There is a copy in the Hamburger Kunsthalle in pen and brown ink in the same direction as the engraving by a contemporary artist. Inv. no. 1963-772, 210 x 157 mm.

2 Cf., e.g., the *putti* in the engraving *Reciprico Amore* (cat. no. 191).

3 Bartsch III, 78.257; E.K.J. Reznicek, *Die Zeichnungen von Hendrick Goltzius* (Utrecht, 1961), 197; Hollstein VIII, p. 102; Walter Strauss, *Hendrick Goltzius Complete Engravings, Etchings, Woodcuts* (New York, 1977), no. 284.

4 Goltzius' prints: Strauss 325, 329. Bartolommeus Spranger also employed the theme in a painting. See Reznicek p. 197. The subject comes from Terence, *Eunuchus IV,* 732.

5 Poses similar to that of the Venus were used in the Galleria Farnese and other places by the Carracci. It is almost that of the courtesan in reverse in *Ogni cosa vince l'oro* (cat. no. 190), but a comparison also points up the differences. The pose of Venus is far more languid and enticing than that of the courtesan. Although none of the poses of the goddesses on the Farnese ceiling is exact, the overall feeling is similar. The pose closest to this is that of Polyphemus in the fresco *Polyphemus and Acis* on the ceiling (Martin, fig. 64).

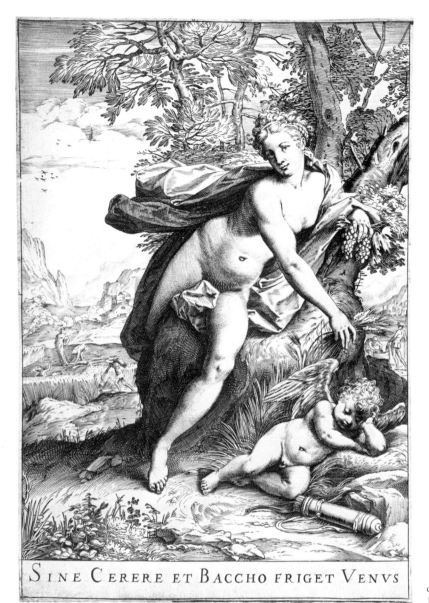

SINE CERERE ET BACCHO FRIGET VENVS

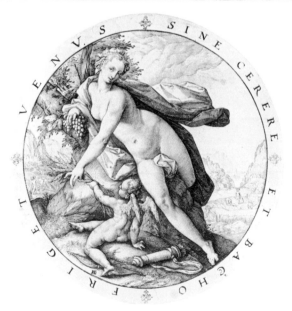

fig. 211a. Hendrick Goltzius, *Sine Cerere et Baccho Friget*. Vienna, Graphische Sammlung Albertina

212*

Portrait of Giovanni Gabrielli, Called "Il Sivello"
(B. 153) c. 1599

Engraving. 187 x 126 mm.

Literature: Baglione p. 390; Bellori p. 116; Malvasia p. 80; Oretti pp. 818-819; Mariette ms. 21; Heinecken p. 628, no. 16; Bolognini Amorini p. 57; Mariette III, 151; LeBlanc 241; Nagler I, 1450; Foratti p. 175; Luigi Rasi, *I comici italiani*, Florence, 1905, vol. II, p. 954; Kristeller p. 283; Pittaluga p. 349; Bodmer 1940, p. 69; Petrucci p. 134; *Mostra-Dipinti* 258; Calvesi/Casale 173; Bertelà 256; Pamela Askew, "Fetti's 'Portrait of an Actor' Reconsidered," *Burlington Magazine,* 120 (February, 1978): 59.

States:

	B	CC
I	—	1

Head and collar only indicated. (Chatsworth)

II	1	2

Portrait and background finished. In margin: *Solus instar omnium / Joannes Gabriel Comicus Nuncupatus* SIVEL. Below margin along bottom: P S F. Above margin lower right: AVG. F. (Alb, Ber, BM, BN, Bo, Dres, MMA, and others)

Preparatory Drawings: 1. Chatsworth* Inv. no. 415. 167 x 125 mm. State I of the engraving finished in black chalk. Collections: Lord Somers. Laid down.

cat. no. 212, state II. Philadelphia
Museum of Art, Charles M. Lea Collection

Baglione was the first to mention this portrait, suggesting that Agostino made it "almost for fun."[1] It has been dated by most sources to c. 1599, probably because of its similarity in handling to Agostino's *Omnia vincit Amor* of this year. Calvesi/Casale, however, believed it to be a little later than 1593/1594, indicating that the sitter may have been the same as the one in Annibale's famous painting of the *Lute Player* of c. 1593/1594 in Dresden.[2] The sitter for the latter has been unquestionably identified as Mascheroni by Mahon, Posner, and, more recently, by Pamela Askew.[3] In addition, the physiognomy of the sitters appears different to most observers.

The dating here of c. 1599 is based on the extravagant curlicues of the hair and the juxtaposition of different strokes in the face, much like the work of Hendrick Goltzius whose style, as already noted, was influential on Agostino after 1595.[4] In addition, the burin technique approaches that in *Omnia vincit Amor*, dated 1599 (cat. no. 210).

The first state of this print is found in only one location—the Duke of Devonshire Collection at Chatsworth. On this sheet Agostino engraved the head and worked out the rest of the composition in black chalk. Only one change is made between this proof and the final version: the mask carried by Sivello was turned to face the sitter, closing the composition at left, rather than facing outward as it does in the drawing. Agostino indicated the margin line in the drawing as a sill on which the actor's arm rests. It is likely that in engraving the body and mask, the artist drew directly on the plate free-hand as he did in the first state of his engraving after Veronese of the *Holy Family with Saints Catherine and Anthony* (cat. no. 103), following the contours he outlined in his drawing. The dryness of the hatching and the background made of very regular strokes in the completed engraving hint that perhaps a member of the workshop finished the print after Agostino outlined the form on the copperplate.

A drawing of this period by Agostino (fig. 212a), formerly on the art market, is much like what Agostino's first study drawing for the engraving must have been.[5] A similar pose as well as similar hatching and dots on the face are employed. Although of a different sitter, this portrait reflects Agostino's facility in capturing a likeness with the pen, while the Sivello engraving shows his ability to retain this immediacy of expression when working in a much more labored technique.[6]

*State II in the exhibition from the Philadelphia Museum of Art, Charles M. Lea Collection.

1 ". . . quasi per ischerzo, fece il ritratto del Siel, famoso Comico, esquisitissima testa;"

2 Dresden, Gemäldegalerie, Inv. no. 308. Reproduced in Posner, plate 76.

3 Posner, 76. Mahon in *Mostra-Dipinti*. Askew, pp. 59-60 identified the sitter as perhaps Teodoro Mascheroni. She proved unquestionably that the sitter comes from the Bolognese family of the Mascheroni. Malvasia p. 359 had earlier identified the sitter as Mascheroni, a friend of Annibale's.

4 See Introduction and cat. nos. 203, 205.

5 Pen and brown ink and red chalk. 162 x 112 mm. Christies, *Fine Old Master Drawings*, December 9, 1975, no. 13A.

6 Giovanni Gabrielli, called il Sivello, was a famous actor known especially for his impersonations of both men and women. He could recite an entire *commedia,* changing voices and clothes, without the assistance of other actors. According to Rasi he was born

cat. no. 212, state I. Chatsworth, Devonshire Collection, The Trustees of the Chatsworth Settlement

fig. 212a. Agostino Carracci, *Portrait of a Young Courtier*. London, Art Market

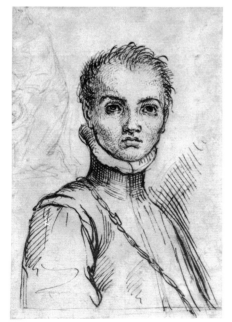

about 1588, but that would make him only about twelve years old when Agostino immortalized him. Rasi, however, believed that Agostino's print dated to 1633. Judging from the age of the sitter in Agostino's print, Sivello was probably born in the 1570s, putting him in his twenties or about thirty in c. 1600. He probably died before 1611. See Rasi pp. 953-957. He was the father of another famous actor, Scapino, portrayed by Callot. See H. Diane Russell, *Jacques Callot: Prints and Related Drawings*. National Gallery of Art, Washington, D.C., 1975, no. 95.

213*

Saint Jerome
(B. 75) c. 1602

Engraving. 384 x 276 mm.

Literature: Bellori p. 116; Malvasia pp. 76, 312; Oretti pp. 797-798; Heinecken p. 635, no. 41; Gori Gandellini p. 314, nos. XXVII and XXVIII; Joubert pp. 343-344; Bolognini Amorini p. 55; Nagler 1835, p. 396; Mariette III, 146; Nagler I, 296 (14); LeBlanc 68; Andresen 11; Foratti p. 176; Kristeller p. 283; Pittaluga pp. 345-346; Disertori p. 264; Bodmer 1940, p. 69; Petrucci pp. 134, 142, note 22; Calvesi/Casale 179; Ostrow 54; Bertelà 192-194.

States:

	B	CC	Ost
I	—	—	—

Incomplete plate. The saint's left leg, left arm, and much of the right side of the composition indicated only in outline. Only right side of lion's head completed, rest outlined. (Ber)

	B	CC	Ost
II	1	1	1

As state I but with third finger of saint's left hand completed. (Alb, BM, Bo, Br, Dres, MMA, and others)

	B	CC	Ost
III	—	—	—

Plate completed.[1] (Bo)

	B	CC	Ost
IV	2	2	2

As state III but with *Aug: Caracius. faciebat* center-right above margin. Below margin line along bottom edge: P. S. F. In some examples, added along the bottom is a second engraving (30 x 27 mm.) containing an inscription and dedication beginning: D. HIERONYMO/ *Purpura, fastus*, . . . and ending: *Petrus Stephanonius Vicentinus amicitiae, et grati animi ergo D.D./ Superior pmissu.* (Alb, BM, BN, Br, Dres, MMA, and others)

Preparatory Drawings: 1. *Studies of St. Jerome.* Frankfurt Städelisches Institut, Inv. No. 5656 recto and verso. 173 x 271 mm. Recto: pen and brown ink. (fig. 213a). Verso: pen and brown ink. Black chalk notations in a later hand.[2] (fig. 213b). 2. *Studies of St. Jerome*. Windsor Castle 2000 (Wittkower 105) 212 x 139 mm. Pen and brown ink. (fig. 213c). 3. *St. Jerome.* Formerly Avnet Collection. Black chalk on buff paper. (fig. 213d)[3] 4. *Studies of lion's head.** Windsor Castle 2161 (Wittkower 106) 259 x 186 mm. Pen and brown ink. (fig. 213e). 5. *Study of lion's head.* Windsor Castle 1977 (Wittkower 212) 235 x 184 mm. Red chalk. (fig. 213f). 6. Vienna, Albertina 2104. 346 x 264 mm. Pen and brown ink over black chalk. (fig. 213g).[4]

Copies: 1. Engraving in the same direction by Jacob Frey. 386 x 275 mm. (sheet: Alb). Lower

The *Saint Jerome* engraving is Agostino's most documented and probably his best-known work. There are no fewer than six extant preparatory drawings for this print, through which we can study his working methods. Malvasia related that this print, which is found often in its early incomplete state, was left unfinished at the time of Agostino's death and that Francesco Brizio completed the plate. Bartsch mentioned that Lodovico Carracci initiated the completion of the work by Brizio, who was his student. Bodmer suggested that Lodovico may have taken this engraving to Rome with him in 1602 to have it published by Stefanoni. Pietro Stefanoni, a Roman publisher,[5] did issue Lodovico's 1604 engraving and drypoint of the *Madonna and Child with Saint John* (Lodovico, cat. no. 4) and could easily have published this engraving at the same time.

The numerous drawings related to this engraving indicate how carefully and completely Agostino worked out his compositions. On the sheets in Frankfurt (figs. 213a, b) and Windsor (fig. 213c)* of the saint himself, the artist experimented with several different positions and directions before he settled on his final composition.[6] In both sheets, he considered the saint facing the viewer, either in an act of supplication to heaven (fig. 213b) or in resignation (fig. 213c). Also, he had not as yet decided to place the figure in a landscape but considered him praying at an altar, perhaps in his study. Another drawing, formerly in the Avnet Collection (fig. 213d), is probably also connected with the engraving. At this point, St. Jerome, praying toward heaven, is placed against a rock similar to the one in the final composition.

In separate studies, Agostino experimented with the head of the lion. In a pen and ink study at Windsor (fig. 213e),* the lion is seen from the side and frontally. Agostino discarded the profile view and instead directed the lion's gaze at the viewer in a rather unferocious, imploring fashion. He continued this attitude in a red chalk study, also at Windsor, which Wittkower incorrectly doubted (fig. 213f). In the final version, however, the artist chose to pose the heavy beast sleeping peacefully.[7]

Agostino's final compositional study, in the Albertina (fig. 213g), is incised for transfer to the plate and probably blackened on the verso.[8] The sheet is more carefully worked than other final preparatory drawings by the artist,[9] but it is still much freer than the completed engraving. It is obvious from this drawing that Agostino did not need to go into elaborate detail in his final studies for engravings, but worked those out as he used the burin.[10] As with the first state of the engraving of the *Holy Family with Saints John the Baptist, Catherine, and Anthony Abbot* (cat. no. 103), in this early state[11] the artist also drew the entire composition lightly with the burin and filled in the shading and interior portions arbitrarily, although he appears to have worked generally from the most important parts of the composition to the least important.

If one accepts the strong evidence that this was Agostino's last print, we can see the direction in which the artist was heading at the time of his death. Although in Rome he had been influenced compositionally and in his figure style by Raphael and classical sculpture, this influence appears to have been wearing off once he moved to Parma. The virtuoso handling of the burin, always with him as a youth but rekindled by his knowledge of Goltzius' prints, is evident. But, Goltzius may

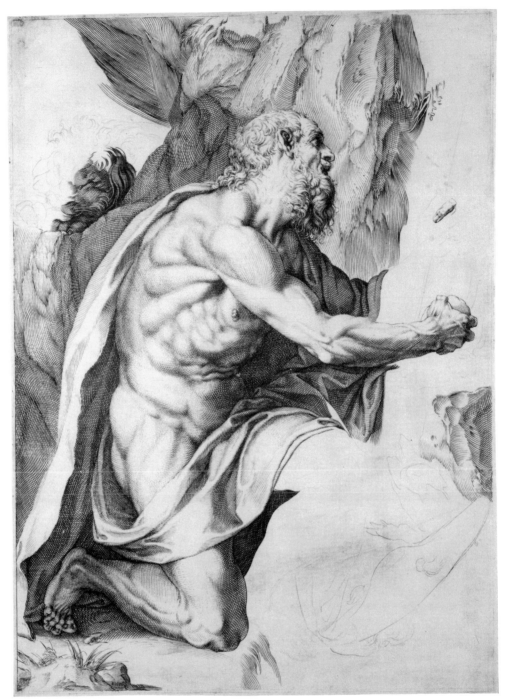

cat. no. 213, state II. Boston, Museum of Fine Arts. William A. Sargent Fund

have had another subtle influence on Agostino by reminding him of the style of the mannerists of the previous generation. The extremely stylized musculature of the saint is removed from Agostino's naturalistic studies of the 1580s and closer to Goltzius' elaborate works. Agostino may have been moving in the direction of reanalyzing and developing his already refined style when he died.

It appears reasonable to accept Malvasia's report that Brizio finished this engraving after Agostino's death.[12] The regularity of the hatching on the saint's left leg and the flatness of the still life in the lower right are typical of his work.[13]

left: *Augustin. Carracci: Inven.* Center: S. HIER-
ONYMUS. Right: *Iacob. Frey Sculp: Romae.* (Alb).
2. Engraving in reverse with minor changes by
Io. Van Sande. Lower left: *Goffart Ex.* Center:
S. IERONIMVS. Lower right: *Io. Van. Sande facit
Antverpiae.* (MMA). 3. Engraving in the same
direction by C. Galle. 317 x 212 mm. (sheet:
BN). Lower center: *Aug. Car. inv.* Lower right:
C. Galle ft. In margin two sets of verses of two
lines beginning with: *Purpura fastus. . . .* (BN).
4. Engraving in reverse. 387 x 275 mm.
(irregular corners). In margin: S. GIROLAMO *gio
Jacomo Rossi le stampa in Roma alla Pace.* (plate
in Calcografia Nazionale, Rome). 5. Engraving
of St. Jerome's head in same direction. 125 x
89 mm. Lower left in margin: *a.c. in.* In
center: *S. Jeronimus.* At right: *J. Stanzoni.*
(Alb). 6. Engraving in reverse. 410 x 285 mm.
In margin left: *Ag.⁰ Carracci Inv.* Lower right:
Tom Piroli Sculp. In center: *Sanctus Hieronymus.*
(Alb). 7. Engraving in reverse. 339 x 257 mm.
(sheet: Par). In margin: S. HIERONYMVS. Lower
right: *in Augsburg:/ zu finden buy Elias
Hainzelman in Jacober vorstatt.* (Par). 8.
Engraving in reverse. 367 x 281 mm. No
inscriptions (Ber). 9. Engraving in the same
direction. 163 x 118 mm. (sheet: Dres). Lower
right: *Aug: Car: Fe:* (Dres).

As seen under "Copies," this engraving was famous during the seventeenth century, and many reproductions were made of it. Annibale chose the pose for a figure of St. Jerome to be used in the Cappella S. Diego in S. Giacomo degli Spagnuoli in Rome. The figure is recorded in a drawing by Annibale in Windsor, and the relationship with Agostino's engraving was noted by Wittkower.[14] As discussed elsewhere[15] Annibale borrowed from Agostino as well as vice versa.

A painted version of the *Saint Jerome* in Naples (fig. 213h) has been attributed with some doubt to Agostino by Ostrow,[16] but is, in the opinion of this author, an elaborate copy of Agostino's engraving.[17]

1 This state was known to Andresen.

2 The drawing was first published as Agostino by Stephen D. Pepper in "Augustin Carrache, Maitre et Dessinateur," *Revue de l'Art*, 14 (1971): 44.

3 *Old Master Drawings from the Collection of Mr. and Mrs. Lester Francis Avnet*, New York, 1968, no. 9 with previous literature. Known to author only in a photograph.

4 Bodmer, *Old Master Drawings*, pl. 62; Stix and Spitzmüller, cat. no. 91; Wittkower under cat. 105.

5 For information on Stefanoni, see Appendix I.

6 As noted in cat. no. 204, this was a typical working method of the artist, who wanted to see the reversed image before settling on which direction to make the print.

7 Both Ostrow and Wittkower attributed to Agostino a drawing in the Uffizi (inv. no. 12367F recto and verso) of the lion sleeping and the saint's legs and hands, calling it a study for this print. That drawing is an extremely weak copy after portions of the engraving and has nothing to do with Agostino. As witnessed by other drawn copies of Agostino's prints, partial copying of engravings was a common practice during this period.

8 The drawing is laid down, and it is difficult to see the color of the verso.

9 Cf., e.g., the drawing for the *Coat of Arms of Cardinal Fachenetti* (cat. no. 196 & fig. 196a).

10 The musculature, especially, is defined only marginally in the drawing but immensely elaborated in the print. The drapery over St. Jerome's bent arm is merely hinted at in the drawing but fully defined in the print.

11 The unusual state I at Berlin is a mystery in that it differs only in the lack of the third finger on the left hand. Why a pull was taken at this point and only slightly more elaboration made on the plate before the next pull is unknown.

12 Gori Gandellini alone believed that the print was finished by Villamena.

13 Cf, e.g., the hatching in the *St. Roch* after Parmigianino (Bartsch XVIII, 258.9).

14 Inv. no. 1945 recto. Wittkower 340, plate 80.

15 Introduction and Annibale cat. no. 19.

16 Ostrow cat. no. II/9 with previous literature.

17 An inspiration for this composition may have come from several prints of Saint Jerome in the wilderness by Battista Franco (Bartsch XVI, 131.37-38), in which the kneeling saint is placed in front of a limited rocky background. In these prints, as in the Agostino, the vertical backdrop of the rocks emphasizes the confinement of space, and attention is focused on the suffering saint who fills most of the page.

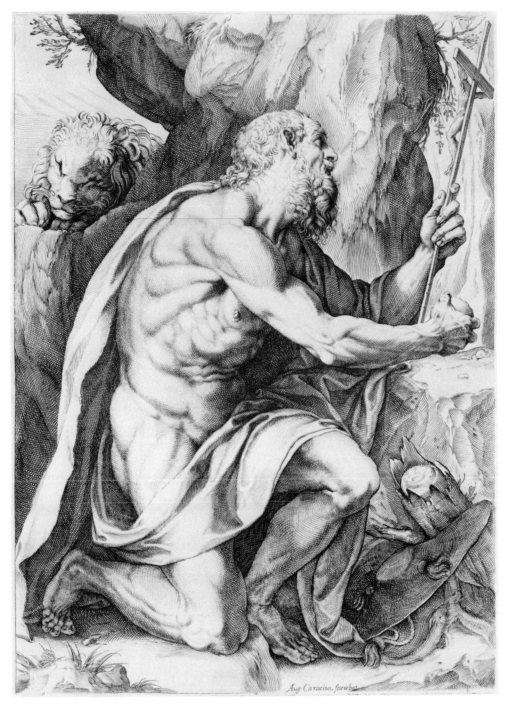

cat. no. 213, state IV. New York, The Metropolitan Museum of Art, Harris Brisbane Dick Fund,
1927

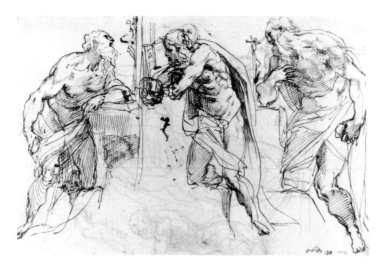

fig. 213a. Agostino Carracci, *Studies for Saint Jerome.* Frankfurt, Städelisches Institut

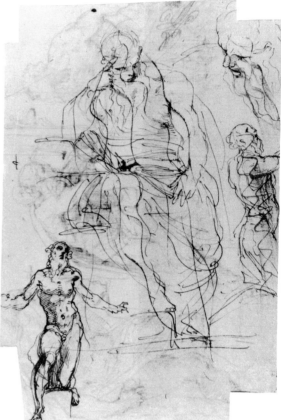

fig. 213b. Agostino Carracci, *Studies for Saint Jerome.* Frankfurt, Städelisches Institut

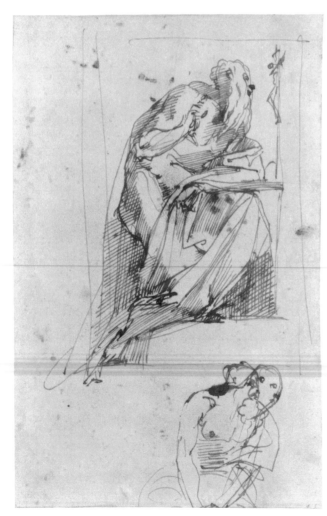

fig. 213c. Agostino Carracci, *Studies for Saint Jerome.* Windsor Castle, Royal Library, Her Majesty Queen Elizabeth II

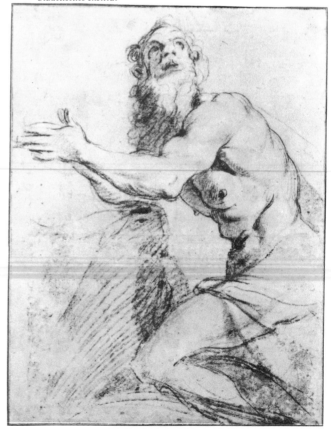

fig. 213d. Agostino Carracci, *Saint Jerome.* Formerly Avnet Collection

fig. 213e. Agostino Carracci, *Studies of a Lion*. Windsor Castle Royal
Library, Her Majesty Queen Elizabeth II

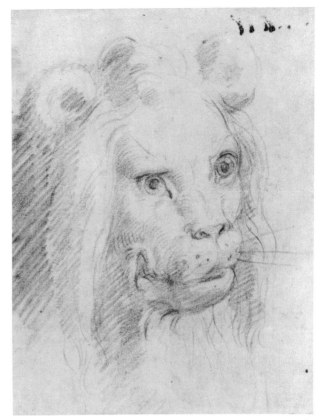

fig. 213f. Agostino Carracci, *A Lion's Head*. Windsor Castle, Royal Library,
Her Majesty Queen Elizabeth II

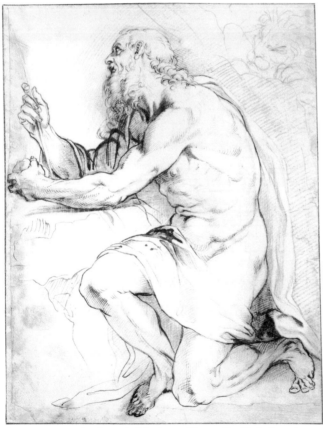

fig. 213g. Agostino Carracci, *Saint Jerome*. Vienna, Graphische Sammlung
Albertina

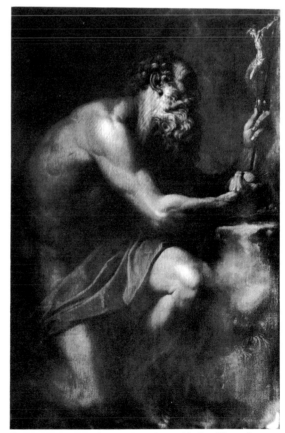

fig. 213h. Artist unknown. *Saint Jerome*. Naples, Museo di
Capodimonte

AGOSTINO CARRACCI (?)

Cat. Nos. 214-234

The following prints are those which this author cannot with security attribute to Agostino Carracci. In every instance, the case for and against an attribution to Agostino is stated. In some cases, the evidence weighs in favor of an attribution to him, in others, against him, but doubt remains. The prints are arranged chronologically in Agostino's career, as if they were in fact part of his oeuvre.

214

The Birth of the Virgin
(B. 40) c. 1576

Engraving. 241 x 356 mm. (after Andrea del Sarto fresco in the cortile of SS. Annunziata, Florence)

Literature: Gori Gandellini p. 318, no. XV; Heinecken p. 631, no. I; Joubert p. 347; Nagler 1835, p. 396; LeBlanc 8; Foratti p. 167; Petrucci p. 133; Bodmer 1940, p. 71; Calvesi/Casale 2.

States:

	B	CC
I	I	I

Bottom center: NATIVITAS BEATAE MARIAE VIRGINIS. Lower right: *Andreas de Sarto Inve.* (Alb, Br, PAFA, Ro, and others)

All critics who have cited this engraving have accepted it as one of Agostino's earliest works. The extreme simplicity of the hatching, the unsophisticated compositional techniques, and the awkward poses of the figures justify attributing the sheet to an apprentice artist. However, the precocity of Agostino's signed and dated prints of 1576 of the *Holy Family* after Bagnacavallo (cat. no. 4) and the *Virgin and Child* after Marcantonio (cat. no. 3) is lacking here. The two attendants in the center foreground come closest to what could be considered a Carracci type, but otherwise the lack of individuality portrayed gives one little chance to prove this work is Agostino's. But, if this sheet were produced by our artist as his first venture into engraving, his style—even in a reproductive print—would naturally be embryonic.

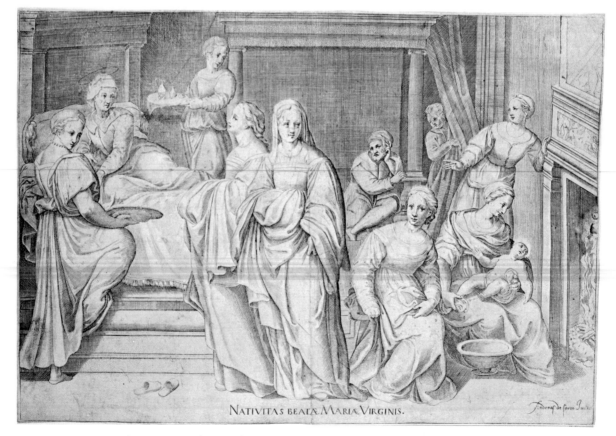

cat. no. 214, state I. Philadelphia Museum of Art. Academy Collection

215

Portrait of Pope Gregory XIII (B. 146) c. 1576-1579

Engraving. 137 x 100 mm. (oval)

Literature: Malvasia p. 81 and footnote 2; Oretti p. 825; Heinecken p. 628, no. 2; LeBlanc 235; Bodmer 1939, p. 126; Bodmer 1940, p. 71; Ostrow 3.

States:

	B	Ost
I	I	I

In margin: GREG: XIII: P: MAX: BONON: [with center N backwards] CREATVS:FVIT./ 1572 (Alb)

II	—	—

Margin changed to read: LEONE: XI: P̀: MAX:/ FLO.ˢ CREATVS FV*it*/ 1605 (Fitzwilliam Museum)

cat. no. 215, state I. Vienna, Graphische Sammlung Albertina

This very rare print was first attributed to Agostino by Malvasia, and later by Bartsch. Heinecken followed Malvasia's dating of 1571. Zanotti, in his notes to Malvasia, rejected the attribution, as did Bodmer. Ostrow was unsure that the work was Agostino's and added that the date on the print, 1572, was the date of the accession of Gregory XIII as pope and not the date of execution. The style of the print, with its awkward hatching and cowl of the mantle, indicates that if the print belongs to Agostino it must date early in his career. It is closest in technique to his early dated reproductive works (cat. nos. 2-4). On a second, unrecorded state of the print in Cambridge, a publisher conveniently changed the name of the sitter to Pope Leo XI, who became pontiff in 1605.

216

Baptism of Christ
(B. 16) c. 1579

Engraving. 192 x 142 mm. (sheet: Alb) (after Orazio de Sanctis engraving, Bartsch XVII, 9.6)

Literature: LeBlanc 38; Nagler 1835, p. 395; Nagler I, 296(2).

States:

I I

In margin: *Abluitur nullo foedatus crimine Christus Nos quoq servandos hac ratione docens* ·A·C· (Alb)

When Bartsch attributed this engraving to Agostino, he noted that the original composition was by Pompeo Acquilano. He did not notice that this work is a copy, with slight variations, after Orazio de Sanctis' print after Pompeo Acquilano (fig. 216a).[1] The artist of the present sheet removed a second angel and cut the composition at the bottom. He also added the symbol for the Holy Ghost at top while cutting out the form of God the Father in the clouds in de Sanctis' print. The shading is an exact replica of de Sanctis', and in cutting the composition, the artist failed to remove the wing from the angel he retained, giving a rather humpbacked appearance to the form without defining it as a winged angel. One wonders if he had only a trimmed down version of the original composition with which to work. The artist also failed to increase the width of the hatching on the waves as had de Sanctis; his more mechanical lines negate the shimmering quality of the water in the earlier print. Agostino may easily have copied this print in his youthful period for in his other works of these years, he was not proficient in varying the width of his burin lines. On the other hand, there is no reason other than the monogram "A.C." in the lower right hand corner to attribute the engraving to him.

1 Orazio de Sanctis' print is monogrammed and dated 1572, and in the lower edge toward the right is "Pompeo Acquilanu."

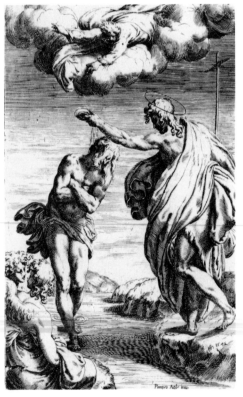

fig. 216a. Orazio de Sanctis, *Baptism.* Vienna, Graphische Sammlung Albertina

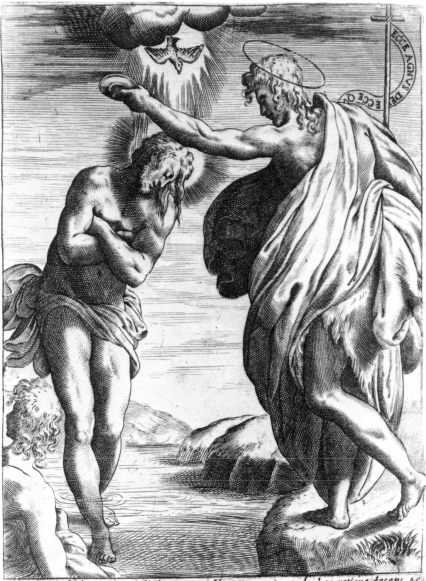

Abluitur nullo foedatus crimine Christus Nos quoq̃ seruandos hac ratione docens .A.C

cat. no. 216, only state. Vienna, Graphische Sammlung Albertina

217

Crucifixion
(B. 22) 1580

Engraving. 415 x 393 mm.

Literature: Heinecken p. 631, no. 22; Mariette III, 87; LeBlanc 47; Bodmer 1939, p. 134; Bodmer 1940, p. 71; Calvesi/Casale 11; Ostrow 17.

States:

	B	CC	Ost
I	I	I	I

Lower center: *Lucae Bertelli formis.* Lower right: *1580*[1] (Alb, BN, Dres, MMA, U)

—	—	—	2

AG.C (not found)

Attributions have varied with regard to this sheet. Heinecken, Mariette, LeBlanc, and Calvesi/Casale have accepted it, whereas Bartsch, Foratti, and Bodmer have dismissed it as an anonymous piece. Most recently, Ostrow accepted the engraving as coming from Agostino's hand in his "independent style." If Agostino did execute the sheet, it is one of his earliest dated nonreproductive prints.[2] Yet, nagging questions remain as to its authenticity. In 1580 Agostino was capable of delineating forms in a far more three-dimensional manner.[3] Here the figures are piled one upon the other without a rational ground line.[4] None of Agostino's figures portrays the awkward postures of the Marys in the lower left. On the other hand, there are certain correspondences, especially of the figure of Mary Magdalen, with Agostino's nonreproductive prints of the late 1570s.[5] Compositionally and in burin technique, the artist followed Cornelis Cort's lead but was unable at that time to integrate figures in space or foreground with background. If, as Ostrow believed, Agostino's independent style lagged behind that of his reproductive work, one could reasonably accept this sheet as his. Yet, it seems that an artist as skilled as the one who executed such pieces as the *Adam and Eve* and *Jacob and Rachel* (cat. nos. 25 and 27) in 1581 would have been more capable of reproducing volumetric form than is obvious here.[6]

1 Heinecken mistook the date for 1500.

2 Agostino's earliest accepted nonreproductive prints are the series of female saints executed c. 1576-1579 (cat. nos. 5-8).

3 See for example cat. nos. 9ff.

4 See the group at left as an example.

5 Cf. especially the Dresden saints (cat. nos. 5-8).

6 See the Introduction on Agostino's "independent style."

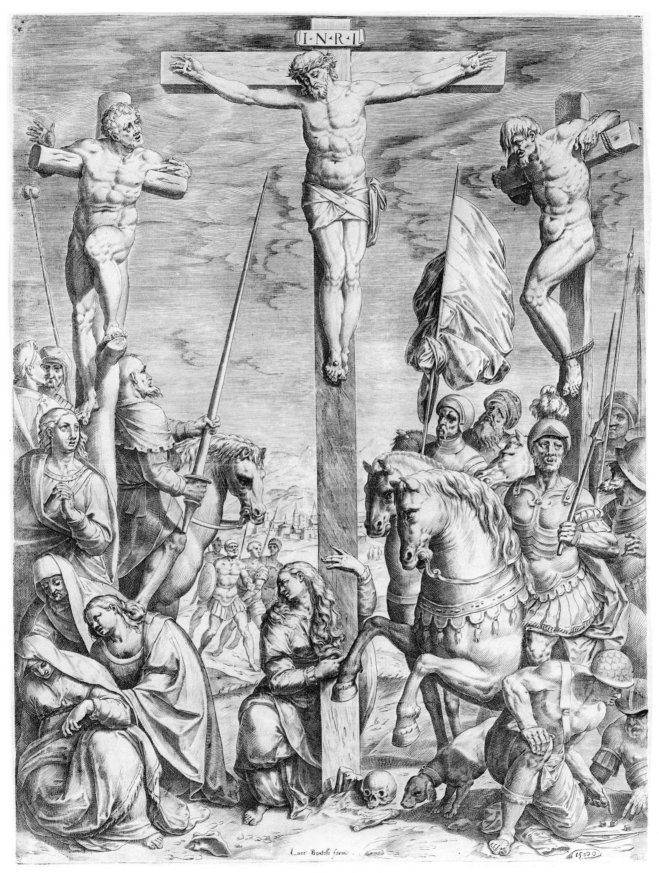

Lucae Bertelli formis · 1500

cat. no. 217, state I. New York, The Metropolitan Museum of Art, Harris Brisbane Dick Fund, 1953.

218

Saint Veronica

c. 1576-1581

Engraving. 285 x 212 mm.

Unpublished.

States:
I

Bottom center: S. VERONICA (Ber)

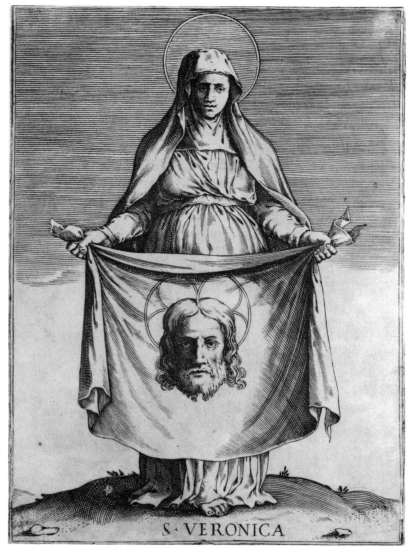

cat. no. 218, only state. Berlin (Dahlem), Staatliche Museen Kulturbesitz Kupferstichkabinett

The present engraving, known to the author in one impression, was found among the anonymous Italian prints in Berlin. In concept and composition, it approaches the four prints of female saints in the Dresden Kupferstickabinett (cat. nos. 5-8) of c. 1576-1579. The rarity of this and the Dresden sheets may result from their popularity as votive images. In any event, they did not survive in sufficient quantity to be noticed by Malvasia.[1]

If this is a nonreproductive print by Agostino of c. 1576-1581, one can account for the simplicity of technique, pose, form, and composition as well as the awkwardness of the nose, hands, and limbs. Conversely, it is difficult to believe that the artist responsible for the head of Christ in the *Sudarium of Veronica* (cat. no. 24) could have produced the flattened visage appearing here on the saint's cloth.

1 Unless Malvasia knew the prints but failed to accept them as Agostino's.

219

Christic on the Mount of Olives
c. 1581-1582

Engraving. 224 x 166 mm.

Unpublished.[1]

States:
I

As reproduced. Lower right: *Luca Bertelli*. (BN)

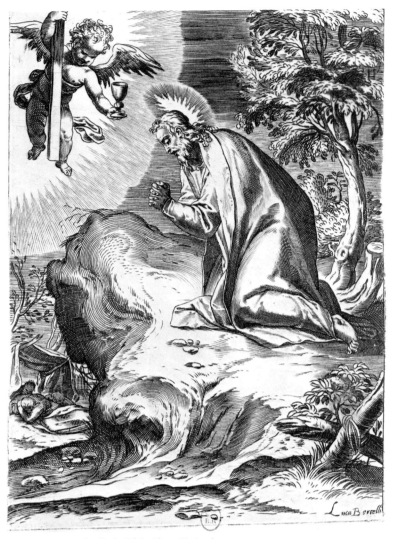

cat. no. 219, state I. Paris, Bibliothèque Nationale

The curving lines for the cliff, the simple rendering of the sleeping apostles, and the sweetened expression of the cherub offering the chalice to Christ are traits of Agostino's work of c. 1581, but the signature of Luca Bertelli as publisher suggests that the print was executed in Venice, and therefore after 1582.[2] The style of the sheet is dependent on Cornelis Cort's works, as are most of Agostino's prints of the early 1580s. However, there are not enough specific characteristics of Agostino's style to attribute this engraving to him without some hesitation.

1 Mariette attributed the print to Agostino in his notes, but his attribution was not published in the *Abecedario*.

2 See Appendix I.

220

Portrait of Christina of Denmark
(B. 229) c. 1582-1585

Engraving. 150 x 115 mm.

Literature: Malvasia p. 82; Oretti pp. 827-828; Heinecken p. 628, no. 22; LeBlanc 229; Nagler I, 304.

States:

	B
I	I

Lower left: *A. Car. fecit.* (Alb, BN, Br, MMA, and others)

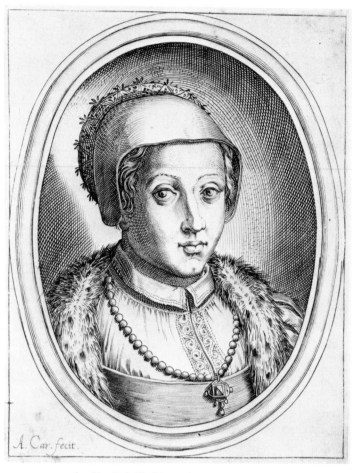

cat. no. 220, state I. New York, The Metropolitan Museum of Art, Harris Brisbane Dick Fund, 1927

This print is, as Bartsch noted, a repetition in reverse of the portrait of Christina of Denmark in the *Cremona Fedelissima* (cat. no. 85). Although it is a faithfully executed copy, there are slight variations in the shading, changes in details of the costume, and a broadened conception of the form. It is possible that Agostino wished to repeat one of the more successful portraits in the series, or the sheet could have been a trial proof before the other portraits were executed. The signature at lower left would have been added to convince Antonio Campi of Agostino's skill in portraiture.[1] Yet, many of the examples of this print are found on paper with later watermarks, leading one to speculate that it may be a copy of cat. no. 85 by a later hand.

1 See cat. no. 55 for Malvasia's comments on Agostino's execution of the *Saint Paul Raising Patroclus* (cat. no. 108) made as a trial to receive the *Cremona Fedelissima* commission. It seems more likely that if Agostino were attempting to prove his ability to undertake the project, he would do so by engraving a portrait and not a religious scene, as was suggested by Malvasia.

221

The Stigmatization of Saint Francis

c. 1582

Engraving. 227 x 191 mm. (after Federico Barocci etching, Bartsch XVII, 3-4.3)

Unpublished.

States:

I

Lower left: *Federicus Baro./Ur. in.* Lower left toward center: *Pietro Bertelli for.* (Parma)

Copies: 1. Engraving in same direction. Lower left: *Federicus Baro/ Ur: in:* Background transformed. Much simpler method of shading.

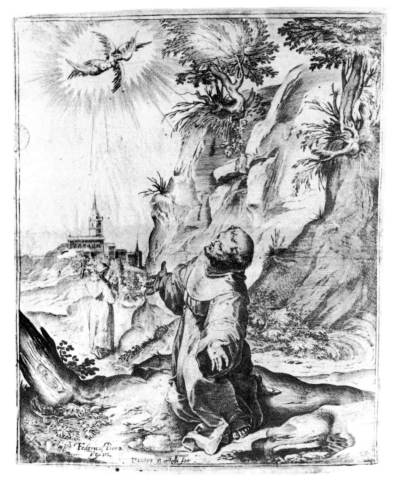

cat. no. 221, state I. Parma, Biblioteca Palatina

This reproductive print drastically transforms the atmospheric feeling inherent in Barocci's original etching, as does Agostino's copy of Barocci's *Madonna and Child on the Clouds* (see cat. no. 98 and fig. 98a). In the etching, the saint floats mystically above the ground, whereas in the engraving he is firmly kneeling on the earth. It is generally believed that Barocci's print dates from c. 1581;[1] therefore, this copy must postdate that year.

The author of this print was apparently trained in the manner of Cornelis Cort, as the feathery concept of the leaves and the calligraphic rendering of the distant landscape are characteristics of his style. These are also characteristics of some of Agostino's prints of the early 1580s. The expert handling of the network of hatching bespeaks Agostino's hand as does the sharp foreshortening of the saint's right hand cast in shadow. Yet, there is no true individuality to the morphology of the face of Saint Francis, and the almost mechanical hatching of the mountain behind is not up to Agostino's capabilities. If this is indeed an engraving by our artist, a date of c. 1582, the year of Agostino's first Venetian trip, would be appropriate.[2] However, none of the contrasts of light and shade so prevalent in his work after this trip is apparent here.

1 For a discussion of the Barocci etching, see Harald Olsen, *Federico Barocci* (Copenhagen, 1962), 160-161, no. 28; Emiliani, pp. 100-101; and Pillsbury and Richards, no. 72.

2 The print is signed by the Venetian publisher Pietro Bertelli. See Appendix I for the dating of works with his signature.

222

The Transfiguration
(B. 25) after 1582

Engraving. 440 x 329 mm.

Literature: Heinecken p. 631, no. 32; Mariette III, 91; LeBlanc 55; Nagler 1835, p. 395; Nagler II, 1303; Zani part II, 9, pp. 142-144; Bodmer 1939, p. 135-136; Bodmer 1940, p. 71; Calvesi/Casale 5; Ostrow 41; Bertelà 154; Boschloo II, p. 184, note 23.

States:

	B	CC	Ost
I	1	1	–

Lower left: *Do: P.F.* Lower center: *Hora Ber. For. 1588.* (BN, Bo, Br, MMA, Ro)

	B	CC	Ost
II	2	–	–

Plate broken at top right above two angels. (Br, Dres, Phil)

	B	CC	Ost
III	–	–	–

Plate also broken in the upper left. (Frankfurt, Städelisches Institut)

	B	CC	Ost
IV	–	–	–

Do: P. F. effaced. (Alb, PAFA)

Modern critics as well as earlier ones have disagreed on the authenticity of this sheet. It was accepted by all except Bartsch, Bodmer, and Ostrow. Calvesi and Casale noted a state with the initials "AC" in the lower right. These initials found on the example in Rome were added by a stamp and are not part of the engraving itself. In this author's opinion, if the inscriptions were ignored and the attribution were based solely on stylistic evidence, there would be no doubt that the sheet is Agostino's dating from after 1582. The dramatic contrasts of light and shade are evident in works by Agostino after his trip to Venice in this year. From 1582 on, he depended more on the white of the paper to emphasize highlights and produce dazzling light. Also, the angels' heads are similar to those produced throughout the 1580s.[1]

On the other hand, the inscriptions suggest that Domenico Tibaldi produced the print and that the print is datable to 1588. There is no known example of this print without the inscriptions. It can logically be assumed that it was the publisher who added both inscriptions. Domenico Tibaldi died in 1583, and if he is the author of the print, the date belongs to its publication and not to its execution. If Bertelli owned the plate in 1588, he may have assumed it was engraved by the deceased artist and added the attribution accordingly.

The attribution to Tibaldi is untenable if comparisons are made with his known signed oeuvre and with the expanded oeuvre in this catalogue. Although that artist was completely capable of the refinement of technique evident here, his morphology is at variance.[2]

In 1588 Agostino was certainly able to produce this engraving and to be the author of the original composition. Although the undulating clouds reappear in the *intermezzi* after Buontalenti (cat. nos. 153 and 154), the head of the apostle at the left in the shadow looking at the spectator shows up in the rejected engraving of the *Presentation in the Temple* (cat. no. R53). Also, Bertelli published Agostino's prints in this period and surely should have known what prints were engraved by him.[3] Until the numerous discrepancies are cleared up, an earlier state of the print found, and Domenico Tibaldi's oeuvre defined, critics will continue to vacillate between an attribution of the *Transfiguration* to Tibaldi and to Agostino Carracci.[4]

1 See especially cat nos. 32-34, 105, 107.

2 Cf. cat. nos. R53ff.

3 For information on Bertelli as a publisher of Agostino's prints see Appendix I.

4 Zani's ingenious suggestion for the discrepancy of date and inscription is that Tibaldi left the plate unfinished at his death; Agostino finished it and signed it with his teacher's initials to honor his memory and to indicate Tibaldi had begun the work. Then Bertelli published it in 1588. Although this reasoning is possible, there do not seem to be two hands at work on the engraving.

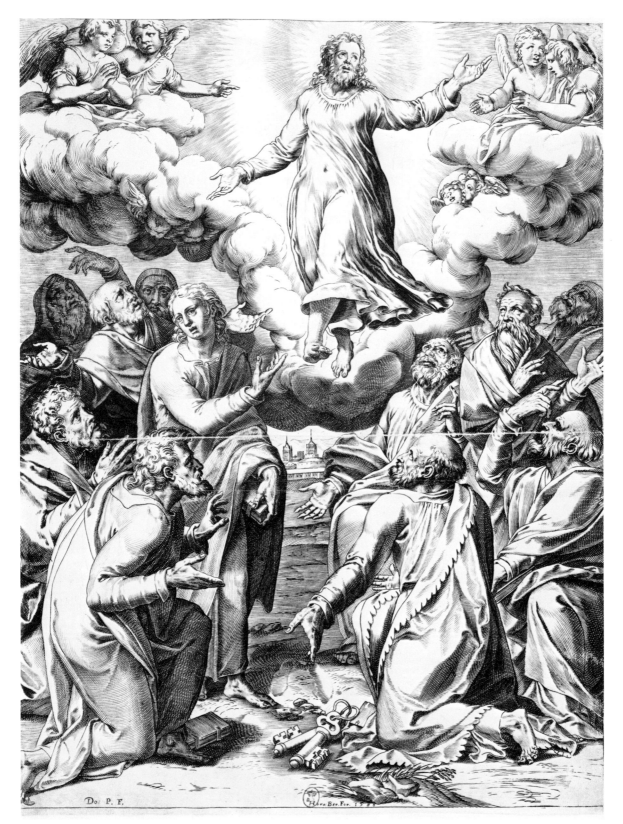

Do: P. F. H. Hon: Bee For. 1588

cat. no. 222, state I. Paris, Bibliothèque Nationale

223

Bust of an Old Man
(B. 155) c. 1583

Engraving. 116 x 98 mm.

Literature: Malvasia p. 83; Oretti p. 833;
Heinecken p. 629, no. 21; Joubert p. 345;
LeBlanc 227.

States:

I

No inscriptions. As reproduced. (Alb, BMFA,
Dar, MMA)

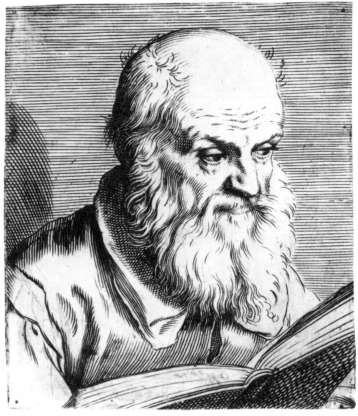

cat. no. 223, only state. Vienna, Graphische Sammlung Albertina

Malvasia believed this engraving to be a portrait of the artist's father,
Antonio Carracci. Although relevant to Agostino's early style, there is
something disturbing about the mechanical hatching of the print, which
is more like the technique of one of Agostino's followers, perhaps Luca
Ciamberlano. On the other hand, the morphological similarity of the
face with the heads in some of Agostino's apostles of 1583 (cat.
nos. 110-123) precludes the absolute removal of this print from his
oeuvre.

224

Coat of Arms of Cardinal
Alessandro Peretti
(B. 175) 1585-1590

Engraving. 108 x 149 mm. (sheet: BN)

Literature: LeBlanc 263; Bodmer 1940, p. 51.

States:

	B
I	1

As reproduced. No inscriptions. (Alb, BN)

The *terminus post quem* of this engraving is 1585, the year in which Alessandro Peretti was created cardinal by Sixtus V.[1] The use of a cartouche within a niche repeats Agostino's earlier *Coat of Arms of Cardinal Fieschi* of c. 1581 (cat. no. 30). Yet, if by Agostino, this print obviously is more developed compositionally and must date in the later 1580s when the artist incorporated complicated formats within one composition. There is little reason to doubt that this print comes from Agostino's hand if one studies the burin technique and the volumetric conception of the whole. Yet, the morphology of the *putti's* faces creates an uncertainty as to whether Agostino is the author of the print.

1 Berton, p. 1360 mentioned that Alessandro was created cardinal in 1585 and died in 1623, the *terminus ante quem* for the engraving. Ciaconi noted another Peretti cardinal—Francesco Felix Peretti, who was created cardinal under Pius V and died in 1585.

cat. no. 224, only state. Vienna, Graphische Sammlung Albertina

225

Coats of Arms of the Bolognese Popes and Cardinals
(B. 181) 1590

Engraving. 336 x 376 mm. (after Francesco Cavazzone)

Literature: Malvasia p. 77; Crespi pp. 16, 19; Oretti p. 798; Heinecken p. 642, no. 9; Bolognini Amorini p. 55; Nagler 1835, p. 399; Bodmer 1940, p. 51; Calvesi/Casale 131; Raniere Varese, *Francesco Cavazzoni critico e pittore,* Florence, 1969, p. 40.

States:

	B	CC
I	1?	1

As reproduced. In margin below: BONONIAE, *Apud Ioannem Rossium* MDXC. *De Superiorum . . .* FRANCISCVS CAVAZZONIVS *Bono. Inventor.* (Bo)

This print has been accepted by all writers except Crespi, who attributed the work to Giovanni Pietro Melara. The only known example of the print is the one in Bologna dated 1590. However, Bodmer, who dated the print in the early 1580s, knew an engraving in a state before letters.[1] Malvasia's date for the print was 1600. Following him, Bolognini Amorini reiterated the 1600 dating.

There are several reasons for questioning this sheet. The first is the feeling that Agostino, who was well known and popular by the year 1590, would probably not do a reproductive print after a virtually unknown artist who may even have been his student.[2] The second reason is the notion that Giovanni Pietro Melara is the author of this engraving. Crespi is the only source to advance this idea, and although he refuted Malvasia, who was writing at a time when some students of Carracci and Cavazzone were still alive, he was adamant in his rejection of the print as Agostino's.[3] Melara does not seem to be mentioned in any biography, old or new, and one wonders where Crespi obtained his information. Another reason for questioning the print is based on stylistic analysis; although the arms of the popes are shaded in a way to give them a sculptural feeling, the cardinals' arms are dull and flat.

On the other hand, there are several arguments for accepting the sheet as Agostino's: namely, Malvasia's attribution and a comparison of the cherub's face with Agostino's *putti* in accepted works, the closest being the small figures in the lower right of *Reciprico Amore* (cat. no. 191), datable to the same period.

1 Heinecken also knew a state before letters. Bartsch did not mention the date 1590 and thus may have known the state referred to by Heinecken.

2 In fact, why did Agostino not put his name on the print as the engraver? True, the inventor of the design is more important, but in this case the more famous engraver, Agostino, would have increased the saleability of the print by attaching his name. Cavazzone is mentioned only in passing by Malvasia (I p. 408); his first biography is found in Luigi Crespi, *Vite de' Pittori Bolognesi non descritte nella Felsina Pittrice,* Rome, 1769, pp. 16-19. Crespi repeated Malvasia's statement that Francesco was a student of Bartolomeo Passarotti and in the school of the Carracci, whose style he emulated. Crespi added the dates of Cavazzone's life which Malvasia had neglected. He was born in 1559 and was still working in 1616. Orlandi called him a student of Carracci (Crespi p. 16).

Very little was written on Cavazzone subsequent to Crespi's life until Raniere Varese's reevaluation of him in 1969. See Varese pp. 20-27 for bibliography and sources. He was a better historian than artist, but none of his manuscripts was published. He appears to have been a better painter, in the manner of Sammacchini, than draftsman. See Varese for reproductions.

3 Crespi said, "In quanto poi all'*Opera dell'armi de' Pontefici &c.* menovata come sopra, posso dire averla veduta, e che ella è in quarto grande stampata in Bologna nel 1590. e che è un Opera fatta da un tale Gio. Pietro Melara, in lingua Latina, nella quale non si fa menzione nè pur per ombra del Cavazzoni, che non saprei dire, se quell'armi inventasse, e disegnasse, ma dirò bene, che assolutamente non sono intagliate da'Carracci, come asserisce il Malvasia." Unfortunately, this is the only mention found of Melara anywhere. This passage is very intriguing as there may be many prints by this unknown engraver currently attributed to others.

cat. no. 225, only state. Bologna, Pinacoteca Nazionale

226

Coat of Arms of Cardinal Giovanni Battista Castagna [1]
(B. 166) c. 1590

Engraving. 126 x 191 mm.

Literature: Oretti pp. 816-817; Heinecken p. 641, no. 3; LeBlanc 254; Bertelà 265.

States:

	B
I	I

As reproduced. No inscriptions. (Alb, BN, Bo, Br)

Heinecken attributed this sheet to an anonymous artist; Bartsch asserted that the engraving was by Agostino after another's design. The similar flatness of technique and the cherubic head found in the *Coats of Arms of the Bolognese Popes and Cardinals* (cat. no. 225) suggest that the engraver is the same for both works. If the little-known Giovanni Pietro Melara is the author of this print,[2] his style is so close to Agostino's that one may assume that he was a Bolognese artist working in the Carracci circle.

An argument for accepting the sheet as Agostino's is the similarity of the burin technique on the faces of the flanking virtues, Prudence and Justice, with those of the female figures in the *Lascivie* series (cat. nos. 176-190) and in *Reciprico Amore* and *Love in the Golden Age* (cat. nos. 191-192). The short vertical strokes for the shading of the eyes is evident in most of these sheets. Likewise, the morphology is Carraccesque: small pointed chins and sweetened expressions are apparent in the *Lascivie* as well as on the figures represented here.

In composition and feeling the print approaches one engraving by Giovanni Luigi Valesio;[3] however, the wavy lines so prevalent in Valesio's works are not in evidence here.

1 Giovanni Battista Castagna (1521-1590) was created cardinal in 1583 by Gregory XIII. He became Pope Urban VII in 1590, and he seems not to have created any cardinals during his brief reign (see Ciaconi IV, 71).

2 See cat. no. 225 for a discussion of Melara.

3 Not described by Bartsch. Bertelà 998, reproduced. It carries Valesio's monogram lower right.

cat. no. 226, only state. Vienna, Graphische Sammlung Albertina

227

A Coat of Arms with the Device: Nostrum Est
(B. 271) 1590-1595

Engraving. 155 x 134 mm.

Literature: Malvasia p. 81; Oretti p. 824; Heinecken p. 641, no. 12; LeBlanc 147; Calvesi/Casale 133; Bertelà 297.

States:

	B	CC
I	–	–

Arms with a crenelation and three staffs of wheat. (unknown)

	B	CC
II	1	1

Arms effaced. (Alb, BN, Bo, Ham)

	B	CC
III	–	2

Lower center: A.C. (Bo, Br, Dres, and others)

cat. no. 227, state II. Paris, Bibliothèque Nationale

Although the burin technique is Carraccesque, the elaborate and fussy fronds emanating from the cartouche are more typical of seventeenth-century coats of arms. Also, the facial types of the *putti* are not similar to those in other Agostino prints. If the print is by Agostino, a date of c. 1590-1595, before the Roman period, would be indicated.

228

Cartouche with Trophies of Arms
(B. 265) c. 1590-1595

Engraving. 216 x 164 mm. (sheet: BN)

Literature: Malvasia p. 82?; Heinecken p. 641,
no. 13; Bolognini Amorini p. 59; Nagler 1835,
p. 399; LeBlanc 265; Bodmer 1940, p. 64.

States:

	B
I	1

Above arms: SINE PALLADE TORPENT in reverse
(Alb, BN, Br)

cat. no. 228, only state. Paris, Bibliothèque Nationale

Unlike any of Agostino's authentic works, the inscription in this print is
backwards. It is unusual that in such an elaborate motif, no care would
be given to ensure that the inscription reads correctly. The form of the
cartouche within a niche is an Agostino type. The overelaboration of this
composition, however, is atypical of his style. The hand at work here is
the same as that which executed the *Coat of Arms of Cardinal Filippo Sega*
(cat. no. 229).

229

Coat of Arms of Cardinal Filippo Sega [1]
(B. 179) 1592

Engraving. 125 x 185 mm.

Literature: Malvasia p. 80; Heinecken p. 643, no. 27; Bolognini Amorini p. 57; Nagler 1835, p. 399; LeBlanc 267; Bodmer 1940, p. 64; Calvesi/Casale 157; Bertelà 275.

States:

	B	CC
I	–	1

Before letters and before completion of the plate. (Bo)

	B	CC
II	1	2

Plate almost completed. With letters. Lower right: *1592.* In the left banner: REGERE IMPERIO POPVLOS. Center: TIBI ERVNT/ HÆ ARTES. Right banner: PACIO IMPONERE MOREM. (Ber, Bo, BN, Ham, MMA, Ro)

	B	CC
III	–	–

Plate completed with marbleized columns (Alb, BN, Bo, Fitzwilliam)

Malvasia was the first to attribute this print to Agostino, and all writers since have agreed with his attribution. Although the general compositional technique of including a cartouche supported by *putti* in a niche is typical of Agostino, the general flatness of that cartouche is unlike Agostino's authentic works.[2] In addition, the morphology of the *putti's* faces and the awkwardness of the bodies of harpies suggest that Agostino may not have produced such an engraving.

1 Filippo Sega (1537-1596) was a Bolognese created cardinal by Innocent IX in 1591. See Ciaconi IV, 246-7; Fantuzzi, vol. 7, pp. 372-376; and Berton, p. 11511-11512.

2 The inherent flatness could be a result of the generally very poor impressions of the existing examples of this print.

cat. no. 229, state II. Bologna, Pinacoteca Nazionale

230

Coat of Arms of
Cardinal Lorenzo(?) Bianchetti[1]
(B. 164) c. 1592-1595

Engraving. 222 x 263 mm. (sheet: BM)

Literature: Malvasia p. 79; Oretti p. 813;
Heinecken p. 641, no. 2; LeBlanc 251;
Bertelà 263.

States:

	B
I	I

In plaque below coat of arms: HIS DVCIBVS
(Alb, BM, Bo, Br)

The figures of Religion and Prudence stand on an elaborate pedestal
inexplicably floating in space. This, along with the shorter and wavier
burin lines than usual in Agostino, is the rationale for questioning the
authenticity of the print. Similar compositions and burin technique are
seen in the work of Giovanni Luigi Valesio, and in certain instances a
similar morphology occurs.[2] Conversely, a cartouche corresponding to
this one appears in the accepted *Coat of Arms of a Duke of Mantua* (cat.
no. 195). In addition, the figure of Prudence at right has a decidedly
Carraccesque flavor. If by Agostino, the print must date after 1592,
since Lorenzo Bianchetti was made cardinal after that year. Yet, the
sharpness of drapery and contours and the svelteness of the figures indi-
cate the print was executed before Agostino's Roman period when his
forms became more amplified.

1 The only Bianchetti cardinal listed by Ciaconi was Lorenzo, who was made cardinal
under Clement VIII (i.e., after 1592) and died in 1612 (Ciaconi, IV, columns 304-305).

2 See, for example, the *Arms of Cardinal Lodovisi* (Bertelà 994) and the frontispiece for a
book dedicated to Francesco Palleotto (Bartsch XVIII, p. 242, no. 109; Bertelà 1000).

cat. no. 230, only state. London, the British Museum

231

Portrait of Henry IV
(B. 147) 1595

Engraving. 116 x 96 mm. (after François Bunel)

Literature: Malvasia pp. 89, 293; Oretti p. 833; Heinecken p. 628, no. 6; Gori Gandellini p. 313, no. III; Joubert p. 345; Bolognini Amorini p. 59; Nagler 1835, p. 398; Paul Lafond, *François et Jacob Bunel peintres de Henri IV,* Paris, 1898, p. 22; Paul Lafond, "A Propos de Trois Nouveaux Portraits de Henri IV," *Réunion des Sociétés des Beaux-Arts des Départements* (1904): 143; Bodmer 1940, p. 68.

States:

	B
I	1

Lower left: *Francois Bunel Peintr.* Lower right: *en Paris. 1595.* Around oval: HENRICVS III. DEI GRATIA GALLIÆ ET NAVARRE REX. ÆT. 4. 3. +. (Alb, Fitzwilliam)

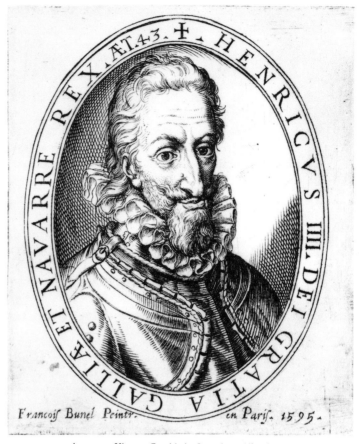

cat. no. 231, only state. Vienna, Graphische Sammlung Albertina

This is one of the most problematic engravings considered to be part of Agostino's oeuvre. The print, found in only two impressions today, was first mentioned by Malvasia in 1678. According to him, Agostino was paid very highly for this work, and the artist remarked that if everyone paid him as well he would be able to live like a king. Other sources have also accepted the sheet. Bodmer noted that Henry IV was honored by the Roman curia in 1595, and thus there would be reason for Agostino to record his likeness on commission the same year. According to Lafond, there were very few of these prints pulled due to the poor likeness of the king, adding to its rarity today.[1]

An infamous portrait of Henry IV by Philippe Thomassin, executed in 1590, is not known in any impression today. At that time Henry IV had not as yet accepted Roman Catholicism and was thus *persona non grata* in Rome. Thomassin was brought before the Roman tribunal and sent to prison for his participation in distributing the likeness of the king.[2] In his defense, Thomassin noted that he had made only twenty-five or thirty pulls of the engraving and that he would destroy them all. Consequently, a valuable record has been lost to us, but we have been informed of the usual number of impressions taken of an engraving of this type.

A further problem facing us in attributing this sheet is the loss of the original painting by Bunel. In fact, no likenesses of the king by Henry's court painter have come down to us. We are left then with a

rather mediocre engraving which, although it is not signed, is inscribed: *Francois Bunel Peintr. en Paris. 1595.* Does the French inscription, found nowhere else in Agostino's oeuvre, indicate that the painting was executed in Paris or that the print itself was made in that city which Agostino had not visited?

The attribution of the engraving rests on a stylistic analysis of the work and on Malvasia's contention that Agostino made a portrait for Henry. Stylistically, the crosshatching within the oval is harsh, the armor is awkward, and the face is unattractive and simply executed. On the other hand, the penetration of the expression is typical of Agostino's portraits. Without the original painting, it is impossible to see the quality of the model with which the artist was working. Malvasia may have been correct in attributing a portrait of Henry IV to Agostino, but with the loss of so many portraits of the king, one wonders whether this is the engraving Malvasia knew.[3]

1 Lafond 1898, p. 22, quoted Mariette as saying that there were few impressions made due to the poor likeness.

2 Edmond Bruwaert, "Le Maitre de Jacques Callot," *La Revue de Paris,* 18, no. 2 (January 15, 1911): 403-404.

3 An interesting comparison with this very simple conception of the portrait is Cherubino Alberti's elaborate engraving of Henry IV, signed and dated 1593 (Bartsch XVII, 93.124). In Alberti's print, Henry, wearing a detailed cuirass, appears in a roundel surrounded with ornamentation of flying *putti,* banners, arms, allegorical figures, fronds, armor, etc. The engraving is so ornate that the portrait of Henry is almost lost in the elaboration of the cartouche.

232

Coat of Arms of Cardinal Aldobrandini[1]
(B. 162) c. 1595

Engraving. 249 x 314 mm. (sheet: BM)

Literature: Oretti p. 801; Heinecken p. 642, no. 11; LeBlanc 249; Bodmer 1940, p. 63; Calvesi/Casale 162 ter; Bertelà 261.

States:

	B	CC
I	1	1

No inscriptions. As reproduced. (Alb, BN, Bo, Dres, Ham)

This print has been accepted by all of the sources and noted by Bartsch as a free variant of cat. no. 198. Although the workmanship of the engraving is competent, it is obvious from the reversed shading that it is a copy. However, the changes incorporated in this print are rather ingenious and indicate that the artist responsible was thoroughly cognizant of the nuances of the original.[2] If by Agostino, it is not surprising that he would be asked to produce several different cartouches for coats of arms for various cardinals of the Aldobrandini family.

1 There were several Aldobrandini cardinals during this period: Ippolito, who was made cardinal in 1586 and became Clement VIII in 1592; Cinzio, made cardinal in 1593 and died in 1610; Pietro, who was made cardinal by Clement VIII in 1595 and died in 1620; Silvestre who was also created cardinal by Clement VIII in 1604 and who died in 1612. Another Ippolito was created cardinal by Gregory XV in 1621. (See Ciaconi IV, 249 ff; 282-287; 344; 483.)

2 For example, see the foreshortening of the mask below the arms; the form is fully integrated into the composition and not merely a substitute for the winged harpy it replaces.

cat. no. 232, only state. Paris, Bibliothèque Nationale

233

Portrait of
Bonaventura Vulcanius
1596

Engraving. 127 x 95 mm.

Unpublished.

States
I

Around oval: BONAVENTURA VULCANIUS
BRUGENSIS. ANNUM AGENS LVIII; AN. DNI (I);
I); XCVI; In oval to left of head: IDEM
OMNIBUS. (Fitzwilliam)

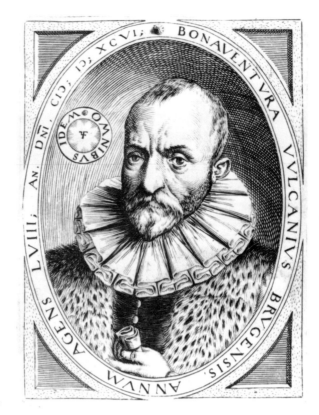

cat. no. 233, only state. Reproduced by Permission
of the Syndics of the Fitzwilliam Museum, Cambridge

Although this author has little doubt that this print is by Agostino, there are several reasons for placing it in the questionable category. The date of 1596 in the inscription would seem to be later than the style of the engraving, which by its simplicity of technique and cartouche appears to be closest to works of the mid 1580s. In 1596 Agostino was concerned more with virtuosity of technique than simplicity of presentation. However, the penetration of the eyes is common to portraits by Agostino, as is the burin technique used for the fur collar and the bodice of the sitter's garment. If one were to accept the rather weak portrait of Henry IV (cat. no. 231), there would be no reason to doubt this sheet. Moreover, Agostino was busy with many commissions during this period, and if he were doing the portrait for purely commercial reasons, there is a possibility that he did not spend much time on its execution. In addition, this portrait of the Flemish Vulcanius and the portrait of Henry IV depict non-Italians. It is intriguing that neither of these engravings reaches the quality which is apparent in Agostino's portraits of his own countrymen.[1] Also, there is only one known example of this print—in the Fitzwilliam Museum, Cambridge—and only two known examples of the portrait of Henry IV. If Agostino were working for a limited audience and needed just twenty-five or thirty examples of the print,[2] perhaps he did not feel the need to lavish the attention that he would on engravings which would reach a wider, and mainly Italian, audience. Likewise, if this print were destined as a frontispiece, it would necessitate the simpler technique involved.

1 See especially the *Portrait of Titian* (cat. no. 145) and the *Portrait of Ulisse Aldrovandi* (cat. no. 204).

2 See cat. no. 231 for a discussion of the number of pulls taken from plates.

234
Coat of Arms of Cardinal Bartolomeo Cesi
(B. 167) c. 1596-1600

Engraving. 143 x 179 mm.

Literature: Malvasia p. 80; Oretti p. 816; Heinecken p. 642, no. 16; Bolognini Amorini p. 57; Nagler 1835, p. 398; LeBlanc 255; Calvesi/Casale 161; Bertelà 266.

States:

	B
I	I

Without letters but with arms of the Cesi family (Alb, BN, Bo, Br)

II	—

Arms effaced (Ber)

This print has been accepted by all the sources cited. It was dated by Calvesi and Casale to c. 1594. The earliest date for the print must be 1596, the year in which Bartolomeo Cesi was made cardinal. Other cardinals of this period in the Cesi family were Pierdonato I, who was created cardinal in 1570 and who died in 1586, and Pierdonato II, who was appointed cardinal in 1641.[1] The style of the engraving comes close to Agostino's works of the 1590s, and therefore one assumes that the arms are those of Bartolomeo Cesi and not of his older relative. Although the print could belong to Agostino, the cartouche is a copy of the one in the print of the *Coat of Arms of a Duke of Mantua* (cat. no. 195) and thus raises questions as to its authenticity.

1 Bartolomeo died in 1622. For information on the various cardinals in the Cesi family see Berton p. 650, and Edoardo Martinori, *Genealogia e Cronistoria di una Grande Famiglia Umbro-Romano I Cesi,* Rome, 1931.

cat. no. 234, state I. Bologna, Pinacoteca Nazionale

PRINTS NOT BY AGOSTINO CARRACCI

Cat. Nos. R I - R 59

The following fifty-nine prints are those here removed from Agostino Carracci's oeuvre. Listed are works attributed to Agostino by either Bartsch or Calvesi and Casale. These two catalogues have been chosen as the basis for considering the artist's oeuvre for several reasons. Bartsch's is the only catalogue raisonné of Carracci prints for which the works listed are still extant. Some of the prints attributed to the artist by Malvasia and others appear to be lost. Calvesi and Casale is the most recent critical work attempting to catalogue the artist's prints and, as such, presents modern opinions as to the authenticity of the engravings. If an extant print attributed to Agostino by cataloguers other than Bartsch or Calvesi/Casale is not listed in this section, it is here rejected. States for the engravings are not given in the beginning of each entry, but if there is more than one, it is mentioned in a footnote. In addition, location of prints is generally omitted.

Anonymous Bolognese, 1597	R I - R IO
Anonymous Bolognese, early seventeenth century	R II
Anonymous Bolognese, seventeenth century	R I2 - R I4
Anonymous Italian, 1577	R I5
Anonymous Italian, sixteenth century	R I6 - R 22
Anonymous Italian, 1582	R 23 - R 24
Anonymous Italian, late sixteenth century	R 25
Anonymous Italian, mid seventeenth century	R 26 - R 27
Francesco Brizio	R 28 - R 37
Francesco Brizio?	R 38 - R 39
Agostino Carracci, Copy of	R 40
Agostino Carracci, Manner of	R 41 - R 44
Luca Ciamberlano	R 45 - R 48
Luca Ciamberlano?	R 49
Anton Eisenhoit	R 50
David de Laude	R 51
Girolamo Olgiati?/Cornelis Cort?	R 52
Philippe Thomassin?	R 53
Domenico Tibaldi	R 54 - R 59

Emblems for the 1597 edition
of *Rime de gli Academici Gelati
di Bologna*

As was explained in the discussion for the *Ricreationi amorose de gli Academici Gelati di Bologna* (cat. nos. 165-174), Agostino did not execute the ten prints which were added to the second issue of the book of poetry published by the Accademia de' Gelati. In 1597 he was in Rome, busy with his work on the Galleria Farnese. More importantly, the execution of these prints is on a cruder technical level than anything here attributed to the master. It is probable that a Bolognese artist training under the Carracci was responsible for these works. Melchiore Zoppio, the founder of the academy and a friend of Agostino's, may have turned to a Carracci student to help him update the 1590 edition by adding further devices in a similar style to those executed by Agostino. The artist also recut the title page and several legends of the earlier prints.[1]

The name of the artist responsible for these prints is difficult to determine. He obviously turned to Agostino's *Gelati* prints for inspiration but was not capable of producing, on this small scale, anything as dramatic as the earlier engravings. His burin technique is rudimentary and searching, and his compositions are crowded from an overzealous attempt to be complete. These characteristics suggest the work of a youthful artist. Stylistically, the engravings are close to the mature works of Oliviero Gatti, who, according to Malvasia, was a pupil of Agostino's.[2] The short, scratchy strokes found here appear in some of Gatti's later engravings. Further similarities are the backward forms of the *putti,* in R 6, to Gatti's *Coat of Arms of Cardinal Cheli,* a signed work,[3] and to the artist's Holy Family series, small-scale sheets marked by the tentative use of the burin.[4]

Information about Gatti is scarce. As a pupil of Agostino's, he would have been in Bologna before Agostino's departure for Rome in 1595. It is quite possible that he stayed on in the city, for he is said to have been active there as a printmaker from c. 1602 to 1626. If so, in 1597 he would have been a likely choice of Zoppio's to prepare these prints.

1 See cat. nos. 167, 171.

2 Malvasia p. 104 mentioned Gatti in passing, saying that he was of Parmesan origin but worked under Agostino as a student. Malvasia did not seem to have had much respect for his engraving style.

3 Signed and dated 1620, reproduced in Bertelà 682.

4 See for example the *Circumcision* (Bartsch XIX. 7, 8), reproduced in Bertelà 621.

R 1

ANONYMOUS BOLOGNESE
1597

L'Avvelenato (Nicolo Coradino)
(B. 236)

Engraving. 65 x 65 mm.

Chapter 5, p. 54

L'Avvelanato (the poisoned or saddened one) was the Gelati's name for Nicolo Coradino. According to Gelli, the emblem means that ice contains an antidote for the deer who is wounded by the bite of a poisonous serpent. He is plunged into the water (or the academic *gello*) which can cure him of the wounds of ignorance.[1] Zani mentioned Coradino in the *Memorie;* he was a *cavaliere* born in Mirandola da Sirpe Onorevole. As a youth he studied humane letters and wrote poetry and prose and in 1599 was *principe* of the Gelati.[2]

1 Gelli, p. 200, no. 746. The motto translates "from ice the antidote."

2 *Memorie,* pp. 337-340.

R 2

ANONYMOUS BOLOGNESE
1597

Il Diretto (Romeo Pepoli)
(B. 237)

Engraving. 69 x 66 mm.

Chapter 6, p. 84

Il Diretto (the straight one) is the name ascribed to Romeo Pepoli who was *principe* of the Gelati in 1600.[1] According to Dolfi, he was a doctor of law and married to Margarita Torfanini.[2]

1 *Memorie,* p. 405.

2 Dolfi, p. 602.

R 3

ANONYMOUS BOLOGNESE
1597

L'Arido (Ippolito Cattaneo?)
(B. 238)

Engraving. 65 x 67 mm.

Chapter 7, p. 85

Literature: Oretti p. 831

The initials I.P. Cat. at the lower center of the print may stand for Ippolito Cattaneo, who was *principe* of the academy in 1596 and 1605.[1]

1 *Memorie,* p. 405. In fact, Oretti said this print, which he attributed to Agostino, was for the *impresa* of Cattaneo.

R 4

ANONYMOUS BOLOGNESE
1597

Il Rugginoso (Ridolfo Campeggi)
(B. 239)

Engraving. 64 x 66 mm.

Chapter 8, p. 87

Il Rugginoso (the rusty one) was the academic title of one of the most famous men in the Accademia de' Gelati, Ridolfo Campeggi (1565-1624). The author of many volumes of poetry, he was *principe* of the academy in 1598 and 1614. He also belonged to other academic societies in Venice and Rome. When he was married to Pantafilea Cattani in 1598, the Accademia de' Gelati dedicated an epithalamium in honor of the wedding. A true Renaissance man, he studied not only poetry but also grammar, philosophy, letters, and law.

1 For the information on Campeggi's life see *Memorie,* p. 405; Dolfi, p. 237; Fantuzzi, 62-65, with a bibliography of Campeggi's work; *Dizionario Biografico degli Italiani,* 17 (Istituto della Enciclopedia Italiana, Rome, 1960), 470-472, also with bibliography; and Mario Emilio Cosenza, *Bibliographical and Biographical Dictionary of the Italian Humanists and the World of Classical Scholarship in Italy, 1300-1800,* 6 (Boston, 1962), 66, also with bibliography.

cat. no. R 1. Anonymous Bolognese, 1597. Washington,
By permission of the Folger Shakespeare Library

cat. no. R 2. Anonymous Bolognese, 1597. Washington,
By permission of the Folger Shakespeare Library

cat. no. R 3. Anonymous Bolognese, 1597. Washington,
By permission of the Folger Shakespeare Library

cat. no. R 4. Anonymous Bolognese, 1597. Washington,
By permission of the Folger Shakespeare Library

R 5

ANONYMOUS BOLOGNESE
1597

L'Irrigato
(B. 240)

Engraving. 67 x 68 mm.

Chapter 9, p. 110

L'Irrigato may stand for Lodovico Marchese, Senator Fachenetti, whose name is given in the *Memorie* as Irrigato and as *principe* in 1620.[1] Of course Fachenetti may not have been the same Irrigato of 1597.

1 *Memorie*, p. 405.

R 6

ANONYMOUS BOLOGNESE
1597

L'Informe
(B. 241)

Engraving. 69 x 68 mm.

Chapter 10, p. 114

There is no coat of arms within the shield of this print, implying that the print is either unfinished or the person to be given the name *L'Informe* (the unformed or shapeless one) had not been chosen.

R 7

ANONYMOUS BOLOGNESE
1597

Il Deliberato (Severo Severi)
(B. 242)

Engraving. 66 x 67 mm.

Chapter 11, p. 119

Severo Severi, *Il Deliberato,* was *principe* in 1609. The *Memorie* called him "Dottore Giurista."[1]

1 *Memorie*, p. 405.

R 8

ANONYMOUS BOLOGNESE
1597

Il Tetro
(B. 243)

Engraving. 62 x 63 mm.

Chapter 12, p. 127

Literature: Oretti p. 831

Il Tetro (the dark one) could have been Angefilao Marescotti, who used this name and was *principe* in 1606.[1]

1 *Memorie*, p. 405. In fact, Oretti claimed this was the *impresa* of Marescotti.

cat. no. R 5. Anonymous Bolognese, 1597. Washington,
By permission of the Folger Shakespeare Library

cat. no. R 6. Anonymous Bolognese, 1597. Washington,
By permission of the Folger Shakespeare Library

cat. no. R 7. Anonymous Bolognese, 1597. Washington,
By permission of the Folger Shakespeare Library

cat. no. R 8. Anonymous Bolognese, 1597. Washington,
By permission of the Folger Shakespeare Library

R 9

ANONYMOUS BOLOGNESE
1597

L'Involto
(B. 244)

Engraving. 69 x 64 mm.

Chapter 13, p. 130

It has not been possible to identify anyone as *L'Involto* (the involved one).

R 10

ANONYMOUS BOLOGNESE
1597

L'Indefesso (Giorgio Contenti)
(B. 247)

Engraving. 66 x 65 mm.

Chapter 16, p. 157

L'Indefesso (the untiring one) was Giorgio Contenti, *principe* in 1607.

1 *Memorie*, p. 405.

R 11

ANONYMOUS BOLOGNESE
early seventeenth century

Print for the Confraternity of Saint Roch
(B. 86) 1603

Engraving. 324 x 240 mm.

Literature: Malvasia p. 84 and note 2; Oretti p. 836; Heinecken p. 636, no. 54; Bolognini Amorini p. 59; LeBlanc 72; Foratti pp. 167-168; Bertelà 204.

Foratti agreed with Zanotti who, in his notes to Malvasia, indicated that the confraternity made the trip to Venice commemorated in this print after Agostino's death.[1] Not only the date, after Agostino's death, but also the style of the print—the lack of light and shade and the relative flatness of the cartouche—indicate that Agostino was not the engraver of this print. There are two similar prints in Bologna which Bertelà suggested are by Valesio, but his authorship is not conclusively proved.[2]

1 He added that the figure of Saint Roch in a medal derives from a pastel by Lodovico Carracci in the Pinacoteca Nazionale.

2 Bertelà noted that Kristeller attributed the design of the print to Francesco Francia.

R 12

ANONYMOUS BOLOGNESE
seventeenth century

Emblem of the Heirs of Giovanni Agocchia and Sforza Certani
(B. 270)

Engraving. 145 x 113 mm.

Literature: Malvasia p. 82; Oretti p. 827; LeBlanc 146.

Although the writers who mentioned this rare print accepted it as a work of Agostino's,[1] the extremely dry hatching is more characteristic of such followers as Francesco Brizio and Luca Ciamberlano. Moreover, if this print is the emblem for the heirs of Monsignor Giovanni Battista Agucchi (Agocchi, Agocchia), who lived from 1570 to 1632, then the *terminus post quem* for this work must be 1632, long after Agostino's death.[2]

1 Known in only two impressions: at the Bibliothèque Nationale in Paris and the Albertina in Vienna.

2 For information on Agucchi, friend of the Carracci and important seventeenth-century art theorist, see Mahon, pp. 60 ff.; 111 ff. with bibliography.

cat. no. R 9. Anonymous Bolognese, 1597. Washington, By permission of the Folger Shakespeare Library

cat. no. R 10. Anonymous Bolognese, 1597. Washington, By permission of the Folger Shakespeare Library

cat. no. R 11. Anonymous Bolognese, early seventeenth century. Bologna, Pinacoteca Nazionale

cat. no. R 12. Anonymous Bolognese, seventeenth century. Paris, Bibliothèque Nationale

R 13

ANONYMOUS BOLOGNESE
seventeenth century

*Emblem of Giovanni Fiumi's
Shop*
(B. 269)

Engraving. 160 x 126 mm.

Literature: Malvasia p. 81; Oretti pp. 823-824;
Heinecken p. 642, no. 14; Nagler 1835,
p. 399; LeBlanc 145.

This print, known in only one impression (Vienna, Albertina), has been accepted by writers since Malvasia. However, it has not been discussed by modern critics of the Carracci, perhaps owing to its rarity. Unfortunately, it has been impossible to find anything written about the "fabrica di Gio: Fiumi," and consequently the print cannot be dated from the inscription. The artist who executed the engraving was familiar with the prints not only of Agostino Carracci but also of Cherubino Alberti, whose rather irregular and scratchy hatching is similar to that used in this print. One Bolognese artist to work in this style was Lorenzo Tinti (1634-c. 1672). Tinti was a little-known printmaker who executed a title page after Agostino's 1590 *Ricreationi Amorose degli Academici Gelati*. Nevertheless, little comparative material is available, and the attribution to him must remain tentative.

R 14

ANONYMOUS BOLOGNESE
seventeenth century

Emblem of the Sforza Certani

Engraving. 145 x 114 mm.

Literature: Calvesi/Casale 167; Bertelà 277.

This print was not cited by Bartsch; it was first attributed to Agostino by Calvesi and Casale, followed by Bertelà. The only impression known to the author is in Bologna. The crudity of the hatching and unusual facial types preclude Agostino's authorship. However, Lorenzo Tinti[1] is a possible candidate. The family by the name of Sforza Certani is unknown to this writer.

1 See R 13 for information on Tinti.

R 15

ANONYMOUS ITALIAN 1577

Saint James the Major
(B. 70) 1577

Engraving. 422 x 285 mm. (sheet: Alb)

Literature: LeBlanc 63; Nagler 1835, p. 396;
Petrucci p. 133; Ostrow 9.

The early date of 1577 on this print led Bartsch to express some doubt when attributing it to Agostino. On the other hand, Petrucci accepted the print wholeheartedly, while Ostrow rejected it on the basis of the early date. Because the publisher, Francesco Testa, was a Roman, Petrucci advanced the theory that Agostino made a trip to Rome in 1577. This sheet is far more technically and stylistically sophisticated than Agostino's two dated reproductive prints of 1576, and such a remarkable change is unlikely to have occurred in one year.

The pose of St. James is obviously based on the print of *St. John the Baptist* by Giulio Campagnola (Bartsch XIII, 371.3), and the figure, shown from a similar angle, is reversed.[1] These elements and the linear handling of the figure suggest a late follower of Marcantonio Raimondi. The artist had also seen the Roman works of Cornelis Cort, whose landscape style is evident here.

1 For a discussion of Campagnola's print and its sources in Mantegna and/or Mocetto see A. M. Hind, *Early Italian Engravings,* part II (London, 1948), 201, no. 12, and 164, no. 9.

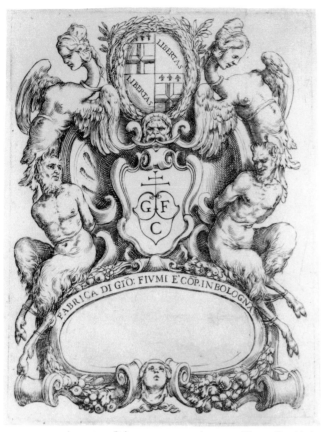

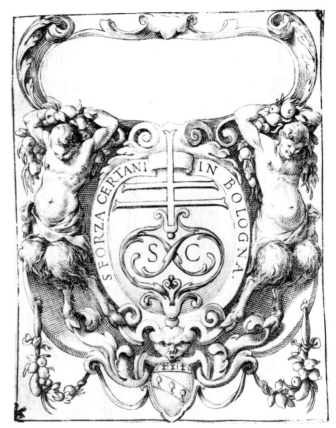

cat. no. R 13. Anonymous Bolognese, seventeenth century. Vienna, Graphische Sammlung Albertina

cat. no. R 14. Anonymous Bolognese, seventeenth century. Bologna, Pinacoteca Nazionale

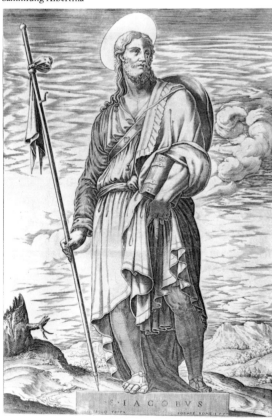

cat. no. R 15. Anonymous Italian, 1577. Vienna, Graphische Sammlung Albertina

R 16-R 22

ANONYMOUS ITALIAN
sixteenth century

Various Masks
(B. 250-256)

Engravings. Each measuring about 75 x 61 mm. (sheets, Alb)

Literature: Malvasia p. 82 and note 1; Oretti p. 840, Bolognini Amorini p. 59; Heinecken p. 641, no. 23 ff.; LeBlanc 130-136; Bodmer 1940, p. 71.

Accepted by Malvasia, Oretti, Heinecken, and Bartsch, who ascribed them to Agostino's first manner, these seven prints were rejected by Bodmer and ignored by others. Their quality is too low to ascribe them even to Agostino's apprentice period. Their style is rather that of a late follower of Marcantonio and his school.

A cursory comparison with Agostino's drawing of a mask in the Ashmolean (fig. R 16a),[1] makes it clear that the author of the drawing was not the author of the prints. The former is lively, with a sense of movement to the face and beard, whereas the latter lack any kind of sympathetic rendering and instead portray static, flat forms.[2]

1 Ashmolean, Parker 147. Pen and brown ink. Laid down. 115 x 115 mm.

2 R 19 differs from the other prints in representing a screaming head rather than a mask. The head is based on Leonardo and was taken up later in one of Ciamberlano's prints for the *Scuola perfetta* . . . (Bartsch XVIII, 162.27).

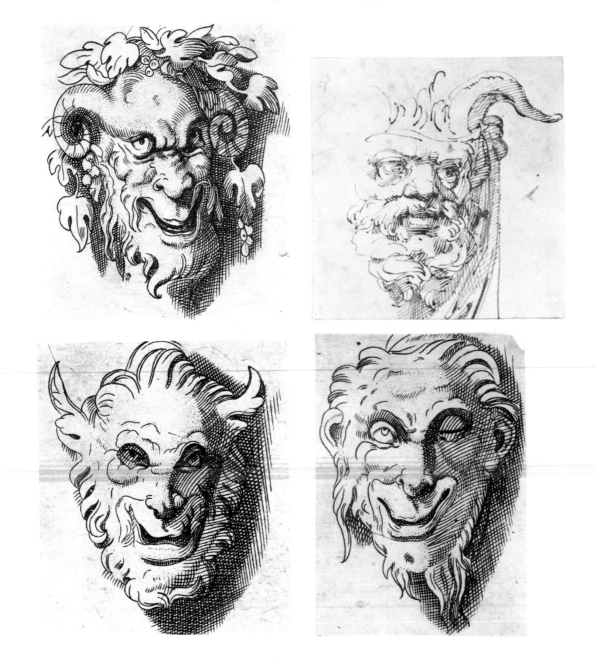

R 23

ANONYMOUS ITALIAN 1582

Aeneas and Anchises
(B. 111) 1582

Engraving. 194 x 145 mm.

Literature: Heinecken p. 637, no. 2; Nagler 1835, p. 397; Mariette IV, 258?; LeBlanc 183; Bodmer 1940, p. 71; Ostrow 30.

Aeneas and Anchises was accepted as an authentic Agostino engraving until it was correctly rejected by Bodmer, followed by Ostrow. The loose, feathery hatching of the landscape is foreign to Agostino's burin technique of 1582, the date on the print. The work was published by Luca Bertelli, for whom Agostino worked this year in Venice,[1] but his Venetian engravings, as noted by Ostrow, emphasized tonal contrasts, missing in this work. If the date on the engraving is correct (and there is no reason to doubt it), the work could not come from Agostino's hand.

1 See Appendix I for information on Bertelli.

R 24

ANONYMOUS ITALIAN 1582

Dancing Nymphs
(B. 113)

Engraving. 211 x 147 mm. (sheet: BN)

Literature: Malvasia p. 80; Oretti p. 810? 814?; Heinecken p. 638, no. 9; Bolognini Amorini p. 57; Nagler 1835, p. 397; LeBlanc 127; Bodmer 1940, p. 71; Bertelà 220.

This engraving was accepted by all writers except Bodmer. Although the features of some of the nymphs approach those in Agostino's *Reciprico Amore* and *Love in the Golden Age* of the early 1590s (cat. nos. 191-192), the engraving must date to 1582, so closely does it approach the *Aeneas and Anchises* (cat. no. R 23) of that year. In addition, the similarity of composition, burin technique, inscription, and measurements determine that this work is a companion piece to the other engraving. The same hand was at work on each.

R 25

ANONYMOUS ITALIAN
late sixteenth century

Portrait of Cesare Rinaldi
(B. 151) 1590

Engraving. 70 x 59 mm.

Literature: Malvasia pp. 83 and 293; Oretti pp. 840-841; Crespi, p. 2; Heinecken p. 628, no. 10; Bolognini Amorini p. 59; Nagler 1835, p. 398; LeBlanc 240; Bodmer 1940, pp. 68, 71; Bertelà 254.

This portrait forms the frontispiece to the third part of the book of poetry by Cesare Rinaldi.[1] All early sources accepted Malvasia's attribution of the engraving to Agostino, although Bartsch admitted that there was little of his style recognizable here. Later, Bodmer rejected the print.

Agostino was a friend of Rinaldi's, and thus it seems likely that he would have been asked to do the poet's portrait.[2] Rinaldi wrote a sonnet for Agostino's funeral and was lauded by Malvasia, whose teacher he was.[3] Because of Malvasia's connection with Rinaldi, his attribution of the portrait of Rinaldi to Agostino would seem to be accurate. On the other hand, perhaps Rinaldi never spoke of the portrait, and Malvasia, knowing the poet and the artist had been friends, assumed it was by Agostino. The stylistic analysis of this print speaks in favor of the latter contention. The stippling for the face is not found in authentic prints by Agostino, and the lack of connection between head and torso indicates a lesser artist. That artist was obviously influenced by Agostino's portraits of the eighties, such as those in the *Cremona Fedelissima,* and perhaps also by the 1590 portrait of Giovanni Battista Pona (cat. no. 175). The short parallel strokes used to delineate the hair and the closely spaced strokes for the costume are traits that the artist picked up from Agostino.

1 The title found on this book is: DELLE RIME/DI CESARE RINALDI/BOLOGNESE/ PARTE TERZA/ ALLA ILL.MA ET ECC.MA SIG.RA LA SIG.RA/ PELLEGRINA CAPELLO/ BENTIVOGLIA. The book was published by the Benacci in 1590 in Bologna.

2 Malvasia said, "il Rinaldi suo grande amico."

3 The sonnet is reprinted in Malvasia p. 312. Found in Morello p. 44. See Malvasia pp. 433-434 for his appreciation of Rinaldi. For a short biography of the poet, see Fantuzzi, VII, pp. 187-188.

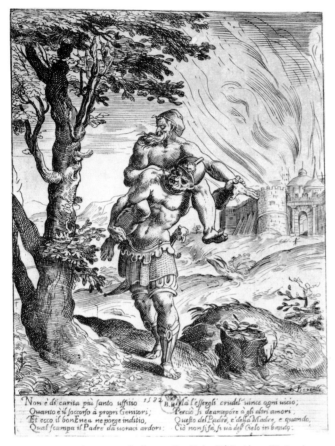

Non è di carita più santo uffitio 1582 B. viVa l'essergli crudel vince ogni vicio;
Quanto è il soccorso à proprij Genitori; Perciò si deamopore à gli altri amori;
Et ecco il bonEnea ne porge inditio, Questo del Padre, e della Madre, e quando,
Qual scampa il Padre da voraci ardori; Ciò non si fa, si va del Cielo in bando;

cat. no. R 23. Anonymous Italian, 1582. Paris, Bibliothèque Nationale

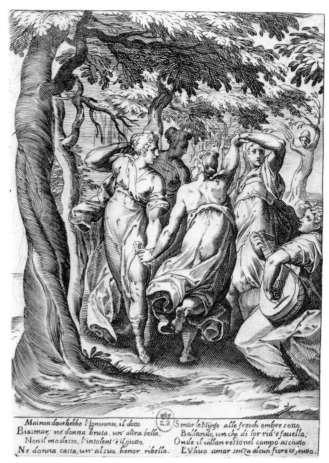

Mainon dourkebbe l'Ignorante, il dotto Sentir le Ninfe alle fresch ombre sotto.
Biasmar; ne donna bruta un'altra bella. Ballando, un che di lor rid'e fauella:
Non il modesto, l'insolent'è il giotto, Onde il villan restò nel campo asciutto
Ne donna casta, un'al suo honor ribella. L'Vhuo amar senza alcun fiore o frutto.

cat. no. R 24. Anonymous Italian, 1582. Paris, Bibliothèque Nationale

cat. no. R 25. Anonymous Italian, late sixteenth century.
Berlin (Dahlem), Staatliche Museen Kulturbesitz
Kupferstichkabinett

R 26

ANONYMOUS ITALIAN
mid seventeenth century

Portrait of Pietro Opezingo

Engraving. 133 x 103 mm.

Literature: Calvesi/Casale 155; Bertelà, suppl. 754.

Calvesi and Casale attributed this portrait and the following to Agostino on the basis of the inscription in the lower right: *A.C. fe.*[1] Although the style is reminiscent of Agostino's, the costume and hair style come from a much later period—well into the seventeenth century. In fact, Pietro Opezingo, who was a Palermitan nobleman and military man, died in Rome in 1677.[2]

1 Around the oval of the portrait is written PETRUS OPEZINGUS PATRITIUS PANORMITANUS D. The print is found in Bologna and Rome.

2 See Giuseppe M. Mira, *Bibliografia Siciliana ovvero Gran Dizionario Bibliografico,* I (Palermo, 1875), 143.

R 27

ANONYMOUS ITALIAN
mid seventeenth century

Portrait of Obizzo Annibale Marescalchi

Engraving. 133 x 101 mm.

Literature: Calvesi/Casale 156; Bertelà, suppl. 755.

This engraving, by the same hand as R 26, can also be dated much later than Agostino's lifetime.[1] In 1670 when Dolfi wrote his biography,[2] Obizzo Annibale Marescalchi was a colonel of the Bolognese militia.

1 The print is found in Bologna and also, according to Calvesi/Casale, in the Raccolta Civile, Milan.

2 For a short biography see Dolfi, 522 and Fantuzzi, 236.

cat. no. R 26.　Anonymous Italian, mid seventeenth century.
Bologna, Pinacoteca Nazionale

cat. no. R 27.　Anonymous Italian, mid seventeenth century.
Bologna, Pinacoteca Nazionale

R 28-R 37

FRANCESCO BRIZIO
(Bologna 1575-1623)

Brizio was a painter, architect, and printmaker, known mostly for his engravings after the Carracci. He studied with Bartolomeo Passerotti and later with Lodovico Carracci, with whom he worked on the frescoes of S. Michele in Bosco and whose drawings, mostly of coats of arms, he engraved. His collaboration with Agostino Carracci included finishing Agostino's last engraving (cat. no. 213), and with Guido Reni, he produced prints for Morello's publication on the funeral of Agostino. His engraving style is based on that of Agostino; he was an apt technician, but his figures tend toward a flatness, and his morphology is awkward. In spite of this, he seems to have been a favorite of the Carracci. Besides reproducing designs by that family, Brizio engraved after such Emilian artists as Parmigianino and Correggio. He was an active printmaker; Bartsch listed thirty works under his name. Although important as a key to understanding the school of the Carracci in Bologna, Brizio has not been studied thoroughly, and his graphic style is still not well understood. His first biography, that by Malvasia, is still the most complete. In the twentieth century, he is usually mentioned only in passing. Fortunately, the large collection of his engravings in Bologna is reproduced in Bertelà.

Bibliography: Malvasia pp. 379-384. For publications until 1972, see A. Ottani's enlightening biography in *Dizionario biografico degli italiani*, 14 (Rome, 1972), 369-370; Bertelà 37-60. See also Fiorella Frisoni, "Per Francesco Brizio," *Paragone*, 323 (January, 1977): 72-84.

R 28

FRANCESCO BRIZIO

Virgin Nursing the Christ Child in a Landscape
(B. 39) 1595

Engraving. 307 x 224 mm. (after Agostino Carracci)

Literature: Bellori p. 116; Malvasia pp. 88, 293; Heinecken p. 234, no. 28; Gori Gandellini p. 314, no. XVI; Nagler 1835, p. 396; Nagler I, 326(1); LeBlanc p. 599; Bodmer 1940, p. 71; Wittkower under 260; Calvesi/Casale 170; Ostrow 49; Bertelà 160.

Most writers have attributed this work to Francesco Brizio after an invention by Agostino.[1] The finely engraved burin lines with the feathery and furlike grass is typical of Brizio's work and is seen also in his engraving after Agostino of a *Satyr Spying a Sleeping Woman* (cat. no. R 30). The inscription, A·C·I· *1595* in the lower left indicates that the design of the composition is Agostino's. There are several extant drawings in reverse of the engraving, the best of which (in the British Museum) is incised, but none seems to be Agostino's original, which in Malvasia's day was in the collection of Coradino Areosti.[2]

1 Bellori and Gori Gandellini accepted the engraving. Malvasia listed it under works after Annibale Carracci but noted that the original drawing was by Agostino. Bartsch included the work in his listing of Agostino's prints but still rejected it, citing Brizio as the engraver. Both Bodmer and Calvesi/Casale doubted the engraving.

2 The drawing in the British Museum (Pp 3-4. Pen and brown ink. Laid down. 336 x 228 mm., fig. R 28a) is in such poor condition, it is difficult to attribute it with confidence, but it appears to be a copy and may be Brizio's working drawing after Agostino's original. A note on the mat by Rudolf Wittkower attributes the sheet to Agostino. A copy of the drawing in Windsor Castle (Wittkower 260) was attributed by Wittkower (with a question mark) to Brizio. According to Nancy Ward Neilson, there is also a copy in the Uffizi (Inv. 11030), listed there as anonymous Lombard school.

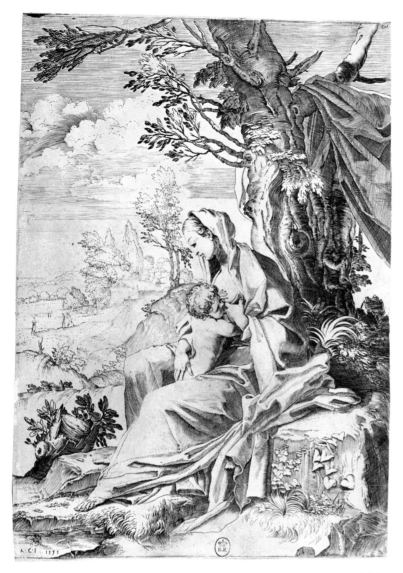

cat. no. R 28. Francesco Brizio.
Paris, Bibliothèque Nationale

fig. R 28a. Francesco Brizio?, *Virgin Nursing the Christ Child
in a Landscape.* London, The British Museum

R 29

FRANCESCO BRIZIO

Mary Magdalen
(B. 83)

Engraving. 231 x 182 mm. (after Lodovico
Carracci?)

Literature: Malvasia p. 74; Nagler 1835, p. 396;
LeBlanc 84; Bodmer 1940, p. 71; Bertelà 202.

Malvasia listed this engraving among those after Lodovico Carracci and
attributed it to Valesio. Bartsch, on the other hand, included it in his
list of works by Agostino but gave the execution to Francesco Brizio.
The peculiar morphology of the face and the fine burin work strongly
suggest that Brizio is the author.[1]

The design for the composition could well be by Lodovico, whom
Brizio often engraved, but this type of Mary Magdalen seen in supplica-
tion close up is based ultimately on Titian.[2]

1 Bartsch knew the print only in a later state with the addition of the publisher's mark
in the lower right in the margin: *Nicolo van aelst formis.* There is also an unpublished
earlier state (BN, Br, and Stu) with only the legend in the margin: SPECULUM PENITEN-
TIAE.

2 Cf. Harold E. Wethey, *The Paintings of Titian I. The Religious Paintings* (London,
1969), pls. 182-183.

R 30

FRANCESCO BRIZIO

Satyr Spying a Sleeping Woman
(B. 112)

Engraving. 187 x 127 mm. (After Agostino
Carracci)

Literature: Gori Gandellini p. 315, no. xxx;
Nagler 1835, p. 397; LeBlanc 121; Bodmer
1940, p. 71; Calvesi/Casale 178; Bertelà 219.

Although Bartsch listed this print, he was unsure of the attribution to
Agostino and suggested the name of Valesio.[1] Bodmer rejected it out-
right. Calvesi and Casale reinstated the print to Agostino's oeuvre and
dated it very late, proposing that it was among the prints which
Lodovico took to Rome in 1604.[2]

The composition and subject matter are so similar to Agostino's
Lascivie that one must accept the print's design as his. Calvesi and Casale
were probably correct in a late dating of the work. The execution, how-
ever, is not Agostino's, nor is it similar to any of Valesio's prints. It is,
rather, characteristic of Francesco Brizio's style. Unlike Agostino, Brizio
favored abrupt linear contrasts within a single engraving, seen here in
the wide burin work of the figures and the delicate, furlike flicks of grass
on the rocks. The same technique may be observed in Brizio's *Virgin
Nursing the Christ Child in a Landscape* (cat. no. R 28).

1 First state without letters. The more common second state is inscribed in the lower
center: *Andrea Vaccario Forma in roma 1604.*

2 For Lodovico's Roman trip see Lodovico, cat. no. 4.

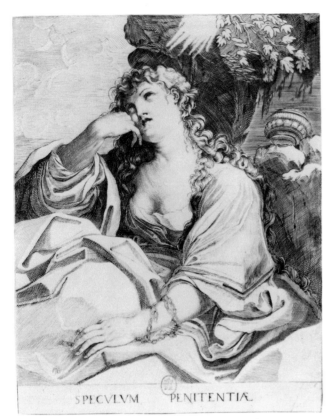

SPECVLVM PENITENTIÆ

cat. no. R 29. Francesco Brizio. Paris, Bibliothèque Nationale

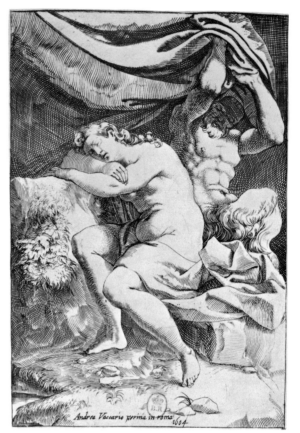

Andrea Vaccario perina in roma
1604

cat. no. R 30. Francesco Brizio. Paris, Bibliothèque Nationale

R 31

FRANCESCO BRIZIO

Coat of Arms of Cardinal Bartolomeo Cesi[1]

(B. 163)

Engraving. 219 x 330 mm. (sheet: Alb) (after Lodovico Carracci?)

Literature: Malvasia p. 77; Oretti p. 800?; Heinecken 641, no. 1; Nagler 1835, p. 399; LeBlanc 250; Bodmer 1940, p. 71.

Bartsch believed this sheet to be an early work by Agostino after his cousin Lodovico's design.[2] Bodmer correctly rejected it. The design may in fact be by Lodovico, but the engraver must be Francesco Brizio, not Valesio as purported by Malvasia. The soft, wavy, delicate burin strokes are characteristic of his style as is the peculiar morphology of the *putti*, apparent in his famous print after Lodovico of the *Coat of Arms of Cardinal Aldobrandini*.[3]

1 These arms must be those of Bartolomeo Cesi (1568-1621). There were two other cardinals in the Cesi family around this period (c. 1580-1620): Pierdonato I (1521-1586) who was made cardinal in 1570 and Pierdonato II (1585-1656) who was elevated to the purple in 1641. The style of this print indicates that it was done after Pierdonato I died and before Pierdonato II was made a cardinal. Thus the arms must belong to Bartolomeo Cesi who was elevated to the cardinalate by Clement VIII in October 1596 with the title of S. Maria in Portico. Consequently, the arms must date from after 1596. (For biographical information on the Cesi family see Edoardo Martinori, *Genealogia e Cronistoria di una Grande Famiglia Umbro-Romano I Cesi* (Rome, 1931).

2 Bartsch mentioned only the arms of the Bianchetti family, but these arms are found only the second state. The first state portrays the Cesi family arms. The only Bianchetti cardinal of the sixteenth century was Lorenzo di Cesare Bianchetti (1545-1612), who received the purple in 1596 (Dolfi, p. 146; Cardella VI, p. 35). The print is extremely rare: only one example of the first state exists, in the Albertina in Vienna, and there are two examples of the second state—one in the Albertina and one in Berlin (Dahlem) Kupferstichkabinett.

3 Bartsch XVIII, 261-2, 15.

R 32

FRANCESCO BRIZIO

Coat of Arms of Cardinal Antonio Fachenetti?[1]

(B. 168)

Engraving 197 x 279 mm.

Literature: Oretti p. 811; Heinecken p. 643, no. 17; LeBlanc 256, Bodmer 1940, p. 71; Bertelà 1003.

This print was accepted by Oretti, Bartsch, and Heinecken but rejected by Bodmer, who attributed the engraving to Brizio. Later, Bertelà gave it to Valesio. Although the undulating lines are characteristic of Valesio's prints, they are also found in Brizio's works. In addition, the facial types of the *putti*, especially that on the left, are evidence of Brizio's hand.

1 The two Fachenetti cardinals of the sixteenth and early seventeenth centuries were Giovanni Antonio and Antonio. Giovanni Antonio Fachenetti was created cardinal in 1583 and elected pope in 1591. As the style of this print is later than the period 1583 to 1591, it is likely that the arms belong to Antonio Fachenetti, who was made cardinal in 1591 with the title SS. Quattro and who died in 1612 (see Ciaconi, IV, 247-8 and Dolfi, pp. 294-295). Bertelà believed the arms could be those of Cardinal Vincenzo Lauro di Tripea.
 Only two examples of this print are known, one in the Albertina and one in Bologna.

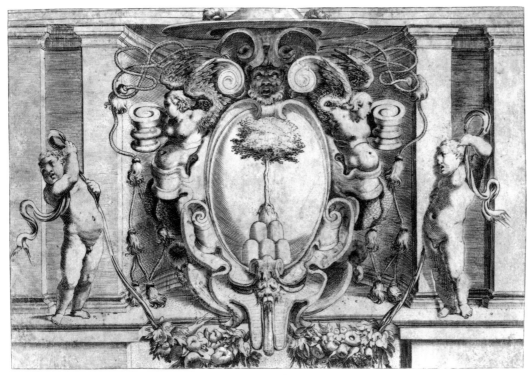

cat. no. R 31. Francesco Brizio. Vienna, Graphische Sammlung Albertina

cat. no. R 32. Francesco Brizio. Vienna, Graphische Sammlung Albertina

R 33

FRANCESCO BRIZIO

Coat of Arms of Cardinal Sampieri[1]
(B. 178)

Engraving. 124 x 104 mm.

Literature: Oretti p. 818; Heinecken p. 643, no. 29; LeBlanc 266; Bodmer 1940, p. 64

The print, found only at the Albertina and the Bibliothèque Nationale, was accepted by the critics and dated variously: early, by Bartsch, and c. 1593-1595, by Bodmer. It seems, however, that the scratchy quality of the hatching and the emphasis on curvilinear forms bespeaks the hand of Francesco Brizio rather than Agostino.

1 Neither Ciaconi nor Berton mentioned any members of the Sampieri family in their lists of cardinals.

R 34

FRANCESCO BRIZIO

Cartouche with Cornucopiae
(B. 266)

Engraving. 105 x 82 mm. (sheet: Alb.)

Literature: Malvasia p. 84; Oretti pp. 835-836; Heinecken p. 642, no. 1; Nagler 1835, p. 399; LeBlanc 142.

All writers mentioned attributed this sheet to Agostino; however, Zanotti, in his annotations to Malvasia, gave it to Villamena. It seems likely that the engraving is by Francesco Brizio, whose similar compositional and burin techniques are found in the frontispiece to Morello's account of Agostino's funeral (Bartsch XVIII.268.29) and in the *Announcement of a Meeting of the Accademia degli Incamminati* (cat. no. R 37). Also akin and by the same hand is the engraving of *The Coat of Arms of Cardinal Sampieri* (cat. no. R 33).[1]

1 This print is known only in the impression in the Albertina.

cat. no. R 34. Francesco Brizio. Vienna, Graphische Sammlung Albertina

cat. no. R 33. Francesco Brizio. Paris, Bibliothèque Nationale

R 35

FRANCESCO BRIZIO

Bear and a Bee
(B. 258)

Engraving. 125 x 152 mm. (sheet: BM) (after Agostino Carracci)

Literature: Malvasia p. 83; Oretti p. 833; Heinecken p. 640, no. 8; Bolognini Amorini p. 59; LeBlanc 138; Bodmer 1940 p. 7.

Malvasia attributed this charming engraving to Agostino, but Bartsch suggested that Brizio was the actual engraver, working after a design by Agostino. Other sources accepted the print until Bodmer rejected it in 1940, and since then there has been silence. Bartsch was correct in his rejection of the work, its reattribution to Brizio, as well as in the attribution of the design to Agostino. As far as the execution of the engraving is concerned, the very delicate burin work is seen almost without exception in Brizio's oeuvre. Typical signed examples include the *Saint Roch* after Parmigianino (Bartsch XVIII. 258. 9) and the *Rest on the Flight into Egypt* after Correggio (Bartsch XVIII.225.4). In the *Virgin Nursing the Christ Child in a Landscape* (cat. no. R 28) and the *Satyr Spying a Sleeping Woman* (cat. no. R 30), here attributed to Brizio, the same use of lightly applied burin imparts a feathery quality to the forms. Brizio most often used this technique when defining grass or, as here, fur.

There are several drawings by Agostino with studies of bears which are similar to this print, leading one to accept Agostino as the author of the composition. One delightful example at Windsor Castle (fig. R 35a) and another at the Courtauld (fig. R 35b), although not connected with this print, are close enough in general stylistic concept to consider the possibility of a lost drawing by Agostino from which Brizio worked. The *terminus post quem* for the Windsor drawing is 1595,[1] and one would definitely assume that Agostino's design for this print was also late in his career.[2]

1 For the dating of the Windsor sheet (Inv. 2002, Pen and brown ink and wash, 257 x 195 mm. Laid down), see Wittkower 158 and his interesting discussion, in which he noted that Agostino was probably considering an emblem for the Carracci family with the motto "Immortale." Francesco, whose name appears on the drawing, was not born until 1595. The drawing in the Courtauld Institute of Art (Inv. no. 1159, Witt Collection) has been attributed to Annibale Carracci (photo in Witt Library) and at the Courtauld to Sinibaldo Scorza (1589-1631), whose style it does not approach. The sheet in pen and brown ink (270 x 168 mm., lower right: *Titiano.* Collections: I. P. Zoomer, Robert Witt) looks like Agostino's drawings in an engraver's technique after his trip to Rome (1594 on). Unlike the playful bear in the Windsor sheet, this one is far more forbidding and is drawn with more formal pen technique. Parts of the sheet have been reinforced, probably by another hand.

2 This print, found only at the British Museum, London, the Albertina, Vienna, and the Kupferstichkabinett, Dresden, does not come in good impressions. The print reproduced here is finished by hand on the left—the hind legs—in brown ink.

fig. R 35a. Agostino Carracci, *Various Studies.* Windsor Castle, Royal Library, Her Majesty Queen Elizabeth II

fig. R 35b. Agostino Carracci?, *Bear.* London, Courtauld Institute of Art

cat. no. R 35. Francesco Brizio. London, the British Museum

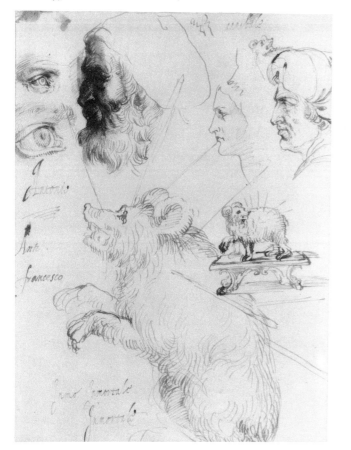

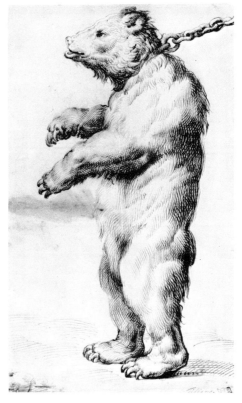

R 36

FRANCESCO BRIZIO

Title page to the *Tempio all'Illustrissimo et Reverendissimo Signor Cinthio Aldobrandini* (B. 261) 1600

Engraving. 178 x 122 mm.

Literature: Malvasia pp. 80-81, and note 4; Oretti p. 819; Nagler 1835, p. 399; Bolognini Amorini p. 57; Heinecken p. 620 and p. 643, no. 5; LeBlanc 221; Bodmer 1940, p. 64; Wittkower under no. 179; Calvesi/Casale 166; Bertelà 295.

This print was accepted by all critics except Zanotti and Wittkower.[1] Wittkower and Bodmer published the preparatory drawing for the print in Windsor (Inv. no. 1859). Although both accepted the drawing as Agostino's, Wittkower suggested that the print may be by Valesio, as Zanotti had contended earlier. In the opinion of this author, both drawing and print are by Francesco Brizio. One may compare the facial morphology and figural placement with Brizio's *Coat of Arms of Cardinal Altieri.*[2]

The sources unanimously dated the print about 1593-1594 noting that Cinzio Aldobrandini became a cardinal with the title S. Giorgio in 1593. Yet, this engraving forms the title page to the book *Tempio all' . . .*, published by the heirs of Giovanni Rossi in Bologna in 1600.[3] The print probably dates from the same period.

1 Zanotti noted that Pasinelli attributed the print to Valesio.

2 Reproduced Bertelà 55. Not in Bartsch.

3 An example of the book with the title page is found in the Biblioteca Archiginnasio in Bologna.

R 37

FRANCESCO BRIZIO

Announcement of a meeting of the Accademia degli Incamminati (B. 272)

Engraving. 137 x 99 mm.

Literature: Malvasia pp. 82-83; Oretti p. 829; Heinecken p. 641, no. 21; Bolognini Amorini p. 59; LeBlanc 148; Bodmer 1935, p. 62; Bodmer 1940, p. 71.

Although Malvasia attributed this engraving to Agostino, Bartsch gave it to Francesco Brizio. Bodmer had accepted it in 1935 but rejected the print in 1940. Because of the simplicity of the composition and burin technique, it is difficult to attribute the sheet on stylistic grounds; however, there exists another engraving which appears to be by the same hand. The second engraving is the title page to *Il funerale d'Agostin Carraccio* (Bartsch XVIII.268.29), published in 1603. The title page is traditionally attributed to Francesco Brizio, who is known to have made prints for the publication along with Guido Reni and others.[1] On the basis of this comparison and the traditional attribution to Brizio, it seems safe to add this sheet to his oeuvre. A date of about the same time as that of the funeral of Agostino, in the early years of the seventeenth century, is appropriate.[2]

1 Malvasia, p. 297 in his discussion of the funeral and the subsequent publication by Morello: ". . . lo disegnò l'istesso Lodovico, l'intagliò il Brizio e Guido, . . ."

2 This print is extremely rare, known in only two examples, one at the Bibliothèque Nationale in Paris, the other in the Albertina, Vienna.

cat. no. R 36. Francesco Brizio. Boston, Museum of Fine Arts, Harvey D. Parker Collection

cat. no. R 37. Francesco Brizio. Paris, Bibliothèque Nationale

R 38

FRANCESCO BRIZIO(?)

Portrait of Dr. Gabriele Faloppio
(B. 144)

Engraving. 166 x 125 mm.

Literature: Malvasia p. 86; Heinecken p. 628, no. 15; LeBlanc 233; Bolognini Amorini p. 57?; Foratti, p. 174; Petrucci p. 139; Bertelà 252.

This print, found in two states, is quite rare.[1] Bartsch rejected the print but acknowledged the design to be Agostino's. The engraving itself was originally attributed to the artist by Malvasia. LeBlanc doubted the piece. Foratti, who accepted it, noted an influence of Dürer, and Petrucci suggested that the work was done by a student of Agostino's. This suggestion appears sound in the face of the burin technique, which was used by Agostino and his followers. The gridwork of hatching on the sleeve, for example, is of a type first used by Agostino in his *santini* of 1581 (cat. nos. 40-49). The closely spaced hatching on the chair back and in the fur are traits which appeared early in his portraits for the *Cremona Fedelissima* (cat. nos. 60-92). Yet, the entire composition lacks the vitality of Agostino and looks much flatter, characteristics of Francesco Brizio.[2]

The portrait may have been destined as a frontispiece to a posthumous edition of one of Faloppio's books, which were enormously popular and came out in many editions.[3]

1 State I is without inscriptions (found at Alb, Bo, and MMA). State II, also without inscriptions, has been recut (found at BM).

2 Most notably in his *Virgin Nursing the Christ Child in a Landscape* (cat. no. R 28) and the signed *Virgin and Child with St. Joseph* after Correggio (Bartsch XVIII.255,4).

3 Gabriele Faloppio (Modena 1523-1562) was an excellent anatomist and surgeon, known primarily for his work on the fetus and reproductive tract. His best-known work is *Observationes anatomicae*, first published in Venice in 1561 but appearing in numerous subsequent editions. He appears in this print to be about forty or fifty, indicating that the engraver had an earlier portrait model from which to work.

R 39

FRANCESCO BRIZIO(?)

Coat of Arms of Cardinal Antonio Fachenetti(?)[1]
(B. 169)

Engraving. 202 x 281 mm. (sheet: Alb)

Literature: LeBlanc 257; Bodmer 1940, p. 63.

Bartsch dated this print early in Agostino's career, but Bodmer correctly rejected it. Francesco Brizio is a good candidate for the authorship of such a print: his compositions are similar, burin technique almost identical, and the figures similarly misshapen.

1 According to Berton (p. 888-889) the cardinals of the Fachenetti family of this period were Giovanni Antonio, who became Pope Innocent IX in 1591 and Antonio (born in 1573), whom Innocent IX created cardinal in 1591. (See also Ciaconi IV, columns 247-8.) The style of the sheet suggests a period after 1591, and most likely after 1600, and it seems likely that the arms portrayed are those of Antonio. The print is rare; the only known example is in the Albertina.

R 40

COPY OF AGOSTINO CARRACCI

Cartouche for the Coat of Arms of a Pope
(B. 158)

Engraving. 91 x 69 mm.

Literature: Malvasia p. 84?; LeBlanc 271

This print[1] is a faithful copy in reverse of the cartouche in the background of Agostino's *Portrait of Pope Innocent IX* (cat. no. 194).

1 Bartsch mentioned only one state without letters, but in the examples found, the publisher Pietro Stefanoni's letters "PSF," probably unnoticed by Bartsch, are along the bottom edge of the print.

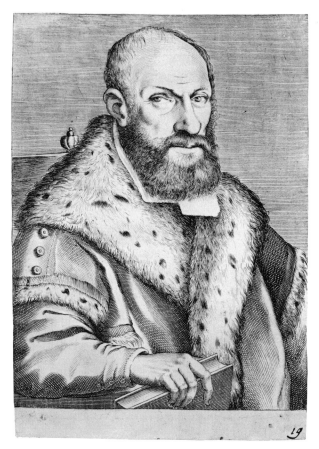

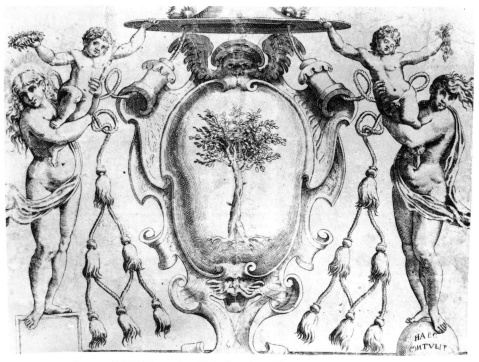

cat. no. R 40. Copy of Agostino Carracci.
Vienna, Graphische Sammlung Albertina

cat. no. R 38. Francesco Brizio? New York, The Metropolitan Museum
of Art, Harris Brisbane Dick Fund, 1947

cat. no. R 39. Francesco Brizio? Vienna, Graphische Sammlung Albertina

R 41

MANNER OF AGOSTINO
CARRACCI

Saint Francis de Paul
(B. 69)

Engraving. 147 x 115 mm. (after Agostino
Carracci?)

Literature: Malvasia p. 86; Mariette II, 66 and
111, 134; Heinecken p. 635, no. 50; LeBlanc
61; Nagler I, 396 (3); Bodmer 1940, p. 71;
Calvesi/Casale 130.

In the sun above is inscribed CHA/RI/TAS, in the lower left A.C., and
along the bottom P.S.F. Malvasia believed that this print was after Agos-
tino and not by him. Bodmer also doubted it, but Bartsch (followed by
Nagler) assumed that Agostino engraved the head, while the rest of the
body was by a mediocre hand. Calvesi and Casale agreed with him and
dated the print c. 1590. To this writer, there is no discrepancy between
head and body. The entire work is executed poorly and cannot be attrib-
uted to Agostino, who could not have been responsible for the missha-
pen, sunken right shoulder. Although the mechanical shading disavows
his hand, Agostino's facial types are similar. Thus the A.C. must refer to
Agostino as the inventor of the composition, the execution of which
belongs to a follower of the artist.

R 42

MANNER OF AGOSTINO
CARRACCI

Mary Magdalen
(B. 82) 1598?

Engraving 167 x 127 mm.

Literature: Mariette ms. II, 97; Nagler 1835,
p. 396; LeBlanc 83; Bodmer 1940, pp. 67-68;
Ostrow 52.

This engraving is a pastiche of 1) a figure by Agostino in a print after
Veronese (cat. no. 149) and 2) a hillock in another Agostino print (cat.
no. 184).[1] The burin style is akin to that of Luca Ciamberlano, but there
is no certainty in an attribution to him.

1 Bartsch incorrectly noted that the print was a copy of his nos. 116 and 127 when in
reality he meant nos. 117 and 128. The states known are 1) In the margin SANCTE
MARIE MAGDALENE IMAGO. *Rome caelata: 1598.* Above the margin in the lower left:
Ionnes Orlandis For. Ro. 2) The *Ionnes Orlandis* crossed out with a line. *Andrea Vaccario*
and *1604* added after *For. Ro.*

R 43

MANNER OF AGOSTINO
CARRACCI

Bust of the Saviour
(B. 90)

Engraving. 82 x 66 mm. (sheet: Alb) (after
Agostino Carracci?)

Literature: Mariette ms. 10?; LeBlanc 88;
Bertelà 208.

This rare print, found in only three examples,[1] was attributed by
Bartsch to Agostino and dated very early in his career.[2] Although it is
similar in the broad handling of the burin and simple crosshatching to
Agostino's apostles (cat. nos. 109-123), the freshness of those works is
missing, and there appears instead a flatness of form. The design is
probably by Agostino, but the execution by a person of little inventive-
ness, familiar with Agostino's style of the early 1580s.

1 Vienna, Albertina; Bologna, Pinacoteca Nazionale; Bremen, Kunsthalle.

2 LeBlanc, however, correctly rejected the piece.

R 44

MANNER OF AGOSTINO
CARRACCI

*Cartouche for the Coat of Arms of
a Cardinal*
(B. 157)

Engraving. 146 x 164 mm. (sheet: Alb)

Literature: LeBlanc 270; Bodmer 1940, p. 64.

This engraving, known only in the impression in the Albertina, has been
accepted by all the sources cited; however, the wooden representation
and the lack of depth to the hatching preclude its attribution to the
master, who, in his mature period, always suggested forms logically in
space.

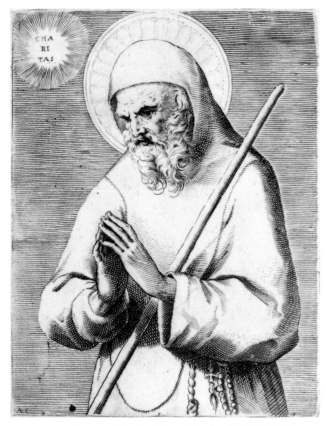

cat. no. R 41. Manner of Agostino Carracci. London, The British Museum

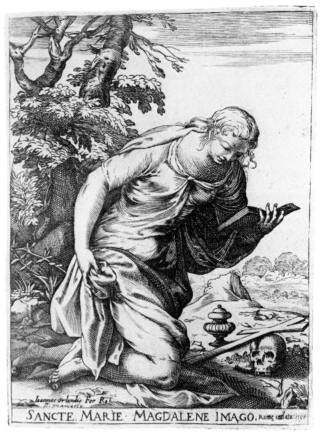

cat. no. R 42. Manner of Agostino Carracci. Vienna, Graphische Sammlung
Albertina

cat. no. R 43. Manner of Agostino Carracci.
Vienna, Graphische Sammlung Albertina

cat. no. R 44. Manner of Agostino Carracci. Vienna, Graphische Sammlung Albertina

R 45-R 48

LUCA CIAMBERLANO
(active 1599-1641)

Very little is known about Luca Ciamberlano, most of the information coming from his signatures on engravings. He was supposedly a lawyer from Urbino turned painter and engraver. His engravings issued from Rome, where he appears to have been active. He is said to have been a student of Villamena. Bartsch attributed 130 prints to Ciamberlano, but he probably executed many more. He was the chief engraver of Agostino's designs for the book, never formally published, of a series of engravings, the *Scuola perfetta per imparare a disegnare*. . . .[1] His engraving style, mostly reproductive, followed Agostino in almost every aspect, except that his prints lack the flair and originality of the master and tend toward mechanical perfection. However, he approached Agostino's style more closely than any other imitator. Thus, some of his prints are still confused with Agostino's.

1 For information on this drawing study book, see the Introduction p. 58

Bibliography: Thieme-Becker, VI, pp. 559-60 (article by R. Kristeller) with previous literature.

R 45

LUCA CIAMBERLANO

Jonah and the Whale
(B. 6)

Engraving. 137 x 174 mm.

Literature: Heinecken p. 629, no. 6; Mariette II, 45 and III, 63; Nagler 1835, p. 394; LeBlanc 583; Petrucci 1953, cat. no. 595.

Plate extant in Calcografia Nazionale, Rome.

Although Bartsch included this engraving in his listing of Agostino's prints, he attributed it to Luca Ciamberlano,[1] whose monogram is found in the upper right. As he noted, the figure of Jonah is copied in reverse from Agostino's *Orpheus and Eurydice* (cat. no. 178), and the whale from the water beast in the *Andromeda* (cat. no. 179).

1 It is also found under Ciamberlano (Bartsch XX, 29.1)

R 46

LUCA CIAMBERLANO

The Legandary Prester John, King of the Indies[1]
(B. 152)

Engraving. 200 x 158 mm. (after Agostino Carracci)

Literature: Malvasia p. 80; Oretti p. 817; Mariette ms. 15; Heinecken p. 628, no. 8; Bolognini Amorini p. 57; Nagler I, 296 (16); Mariette III, 148; LeBlanc 232; Foratti p. 175; Bodmer 1940, .p. 68; Bertelà 255.

Malvasia first attributed this print to Agostino, noting a proof dated 1605. Bartsch mentioned only a first state but acknowledged the possible existence of this later state. There are in fact two known states of the print, and a third dated 1605 is not an impossibility. It is still unknown and has no bearing on the attribution of the work; according to the inscription, the print was finished in 1599.[2]

The print has been accepted by all critics, excluding Foratti, yet this acceptance is based on the quality of the design as much as on the burin work. The lively face must indeed be based on a drawing by Agostino, but the hardness of the engraving technique is certainly closer to his follower Luca Ciamberlano. In fact, comparisons abound with his prints in the *Scuola perfetta* . . ., which are after designs by Agostino.[3]

1 For information and bibliography on Prester John, a legendary ruler whose name first appeared in the twelfth century, see the *Encyclopedia Britannica,* 1972, vol. 18, pp. 480-481.

2 There is a first state, undescribed by Bartsch, in the Albertina with a partially finished background and the top of the turban unfinished. The second state, with letters is reproduced here.

3 Cf. especially the *Profile of an Old Man* (Bartsch XVIII, p. 163, app. 32, reproduced Calvesi/Casale 185) and the *Head of St. Lucy* (Bartsch XX, 38-39.77). The latter, dated 1599, was given (with a question mark), to Agostino by Bertelà (Bertelà, suppl. 760), although Bartsch recognized it as Ciamberlano's.

cat. no. R 45. Luca Ciamberlano. London, the British Museum

IL PRETEIANNI, RE D'
ETHIOPIA

Romę Kal: Mar: 1599 IoannicOrla. formis.

cat. no. R 46. Luca Ciamberlano. Vienna,
Graphische Sammlung Albertina

R 47-R 48

LUCA CIAMBERLANO

Models for a Keyhole

(B. 273 and 274)

Engravings. (after Agostino Carracci) Each
composition made up of two plates, but the left
plate is repeated in each. Compositions measure
141 x 290 mm. and 140 x 287 mm.

Literature: Malvasia p. 82 and footnote 1;
LeBlanc 149-150; Bodmer 1940, p. 71;
Calvesi/Casale 176 and 176 bis; Bertelà
299-300.

Rejected by Bodmer and questioned by Bertelà, the prints[1] were accepted by Calvesi and Casale, who dated them to Agostino's Roman period. Bartsch, on the other hand, who also accepted the works, dated the prints very early. According to a note on the example in the British Museum, they were made for a door of the Galleria Sampieri in Bologna, a building which is no longer extant.[2]

Like the other prints here attributed to Luca Ciamberlano, there is a dry, mechanical quality to the burin technique in these engravings. The design, however, appears to have been by Agostino, most likely from the Roman period.

1 There are two states of these prints: the first, mentioned by Bartsch and in Bologna, Pinacoteca Nazionale, are without inscriptions; the second, found in the Bibliothèque Nationale, Paris, are inscribed in the lower right: *Ag. Carraz. f.*

2 The inscription says "per le porte" not "dalle porte" or "after the doors." This may support the theory, proposed in the Introduction p. 49, that some prints were made as models for sculptural decoration.

R 49

LUCA CIAMBERLANO(?)

*Coat of Arms of Cardinal
Francesco Sforza?*[1]

(B. 180)

Engraving. 212 x 282 mm. (sheet: BN) (after
Francesco Cavazzone?)

Literature: Malvasia p. 79 and note 1; Oretti
p. 803; Bolognini Amorini p. 56; Heinecken,
p. 643, no. 26; LeBlanc 268; Bodmer 1940,
p. 51; Bertelà 276.

Malvasia first attributed this engraving to Agostino, but Zanotti disagreed with his attribution, giving the work to Brizio. Bodmer dated the print c. 1583-1585, perhaps based on a striking similarity between this work and the large nonportrait plates in the *Cremona Fedelissima* (cat. nos. 56-59). Bertelà questioned the attribution, probably due to the unexplained inscription in the right hand corner: F.C.I. Although the quality of the burin is excellent, there are several disturbing elements about this print which tend to suggest an author other than Agostino. Primarly, there is no true relation between the figure of Prudence and Magnanimity and their background. The artist attempted to place each on a seat, but did not define the space in which this seat exists. The elaborate cartouche below tends to negate the space above, where the figures sit. In addition, such a cartouche, floating in space, is not found in Agostino's accepted works. With few exceptions, he attempted to place his figures on some kind of solid ground. The morphology of the figures is also disturbing: there are no real analogies with Agostino's authentic works.

Luca Ciamberlano is one artist whose burin technique and style come surprisingly close to Agostino. Yet, Ciamberlano was not an original, but a reproductive engraver. In this case the originator of the design may have been Francesco Cavazzone, the inventor of the *Coats of Arms of the Bolognese Popes and Cardinals* (cat. no. 225). It is possible that the initials F.C.I. stand for "Francesco Cavazzone invenit."

1 Ciaconi mentioned only one cardinal from the Sforza family during this period—Francesco, who was created cardinal in 1583 and died in 1624.

cat. no. R 47. Luca Ciamberlano.
Bologna, Pinacoteca Nazionale

cat. no. R 48. Luca Ciamberlano.
Bologna, Pinacoteca Nazionale

cat. no. R 49. Luca Ciamberlano. Vienna,
Graphische Sammlung Albertina

R 50

ANTON EISENHOIT (German 1553-1603)

Portrait of Pope Gregory XIII
(B. 148) 1581

Engraving. 499 x 413 mm.[1]

Literature: LeBlanc 236; Bolognini Amorini, p. 58; Nagler 1835, p. 398; Nagler I, 296 (15); Disertori pp. 271-272; Bodmer 1939, p. 126; Bodmer 1940, p. 71; Anna Maria Kesting, *Anton Eisenhoit, Ein Westfälischer Kupferstecher und Goldschmied,* Münster Westfalen, 1964, p. 55, no. 2 and fig. 3; Ostrow 2; F. W. H. Hollstein, *German Engravings, Etchings and Woodcuts c.* 1400-1700, 8, Amsterdam, 1968, p. 19, no. 14 (with further bibliography).

Bartsch incorrectly read the date of this print as 1571, probably confusing it with the date Gregory XIII ascended the papal throne. Ostrow continued the error of the date although rejecting the attribution to Agostino.[2] The problem of the attribution and dating was clarified in Kesting's book on Eisenhoit, a German engraver and goldsmith active in Rome c. 1580. Unlike the cut-down versions found in the Albertina and the British Museum (as reproduced here), the example reproduced by Kesting includes the elaborate and minutely rendered frame with the correct date of the print as well as Eisenhoit's signature in the lower left.[3] The burin technique, which is unlike that in any of Agostino's accepted prints or in any engravings by other Italians working in Rome or Bologna at this time, should have convinced Bartsch and others that this engraving could not have been executed by Agostino.[4]

1 Measurement from Hollstein.

2 He knew only the example in the British Museum, which not only has been cut down, but the letters from the bottom of the cartouche have been rearranged at the top of the print in erroneous form: e.g., the XXXI comes from the MDLXXXI of the whole version.

3 The frame is certainly reminiscent of a goldsmith's work. The inscription in the margin reads as follows: GREGORIUS · XIII · PONT · MAX · / AETATIS · ANNO · LXXX/ M·D·LXXXI. In the lower left is the signature: *Ant: Eisen: War: W:* and in the lower right the privilegio of the pontiff. This writer has not seen this example in the original.

4 ·Disertori p. 271 reproduced a copy of this engraving, in reverse, as by an anonymous Carracci follower.

R 51

DAVID de LAUDE (active Cremona, 2nd half sixteenth century)[1]

Map of the City of Cremona

Engraving. 442 x 858 mm.

Literature: Calvesi/Casale 112

This engraving is found in Antonio Campi's *Cremona Fedelissima.* Calvesi and Casale mistakenly attributed it to Agostino because he had executed all of the portraits in the volume. They obviously took no notice of the signature in the lower right: *David de Laude Crem. incid.* Calvesi and Casale did not mention the other engraved maps and architectural renderings in the book, all of which seem to have been engraved by the Cremonese de Laude.[2]

1 Almost nothing is known about de Laude. For the small bibliography see Thieme-Becker, vol. 22, p. 433.

2 The other prints included in the book are a plan of the Baptistery of Cremona, an exterior view of the Duomo, an exterior view and plan of the tower of Cremona, and a map of the territory of the diocese of Cremona, this last also signed by de Laude.

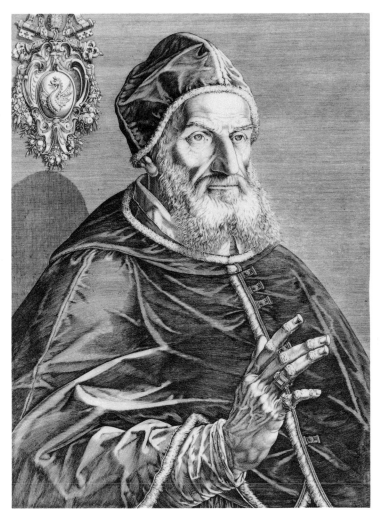

cat. no. R 50. Anton Eisenhoit. Vienna,
Graphische Sammlung Albertina

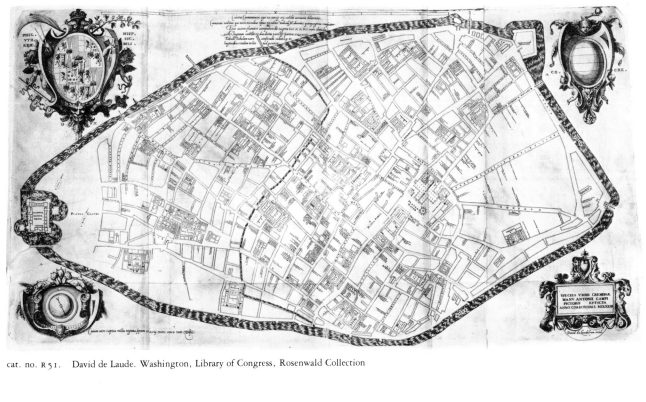

cat. no. R 51. David de Laude. Washington, Library of Congress, Rosenwald Collection

R 52

GIROLAMO OLGIATI(?)
CORNELIS CORT (?)[1]

The Resurrection
(B. 24) 1575

Engraving. 455 x 321 mm. (sheet: Alb)

Literature: Heinecken p. 631, no. 33; Gori Gandellini p. 314, no. XXIII; Mariette III, 90?; Joubert p. 344; LeBlanc 54; Bodmer 1939, p. 126; Bodmer 1940, p. 71; Ostrow 6.

Until Bodmer attributed this print to Girolamo Olgiati, the sources had agreed on Agostino as its author. Ostrow, who also attributed the engraving to Olgiati, noted that it bears no relation to Agostino's works of the 1570s. Far too developed in technique and form, this print could not have been created by Agostino as a fledgling engraver in 1575, the date in the lower left on the print. On the other hand, Olgiati was at the peak of his powers in this decade, and, in fact, the head of Christ with its bulbous staring eyes is similar to the Christ seen in profile in Olgiati's print of *Christ and the Samaritan Woman* (fig. 20b), signed and dated 1570. The overall use of the burin, filling most of the background as it does, is also characteristic of Olgiati's prints.

Some of the figures in the composition reflect a striking similarity with figures by Cornelis Cort; e.g., the head of the sleeping soldier at right is akin to some heads in Cort's engraving *Ecce Homo* (Bierens de Haan 82). Moreover, the burin technique is rather more delicate than Olgiati's, which tends to be broader and resemble that of etching. Since the *Resurrection* is known to this author in only one impression, that in the Albertina, and there attributed to Agostino, it is a possibility that Bierens de Haan overlooked it. But, without further documentary or stylistic evidence, one must question the authorship of the sheet.

1 For information on Olgiati and Cort, see the Introduction and Appendix II.

R 53

PHILIPPE THOMASSIN(?)
(FILIPPO TOMMASSINO)
(1562-1622)[1]

The Presentation in the Temple
(B. 13)

Engraving. 451 x 326 mm. (after Cornelis Cort engraving of 1568, Bierens de Haan 51/52)

Literature: LeBlanc 34; Calvesi/Casale 4.

Although Bartsch doubted the authenticity of this print,[2] he suspected it was in Agostino's first manner. Ignored by the other sources, it was recently attributed to Agostino by Calvesi and Casale, who dated it about 1577-1578. There are numerous similarities with the early works of Agostino, but the print is still closer to the works of Philippe Thomassin. The facial forms with their pinched lips and un-Italian character are much like Thomassin, as are the closely placed burin strokes.

None of the writers noticed that the print is a copy of Cornelis Cort's rendering of the same subject (fig. R 53a) of 1568. Cort's print is about half the size of the copy.[3] The original design belongs to Federico Zuccaro, as indicated in the margin of Cort's print.

This is probably the same print which Zani and Bierens de Haan attributed to Domenico Tibaldi.[4] Although the burin technique is typical of Tibaldi's works, the facial morphology is foreign to him, and it is doubtful that he was the author of this engraving.

1 For information on Thomassin see Appendix I and Appendix II.

2 This author has found but one example of this print, in Rome; however, according to the catalogue of the Albertina, that print room also owns an example.

3 291 x 205 mm. Bierens de Haan 51/52.

4 Bierens de Haan, p. 73, 52k.

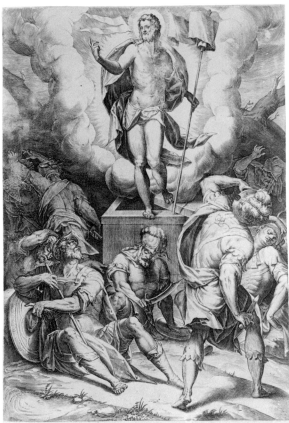

ET ERIT SEPVLCRVM EIVS GLORIOSVM. *cum*.

cat. no. R52. Girolamo Olgiati? Cornelis Cort? Vienna, Graphische Sammlung Albertina

cat. no. R53. Philippe Thomassin. Rome. Gabinetto nazionale delle stampe

fig. R53a. Cornelis Cort, *Presentation in the Temple*. Reproduced by Permission of the Syndics of the Fitzwilliam Museum, Cambridge

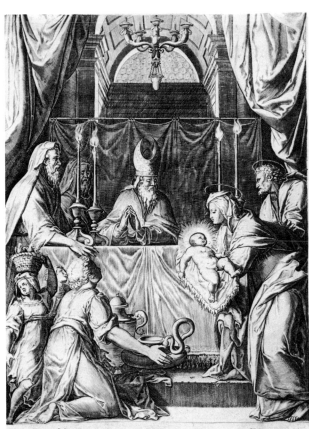

VENIET AD TEMPLVM SANCTVM SVVM DOMINATOR DNVS. *Jnl*.

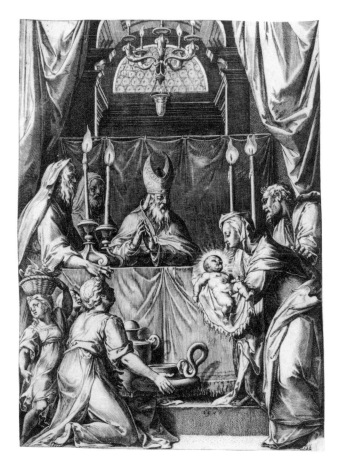

R 54

DOMENICO TIBALDI (Bologna 1541-1583)[1]

The Annunciation

(B. 8)

Engraving. 477 x 322 mm. (sheet: Alb) (After Orazio Sammacchini paintings in Pinacoteca e Musei Comunali, Forli, and the Chapel of the Villa Guastarillani, Bologna.)

Literature: Nagler 1835, p. 395; LeBlanc 16.

This print[2] is extremely close to the engraving by Agostino of the same subject (cat. no. 34), the difference being the substitution of the Holy Spirit in this print for the Christ Child carrying the cross (as symbol of the Holy Spirit) in the Agostino print. Bartsch considered this engraving to be a repetition of the Agostino work, executed by another artist under his supervision. The early dating of Agostino's *Annunciation* would preclude his having a student or assistant at that time. In fact, it is probable that Agostino's print is actually a copy of the present sheet, which is here attributed to his teacher Domenico Tibaldi. At this period Agostino was attempting to develop and perfect his burin style by copying prints by other artists, and it would seem likely that one of the artists he would copy would be his employer. The burin technique of this print, so close to Agostino's yet varying from it in its tendency toward a finer line, which creates softer and flatter forms, is closely akin to that in Tibaldi's works, especially his signed *Trinity* (Bartsch XVIII, 12.2).

1 For information on Tibaldi see the Introduction and the Appendix I.

2 Three examples of this print exist, in Vienna, Dresden, and Berlin.

R 55

DOMENICO TIBALDI

Madonna and Child on a Crescent Moon

(B. 37) 1575

Engraving. 408 x 295 mm. (after Lorenzo Sabbattini drawing in the National Gallery, Canada)

Literature: Heinecken p. 633, no. 27; Gori Gandellini p. 319, no. XX; LeBlanc 23; Foratti, p. 167; Bodmer 1939, p. 124; Ostrow 5.

The first state of this print, found at the British Museum and the Albertina, is inscribed in the lower left: *Bonon* and *1575*. In the center is *Laurens. Sabadinus Inven:*. In the lower right appear the letters that might be either *Fst* or *TF*.[1] Unfortunately, the letters are difficult to decipher in the known examples. The print was accepted by Gori Gandellini, Heinecken, LeBlanc, Foratti, and Bodmer and rejected by Ostrow. As noted by Ostrow and as seen in comparison with Agostino's works of 1576, his earliest dated prints, his style was not as developed as this in 1575. The artist of this print was obviously a mature engraver. The only Bolognese artist (n.b. *Bonon* on print) of this period with an engraving technique similar to this and easily confused with Agostino is Domenico Tibaldi, his teacher. It is possible, then, to interpret the letters in the right-hand corner as TF or *. .Tibaldi fecit.* Although most of the nine prints attributed to Tibaldi by Bartsch employ a finer line, Tibaldi did sometimes use a thicker burin, as here. One such print, undescribed by Bartsch, of a *Deposition,* is signed in the lower right hand corner DF and is in the style of Cornelis Cort.[2]

If the present engraving is by Domenico Tibaldi, it is not surprising that it was copied by Agostino (see cat. no. 15), who early in his career practiced his craft by interpreting the engravings of other artists.[3] It would therefore be logical that he would copy a print by his teacher. Bartsch believed that R 55 was a variant of Agostino's print (cat. no. 15), but it seems more likely that Agostino's print is a copy of this, the earlier sheet. The other possibility, less likely, is that Agostino's engraving is also a reproductive print after Sabbattini's drawing (fig. 15a).

1 There is a second state of this print in the Metropolitan Museum of Art, New York, with the addition of the publisher's name, bottom, left of center: *Donati Rasicoti form.*

2 It is probable that Agostino became interested in Cort through his teacher, who, in the *Deposition,* copied an invention by Giulio Clovio in a manner very close to Cort. An example of this print is found in the Albertina (It, I, 39, p. 9).

3 Cf, e.g., cat. nos. 1, 3, 9, 10, 16, 17, 20, and 39.

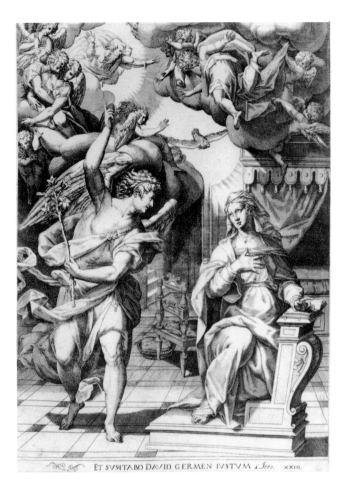

ET SVSITABO DAVID GERMEN IVSTVM 1.Iere. XXIII.

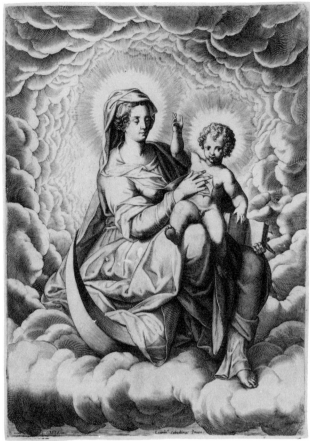

cat. no. R 54. Domenico Tibaldi. Vienna, Graphische Sammlung Albertina cat. no. R 55. Domenico Tibaldi. London, The British Museum

R 56

DOMENICO TIBALDI

Madonna and Child
(B. 41)

Engraving. 423 x 275 mm. (sheet: Alb)

Literature: Heinecken p. 633, no. 24; Bodmer 1940, p. 71.

R 57

DOMENICO TIBALDI

Madonna and Child with Saint John the Baptist
(B. 46)

Engraving. 432 x 319 mm. (sheet: BN) (after Raphael, *Madonna della Seggiola* Palazzo Pitti, Florence)

Literature: Mariette ms. II no. 33?; Nagler 1835, p. 396; Joubert p. 347; LeBlanc 29.

R 58

DOMENICO TIBALDI

Holy Family under the Oak
(B. 47)

Engraving. 476 x 383 mm. (sheet: Alb) (after Giulio Romano? painting *Holy Family under the Oak,* Madrid, Prado)

Literature: Heinecken p. 632, no. 15; Gori Gandellini p. 318, no. XVIII; Nagler 1835, p. 396; LeBlanc 30; Bodmer 1940, p. 71.

R 59

DOMENICO TIBALDI

The Mystical Crucifix
(B. 107)

Engraving. 458 x 318 mm. (sheet: Alb)

Literature: Heinecken p. 631, no. 25; Gori Gandellini p. 314, no. XXII; Joubert p. 344; Nagler 1835, p. 397; Bodmer 1940, p. 71; Calvesi/Casale 6.

Heinecken was the only author to accept this print as Agostino's. Although he included it in his catalogue, Bartsch rejected the sheet. The delicacy of the burin, the closely spaced hatching for the drapery folds, the facial morphology—especially the small dimpled chins—and the abruptness of contour are characteristics of Agostino's teacher Domenico Tibaldi. This sheet accords with signed works by the artist such as the *Portrait of Gregory XIII* (Bartsch XVIII, 16. 7) and the *Madonna of the Rose* (Bartsch XVIII, 13.3; Introduction fig. I) as well as with that group which is here removed from Agostino's oeuvre and attributed to Tibaldi.

The print is probably a reproduction of a lost painting or drawing by Lorenzo Sabbattini.[1]

1 Only one impression of the print is known, in the Albertina, Vienna.

This print was ignored by most writers; however, Bartsch believed it to be Agostino in his first manner. Although close in spirit to Agostino's reproductive prints executed under his teacher and employer, Domenico Tibaldi, this sheet is closer to the master than the pupil. The facial types are extremely close to those in the previously discussed *Madonna and Child* (cat. no. R 56), and the print is stylistically akin to the group here attributed to Tibaldi.[1]

1 Only three examples of the engraving are known: Alb, Ber, BN.

Bodmer was the single critic to exclude this print correctly from Agostino's oeuvre. The billowing folds of the drapery of the Madonna's gown are not found in any of Agostino's accepted engravings, even in the early reproductive works. The uniform, straight hatching of the right background, the regularity and stiffness of the trees, and the flatness of the drapery folds suggests that Tibaldi is responsible for the execution of the engraving. In addition, the filling of the entire sheet with the burin lines appears in most of Tibaldi's prints.[1]

1 Compare this type of overelaborate composition with his print of the *Flight into Egypt* (Bartsch XVIII, 12. 1; Introduction fig G).
 As noted by Bartsch, *The Holy Family Under the Oak* comes in two states. The first is reproduced here. The second carries the publisher's mark: *Donati Rasicoti form.* in the lower left.

Of the sources, only Bodmer rejected this print. Bartsch dated it c. 1579, Calvesi and Casale even earlier.[1] The subject matter was explained by both Bartsch and Gori Gandellini: on the left stands the personification of Christianity receiving the blood of Christ and on the right Judaism rejects that offered by the Saviour.

This sheet, found in impressions at the Albertina and the Uffizi, is characteristic of the prints which are here attributed to Tibaldi. In addition, similar heads of children appear in Tibaldi's print of the *Trinity* after Sammacchini (Bartsch XVIII, 12-13.2). The flat, and at times misunderstood, forms, as seen especially in the upraised arm of Christianity, are sometimes found in Agostino's early work, yet the overall spirit is much closer to Tibaldi.

1 Calvesi and Casale said unjustifiably that the print is based on Michelangelo's *Crucifixion* for Vittoria Colonna. The figures do, however, stem from Michelangelo.

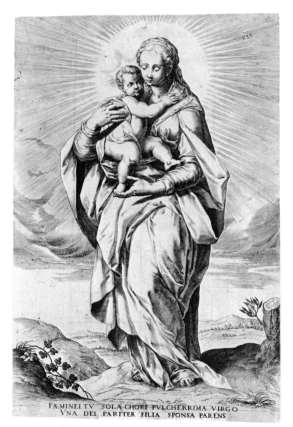

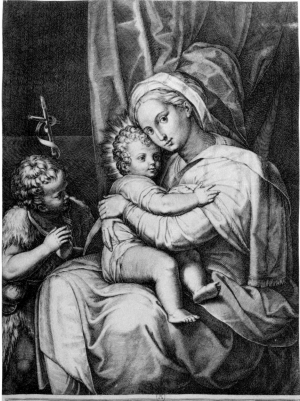

cat. no. R 56. Domenico Tibaldi. Vienna, Graphische Sammlung Albertina

cat. no. R 57. Domenico Tibaldi. Paris, Bibliothèque Nationale

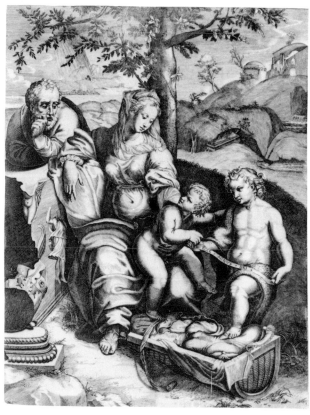

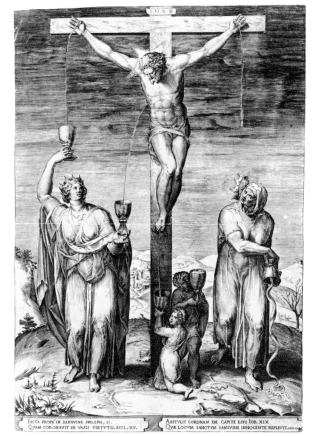

cat. no. R 58. Domenico Tibaldi. Vienna, Graphische Sammlung Albertina

cat. no. R 59. Domenico Tibaldi. Vienna, Graphische Sammlung Albertina

ANNIBALE CARRACCI
(1560-1609)
Cat. Nos. 1-22

I*

The Crucifixion
(B. 5) 1581

Engraving. 492 x 347 mm.

Literature: Heinecken p. 631, n. 24; Nagler 1835, p. 388; P. Zani, part 2, vol. 8, pp. 126-127; LeBlanc 16; Nagler I, no. 1047; Bodmer 1938, p. 107-108; *Mostra-Dipinti* p. 72; Calvesi/Casale p. 6; Posner II, p. 12.

States:

	B
I	I

Lower left: *Anj. in. Fe.* Toward bottom left: *1581.* (Alb, Ham, Stu)

The attribution of this print has been debated in the literature. Bartsch, Nagler, Zani, Bodmer, Cavalli (*Mostra*), and Calvesi/Casale accepted the signature as authentic, whereas Heinecken, LeBlanc, and Posner felt that the print was falsely attributed to Annibale.[1] The style of the print makes the attribution to Annibale problematical because of its proximity to Agostino's graphic style of this year. In fact, the harshness of the limbs and the lighting are reminiscent of Agostino's *Baptism of Christ* after Annibale (Agostino cat. no. 23), dated here to the period of Agostino's career when he was most influenced by his teacher Tibaldi, 1579-1581. Also similar is the print *Sudarium of Veronica* by Agostino (Agostino cat. no. 24). It is evident that the stiffness of the figure, the fine burin lines, and the groping quality of certain curved lines as well as the misshapen extremities are all aspects of Agostino's work until 1582.

However, one cannot ignore the signature on this print, which attributes both the invention and the execution of the work to Annibale. According to Malvasia, Annibale was taught the rudiments of engraving by his brother Agostino.[2] Yet, Malvasia believed that Annibale's first print was his *Saint Jerome* (cat. no. 4), dated here c. 1583-1585, a work distant in style from Agostino. If Agostino taught his brother the technique of engraving and perhaps aided him on his first print, as purported by Malvasia, it is likely that the first effort of the younger brother would be extremely close in technique and style to his teacher, especially if the teacher had a hand in the print itself. None of Annibale's prints of c. 1583-1585 shows any influence at all of Agostino's technique or style, as does this print, and it is hard to believe that Agostino could have had a hand in the distinctive *Saint Jerome*, as purported by Malvasia. It is highly probable, on the other hand, that much of the work on Annibale's first print was handled by Agostino; consequently, the style of this sheet resembles Agostino's works of the same period. Moreover, Agostino may have decided that Annibale had completed a sufficient portion of the engraving to warrant his signing the work.[3]

Posner did not believe that the design had been invented by Annibale either, although the signature on the print indicates as much. It is the opinion of this writer that not only much of the execution but also the design is by Annibale. The composition of Agostino's *Baptism of Christ* (Agostino cat. no. 27) is attributed to Annibale on the plate and, as discussed in the entry for that print, it belongs to the same period as this. In addition, it is likely that another engraving of the same year by Agostino, *Adam and Eve* (Agostino cat. no. 25), may be after a drawing by Annibale.[4] Therefore, when Posner asserted that the composition of this print is by "a Roman or Romanizing Mannerist," he discounted compositions in a similar style already accepted as by Annibale by most critics.[5]

1 LeBlanc and Posner did not reattribute the engraving, but Heinecken attributed it to Agostino. Unfortunately, the earliest writers—Baglione, Bellori, and Malvasia—ignored it.

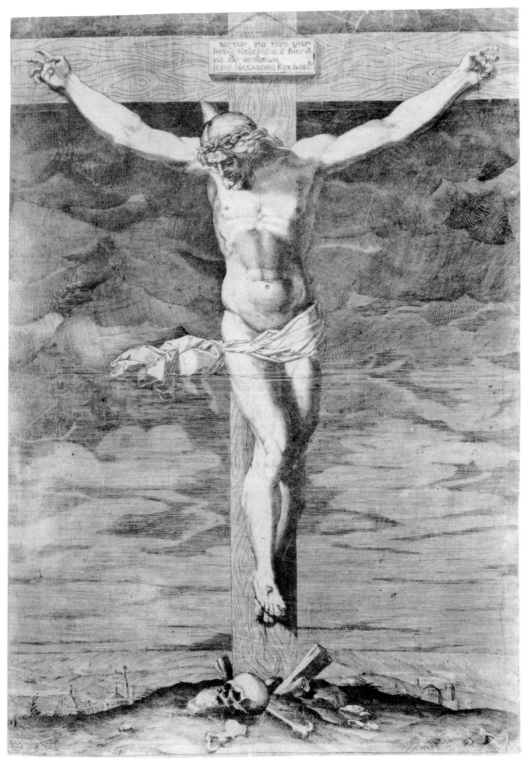

cat. no. 1, only state. Vienna, Graphische Sammlung Albertina

2 Malvasia p. 294. See the Introduction for a discussion of their relationship.

3 It seems unlikely that Agostino would sign his brother's name to his own print, and there does not exist an example before the letters. It is doubtful, then, that a publisher added the attribution. 4 See Agostino cat. no. 25 for an explanation.

5 In fact, Annibale's *Crucifixion* in Santa Maria della Carità in Bologna of 1583 (Posner 6a) is stylistically similar, as is the design of the *Baptism* (Agostino cat. no. 23) attributed to Annibale.

2*

Holy Family with Saints John The Baptist and Michael
(B. 12) 1582

Engraving. 460 x 296 mm. (after Lorenzo Sabbattini and Denys Calvaert painting in San Giacomo Maggiore, Bologna)

Literature: Malvasia pp. 76, 270; Oretti p. 796; Mariette ms. V, 29; Strutt p. 181; Heinecken p. 632, no. 14; Gori Gandellini p. 318, no. XIX; Bolognini Amorini p. 55; Nagler 1835, p. 388, Mariette III, 62; LeBlanc 15; Nagler I, no. 1378, IV, no. 931; *Mostra-Dipinti* p. 72; Francesco Arcangeli, "Sugli inizi dei Carracci," *Paragone,* 79 (1956): 24; Calvesi *Commentari,* pp. 264-265 note 5; Calvesi/Casale 39; Posner II, p. 12; Bertelà 145; Boschloo pp. 181, 207, note 5.

States

	B	CC
I	I	I

Lower right: *Laurentius Sabad:/ Bononien inu en:/ Ani: Cara: fe. 1582.* (Alb, Ber, BM, BN, Bo, Dres, MMA, and others)

| II | — | — |

As state I but to left of *Ani:* is *Ionnes Orlandis a pasquino formis romae.* (BM, MMA)

| III | — | — |

Inscription of state II burnished out. Very weak. (Dar, Ro, and others)

Preparatory Drawings: 1. Chatsworth,* Collection of the Duke of Devonshire. (Inv. no. 397). 497 x 296 mm. Black chalk and brown washes with white heightening on paper washed pinkish brown. Squared in black chalk. Collections: William Cavendish, 2nd Duke of Devonshire (Lugt 718). Unpublished. (fig. 2b).

cat. no. 2, state I Detail

The attribution of this print has been debated in the literature since Bartsch's time. Malvasia originally attributed the engraving to Agostino, and his attribution was upheld by Oretti, Strutt, Gori Gandellini, Heinecken, Nagler, and Bolognini Amorini. Bartsch reread the inscription on the print and decided the engraving was by Annibale. In the twentieth century, Bodmer, Cavalli (*Mostra*), and Arcangeli have agreed with Bartsch, but Calvesi/Casale, Posner, and Boschloo stayed with Malvasia's original attribution to Agostino. The problem of authorship lies as much with the signature in the lower right as with the style of the engraving. Those who believed the work to be by Agostino have read the letters as *Au:Cara: fe. 1582*. But, one can see in a detail of the letters that the signature is in fact *Ani: Cara: fe. 1582*. The left part of the "n" of "Ani" forms part of the capital letter "A" and the "i" is dotted. Moreover, there are other prints by Annibale signed with "Ani," whereas there are no known prints by Agostino in which he used the letters "Au" alone for his first name.[1]

Stylistically, there are a number of reasons to attribute this work to Annibale. As with the engraving after Barocci (cat. no. 3), Annibale used a fine burin technique learned from his brother Agostino. Although in his later prints his technique became broader, there is one undisputed work in which a similar delicacy of the burin is evident, the print of *Susanna and the Elders* (cat. no. 14) from the early 1590s. In addition, the profile of St. Michael belongs to the same family as that of Susanna in the later work. Similar aquiline noses, full lips, and softened expressions are apparent in each face.

There are also similarities between the heads of the Christ Child and St. John in this print and the Infant in the *Madonna and Child on the Clouds* (cat. no. 3). These stylistic and figural traits do not extend to Agostino's accepted print of the *Madonna and Child and Saints* after Sammacchini (Agostino cat. no. 54) of 1582 which Calvesi/Casale connected with this sheet.[2] The burin in Agostino's print is broader than that used in the present engraving, and morphologically, the figures, especially the child, have broader faces, lower foreheads, and less animated expressions. It seems likely that Annibale and Agostino were attempting to engrave similar compositions after similar Bolognese mannerist artists in the same way as they had each copied Barocci's print, bringing to the works related but divergent personalities.

Other evidence suggests that the authorship of this print is Annibale's. A drawing in Chatsworth (fig. 2b),* hitherto attributed to Lorenzo Sabbattini as a preparatory drawing for the painting which this print reproduces (fig. 2a), is a work by Annibale after the painting in preparation for the engraving. A cursory study of the drawing reveals its closer proximity to the engraving than to the painting.[3] The broader faces of the Virgin and St. Joseph are closer to the print than to the oil. The background is closer to Annibale's engraving than to the painting, and the format, slightly shortened in engraving and drawing, diverges from the more elongated format of the painting. In addition, there are no Sabbattini drawings which employ line or heightening in the manner used in this drawing. Sabbattini's drawings are normally exercises in controlled contour lines which delineate figures and controlled lighting to accentuate the contours. Never does the heightening land in blotches or *macchie* as it does here.[4] On the other hand, the repeated contour

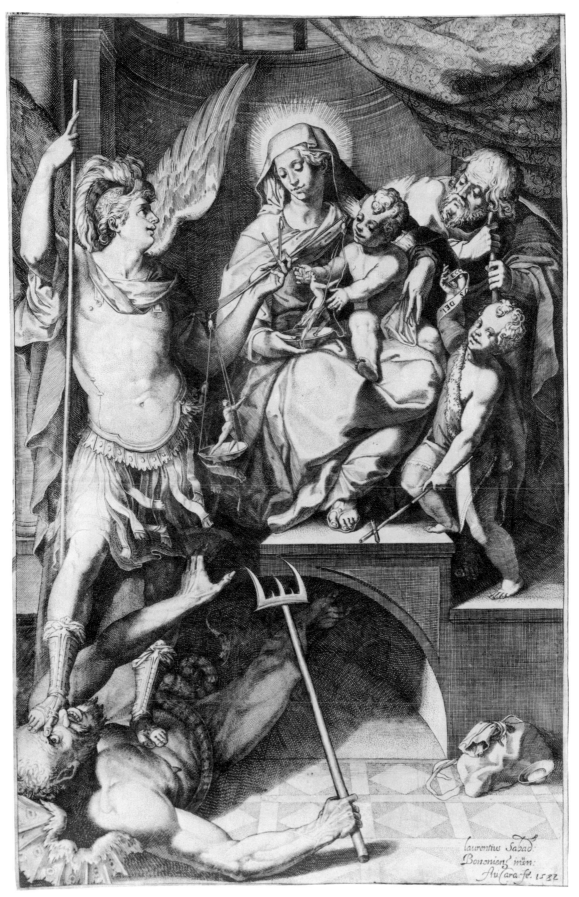

laurentius Sabad:
Bononieñ iñen:
Añ Cara: fe: 1582

cat. no. 2, state I. The Baltimore Museum of Art, Garrett Collection

425 ANNIBALE

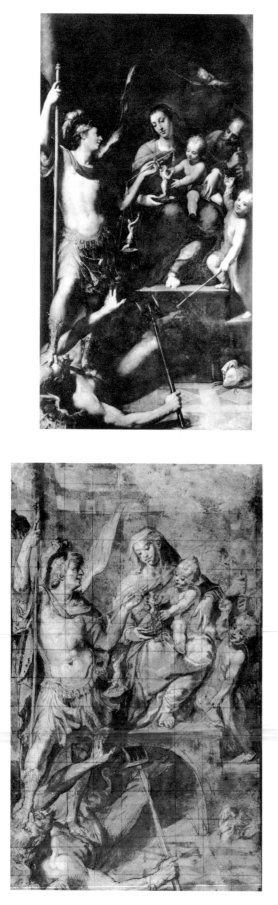

strokes, and the fluidity and coloristic effects of the wash and heightening, especially on the Christ Child, are characteristics of Annibale's early drawing style. Extremely close to the figures of the two children are drawings in the Fogg Museum and in Chatsworth in which similar broad washes are used to define the forms.[5] Moreover, the characteristic sweetened expressions of the Christ Child and St. John are repeated in the paintings of the Palazzo Fava[6] and in the music-making angels in the *Baptism of Christ* in S. Gregorio in Bologna of 1595.[7]

As with cat. no. 3, Annibale and Agostino worked here on similar compositions (see Agostino cat. no. 54). This was the year in which the Accademia degli Incamminati was formed by the two brothers, and it is likely that in an effort to learn they chose projects to work on together, perhaps even as friendly rivals.

1 Agostino normally signed his prints "Ago." or "Aug." but never "Au." Annibale signed cat. nos. 2, 3, 6, and 7 with "Ani" for his first name.

2 Calvesi/Casale nos. 39-40.

3 Usually, Agostino followed an artist's preparatory drawing for his reproductive prints rather than the painting itself. But in this case, the drawing is not by the artist of the painting but by the printmaker.

4 As one example only, see Agostino fig. 15a by Sabbattini in which the contour lines are very precise and the shading is used only to reinforce these lines.

5 Fogg Art Museum, inv. no. 1932-333, *The Judgment of Paris*. It was variously attributed to a late follower of Correggio and Johann Liss. Volpe (Carlo Volpe, "Un disegno di 'Annibale, 1584'," *Paragone*, 10, no. 115, July, 1959, pp. 53-57) reattributed it to Annibale, and the attribution has been upheld by Carracci scholars. For a history of the opinions on the drawing, see Posner II, pp. 10-11. Chatsworth, Inv. no. 420. Posner rejected the sheet, but Boschloo (reproduced fig. 17) accepted it with reservations (Boschloo 1972).

6 See especially *The Infant Jason Carried in a Coffin to Cheiron's Cave* and *Three Episodes in the Youth of Jason* (Posner figs. 15b and 15c.).

7 Posner fig. 21a. Moreover, note the same kind of broad, flat planes of color used in the marvelous painting of the *Allegory of Truth and Time* in Hampton Court of the same time (Posner, plate 19).

fig. 2a. Lorenzo Sabbattini and Denys Calvaert, *Holy Family with Saints John the Baptist and Michael.* Bologna, San Giacomo Maggiore

fig. 2b. Annibale Carracci, *Holy Family with Saints John the Baptist and Michael.* Chatsworth, Devonshire Collection, the Trustees of the Chatsworth Settlement

3*

Madonna and Child on the Clouds
(B. Annibale 10 & B. Agostino 33)
c. 1582-1584

Engraving. 247 x 174 mm. (after Federico
Barocci etching Bartsch XVII, 3. 2)

Literature: Nagler 1835, p. 388; Nagler I,
1044; LeBlanc 7; Bodmer 1938, p. 107;
Petrucci p. 143, no. 33; *Mostra-Dipinti* p. 72;
Calvesi/Casale 191; Posner II, no. 213 [R];
Boschloo 1972, pp. 77-78; Boschloo
p. 176-177.

States:

	B	Pos
I	I	I

Lower left: F·B·V·I· Lower center: *Ani fe.* (Alb,
Dres, Ham, PAFA)

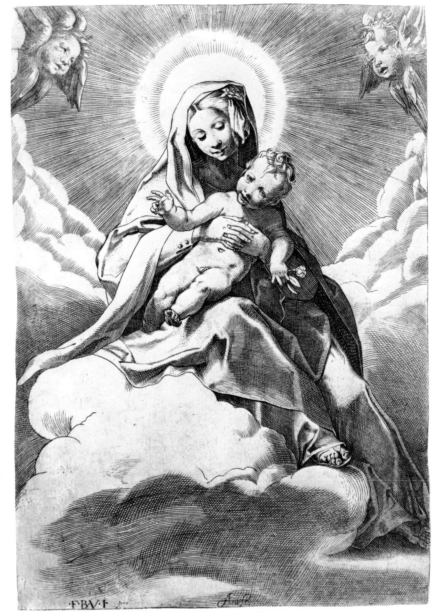

cat. no. 3, only state. Vienna, Graphische Sammlung Albertina

Bartsch catalogued this engraving under both Annibale (B. 10) and
Agostino (B. 33) but leaned strongly toward an attribution to Annibale.
Since that time it has been accepted by all writers on the subject except
Posner, who rejected it on the basis of technique and the lack of repro-
ductive prints in Annibale's oeuvre. In refutation of Posner's assertion
that Annibale was "not known to have made reproductive prints," one
must cite the many drawn copies Annibale made of works by Correggio
as well as his painted quotations from other artists.[1] In addition, attrib-
uted in this catalogue to Annibale is a reproductive print after Lorenzo
Sabbattini and Denys Calvaert (cat. no. 2). Posner also said that the
present engraving is an instance in which a false inscription was added to
the print by the publisher. However, as with the *Crucifixion* (cat. no. 1),
there appear to be no known examples of this engraving without the
address, and it would therefore seem as if the artist himself added the
inscription.

Stylistically, the print is not foreign to Annibale's mode of working. In fact, the delicacy of the Virgin's expression and the high foreheads and small pointed chins of both the Mother and Child are precursors of some of the figures in the frescoes of the Palazzo Fava of 1583/1584.[2] Also similar are the contemporaneous paintings of the *Heads of Four Boys* in a London private collection and the *Madonna and Child with Saints* belonging to the Uffizi.[3] These paintings and this engraving exhibit an awareness of the works of Parmigianino and Correggio in the sweetness of expression as well as in the general facial types.[4] When compared with Barocci's etching (Agostino fig. 98a), the increased elongation of the forms in this engraving also hints at a Parmigianinesque influence.

The print is sometimes attributed to Agostino,[5] but a cursory comparison of this engraving with Agostino's of the same subject (cat. no. 98) indicates disparate hands. The sharp changes of direction of the drapery folds in the Agostino are here transformed into softly flowing contours. Although the burin style of this engraving is reminiscent of Agostino's prints from c. 1579 to 1581 and his print of the same subject from 1582, before his burin strokes widened and his use of light increased, the general tenderness exhibited here is lacking in Agostino's works. In comparing both Carracci copies with Barocci's original, it is apparent that neither artist successfully captured Barocci's atmospheric rendering. Some of this lack of *sfumato* in the Carracci engravings that is so prevalent in Barocci's etching can be attributed to the differences in medium. Annibale's engraving does, however, approach the feeling of Barocci's print through a delicately handled burin, missing entirely in Agostino's work.

Although Bartsch believed that Annibale copied Agostino's print, it seems, rather, that Annibale went directly to Barocci's original. The lower section of the composition, with an emphasis on the mass of clouds flowing toward us, is closer to Barocci's print than to Agostino's, as are the flattened form of the child and the placement of the rose in his hand. Of course, Annibale would have known both prints.

The morphological similarities of the figures of this engraving and those in the paintings mentioned indicate a contemporaneous dating. The relative advancement in burin technique away from the stiffness of form in the *Crucifixion* (cat. no. 1) suggests a date later than that print. In addition, the evidence of Agostino's print of 1582 may suggest that the brothers had each chosen to make a copy of Barocci's etching either in competition or for commercial reasons. The same kind of mutual interest in the subject of another artist took place in the prints of 1582 after Sabbattini and Calvaert (Annibale cat. no. 2 and Agostino cat. no. 54). As discussed earlier (Agostino cat. no. 98), Lodovico was copying a similar work by Barocci at the same time. This suggests a close working relationship among the Carracci in this year, probably encouraged by the foundation of their academy.

Based on the above evidence, it appears that Annibale's early prints (cat. nos. 1-3), hitherto disputed, bring a new light to this artist's early career. He seems to have been precocious in learning the techniques of the burin passed on to him by his older brother and was proficient as a reproductive engraver, both after his own invention (cat. no. 1) and after those of others (cat. nos. 2-3). After these early successful efforts, he

turned to painting, always his major occupation, but interspersed it with serious returns to printmaking in more original modes.

* Engraving in exhibition from the Philadelphia Museum of Art, Academy Collection.

1 See, e.g., the red chalk drawings in Dresden by Annibale. Inv. nos. 1860 c368, 1860 c369. Discussed in A. E. Popham, *Correggio's Drawings,* London, 1957, A23-24; the British Museum (Posner 21c). See also Annibale's playful quotation from the *Battle of Cascina* by Michelangelo in the *Sleeping Venus* in Chantilly (Posner 134a.)

2 Especially in the *Infant Jason Carried in a Coffin to Cheiron's Cave* (reproduced Posner, plate 15b).

3 Posner, plates 11 and 13.

4 The influence is acknowledged by Posner, II, nos. 11, 13.

5 According to Bartsch, but in recent literature only Posner rejected it from Annibale's oeuvre.

4*

Saint Jerome
(B. 13) c. 1583-1585

Engraving. 98 x 89 mm.

Literature: Malvasia pp. 87, 294; Oretti
p. 707-708; Gori Gandellini I, p. 181; p. 27,
no. IX: Joubert p. 349; Nagler 1835, p. 388;
LeBlanc 13; Bodmer 1938, p. 108;
Calvesi/Casale 192; Posner 22; Bertelà 320;
Boschloo pp. 29, 196, note 17.

States:

	B	CC
I	I	I

As reproduced. No inscriptions. (Alb, BM,
BN, Bo, Br, MMA, and others)

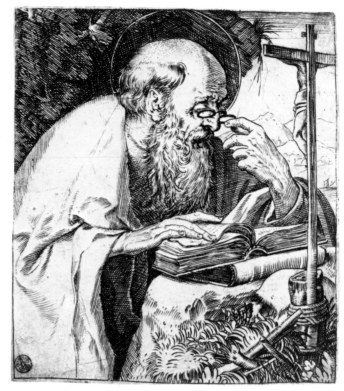

cat. no. 4, only state. London, The British Museum

Malvasia indicated that this was Annibale's earliest print and that it was
retouched by his teacher Agostino. Bartsch followed this reasoning.
Twentieth-century critics, beginning with Bodmer, realized that the
entire print was executed by one hand. Posner believed that this was
Annibale's earliest print and dated it c. 1585, due to its stylistic rela-
tionship with the artist's dated *Saint Francis of Assisi* (cat. no. 7). As
indicated here, this is probably Annibale's fourth print, following his
earlier prints in Agostino's style.[1]

The relationship of this print to Agostino's engravings of Saints
Jerome and Francis (Agostino cat. nos. 124-126) from about 1583 sug-
gests again the close working contact of the two brothers during this
early period. Agostino's prints are also of half-length figures, mostly in
profile. However, Agostino's burin technique is somewhat broader than
his brother's at this period. In Annibale's *Saint Jerome,* the delicacy of the
lines of the saint's robes develops from his earlier handling of the graver,
but the stylized rendering of the grassy rock in the lower right stems
from his interest in his brother's works. A comparison of his print with
Agostino's *Saint Jerome* of c. 1583 (Agostino cat. no. 125) shows a prox-
imity in composition but a diversity of style. Annibale, working on the
same small scale as Agostino, included much more detail in his render-
ing. More contrast of burin strokes is apparent as well as a greater use of
different widths and lengths of strokes. In all, it is obvious that by the
early 1580s Annibale was a very competent engraver. He had the ability
to perform simple as well as complicated tasks with the graver as early as
1582 (cat. no. 3) but chose during the following years to use this talent
for more expressive effects, as can be seen in his prints of the late 1580s.

1 Cat. nos. 1-3. In any case, it must come after these prints. Whether it is earlier than
cat. nos. 5-8 is merely supposition.

5*

The Madonna Nursing the Christ Child

(B. 6) c. 1583-1587

Etching and engraving. 89 x 65 mm. (oval plate)

Literature: Malvasia p. 87; Oretti pp. 708-709, Gori Gandellini I p. 181; p. 27, no. 1; Joubert p. 350; LeBlanc 3; Nagler I, no. 1038; Petrucci p. 138; Petrucci 1953, cat. no. 324; Calvesi/Casale 197; Posner 37; Bertelà 313.

States:

	B	CC
I	–	–

Before inscription. (BM)

	B	CC
II	I	I

Lower left: *Anib.* Lower right: *Carr.* Below that: *Gasparo da lolio exc.* (Alb, BN, Bo, Br, Dres, MMA, Ro, and others)

*Plate extant in the Calcografia Nazionale, Rome (verso is cat. no. 6)

Preparatory Drawings: 1. Louvre 7139. Pen and brown ink and wash. 74 x 81 mm. (fig. 5a).* Perhaps an early study for this print.[1]

Copies: 1. Engraving in reverse by Raphael Sadler. 144 x 101 mm. Inscription: ECCE TV PVLCHER ES DILECTE MI. ET DE-/ CÖRVS. LECTVLVS NOSTER FLORIDVS EST. Lower right: *G de lolj ex.* Changes in print: flowers and crown of thorns surround oval.[2] 2. Engraving in reverse 91 x 64 mm. (sheet: BM) Bottom: *Anib. Carr. In.* 3. Etching in same direction. 86 x 64 mm. (sheet: PAFA). 4. Engraving in reverse. 129 x 102 mm. (sheet: Parma). In oval below Madonna: *Anib. 'Carr'.* Around oval: *putti* and other decorations.

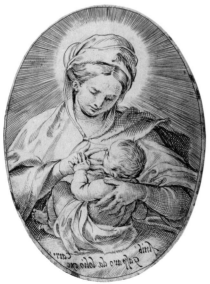

cat. no. 5, copperplate. Rome, Istituto Nazionale per la Grafica—Calcografia

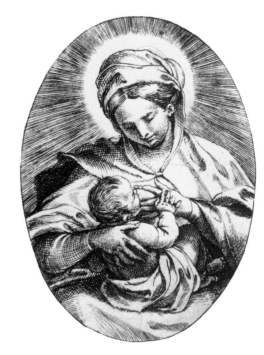

cat. no. 5, state I. London, The British Museum

This print appears to be the first exercise by Annibale in the field of etching and suggests that the artist was moving away from his brother Agostino both stylistically and technically. As with the engraving of *Saint Jerome* (cat. no. 4), Annibale used a fine and delicate line, but there is more freedom of movement in both the figure and the lines themselves, due perhaps to the more spontaneous medium of etching, but also more in keeping with Annibale's personality. From this point on, his prints lacked the finish of his earliest works and also exhibited less detail, a characteristic of the engraving technique but seldom used by etchers of the period. Consequently, Annibale was able to translate into the printed medium the spontaneity and fluidity of his pen and wash drawings. There is, in fact, a drawing in the Louvre (fig. 5a)* which may be an early thought for this print. A *Madonna and Child in a Roundel* is drawn with the quickness and sureness of an artist seeking both the broad outlines of a composition and the expressive nature of the figures. The *pentimenti* of the roundel and the Virgin's left hand, the wide areas of wash with subtle gradations, and the dripping lines from the thickly coated quill are all distinctive features of Annibale's drawing style of the 1580s. The tender expression of the Madonna also appears in the etching as she lovingly nurses her child. The human quality of his protagonists is one of the main qualities which separate Annibale's work from Agostino's. A beautiful drawing by Agostino from the 1580s (fig. 5b)* of the same subject points up this difference.[3] Although there is a tenderness in the Madonna's expression, it is not directed at the Child but frozen in a rather stylized mode. The interest here is not in the relationship of mother and infant son but in the sculptural qualities of the figure set within a roundel.[4]

Petrucci dated this print c. 1581, but Posner and Calvesi/Casale

believed it to be c. 1587, contemporaneous with the *Madonna of the Swallow* (cat. no. 9).[5] The signature of the Bolognese publisher Gaspare dall'Olio is of little help in dating the print since it appears only on the second state and because we know little about him.[6] The work on the verso of the extant plate (cat. no. 6) is not of aid either, for it contains only study sketches by the artist. There seems no reason to date the print as late as 1587, although there are resemblances between the Madonnas in each work. The etching is as close to Annibale's dated *Saint Francis of Assisi* (cat. no. 7) of 1585 as it is to the *Madonna of the Swallow*. Moreover, he could have produced this work at anytime after the artist's first attempts with the burin and his realization that his talent lay in etching. Therefore, it seems advisable to place it in a wider time span, sometime between 1583, after the *Saint Jerome* (cat. no. 4), and 1587, before the *Madonna of the Swallow* (cat. no. 9).[7]

1 The drawing is laid down. Unpublished. The size of the sheet is very close to that of the finished print.

2 There is a copy of this print in reverse. An etching with inscriptions of two lines in two sections beginning with *Sancte Vierge*. . . . 230 x 167 mm. (BM). It should be noted that this is a copy of the Sadeler and not a direct copy of the Carracci.

3 British Museum inv. no. 1972-7-22-11. Formerly in the Ellesmere Collection. For bibliography see Ellesmere sale, no. 25. Pen and brown ink and wash over black chalk heightened with white. 190 x 164 mm.

4 This is not at all meant to demean the Agostino drawing, which is one of his finest sheets and more attractive in most ways than the Annibale drawing. It is only meant to point up the difference in the purposes of each sheet.

5 Petrucci also believed the work contemporaneous with the *Madonna of the Swallow* but misread the date of the latter as 1581 rather than 1587.

6 See Appendix I for information on dall'Olio.

7 It may be added here that there is another drawing in the Uffizi (inv. no. 772 Esp) attributed to Annibale which is close compositionally and technically to this etching. However, this author believes the drawing to be a copy after Annibale by someone close to Guido Reni (Gernsheim 1622).

fig. 5a. Annibale Carracci, *Madonna and Child in a Roundel*. Paris, Cabinet des dessins du Musée du Louvre

fig. 5b. Agostino Carracci, *Madonna and Child in a Roundel*. London, The British Museum

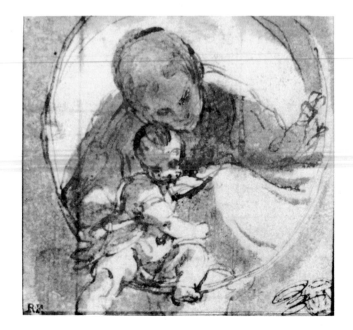

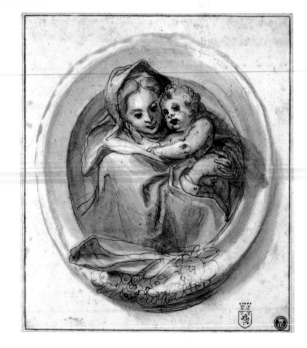

6*

Various Studies

c. 1583-1587

Engraving. 90 x 68 mm.

Literature: Posner, under 37; Calvesi/Casale 198.

States:

	CC	Pos
I	I	I

As reproduced. No inscriptions. (Rome: Calcografia Nazionale)

*Plate extant in Calcografia Nazionale, Rome (recto is cat. no. 5)

cat. no. 6, Rome Istituto Nazionale per la Grafica—Calcografia

The versos of several plates in the Calcografia Nazionale in Rome from which modern impressions have been made (cat. nos. 6, 8, 10) give us an idea of the artist's working methods. In this case, Annibale practiced using the burin in making hatching marks and in drawing heads. If these practice strokes were made before the work on the recto, the plate would have had to have been protected on this side with resin before it was dipped into the acid. It seems more probable that Annibale kept the plate around and practiced on it after taking impressions of the recto (cat. no. 5).

cat. no. 6, copperplate. Rome, Istituto Nazionale per la Grafica—Calcografia

7*

Saint Francis of Assisi
(B. 15) 1585

Engraving. 143 x 106 mm.

Literature: Bellori p. 88; Malvasia p. 87; Oretti
p. 707; Gori Gandellini I, p. 181, p. 27,
no. X; Nagler 1835, p. 388; Nagler I,
no. 1041(2); Joubert p. 349; LeBlanc 12;
Disertori p. 262; Bodmer 1938, p. 108;
Pittaluga p. 352; Petrucci p. 138; Petrucci
1953, cat. no. 327; *Mostra-Dipinti* p. 75;
Calvesi/Casale 193; Posner 23; Bertelà 322;
Boschloo p. 196, note 16

States:

	B	CC	Pos
I	I	I	I

Lower center: *1585*. Lower left on rock: *Ani.
Ca./in. fe.* (Alb, BM, BN, Bo, Br, MMA, Ro,
and others)

*Plate extant in the Calcografia Nazionale,
Rome (verso is cat. no. 8).

Copies: 1. Etching and engraving in reverse.
150 x 103 mm. Lower center: *Rome 1585 Carat
fecit*. In margin: S. FRANCISCVS. (BN)[1]
2. Etching in reverse. 145 x 106 mm. No
inscriptions. (Alb) 3. Engraving in reverse.
146 x 107 mm. (sheet: Alb). No inscriptions.

cat. no. 7, copperplate. Rome, Istituto Nazionale
per la Grafica—Calcografia

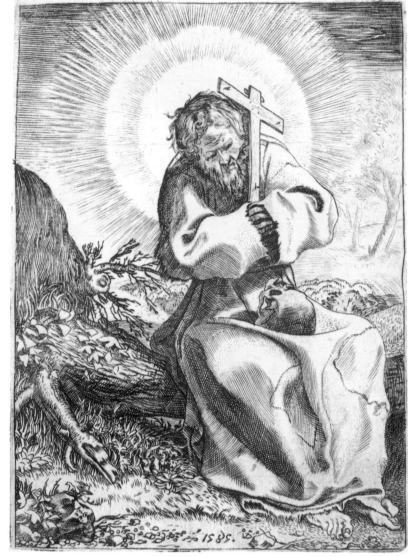

cat. no. 7, only state. New York, The Metropolitan Museum of Art, Harris Brisbane Dick Fund,
1926

The *Saint Francis of Assisi* was first mentioned by Bellori and again by
Malvasia, who mistakenly believed it to be an etching retouched by the
burin. It is the first undisputed dated print by Annibale, but, as has
been proposed here, it is hardly his first engraving. The apparent crudity
of the line was used earlier in the engraved *Saint Jerome* (cat. no. 4) and
the etched *Madonna Nursing the Christ Child* (cat. no. 5). The scratchy
lines of the robe and face as well as the hastily sketched background of
trees tend to emphasize the spontaneity of the scene. The gnarled hands
and feet, the shabbiness of the robe, delineated by apparently random
hatching and dots, portray the asceticism of the poverty-loving saint.
The foreground of rocks and leaves, as in the *Saint Jerome* (cat. no. 4), is
still reminiscent of Agostino's flora, but the intensity of expression on
the saint's face and the sharply indicated body and robe emphasize the
purpose of Annibale's art at this time: an insistence on the content of the
work over the method of delineation, a subordination of finish to the
immediacy and naturalism of expression.

1 A first state of this print lacks the inscription in the margin.

8*

The Crucifixion
c. 1585

Engraving. 143 x 106 mm.

Literature: Calvesi/Casale 194; Posner 23b.

States:

	CC	Pos
I	I	I

As reproduced. No inscriptions. (Rome: Calcografia Nazionale)

*Plate extant in the Calcografia Nazionale, Rome (recto is cat. no. 7)

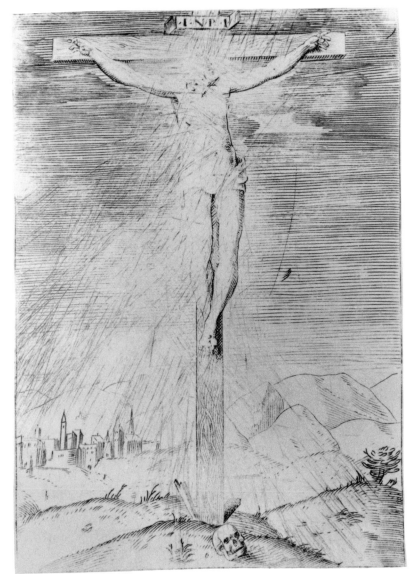

cat. no. 8, only state. Rome, Istituto Nazionale per la Grafica—Calcografia

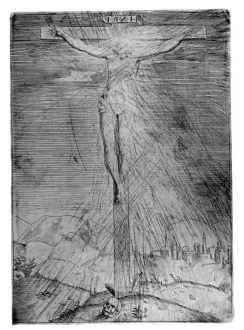

cat. no. 8, copperplate. Rome, Istituto Nazionale per la Grafica—Calcografia

The *Crucifixion* may well predate the *Saint Francis of Assisi* (cat. no. 7), found on the recto of the copperplate. The composition is simpler, even somewhat crude, and the artist obviously cancelled it in disappointment with the resultant image. One is tempted to compare it with Annibale's first and more successful print of the *Crucifixion* (cat. no. 1), made four years previously. Although it could be argued that the detail of the earlier work contrasts markedly with the simplicity of this engraving, it should be remembered that the 1581 engraving is almost four times larger in scale, leaving room for detail. This small piece may have been only an exercise in making a devotional image for commercial purposes. The artist rejected the work and instead produced the extremely complicated image of *Saint Francis of Assisi*.[1]

1 A drawing in the Ashmolean (inv. no. 160) which Posner connected with the 1594 *Crucifixion* in the Staatliche Museen, Berlin-Dahlem (Posner 81) may be earlier than that and connected with this aborted engraving.

9*

The Madonna of the Swallow (La Madonna Della Rondinella) (B. 8) 1587

Engraving. 158 x 123 mm.

Literature: Baglione p. 391; Bellori p. 88; Malvasia pp. 87, 294; Oretti pp. 706-707; Gori Gandellini I p. 181, p. 27, no. III, Nagler 1835, p. 388; Nagler I, no. 1043; Joubert p. 350; LeBlanc 5; Andresen 6; Kristeller p. 281; Pittaluga p. 352; Disertori p. 262; Foratti p. 192; Petrucci p. 138; Petrucci 1953, cat. no. 323; *Mostra-Dipinti* p. 72; Arcangeli, "Sugli inizi dei Carracci," *Paragone* 79 (1956): 22; Bodmer 1938, p. 108; Calvesi/Casale 195; Posner 36; Bertelà 315; Boschloo p. 196, note 19.

States:

	B	CC	Pos
I	1	1	1

On pedestal at left: ANI. CAR BOL. F/IN. Lower left: *1587*[1] (Alb, BN, Bo, Ber, Dres, NGA and others).

Plate extant at the Calcografia Nazionale, Rome (verso is cat. no. 10)

Copies: 1. Engraving in the same direction. 151 x 114 mm. Lower left: *1587*/ ANI. CAR. BOL. IN. (MMA) 2. Etching in reverse. 154 x 119 mm. (sheet: Ham) Lower right: *1665*.

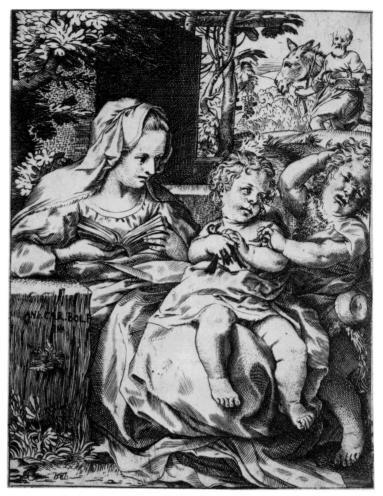

cat. no. 9, only state. Washington, National Gallery of Art, Ailsa Mellon Bruce Fund

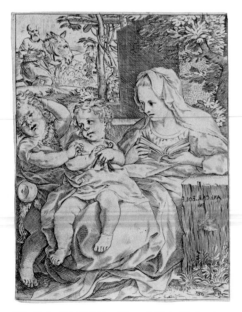

cat. no. 9, copperplate. Rome, Istituto Nazionale per la Grafica—Calcografia

Malvasia, Bartsch, Disertori, Petrucci, and Cavalli *(Mostra)* incorrectly read the date of this engraving as 1581 rather than 1587. All other writers have read the date correctly, and one should note that the "1" of "1587" differs markedly from the "7," proving again that the date is indeed 1587. Moreover, stylistically, the print has nothing to do with Annibale's early engravings such as the *Crucifixion* and the *Holy Family with Saints John the Baptist and Michael* (cat. nos. 1, 2), whereas the scratchier lines and cruder detail are markedly similar to the *Saint Francis of Assisi* dated 1585 (cat. no. 7). Like the figure of Saint Francis, the Madonna's form is made up of varying strokes and dots which emphasize broad planes of light on the garment, similar to the broad areas of wash the artist employed in contemporaneous drawings.[2]

Arcangeli saw the influence of Agostino in this print, but as in the *Saint Francis* (cat. no. 7) and the *Madonna Nursing the Christ Child* (cat. no. 5), Annibale forsook the more finished aspects of his brother's technique in favor of the spontaneous, expressive strokes. Burin lines do not flow easily into each other and are not placed regularly at precise intervals but tend to approximate the more quickly executed medium of pen drawings.

1 Andresen listed another state with Rossi's address. This author has not found an impression of that state.

2 See cat. no. 2 for a discussion of some of the drawings of the period.

10*

Various Studies

c. 1587

Engraving. 158 x 123 mm.

Literature: Calvesi/Casale 196; Posner under 36.

States:

	CC	Pos
I	I	I

As reproduced. (Rome: Calcografia Nazionale)

Plate extant in the Calcografia Nazionale, Rome (recto is cat. no. 9)

cat. no. 10, only state. Rome, Istituto Nazionale per la Grafica—Calcografia

On this plate Annibale was trying out the graver before attacking a composition, probably the recto of the plate. Posner, however, saw these scratches and doodles as "proto-caricatures."[1]

1 See the Introduction on the Carracci and caricatures.

cat. no. 10, copperplate. Rome, Istituto Nazionale per la Grafica—Calcografia

11*

The Holy Family with Saint John the Baptist
(B. 11) 1590

Etching and engraving. 162 x 218 mm.

Literature: Baglione p. 391; Bellori p. 87; Malvasia p. 86; Oretti p. 704; Basan p. 113; Strutt p. 182; Gori Gandellini I p. 181, p. 29, no. II; Nagler 1835, p. 388; LeBlanc 8; Nagler I, no. 1052 (1); Andresen 8; Foratti p. 192; Kristeller p. 281; Pittaluga p. 349; Disertori p. 266; Bodmer 1938, pp. 108-109; Petrucci p. 139; Ludwig Münz, *Rembrandt's Etchings, a Critical Catalogue,* London, 1952, I, p. 40, II under cat. no. 193; *Mostra-Dipinti* p. 82; *Mostra-Disegni* 260; Calvesi/Casale 200; Posner 56 and I, p. 46; Bertelà 319; Boschloo p. 30.

States:

	B	CC	Pos
I	1	1	1

Lower right: *Anni Car. in. fe. 1590.* (Alb, BM, Bo, Br, Dres, MMA, and others)

	—	2	—	—

Retouched. "C" of "Car" on same line as "ar" rather than below as in state I.[1] (Alb, BM, BMFA, BN, and others)

II	—	—	—

Lower right: *Si Stampa da Matteo Giudici alli Cesarini.* Weak.[2] (BN)

III	—	—	—

Si stampa. . . . burnished out. *Sandraert excud* added. (Alb)

Copies: 1. Etching and engraving in same direction. 165 x 221 mm. Same inscription as State I but with "C" below on same line as "ar" of "Car." This is Bartsch's state 2. 2. Engraving in reverse. 199 x 236 mm. Figures placed within a hall. Tile floor; columnar alcove and vault behind. Addition of lilies. Two sets of two lines in address below. *Dominic Cust exec.* Eighteenth century. (MMA). 3. Etching in same direction. 166 x 220 mm. (sheet: Dres). Faithful but harsher than original. 4. Engraving in reverse published by Mariette. 202 x 290 mm. (sheet: Dres). Lower left: *Annibal Car. invent.* Lower right: *Mariette excudit.* Center: *Mille dat Aeternae. . . .* 5. Etching in reverse 157 x 215 mm. (image) No inscriptions (BM).[3]

Bartsch was correct in calling this one of Annibale's tenderest prints. The maternal attitude of the Madonna in her light embrace of the children and her loving gaze toward the pensive Saint Joseph contribute to the familial mood of the composition. Münz believed that even Rembrandt's etching of the *Holy Family* of c. 1631 was influenced by it.[4]

Posner suggested that the composition may have been a critique of Lodovico's print of the *Holy Family under the Arch* (Lodovico cat. no. 1), but as the latter is undated there is a small possibility of its following the Annibale print rather than the other way around.[5] In any case, Posner rightly saw the influence of Andrea del Sarto's famous painting of the *Madonna del Sacco.*[6]

In this etching Annibale reached a new technical height in his graphic career. He produced atmospheric effects missing from his works of the 1580s but characteristic of his works from this point on. Posner believed that in the prints of this period Annibale experimented with coloristic effects inherent in Venetian painting. As he pointed out, Annibale had probably visited Venice by this year because of the Venetianizing influence on his paintings. As stated in the Introduction, Annibale had probably been to Venice as early as 1580. Yet, this new surface softness of Annibale's prints is not of the same quality as in his paintings which, although bathed in a new *sfumato,* still carry a certain finish in the contours of figures.[8] In the *Holy Family,* however, Annibale purposely left his contour lines broken and discontinuous to merge his figures with the surrounding atmosphere. This is especially evident in the left arm of the Virgin, which is almost part of the foliage of the background. These broken contour lines also add to the effect of movement of the forms, giving a kind of shimmering quality to the whole. Annibale accomplished this by using a wide variety of strokes within a small area, as in the Virgin's face and left sleeve. Depth and shadow are achieved not by increased biting of the surface to show darkness or light but by increased hatched lines placed close together, as in the leg of St. Joseph, or fewer lines farther apart, as in the distant landscape.

These special effects suggest an increased awareness of the possibilities of the etching medium. One wonders if Annibale looked again more closely at Barocci's etchings and attempted to achieve the same kind of atmospheric rendering by taking advantage of the graphic technique employed. The influence of Barocci may be as important here as the continued influence of Venetian paintings.

*Print in exhibition from the Museum of Fine Arts, Boston, Gift of Mrs. Thomas Hockley.

1 This state is here called a copy and is very deceptive. States II and III have the "C" below the line as in state I.

2 Andresen knew this state but called it state 3, having accepted Bartsch's state 2.

3 This is probably an impression from an extant plate in the Calcografia Nazionale. 169 x 220 mm. is the size of the plate.

4 Münz admitted it is difficult to see the relationship. Rembrandt's image, in reverse, is more compact, and only the figure of Joseph reading could be a quotation. But Münz's observation that Rembrandt was influenced by the Italian etching technique which emphasized the ability of light to dissolve forms was well made.

5 But, Lodovico's print is dated earlier than Annibale's in this catalogue.

6 Reproduced John Shearman, *Andrea del Sarto,* Oxford, 1965, vol. I, pl. 134.

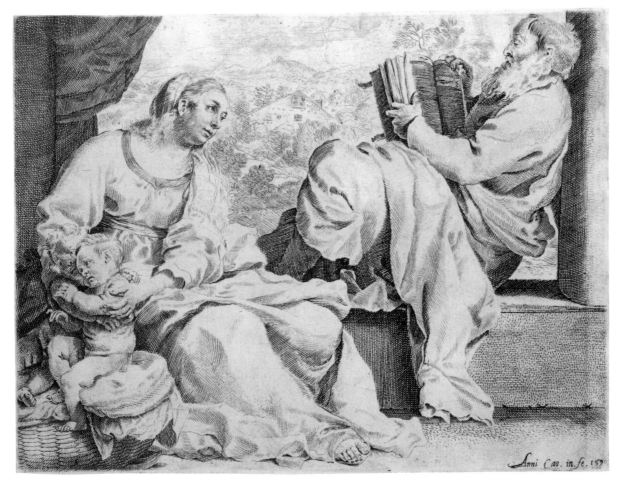

cat. no. 11, state I. Prints Division, The New York Public Library, Astor, Lennox, and Tilden
Foundations

7 Posner I, p. 46.

8 Compare this, for example, with Annibale's 1592 painting of the *Assumption of the
Virgin* in the Pinacoteca Nazionale in Bologna (Posner 69).

12*

Mary Magdalen in the Wilderness
(B. 16) 1591

Etching and engraving. 223 x 160 mm.

Literature: Baglione p. 391; Bellori p. 88;
Malvasia p. 86; Oretti p. 704; Gori Gandellini I
p. 182; Joubert p. 350; Nagler I no. 2269;
Nagler 1835 p 388; LeBlanc 16; Andresen 10;
Pittaluga p. 351; Bodmer 1938, p.109;
Petrucci p. 139; Calvesi/Casale 203; Posner 63;
Bertelà 323.

States:

	B	CC
I	1	1

At left on rock: *Carra: in.* Lower edge toward
center *1591.* (Alb, BM, BN, Br, Dres, NGA,
and others)

	B	CC
II	2	2

Added along bottom below margin line: *P S F.*
(Alb, BN, Bo, Dres, MMA, and others)

	B	CC
III	—	—

Lower right: *Si stampa da Matteo Giudici alli
Cesarini.* (Ber)

	B	CC
IV	—	—

This last burnished out. (Ber)[1]

Preparatory Drawings: 1. Louvre 7173. 216 x
163 mm. Red chalk. Incised. Laid down.
Collection: Mariette (Lugt 1852). (fig. 12b)*.[2]

Copies: 1. Etching in reverse of the upper half.
149 x 161 mm. Instead of leaning on blanket,
Magdalen leans on ointment jar and skull.
Inscriptions. 2. Etching in reverse. 215 x
162 mm. Without inscriptions. Deceptive.
3. Etching in reverse. 247 x 176 mm. (sheet:
Windsor Castle)

Although this dated print has been accepted unquestionably by all
writers on Annibale, very little has been said about the work itself,
perhaps because the figure of the Magdalen is not attractive and the
composition not especially unusual. But, like several other prints by the
artist, the *Mary Magdalen in the Wilderness* is an example of the artist
using and reusing forms, in an effort to perfect them, in different
media.[3] In this case, however, it is debatable which work came first.
The problem lies with our inability to date Annibale's works accurately.
It is possible that the first work in the Mary Magdalen series is a paint-
ing in the collection of Denis Mahon (fig. 12a), who dates the horizontal
composition to c. 1586-1587.[4] The painting, known to the author only
in photographs, was accepted as authentic by Posner in 1965 but re-
jected as a seventeenth-century interpretation of the etching in 1971.[5] In
any case, Annibale made this print in 1591, based on a drawing in
reverse in the Louvre (fig. 12b),* in which the Magdalen is in a position
suited to the vertical format of the print. She is balanced by foliage and
the cross in the right-hand side of the composition.

An unpublished drawing in a private collection in New York
(fig. 12c)* is a copy by Annibale of the upper portion of the print: the
inclination of the Magdalen's head is similar, as is the intertwining styli-
zation of the clasped fingers.[6] Annibale may have been considering a
small devotional painting of the subject, like those he made of St. Fran-
cis adoring the crucifix.[7] One is inclined to date this beautiful free wash
sketch in the 1580s, but its relationship with the print and some of the
drawings for the Palazzo Magnani frescoes, finished in 1592, suggests
that it dates from the early 1590s.[8]

Painted about the same time is the *Venus and Adonis* in the Prado,
which no one has thought to connect with the Mary Magdalen etching,
but which, in this author's opinion, was inspired by it.[9] Posner, follow-
ing Mahon, dated the painting c. 1588-1590, comparing it with the
Dresden *Madonna of Saint Matthew* of 1588 and with the two preparatory
drawings in Madrid and Florence.[10] There seems no reason, however, to
be so exact in a chronology for the painting, which could have been
painted as late as 1592-1594. In fact, the preparatory drawings do not
necessarily have to belong to the 1580s. But, these are nitpicking argu-
ments: critics attempt to pin down works to a narrow span of years,
when in fact evidence suggests the Carracci, between the period of the
Fava and Magnani frescoes, that is, between c. 1584-1592, slowly
evolved stylistically. The point here is that Annibale reused the form of
the Magdalen for Venus, the goddess of love, an apt translation.
Moreover, in the painting, Adonis balances the figure of Venus as the
trees to the right of Magdalen balance her form in the etching. Yet, in
transferring the composition to a horizontal format, some of the upward
swinging movement along the Magdalen's body is dissipated in the
painting. The contrapuntal pose of the Magdalen and the Venus were to
become stock in Annibale's work: his Susanna in the engraving *Susanna
and the Elders* (cat. no. 14), of about the same time, reuses a similar
pose.

Technically, the etching is a continuation of Annibale's interest in
atmospheric effects possible in the etching medium, which he began
exploring in the *Holy Family with Saint John the Baptist* (cat. no. 11). As
discussed in the following catalogue entry, there is a possibility that

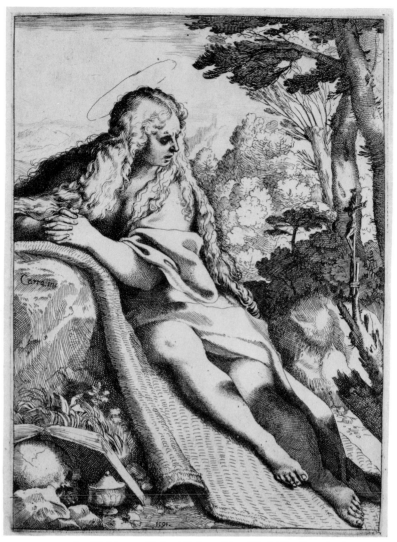

cat. no. 12, state I. Washington, National Gallery of Art, Ailsa Mellon Bruce Fund

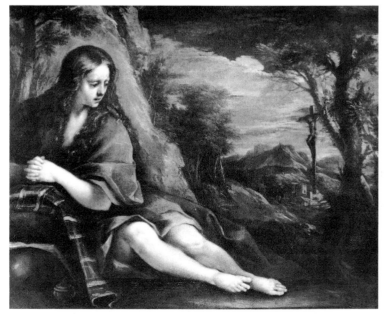

fig. 12a. Annibale Carracci(?), *Mary Magdalen in the Wilderness*. London, Collection Denis Mahon

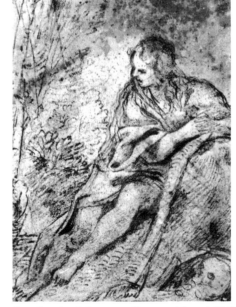

fig. 12b. Annibale Carracci, *Mary Magdalen in the Wilderness*. Paris, Cabinet des dessins du Musée du Louvre

Annibale thought of these works in terms of a diptych.[11]

1 Andresen knew of these four states and mentioned a fifth one in which the first address was crossed out. This state is unknown to this writer.

2 For complete bibliography see Bacou, cat. no. 26.

3 See cat. no. 19.

4 Letter to the author, September 1978. See also Detroit Institute of Arts, *Art in Italy 1600-1700* (New York, 1965), cat. no. 71.

5 Posner wrote the catalogue entry for *Art in Italy.* See also Posner 63, and Posner 194R.

6 Pen and ink and gray wash. 125 x 105 mm. Laid down. Collections: Nathanial Hone (Lugt 2793), his second sale, February 7-14, 1785; A. F. Creswell, from his album; E. A. Wrangham, sold Sotheby July 1965, no. 18; Dr. Toller.

7 See, e.g., Posner 29, 90.

8 Cf. especially the landscape and the drawing for *Romulus and Remus Nursed by the She-Wolf* in the Louvre (Posner 52k, 521).

9 Posner 46c. Also dated early 1590s by Bissell: R. Ward Bissell, review of Posner in *Art Bulletin,* 56 (1964): 132. In fact, as pointed out by Boschloo (I, p. 31, II, p. 197, note 24), the poses of the Venus and Adonis (and thus the Mary Magdalen herself) come from Agostino's engraving after Tintoretto, *Mars Driven from Peace and Abundance by Minerva* (Agostino cat. no. 148). If the Mahon painting is in fact by Annibale and dates c. 1586/1587, the figure of Magdalen there is taken directly from the Tintoretto painting.

10 Reproduced Posner 46a, 46b. *Madonna of St. Matthew* reproduced Posner 45.

11 There are several painted copies of this etching, mentioned by Posner. One is by Gimignani in a private collection, Rome (reproduced Gemma di Domenico Cortese, "Profilo di Ludovico Gimignani," *Commentari,* 14, 1963, pl. 13), and another by Burrini in the Galleria Nazionale, Parma, unknown to this writer. The Gimignani could be a copy after the Mahon painting; note the horizontal format.

fig. 12c. Annibale Carracci, *Mary Magdalen.* New York, Private Collection

13*

Saint Jerome in the Wilderness
(B. 14) c. 1591

Etching and engraving. 248 x 192 mm.

Literature: Bellori p. 88; Malvasia p. 86; Orett p. 703; Gori Gandellini I p. 182, p. 27, no. X Nagler 1835, p. 388; LeBlanc 14; Andresen 9 Bodmer 1938, p. 109; Petrucci 140; Calvesi/Casale 204; Posner 64; Bertelà 321.

States

	B	CC
I	1	1

Without inscription. (Alb, BM, Cleveland, Ham)

II	—	—

Along lower edge: *P. S. F.* (Alb, Ber, BM, Dres, NGA, and others)[1]

III	2	2

As above but with *An. Caracci fe.* lower right. (Alb, BM, BN, Bo, NGA, and others)

IV?	—	—

Inscriptions of States II and III burnished out, but still somewhat visible. (Chatsworth)[2]

Copies: 1. Etching in reverse. 242 x 167 mm. Lower left: ANI. CAR. IN. Lower center: S. HIERONYMUS. Lower right: CAR. GAR. F. 1646. (Alb). 2. Engraving in reverse. 207 x 165 mm. Inscription that begins with SANCTUS HIERONYMUS *Illustrissimo.* (MMA)

cat. no. 13, state II. Washington, National Gallery of Art, Ailsa Mellon Bruce Fund

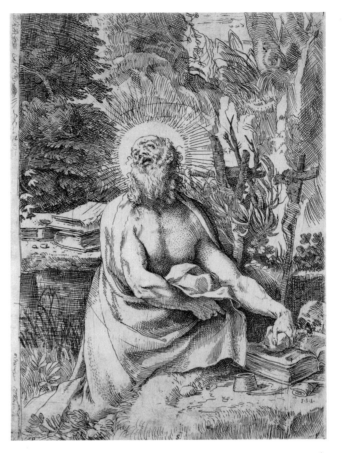

Bodmer dated this print c. 1595, but Posner and Calvesi/Casale correctly dated it c. 1591, noting its proximity to the *Mary Magdalen in the Wilderness* (cat. no. 12), which is dated 1591. In the *Saint Jerome* Annibale widened the spacing between hatching and used fewer short strokes and dots; consequently, there is less variation in shading or depth in this print. This kind of handling became characteristic of the followers of Annibale in the early seventeenth century.[3] Foregrounds, backgrounds, and figures tend to merge together emphasizing an overall pattern of decorative lines.

Although the looser handling of the composition is different from that in the *Mary Magdalen,* there are several features which connect the works. The vertical formats are similar, as are the penitent attitudes of the saints, each found in a desert setting adoring the crucifix.[4] If the *Saint Jerome* is placed at the right of the *Mary Magdalen*, it tends to complete a larger composition. The sizes of the plates are also fairly close. There is a possibility that Annibale decided to produce a second devotional image after he had completed that of the Magdalen, perhaps not as a pendant, but at least to be connected visually with the first.

1 Andresen noted the existence of this state.

2 There is a distinct possibility that the example in Chatsworth, the only one known to this writer, has erasures on the paper surface rather than on the plate.

3 See the discussion of Annibale's influence in the Introduction.

4 The same soulful expression on the face of Saint Jerome is found on the figure of Christ in a beautiful black chalk drawing in the Codice Resta (Inv. no. 90, p. 87) in the Biblioteca Ambrosiana in Milan. This powerful drawing dates probably to the early Roman years of the artist.

14*

Susanna and the Elders
(B. 1) c. 1590-1595

Etching and engraving. 351 x 310 mm.

Literature: Bellori p. 88; Malvasia p. 86; Oretti pp. 670, 703; Basan p. 112; Strutt p. 182; Gori Gandellini I p. 182, p. 28, no. XX; Joubert p. 350; Nagler 1835, p. 388; LeBlanc 1; Andresen 1; Disertori pp. 259-261; Pittaluga p. 349; Bodmer 1938, p. 112; Petrucci p. 140; Louis Dunand "La Figuration de Suzanne Surprise au Bain par deux vieillards dans les estampes—apropos de deux graveurs des Carracche sur ce theme au Musée des Beaux-Arts de Lyon," *Bulletin des Musées et Monuments Lyonnais,* 5, no. 4, 1972 pp. 57-79; Calvesi/Casale 207; Posner 57; Bertelà 307.

States:

	B	CC	Pos
I	1	1	–

Before inscriptions. (Alb, BM, Br, NGA, and others)

	B	CC	Pos
II		2	1

With inscription in margin: PERILL.^{TRI} ADMODV̄ D·D· FRAN·^{CO} GVALDO S· STEPHANI EQVITI· LEONIS XI. INT.^{MO} CVBIC^{RIO} PAVLI V· ET GREG·^{XV·} FAMILIARI. Four lines of inscription: *Ariminae Gentis occus. et sacra gloria Gualde,/Prisca vetustatis qùem monumenta iuvant:/Accipe' tentatae Exemplar sine labe Sylvannae,/Signet avita fides quam sit avitus amor.*

In center: PROÑO SVO COLEND°/ *Petrus Stephanonius observatiae ergo / D D.*

	B	CC	Pos
III		2	2

As above but with following lower left: *Anibal. Car. Invent. et sculp.* (Baltimore, Bo, Dres, and others)

	B	CC	Pos
IV	–	–	–

Reworked. Very weak. (BMFA)

Copies: 1. Etching and engraving in reverse published by Sadeler. 220 x 160 mm. Composition compressed and more vertical. In margin left: *Carazz. inc:* Right: *Iustus Sadeler ex.* Center: *Circumventa Senum est technis Susanna neptem./ Dum Se Secreto in fonto pudica lavat.* (MMA).

Bodmer dated this etching c. 1595, Calvesi/Casale c. 1592, and Posner about 1590, the latter two mentioning the correspondence of the Susanna with the figure of Venus in the painting of *Venus and Adonis* in the Prado, Madrid.[1] Calvesi/Casale also pointed out that the gesturing hand of the Adonis is repeated in the figure of the old man at right, but, of course, this is a commonly used gesture. It is interesting that about the same period Annibale reused parts of this composition in his *Mary Magdalen in the Wilderness* (cat. no. 12).

There seems no reason to date this print to any particular year in the early nineties, since it is close stylistically and technically to most of the other prints executed by Annibale before he went to Rome. Thus, a dating within the five year span of 1590 to 1595 seems fitting, but a date toward the beginning of this period is favored by this writer. The etching is closest to the *Holy Family* of 1590 (cat. no. 11) in the diversity of hatching and atmospheric interest. The *Susanna and the Elders* is technically the most complicated print since Annibale's engraving after Sabbattini and Calvaert of 1592 (cat. no. 2). Annibale proved again with this etching that he was as technically proficient in printmaking as his brother.

Annibale took up the theme again in a painting known only in copies, the best of which may be by Lanfranco, in the Doria Pamphilj Gallery in Rome.[2] A drawing by Annibale in the British Museum,[3] connected by Posner with the painting, employed this pose of Susanna as its starting point. It is doubtful that the study is early enough to be preparatory to this print but is datable in the late 1590s, as proposed by Posner.

One should compare this print with Agostino's *Lascivie* of about the same time, especially his engraving of the same subject (cat. no. 176). Compositionally, there is some connection; the figures brought up close to the picture plane with a landscape background. Yet, Annibale's work was a major technical undertaking, unlike Agostino's.[4]

1 Posner dated the *Venus and Adonis* c. 1588-1589, whereas Calvesi/Casale believed it to be c. 1592. The latter also compared this print, erroneously in the opinion of this author, to the *Venus and a Satyr* of 1592 (cat. no. 17).

2 Posner 131a.

3 Reproduced Posner 131b.

4 Michael Levey (*National Gallery Catalogues, The Seventeenth and Eighteenth Century Italian Schools,* London, 1971, pp. 81-82, under cat. no. 28) noted the "vague similarity in disposition of the figures, though virtually in reverse" with Lodovico's 1616 painting of the same subject in the National Gallery, London. Of course, the theme was a popular one at this period, and by the teens of the seventeenth-century visual quotations were in fact becoming stock. See also Agostino's (?) painting of the same subject in the Ringling Museum in Sarasota of the late 1590s (Ostrow cat. no. II/11).

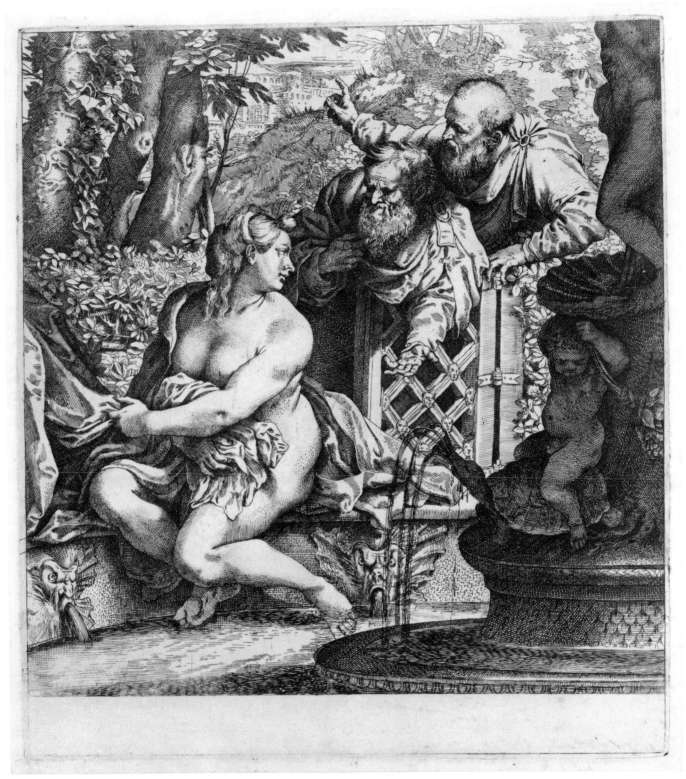

cat. no. 14, state I. Washington, National Gallery of Art, Ailsa Mellon Bruce Fund.

15*

Madonna and Child With an Angel

(B. 7) c. 1590-1595

Etching. 90 x 91 mm. (sheet: LC)

Literature: Malvasia p. 87; Oretti p. 708; Gori Gandellini I, p. 183, p. 27, no. II; Joubert p. 350; LeBlanc 4; Nagler I, no. 1404(2); Andresen 5; Bodmer 1938, p. 109; Calvesi/Casale 216; Posner 173.

States:

	B	CC	Pos
I	1	–	–

Upper left: A.C.I.F. (Alb, BM, BN, PAFA)

	B	CC	Pos
II	2	1	1

Below A.C.I.F.: *Pietro Stefanone for.* (Alb, BM, BN, Br, Dres, LC, Par, and others)

Copies: 1. Etching in reverse. Inscription: *Al Molto Ill.ʳᵉ Sig.ˢ et Pro.ⁿ Oss.ᵐᵒ il Sig. Cavalier Francisco Gual-/ di Ariminese di V.S. Viᵐᵒ Servitore Jacomo Stefanoni/ Dana Da et Dedica.* Upper right: ANIBAL CARACCI/ INVENT. (LC). 2. Etching in same direction. 91 x 89 mm. Upper left: ANIBAL CARACC / INVENTOR. Lower left in margin: *In Roma presso Carlo Losi.* (LC). 3. Engraving in reverse. In circle. Diameter: 114 mm. By I. Sadeler. (MMA). 4. Etching in same direction. 110 x 88 mm. Lower left: *Io Baptistae de Rubeis formis.* Upper left: ANIBAL CARACCI/ INVENTOR. (Alb). 5. Engraving in reverse. Upper right: ANIBAL CARACCI/ INVENTe. 124 x 90 mm. (sheet: Par). 6. Engraving in reverse. 93 x 90 mm. Upper right: A.C.I. Eighteenth century. (Par). 7. Etching in the same direction. No inscription. 95 x 93 mm. Very deceptive.

Bodmer dated this delicate composition about 1595, but Calvesi/Casale and Posner believed it to be a late etching, c. 1606, comparing it to Annibale's other prints of this period (cat. nos. 20-22). There seems no stylistic reason to place this etching that late. First of all, Annibale's prints after he arrived in Rome, except for the *Christ of Caprarola* (cat. no. 18), all exhibit an influence of classically inspired forms. In the *Madonna della Scodella* (cat. no. 20), for example, the figures are more sculptural, as they are in the *Christ Crowned with Thorns* (cat. no. 21). In the *Adoration of the Shepherds* (cat. no. 22), also of 1606, faces have aquiline features, typical of the artist after the frescoes in the Palazzo Farnese.

On the other hand, the figure of the Child is extremely close to the one in the etching of the *Madonna and Child* (cat. no. 16), which must predate 1593. Likewise, technically, this etching falls within the range of other prints of this period, in which Annibale used broken contour lines and shortened hatching to effect a feeling of casual execution or to approximate drawings.[1]

1 A drawing in the Uffizi (Inv. no. 772), which is there attributed erroneously to Agostino, is probably influenced by this etching as well as by the *Madonna Nursing the Christ Child* (cat. no. 5). See cat. no. 5, footnote 7 for further discussion. Nancy Ward Neilson mentioned a painted copy in the same direction in the R. M. Rush Collection, New York as Sisto Baldalocchio.

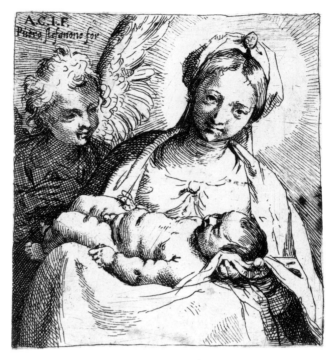

cat. no. 15, state II. Washington, Library of Congress.

16*

The Madonna and Child
(B. 31 as Agostino) before 1593

Etching and engraving. 152 x 109 mm. (after Agostino Carracci)

Literature: Malvasia p. 81; Oretti pp. 824-825; Mariette ms. 3; Heinecken p. 633, no. 25; Gori Gandellini p. 313, no. XV? as Agostino?; Nagler 1835, p. 395; Nagler I, no. 646; Mariette III, 77; LeBlanc 20; Bodmer 1940, p. 71; Petrucci p. 139; Calvesi/Casale 201; Posner 55; Bertelà 330.

States:

	B	CC	Pos
I	1	1	—

Upper left: AGO. CA. I. (Alb, BM, Br, PAFA, and others)

	B	CC	Pos
II	2	2	1

To the right of the inscription in state I: *Pietro Stefanani for.* (Alb, BM, BN, Bo, Dres, MMA, and others)

Copies: 1. Etching in reverse. No inscriptions. 154 x 107 mm. (MMA). 2. Etching in reverse. 183 x 135 mm. (sheet: Bo). *Ag Carazzi inv.* MATER ADMIRABILIS L. *Mattioli A.C. f.* Dated 1726. 3. Engraving in reverse with drapery overflowing parapet. Lower center: INVENI QVEM/ DILIGIT ANIMA/ MEA/ *Can. 3.* Lower right: *Raphael Sadeler fecit. Monachij 1593.* 160 x 108 mm. (MMA).[1] 4. Engraving in reverse with parapet below and with inscription: INVENI QVUM/ DILIGIT ANIMA/ MEA/ *Can 3.* Lower left partly covered with hatching: A CARAC *invent.* Center: *Io'Antoij de paulis for.* 184 x 125 mm. (Ro). 5. Print in same direction but with aureole filled in. Lacing the letters AGO. CA.I. (Mentioned by Bartsch). 6. Etching in reverse. 154 x 95 mm. Upper right: AGG. CA. L. *Pietro Stefanoni for.* (Alb). 7. Copy with *Corn. van Tienen* (according to Heinecken). 8. Etching in reverse. 170 x 121 mm. (sheet: Alb). In margin: *Ag. Carracci Inv.* MATER ADMIRABILIS. *Gio. Ant. Belmondo f.* 9. Engraving in reverse. 192 x 136 mm. (sheet: Alb) Aureole has stars surrounding it. Lower left: *Anno Dni 1625.* 10. Etching and engraving in reverse. 155 x 106 mm. (sheet: Ham) In margin: MATER ADMIRABILIS *Ora pro me.* Lower left above margin: A

Due to the inscription AGO. CA. I. in the upper left, this print was traditionally attributed to Agostino Carracci.[2] Bodmer, however, rectified the misattribution and rightly listed the etching among Annibale's works, and all other writers have followed him in this attribution. The inscription does not indicate that Agostino executed the print but that he invented the design. Posner believed that the invention was not Agostino's and that the inscription was a mistake of the publisher Stefanoni. He failed to notice the first state of this print without Stefanoni's address, indicating that the design was attributed to Agostino before it was published by Pietro Stefanoni. Posner believed also that the "flowing internal movements and sentimental character" were unlike Agostino. This is true, but we do not have Agostino's original design to compare the liberties taken by Annibale in translating the design to a print. It seems, rather, that the full-bodied figure of the Madonna, her hairstyle, and her ample drapery are elements characteristic of Agostino's art which Annibale could easily have transferred to the etching, infusing these elements with the emotional qualities of his own art. In fact, a later (1597) print by Agostino of the *Holy Family* (Agostino cat. no. 208) has a figure of the Madonna very close in attitude and stance to this one. One may remark that Agostino could have copied this figure from Annibale's earlier print, but this kind of figure was common to Agostino's and not to Annibale's art. Moreover, a drawing by Agostino, also later, exhibits these same qualities (fig. 16a).[3] In addition, we know from earlier works by Annibale that he was a reproductive artist and that he worked closely with Agostino. There is no reason to doubt that he would copy a work by his brother at this time.

A *terminus ante quem* of 1593 may be given to this etching, for in that year Raphael Sadeler made an engraved, dated copy of the print.[4] The etching technique of shortened strokes and broad areas between hatching is characteristic of the prints after 1590, as previously discussed (cat. nos. 11-15). Consequently a loose dating of c. 1590-1593 for the *Madonna and Child* is indicated.

*Etching in exhibition from the Philadelphia Museum of Art, Academy Collection.

1 There is a copy of this print in reverse with a similar inscription on the parapet but with the following words in the lower right: *A. Caraz Invent.* 158 x 116 mm. (sheet: MMA). A first state of this print does not have the inscription in the lower right and also lacks the *Can.*3 below the other inscription.

2 Although LeBlanc called it an anonymous copy.

3 British Museum Inv. no. 1895-9-15-702. 168 x 128 mm. Pen and brown ink.

4 Posner incorrectly called this copy the one described in footnote 1. He mentioned that Malvasia had noted a copy that was inscribed: *An. Carat. invent. . . .* That copy is unknown to this author.

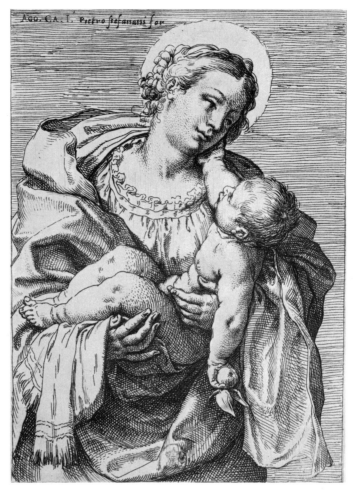

cat. no. 16, state II. Paris, Bibliothèque Nationale

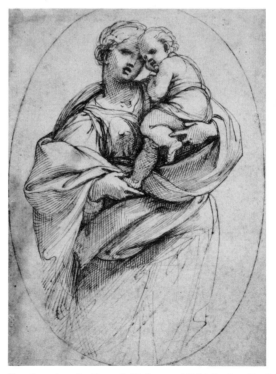

fig. 16a. Agostino Carracci, *Madonna and Child.* London, The British Museum

17*

Venus and a Satyr
(B. 17) 1592

Etching and engraving. 156 x 227 mm. (after Agostino Carracci?)

Literature: Baglione p. 391; Bellori p. 88; Malvasia p. 86; Oretti pp. 704-705; Basan p. 113; Strutt p. 182; Gori Gandellini I, p. 182, p. 315, no. XXIX or p. 28, no. XVI; Joubert p. 349; LeBlanc 17; Nagler 1835, p. 388; Nagler I, no. 297 (4); Andresen 11; Foratti p. 192; Pittaluga p. 351; Bodmer 1938, p. 109; Petrucci p. 139; Ludwig Münz, *Rembrandt's Etchings, a Critical Catalogue,* London, 1952, under cat. no. 143; *Mostra-Dipinti* pp. 83-84; *Mostra-Disegni* no. 261; Posner 66; Bertelà 325; Boschloo pp. 31, 197, note 23.

States:

	B	CC	Pos
I	I	I	I

Lower left: *1592. A.C.* (Alb, BM, BN, Bo, Dres, MMA, and others)

Copies: 1. Etching in the same direction. 152 x 222 mm. Lower left: *A.C.* (MMA). 2. Etching in reverse. 115 x 172 mm. Lower right: *Godfindt Muller: excu. AC inv.* (Alb). 3. Etching in reverse. 171 x 225 mm. Lower left: *1592 A.C.* Empty margin. Very harsh. (Ber).

No controversy has arisen in the literature as to the date or attribution of this print, yet the subject matter has been disputed continually.[1] It seems to this writer that a painting by Titian, which may have influenced this etching, can shed light on the iconography of the work. The subject matter of a portion of Titian's *Pardo Venus*[2] of c. 1535-1540, in the Louvre, is very close to Annibale's work, as is the attitude of the lecherous satyr uncovering the sleeping woman. In both, a figure of Cupid hovers about. Although the painting was shipped to Spain in the 1560s, it is probable that Annibale (and Agostino) knew it in some kind of copy, either painted or printed.[3] The subject matter of the *Pardo Venus* has long been disputed, but Panofsky's explanation that the iconography is that of Venus and a satyr instead of Jupiter and Antiope appears correct.[4] Moreover, there is no justification for the presence of Cupid in the scene of Jupiter and Antiope, and no other version of the subject includes him.

But, if Annibale looked to Titian for inspiration in his work, he looked more closely to Agostino's interpretation of the subject. A drawing by Agostino in the Albertina (fig. 17a)[5]* is so close to Annibale's final version (and even in reverse) that the connection cannot be accidental. Annibale changed the configuration of the forms, but Agostino's drawing certainly must have been his working study for this print. Again it proves that in the 1590s Annibale was still dependent on his brother for inspiration and that their working relationship continued. Agostino's drawing may have been produced in connection with his series of prints showing mythological subjects—the *Lascivie*—which belong to the period c. 1590-1595 (Agostino cat. nos. 176-190). Annibale may have used an idea discarded by Agostino for his own print.[6]

Although this etching is connected with Agostino's drawing, there is no reason to suspect that the print is by Agostino or the drawing by Annibale. The florid use of the pen is typical of Agostino's drawing style but still more characteristic is the engraver's influence in the hatching of the legs and the addition of dots around the breast. In Agostino's pen and ink drawings, his use of a burin technique always betrays him. The etching, on the other hand, belies Annibale's hand; the widely placed hatching and the loosely constructed foliage connect this print with others executed in the early 1590s (cat. nos. 11-16).

This etching was very popular in the seventeenth century, witnessed by the numerous examples of it in rather poor impressions still extant today. As with the print of the *Holy Family with Saint John* (cat. no. 11), Rembrandt was influenced by it and did an etching of the same subject, very close to Annibale's.[7]

1 Baglione, Bellori, Malvasia, and Posner called the print *Venus and a Satyr* whereas Bartsch, Calvesi/Casale, and Bertelà believed it to be of *Jupiter and Antiope.* Nagler called it *Jupiter and Io.*

2 Reproduced in Harold E. Wethey, *The Paintings of Titian,* 3 (London, 1975), pl. 74 & 75.

3 The only copy Wethey (p. 162) mentioned was made in the seventeenth century, but it seems likely that copies of it were made before the painting left for Spain.

4 The reasoning behind Panofsky's appellation of *Venus and a Satyr* is too long to go into here, but the reader is referred to Erwin Panofsky, *Problems in Titian Mostly Iconographic* (New York, 1969), 190-193 for a full discussion. Wethey disputed this interpretation (pp. 53-56), calling the painting *Jupiter and Antiope* on evidence that that was its name in the sources closest to Titian's period. He gives an unsatisfactory interpretation of

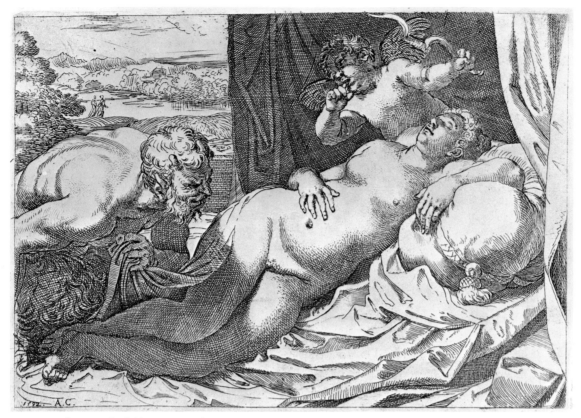

cat. no. 17, only state. Cambridge, courtesy of the Fogg Art Museum, Harvard University

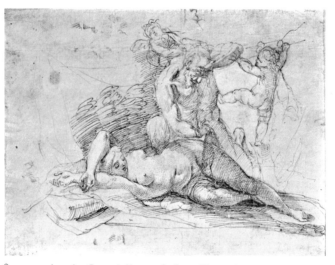

fig. 17a. Agostino Carracci, *Venus and a Satyr.* Vienna, Graphische Sammlung Albertina

the presence of Cupid in the painting. Although Posner did not mention this painting by Titian, he did note that the print was influenced by the coloristic atmosphere of Titian's works (Posner II, p. 46).

5 Inv. no. 2113. (Stix-Spitzmuller 86). 184 x 244 mm. Pen and brown ink over red chalk. Laid down. Boschloo noted the connection of this print with Agostino but with his series of the *Lascivie.*

6 Petrucci noted earlier that this print was influenced by Agostino, but, like Boschloo, did not mention this drawing.

7 Münz was certainly correct in noting the influence of Annibale's etching on Rembrandt's 1659 print. The pose of Antiope is almost the same in reverse to the original. Moreover, the shading is similar in each.

18*

Pietà (the "Christ of Caprarola") (B. 4) 1597

Etching, engraving, and drypoint. 123 x 160 mm.

Literature: Baglione p. 391; Bellori pp. 87-88; Malvasia p. 86 and n. 1, p. 104; Oretti pp. 685, 706; Basan p. 112; Strutt p. 182; Gori Gandellini I p. 182, p. 27, no. VII; Zani, part 2, vol. VIII, p. 207; Joubert p. 349; Bolognini Amorini p. 83; Mariette I, p. 318; Nagler 1835, p. 387; LeBlanc 11; Foratti pp. 171, 191; Andresen 4; Kristeller p. 281; Borenius pp. 126-217; Bodmer 1938, p. 113; Petrucci p. 140; Pittaluga p. 350; Kurz 1955, pp. 286-287; *Mostra-Dipinti* p. 91; Calvesi/Casale 211; Posner 97; Bertelà 311.

States:

	B	CC	Pos
I	—	—	1

On rock at right: *1597* with "7" written backwards.[1] (BM, LC)

	B	CC	Pos
II	—	—	2

1597 hatched over. Lower left: *Caprarola'. 1597.* (Alb, BM, Br, and others)

	B	CC	Pos
III	1	1	—

Caprarola'. now reads *Caprarolae.* (Alb, NGA, and others)

	B	CC	Pos
IV	2	2	3

Annibal Caracius fe. added before *Caprarolae.* (BMFA, Par)

	B	CC	Pos
V	—	—	—

in added above *us* of *Caracius.* (Alb, BMFA, BN, Bo, Br, Dres, and others)

	B	CC	Pos
VI	3	3	—

Added at lower right: *Nico Van Aelst for.* (Alb, Ber, BM, BN, Bo, and others)

	B	CC	Pos
VII	—	—	—

The address of Van Aelst burnished out. In its place: *Vincenzo Cenci Roma for.* Known only in weak impressions.[2] (Ber, Ro, and others)

Copies: 1. Engraving in reverse. 122 x 161 mm. Toward bottom left: *Annib. Carracius inv.* (MMA). 2. Engraving in reverse. 126 x 159 mm. (sheet: MMA). Face with mustache on stake in rear. 3. Engraving in same direction by Agostino Carracci. 122 x 160 mm. Lower edge: *1598 A. Caraci* (see Agostino cat. no. 209). 4. Engraving in reverse. 122 x 159 mm. *1599* lower left. (Bo). 5. Engraving in reverse. 136 x 161 mm. *Wolf: Kilian fecit Sadeler excud.* Below image: *Cernis ut hic iaccant Jesusque, Parensq, Clorusg? / Sic decus omni Soli, Sole cadonti, cadi.* (MMA). 6. Engraving in same direction. 125 x 160 mm. Lower center: *Carac.⁸ Inventor.* Lower right: *alla Pace Gio Iacomo Rossi forma in Roma*

The theme of the Pietà must have been a fascinating one for Annibale, as he took it up throughout his career in paintings, drawings, and in this print, always approaching the subject somewhat differently, seeking expanded compositions or characters, intensifying the mood. This etching is probably the most moving of all Annibale's prints, partially due to a development in the artist's etching technique. It is likely that Annibale had abandoned printmaking for several years before this, and a renewed interest in the possibilities of the medium may have been an impetus for returning to etching. As in some of Annibale's painted versions of the subject, here also the emphasis is on the painful sorrow of the mother of Christ.[5] The emotionally charged atmosphere is aided by the movement of the sky in the background, suggesting the coming storm after Christ's death. The technical cause of these vertical lines in the sky is the breakdown of the etching ground used by the artist. There is a possibility that this was not an accidental occurrence but that Annibale intended this resultant shimmering atmosphere. But, Annibale is not known to us as a technical innovator nor were there Italian artists at this time experimenting with etching grounds. It seems more likely that the movement in the sky was a lucky accident of the etching process. Another difference in technique is Annibale's use of a finer tool to make the more delicate lines in the work. Hatching is more closely spaced. This is also the only print in which Annibale used the medium of drypoint. Although it is not used widely in the print, it adds to the delicacy and shimmering effect of the whole.

Although most writers mentioned the influence of Correggio on Annibale's work, only Mariette and Borenius did so in connection with this print, and then not specifically. It is evident that Annibale was inspired by Correggio's painting of the same subject in the Pinacoteca Nazionale in Parma.[6] The composition is horizontally emphasized as in Correggio's painting, a similar number of figures are used and a sentimentality pervades both works. Compositionally and emotionally, this print has more in common with Correggio's painting than it does with Annibale's other versions of the Deposition or Pietà.

There are no extant preparatory studies for this print, but one drawing in the Louvre (fig. 18a)* may have been an early thought for the work, although Posner connected it with a later painting from Annibale's studio.[7] Of all the drawings of the Pietà by Annibale, this one comes closest to the etching. A quickly executed composition in which a multitude of seemingly haphazard lines suggest the outlines of the figures, this sheet exhibits the same tenderness of feeling as seen in the etching.[8] A drawing of *St. John*(?) in the Ashmolean (fig. 18b)* may also be connected with this print.[9] The gesture of the saint is much like that of Mary Magdalen in the etching, in reverse, but the boyish sentiment of the face is typical of representations of St. John. In any case, the technique of the sheet, with an emphasis on the crosshatching on the face, hints that it might have been connected with a print.

Bartsch, following Gori Gandellini, believed that this etching was made on silver. Some writers accepted this assertion, but Kurz discovered an engraved silver plate which is a copy after the *Christ of Caprarola,* probably the same silver plate noted by Gori Gandellini. This work, now in the Museo di Capodimonte in Naples, is actually a copy in reverse of Agostino's copy of this print (Agostino cat. no. 209).[10] Posner,

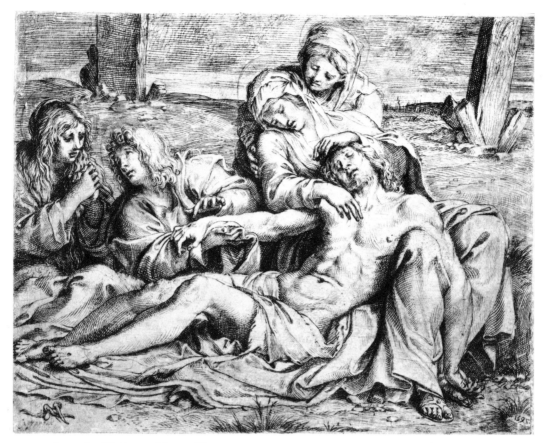

cat. no. 18, state I. Washington, Library of Congress

1649. (BN)[3] 7. Engraving in the same direction. 123 x 158 mm. (image: Alb). Lower left: *Annibal.* Crude. 8. Etching and engraving in reverse. 123 x 160 mm. Lower right: *Annibal Caracius inven. Caprarolae*[4] (Dres). 9. Engraving in the same direction. On rock at right in reverse: *1599* 122 x 158 mm. (Bo). 10. Engraving in reverse. 120 x 160 mm. (sheet: Par) Lower left: *fran^{co} vinandi fe.* 11. Etching in reverse. 125 x 160 mm. (sheet: Par). Lower left: *1640.* 12. Etching in reverse. 152 x 182 mm. (sheet: Par). 13. Under the leg of Christ: *Carrac. Inventor.* (Zani copy E). 14. Copy by Giovanni le Pautre. In the margin: *Carache Inv. Le Blond exc. Potre fecit.* (Zani copy F). 15. Under the foot of the Virgin: *1638.* Letters in reverse: *HI.* 6 and 3 of 1638 reversed (Zani copy L).

who also mistook it as a copy after this Pietà, attributed it to Agostino; Kurz attributed it to Annibale himself.[11]

This is the only print by Annibale with the notation of the place of execution, but that appears only in the third state. However, the place name could have nothing to do with a publisher, and one is inclined to accept it as indicating that Annibale was in Caprarola in 1597. Since Caprarola is only fifty miles from Rome, it would have been unusual if the artist did not go there to study the paintings in the Farnese palace while working in Rome. This sojourn may have been between the time Annibale finished work on the Camerino and before he began the Sala Farnese ceiling. It is possible that he was sent to Caprarola to study the feats of the Farnese family in the Sala dei Fatti Farnesiani painted by Taddeo Zuccaro, for the original plan for the Sala Farnese was to provide a fresco series of the exploits of Alessandro Farnese.[12] Annibale was probably given the commission before the program for the Farnese ceiling was changed to its final theme of the loves of the gods.

*Etching in exhibition from the Library of Congress, Washington, D.C.

1 Borenius was the first to notice this state, known to him only in the British Museum example (Tancred Borenius, "Drawings and Engravings by the Carracci," *The Print Collector's Quarterly,* 9, no. 2, April 1922, pp. 104-127). Posner also knew the same state.

2 Andresen noted this state.

3 The plate is extant in the Calcografia Nazionale. The first state of the print is without the publisher's address. (Ro).

4 In the second state *P.v.d. Berge exc:* is added. (Ber).

5 His most successful are the works in the National Gallery, London (Posner 177) and in the Kunsthistorisches Museum, Vienna (Posner 139).

6 Reproduced in *L'opera completa del Correggio* (Milan: Rizzoli, 1970), pl. XXXII-XXXIII.

7 A tabernacle in the Galleria Nazionale in Rome (Posner 123c).

8 Louvre 7162. 186 x 256 mm. Pen and brown ink over black chalk. For bibliography and collections see Bacou no. 32. Another drawing in the Louvre is also loosely connected with the *Christ of Caprarola:* Inv. no. 7402. Red chalk. 150 x 95 mm. See Bacou, no. 33. Another drawing in the British Museum (1895-915-693) is a copy of the print by another artist.

9 Parker 161, there called a female saint. Pen and blackish brown ink. 224 x 154 mm. Lower right in ink of another color: *Ann. Caracci.*

10 The print from the plate is mentioned as copy no. 3 under Agostino cat. no. 209.

11 Gori Gandellini (Malvasia p. 86, note 1) mentioned an engraved copy on silver of the *Christ of Caprarola* by Brizio extant at that time in the Accademia di Belle Arti in Bologna. It is possible that this is the same work.

12 Martin pp. 8, 51.

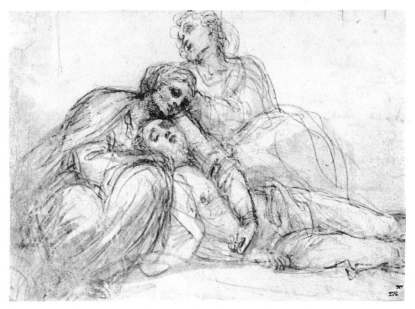

fig. 18a. Annibale Carracci, *Pietà*. Paris, Cabinet des Dessins du Musée du Louvre

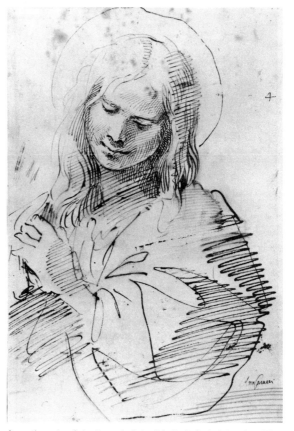

fig. 18b. Annibale Carracci, *Saint John*(?) Oxford, Ashmolean Museum

19*

The Drunken Silenus
("The Tazza Farnese")
(B. 18) 1597-1600

Engraving. 323 mm. (diameter)

Literature: Mancini p. 220; Baglione p. 391;
Bellori p. 88; Malvasia p. 86; Oretti p. 703;
Basan p. 113; Strutt pp. 182-183; Gori
Gandellini I, p. 181, p. 28, no. XVII; Nagler
1835, p. 388; Joubert p. 349; Mariette I,
pp. 319-320; LeBlanc 19; Disertori
pp. 267-268; Pittaluga p. 352; Petrucci p. 140;
Kurz 1955, pp. 282-286; *Mostra-Disegni*
no. 262; Martin p. 121; Calvesi/Casale 214;
Posner 113; Bertelà 326.

States:

	B	CC
I	I	I

As reproduced. No inscriptions. (Alb, BN, Bo,
Br, MMA, and others)

*Silver plate extant in the Museo di
Capodimonte, Naples.

Preparatory Drawings: 1. Louvre 7192. 181 x
133 mm. Pen and brown ink. Laid down.
Unpublished. (fig. 19c).* 2. British Museum
P.p. 3-20. 285 x 274 mm. Pen and brown ink
and washes in brown and gray. Repaired cuts.
Literature: Kurz 1955 p. 283; *Mostra-Disegni*
under cat. no. 114; Posner 113b. (fig. 19f).*
3. Private Collection, England. 273 x 168 mm.
Pen and brown ink and wash. Collections and
literature found in Ellesmere sale, no. 68. (fig.
19g).* 4. MMA 1972.133.4. Diameter: 255
mm. Pen and brown ink and wash over black
chalk. Indented for transfer. Collections and
literature found in Ellesmere sale, no. 69.
(fig. 19h).*

Copies: 1. Engraving in reverse with elaborate
cartouche. 273 x 271 mm. Lower center in
reverse: *Anibal Caracius Invent. F. Villamena. F.*
(fig. 19 l).* Silverplate (*Paniere Farnese*) extant
in Museo di Capodimonte, Naples (fig. 19m).*
2. Engraving in reverse by Luca Ciamberlano.
In octagonal form. 243 x 247 mm (image: BM).
An. Carracci Inv. Plate extant in Calcografia
Nazionale, Rome. 3. Etching in reverse in a
landscape. 140 x 208 mm. (sheet: Par) Lower
right: CARASIO. 4. Engraving in reverse.
Diameter: 219 mm. (sheet: Ber). No
inscriptions.

This engraving and the extant silver plate from which it was pulled have
the most interesting history of any of Annibale's graphic projects. The
survival of so many drawings for and after the work and the information
from the sources show that the subject was of continuing interest for the
artist and that in making the engraving he again worked closely with his
brother Agostino.

Baglione, Bellori, and Malvasia all described a silver *tazza* or dish
decorated by Annibale for Cardinal Odoardo Farnese. Later, in describ-
ing the present engraving, Bartsch made the assumption that it was a
copy of the famous, lost silver dish. Kurz discovered the silver *tazza* in
the Museo di Capodimonte in Naples and proved that these engraved
impressions were made from the silver itself. The object had been listed
in a Farnese inventory of the Palazzo del Giardino in Parma in 1708 and
was later transferred to the Museo di Capodimonte.[1] Kurz showed that
the remains of solder on the bottom of the *tazza* belonged to the joining
of the piece with its base. Impressions were taken from it in Mariette's
time, and sometime after that the base and decorative trim, now lost,
must have been removed permanently.[2]

Bellori's description of the *Tazza Farnese* is vital to a discussion of
the project's history. He wrote:

> More beautiful than these [other works previously discussed] is Silenus en-
> graved on a silver salver for Cardinal Farnese to harmonize with another one
> by Agostino. On it Silenus is shown seated, drinking. A kneeling satyr
> holds a goatskin full of wine in back of his head and a faun pours wine into
> his mouth. The surrounding ornamentation is a garland of grape leaves and
> grapes. For the design and for the engraving, this composition with its very
> complete idea of the Antique, is equal to the style of Marco Antonio and to
> the beautiful engravings of Raphael.[3]

Thus Bellori knew from a previous source or by the existence of a dish by
Agostino that the project called for two engraved silver *tazze*. If Agos-
tino completed his dish, it is lost to us today, but his ideas for its
decoration are preserved in several drawings (figs. 19b, 19d). From these
and another drawing by Annibale (fig. 19c) for the project, its purpose
unknown until now, one can reconstruct the evolution of ideas and the
close working relationship of the two men in their plans for twin silver
tazze.

When Annibale and Agostino began their work on the Farnese
tazze they planned to make matching heads of Bacchus and Silenus, sur-
rounded by grape leaves and boughs. The designs are shown in drawings
by each in Stockholm and Paris. The drawing by Agostino in the
Nationalmuseum Stockholm (fig. 19b)* was probably the first thought
for his design.[4] A frontal head of Bacchus bedecked with grapes and
grape leaves is further surrounded by a wreath of grape leaves. At the
lower left, a head of Silenus is rapidly delineated. Another drawing by
Agostino in the National Gallery of Art, Washington, D.C. (fig. 19a)*
could have been Agostino's inspiration for this design.[5] Although that
drawing has been dated several years earlier by this author and others,[6]
there is no foundation for doing so. This sheet could date as late as 1597,
the year the ideas for the *tazze* were probably developing. The classically
influenced drawing postdates Agostino's journey to Rome in 1595, and
the very careful crosshatching is characteristic of many of his drawings of
the Roman period. Although no antecedent has been found for the de-
sign, a Roman relief or gem could have been its source.

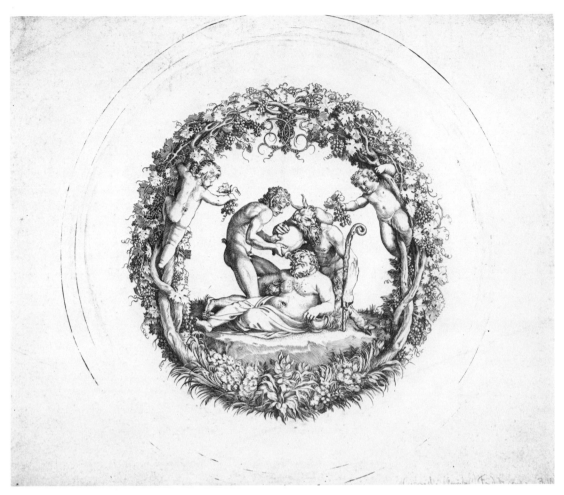

cat. no. 19, only state. Washington, National Gallery of Art, Rosenwald Collection

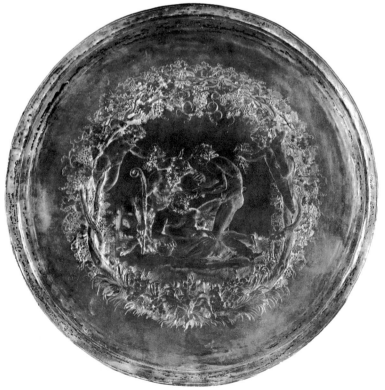

cat. no. 19, silverplate. Naples, Museo Nazionale di Capodimonte

To complement Agostino's head of Bacchus, Annibale conceived of a head of Silenus, much like the head in the lower left of Agostino's sheet in Stockholm, as seen in the drawing in the Louvre (fig. 19c). Because it is stylistically closer to him than to his brother, the drawing should retain its traditional attribution to Annibale. Moreover, the contorted face of Silenus is typical of other drawings by Annibale,[7] and the head of a goat by the same hand appears again in a later drawing for the Farnese dish (fig. 19g).* It is probable that Annibale took as his source for the Silenus a gem in the Farnese collection with either a head of Socrates or of a satyr.[8] The oval with the head beneath the large roundel suggests a gem as the source. Around the outside of the roundel, Annibale elaborated the design of his brother: goat and calf heads and ribbons are intertwined with the grape leaves. The head of Silenus itself is made to recede within the depth of what must be a dish.

A third drawing by Agostino, a study sheet in Windsor Castle (fig. 19d),*[9] continues the progression toward the final design. In it Agostino adapted Annibale's surrounding grape leaves and heads to fit the circumference of his plate, eliminating the crossed ribbon motif, found in Annibale's Louvre drawing. Two studies of the plate itself at the right give us an idea of how the final *tazze* may have appeared. Agostino used alternate ideas, one for a flat dish with raised edges, the other a similar dish on a pedestal. Since solder exists on Annibale's silver *tazza* in Naples, the second design was probably employed. Moreover, the concentric marks on the plate indicate a raised edge which was removed to take impressions. Also interesting is Agostino's drawing of the Bacchus on the interior of the dish at lower right. He seems to have been toying with the idea of engraving the head itself on the silver and making the surrounding wreath in relief. Agostino began his career as a goldsmith, and his knowledge of jewelry techniques would have made this a logical alternative.

The severe frontal head of Bacchus in the upper right-hand corner of the Windsor drawing suggests the classical prototype for Agostino's design: the famous Roman cameo in the shape of a dish with a Gorgon's head on the back, now in the Museo Nazionale in Naples but in the sixteenth century in the Farnese collection and referred to also as the *Tazza Farnese* (fig. 19c).[10] Agostino had to have known the work for it was famous in the sixteenth century and had once been in Lorenzo de' Medici's collection. The large eyes and aquiline nose of Agostino's Bacchus, grape leaves made to look like hair cascading down the sides of the head, and the ribbon tied under the chin all hark back to the Ptolomaic prototype.

At this point in the project, the central design for the *tazza* or *tazze* changed. Perhaps Agostino and Annibale's well-known quarrels which began at this time became too great to continue working together. In any case, there are no more drawings known for Agostino's *tazza*, no impressions pulled from a plate similar to Annibale's have come down to us, and it is likely that Agostino never completed his *tazza*.

Three more drawings by Annibale complete the progression toward the engraving of the *Tazza Farnese:* one in the British Museum (fig. 19f),* one in a private collection in England (fig. 19g),* and the final preparatory study in the Metropolitan Museum in New York (fig. 19h).* In the British Museum sheet, a scene in a landscape shows the drunken

fig. 19c. Annibale Carracci, *Studies for the "Tazza Farnese."* Paris, Cabinet des dessins du Musée du Louvre

fig. 19a. Agostino Carracci, *Head of a Faun in a Concave Roundel*. Washington, National Gallery of Art, Ailsa Mellon Bruce Fund

fig. 19b. Agostino Carracci, *Studies for a Bacchus and Silenus*. Stockholm, Nationalmuseum

cat. no. 19d. Agostino Carracci, *Studies for the "Tazza Farnese."* Windsor Castle, Royal Library, Her Majesty Queen Elizabeth II

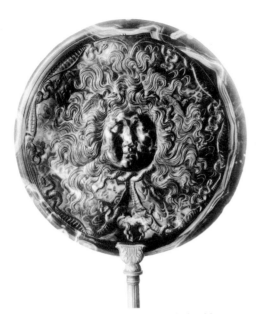

fig. 19e. *Tazza Farnese,* cameo. Naples, Museo Nazionale

Silenus attended by fauns and surrounded by the wreath of grape vines with goat and calf heads. A *putto* clinging to the vines offers grapes to the trio, thus incorporating the framework into the mythological scene. Perhaps Annibale abandoned the motif of a single Silenus head when he knew that Agostino would not be completing a matching silver dish. Thus he was able to produce an entire composition rather than just a single head within a decorative surrounding.[11] The drawing in the private collection in London is the next in the series. At top right on this sheet, the artist worked on the details of his decorative band of heads and ribbons, eventually abandoning them for the more naturalistic grape arbor seen at the left of the sheet. Below, the relationship of the figures has changed so that the faun behind Silenus actively takes part in feeding him wine from the goat skin. Not completely satisfied with the figure at the left, Annibale left him unfinished in this drawing. The final drawing, in the Metropolitan, is incised for transfer and relates almost exactly with the engraving of the *Tazza Farnese,* with only the awkward staff removed from the center and put in the arm of the figure of Pan at left and Silenus' cup used as a support rather than being held in his hand.[12] The design was then transferred to the decorative dish.

After the *Tazza Farnese* was finished, Annibale did not abandon the theme of the drunken Silenus. Kurz pointed out that a drawing in the Uffizi (fig. 19i) was a copy by Annibale after an impression pulled from the *Tazza Farnese,*[13] and that two other drawings in Windsor, once connected with the Farnese ceiling (figs. 19j, 19k),*[14] are actually connected with a project arising from the Farnese salver. It would seem then that since the Uffizi drawing presents the composition of the drunken Silenus drawn in the same direction as the engraving, Annibale must have taken some impressions from the plate before the decorative rim and base were added. Above the three figures the artist added a grape arbor. In the two Windsor drawings, he worked out ideas for a decorative framework of grape leaf fronds, herms, *putti,* goats, a lion, and a Bacchic head to surround the composition on the Uffizi sheet. The Bacchic head is reminiscent of Agostino's head in the right-hand corner of his study sheet in Windsor (fig. 19d) and may be dependent on it. The result of these studies is the so-called *Paniere Farnese* or silver breadbasket (fig. 19l),* also in the Museo di Capodimonte in Naples, engraved and signed by Francesco Villamena (fig. 19m).[15] Impressions taken from the silver are numerous. Whether Annibale planned to engrave the breadbasket himself and was prevented from doing so by pressures of finishing the Farnese ceiling is unknown, but this is a possibility.

Probably concurrent with Annibale's designs for the *Paniere Farnese* and also evolving from his design for the *Tazza Farnese* is the painting of *Silenus Gathering Grapes* in the National Gallery, London (fig. 19n). This tempera panel and its companion piece of *Bacchus and Silenus,* also in the National Gallery, London, once adorned a musical instrument, possibly a harpsichord.[16] The two *putti* gathering grapes at either side of the *Tazza Farnese* arbor are repeated in the painting. Since they appear in the same direction as in the engraving, one is doubly convinced that impressions of the *Tazza Farnese* were taken by the artist before the decorative rim and base were added. An unpublished drawing in the Städelisches Institut in Frankfurt (fig. 19o),[17] incorrectly attributed to Passerotti, is Annibale's preparatory drawing of the *putti* for the panel. This rather

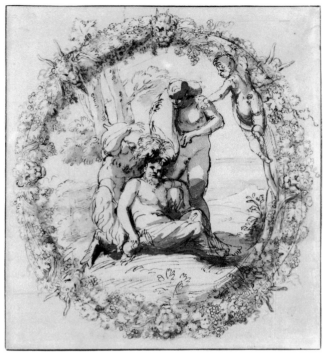

fig. 19f. Annibale Carracci, *Study for the "Tazza Farnese."* London, The British
Museum

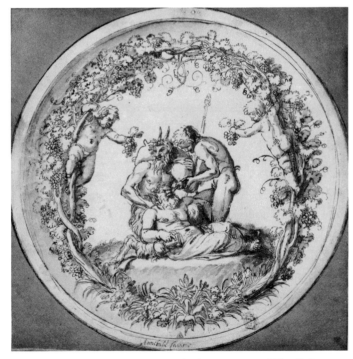

fig. 19h. Annibale Carracci, *Study for the "Tazza Farnese."* New York,
The Metropolitan Museum of Art, Harris Brisbane Dick Fund and Rogers
Fund, 1972

fig. 19g. Annibale Carracci, *Studies for the "Tazza Farnese."* London,
Private Collection.

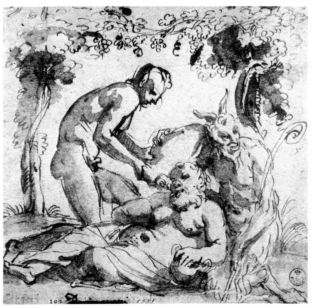

fig. 19i. Annibale Carracci, *Study for the "Paniere Farnese."* Florence, Gabinetto
disegni e stampe degli Uffizi

461 ANNIBALE

large, lively drawing shows, in the rapid delineation of the landscape and grape bough as well as in the *pentimenti* by means of chalk and ink corrections, that it is a preparatory study rather than a copy of the painting.

The *Tazza Farnese, Paniere Farnese,* and *Silenus Gathering Grapes* have been dated by Posner c. 1599, but the works' subject matter and possible use indicate a wider span of years, 1597-1600. These are the years that Annibale is documented as working on the ceiling in the Galleria Farnese.[18] On the verso of the study for the *tazza* in the English private collection is a study of the Eros and Anteros fighting, which is found in one of the corners of the vault.[19] In addition, the head looking up at left in one of the Windsor studies for the *Paniere Farnese* (fig. 19k) is suspiciously close to the *ignudo* to the left of *Jupiter and Juno* on the ceiling.[20] Thus, Annibale was working on these other projects concurrent with the painting of the ceiling.

The purpose of the *Tazza Farnese* and *Paniere Farnese* is even more interesting. Charles Dempsey has convincingly advanced the theory that the Farnese ceiling's subject matter is the triumph of love and that it was painted as an epithalamium for the wedding of Ranuccio Farnese and Margherita Aldobrandini in 1600.[21] Since these two silver decorative pieces date from the same period, have a merrymaking theme, appear to be companion pieces, and have a provenance dating to the Palazzo del Giardino in Parma (owned and expanded by Ranuccio), could they not also have been made in connection with the Farnese-Aldobrandini wedding, in fact, as wedding presents? What better gifts than a silver breadbasket and silver dish?[22] It is tempting to expand this theory to include the musical instrument decorated so colorfully by Annibale. Its provenance, however, dates only as far back as 1664 when it was in the Palazzo Lancellotti in Rome. Although it may never have been in the Farnese collection, Annibale did work primarily for this family during these years. One wonders whether music from this harpsichord was heard during the wedding festivities of Ranuccio and Margherita in 1600.[23]

1 Campori, p. 489: "Una sottocoppa d'argento con un Baccanale tagliatovi per mano d'Annibale Carazzi."

2 Mariette said, "Cette soucoupe, qui étoit à Parme, est maintenant à Naples, chez le Roy des Deux-Siciles, et j'ay obtenu, par le moyen de M. le comte Tessin, une épreuve de ce qu'Annibale Carrache a gravé. J'avois fourni un mémoire à M. de Tessin, qu'il a envoyé à la cour de Naples, et c'est en suivant la méthode, que j'avois tracée, qu'on a fait tirer deux épreuves qu'on a envoyés à M. de Tessin, et dont il m'a fait présent d'une. Elles ont le défaut d'etre neigeuses dans quelques parties; mail il n'est pas possible qu'elles soient autrement, vu la difficulté d'imprimer cette soucoupe d'argent."

3 Translation from the 1968 English edition of Bellori, *The Lives of Annibale & Agostino Carracci,* translated by Catherine Enggass, p. 74. The original Italian follows:
 Ma sopra questi bellissimo è il Sileno intagliato in una sottocoppa d'argento del Cardinale Farnese, in accompagnamento d'un altra d'Agostino; & in essa è figurato Sileno à sedere bevendo, mentre un satiro ginocchione gli regge dietro la testa, l'otre pieno di vino; & un fauno gliè lo accosta, e versa alla bocca. L'ornamento intorno è un serto di tralci, di pampini, e d'uve. Questo componimento è uguale per disegno, e per intaglio allo stile di Marco Antonio, & alle belle stampe di Rafaelle, con l'Idea più perfetta dell'antico.

4 Inv. no. 937/1863. Pen and ink. 190 x 120 mm. Published in Stockholm, Nationalmuseum. *Italienska Barockteckningar.* Juni-Augusti 1965, no. 52.

5 NGA Inv. no. B-26, 198. 181 x 187 mm. Pen and brown ink. Previous bibliography

fig. 19l. Francesco Villamena, *Paniere Farnese.* Naples, Museo Nazionale di Capodimente

fig. 19j. Annibale Carracci, *Study for the "Paniere Farnese."* Windsor Castle, Royal Library, Her Majesty Queen Elizabeth II

fig. 19k. Annibale Carracci, *Study for the "Paniere Farnese."* Windsor Castle, Royal Library, Her Majesty Queen Elizabeth II

found in National Gallery of Art, *Recent Acquisitions and Promised Gifts* (Washington, June 1974), no. 29.

6 In *Recent Acquisitions and Promised Gifts,* no. 29, and *Ellesmere Sale,* no. 29.

7 For example, the Chatsworth study for *Christ Crowned with Thorns* (fig. 21a), and see similar pen work in drawings in the Louvre (Posner 134c, 140c), Chatsworth (Posner 140b), Windsor Castle (Posner 128b, 130d), and Lille (Posner 103b).

8 There is a very similar sculpture of the head of Socrates in the Museo Nazionale in Naples which was originally in the Farnese collection. Reproduced in Gennaro Pesce, *Il Museo Nazionale di Napoli* (Rome, 1932), 48, pl. 7. This square face with pug nose and beard is typical of portraits of both Socrates and of satyrs. It has not been possible to study the gem collection in the Museo Nazionale, a perusal of which might yield proto-types for other Carracci inventions.

9 Inv. no. 1986. Wittkower 100. Pen and brown ink and wash. Laid down 287 x 412 mm. (The figure of a woman, with child, in the upper left is also seen in the Stockholm drawing.)

10 This, of course, is the more famous *Tazza Farnese,* one of the largest and most impressive cameos from classical times. The obverse represents an allegory of the river Nile. It dates from the Ptolomaic period and probably comes from Alexandria. See Bianca Maiori, *Museo Nazionale di Napoli* (Novara, 1957), 162.

11 Perhaps Annibale decided on this motif because he wanted to expand on a part of the Silenus composition in the *Triumph of Bacchus and Ariadne* on the Farnese ceiling. (Posner pl. 111x).

12 It is possible that the drawing now in the Metropolitan Museum is the same one mentioned in an eighteenth-century inventory of the Casa Gonzaga in Novellara: "*Annibale Caracci.* Sileno, a cui due satiri porgono da bere, e puttini sopra arbori d'uva: disegno a penna ed acquerellato, zecchini 8." (Campori, p. 665).

13 Inv. 1551orn; 149 x 159 mm. Pen and brown ink and wash. Laid down. Traces of red chalk. Lower left in pencil erased: *Carracci.* In brown ink: *102.* Something in brown ink crossed out. See Posner 114b and *Mostra-Disegni* 114 for bibliography.

14 Wittkower 289, 290. Inv. nos. 2165, 1967. Wittkower 289: Pen and brown ink and wash over black and red chalk. Laid down. 257 x 380 mm. Wittkower 290: Pen and brown ink and wash. 245 x 187 mm. Laid down. See Kurz 1955.

15 270 x 278 mm. The *Paniere Farnese* was listed in the 1708 inventory of the Palazzo del Giardino in Parma, erroneously attributed to Annibale: "Una panattiera d' argento con cornice dorata pure d'argento in quadro, intagliatovi sopra un Bacchanale di An-nibale Carazzi." (Campori, p. 489). Villamena signed his name in reverse on the plate, so one assumes that printings were always meant to be taken from the silver.

16 Inv. no. 93. Posner 115 and 116. Tempera on panel. 545 x 695 and 361 x 190 cm. Michael Levey, *London National Gallery Catalogues, The Seventeenth and Eighteenth Century Italian Schools* (London, 1971), 65. The figure of Silenus comes from a gem in the Farnese collection, a gold mine of ideas for the Carracci (Museo Nazionale Naples; Pesce, pl. 31, p. 66).

17 Inv. 4272 as Passerotti. 234 x 400 mm. Pen and brown ink and wash over red chalk. Two vertical cuts, repaired.

18 See Martin, pp. 51ff.

19 Posner, pl. 111l. Ellesmere Sale no. 68.

20 Posner, pl. 111p.

21 Charles Dempsey, " 'Et nos Cedamos Amori: Observations on the Farnese Gallery,"*Art Bulletin,* 50 (1968): 363-374.

22 This suggestion was first made by Charles Dempsey to the author, December 1977.

23 There is a drawing, a counterproof touched in red chalk, in Chatsworth, which is a copy of the engraving of the *Tazza Farnese.* Inv. no. 681; 234 x 216 mm. Michael Jaffé (*Rubens and Italy,* Oxford, 1977, pl. 163) attributed it, erroneously, to Peter Paul Rubens. It is too weak to be from his hand.

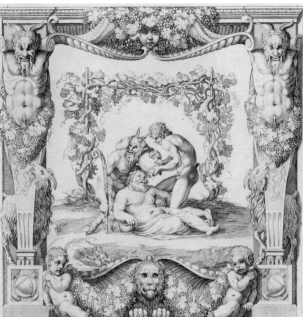

fig. 19m. Francesco Villamena, *Drunken Silenus*. New York, The Metropolitan Museum of Art, Harris Brisbane Dick Fund, 1953

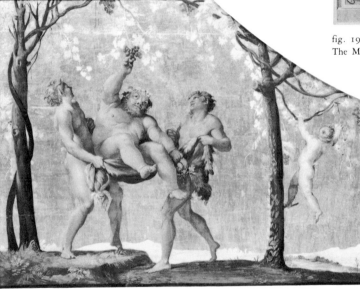

fig. 19n. Annibale Carracci, *Silenus Gathering Grapes*. London, National Gallery

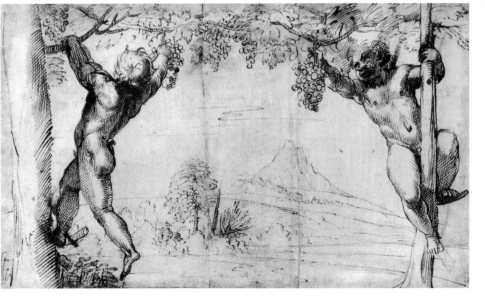

fig. 19o. Annibale Carracci, *Study for "Silenus Gathering Grapes."* Frankfurt, Städelisches Institut

20*

Madonna and Child with Saints Elizabeth and John the Baptist (La Madonna della Scodella) (B. 9) 1606

Etching and engraving. 123 x 160 mm.

Literature: Bellori p. 87; Malvasia p. 86; Oretti p. 706; Basan p. 113; Strutt p. 182; Gori Gandellini I, p. 182, p. 27, no. VI; Nagler 1835, p. 388; Joubert p. 349; Mariette I, p. 317; LeBlanc 6; Andresen 7; Nagler I, no. 1053; Foratti p. 192; Bodmer 1938, p. 117; Petrucci p. 140; *Mostra-Dipinti* p. 97; *Mostra-Disegni* no. 264; Posner 176 and I, p. 148; Calvesi/Casale 218; Bertelà 316.

States:

	B	CC	Pos
I	1	1	1

Before letters (Alb, BM, Cleveland, MMA, and Ro)

	B	CC	Pos
II	2	2	2

Upper right: *Annib. Carracius in. et fecit. 1606.* (Alb, BM, BN, Bo, Ber, Dres, MMA, Ro, and others)

	B	CC	Pos
III	3	3	3

Below inscription of state II: *Nico van Aelst for.* (Alb, Ber, BM, BN, Bo, Dres, MMA, Ro, and others)

Preparatory Drawings: 1. Louvre Inv. no. 7142. 143 x 179 mm. Pen and brown and black ink and wash with white highlights on greenish gray paper. Corrections in gray body color. Incised for transfer. Laid down on a larger piece of paper to enlarge composition at left and top. Collections: Mariette (Lugt 1852, lower right). Bibliography in Bacou, no. 42. (Fig. 20a).

Copies: 1. Engraving in reverse without St. Elizabeth. *Ani: Car: in./ Nicholaus fran.ur Maffei/ fecit.* 133 x 169 mm. (MMA). 2. Etching in reverse. 118 x 157 mm. image. Upper left: *Annib. Carraccius in.* (BN). Earlier state without letters (BN). 3. Engraving in reverse. 173 x 160 mm. In margin lower left: *Annib. Car. in.* Two lines of verse beginning with *Nascitur his ambolus . . .* (Bo). 4. Etching in reverse. 133 x 164 mm. In margin: *Annibal. Caracius. inventor.* Added lower right in second state: *Frederick de Widt excu.* (Dres, Windsor). 5. Etching in reverse. 134 x 163 mm. Lower center toward right: *Anni Car in.* (Alb). 6. Etching and engraving in reverse. 126 x 165 mm. (sheet: Achenbach Foundation). Lower left: *Annib. Carracius inv.* 7. Etching in reverse. 120 x 156 mm. No background hatching. (Alb). 8. Engraving in reverse. 124 x 156 mm. No inscriptions. Horizontal hatching for background. No hatching in haloes. Crude. (Bo). 9. In reverse, without St. Elizabeth. By

This is Annibale's first known print executed after 1600. The change in style from his last effort (*The Drunken Silenus,* cat. no. 19) is evident. Forms are more simplified, almost geometric in shape, and an emphasis on strong contrasts of light and shade appears, along with a sculptural effect. The preparatory drawing for the print in the Louvre (fig. 20a), mentioned by Mariette when in his collection, exhibits these features even more strongly than does the print. As in his paintings of the first decade of the seventeenth century, the figures in the *Madonna della Scodella* drawings are made of simple plastic forms which are lightly embellished by large, voluminous drapery folds.[2] The *pentimento* of the Virgin's face with its sharp, angular outlines and the *pentimenti* of Saint Elizabeth's left hand exemplify these traits. This powerful drawing is also important as a record of Annibale's working method. The artist at first positioned the Virgin's and Elizabeth's heads closer to the Christ Child, but he chose to open this constrained triangle by moving each head farther to the outside of the composition. The outcome is a simplified rectangle made up of heavy and blocky forms. Annibale's changes of mind in his drawings are reflected by either linear *pentimenti,* as seen in the head of the Virgin and the hands of Elizabeth, or by wiping out his original thoughts with brown wash or body color and drawing in the changed figure or form, as seen in the head of Elizabeth.

The simplification of the composition and figures in the Louvre drawing are further emphasized in the etching by the regular, unvaried hatching. In prints of the 1580s and early 1590s such as the *Saint Jerome* (cat. no. 13), Annibale employed a wide range of hatching lengths and spacing. In the *Madonna della Scodella,* on the contrary, he regularized the technique into outlines and simple hatching and crosshatching. Sharp contrasts of light and dark consequently lessen the *sfumato* effect of forms slowly disappearing into space. Further simplification occurs with the figures placed against a neutral background or curtain, which tends to emphasize the horizontality of the frontal plane. These tendencies of Annibale's late paintings toward simplification and geometricality are apparent in two of his prints of 1606, the *Madonna della Scodella* and the *Christ Crowned with Thorns* (cat. no. 21), but tend to be counterbalanced by his last print of the *Adoration of the Shepherds* (cat. no. 22) in which his graphic style may have been taking a different route.

*Etching in exhibition from the National Gallery of Art, Washington, D.C.

1 Posner mentioned a painted copy of the composition by Sassoferrato in Glasgow.

2 The frescoes of the Herrera Chapel, executed by assistants, are the most conspicuous for this style. See Posner nos. 154-172.

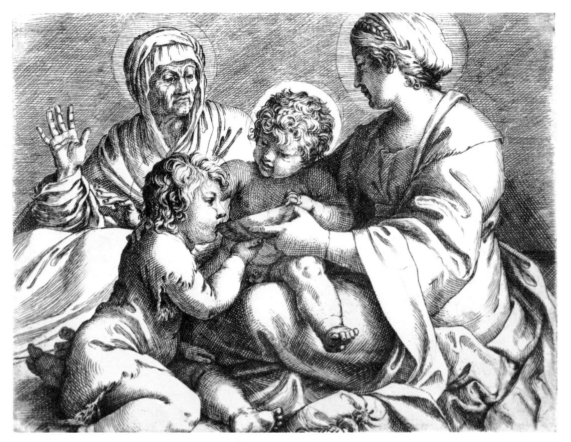

cat. no. 20, state I. Vienna, Graphische Sammlung Albertina

Johannes Panneels. 140 x 153 mm. (Hollstein XV, p. 108, no. 1). In margin: GLORIA TIBI DOMINE QVI NATVS ES DE VIRGINE. Lower left: *Anni Carratius in.* Lower right: *Joannes Panneels fec. francft.* 10. Etching in reverse. 130 x 163 mm. Upper left: *Annib. Carracius in.* (Stu). 11. Engraving in reverse. 120 x 160 mm. Upper left: *Annib. Carracius/ inv. 1606.* (Par). 12. Etching in reverse. No background. 148 x 173 mm. Lower right: *A.b.C.I.* (Ber). 13. Etching in same direction. 122 x 160 mm. Upper right in reverse: *Annib. Carracius/ in. 1606.* (Ber). 14. Engraving in the same direction. 114 x 153 mm. (sheet) Bottom on pillow: *boudan. ex.* Toward bottom right: *I Couuav (?) f.* Lower right: *Annib. Caracius in.* (Dres). 15. Engraving in reverse. 135 x 165 mm. Inscription in margin and lower right: $\overset{c}{v}$ excu. [Cornelis Visscher]. (Ashmolean).[1]

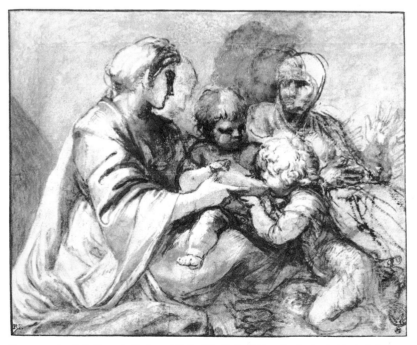

fig. 20a. Annibale Carracci, *Madonna della Scodella.* Paris, Cabinet des dessins du Musée du Louvre

21*

Christ Crowned with Thorns
(B. 3) 1606

Etching. 179 x 134 mm.

Literature: Baglione p. 391; Bellori p. 87; Malvasia p. 86; Oretti p. 705; Basan p. 112; Strutt p. 182; Gori Gandellini I, p. 182, p. 27, no. VIII; Joubert p. 350; Nagler 1835, p. 388; Le Blanc 9; Andresen 3; Bodmer 1938, p. 117; Petrucci p. 140; Calvesi/Casale 219; Posner 173; Bertelà 309.

States

	B	CC	Pos
I	1	1	–

Before letters. (BM, Chatsworth, Dres)

II	2	2	1

Lower left: *Annib. Carracius in. et fecit. 1606.* (Alb, BM, BN, Bo, Br, Dres, MMA, Ro, and others)

III	–	–	–

Lower right: *Nico. Van Aelst for Romae.* (BN, Bo, Dres, Ro, and others)

IV	–	–	–

The address of Van Aelst burnished out.[1] (Ber)

Preparatory Drawings: 1. Chatsworth, the Duke of Devonshire Collection. Inv. no. 430. 164 x 132 mm. Black wash, white heightening on paper washed a dark green. Deeply incised. Laid down. Some creases. Collections: The 2nd Duke of Devonshire (Lugt 718, lower right). Bibliography: See Posner 174 and James Byam Shaw, *Old Master Drawings from Chatsworth,* International Exhibitions Foundation, Washington, D.C., 1969-70, no. 24. (fig. 21a).*

Copies: 1. Etching and engraving in reverse. 182 x 137 mm. *Annibal. Carras Inventur.* (Alb). 2. Etching in reverse 184 x 135 mm. Lower left: *Anibal Caraza. In.* Lower right: GIO. VIAM *Fece.* (MMA). 3. Etching in reverse. 178 x 136 mm. (sheet: MMA). Lower left: *Annib. Carratius in. 1606.* Lower right: *A. Blooteling excudit.* 4. Etching in reverse. 175 x 140 mm. Lower left: *A. Waeb. exc.* (Fogg). 5. Etching in reverse. 183 x 132 mm. (sheet: PAFA). Lower left: *Annib. Carracius inv.* 6. Etching in reverse. 171 x 134 mm. (sheet: Alb) No inscriptions. 7. Engraving in reverse. 174 x 133 mm. Along bottom: ILL.^{mo} ADMODV̄. GANOTO. TROMBAE. EQVITI. ORNATISS.^{mo}/ DONAT, DICATO; and in center lower: *Gio. Batta Pasqualini.* Lower right: *An^b. C. in.* over something burnished out. (Par). 8. Engraving in reverse. 221 x 165 mm. In margin: *Coronam de spinis imposuerunt Capiti ejus.* Margin at right: *appo Wagner Ven.^a* C.P.E.S. (Par). 9. Engraving in reverse. 162 x 135 mm. (Sheet: Dres) Soldier holding Christ is squinting. 10. Engraving in same direction. 146 x 98 mm. In margin: ET

Annibale conceived the composition of this print in the same way as that of the *Madonna della Scodella* (cat no. 20): forms are blocked out in the most general of terms, compositional details are kept to a minimum, and figures are brought close to the picture plane backed by a curtain of hatching. In addition, in the *Christ Crowned with Thorns,* the geometric conception of the figures is emphasized by the contrast of several kinds of simplified hatching in the background, reducing the human elements to a set of decorative patterns. As in the *Madonna della Scodella,* the figures are sharply illuminated in contrasting light and shadow. The idea for this juxtaposition of light and dark was conceived in the preparatory drawing in Chatsworth (fig. 21a),*[2] in which Annibale highlighted the figures in white, pulling them out of the dark of the colored paper. The simplification and clarification of the composition gave the artist the opportunity to concentrate on the dramatic importance of the scene; attention is drawn directly to the soldier attacking Christ, more powerfully stated in the drawing, but still presented with an impact in the etching.

This etching is the only example of this subject in Annibale's oeuvre.[3] As noted by Posner, Annibale's subject matter tended to be increasingly personal in such late, small devotional prints.[4]

*Etching in exhibition from the Museum of Fine Arts, Boston, Harvey D. Parker Collection.

1 Andresen noted these four states and also a fifth state, unknown to this writer, in which the plate was retouched.

2 Bodmer called this drawing a copy of the print, but all other writers have correctly attributed it to Annibale. The use of paper that the artist prepared himself, rather than the choice of colored paper, indicates that Annibale was especially interested in emphasizing dark and light contrasts. This drawing is one of the artist's most dramatic and powerful.

3 There is a painting of *Christ Mocked* in the Pinacoteca Nazionale in Bologna (Posner 89) which dates to the second half of the 1590s. A drawing, possibly by Annibale, which may be connected with that painting, not mentioned by Posner, is in the Städelisches Institut in Frankfurt. Inv. no. 4047. 104 x 148 mm. Pen and brown ink.

4 Compositionally, this etching recalls Titian's *Christ Crowned with Thorns* in the Louvre (reproduced Harold E. Wethey, *The Paintings of Titian, I The Religious Paintings,* London, 1975, pl. 132), especially in the division of the background wall and in the triangular configuration of the foreground figures. Annibale's work is a calm reinterpretation of the Venetian master's painting, which he would have known at least through copies.

MILITES, PLECTENTES CORONAM/ DE SPINIS
IMPOSVERVNT CAPITI EIVS. *Ioan. 19/ Henricus
Van Schoel excu.* (Dres). 11. Etching in the same
direction. 177 x 131 mm. (sheet: Dres). No
marks. Very sharp.

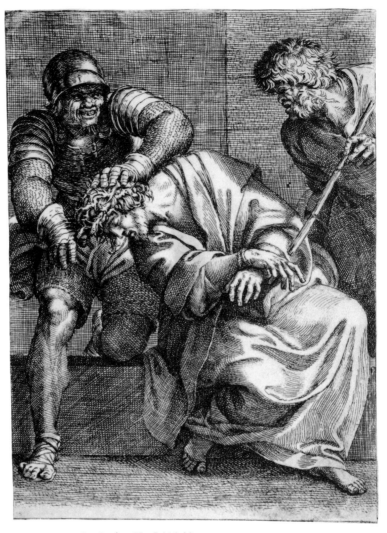

cat. no. 21, state I. London, The British Museum

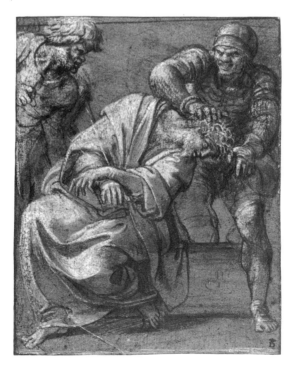

fig. 21a. Annibale Carracci, *Christ Crowned with
Thorns.* Chatsworth, Devonshire Collection,
the Trustees of the Chatsworth Settlement

469 ANNIBALE

22*

The Adoration of the Shepherds
(B.2) c. 1606

Etching and engraving. 105 x 131 mm.

Literature: Baglione p. 391; Bellori p. 87; Malvasia p. 87; Oretti p. 707; Basan p. 112; Strutt p. 182; Gori Gandellini I, p 181, p. 27, no. V; Joubert p. 349; Nagler 1835, p. 388; LeBlanc; Andresen 2; Foratti p. 191; Disertori p. 266; Bodmer 1938, p. 117; Petrucci p. 139; *Mostra-Disegni* no. 263; Calvesi/Casale 215; Posner 175; Bertelà 308.

States:

	B	CC	Pos
I	1	–	–

Before inscriptions. (Ber, BM, BN, Ham, MMA, NYPL, and Par)

	B	CC	Pos
II	2	1	1

Lower left: *Annibal Caracius fecit et inve.*[1] (Alb, BM, BMFA, Br, Dres, and others)

	B	CC	Pos
III	3	2	2

Lower right: *Nico. van Aelst for.* (Ber, BN, Bo, PAFA, Ro, and others)

Preparatory Drawings: 1. Windsor Castle Inv. no. 2118 (Wittkower 356). Pen and brown ink. 110 x 145 mm. Some incising evident. Vertical cut to left of column. Image: 106 x 129 mm. Lower left: *A Caracci.* Drawing is laid down on paper that has been extended with a frame of brown ink lines (photograph in Wittkower shows this extension of the composition, which belongs to another hand). Bibliography: Wittkower 356 with previous bibliography; Posner 175b. (fig. 22a).* 2. New York, Pierpont Morgan Library. Pen and brown ink. 153 x 217 mm. Executed on the verso of state I of cat. no. 21. Perhaps an early thought for this print. Bibliography: Felice Stampfle and Jacob Bean, *Drawings from New York Collections II, The Seventeenth Century in Italy,* Greenwich, 1967, no. 14. (fig. 22b).*

Copies: 1. Etching in reverse. 102 x 131 mm. (image: MMA). 2. Etching and engraving in the same direction. 106 x 132 mm. Tree has foliage at top. Lower left: *A, Carr.* (Alb). 3. Etching in reverse. 165 x 140 mm. Roof and background added at top. Lower left: *Caracc. Inv.* Lower right: *Matthiolus faciebat.* Further inscriptions below that. (MMA). 4. Etching in reverse. 107 x 135 mm. State 1: *Annib. Carracius inv.* lower center. (BM) State 2: *P. de Iode excudit.* added lower right. (BM). 5. Etching in reverse. 111 x 135 mm. Lower right: *Ani: Car. Inv.* (Par). 6. Etching in reverse. 100 x 131 mm. Lower right: *Anib. Caracius inve./ et fecit.* (Par).

The dating of this universally accepted print is somewhat complicated. Wittkower, Mahon, and Calvesi/Casale placed it late in Annibale's career, but before the *Madonna della Scodella* and the *Christ Crowned with Thorns* (cat. nos. 20-21), that is, about 1604-1605. Posner correctly dated the print c. 1606 on the basis of a preparatory drawing (fig. 22b),* in the Pierpont Morgan Library, New York, which is on the verso of a first state of the etching *Christ Crowned with Thorns* (cat. no. 21), giving the sheet a *terminus post quem* of 1606. The drawing is problematic, however, in that, although the subject is an Adoration of the Shepherds, it may or may not be a first thought for this etching. The faces of the angels bent over the figure of the Madonna and Child are close to the attitude of the two angels in the print, but the rest of the ideas on this sheet were discarded, if this indeed was Annibale's earliest thought for the etching. Moreover, the figure of the shepherd on the left is very similar to a figure in Annibale's lost *Adoration of the Shepherds,* known only in Domenichino's copy in the National Gallery of Scotland, Edinburgh (fig 22c).[2] The painting was assigned a date of c. 1606 by Stampfle and Bean, who connected this drawing with it. If the drawing were an early study for the lost painting, the painting would be the only one executed by the artist after his illness of 1605.

Wittkower, Mahon and Posner, however, dated the canvas of the *Adoration* c. 1598-1600 on the basis of a preparatory drawing in Windsor for the boy holding a dove in the painting.[3] On the verso of the Windsor study is a figure of a herm which exactly reproduces a figure on the Farnese ceiling, which dates from 1597 to 1600.[4] Wittkower admitted that the herm was not as lively in attitude as Annibale's other drawings for *ignudi* and herms on the ceiling, and Martin called the drawing a "study for, or perhaps a copy after, the atlas herm . . ." on the ceiling.[5] The argument advanced here is that the herm on the Windsor sheet is a replica of the ceiling figure rather than a study for it. The mechanical shading reproduces the exact fall of darkness on the form in the ceiling. This kind of duplication of effect in drawing and painting does not exist elsewhere in Annibale's work. If indeed the herm is a copy by another, what is the authorship of the recto of the Windsor sheet? It has all the characteristics of the original drawings by Annibale, and no one has questioned its authenticity. Stylistically, it could be placed late in Annibale's career, even in the period after 1600. The simplification of the hands and drapery folds, although evident in some works for the Farnese ceiling, appears regularly in the artist's final phase. Comparisons can be made with the preparatory drawings in Paris and Chatsworth for the *Madonna della Scodella* and the *Christ Crowned with Thorns* (figs. 20a, 21a). Therefore, on the basis of the drawing on the back of the *Christ Crowned with Thorns* (fig. 22b) and this study for the boy holding a dove, both preparatory for Annibale's lost *Adoration of the Shepherds,* the painting can be dated to c. 1606.[6]

One further obstacle stands in the way of this late dating for the painting: a drawing by Agostino, formerly in the Ellesmere collection.[7] Several figures on this study sheet correspond to those in the Edinburgh painting. Wittkower, Mahon, and Posner believed that Agostino copied these motifs from Annibale's painting. The *terminus ante quem* for the drawing is 1602, the date of Agostino's death. Stampfle and Bean, in mentioning the drawing, did not convincingly account for its existence,

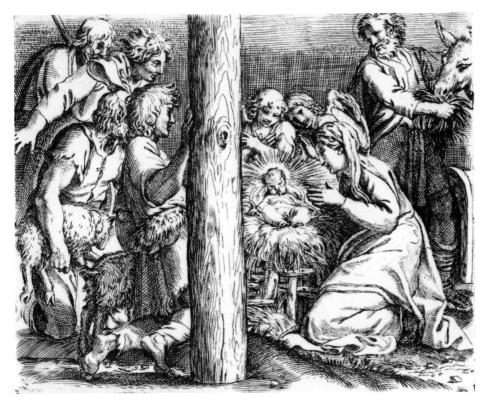

cat. no. 22, state I. London, The British Museum

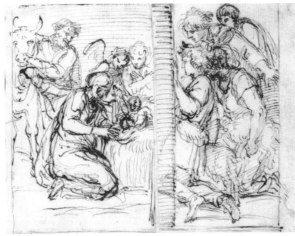

fig. 22a. Annibale Carracci, *Adoration of the Shepherds*. Windsor Castle, Royal Library, Her Majesty Queen Elizabeth II

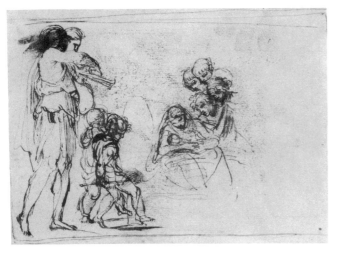

fig. 22b. Annibale Carracci, *Study for an Adoration of the Shepherds*. New York, Pierpont Morgan Library

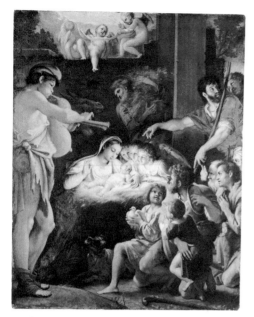

fig. 22c. Domenichino, *Adoration of the Shepherds*. Edinburgh, National Gallery of Scotland

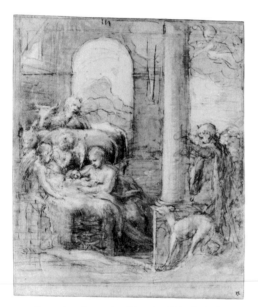

fig. 22d. Correggio, *Adoration of the Shepherds*. Cambridge, The Fitzwilliam Museum

unless the *Christ Crowned with Thorns* was produced before 1606, which, as they admitted, seems unlikely.[8] The solution to the dilemma is simpler than that. As advanced in this catalogue, Agostino was not always dependent on his brother for motifs in his works; in some cases, Annibale borrowed from Agostino.[9] That appears to be the case with the present drawing. The composition of the central group of figures in the Ellesmere sheet, the portion with similar motifs to the painting, is cohesive as a unit. In the painting, however, the figure of the man with a hat, the boy with a dove, and the attentive dog are taken from Agostino's drawing and placed in the *Adoration* without an especially coherent relationship. It is Annibale's painting which has the traits of a pastiche, not Agostino's drawing.

With the preceding discussion in mind, one returns to the question of the dating of the etching of the *Adoration of the Shepherds*. Although the Edinburgh painting may be after 1606, the drawing in New York may be a study for the etching with the recently completed painting in mind. An indication of this could be the margin lines which suggest a design for a horizontal format, a format which occurs in the etching but not in the painting. Moreover, margin lines in drawings preparatory for prints are common. As shown in the studies surrounding the *Tazza Farnese* (cat. no. 19), Annibale reworked a composition in various media at least once before. In any case, this composition for the *Adoration* was discarded. Another drawing, in Windsor (fig. 22a),* is the final preparatory sheet for the etching. Freely drawn in the same manner as the first sheet, it obviously dates from the same period. There are only minor adjustments from drawing to print, and, as in the sheet in New York, a margin line encloses the composition.

Corrado Ricci, followed by Popham and Posner, noted the influence of a Correggio drawing in the Fitzwilliam Museum, Cambridge (fig. 22d) for the composition of this etching.[10] In both, a columnar element separates some of the shepherds from the miraculous birth, and several of the figures in Correggio's drawing are repeated in the etching. It is interesting to note that Annibale's continuing interest in Correggio is evidenced in both the etching and the painting of the *Adoration of the Shepherds*. The painting, as suggested by others, was based on Correggio's *La Notte* in the Dresden Gemäldegalerie,[11] for which the drawing in Cambridge is a study. The coincidental influence of Correggio on both painting and etching further corroborates the evidence for the contemporaneity of both Annibale works.

The oddity of the composition of this late etching has never been mentioned in the literature. Annibale moved the column in Correggio's drawing to almost the center of his composition, causing the viewer to divide his attention between the shepherds and the figure of the Madonna and Child. Although now a tree, the vertical element has columnar qualities, made more apparent in the drawing than in the print. In Correggio's drawing, the shepherds are eyewitnesses to the scene of Christ in the manger. In the etching, they are apart from the scene but are made almost as important as the figures on the right side of the composition. The viewer's attention is almost equally divided between the left and right sides of the work. This unusual composition is rare but not unknown in Annibale's oeuvre. Another late drawing in Windsor, based on a Tintoretto painting of the Annunciation, uses the same tech-

nique of vertically dividing the picture space into two parts.[12] Posner suggested that Annibale, by cutting off half of the archangel Raphael as he flies through a brick building, was poking fun at Tintoretto's painting.[13] Although Posner was probably correct in this assumption, it is fascinating that Annibale again took up this compositional device in all seriousness in the etching of the *Adoration of the Shepherds*. The apparent artificiality of such a device is explained iconographically. When Annibale laid out the composition, he did so in two parts which were unified by the strong forward movement of the shepherds gazing at and rushing toward the Christ Child. This basic unity was then harshly interrupted by the central placement of the tree which prevents the mortal shepherds from approaching the Holy Family and angels, thus dividing a terrestrial from a spiritual world. Annibale made the composition function symbolically as a reminder of the divinity of Christ, but stylistically he broke the visual rules of his "ideal" style, to use Posner's terminology.[14] This radical composition may even have bothered the artist. The drawing in Windsor is vertically cut and repaired to the left of the column. Perhaps Annibale attempted to rearrange the composition into a traditional format by cutting it himself. Fortunately, the final result remained as it was in the drawing.

Annibale may have known other precedents for this division of space. There were two such Adoration scenes—one a woodcut by Albrecht Dürer (fig. 22e) in which a wall divides the figure of Joseph from the Nativity,[15] the other a painting by Titian of the *Adoration of the Magi* in which the post of the shed over the manger separates the scene into two parts.[16] But in neither of these were the celestial figures separated so completely from the earthly ones. H. Diane Russell has pointed out another iconographical feature important to the understanding of this print. The body of Christ has been moved from an active, diagonal position in the drawing to a rigid, frontal position in the print, a conscious allusion to the death of Christ.[17]

The new and challenging composition to the *Adoration of the Shepherds* is at odds with the compositional simplicity of the artist's two previous late etchings (cat. nos. 20-21) and antithetical to the idea of Annibale as a proponent of an ideal style in his late years. Perhaps Annibale was moving away from the classicism of his earlier works and toward a new expressive style, merely hinted at here. In any case, in what may have been Annibale's last work, he presented us with a new hierarchy of meaning and a more intense visual and religious representation of the subject of the Adoration.[18]

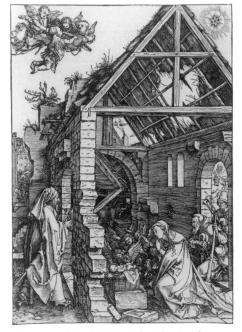

fig. 22e. Albrecht Dürer, *The Adoration of the Shepherds*. Washington, National Gallery of Art, Rosenwald Collection

*Etching in exhibition from the Museum of Fine Arts, Boston, Harvey D. Parker Collection.

1 Andresen noted these three states as well as another which he called State II in which the words "et inve." are not evident. He also said that the plate was extant.

2 See also Posner 108a.

3 Wittkower 344; *Mostra-Disegni*, no. 71; Posner 108. The drawing is reproduced in Wittkower and Posner.

4 Wittkower 110. The drawing is reproduced in Martin, pl. 227.

5 Martin, p. 267, no. 113.

6 If one accepts the date of 1606 for the painting and the drawing in Windsor, the

authorship of the verso of the sheet becomes easier. With Annibale's large workshop, one of his assistants could have used the verso of the sheet to make a copy of the herm on the Farnese ceiling. Albani would be a likely candidate.

7 Ellesmere sale, no. 32. Reproduced. Dated by Mahon c. 1598-1600 (*Mostra-Disegni*, no. 71.)

8 Both the *Christ Crowned with Thorns* and the *Madonna della Scodella* exist in states before letters, and both are dated 1606 in the second state. Since the second state does not appear to have been made by a publisher, whose address is not evident until the third state, it seems probable that the artist himself added the signature and date to the second state.

9 As in cat. no. 16, *Madonna and Child*, cat. no. 17 *Venus and a Satyr*, and in the early studies for the *Tazza Farnese* (cat. no. 19). This does not even take into account the artist's early graphic dependence on Agostino (cat. nos. 1-3).

10 Inv. no. PD. 119-1961. 243 x 208 mm. Pen and brown ink, brown wash, heightened with white. Corrado Ricci, *Correggio*, Rome, 1930, p. 171. A. E. Popham, *Correggio's Drawings*, London, 1957, cat. no. 72, reproduced plate LXXXVI. Further bibliography in *European Drawings from the Fitzwilliam*, International Exhibitions Foundation, 1976-1977, Washington, D.C., no. 15.

11 Posner, vol. I, fig. 31. See Posner 108 for discussion.

12 Annibale's drawing (Wittkower 439) and Tintoretto's painting in the Scuola di S. Rocco in Venice are reproduced in Posner, vol. I, figs. 78-79. For a discussion in Posner, see vol. I, p. 84.

13 Posner, I, p. 84.

14 Posner I, pp. 126-128 discussed Annibale's late years.

15 Dürer's print dates c. 1502-1504. Reproduced in National Gallery of Art, *Dürer in America, His Graphic Work* (Washington, 1971), no. 144. It is possible that this print was influential on Tintoretto's painting.

16 The painting comes in several versions. See the one in the Escorial, dating c. 1559-1560. Reproduced in Harold E. Wethey, *The Paintings of Titian I. The Religious Paintings* (London, 1969), pl. 120.

17 H. Diane Russell, in a conversation with the author, pointed out the similarity of the Christ Child with Mantegna's painting of the *Dead Christ*. That Annibale was familiar with Mantegna's portrayal is evidenced by his own painted version of the subject in the Staatsgalerie in Stuttgart, datable to the early 1580s. Reproduced in Posner, no. 3.

18 In an unusual late landscape drawing in a private collection in New York (fig. 22f,* unpublished, pen and brown ink. 193 x 285 mm. Corners cut top and repaired with added sheets of paper), Annibale continued this division of space into equal, or almost equal, sections. However, in this drawing, the double archway is not in the least visually disruptive. It is doubtful that the motif is based on nature (single rusticated archways are known, but double ones would have been unusual) but harks back to the artist's painting of a *Landscape and River Scene* in Berlin (Posner 74), in which there is a similar arched bridge in the right background. The arched composition was probably Annibale's, even though the top corners may have been cut later to a rounded shape, because the rustication of the stone curves in an arched pattern. It is highly likely that this drawing was made in relation to the commission for the Aldobrandini lunettes, commissioned about 1604 and finished before 1613 with the help of assistants. (For the chronology of the works and Annibale's participation see Posner 145-150.) Annibale could well have been toying with the idea of a divided river landscape, like the one here, but may have discarded the composition either because it was carried out in all the lunettes or to avoid visual disharmony.

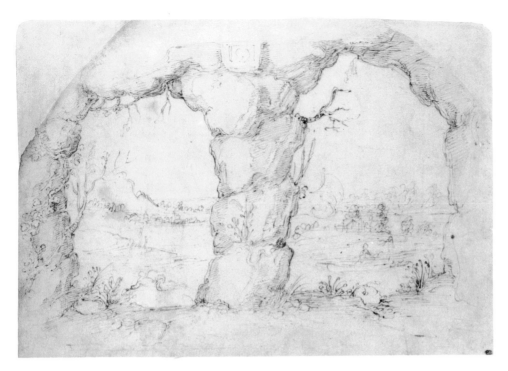

fig. 22f. Annibale Carracci, *Landscape*. New York, Private Collection.

PRINTS NOT BY ANNIBALE CARRACCI

Cat. Nos. R 1 - R 3

R 1

ANONYMOUS BOLOGNESE,
seventeenth century

The Christ Child and Saint John the Baptist
(B. appendix, p. 204)

Etching and engraving. 89 x 127 mm.

Literature: Gori Gandellini I, p. 182; Calvesi/Casale 199; Posner 212[R]. Bertelà 334.

States:

	B	CC	Pos
I	I	I	I

On banner: ECCE AGN.ˢ DEI.

Calvesi and Casale attributed this print to Annibale with little reason, and they dated it c. 1590-1591. Posner correctly removed the print from Annibale's oeuvre, citing its poor quality. In addition, morphological traits do not even approach those of our artist. As indicated by Posner, the print must be by a follower. The artist may be the one who produced a similar print of the same subject after Guido Reni (Bartsch, XVIII, 287.12).[1]

1 Bertelà 861.

R 2

GIOVANNI BATTISTA CARACCIOLO[1]
(Naples c. 1570-1637)

Saint John the Baptist in the Wilderness

Etching. 115 x 163 mm.

Literature: Nagler, I no. 308; Calvesi/Casale 205; Posner 214[R]; Bertelà 335.

States:

	CC	Pos
I	I	I

Lower right: CAB (letters on top of one another).

Although attributed by Nagler and Calvesi/Casale to Annibale, this print was done by Giovanni Battista Caracciolo, whose monogram is on the rock at right. The same monogram is found on paintings in Berlin and elsewhere.[2] Moreover, the very loose technique, although influenced by Annibale's etchings, is less ordered than the master's.

1 For information and bibliography on Caracciolo see Vincenzo Pacelli, "Caracciolo Studies," *Burlington Magazine*, 110 (August, 1978): 493-497.

2 The Berlin painting of *Sts. Cosmas and Damian* (reproduced Staatliche Museen Berlin, *Die Gemäldegalerie, die Italienische Meister 13 bis 15. Jahrhundert*, Berlin, 1930, p. 111—Inv. 1981) has the monogram in the lower left. A painting in the collection of Mr. and Mrs. Paul Ganz of *Mary Magdalen at the Foot of the Cross* (reproduced Detroit Institute of Arts, *Art in Italy 1600-1700*, New York, 1965, no. 146) displays the monogram along the upper edge.

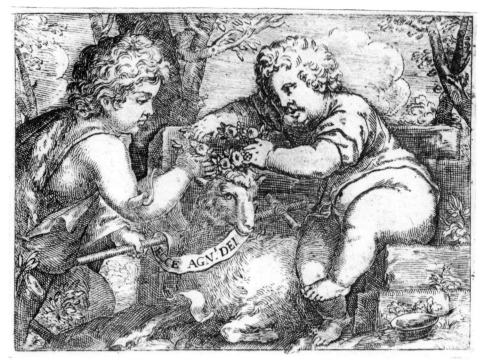

cat. no. R 1. Anonymous seventeenth-century Bolognese. Bologna, Pinacoteca Nazionale

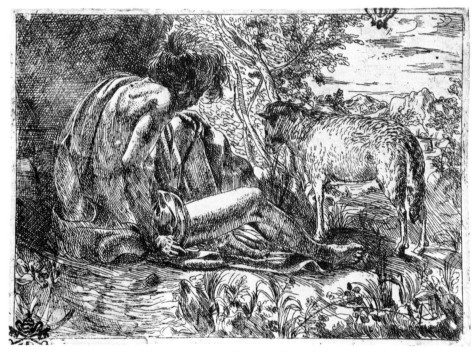

cat. no. R 2. Giovanni Battista Carracciolo. Bologna, Pinacoteca Nazionale

R 3

GUIDO RENI? (1575-1642)

Virgin with a Pillow

Etching and engraving. 163 x 119 mm.
(Bartsch XVIII, 201.4 as Francesco Brizio)

Literature: Malvasia p. 87; Gori Gandellini I, p. 182; Joubert p. 350; Calvesi/Casale 202; Posner 84; Bertelà 332.

States:

	B	CC	Pos
I	–	–	–
Before inscriptions. (BN)			
II	–	–	–
Lower right: A.C. (BMFA, Frankfurt, MMA)			
III	I	I	I
As state II, but with *I. Sad. exc.* lower left. (Alb, Ber, BM, BN, Bo, MMA, U, and others)			

Copies:
1. Etching in reverse. 157 x 119 mm. No inscriptions. (BM). 2. Etching in the same direction. 157 x 114 mm. No inscriptions. (Bo). 3. Engraving in reverse. 135 x 108 mm. (sheet: Par). Lower right: *R. Sadeler F.* In margin: NONNE DVO PASSERES ASSE VOENEVNT. *Matt. 10.* 4. Etching in reverse. 162 x 127 mm. (sheet: Dres). Lower left: *A. Carache* and *F. Bour. ecc. cu D. R. C. APar.*

Malvasia was the first to attribute this etching to Annibale Carracci and was followed in this thinking by Gori Gandellini and later Joubert. Bartsch, however, believed that the print was executed by Francesco Brizio. In this century, Calvesi and Casale returned it to Annibale's oeuvre and were supported by Posner, who dated the print c. 1594. Posner did admit a certain clumsiness in the right arm but justified this by the artist's use of *pentimenti* in this portion of the print. Unfortunately, the clumsiness appears in other parts of the etching as well—in the Virgin's hands and the Child's right leg. In no other print by Annibale does such a misunderstanding of anatomy appear. That the design of the print is by Annibale, as Bartsch suggested, is correct, but the execution must belong to another less experienced artist.[1] The addition of the initials "A.C." does not occur until the second state, and they could indicate the author of the design and not necessarily the maker of the etching itself.

Bartsch's opinion that Brizio executed the *Virgin with a Pillow* is hard to accept. Although Brizio appears to have been able to accommodate his style to both Agostino's and Lodovico's working methods, he never approached Annibale as closely as did the artist of this print. In addition, Brizio's morphology is often easy to recognize. Another youthful artist is at work here, perhaps Guido Reni, who was in the Carracci Academy in the mid 1590s, and who was influenced by other artists in his reproductive prints.[2] Moreover, the child's face with its wide forehead and lack of chin comes close to works by Reni.[3]

1 The composition with the figures dominating the foreground plane and a distant landscape off to one side is seen in Annibale's *Venus and a Satyr* (cat. no. 17).

2 See, for example, Reni's etching of the *Holy Family,* approaching Parmigianino's style, and probably after him (Bartsch XVIII, 284-5. 9).

3 Such as the *Christ Child and St. John the Baptist* (Bartsch XVIII, 287-8.13) and the *Holy Family* (Bartsch XVIII, 285-6.10).

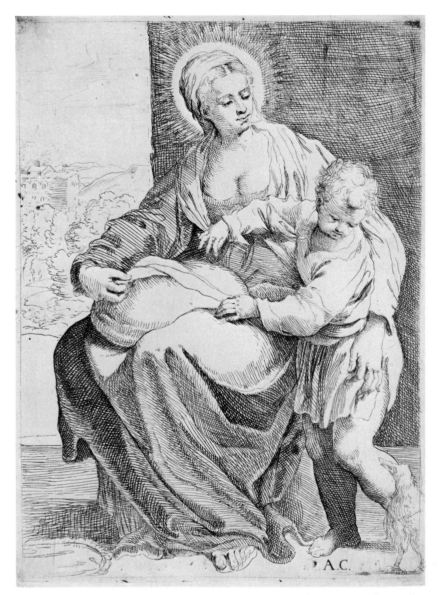

cat. no. R3. Guido Reni (?). New York, The Metropolitan Museum of Art, Harris Brisbane Dick
Fund, 1926

LODOVICO CARRACCI
(1555-1619)

Cat. Nos. 1-4

1*

The Holy Family Under an Arch
(B. 4) c. 1585-1590

Engraving. 267 x 327 mm.

Literature: Malvasia p. 86; Oretti p. 632; Gori
Gandellini p. 42, no. VI; Basan p. 108; Strutt
p. 179; Heinecken p. 618, no. 2; Joubert
p. 342; Nagler 1835, p. 384; Mariette I,
no. 572, bis, 14 ff; LeBlanc 4; Andresen 4;
Bodmer *Lodovico* p. 156; Petrucci p. 141;
Mostra-Disegni no. 252; Calvesi/Casale 187;
Bertelà 342.

States:

	B	CC
I	1	1

Lower left: *lodovicus Carraccys./In. fe.* (Alb,
BM, BN, Br, Ro, and others)

| II | – | – |

Lower left in margin: *Ioan.ˢ Orlandis a pasquino/
form. roma.* (Ber, BM, Stu)

| III | | |

Along bottom below margin: *P.S.F.* (Dres,
MMA, PAFA)

| IV | – | – |

Inscriptions in margin burnished out. (Alb,
BN, Bo, PAFA, and others)[1]

Preparatory Drawings: 1. Oxford, Ashmolean
Museum. Inv. no. 174. Pen and brown ink and
wash. 139 x 120 mm. (measured widest
points). Top corners cut. Several holes and
abrasions. Collections: Sir Joshua Reynolds
(Lugt 2364, lower right). Literature:
Mostra-Disegni no. 4 with previous
bibliography. (fig. 1a).* 2. Collection Mr. John
Winter. 254 x 347 mm. Black chalk. Made up
of five pieces of paper. Collections and
bibliography found in Ellesmere sale, no. 2.
(fig. 1b).*

Copies: 1. Engraving in reverse. 204 x
243 mm. No inscriptions. (MMA)

Malvasia believed that this engraving was designed but not executed by
Lodovico. Oretti rejected it outright, calling it badly engraved. All
other writers have correctly given it to the artist. As there are but four
authentic prints by Lodovico, with only two dated (cat. nos. 2, 4), it is
difficult to place the other two within periods or discuss any stylistic or
technical development in his prints. There are two drawings, however,
which are connected with this print and are fairly easy to date stylisti-
cally. Moreover, the composition and drapery folds of the figures in the
Holy Family under an Arch are similar to the painting of the *Madonna dei
Bargellini* in the Pinacoteca Nazionale in Bologna, signed and dated by
Lodovico in 1588.[2] Both Mahon and Lenore Street dated the print
c. 1588.[3] The drawings support this contention. The brilliantly and
rapidly executed study in the Ashmolean (fig. 1a)* of a pensive figure
reflects the pose of Joseph in reverse. Obviously from a model, it is
typical of Lodovico's pen style of the 1580s in its contrasting light and
shade by means of *macchie* of wash. The study for the *Madonna and Child*
in the John Winter Collection (fig. 1b),* in its faceting of drapery and
softly delineated contours, is reminiscent of the chalk studies of this
period and of the early 1590s.[4]

In the nineteenth century, the influence of Andrea del Sarto's
Madonna del Sacco on Lodovico's composition was pointed out.[5] The
similarity with Andrea's painting does not indicate a trip to Florence
(although we assume that Lodovico did go to Florence),[6] but there was
contact with either the original in the Chiostro de'morti, SS. Annunziata
in Florence or with an engraved copy of this well-known and influential
fresco.[7]

More influential than Andrea's fresco are the prints of Barocci
which Lodovico appears to have been emulating in this engraving. Simi-
lar faceting of the drapery occurs in the Madonna's voluminous robe and
in Barocci's draperies, but the atmospheric effects achieved in the Ur-
binese artist's etchings were unattainable for Lodovico as they were for
Annibale and Agostino. Lodovico's natural interest in color and rich
tonal effects may have led him to his reevaluation of Barocci's prints.

There is nothing technically innovative in this print by Lodovico,
but there is an experimentation with various forms of hatching, espe-
cially in the wall to the left of St. Joseph's head. What is more striking
is the experimentation with different colors of paper, unusual in Italian
engravings but not in woodcuts before the seventeenth century. There
are at least two examples of the first state of this engraving on blue
paper,[8] suggesting that the artist himself was attempting to expand the
possibilities of tonal ranges in the graphic medium. Like Annibale,
Lodovico often employed blue paper for drawings, but Annibale did not
extend this use to prints. Lodovico, moreover, was more interested in
coloristic possibilities in drawings than either his cousins.[9] The result in

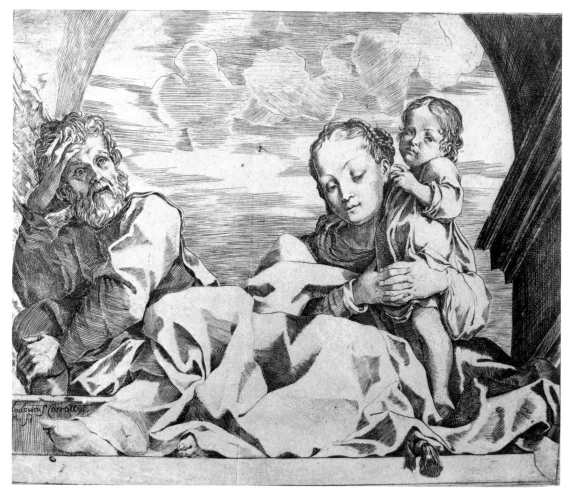

cat. no. 1, state I. Los Angeles, Grunwald Center for the Graphic Arts, University of California

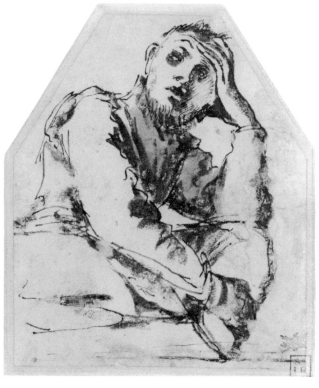

fig. 1a. Lodovico Carracci,
Study for Saint Joseph.
Oxford, Ashmolean Museum

the *Holy Family under an Arch* is a warmth of tone unapproachable in the pristine white and black contrasts evident in conventional cream or buff paper.

1 Andresen noted that the plate was extant in his time. He also cited all four states.

2 *Mostra-Dipinti,* no. 8.

3 Ellesmere sale, no. 2.

4 For example, see *Mostra-Disegni* nos. 8, 25, and 29.

5 William Young Ottley, *The Italian School of Design,* 1823, p. 65. See John Shearman, *Andrea del Sarto,* Oxford, 1965, pl. 134 for a reproduction of Andrea's fresco.

6 Malvasia p. 264 discussed a trip by Lodovico to Florence early in his career. See also Charles Dempsey pp. 17, 81-82, note 38.

7 Shearman, p. 264, mentioned an anonymous engraving dated 1573. He also noted, p. 265, eight copies, some from the sixteenth century.

8 In the Bibliothèque Nationale in Paris and at the Grunwald Center for the Graphic Arts, UCLA.

9 The drawing for St. Joseph is a good example of this; the contrast of the dark washes and the lack of emphasis on contour lines is characteristic of Lodovico's drawing style.

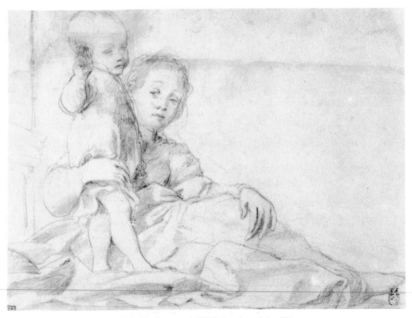

fig. 1b. Lodovico Carracci, *The Madonna and Child.* London, John Winter

2*

Madonna Nursing the Christ Child

(B. 1) 1592

Etching. 153 x 119 mm.

Literature. Malvasia p. 72; Oretti p. 624; Basan p. 108; Strutt p. 179; Heinecken p. 618, no. 5; Gori Gandellini p. 42, no. III; Joubert p. 342; Nagler 1835, p. 383; Mariette I, 572 bis, 3; LeBlanc 2; Andresen 1; Nagler IV, no. 1240; Foratti p. 190; Bodmer *Lodovico* p. 156; Petrucci p. 141; *Mostra-Dipinti* p. 83; *Mostra-Disegni* p. 170; Calvesi/Casale 188.

States:

	B	CC
I	—	—

Lower right: *lod: Carr·in·f·1592.* (Ber, BM, Dres, PAFA)

	B	CC
II	I	I

Above signature: *Pietro Stefanoni for.* (Alb, Ber, BM, MMA, Ro, and others)

Copies: 1. Etching in the same direction. 149 x 115 mm. Lower right: *Lod, Carr, in,* Very deceptive. (Alb). 2. Engraving in reverse. 150 x 104. mm. No inscriptions (Bo). 3. Engraving in same direction. 197 x 198 mm. Halo gone, background crosshatched. In a circle in a square. Lower left: *Carage Inventor.* Lower right: *Io enfant Sc.* (Alb). 4. Engraving in reverse. An oval with inscription around it and St. Joseph added at right, and a landscape. 121 x 165 mm. (oval). Inscription begins with MANE SVRGAMVS. . . . At right: *Ioan Sadeler Scalpsit et ex.* (Dres). (There are at least three copies of Sadeler's print.)

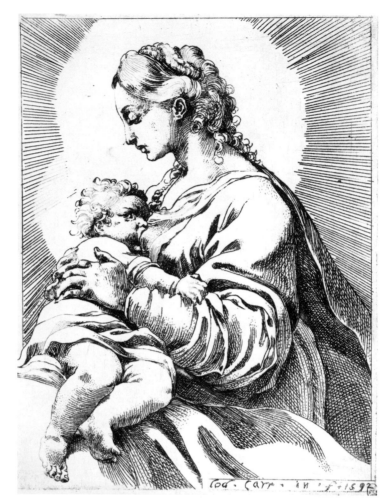

cat. no. 2, state I. London, The British Museum

This is one of two signed and dated prints by Lodovico and gives us some kind of chronological base for his work in prints. Calvesi/Casale astutely noted that there is some relationship with Annibale's graphic style in this etching. Especially close, it seems, is Annibale's *Venus and a Satyr* (Annibale cat. no. 17), also dated 1592. A similar interest in contour lines and variation of hatching technique is evident as is the contrast of bright areas of light against dark shading. But the juxtaposition of light and dark is more dramatic in Lodovico, a trait that does not become evident in Annibale's prints until his very late etchings of the *Madonna della Scodella* (Annibale cat. no. 20) and the *Christ Crowned with Thorns* (Annibale cat. no. 21). Typical of Lodovico is the tender expression of the Madonna and the close relationship of mother and child. The lighter printing of portions of the Christ Child's hair, his foot, and the Madonna's right hand are perhaps intentional, caused by blocking out these portions and rebiting the rest of the plate. Indicative of this technique are the light strokes of the Madonna's hair which emphasize the undulation of her locks by highlighting certain portions of them.

3*

Madonna and Child with Angels
(B. 2) c. 1595-1610

Etching and engraving. 162 x 116 mm.

Literature: Malvasia p. 72; Oretti pp. 623-4; Strutt p. 179; Heinecken p. 618, no. 4; Gori Gandellini p. 41, no. II; Joubert p. 342; Nagler 1835, p. 383; Mariette I, no. 572, bis, 5; LeBlanc 5; Andresen 2; Nagler IV, no. 1239; Foratti p. 190; Bodmer *Lodovico*, p. 156; Petrucci p. 141; Calvesi/Casale 189; Bertelà 338.

States:

	B	CC
I	1	1

Lower left: *Lo. C. Petri Stephanony Exc.* (Alb, BM, Bo, Br, Dres, U, and others)

II	–	–

Lower right: *Ioannes Orlandi formi.* (Turin: Biblioteca Nazionale)

III	–	–

The Orlandi address burnished out and in its place: *Nico. Van Aelst. for.*[1] (Ber, BMFA, Bo, Dres, and others)

Preparatory Drawings: 1. British Museum, Inv. no. 1895-9-15-686. 167 x 116 mm. Red chalk and pen and brownish ink. Unpublished. (fig. 3a).*

Copies: 1. Engraving in reverse. 197 x 142 mm. (sheet: Dres.) Adds music book for leaning angel. Adds rose for manger. Adds design for edge of Madonna's cloak and covers her breasts. Adds small figure walking in the distance following star in sky. Adds tree. Lower right: *L.K. scalp.* In margin: *Te* CHRISTE; *et* GENETRICE *tua;* GENISQVE *beatis;/ Quid tribus his, dici,* CASTIVS *epse potest?/ Aug.⁸ Carraz. inv. D. Custod. excud.* 2. Engraving in the same direction. 157 x 124 mm. (sheet: Bo) No inscriptions. 3. Etching in reverse. 152 x 115 mm. Lower left: *Lo. Car./inven.* Toward right: *s* (Ber). 4. According to Heinecken and LeBlanc a copy by Lo. Carino. 5. Engraving in reverse. 163 x 111 mm. (sheet: Par). *Lodovico Carracio/ inventor.* 6. Etching in reverse. 157 x 115 mm. (sheet: Par) Lower left: *Lo. c. in.* Lower right: *Barbieri fecit 1645.* 7. Etching in same direction. 154 x 112 mm. (sheet: Ber). No inscriptions. 8. Engraving in reverse. 162 x 114 mm. (sheet: Ber) Lower right: *Lodovico Caraccio.* 9. Engraving in reverse. No inscriptions (Br).

This signed print has been accepted by all sources except Bodmer, who called it a copy after Lodovico; but he mistakenly reproduced a copy of the etching, not the original, in his monograph (copy no. 3). Malvasia was not enamored with the print either, but there seems no reason to doubt it. Authenticity is supported by a preparatory drawing in reverse in the British Museum (fig. 3a),* which is characteristic of Lodovico's style.[2] The print was dated by Calvesi/Casale c. 1600 by relating it to a painting of the *Holy Family with Saints Francis and Catherine* in the Pinacoteca Capitolina in Rome.[3] That comparison seems gratuitous, and a dating of a wider time span is indicated. The flowing drapery and undulating curves of the composition appear in many of Lodovico's paintings of the late 1590s and early 1600s such as the *Martyrdom of Saint Ursula* in Imola, the *Flight into Egypt* in the Casa Tacconi, Bologna, and the *Madonna and Child with Saints* in London, Marquise of Lansdowne.[4] Moreover, Lodovico's drawing style of this period exhibits a fluidity of contour line apparent in this etching.[5]

1 LeBlanc also noted three states but placed the Orlandi address after that of van Aelst rather than before. Andresen found four states, the three indicated here and an earlier state before the inscription, unknown to this writer. Heinecken knew the first two states.

2 There is a notation on the mount of the drawing by Bodmer questioning the drawing, but if he thought copy 3 after Lodovico's print was the etching Bartsch attributed to Lodovico, he probably thought that this sheet, which is in the same direction as the copy, was made after that print.

3 *Mostra-Dipinti,* no. 25.

4 *Mostra-Dipinti* nos. 24, 20, and 34. Each of these paintings is dated within this period according to stylistic evidence alone, which puts us on very unstable ground when dating the prints in relation to these works. Arcangeli (*Mostra-Dipinti*) dated the first two paintings to the late 1590s and c. 1600 and the third painting c. 1617. This author prefers to keep Bodmer's dating of the first decade of the seventeenth century fot the *Madonna and Child with Saints.* More on this painting is found in cat. no. 4.

5 Cf., for example, Wittkower 19, pl. 15, which is close in style to the British Museum drawing or Wittkower 17, pl. 9, which is similar in style to the etching and is a study for a painting of 1605.

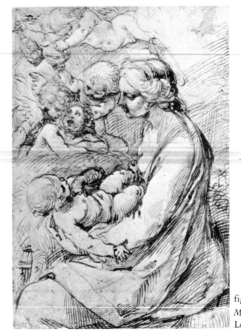

fig. 3a. Lodovico Carracci, *Madonna and Child with Angels.* London, The British Museum

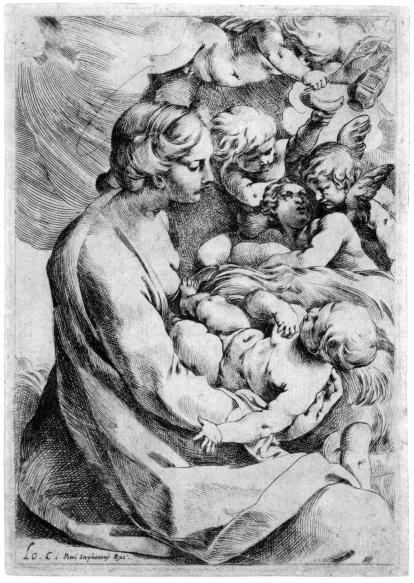

cat. no. 3, state I. Washington, National Gallery of Art, Ailsa Mellon Bruce Fund

4*

Madonna and Child with Saint John (?)
(B. 3) c. 1602-1604

Engraving and drypoint. 211 x 135 mm.

Literature: Malvasia p. 72; Oretti p. 623; Mariette ms. I, no. 522, bis. 11; Basan p. 108; Strutt p. 179; Heinecken p. 618, no. 3; Gori Gandellini p. 42, no. V; Joubert p. 342; Nagler 1835, p. 383; Mariette I, p. 325; LeBlanc 3; Andresen 3; Foratti p. 190; Bodmer *Lodovico* p. 156; Petrucci p. 141; *Mostra-Dipinti* p. 96; Calvesi/Casale 190; Bertelà 339.

States:

	B	CC
I	–	–

Before inscriptions. (BM)

	B	CC
II	1	1

Lower right: *Ludouico Caratio. fece.* Lower left: *1604.* In margin a two-line (in two sections) inscription beginning with *O Regina del Ciel, . . .* Lower right in margin: *Stampata per Pietro Stefanoni.* (Alb, BM, Bo, Br, Dres, MMA, and others).

Preparatory Drawings: 1. Biblioteca Ambrosiana. Codice Resta, Inv. 190, p. 180. 170 x 132 mm. Pen and brown ink, red and black chalk. Incised. Collections: Padre Resta. (fig. 4a). 2. Collection Timothy Rice. 193 x 136 mm. Pen and brown ink reinforced with black chalk. Incised. Blackened on the verso. Collections: Alfonso III d'Este, Duke of Modena (Lugt 112); Francesco II d'Este, Duke of Modena (Lugt 1893); Sir Thomas Lawrence (Lugt 2445); Lord Francis Egerton, 1st Earl of Ellesmere (Lugt 2710[b]). For bibliography see Ellesmere sale no. 7. (fig. 4b).*

Copies: 1. Etching in reverse. 194 x 130 mm. Lower left: *L. Caratio fecit.* Lower right: *Romae per Pietro Stefanoni; · 1604.* In margin same verse as original. Below in second state: *A bon enfant exc.* (MMA). 2. Engraving in reverse. Lower right: *Lodovico Caraccio/ inventore.* 161 x 113 mm. (image: Madrid, Biblioteca Nazionale). 3. Engraving. in reverse. *Lob.[co] C.I.* 186 x 131 mm. (approximate: Bo), crude.

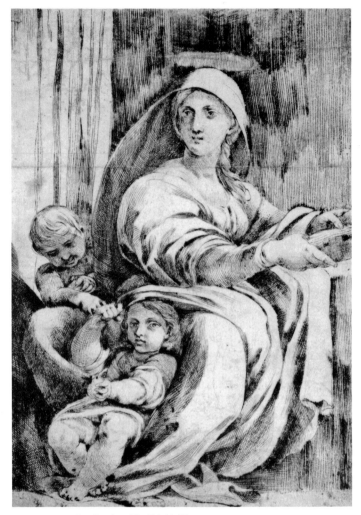

cat. no. 4, state I. London, The British Museum

Calvesi/Casale agreed with Bartsch that this drypoint was on tin rather than copper. The first state without inscriptions, known in one impression in the British Museum, shows how strong the burr was before it began to wear off in later impressions. Even in subsequent impressions, the burr tends to produce an undulating quality to the curtain in the background. The ink marks on all of the impressions suggest the breakdown of the plate used, which, as Bartsch suggested, was probably a weaker metal than copper.

Mariette believed that the date of 1604 referred only to the publisher's date and not to the date of execution. Most sources believe that the date of 1602 is fitting, since Lodovico went to Rome that year, and Stefanoni was a Roman publisher.[1] It is assumed that Lodovico produced the present work either in Rome during this trip or before his arrival and left the plate with Stefanoni to publish. Stylistically, there is an influence of what could only be termed classically inspired forms, more obvious in the first drawing for the print, and one assumes the design was made after Lodovico arrived in the Eternal City. He either left the plate with Stefanoni in 1602 or sent it to him after his return to Bologna. In any event, the *terminus post quem* for the print in 1604.

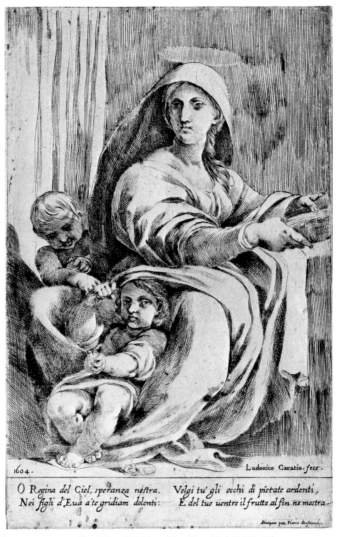

O Regina del Ciel, speranza nostra, Volgi tu' gli occhi di pietate ardenti,
Noi figli d'Eua a'te gridiam dolenti: E del tuo uentre il frutto al fin ne mostra.

cat. no. 4, state II. Prints Division, The New York Public Library,
Astor, Lenox, and Tilden Foundations

The lively first thought for this print in the Codice Resta in the
Biblioteca Ambrosiana in Milan (fig. 4a) is a freely drawn work in which
the pen lines calm the exuberance of the red chalk beneath. Lodovico was
thinking of a scene of the Virgin and Child with an angel behind, but as
his ideas progressed, the angel's wings were clipped, and a resultant
figure of St. John the Baptist appeared. A curtain behind the figures is
indicated by the merest suggestion of vertical lines. The voluminous
folds of the drapery, sculptural form, and the aquiline nose of the Virgin
hint that Lodovico was influenced by a Roman trip. The second and final
study for the print (fig. 4b)*, also incised, still produces a statuesque
form of the Madonna and, in fact, she has become a monumentally im-
movable object, unlike her predecessor. Tomory rejected this drawing,[2]
but as pointed out in the Ellesmere sale catalogue, it was certainly the
drawing transferred to the plate. The billowing mantle behind the Vir-
gin's head suggests a Raphaelesque influence, perhaps from the *Sistine
Madonna,* which Lodovico would have known when it was in Piacenza.[3]

 Calvesi/Casale compared the final work to the painting of *Providence*
by Lodovico in the Pinacoteca Capitolina in Rome, usually dated after
Lodovico's trip to Rome due to the classically simple composition and

figural types.[4] Also very close is the painting of the *Madonna with Child and Saints*,[5] dated by Arcangeli (*Mostra-Dipinti*) to Lodovico's late years, but compositionally similar to the present print. If this painting also dates, as suggested by Bodmer, to the early years of the seventeenth century, the study in Milan could well be connected with this painting as well as with the print. The pose of the twisting Virgin is similar in both. Of course, the artist may have returned to a successful prototype he had used earlier.

Bodmer unjustly rejected this print from Lodovico's oeuvre, but reproduced a copy (copy 1) rather than the original.

1 Malvasia p. 297 documented the trip by means of a letter written by Lodovico to Brizio. *Mostra-Dipinti* p. 94. For information on Stefanoni see the Appendix I.

2 P. A. Tomory, *The Ellesmere Collection of Old Master Drawings* (Leicester, 1954), 71.

3 The painting, now in the Dresden Gemäldegalerie, was in San Sisto in Piacenza in the sixteenth century. See Luitpold Dussler, *Raphael,* London and New York, 1971 (translated by Sebastian Cruft), pp. 36-38 and reproduced pl. 83.

4 *Mostra-Dipinti,* no. 30.

5 *Mostra-Dipinti,* no. 34.

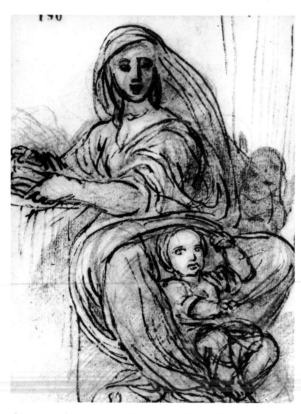

fig. 4a. Lodovico Carracci, *Madonna and Child with an Angel.* Milan, Biblioteca Ambrosiana

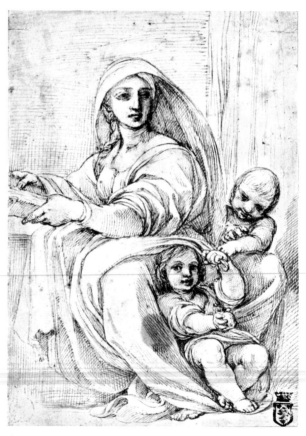

fig. 4b. Lodovico Carracci, *Madonna and Child with Saint John the Baptist.* London, Tim Rice

PRINT NOT BY LODOVICO CARRACCI

Cat. No. R 1

R 1

FRANCESCO BRIZIO

The Virgin Washing Linen
(B. 5)

Engraving. 206 x 153 mm. (measured right and top)

Literature: Malvasia p. 88; Heinecken p. 618, no. 6; Gori Gandellini p. 42, no. IV; Nagler 1835, p. 384; Joubert p. 342; Nagler IV, no. 995; LeBlanc 6; *Mostra-Disegni* 253; Bodmer *Lodovico* p. 156; Calvesi/Casale 186; Bertelà 344; Evelina Borea, *Pittori Bolognesi del Seicento nelle Gallerie di Firenze,* Florence, 1975, pp. 85-86.

States:

	B
I	I

Lower right: *L.C.I.* In margin left: *All' Ill. Sig.*ʳᵉ*ePrōn*/ GUIDO ANTONIO. Right: *Col.*ᵐᵒ *Il Sig.*ʳᵉ *Marchese*/ *Lambertini Senatore.* Lower right: *Hum.*ᵒ *Ser*ᵉ *Gio. Batta Fontanelli D.D.D.* (Alb, Ashmolean, Bo, Dres, PAFA)

Copies: 1. By J. B. Fontana (according to Heinecken). 2. By Gio. Batt. Fontanelli (according to LeBlanc).[1]

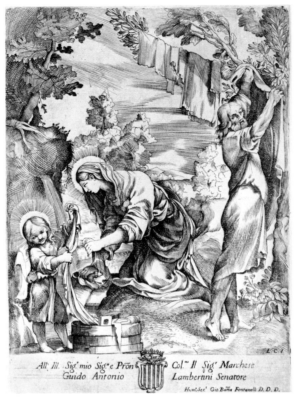

cat. no. R 1. Francesco Brizio. Vienna, Graphische Sammlung Albertina

This print was rejected by Malvasia, who attributed it to Fontanelli after Lodovico's design. Bartsch reattributed it to Lodovico, noting that there was no artist named Fontanelli listed during the period. He did indicate a G. B. Fontanelli who wrote a mathematical book which was adorned by a print after Guido Reni. In this century, Bodmer rejected the print, and Mahon and Calvesi/Casale accepted it into Lodovico's oeuvre, dating it in the 1580s and suggesting, following Bartsch, that the print was executed for, not by, Fontanelli. As was the case with Fontanelli's mathematical treatise, this engraving could have been made for a literary work by Fontanelli to be dedicated to Lambertini. But, although the design of the composition is like Lodovico's works, the execution is closer to Brizio than to our artist.[2] In fact, the engraving of the *Flight into Egypt* (Bartsch XVIII, 224-225.2), also after Lodovico, offers the closest parallels in composition and burin technique. Moreover, the unattractive visages of the Christ Child and the Madonna are typical of Brizio's morphology. Even the face of Saint Joseph at right has some correspondence to that of the same figure in another print by Brizio of the *Rest on the Flight into Egypt* (Bartsch XVIII, 225.4).[3]

1 These copies are listed, although it is probable that each author was referring to the print under discussion.

2 There is no reason to assume that since the print is not by Fontanelli, it is by Lodovico.

3 A copy of Lodovico's lost design is in the Uffizi, a painting there attributed to Lucio Massari (Borea, pl. 39). It is in reverse of the engraving, which Borea also rejected. Borea mentioned another painted copy of Lodovico's design, also in reverse of the engraving, in Dresden, the Gemäldegalerie, there attributed to the school of Albani. In 1935 Buscaroli attributed the same painting to Antonio Carracci (Rezio Buscaroli, *La pittura di paesaggio in Italia,* Bologna, 1935, pl. XLII).

489

FRANCESCO CARRACCI(?)
(c. 1595-1622)

Cat. Nos. 1-2

Francesco, or Franceschino, Carracci is one of those minor, shadowy figures in art history, about whom very little has ever been written and whose personality will forever remain vague. According to Malvasia, he was the brother of Agostino and Annibale, and he died in Rome in 1622 at the age of twenty-seven.[1] But, as has been pointed out since, and one can see on the Carracci family tree (frontispiece), Franceschino was the son of Giovanni Antonio Carracci and thus the nephew of Agostino and Annibale.[2] He studied with Lodovico, and learned the manner of Procaccini. According to most biographers, although he was talented, he did not apply himself to his profession and wasted away his life, causing his early death.[3]

Malvasia did not mention that Franceschino was a printmaker, but Oretti attributed three prints to him: a Blessed Virgin, a S. Carlo Borromeo genuflecting, and an Angel genuflecting.[4] To these were added several more by Gori Gandellini, and Heinecken accepted those works.[5] Bartsch rejected all these prints and added only one to the artist's oeuvre (cat. no. 1), a print which Basan had also attributed to him: the *Madonna and Child on the Clouds.* Nineteenth-century scholars varied in their attributions of prints to him.[6] In the twentieth century, he has been ignored.

Although Franceschino may not have been a printmaker at all, there are some prints after the Carracci with the inscriptions "f c" which may indicate his hand. Nagler said that some of these works belonged to Francesco Camullo, another little-known Bolognese from the Carracci school. And, of course, there was Francesco Curti, whose style and technique does not approach either of the prints published here.[7] Also obvious is that cat. nos. 1 and 2 differ stylistically from one another and may themselves belong to two different hands. In any case, until further work is done on the Bolognese followers of the Carracci, we can only guess at attributions to Franceschino.

1 Malvasia pp. 373-374.

2 Zanotti in his notes to Malvasia (p. 373, note 2) and Heinecken p. 610.

3 Malvasia p. 373: "Non aveva spirito il primo per le cose del Mondo, non che per sì difficil professione, ed era così semplice, che serviva per il giocolare e passatempo della stanza; raccontandosi fra l'altre cose, che mandandolo e rimandanolo gli altri a cacciar vino da una botte. . . ." "Troppo spiritoso poi, per non dire spiritato, era l'altro: perchè negando Lodovico dare a Gio. Antonio suo padre la mentovata Assunta, lasciatagli da Antonio per testamento, dalle lite civile, passò alla criminale, e furono tante e tali l'impertinenze di costui contro l'onorato vecchio, che meglio è il tacerle, che il ridirle."

4 Oretti p. 890.

5 Gori Gandellini VIII, p. 29, gave the artist at least seven prints; Heinecken, p. 610, said he engraved three pieces and added four others, p. 622.

6 Basan also gave him four other prints. In the nineteenth century, Nagler took prints away from him and gave them to Francesco Camullo (Nagler I, no. 1984), but he (Nagler 1835 p. 400) did attribute four works to him. Strutt I p. 183 attributed five prints to him; LeBlanc seven; Andresen one (cat. no. 1), but with a question.

7 See Bertelà 496-564 for reproductions of prints attributed to Francesco Curti.

I

Madonna and Child on the Clouds

(B. 1)

Etching. 150 x 120 mm. (after Annibale Carracci?)

Literature: Basan I pp. 113-114; Strutt I p. 183; LeBlanc 1; Andresen p. 243.

States:

	B
I	1

Toward left, below edge of robe: ·*A* ·*C* ·*I* ·. Lower right below Madonna's foot: *F* ·*C* ·*S* · (Alb)

Copies: 1. Engraving in reverse by Josse de Pape. State 1 without letters. State 2 signed lower right: *J. de Paper f.* (Hollstein XV, p. 128).

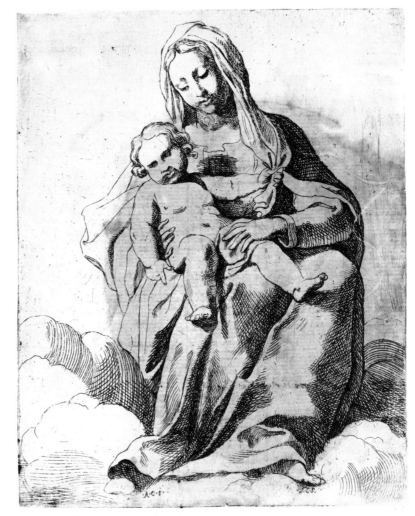

cat. no. 1. Vienna, Graphische Sammlung Albertina

Bartsch believed this print was after a work by Agostino Carracci, but Andresen was probably correct in stating the original to have been by Annibale. Judging from the solidity of the figure of the Madonna and simplicity of execution, it was probably a late work. Since we do not know Franceschino's engraving style, if indeed he had one, we can only suggest that this print may be his. It should be noted that it differs in technique and figural morphology from cat. no. 2.

2

Saint Francis Consoled by the Musical Angel

Engraving. 176 x 132 mm. (after Agostino Carracci cat. no. 204)

Unpublished.

States:

I Lower left: *fc F.* (NGA)

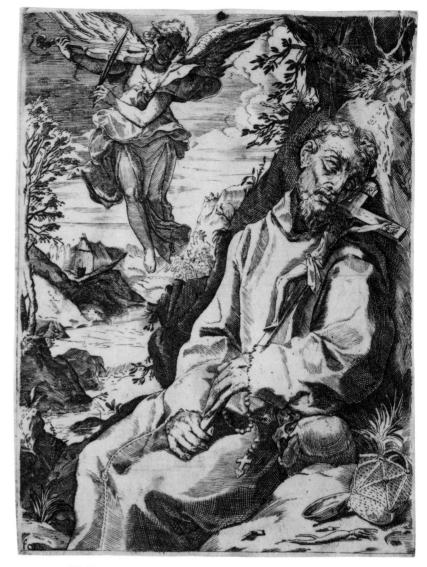

cat. no. 2. Washington, National Gallery of Art, gift of Dr. David Landau

This engraving, unknown to Bartsch and others, was brought to the attention of the author by Dr. David Landau. It is a copy, in reverse, of Agostino's engraving of *Saint Francis Consoled by the Musical Angel* (cat. no. 204). The engraving technique is typical of the Bolognese followers of Agostino, but Francesco Curti, whose initials are the same as Franceschino's, had a different morphology than is seen here. Although stylistically different from cat. no. 1, the name of Francesco Carracci is suggested here, due to the monogram alone.

APPENDIX I

CARRACCI PRINTERS AND PUBLISHERS

Until recently very little was published on the businessmen who were print dealers and publishers of Italian etchings and engravings in the sixteenth and seventeenth centuries. Until Paolo Bellini's article of 1976,[1] only two studies were available—that of Ehrle of 1908, which dealt mostly with the beginnings of the trade in Italy,[2] and that of Ozzola of 1910, which concentrated on the activities of the de Rossi family of the seventeenth and eighteenth centuries.[3] Print publishers were mentioned only in passing, as in Petrucci,[4] or simply not mentioned at all. Much of the reason for the lack of literature on the subject lies in the fact that information on these dealers often comes only from the prints themselves. Biographers usually ignored the employers of engravers.[5] Vasari did mention the publishing activity stemming from Raphael's shop,[6] and Malvasia noted two promoters of Agostino's prints in Venice,[7] but on the whole the sources have been silent in this matter.

It is not the purpose of this section to attempt a reconstruction of the print publishing business in the late sixteenth and early seventeenth centuries. Instead, the reader is encouraged to turn to the articles cited above for this information[8] and further bibliography. It is rather the intention here to list those persons engaged in the promotion of prints by the Carracci family, either as publishers or printers, and to try to recognize by the inscriptions on the prints whether these men were engaged in business with the Carracci or whether they published their prints after the deaths of Agostino, Annibale, and Lodovico.

To achieve this, it is necessary to review the terminology used in the inscriptions so clearly demonstrated in Ehrle's ground-breaking research on the subject.[9] The inscription by the printer and publisher is called an address. After the person's or firm's name are a number of words in either Latin or Italian that refer to the activity of that person. *Inv.* (or *inventore*), *del.* (or *delineatore*) refer to the artist who was the inventor or designer of the image. If the print reproduces a painting, the term *pinx* (or *pinxit*) may follow the name of the painter. The graphic artist who cut the plate will be indicated by the following terms: *inc.* (or *incisor*), *f.* (for *fecit* or *faciebant*), *celavit, scupsit* or *scalpsit* (*sc.*). Sometimes, as in the case of the Carracci, the artist may be both the inventor of the image and the executant of the plate. In this case, the address would read *inv. et sc.* or something similar. The craftsman, usually not the artist, who multiplied the image by running the plate through the press is referred to as the *stampatore,* and the address may read *si stampa, excudit (exc.),* or *curabat.* He is here referred to as the printer rather than Bellini's term, printmaker, which is here used to indicate the artist who made the plate *(fecit, inc.).* The dealer who owned the plates and the printing shop which distributed the prints would be indicated by the terms *for.* (for *forme* or *formis*) or *tipi* (or *typis*). This man, who usually both published and sold the prints in a shop, is sometimes referred to as the editor. That term, which is easily confused with our modern meaning of the word, is eschewed here for the more appropriate appellation of

publisher. In some cases, when the plate was worn out from numerous printings, the publisher would have the plate recut, the term being *restituit* or *reddidit (rest.)*. The publisher either bought plates from the artist or commissioned an artist to make a print which could be run off on his press and sold in his shop. If not dealing directly with the artist, the publisher bought his plates from other dealers. As indicated by Ehrle, the publisher was often the printer and sometimes, as in three cases with Agostino Carracci (Agostino cat. nos. 140, 143, and 203), even the artist.

In the case of prints by the Carracci family, most do not carry addresses of publishers or printers in the first state. This could mean one of three things: either the artist did not make his prints for commercial purposes, the publisher did not bother to inscribe the prints, or the artist published the prints himself. In the first category would fall such engravings as the coats of arms by Agostino, which may have been made as models for other craftsmen.[10] Also in this category would be those prints made in small quantities for the artist himself, for a friend, or for a patron, such as Annibale's *Drunken Silenus* (Annibale cat. no. 19) or the *Christ of Caprarola* (Annibale cat. no. 18) which may have been made for the Farnese family. In the second category would come Agostino's *Lascivie* (Agostino cat. nos. 176-189), which, although made with a commercial goal in mind, were not inscribed to avoid papal condemnation. Religious prints such as the *Saint Sebastian* (Agostino cat. no. 18) may have been published in Tibaldi's shop or by the artist himself. In other cases, the commercial publisher may have decided not to place his address on the print due to a large volume of business or for other reasons unknown to us today.

As shown by the following list of commercial addresses found on prints by the Carracci family, these artists, especially Agostino, were in business with, or worked for, some publishers (e.g., the Bertelli family, Rasicotti, Stefanoni). More often, however, their prints were published over and over again after their deaths by publishers who profited by their art (e.g., van Aelst, de Rossi, Remondini). In some cases, their plates passed from one publisher to another who continued to publish and sell the prints for generation after generation (e.g., Annibale cat. no. 18). A perusal of the following printers and publishers will indicate whether their address on a print by the Carracci means that that state of the print was published during the artist's lifetime or after his death.[11]

1 Paolo Bellini "Printmakers and Dealers in Italy during the 16th and 17th centuries," *Print Collector*, no. 13 (May-June, 1975): 17-45. Bellini published several charts showing how plates passed from publishing house to publishing house through these two centuries.

2 Francesco Ehrle, *Roma prima di Sisto V La pianta di Roma DuPerac-Lafrery del 1577* (Rome, 1908).

3 Leandro Ozzola, "Gli editori di stampe a Roma nei Sec. XVI e XVII," *Repertorium für Kunstwissenschaft* 33 (1910): 400-411.

4 Alfredo Petrucci, *Panorama della Incisione Italiana* (Rome, 1964).

5 As did Bartsch.

6 Vasari, p. 411.

7 Malvasia, p. 270 (Rasicotti and Bertelli).

8 More information is found in Timothy Riggs' dissertation *Hieronymus Cock Printmaker and Publisher*, Yale, 1971; published by Garland, New York and London, 1977.

9 Ehrle, p. 8.

10 See the discussion on these prints in the Introduction p. 4 9.

11 In most cases, further bibliography on the publishers and printers is given under the works cited.

NICOLAS VAN AELST
(active Brussels and Rome 1582-1613)

Identifying marks: "Nico van Aelst formis"

Address found on Agostino cat. no. R 29; Annibale cat. nos. 18[VI], 20[III], 21[III], and 22[III]; Lodovico cat. no. 3[III].

Nicolas van Aelst was a successful Belgian engraver and publisher who settled on the Via della Pace in Rome. The works which he published by the Carracci were not the first states, and consequently he probably had no business dealings with them. He acquired the three 1606 works by Annibale and possibly had them printed in the early teens. He died in 1613.[1] The Lodovico print he published is known in weak impressions and thus was done long after the execution of the work itself. Some of Orlandi's plates passed to him (e.g., Lodovico, cat. no. 3).

1 Bellini, p. 28, note 18.

Bibliography: Bellini p. 22.

ALE

Identifying marks: "Ale: a Via rest:"

Address found on Agostino cat. no. 98[II].

This strange inscription, found on only one impression in the second state of the *Madonna and Child on the Clouds,* suggests that someone with the name of Ale. . . . restored (restaurit), that is, recut this version of the print. But who, when, and on what street ("a Via") is unknown.[1]

1 Possibly the street name is "rest . . ."?

THE BERTELLI FAMILY
(active Venice, Padua, Rome, 1550-1610)

Identifying marks: "frari.[s] bertelli," "Ro. f. Bertellis for."

Address found on Agostino cat. nos. 27[II], 97[II].

The Bertelli, a Paduan family, began its publishing business in Venice, but it also had branches in Rome. Identifying marks are found not only on prints in the second half of the sixteenth century but also on books. The founder of the family, according to Bellini, was Fernando, who worked until 1580. From 1580 to 1590 Pietro was the most active publisher of prints and extended the family printing business as far as Rome. Luca Bertelli worked in both Venice and Rome. Orazio seems to have worked only in Venice, Giovanni in Rome. Malvasia mentioned that Bertelli (he does not mention which one) promoted Agostino's work when he was in Venice.[1]

1 Malvasia, p. 270.

Bibliography: Bellini, pp. 20, 24, 30; Bianca Fantini Saraceni, "Prime indagini sulla stampa padovana del cinquecento," *Miscellanea di scritti di bibliografia ed erudizione in memoria di Luigi Ferrari,* Florence, 1952, pp. 416-426.

LUCA BERTELLI
(active Rome and Venice c. 1560s-1590s)

Identifying marks: "Addictissimi Lucas Bertellus et socius" "Luca Bertelli formis"

Addresses found on Agostino cat. nos. 22[I] 100[I], 101[I], 105[II], and 217[I].

Luca, one of the Bertelli family, published prints by Agostino dated 1581 and 1582; Agostino executed the 1582 prints in Venice after Venetian artists. Luca seems to have been not only a publisher but also a designer of prints, an engraver, and a book dealer.[1] There is evidence that he did a thriving business since so many of his prints have come down to us. There are indications on prints that he worked not only in Rome but also in Venice.[2]

1 Omodeo, pp. 53-54
2 Some works are signed with the indication "Romae" or "Venetiis".

Bibliography: Dizionario Bolaffi II, p. 76; Anna Omodeo, *Mostra di stampe populari venete del 500* (Florence: Gabinetto disegno e stampe degli Uffizi, 1965) 20, pp. 31-32, nos.

26-29; Bellini pp. 24, 30; Thieme-Becker, vol. III, p. 487; Bianca Fantini Saraceni, "Prime indagini sulla stampa padovana del cinquecento," *Miscellanea di scritti di bibliografia ed erudizione in memoria di Luigi Ferrari*, Florence, 1952, pp. 416-426, 485; Cristofari p. 208, no. 240.

ORAZIO BERTELLI
(active Venice 1580s)

Identifying marks: "Hora. Ber." "Oratio Bertelli" "Horatio Bertelli"

Address found on Agostino cat. nos. 32, 98, 106[II], 107[I], 115-117[I], 143, 222[I], R 23.

Another member of the family, Orazio, signed prints by Agostino Carracci in the 1580s, especially the early years 1582 and 1583.[1] According to Bellini, he worked in Rome,[2] but none of the prints by Agostino that he published include the name of that city. On the other hand, several of those published are works after Veronese executed by Agostino when he was in Venice (cat. nos. 106-107). He published Agostino's series of apostles in 1583 (cat. nos. 109-123), indicating that Agostino may still have been in Venice that year.

1 The print dated 1588 (cat. no. 222) is here questioned.
2 Bellini, p. 24. He gives no proof for placing Orazio's activity in Rome.

Bibliography: Bellini p. 24-30; Thieme-Becker, vol. III, p. 488.

PIETRO BERTELLI
(active Venice, Vicenza, and Rome? 1580s and 1590s)

Identifying marks: "Pietro Bertelli for."

Address found on Agostino cat. nos. 21[II], 221[I].

Pietro Bertelli was the most important member of the Bertelli family, and he may be the person Malvasia mentioned as having promoted Agostino in Venice.[1] He published only one print by Agostino, but it was a very early (c. 1580), nonreproductive work by the artist. He is known for his publication of books of engravings by Giacomo Franco and others, mostly costume and theater prints. According to Bellini, he was the member of the family who extended the business to Rome and Vicenza.

1 Malvasia, p. 376.

Bibliography: Cosenza p. 86; Dizionario Bolaffi II, p. 77; Bellini pp. 24, 30; Thieme-Becker vol. III, p. 488; Saraceni, pp. 416-426; Cristofaro p. 208, no. 240.

ANTONIO CARENSANI
(active Rome early seventeenth century)

Identifying marks: "Antonius Carensanus fo"

Address found on Agostino cat. no. 133.

According to Bellini, Carensani worked in Rome from 1604 to 1614 and seems to have bought some of Orlandi's stock, since he cancelled his address in some examples. He also produced some prints after Polidoro. The *Mystic Marriage of St. Catherine* after Veronese (cat. no. 133) was the only print by Agostino he published. The examples with his signature are so weak that it can be assumed he bought the plate after Agostino's death and did not work with the artist at all.

Bibliography: Thieme-Becker vol. V, p. 567; Bellini pp. 22, 31.

AGOSTINO CARRACCI
(Bologna 1555-Parma 1602)

Identifying marks: "Aug: Car: Bon:" "Agostino Caracci Forma" "Augo. Car."

Address found on Agostino cat. nos. 140, 143, and 203[I].

Agostino published three of his own prints, in 1586, 1587, and 1595. No prints by other artists published by him are known, so we must assume he did not go into the publishing business except to release his own works, and probably did so only when he had time away from his engraving and painting. Since the prints he published come throughout his career, as do prints published by others, he does not seem to have intended to be the exclusive publisher of his own prints. Those of his prints which have no publishing marks may also have been published by him.

VINCENZO CENCI
(active Rome seventeenth century)

Identifying marks: "Vincenzo Cenci" "Alle tre Giglie de oro"

Address found on Annibale cat. no. 18[VII].

Cenci must have acquired some plates from van Aelst when he died in 1613, since the inscriptions of both van Aelst and Cenci appear on Annibale's *Christ of Caprarola* (cat. no. 18). The examples of this print are always weak, and therefore it is certain that Cenci never worked with Annibale himself.

Bibliography: Bellini pp. 22, 31.

MATTEO FLORINI (or Florimi)
(active Siena 1580-1612)

Identifying marks: "Mateo flo."

Address found on Agostino cat. no. 205[II].

Florini was an engraver and publisher active in Siena,[1] who is noted as a publisher of city views, embroidery models, and topographical maps. He published Agostino's *Saint Jerome* (cat. no. 205)—"Mateo flo. for." of 1595 and was probably in business with the artist himself.

1 According to Thieme-Becker.

Bibliography: Thieme-Becker, vol. XII, p. 121; Dizionario Bolaffi, V, p. 22; Cosenza p. 242.

GIACOMO FRANCO
(Venice 1550-1620)

Identifying marks: "Franco Forma" "Iocobus Franco. excudit in Frezzaria" "in Frezzaria all'insegna del Sole"

Address found on Agostino cat. nos. 26[II], 101[II], 102[II], 103[III], 104[II], 105[IV].

Giacomo Franco was not only a publisher of prints and books but also an engraver and printer. He worked as a printer for Luca Bertelli and other publishers in Venice in the 1580s and set up his own business about 1596. After this date he published his own works almost exclusively. His *calcografia* was located in via Frezzaria at the sign of the sun, and he may have had a bookshop in San Marco. His association with Agostino probably began in the 1580s when Agostino was in Venice engraving prints for Bertelli. They obviously knew each other by 1590 when they shared the commission for the *Gerusalemme Liberata*. The prints in that book are divided between the two artists; all the prints by Franco are signed.[1] Franco published six engravings by Agostino, all of which date from the 1580s.[2] Yet, since Franco's address always appears in the second state or later, it is likely that he obtained the plates several years after their first edition. In two cases, the first states of the prints were published by Luca Bertelli,[3] so Franco must have acquired many plates from him. Most of Franco's plates were handed down or sold to Stefano Scolari, who worked in S. Zulian.

1 See cat. nos. 155-164 for a discussion of this commission.

2 One wonders if Franco knew that the engraving he printed by Agostino of *Tobias and the Angel* (cat. no. 26[II]) was actually after a work by Raffaellino da Reggio and not Raffaelle da Urbino. In the state he printed he changed the "Regien." to "Vrbin." Since he knew Agostino and was an artist himself, it seems that he should have been aware of the inventor of the composition. Thus the change was probably intentional and meant to deceive.

3 Cat. nos. 101, 105.

Bibliography of Franco as a publisher: Cosenza p. 254; Dizionario Bolaffi V pp. 149-150; Bellini, pp. 24, 32; Carlo Pasero, "Giacomo Franco, editore, incisore e calcografo nei secoli XVI e XVII," *La Bibliofilia*, vol. XXXVII, 1935, pp. 332-345.

GASPARE DALL'OLIO
(or dall' Olio or da Lolio)
(active Bologna late sixteenth century)

Identifying marks: "Gasparo da lolio exc"

Gaspare dall'Olio signed one of Annibale's etchings as the printer in the second state. Other prints signed by him as publisher or printer are a print by Paolo Farinato of the *Crossing of the Red Sea* of 1583 (Bartsch XVI, 168.1) and *Rest on the Flight into Egypt* by Camillo Procaccini (Bartsch XVIII, 20.3). Thieme-Becker indicated that he was also a draftsman and engraver but assigned his activity to c. 1650, much too

"Gaspare dall'Oglio"

Address found on Annibale cat. no. 5II.

late. It is not known whether there was personal contact between Gaspare dall'Olio and Annibale Carracci.

Bibliography: Thieme-Becker vol. XXV, p. 595; Bellini pp. 25, 26, 31.

MATTEO GIUDICI
(active in Bologna c. 1608-1620?)

Identifying marks: "Si stampa da Matteo Giudici alli Cesarini"

Address found on Agostino cat. nos. 208III, 209II and on Annibale cat. no. 11II, 12III.

Practically nothing is known of Giudici, whose workshop was in the "Cesarini" in Bologna. He probably worked after the Carracci's deaths, since his address is found on later states of their prints. The three Carracci works he printed are usually seen in weak impressions.

Bibliography: Bellini pp. 26, 32.

LUIGI GUIDOTTI
(active Bologna second half eighteenth century)

Identifying marks: "Guidotti for. in Bologna"

Address found on Agostino cat. nos. 50III, 51II, 52III, 53II.

Little is known of Guidotti except that he worked in Bologna. Thieme-Becker placed his activity in the second half of the eighteenth century. His address as a publisher is found on Agostino's engravings of female saints, done in c. 1583. They are usually found in weak impressions, confirming the suggestion that Guidotti lived a century after Agostino's death.

Bibliography: Thieme-Becker XV p. 287.

GIOVANNI ORLANDI
(active Rome and Naples c. 1590-1640)

Identifying marks: "Ionnas Orlandis a pasquino formis romae"

Address found on Agostino cat. no. R 42; Annibale cat. no. 3II; Lodovico cat. no. 1II, 3II.

Much is known about Giovanni Orlandi who was active as a publisher in Rome until 1613 and afterwards in Naples. He published works not only by the Carracci but also by Tempesta, Alberti, and others. According to Thieme-Becker he was an engraver following the style of Cornelis Cort. Ehrle noted that his activity dated from 1598 to 1609. His shop in Rome was in the Via del Pasquino. According to Bellini, he acquired many of the plates of Giacomo Gherardi, a publisher who died in 1593. It is possible that he worked with Lodovico Carracci but not with his cousins. Annibale's print dates from the early 1580s, and Orlandi's address appears in a later state. Lodovico's *Holy Family under the Arch* dates from c. 1585-1590. Although Orlandi's address appears in the second state, it comes before that of Stefanoni, whom we know worked with Lodovico. Some of his plates passed to Carensano and van Aelst.

Bibliography: Thieme-Becker vol. XXVI, p. 47 (article by Lotte Pulvermacher); Cosenza p. 449; Dizionario Bolaffi, VIII, pp. 220-221; Bellini pp. 21-22, 33; Ehrle p. 20.

GIOVANNI MARCO PALUZZI
(active Rome seventeenth or eighteenth century)

Identifying marks: "Gio. Marco Paluzzi Formis Romae"

Address found on Agostino cat. no. 204II.

Nothing is known of Paluzzi as a publisher or artist. His address is found on a print by Agostino of 1595, but not until the third state. It comes in weak impresssions, and one assumes the plate passed to him after many years of printing.

Bibliography: none. Bellini, p. 33 mentioned a Giovanni Mario Paluzzi who published works by Marcantonio Raimondi and others in the mid sixteenth century. The present one could be an heir.

JACOPO DE RABI
(active Rome seventeenth or eighteenth century)

Identifying marks: "Iacobus de Rabiis form./Roma"

Address found on Agostino cat. no. 12IV.

The only known engraving published by de Rabi is Agostino's *Adoration of the Magi* of 1579 (cat. no. 12). The large composition in seven plates, still extant at the Calcografia Nazionale in Rome, may have passed to him directly from Thomassin, whose address appears in the third state. The engraving continued to be printed in later years when de Rabi's address was effaced.

DONATO RASICOTTI
(active Venice 1580s and 1590s)

Identifying marks: "Donati Riscachotti formis" "Venetiis Donati Rasicotti formis" "Donati Rasicoti" "Typis Donati Rasecottij"

Address found on Agostino cat. nos. 16[II], 20[II], 142, 146, 147, 178[II], 203[I], R 55, R 58.

Donato Rasicotti owned a printing shop in Venice and published various artists' works, including Agostino's. According to Malvasia, he and Bertelli were Agostino's promoters in that city,[1] and that statement is proven by the numerous prints by Agostino which Rasicotti published. Rasicotti worked with Agostino from the late 1580s until 1595. He acquired the early works which he published for the artist after the first state, but by 1586 when he produced the *Madonna of Saint Jerome,* he was probably getting the plates directly from Agostino. He published the large *Crucifixion* after Tintoretto (cat. no. 147) in 1589, one of the *Lascivie* in the early 1590s (cat. no. 178), and the last of Agostino's works in 1595 (cat. no. 203). Some of his plates passed to Remondini.

1 Malvasia p. 270.

Bibliography: Bellini pp. 24, 33.

GIOVANNI ANTONIO REMONDINI
(active Bassano c. 1660-c. 1711)

Identifying marks: "in Bassano per il Remondini" "Remondini"

Address found on Agostino cat. nos. 16[III], 17[IV], 22[III].

According to Bellini, a very large printing shop was started in Bassano c. 1660 by Giovanni Antonio Remondini. He also printed books and wallpaper and made his own paper. Two of the prints which he published by Agostino (cat. nos. 16 and 17) came to him from Rasicotti, probably via heirs, and one from the Bertelli shop. The impressions of Agostino's prints which come from his firm are usually very weak. The business continued into the nineteenth century.

Bibliography: Bellini pp. 25, 33.

GIOVANNI JACOPO DE ROSSI
(active Rome 1638-1691)

Identifying marks: "Gio: Iacomo de Rossi alla pace"

Address found on Agostino cat. nos. 140, 198[II].

The well-known publishing firm of the Rossi family flourished in Rome on Via della pace throughout the seventeenth and eighteenth centuries. The founder of the shop was Giuseppe de Rossi, who worked from c. 1633-1638.[1] Giovanni, his son, signed his first plate, according to Bellini, in 1638 and worked until 1691. He published not only Agostino's two prints, one religious and one decorative, but also engravings of buildings, churches, statues, and various other saleable items. Many of Orlandi's plates passed into the de Rossi family.[2]

1 For the best information on this important publishing family see Leandro Ozzola, "Gli editori di stampe a Roma nei sec. XVI e XVII," *Repertorium für Kunstwissenschaft,* 33 (1910): 400-411 and Bellini, pp. 22-23, and p. 41 (genealogical tree).
2 In 1738, the plates owned by the de Rossi publishing firm passed to what today is the Calcografia Nazionale, Rome.

Bibliography: Graesse vol. 4, col 1406; Cosenza p. 536; Ozzola pp. 407-408; Bellini p. 22.

GIOVANNI FRANCESCO ROTA
(active late sixteenth or early seventeenth century)

Identifying marks: "Io Franciscus Rot."

Address found on Agostino cat. no. 27[III].

Nothing is known of Giovanni Rota, who published Agostino's *Jacob and Rachel at the Well.* He may have been Venetian since the earlier state of the print was published by Bertelli, and Rota may have acquired the plate from that firm.

JACOB VON SANDRAERT (?)
(Frankfurt 1630-Nürnburg 1708)

Identifying marks: "Sandraert excud"

Address found on Annibale cat. no. 11[III].

STEFANO SCOLARI
(active Venice early to mid seventeenth century)

Identifying marks: "a S. Julia in Ven:[a] apreso Stefano Scolari" or "S. Zulian" "Insegna delle tre Virtu"

Address found on Agostino cat. no. 146[IV].

PIETRO STEFANONI
(Vicenza before 1589?-Rome? after 1614)

Identifying marks: "P S F" "Pietro Stefanoni for." "Petrus Stephanius formis." "Petri Stephanony Exc."

Address found on Agostino cat. nos. 108[II], 201[II], 210[I], 212[II], 213[IV], R 40, R 41; Annibale cat. nos. 12[II], 13[II], 14[II], 15[II], 16[II]; Lodovico cat. nos. 1[III], 2[II], 3[I], 4[II].

It is possible that the publisher of this print was Jacob von Sandraert, a member of the German engraving family. The second state of Annibale's *Holy Family* (cat. no. 11) was published by Matteo Giudici, and the print could have passed from his shop to the German Sandraert.

This print may have been owned by Giacomo Franco since many of his plates were handed down to Stefano Scolari. One would consequently date his activity after 1620. According to G. Caraci, Scolari's first print dates from 1644, his last from 1687. He seems also to have been a cartographer.

Bibliography: Carlo Pasero, "Giacomo Franco, editore, incisore e calcografo nei secoli XVI e XVII," *La Bibliofilia,* 37 (1935); 336; Thieme-Becker, XXX, p. 399; Giuseppe Caraci, "Antiche carte di regioni d'Italia," *La Geografia,* 13 (1925): 161, note 32.

Pietro Stefanoni issued more works by the Carracci than any other publisher. According to Thieme-Becker and Bellini, he was born in Vicenza in 1589. The place of birth is correct since there is an address "Petrus Stephanonius Vicentinus" on a print by Valesio in 1607. But the date of birth should probably be pushed back. Since Stefanoni's address appears on the first state of at least two late works by Agostino (cat. nos. 210 and 212), it may be that Stefanoni worked directly with the artist when he published these works. They date from c. 1599, and it is highly doubtful that Agostino would have trusted a ten-year-old to sell his prints. It is also likely that the artist was given plates by Annibale, already published in a first state, to print after the artist came to Rome in the 1590s. The last print by Annibale published by Stefanoni dates from c. 1597. Stefanoni also knew Lodovico, whose entire oeuvre he either printed or published, in the first or later states. It is probable that when Lodovico came to Rome in 1602 with Agostino's *Saint Jerome* (cat. no. 213), finished by Brizio, he gave Stefanoni that plate as well as his own to print and publish. Stefanoni also worked with many artists of the Bolognese school in the early years of the seventeenth century. His well-known address "P S F" is found on the prints published in the *Scuola perfetta* . . . after Agostino, including prints by Ciamberlano and others. His address is also found on works by Guido Reni (Bartsch XVIII, 304-305.52), Francesco Brizio (Bartsch XVIII, 255.4) and Odoardo Fialetti (Bartsch XVII, 274-275.32).

Bibliography: Thieme-Becker XXXI, p. 532; Bellini pp. 24-25.

FILIPPO SUCCHIELI (active Siena late sixteenth and early seventeenth century?)

Identifying marks: "Filippo Suchielli for. Siena"

Address found on Agostino cat. nos. 153[II] and 154[II].

The only engravings by the Carracci published by this unknown Sienese are Agostino's works for the *intermezzi* of the marriage of Ferdinand de' Medici and Christine of Lorraine. Succhieli also published other engravings and etchings for the book which contained the series of prints having to do with the festivities of the Medici marriage in 1589. He probably obtained the plates for this purpose. This would be the only instance of a publisher from this central Italian region working with Agostino's prints, but since the commission for the prints came from Florence, it is not unusual that they would also be published in the same area.

PHILIPPE THOMASSIN
(Troyes 1562-Rome 1622)

Philippe Thomassin, best known as Callot's teacher, was an engraver, goldsmith, printer, and publisher,[1] born in France but trained in the graphic arts in Rome. He came to Rome in 1585 as a goldsmith but was forced out of that profession by the heavy taxes imposed on jewelry by Sixtus V. He went to work for Claude Duchet, who was the nephew and successor to Antoine Lafrère's enormous printing business, where he began by recutting plates of others but also engraved many reproductive prints of his own. His vast output includes works after Passari, with whom he studied, Tempesta, and Alberti. Jacques Guerard, who took charge of Duchet's shop, died in 1594, and Thomassin took over the business with Jean Turpin. The two men had already been in business together since 1589. In 1602 this partnership ended, and Thomassin then became more active as an engraver. His engraving style followed that of Cornelis Cort and Bernardino Passari.

We are especially fortunate to be able to pinpoint Thomassin's relationship with Agostino Carracci, two of whose prints he published. In 1598 Agostino was godfather in a baptism in which Thomassin's wife was godmother.[2] It was probably around this year that Agostino gave Thomassin the plates of the 1579 *Adoration of the Magi* (cat. no. 12), engravings which were published in the second state by Domenico Tibaldi and which Agostino probably owned. The other print, the *Saint Francis Consoled by The Musical Angel* of 1586 (cat. no. 140), may also have been published by Agostino in the first state and sold to Thomassin when Agostino was in Rome.

1 Thomassin's activity as an engraver is discussed in Appendix II.
2 Bruwaert, 1914 p. 45.

Bibliography: Baglione pp. 396-97, 280ff; Edmond Bruwaert, "Le Maître de Jacques Callot," *La Revue de Paris,* 18, no. 2 (January 15, 1911): 391-416; Edmond Bruwaert, *La Vie et les Oeuvres de Philippe Thomassin* (Troyes, 1914); Thieme-Becker, vol. XXXIII, p. 69; Disertori p. 206; Jean Adhemar, *Bibliothèque Nationale Inventaire du Department des Estampes, Fonds Français, Graveurs du Seizieme Siècle,* vol. 2 (Paris, 1938), 120-137.

DOMENICO TIBALDI
(Bologna 1541-1583)

This second state of Agostino's 1579 *Adoration of the Magi,* previously unknown, indicates that Tibaldi was active not only as an engraver but also as a publisher. This is the only known instance of this aspect of his work.[1]

1 Tibaldi is discussed in the Introduction.

Bibliography: as a publisher, none. As an engraver, see the Introduction.

DOINO E FRANCESCO VALESIO
(active Venice seventeenth century)

Cosenza said that these little-known publishers were active c. 1600; Thieme and Becker suggested that they were born in Bologna and active in Venice c. 1611-1643. Their address on Agostino's prints is found in late states, and consequently they acquired the plates long after the artist's death. They had the print of *Mars Driven Away from Peace and Abundance by Minerva* (cat. no. 148) recut.

Bibliography: Cosenza p. 642; Thieme-Becker vol. XXXIV, p. 71.

IN VENETIA A S.^{TA} FOSCA
(active Venice seventeenth and
eighteenth century)

Identifying marks: as above.

Address found on Agostino cat. nos. 17V, 38II, 54II.

This printing shop published several prints by the Carracci, but the impressions are very weak, leading us to believe that they date rather late. Pasero mentioned that Giacomo Franco had a shop on Santa Fosca,[1] but since cat. no. 17 was signed in this manner after an earlier state by Remondini (active until 1711), Franco's participation is precluded. On the other hand, the second state of the *Madonna and Child with Saints Peter, Stephen, and Francis* of 1582 carries this address (cat. no. 54II), and a third state is dated 1656. One thus assumes that there were either two shops on Santa Fosca or that the business of Giacomo Franco there in the late sixteenth, early seventeenth century was carried on by others into the eighteenth century.[2]

1 Carlo Pasero, "Giacomo Franco, editore, incisore, e calcografo nei secoli XVI e XVII," *La Bibliofilia,* 37 (1935): 333.
2 The *Madonna and Child with Saints Peter, Stephen, and Francis* was probably published by Franco in the 1590s when he printed other works by Agostino.

APPENDIX II

ARTISTS INDIRECTLY RELATED
TO AGOSTINO CARRACCI

In addition to the numerous artists already discussed in the Introduction and throughout the catalogue who were connected with Agostino directly as precursors or followers, there are four other artists whose prints have at times been confused with Agostino's. These engravers—Martin Rota, Girolamo Olgiati, Cherubino Alberti, and Philippe Thomassin—were not directly dependent on Agostino's work or vice versa but developed along parallel lines. However, there may have been contact or reciprocal influence.

MARTIN ROTA (c. 1520-1583)

MAXIMILIANVS II·D·G·ROMAN· IMP· SEMPER· AVG·
GERMAN· VNGAR· BOHEMIÆ· DALM· CROAT·REX
ARCHID·AVSTRIÆ· DVX· BVRGVND· COM·TIROLIS·XC
M D L XX V

fig. 1 Martin Rota, *Maximilian II*. Washington, National Gallery of Art, Rosenwald Collection

There seems to be a definite link between the works of Martin Rota and those of Agostino. Rota was born in Sebenico, in Dalmatia, transferred early to Venice, was also in Rome, and by 1575 was working in Vienna for Maximillian II as court painter. He died in Vienna. Since he tended to sign his prints with his initials and a wheel, his engraved oeuvre is traceable. There are some prints which may be after his own designs, but he was mostly a reproductive engraver. Rota worked mainly as a book illustrator and engraver of maps and portraits. In Vienna, his known paintings are portraits. Rota made engravings after Cort in which he attempted to emulate the older master's technique. In one, *Prometheus Bound,* after Titian, of 1570 (Bartsch XVII, 281. 106; Cort's print is Bierens de Haan, cat. no. 192, reproduced pl. 47), Rota carefully studied Cort's reversed image of 1566. But Rota's forms are flatter, his use of the burin line less varied and curved, and his understanding of volume in depth lacking. His lines tend to emphasize a surface pattern rather than a recession beyond the picture plane. Other prints by Rota indicate that he also carried on the traditions of the school of Marcantonio. For example, in his *Portrait of Maximilian II* (fig. I, Bartsch XVI, 272.83, 216 x 150 mm.) there is little differentiation in the burin work, and lines are made with a fine instrument, giving a precise refinement to the representation. Although an excellent portraitist in his ability to capture the features of the sitter, Rota lacked the imagination to give life to his forms. In addition, in the elaborately rendered cartouches which surround the portraits, there is a penchant for the precious. This leaning is brought out in his costume studies, grotesques, and maps, mostly executed in the 1580s. As indicated in the catalogue, Agostino completed the cartouche surrounding the *Portrait of Cosimo de' Medici,* left unfinished by Rota at his death (cat. no. 136).

Bibliography: See the articles by Lamberto Donati: "Martino Rota, Incisore Sebenicense," *Archivio storico per la Dalmazia,"* anno II, vol. II, fasc. 12 (March 1927): 29-38; "Martino Rota appunti iconografici," *Archivio storico per . . . ,* anno II, vol. III, fasc. 15 (June 1927-V): 123-130; "Alcuni disegni sconosciuti di Martino Rota," *Archivio storico per . . . ,* anno V, vol. X, fasc. 57 (December 1930-IX): 418-431; "Alcune stampe sconosciute di Martino Rota, " *Archivio storico per . . . ,* anno VII, vol. XIII, fasc. 73 (April 1932-X); "Note d'arte Martino Rota," *Archivio storico per . . . ,* anno IV, vol. VI, fasc. 34 (January 1929-VII): 491. See also Oberhuber, p. 198 for further bibliography and Anna Omodeo, *Mostra di stampe popolare venete del'500.* Gabinetto disegni e stampe degli Uffizi (Florence, 1965), cat. no. 42, pp. 47-48.

503

GIROLAMO OLGIATI
(active 1567-1575)

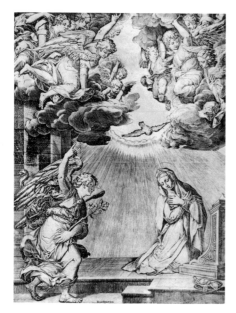

fig. II Girolamo Olgiati(?), *Annunciation*. Bremen, Kunsthalle (after Jacopo Caraglio)

Girolamo Olgiati is an elusive personality, who is known only by the signatures on his few engravings. He came from Venice, was active during the period when Cort was there, and may have worked under him. His style vacillated between a dependence on Cort and on the tenets of Marcantonio's works. But, in addition, his engravings emphasize the plasticity of the figure rather than its transience. In the *Annunciation* (fig. II; Bremen Kunsthalle, engraving. attributed there to Carracci school. Inv. no. 9969. 452 x 333 mm. "Donati Rasicotti form"), here attributed to Olgiati and datable probably early in his career, the engraver relied on the delicate, evenly spaced hatching of the Marcantonio school. The composition, however, after Titian, indicates a thorough knowledge of Cornelis Cort's style in its complexity and the subtle gradation between light and dark. Olgiati's *Christ and the Samaritan Woman* (Agostino fig. 20b) of 1570 is not only very much like Cort but also like some of Agostino's early engravings, in particular the latter's interpretation of the same subject (Agostino cat. no. 20). Here, Olgiati used a much broader burin line, giving a harshness to the composition at times, but more often adding a boldness and vivacity apparent later in Agostino's works. It is a wider line than Cort's, as is Agostino's, and its width results in sharper, less subtle contrasts of light and dark. The resultant drama enlivens the composition. Because of Olgiati's boldness in 1570 and the proximity of the composition with Agostino's of ten years later, there is a possibility that Agostino was interested in Olgiati's works.

Bibliography: Thieme-Becker XXV, p. 594 with previous literature.

CHERUBINO ALBERTI
(1553-1615)

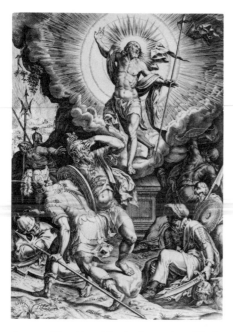

fig. III Cherubino Alberti, *Resurrection*. Windsor Castle, Royal Library, Her Majesty Queen Elizabeth II

It is certain that Agostino knew Alberti, who like Agostino, made prints commemorating the marriage of Ferdinand de' Medici and Christine of Lorraine in 1589 (see cat. nos. 151-154). Alberti was born in Borgo San Sepolcro, but the peripatetic artist worked mainly in Rome as a painter, together with his brother Giovanni, and as an engraver. Although he has been classed as a follower of Agostino Carracci, it was to Cornelis Cort and the mannerist painters that he owed his allegiance. Most of Alberti's engravings date from the 1570s, before Agostino was working, although a rather large part of his prolific output comes from after 1590. He made many prints after Polidoro da Caravaggio, Michelangelo, and, of course, Cornelis Cort. In some of Alberti's early prints, such as the *Holy Family,* after Raphael (Bartsch XVII, 61. 33), and the *Resurrection* (fig. III, undescribed by Bartsch), his dependence on jcort is apparent. Similar complex technical variety is evident, as is the use of the swelling lines. Instead of a dramatic contrast of light and shade which is evident in Agostino's works, Alberti chose to make use of subtle changes in light and depth, as did Cort. In most of his mature works, for instance the *Stigmatization of Saint Francis* of 1577 (Bartsch XVII, 70.56) or the *Petit aethera* of 1591 (Bartsch XVII, 75.68), Alberti's burin line has a scratchy quality, the figures are sharply edged and poorly conceived, with an unfinished appearance, almost approaching etching. The artist had, in fact, attempted the etching medium in 1568 (Bartsch XVII, 60-61.31) but abandoned it in favor of engraving. Also, in these works, Alberti attempted an optical play of lines, brought about by his employment of the swelling burin. This gives a wavy, nervous quality to the atmos-

phere. (Technically, it is accomplished by making swelling crosshatched lines juxtaposed at an extremely slanted angle, about 160°, crossed with lines at right angles, forming triangles and parallelograms.) Technique is freer and forms are more open. There is no evidence that Alberti was influenced in his style by Agostino, but rather his work followed a somewhat parallel development, stemming from Cort and Marcantonio. But his was a delicate burin with an emphasis on elegant, elongated, and decorative elements.

There is an engraving by Cherubino, probably dating from the 1570s, which has been incorrectly attributed to Agostino. The *Adoration of the Shepherds* (fig. IV, Fitzwilliam Museum, Cambridge, Inv. no. 23-I-5 PL 11, 344 x 454 mm., undescribed by Bartsch), after Polidoro da

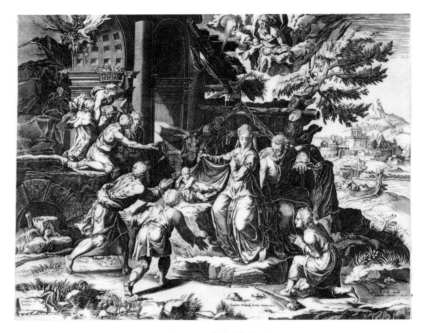

fig. IV Cherubino Alberti, *The Adoration of the Shepherds*.
Reproduced by permission of the Syndics of the Fitzwilliam Museum, Cambridge

Caravaggio, approaches Agostino's early works, but is closer to Alberti's engravings of the 1570s. The frothy tree, the elongated forms, the fussy drapery of the Virgin, the optical play of the burin, and the direct dependence on Cort indicate it is a work by Alberti instead of Agostino.

Bibliography: Bartsch, XVII p. 45, Pittaluga p. 352, and Luigi Servolini, "Cherubino Alberti, Italian Engraver of the Sixteenth Century," *The Print Collector's Quarterly,* 27 (April, 1940): 221 said that Alberti was a follower of Agostino. Petrucci correctly noted that there could not have been a direct influence. For bibliography see Oberhuber, pp. 206-207 and Maria Vittoria Brugnoli, "Un Palazzo Romano del tardo '500 e l'opera di Giovanni e Cherubino Alberti a Roma," *Bolletino d'arte,* 45, pp. 223-246, and Morton C. Abramson, "Clement VIII's Patronage of the Brothers Alberti," *Art Bulletin,* 60 (Sept., 1978): 531-547 with bibliography.

PHILIPPE THOMASSIN
(1562-1622)

Thomassin knew Agostino after the latter came to Rome in the late 1590s. He also published some of Agostino's prints (see Appendix I). Thomassin, like Alberti, was descended from Cort's lineage. A printmaker and publisher from Troyes, he came to Rome in 1585 to work as a goldsmith. He soon changed professions, working first as an engraver of old plates, then on his own plates, but mostly as a publisher.

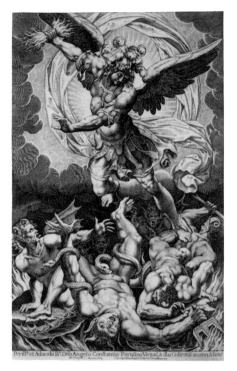

fig. V Philippe Thomassin, *The Fall of the Rebel Angels.* Washington, National Gallery of Art, Andrew W. Mellon Purchase Fund

Bruwaert (1914, p. 14, see below), noted that Thomassin lived in the same quarter as Bernardino Passari, learning engraving from him, and in that way he probably easily fell in with Cort's style. (Passari may have been a student of Cort's.) Since Thomassin began engraving in 1585, when his prints are first dated, he could not have been influential on Agostino, who by this time was already a completely formed artistic personality. Their connection could only have taken place after Agostino transferred to Rome in 1597. Thomassin's engraving technique stems directly from Cort; to achieve the effect of undulating movement and depth, he employed crosshatching with dots, triangles, and dashes. In his *Annunciation* of 1588 after Barocci, he attempted to approximate the etching medium by means of this variety of burin lines, but his resultant forms tend toward the stiff and immoveable. A prolific engraver, Thomassin reproduced the designs of both Renaissance and mannerist artists: Raphael, Vanni, Passari, Michelangelo, etc. His late work of 1618, the *Fall of the Rebel Angels* (fig. V, 497 x 317 mm.) is typical of his style, which wavered between that of Cherubino Alberti and Goltzius, but without the imagination or virtuosity of either. Although a preserver of the tradition of Cort in Rome, Thomassin did not advance the medium of engraving either technically or stylistically. Cat. no. R 53 may be a work by Thomassin.

Bibliography: Edward Bruwaert, "Le Maître de Jacques Callot," *La Revue de Paris,* 18, no. 2 (January 15, 1911): 391-416; Edward Bruwaert, *La Vie et les Oeuvres de Philippe Thomassin* (Troyes, 1914). Further bibliography in Oberhuber, p. 210.

APPENDIX III

The following controversial letters are quoted by Malvasia, pp. 268-270.
Further information is found in the Introduction and note 38.
The English translations were kindly provided by Alexis Mazzocco.

From Annibale, April 18, 1580

Magnifico Signor Cugino.

Vengo con questa mia a salutarla e darli parte a V. S. qualmente io giunsi
in Parma ieri alle ore 17. ove andai a smontare alla s. bettola all'insegne del
gallo, ove ho pensiero di starmene con pochi quattrini e bel gioco e senza obligo
alcuno, e soggezione, non essendomi trasferito costì per stare sulle cerimonie, e
soggezioni, ma per godere la mia libertà, per potere andare a studiare e dise-
gnare, onde prego V. S. per l'amor di Dio a scusarmi: vi do parte come iersera
venne a trovarmi il caporale Andrea, e facendomi tante cerimonie e carezze e
domandandomi se io avevo lettere nissuna da presentare a nissuno, ed anco a lui
di V. S. che gli avele scritto in raccomandazione mia, sì che il suo animo era di
levarmi subito di quel loco che dice che non è da pari nostri, e mi voleva ad
ogni modo condurre a casa sua, senza nissun suo scomodo, e che mi aveva
amanito quella stessa stanza, che servì già a voi, e che non gli era un minimo
suo scomodo: e tanto me ne disse, ch'io non sapevo più che mi rispondere se non
ringraziarlo sempre, e negando di aver la lettera, perchè io voglio la mia libertà;
basta mi liberai con una gran fatica, e se non era mastro Giacomo, che così si
chiama il mio padrone, che mi agiutò molto io non la potevo scappare: io prego
V. S. non l'aver per male e scusarmi presso a lui, come pensate sia meglio,
mostrandosi nel partirsi da me essere andato via alquanto disgustato. Non potei
stare di non andare subito a vedere la gran cupola, che voi tante volte mi avete
comendato, ed ancora io rimasi stupefatto, vedere una così gran macchina, così
ben intesa ogni cosa così ben veduta di sotto in sù con sì gran rigore, ma sempre
con tanto guidizio e con tanta grazia, con un colorito, ch'è di vera carne; o Dio
che nè Tibaldo, nè Nicolino, nè sto per dire l'istesso Rafaello non vi hanno che
fare; io non so tante cose, che sono stato questa mattina a vedere l'ancona del S.
Girolamo e S. Caterina e la Madonna che va in Egitto della scudella: e per Dio
io non baratteria nissuna di quelle con la S. Cecilia; il dire la grazia di quella
S. Caterina, che con tanta grazia pone la testa sullo piede di quel bel Signorino
non è più bella della S. Maria Maddalena? quel bel vecchione di quel S.
Girolamo non è più grande e tenero insieme che quel che importa di quel S.
Pavolo, il quale prima mi pareva uno miracolo, e adesso mi pare una cosa di
legno tanto dura e tagliente? ossù non si può dir tanto che non sia di più, abbia
pur pasienza l'istesso vostro Parmigianino, perchè conosco adesso aver di questo
grand' uomo tolto ad imitare tutta la grazia, vi è pur tanto lontano, perchè i
puttini del Correggio spirano, vivono e ridono con una grazia e verità, che
bisogna che venga, che vedrà cose, che non l'avrebbe mai creduto; sollecitatelo
per l'amor di Dio voi, e che sbrighi quelle due fatture venir subito, perchè
l'assicuro, che staremo in pace, nè vi sarà che dire fra noi, che lo lascierò dire
tutto quello che vole, e attenderò a dipingere, e non ho paura che anch'esso non
facia lo istesso e lascia andare tante ragioni e tante sofisticherie, essendo tutto
tempo perso; l'ho avvisato ancora che del suo servizio starò in pratica e preso un
po' di conoscenze, dimanderò e cercherò ocasione; ma perchè l'ora è tarda e nello

scrivere anco a lui e a mio padre mi è fugito il giorno, mi riservo quest'altro ordinario dirvi più minuto ogni cosa, e a V.S. bacio le mani. Di Parma ec,

From Annibale April 18, 1580

Magnificent Cousin:

With this letter I wish to greet you and tell you that I arrived in Parma yesterday at 5 p.m., and went to the tavern with the sign of the rooster, where I plan to stay with little money and lots of fun and with absolutely no obligation nor discomfort, as I have not moved here to stand on ceremony and awe but to enjoy my independence, in order to be able to study and draw, for which I pray you to excuse me for the love of God: yesterday evening corporal Andrea came to see me and very ceremoniously and with many caresses asked me whether I had any letters of recommendation from anyone including yourself, as you had written to him recommending me, so that he intended to take me from that place which he said was not up to our standards, and wanted at all costs to take me to his home, with no inconvenience to him, saying that he had prepared for me that same room that you had used once already, and that this would in no way inconvenience him: he insisted so much that I didn't know what to say besides thanking him and denying that I had any letter because I want my liberty; finally I freed myself by great effort, and if it hadn't been for Master Giacomo, who is my superior, who helped me a great deal, I wouldn't have escaped: I pray you not to think badly of this and to excuse my actions before him, as you think best, as he seemed somewhat disgusted when he left. I couldn't help going immediately to see the great cupola, which so many times you have commended to me, and still I remained stupefied, seeing such a great machine, everything so well understood, everything seen so clearly from bottom to top with exactness, but at the same time with such judgment, with such grace, and with a color that is so true to life; and God, neither Tibaldo [Pellegrino Tibaldi], nor Nicolino [Niccolo dell'Abbate], nor I want to say even Raphael himself can hold a candle to it; I don't know very much, as this morning I went to see the ancon of St. Jerome and St. Catherine [*The Madonna of Saint Jerome* by Correggio, now in the Galleria Nazionale, Parma] and the Madonna going into Egypt of the Scodella [*The Madonna della Scodella* by Correggio, now in the Galleria Nazionale, Parma]: and by God I wouldn't trade any of those for St. Cecilia [by Raphael, now in the Pinacoteca Nazionale, Bologna]; isn't the grace of that St. Catherine, who with such grace places her head on that lovely Signorino's foot [This is really Mary Magdalen in the painting of the *Madonna of Saint Jerome,* which he has here mistaken to be Saint Catherine], more beautiful than Mary Magdalen? [in Raphael's *Saint Cecilia*] Isn't that beautiful old man, Saint Jerome [in the *Madonna of Saint Jerome*], both greater and more tender than that Saint Paul [in Raphael's *Saint Cecilia*] who at first seemed to me a miracle, and now seems hard and sharp as wood? There's no more to say, tell your Parmigianino to be patient, because I now know I have been able to imitate all the grace of this great man, because Correggio's little *putti* breathe, live and laugh with a grace and reality such that one is compelled to laugh and be happy with them. I am writing to my brother that he absolutely must come, because he will see things that he would never have believed; entreat him yourself for the love of God, and ask him to hurry those two bills along, because I assure you, we will be at peace, you won't have to speak between us, I will let him say anything he wants, and I will paint, and I have no fear that he won't do the same, and will forget about reasonings and petty arguments which are all a waste of time; I have also advised him that as regards his work I will keep at it, as soon as I've met a few people, I will ask and look for an opportunity; but as the hour is late and in writing both to him

and to my father the day has flown, I will leave it to another letter to explain everything to you in detail, and I kiss your hands.

From Parma, etc.

From Annibale, April 28, 1580

Magnifico Sig. Cugino Osservandiss.

Quando Agostino venirà, sarà il ben venuto, e staremo in pace, e attenderemo a studiare queste belle cose, ma per l'amor di Dio senza contrasti fra noi, e diamo ad impossessarci bene di questo bel modo, che questo ha da essere il nostro negozio, per potere un giorno mortificare tutta questa canaglia berettina, che tutta ci è adosso, come se avessimo assassinato . . . l'occasioni che vorebbe Agostino non si trovano, e questo mi pare un paese che non si crederebbe mai così privo di buon gusto, senza dilettazioni di pittore, e senza occasioni: qui da mangiare e bere e far l'amore non si pensa ad altro: promisi a V.S. darvi ragguaglio del mio sentimento, come ancora restassimo prima di partire, ma io vi confesso ch'è impossibile tanto son confuso: impazzisco e piango dentro di me in pensar solo la infelicità del povero Antonio, un sí grand'uomo, se pure uomo, e non più tosto un angelo in carne, perdersi qui in un paese, ove non fosse conosciuto e posto sino alle stele, e qui doversi morire infelicemente: questo sarà sempre il mio diletto, e Tiziano, e sin che non vado a vedere ancora l'opre di quello a Venezia non moro contento. Queste son le vere, dica pur chi vuole, adesso lo conosco, e dico ch'avete ben ragione: io però non la so mescolare, nè la voglio, mi piace questa schiettezza, a me questa purità che è vera non verisimile, e naturale non artifiziata nè sforzata: ognuno la intende a suo mode, io la intendo a così; io non la so dire, ma so come ho a fare e tanto basta.

È stato a trovarmi due volte il gran caporale, e mi ha voluto condurre a casa sua e mi ha mostrato la bella Santa Margherita e la S. Doratea di V. S. che per Dio son due belle mezze figure: dell'altri dioi quadri vostri io l'ho fatto richiesta ma mi ha detto averli fatto esito con molto suo vantaggio: dice che prenderà da me ancora tutte le teste che copierò dalla cupola, e altre ancora di quadri privati, che mi procurerà del Correggio per copiarle, quando io voglio far con lui di un pane, che ogni un ne possa mangiare: gli ho risposto che la voglio in tutto e per tutto rimettere a lui, perchè in sostanza l'è poi un buon omaccio e di core: mi ha voluto donare per forza un coletto di dante che l'ho molto lodato, e non vi è stato ordine, perchè arrivato a casa me l'aveva già mandato e fatto lasciare: ma di che ne ho io da fare non essendo cosa da me? mi vole ancora a dare un abito nero da città a scontare in tanta pittura: io gli ho detto che lo prenderò e farò d'ogni cosa per lui avendo noi tanta obligazione.

Non ebbi risposta da mio padre: io non so imaginarmi il perchè, se ben dubito sia smarrita, perchè Agostino mi scrive pure che mi rispondeva quell'istesso giorno: son stato alla Steccata, e alli Zocoli, e ho osservato quanto V. S. mi diceva alle volte, e confesso ancora io esser vero, ma io sempre dico quanto il mio gusto che il Parmigiano non abbia che far col Coreggio, perchè quelle del Correggio sono stati suoi pensieri, suoi concetti, che si vede si è cavato lui di sua testa, e inventato da se, assicurandosi solo con l'originale: gli altri sono tutti appoggiati a qualche cosa non sua chi al modello, chi alle statue, chi alle carte tutte le opere degli altri sono rappresentate come possono esser, queste di quest'uomo come veramente sono: io non mi so dichiarare nè lasciarmi capire, ma m'intendo bene dentro di me. Agostino ne saprà ben cavar lui la macchia, e discorrerla per il suo verso. Prego V. S. a sollectarlo e sbrigarsi di quelli dioi rami, e a racordare con bella maniera così come da se quel servizio a nostro padre, che non posso far di meno, nè lo infastidirò poi più, e toccati qualche quattrini, come spero, ne manderò poi, o ne porterò io stesso; e per non più incomodarvi resto di V. S. ec.

From Annibale April 28, 1580:

Magnificent and Most Worthy Cousin:

When Agostino comes, he will be welcome, and we will stay in peace, and we will attend to the study of these beautiful things, but for the love of God without conflict between us, and without all that nitpicking and arguing, let us apply ourselves to learn this beautiful style, as this will be our trade, in order to be able one day to mortify this beret-wearing rabble which attacks us as if we were assassins . . . the opportunities Agostino is looking for don't exist, and this country seems to me one that would never consider itself so lacking in good taste, lacking in the love of the painter, and in opportunity; here one thinks of nothing but eating and drinking well and making love: I promised to give you my thoughts, as we agreed before I left, but I confess that it's impossible, so confused am I: it drives me crazy and I cry inside to think of poor Antonio's [Correggio] misery, such a great man, if indeed a man and not an angel incarnate, to lose himself here in a country where he is neither known nor raised to the stars, and to die unhappily: he will always be my favorite, along with Tiziano, and until I go to see his works in Venice I will not die happy. These are truths, let he who wants to, speak, now I know, and think you're right: but I don't know, nor do I want to, how to mix it, I like this clarity, I like this purity that is real not lifelike, is natural, not artificial nor forced: everyone interprets it his own way, I see it this way: I can't express it, but I know what I must do and that's enough.

The great corporal came, twice to see me, and wanted to take me to his house and showed me the lovely Saint Margaret and your Saint Dorothy which by God are two lovely half figures: I asked him about your other paintings but he said he'd sold them at a great profit: he said he'll take from me all the heads that I copy from the cupola, and others from private paintings, that he will obtain from Correggio for me to copy, whenever I want to form a partnership with him [lit. "make with him one bread that both can eat"]; I answered that I want in all and for all to defer to him, because actually he's a good man: he insisted on giving me a leather collar that I had admired, and there was nothing I could do, because as I arrived home he'd already had it sent; but what am I going to do with it as it's not my style? He wants in addition to give me a black city dress which he'll subtract from a certain amount of painting: I told him I'd take it and will do all he asks for him since we owe him so much.

I've had no answer from my father, I can't imagine why, as I doubt it was lost, since Agostino writes that he was answering me that same day; I've been to the Steccata, and to the Zoccolli, and I observed the things you used to tell me about sometimes, and which I, too, confess to be true, but I maintain that in my opinion Parmigianino holds no candle to Correggio, because Correggio's thoughts were his own, his conceptions as well, that one can see he got from his own head, and invented by himself, contenting himself only with original work: the others all rely on something not of their doing, either models, statues, or paper [drawings], the others' works are represented as they can be, this man's works as they truly are: I don't know how to express myself nor how to make myself understood, but I understand my own reasoning very well. Agostino will know how to clarify it [lit: take out the stain] and use it for his own purposes. I pray you to entreat him to hurry with those two copper pieces, and to remind him nicely so that it seems to be of your initiative, that favor to our father, as I can do no less, but will not bother him any more, and as soon as I obtain some money, as I hope to do, I will send some, or bring it myself; and in order not to bother you any further, I remain, etc.

Agostino from Venice:

Quanto ad Annibale non si poteva fare il più bel colpo quanto è stato questo di farlo immediatamente da Parma passare qua a Venezia, perchè vedute le immense machine di tanti valentuomini e rimasto attonito e stordito, con dire che credeva bene di cotesto paese gran cose, ma mon si sarebbe imaginato mai tanto, e dice che adesso si conosce ch'egli anche è un goffo e non sa nulla: di Paolo poi adesso confessa esser il primo uomo del mondo, che V. S. aveva molto ben ragione se tanto glie lo comendava; che è vero che supera anche il Correggio in molte cose, perchè è più animoso è più inventore ec.

Agostino from Venice:

As for Annibale nothing could have been better than to have him come immediately from Parma here to Venice, because seeing the immense works of so many great men he remained amazed and stunned and said he expected great things from this region but that he would never have imagined so much, and he says that now he recognizes himself to be a clod who doesn't know anything: Paolo [Veronese] he now confesses to be the first man of the world, that you were right in commending him so highly; that it's true he surpasses even Correggio in many things, because he's more animated and original etc.

BOHLIN
CONCORDANCE

Bohlin number and title	Bartsch	Calvesi/ Casale	Ostrow
AGOSTINO			
1 Skull of an Ox (after Giulio Bonasone)	257	3	4
2 Holy Family with Saints Elizabeth, John the Baptist, and Four Angels	44	1	1
3 Holy Family (after Marcantonio Raimondi)	–		8
4 Holy Family with Saints Catherine of Alexandria and John the Baptist (after Bagnacavallo)	–	–	7
5 Saint Catherine	–	–	–
6 Saint Lucy	–	–	–
7 Saint Agatha	–	–	–
8 Saint Margaret	–	–	–
9 Pietà (after Michelangelo)	104	8	12
10 Mater Dolorosa (after Giulio Bonasone)	103	7	13
11 Allegory of the Psalm of David (after Orazio Sammacchini)	5	13	11
12 Adoration of the Magi (after Baldassare Peruzzi)	11	10	10
13 Various Studies	–	–	–
14 Various Studies	–	–	–
15 Madonna and Child Seated on a Crescent Moon (after Domenico Tibaldi)	38	–	–
16 Rest on the Flight into Egypt (after Giorgio Ghisi)	99	–	–
17 Saint Roch (after Cornelis Cort)	87	22	15
18 Saint Sebastian (after Francesco Francia)	88	21	16
19 Parable of The Devil Sowing Tares in the Field	28	–	–
20 Christ and the Samaritan Woman (after Cornelis Cort)	27	19	–
21 Christ and the Samaritan Woman	26	20	14
22 Adoration of the Magi (after Marco del Moro)	10	–	–
23 Baptism of Christ (after Annibale Carracci)	17	23	–
24 The Sudarium of Veronica	–	–	–
25 Adam and Eve (after Annibale Carracci)	1	–	23
26 Tobias and the Angel (after Raffaellino da Reggio)	3	24	18
27 Jacob and Rachel at the Well (after Denys Calvaert)	2	25	19
28 Adoration of the Shepherds (after Marco del Moro)	9	–	22
29 Frieze to Accompany a Map of the City of Bologna	263	26	21
30 Coat of Arms of Cardinal Fieschi	170	28	–
31 Presentation in the Temple (after Orazio Sammachini)	12	18	–
32 Virgin Dropping the Holy Girdle to Saint Thomas (after Orazio Sammacchini)	106	16	–
33 Coronation of the Virgin (after Orazio Sammacchini)	93	17	–
34 The Annunciation (after Orazio Sammacchini)	7	15	–
35 Judith with the Head of Holofernes (after Lorenzo Sabbattini)	4	9	–
36 The Flagellation (after Orazio Sammacchini)	18	12	–
37 Holy Family with Saint John the Baptist and an Angel (after Orazio Sammacchini)	45	–	–
38 Preparation for the Flight into Egypt	14	14	–
39 Rest on the Flight into Egypt (after Cornelis Cort)	15	29	–
40 Mary Magdalen	80	48	20
41 The Virgin Annunciate	30	–	20-C
42 Ecce Homo	19	43	20-B
43 Veronica Holding the Sudarium	89	49	20-A
44 Saint Jerome	72	47	–
45 Saint John the Baptist	71	46	–
46 Salvator Mundi	91	50	–
47 The Madonna	29	44	–
48 Body of Christ Supported by Angels	100	51	–
49 The Holy Family	42	45	–
50 Saint Catherine of Alexandria	64	52	–
51 Saint Justina of Padua	77	58	–
52 Saint Lucy	79	56	–
53 Mary Magdalen	81	57	–
54 Madonna and Child with Saints Peter, Stephen, and Francis (after Orazio Sammacchini)	–	40	–
55 Portrait of Caterina Sforza (after Antonio Campi)	–	–	–
56 Title page to the Cremona Fedelissima Allegory in Honor of Philip II (after Antonio Campi) (56-92 after Antonio Campi)	192	75	33
57 Portrait of Philip II	195	76	–
58 Allegory of the City of Cremona	193	77	33-A
59 The Caroccio of Cremona Led into Battle	194	79	33-B
60 Portrait of Antonio Campi	196	78	–
61 Portrait of Oberto Palavicino	197	80	–
62 Portrait of Bosius Dovaria	198	81	–
63 Portrait of Guglielmo Cavalcabo	199	82	–
64 Portrait of Cabrino Fondulo	200	83	–
65 Portrait of Marco Girolamo Vida	201	84	–
66 Portrait of Francesco Sfondrati	202	85	–
67 Portrait of Ponzino Ponzoni	203	86	–

Bohlin number and title	Bartsch	Calvesi/Casale	Ostrow
68 Portrait of Nicolo Sfondrati	204	87	–
69 Portrait of Gian Galeazzo Visconti	205	88	–
70 Portrait of Caterina Visconti	206	89	–
71 Portrait of Giovanni Maria Visconti	207	90	–
72 Portrait of Antonia Malatesta	208	91	–
73 Portrait of Filippo Maria Visconti	209	92	–
74 Portrait of Beatrice de Tenda	210	93	–
75 Portrait of Francesco Sforza	211	94	–
76 Portrait of Bianco Maria Visconti	212	95	–
77 Portrait of Galleazzo Maria Sforza	213	96	–
78 Portrait of Bona Filiberti	214	97	–
79 Portrait of Gian Galeazzo Maria Sforza	215	98	–
80 Portrait of Isabella of Aragon	216	99	–
81 Portrait of Lodovico Maria Sforza	217	100	–
82 Portrait of Beatrice d'Este	218	101	–
83 Portrait of Massimiliano Sforza	219	102	–
84 Portrait of Francesco Maria Sforza	220	103	–
85 Portrait of Christina of Denmark	221	104	–
86 Portrait of the Emperor Charles V	222	105	–
87 Portrait of Isabella of Portugal	223	106	–
88 Portrait of Philip II of Spain	230	107	–
89 Portrait of Maria of Portugal	225	108	–
90 Portrait of Mary, Queen of England	226	109	–
91 Portrait of Elizabeth of Valois	227	110	–
92 Portrait of Anna of Austria	228	111	–
93 Coat of Arms of Cardinal Vincenzo Lauri	173	–	–
94 Coat of Arms of Marchese Emmanuele Filiberti Molazani	174	–	–
95 Dog	259	42	–
96 Portrait of Giovanni Tommasso Constanzo	142	–	–
97 The Virgin Annunciate	35	–	–
98 Madonna and Child on the Clouds (after Federico Barocci)	32	41	24
99 Madonna and Child on the Clouds	36	129	–
100 Print for the Confraternity of the Name of God	108	38	29
101 The Temptation of Saint Anthony (after Jacopo Tintoretto)	63	36	28
102 Pietà (after Paolo Veronese)	102	33	27
103 Holy Family with Saints John the Baptist, Catherine, and Anthony Abbot (after Paolo Veronese)	96	31	–
104 The Mystic Marriage of Saint Catherine (after Paolo Veronese)	98	35	25
105 The Martyrdom of Saint Justina of Padua (after Paolo Veronese)	78	34	26
106 The Madonna Protecting Two Members of a Confraternity (after Paolo Veronese)	105	32	–
107 The Crucifixion (after Paolo Veronese)	21	30	–
108 Saint Paul Raising Patroclus (after Antonio Campi)	85	74	32
109 Saint John the Baptist	50	61	31-C
110 Salvator Mundi	48	59	31-A
111 The Virgin Mary	49	60	31-B
112 Saint Bartholomew	56	71	31-H
113 Saint Thomas	58	72	31-J
114 Saint Peter	51	73	31-D
115 Saint Matthew	57	68	31-I
116 Saint Andrew	52	69	31-E
117 Saint John	54	70	31
118 Saint James Minor	59	62	31-K
119 Saint James Major	53	63	31-F
120 Saint Matthias	62	64	31-N
121 Saint Simon	60	65	31-L
122 Saint Philip	55	66	31-G
123 Saint Judas Thaddeus	61	67	31-M
124 Saint Francis Receiving the Stigmata	65	53	–
125 Saint Jerome	73	55	–
126 Saint Francis Adoring the Crucifix	66	54	–
127 Portrait of Bernardino Campi	139	114	–
128 Coat of Arms of Giacomo Boncampagni, Marchese of Vignola	165	116	–
129 Saint Malachy	84	–	–
130 The Holy Trinity (after Cornelis Cort)	92	–	–
131 Saint Francis of Quito Preaching	–	–	–
132 Portrait of Carlo Borromeo (after Francesco Terzo)	138	117	–
133 The Mystic Marriage of Saint Catherine (after Paolo Veronese)	97	118	34
134 Various Studies	–	119	–
135 Title Page for the Vita di Cosimo de'Medici	262	–	36
136 Cartouche Surrounding a Portrait of Cosimo de'Medici	140	27	–
137 The Letter A with an Eagle	264	–	–
138 Oval vignette with Sun and Moon and Crowns	267	–	–
139 Pastoral Scene for the title page of Horace's Odes	268	–	–
140 Saint Francis Receiving the Stigmata (partially after Lodovico Carracci)	68	121	37
141 The Cordons of Saint Francis	109	120	35
142 The Madonna of Saint Jerome (after Cornelis Cort after Antonio Correggio)	95	122	38
143 Ecce Homo (after Antonio Correggio)	20	123	39
144 Portrait of a Man	156	–	–
145 Portrait of Titian (after Titian)	154	124	–
146 The Madonna Appearing to Saint Jerome (after Jacopo Tintoretto)	76	125	40
147 The Crucifixion	23	37	42
148 Mars Driven Away from Peace and Abundance by Minerva (after Jacopo Tintoretto)	118	126	43
149 Mercury and the Three Graces (after Jacopo Tintoretto)	117	127	–
150 The Madonna and Child Seated on a Crescent Moon (after Jacopo Ligozzi)	34	128	44
151 Portrait of Ferdinand, the Grand Duke of Tuscany	145	–	–
152 Portrait of Christine of Lorraine	141	–	–
153 The Harmony of the Spheres (after Andrea Boscoli)	121	168	–
154 Apollo and the Python (after			

Bohlin number and title	Bartsch	Calvesi/Casale	Ostrow
R 6 L'Informe	241	–	–
R 7 Il Deliberato	242	–	–
R 8 Il Tetro	243	–	–
R 9 L'Involto	244	–	–
R 10 L'Indefesso	247	–	–
R 11 Print for the Confraternity of Saint Roch	86	–	–
R 12 Emblem of the Heirs of Giovanni Agocchia and Sforza Certani	270	–	–
R 13 Emblem of Giovanni Fiumi's Shop	269	–	–
R 14 Emblem of Sforza Certani	–	167	–
R 15 Saint James Major	70	–	9
R 16- R 22 Various Masks	250-256	–	–
R 23 Aeneas and Anchises	111	–	30
R 24 Dancing Nymphs	113	–	–
R 25 Portrait of Cesare Rinaldi	151	–	–
R 26 Portrait of Pietro Opezingo	–	155	–
R 27 Portrait of Obizzo Annibale Marescalchi	–	156	–
R 28 Virgin Nursing the Christ Child in a Landscape	39	170	49
R 29 Mary Magdalen	83	–	–
R 30 Satyr Spying a Sleeping Woman	112	178	–
R 31 Coat of Arms of Cardinal Bartolomeo Cesi	163		
R 32 Coat of Arms of Cardinal Antonio Fachenetti	168	–	–
R 33 Coat of Arms of Cardinal Sampieri	178	–	–
R 34 Cartouche with Cornucopiae	266	–	–
R 35 Bear and a Bee	258	–	–
R 36 Title page to the Tempio all' . . . Cinthio Aldobrandini	261	166	–
R 37 Announcement of a meeting of the Accademia degli Incamminati	272	–	–
R 38 Portrait of Dr. Gabriele Faloppio	144		
R 39 Coat of Arms of Cardinal Antonio Fachenetti(?)	169	–	–
R 40 Cartouche for the Coat of Arms of a Pope	158	–	–
R 41 Saint Francis de Paul	69	130	–
R 42 Mary Magdalen	82	–	52
R 43 Bust of the Saviour	90	–	–
R 44 Cartouche for the Coat of Arms of a Cardinal	157		
R 45 Jonah and the Whale	6	–	–
R 46 The Legendary Prester John, King of the Indies	152	–	–
R 47 Model for a Keyhole	273	176	–
R 48 Model for a Keyhole	274	176 bis	–
R 49 Coat of Arms of Cardinal Francesco Sforza (?)	180	–	–
R 50 Portrait of Pope Gregory XIII	148	–	–
R 51 Map of the City of Cremona	–	112	–
R 52 The Resurrection	24	–	–
R 53 The Presentation in the Temple	13	4	–
R 54 The Annunciation	8	–	–

Bohlin number and title	Bartsch	Calvesi/Casale	Ostrow
R 55 Madonna and Child Seated on a Crescent Moon	37	–	5
R 56 Madonna and Child	41	–	–
R 57 Madonna and Child with Saint John the Baptist	46	–	–
R 58 Holy Family under the Oak	47	–	–
R 59 The Mystical Crucifix	107	6	–

ANNIBALE

Bohlin number and title	Bartsch	Calvesi/Casale	Posner
1 The Crucifixion	5	p. 6	II, p. 12
2 Holy Family with Saints John the Baptist and Michael (after Lorenzo Sabbattini & Denys Calvaert)	12	39	II, p. 12
3 Madonna and Child on the Clouds (after Federico Barocci)	10 & Agostino 33	191	213R
4 Saint Jerome	13	192	22
5 The Madonna Nursing the Christ Child	6	197	37
6 Various Studies	–	198	under 37
7 Saint Francis of Assisi	15	193	23
8 The Crucifixion	–	194	23b
9 The Madonna of the Swallow	8	195	36
10 Various Studies	–	196	under 36
11 The Holy Family with Saint John the Baptist	11	200	56
12 Mary Magdalen in the Wilderness	16	203	63
13 Saint Jerome in the Wilderness	14	204	64
14 Susanna and the Elders	1	207	57
15 Madonna and Child with an Angel	7	216	173
16 The Madonna and Child	31 as Agostino	201	55
17 Venus and a Satyr (after Agostino Carracci?)	17	206	66
18 Pietà ("The Christ of Caprarola")	4	211	97
19 The Drunken Silenus ("The Tazza Farnese")	18	214	113
20 Madonna and Child with Saints Elizabeth and John the Baptist (La Madonna della Scodella)	9	218	176
21 Christ Crowned with Thorns	3	219	174
22 The Adoration of the Shepherds	2	215	175
R 1 The Christ Child and Saint John the Baptist	app. p. 204	199	212 R
R 2 Saint John the Baptist in the Wilderness	–	205	214 R
R 3 Virgin with a Pillow	4 as Brizio	202	84

LODOVICO

Bohlin number and title	Bartsch	Calvesi/Casale	Posner
1 The Holy Family Under an Arch	4	187	
2 Madonna Nursing the Christ Child	1	188	
3 Madonna and Child with Angels	2	189	
4 Madonna and Child with Saint John	3	190	
R 1 The Virgin Washing Linen	5	186	

Bohlin Number and Title	Bartsch	Calvesi/Casale

FRANCESCO

1 *Madonna and Child on the Clouds*
 (after Annibale Carracci?) 1 —

2 *Saint Francis Consoled by the*
 Musical Angel (after Agostino
 Carracci) — —

BARTSCH
CONCORDANCE

Bartsch		Bohlin	Calvesi/ Casale	Ostrow	Bartsch	Bohlin	Calvesi/ Casale	Ostrow
AGOSTINO					47	R 58	—	—
1		25	—	23	48	110	59	31-A
2		27	25	19	49	111	60	31-B
3		26	24	18	50	109	61	31-C
4		35	9	—	51	114	73	31-D
5		11	13	11	52	116	69	31-E
6		R 45	—	—	53	119	63	31-F
7		34	15	—	54	117	70	31
8		R 54	—	—	55	122	66	31-G
9		28	—	22	56	112	71	31-H
10		22	—	—	57	115	68	31-I
11		12	10	10	58	113	58	31-J
12		31	18	—	59	118	62	31-K
13		R 53	4	—	60	121	65	31-L
14		38	14	—	61	123	67	31-M
15		39	29	—	62	120	64	31-N
16		216	—	—	63	101	36	28
17		23	23	—	64	50	52	—
18		36	12	—	65	124	53	—
19		42	43	20-B	66	126	54	—
20		143	123	39	67	203	171	47
21		107	30	—	68	140	121	37
22		216	11	17	69	R 41	130	—
23		147	37	42	70	R 15	—	9
24		R 52	—	6	71	45	46	—
25		222	5	41	72	44	47	—
26		21	20	14	73	125	55	—
27		20	19	—	74	204	174	—
28		19	—	—	75	213	179	54
29		47	44	—	76	146	125	40
30		41	—	20-C	77	51	58	—
31	Annibale	16	201	— (Pos 55)	78	105	34	26
32		98	41	24	79	52	56	—
33	Annibale	3	191	— (Pos 213)	80	40	48	20
34		150	128	44	81	53	57	—
35		97	—	—	82	R 42	—	52
36		99	129	—	83	R 29	—	—
37		R 55	—	5	84	129	—	—
38		15	—	—	85	108	74	32
39		R 28	170	49	86	R 11	—	—
40		214	2	—	87	17	22	15
41		R 56	—	—	88	18	21	16
42		49	45	—	89	43	49	20-A
43		208	175	50	90	R 43	—	—
44		2	1	1	91	46	50	—
45		37	—	—	92	130	—	—
46		R 57	—	—	93	33	17	—

Bartsch	Bohlin	Calvesi/Casale	Ostrow	Bartsch	Bohlin	Calvesi/Casale	Ostrow
94	4	—	7	147	231	—	—
95	142	122	38	148	R 50	—	—
96	103	31	—	149	194	—	—
97	133	118	34	150	175	—	—
98	104	35	25	151	R 25	—	—
99	16	—	—	152	R 46	—	—
100	48	51	—	153	212	173	—
101	209	—	51	154	145	124	—
102	102	33	27	155	223	—	—
103	10	7	13	156	144	—	—
104	9	8	12	157	R 44	—	—
105	106	32	—	158	R 40	—	—
106	32	16	—	159	201	115	—
107	R 59	6	—	160	202	159	—
108	100	38	29	161	198	162	—
109	141	120	35	162	232	162 ter	—
110	203	172	48	163	R 31	—	—
111	R 23	—	30	164	230	—	—
112	R 30	178	—	165	128	116	—
113	R 24	—	—	166	226	—	—
114	190	144	—	167	234	161	—
115	211	—	—	168	R 32	—	—
116	210	177	53	169	R 39	—	—
117	149	127	—	170	30	28	—
118	148	126	43	171	196	164	—
119	191	158	—	172	195	160	—
120	192	under 58	—	173	93	—	—
121	153	168	—	174	94	—	—
122	154	169	—	175	224	—	—
123	178	135	—	176	200	163	—
124	176	136	—	177	197	165	—
125	179	137	—	178	R 33	—	—
126	180	—	—	179	229	157	—
127	177	138	—	180	R 49	—	—
128	184	139	—	181	225	131	—
129	181	140	—	182	155	145	—
130	183	—	—	183	156	146	—
131	185	—	—	184	157	147	—
132	188	141	—	185	158	148	45
133	186	142	—	186	159	149	—
134	187	—	—	187	160	150	—
135	182	143	—	188	161	151	—
136	189	—	—	189	162	152	—
137	207	—	pp. 397-398	190	163	153	45-A
138	132	117	—	191	164	154	—
139	127	114	—	192	56	75	33
140	136	27	—	193	58	77	33-A
141	152	—	—	194	59	79	33-B
142	96	—	—	195	57	76	—
143	206	113	—	196	60	78	—
144	R 38	—	2	197	61	80	—
145	151	—	—	198	62	81	—
146	215	—	3	199	63	82	—

Bartsch	Bohlin	Calvesi/ Casale	Ostrow	Bartsch	Bohlin	Calvesi/ Casale	Ostrow
200	64	83	—	252	R 18	—	—
201	65	84	—	253	R 19	—	—
202	66	85	—	254	R 20	—	—
203	67	86	—	255	R 21	—	—
204	68	87	—	256	R 22	—	—
205	69	88	—	257	1	3	4
206	70	89	—	258	R 35	—	—
207	71	90	—	259	95	42	—
208	72	91	—	260	193	134	—
209	73	92	—	261	R 36	166	—
210	74	93	—	262	135	—	36
211	75	94	—	263	29	26	21
212	76	95	—	264	137	—	—
213	77	96	—	265	228	—	—
214	78	97	—	266	R 34	—	—
215	79	98	—	267	138	—	—
216	80	99	—	268	139	—	—
217	81	100	—	269	R 13	—	—
218	82	101	—	270	R 12	—	—
219	83	102	—	271	227	133	—
220	84	103	—	272	R 37	—	—
221	85	104	—	273	R 47	176	—
222	86	105	—	274	R 48	176 bis	—

Bartsch	Bohlin	Calvesi/ Casale	Ostrow
223	87	106	—
224	57	76	—
225	89	108	—
226	90	109	—
227	91	110	—
228	92	111	—
229	220	—	—
230	88	107	—
231	165	132	46
232	174	—	—
233	170	—	—
234	169	—	—
235	166	—	—
236	R 1	—	—
237	R 2	—	—
238	R 3	—	—
239	R 4	—	—
240	R 5	—	—
241	R 6	—	—
242	R 7	—	—
243	R 8	—	—
244	R 9	—	—
245	168	—	—
246	171	—	—
247	R 10	—	—
248	167	—	—
249	173	—	—
250	R 16	—	—
251	R 17	—	—

ANNIBALE

	Bohlin	Calvesi/ Casale	Posner
1	14	207	57
2	22	215	175
3	21	219	174
4	18	211	97
5	1	p. 6	II, p. 12
6	5	197	37
7	15	216	173
8	9	195	36
9	20	218	176
10	3 & Agostino 35	191	213 R
11	11	200	56
12	2	39	II, p. 12
13	4	192	22
14	13	204	64
15	7	193	23
16	12	203	63
17	17	206	66
18	19	214	113

LODOVICO

	Bohlin	Calvesi/ Casale	
1	2	188	
2	3	189	
3	4	190	
4	1	187	
5	R 1	186	

CALVESI/CASALE CONCORDANCE:

Calvesi/Casale	Bohlin	Bartsch	Ostrow	Calvesi/Casale	Bohlin	Bartsch	Ostrow
AGOSTINO							
1	2	44	1	47	44	72	—
2	214	40	—	48	40	80	20
3	1	257	4	49	43	89	20-A
4	R 53	13	—	50	46	91	—
5	222	25	41	51	48	100	—
6	R 59	107	17	52	50	64	—
7	10	103	13	53	124	65	—
8	9	104	12	54	126	66	—
9	35	4	—	55	125	73	—
10	12	22	—	56	52	79	—
11	217	22	—	57	53	81	—
12	36	18	—	58	51	77	—
13	11	5	11	59	110	48	31-A
14	38	14	—	60	111	49	31-B
15	34	7	—	61	109	50	31-C
16	32	106	—	62	118	59	31-K
17	33	93	—	63	119	53	31-F
18	31	12	—	64	120	62	31-N
19	20	27	—	65	121	60	31-L
20	21	26	14	66	122	55	31-G
21	18	88	16	67	123	61	31-M
22	17	87	15	68	115	57	31-I
23	23	17	—	69	116	52	31-E
24	26	3	18	70	117	54	31
25	27	2	19	71	112	56	31-H
26	29	263	21	72	113	58	31-J
27	136	140	—	73	114	51	31-D
28	172	28	—	74	108	85	32
29	39	15	—	75	56	192	33
30	107	21	—	76	57	195	—
31	103	96	—	77	58	193	33-A
32	106	105	—	78	60	196	—
33	102	102	27	79	59	194	33-B
34	105	78	26	80	61	197	—
35	104	98	25	81	62	198	—
36	101	63	28	82	63	199	—
37	147	23	42	83	64	200	—
38	100	108	29	84	65	201	—
39	Ann. 2	Ann. 12	—	85	66	202	—
40	54	—	—	86	67	203	—
41	98	32	24	87	68	204	—
42	95	259	—	88	69	205	—
43	42	19	20-B	89	70	206	—
44	47	29	—	90	71	207	—
45	49	42	—	91	72	208	—
46	45	71	—	92	73	209	—

Calvesi/Casale	Bohlin	Bartsch	Ostrow	Calvesi/Casale	Bohlin	Bartsch	Ostrow
93	74	210	—	147	157	184	—
94	75	211	—	148	158	185	45
95	76	212	—	149	159	186	—
96	77	213	—	150	160	187	—
97	78	214	—	151	161	188	—
98	79	215	—	152	162	189	—
99	80	216	—	153	163	190	45-A
100	81	217	—	154	164	191	—
101	82	218	—	155	R 26	—	—
102	83	219	—	156	R 27	—	—
103	84	220	—	157	229	179	—
104	85	221	—	158	191	119	—
105	86	222	—	159	202	160	—
106	87	223	—	160	195	172	—
107	88	230	—	161	234	167	—
108	89	225	—	162	198	161 & 162	—
109	90	226	—	163	200	176	—
110	91	227	—	164	196	171	—
111	92	228	—	165	197	177	—
112	R 51	—	—	166	R 36	261	—
113	206	143	—	167	R 12	270	—
114	127	139	—	168	153	121	—
115	201	159	—	169	154	122	—
116	128	165	—	170	R 28	39	49
117	132	138	—	171	204	67	47
118	133	97	34	172	203	110	48
119	134	—	—	173	212	153	—
120	141	109	35	174	205	74	—
121	140	68	37	175	208	43	50
122	142	95	38	176	R 47	273	—
123	143	20	39	176 bis	R 48	274	—
124	145	154	—	177	210	116	53
125	146	76	40	178	R 51	112	—
126	148	118	43	179	213	75	54
127	149	117	—	180	App.		—
128	150	34	44		p. 159		
129	99	36	—	181	—		—
130	R 41	69	—	182	—		—
131	225	181	—	183	—		—
132	165	231	46	184	—		—
133	227	271	—	185	—		—
134	193	260	—				
135	178	123	—				
136	176	124	—				
137	179	125	—				
138	177	127	—				
139	184	128	—				
140	181	129	—				
141	188	132	—				
142	186	133	—				
143	182	135	—				
144	190	114	—				
145	155	182	—				
146	156	183	—				

Calvesi/Casale	Bohlin	Bartsch	
LODOVICO			
186	R 1	5	
187	1	4	
188	2	1	
189	3	2	
190	4	3	

			Posner
ANNIBALE			
191	3	10	213 R
192	4	13	22
193	7	15	23
194	8	—	23b
195	9	8	36
196	10	—	under 36
197	5	6	37
198	6	—	under 37
199	R 1	App. p. 204	212 R
200	11	11	56
201	16	Agostino 31	55
202	R 3	Brizio 4	84
203	12	16	63
204	13	14	64
205	R 2	—	214 R
206	17	17	66
207	14	1	57
208	—	Reni 52	—
209	—	Reni 53	—
210	—	Annibale p. 199 no. 1	—
211	18	4	97

OSTROW
CONCORDANCE

Ostrow	Bohlin	Bartsch	Calvesi/Casale	Ostrow	Bohlin	Bartsch	Calvesi/Casale
AGOSTINO							
1	2	44	1	31-M	123	61	67
2	R 38	144	—	31-N	120	62	64
3	215	146	—	32	108	85	74
4	1	257	3	33	56	192	75
5	R 55	37	—	33-A	58	193	77
6	R 52	24	—	33-B	59	194	79
7	4	94	—	34	133	97	118
8	3	—	—	35	141	109	120
9	R 15	70	—	36	135	262	—
10	12	11	10	37	140	68	121
11	11	5	13	38	142	95	122
12	9	104	8	39	143	20	123
13	10	103	7	40	146	76	125
14	21	26	20	41	222	25	5
15	17	87	22	42	147	23	37
16	18	88	21	43	148	118	126
17	217	22	11	44	150	34	128
18	26	3	24	45	158	185	148
19	27	2	25	45-A	163	190	153
20	40	80	48	46	165	231	132
20-A	43	89	49	47	204	67	171
20-B	42	19	43	48	203	110	172
20-C	41	30	—	49	R 28	39	170
21	29	263	26	50	208	43	175
22	28	9	—	51	209	101	—
23	25	1	—	52	R 42	82	—
24	98	32	41	53	210	116	177
25	104	98	35	54	213	75	179
26	105	78	34				
27	102	102	33				
28	101	63	36				
29	100	108	38				
30	R 23	111	—				
31	117	54	70				
31-A	110	48	59				
31-B	111	49	60				
31-C	109	50	61				
31-D	114	51	73				
31-E	116	52	69				
31-F	119	53	63				
31-G	122	55	66				
31-H	112	56	71				
31-I	115	57	68				
31-J	113	58	72				
31-K	118	59	62				
31-L	121	60	65				

INDEX OF TITLES

AGOSTINO

Numbers refer to catalogue numbers

INDEX OF
SUBJECT MATTER:

INDEX OF ARTISTS
REPRODUCED IN
CARRACCI PRINTS

Numbers refer to catalogue entries. Unless specified otherwise, catalogue entries are those of Agostino. Brackets indicate that the origin of the composition belongs to that artist but came to the Carracci via an intermediary.

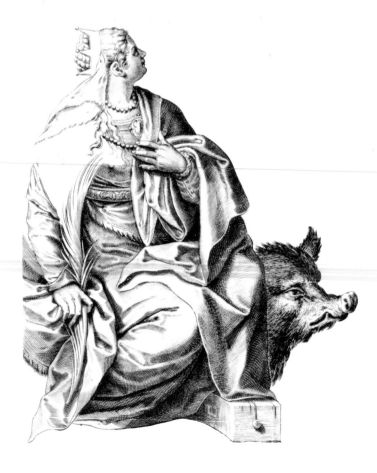

PHOTOGRAPHIC CREDITS

Photographs were provided by the owners of the works reproduced except in the following instances:

Alinari	AGOSTINO: figs. 101a, 103a, 104a, 107a, 142b, 147a, 148a, 149a.
Jörg P. Anders, Berlin	AGOSTINO: figs. 20b, 145a, cat. nos. 188, 203, 218, R25.
Annan, Glasgow	ANNIBALE: fig. 22c.
Will Brown, Philadelphia	AGOSTINO cat. nos. 106, state II, 153, state I, 154, state II, 182, 212, state II, 214, state I.
A. C. Cooper, Ltd., London	AGOSTINO: fig. 212a; all drawings belonging to the Royal Library, Windsor Castle.
Courtauld Institute of Art	AGOSTINO: fig. 153d, cat. no. 212, state I.
	ANNIBALE: figs. 2b, 21a.
Lino DiMarzo, Castello Sforzesco, Milan	AGOSTINO: fig. 108a
John R. Freeman & Co., London	AGOSTINO: figs. 3a, 10b, 130a, 142a, 188a, 204a, cat. nos. 103, state I, R35, frontispiece.
Lichtbildwerkstätte "Alpenland," Vienna	All works belonging to the Graphische Sammlung Albertina, Vienna.
Giorgio Liverani, Forli	AGOSTINO: fig. 34a.
Sotheby & Co., London	Fig. L, LODOVICO fig. 4b.
A Vasari e Figli, Rome	AGOSTINO: cat. nos. 13, 14, 199.
A. Villani & Figli, Bologna	AGOSTINO: fig. 208b; all works belonging to the Pinacoteca Nazionale, Bologna.

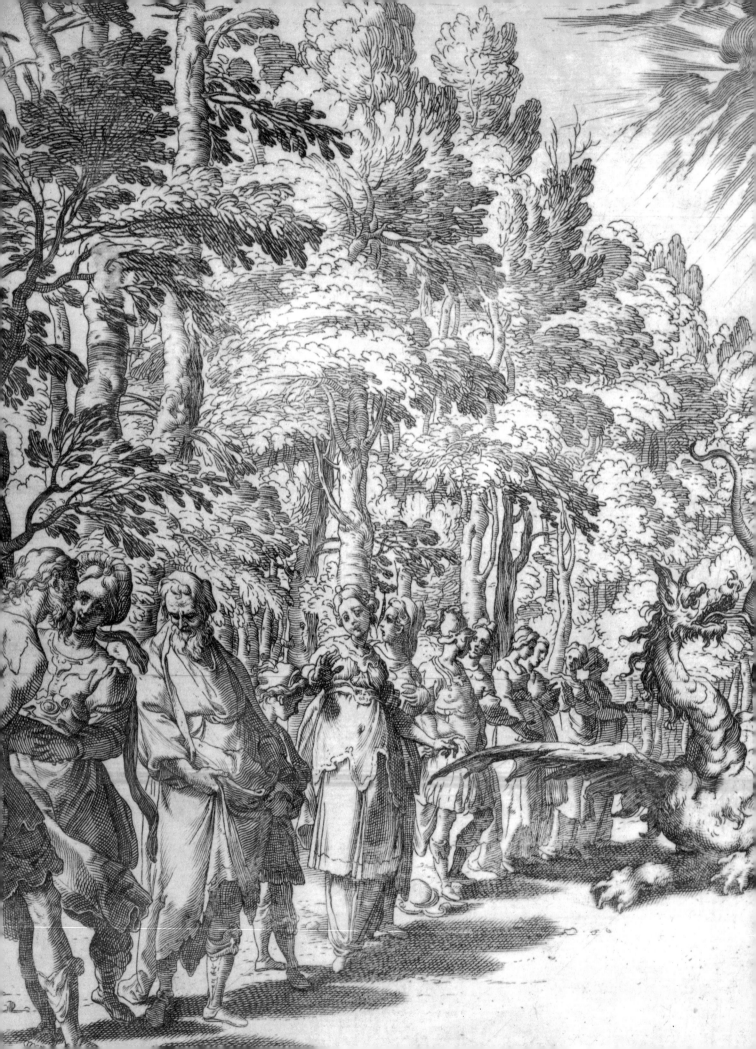